SO-BNR-683

The Nineteenth-Century Visual Culture Reader

The nineteenth century is central to contemporary discussions of visual culture, as it saw the growth of new visual technologies such as photography and cinema, and the development of the modern city and consumer societies. The editors of this Reader have brought together key writings on this subject which focus on the nineteenth century, suggesting that "modernity" rather than "Modernism" is a valuable way of conceiving the changes particular to visual culture in this period. Taken together, these articles advance not just knowledge of the period but also the very consciousness of vision and visuality in this era.

The Reader comprises the following sections, each with an introduction by the editors:

* Visual Culture and Disciplinary Practices
* Genealogies
* Technology and Vision
* Practices of Display and the Circulation of Images
* Cities and the Built Environment
* Visualizing the Past
* Imagining Differences
* Inside and Out: Seeing the Personal and the Political

Vanessa R. Schwartz is Associate Professor of History at the University of Southern California. She is the author of *Spectacular Realities: Early Mass Culture in Fin-de-siècle Paris* (1998) and co-editor, with Leo Charney, of *Cinema and the Invention of Modern Life* (1996).

Jeannene M. Przyblyski teaches in the graduate program at the San Francisco Art Institute and is Executive Director of the San Francisco Bureau of Urban Secrets, an arts and urbanism think tank. She has published widely on photography and cities.

In Sight: Visual Culture
Series Editor: Nicholas Mirzoeff

This series intends to promote the consolidation, development, and thinking-through of the exciting interdisciplinary field of visual culture in specific areas of study. These will range from thematic questions of ethnicity, gender, and sexuality to examinations of particular geographical locations and historical periods. As visual media converge on digital technology, a key theme will be to what extent culture should be seen as specifically visual and what that implies for a critical engagement with global capital. The books are intended as resources for students, researchers, and general readers.

The Feminism and Visual Culture Reader
Edited by Amelia Jones

The Nineteenth-Century Visual Culture Reader
Edited by Vanessa R. Schwartz and Jeannene M. Przyblyski

The Nineteenth-Century Visual Culture Reader

Edited by

Vanessa R. Schwartz and Jeannene M. Przyblyski

Routledge
Taylor & Francis Group

NEW YORK AND LONDON

First published 2004
by Routledge
29 West 35th Street, New York, NY 10001

Simultaneously published
by Routledge
11 New Fetter Lane, London EC4P 4EE

Routledge is an imprint of the Taylor & Francis Group

Selection and editorial material © 2004 Vanessa R. Schwartz and
Jeannene M. Przyblyski

Individual chapters © 2004 the copyright holders

Typeset in Bell Gothic and Perpetua by
Florence Production Ltd, Stoodleigh, Devon
Printed and bound in Great Britain by
TJ International Ltd, Padstow, Cornwall

All rights reserved. No part of this book may be reprinted or
reproduced or utilized in any form or by any electronic, mechanical,
or other means, now known or hereafter invented, including
photocopying and recording, or in any information storage or
retrieval system, without permission in writing from the
publishers.

Library of Congress Cataloging in Publication Data
The nineteenth century visual culture reader/edited by Vanessa R. Schwartz and
Jeannene M. Przyblyski.
 p. cm. – (In-sight visual culture)
 Includes bibliographical references.
 1. Arts and society – History – 19th century. 2. Visual communication –
History – 19th century. 3. Communication and culture – History –
19th century. I. Title: 19th century visual culture reader.
 II. Schwartz, Vanessa R. III. Przyblyski, Jeannene M. IV. Series.
 NX180.S6N55 2004
 701′.03′09034 – dc22 2003025852

British Library Cataloguing in Publication Data
A catalogue record for this book is available from the British Library

ISBN 0–415–30865–8 (hbk)
ISBN 0–415–30866–6 (pbk)

Contents

PART THREE
Technology and Vision

PART FOUR
Practices of Display and the Circulation of Images

PART FIVE
Cities and the Built Environment

PART SIX
Visualizing the Past

PART SEVEN
Imagining Differences

PART EIGHT
Inside and Out: Seeing the Personal and the Political

Illustrations

Notes on contributors

Eric Ames is Assistant Professor of Germanics at the University of Washington, Seattle. He is completing a manuscript on cinema, exoticism and German modernity.

Charles Baudelaire (1821–67) was a French poet and critic. Perhaps best known for his poetry collection *Les Fleurs du mal* (*The Flowers of Evil*) (1857), *The Painter of Modern Life* (1863) can be considered as a foundational text of modern aesthetic criticism.

Walter Benjamin (1892–1940) was a German critic and philosopher whose writings, while living in exile in France, are among the most read and cited by scholars of nineteenth-century visual culture. His unfinished work, *The Arcades Project*, was published in English translation in 1999 by Harvard University Press.

Tony Bennett is Professor of Cultural Studies at Griffith University, Australia. His books include *The Birth of the Museum* (1995).

T.J. Clark is Professor of the History of Art at the University of California, Berkeley, where he holds the George C. and Helen N. Pardee Chair of Modern Art. His most recent book is *Farewell to an Idea: Episodes from a History of Modernism* (1999).

S. Hollis Clayson is Professor of Art History at Northwestern University. Most recently she authored *Paris in Despair: Art and Everyday Life Under Siege (1870–71)* (2002).

Margaret Cohen is Professor of French at Stanford University. Her publications include *Profane Illumination: Walter Benjamin and the Paris of Surrrealist Revolution* (1993), and *The Sentimental Education of the Novel* (1999).

Jonathan Crary is Professor of Art History at Columbia University. He is the author of *Techniques of the Observer* (1992) and *Suspension of Perception* (2001).

Michel Foucault (1926–84) was a French philosopher who has been highly influential in theorizing the constraints of modern visual culture. See especially his *Discipline and Punish* (1975).

Sigmund Freud (1856–1939) was the founder of psychoanalysis. From 1902 to 1938 he was Professor Extraordinary of Neurology at the University of Vienna. His many books and studies, including *The Interpretation of Dreams, Totem and Taboo*, and *The Psychopathology of Everyday Life*, are read not only by members of the psychoanalytic profession but by humanities scholars who have used them as fundamental methodological texts for interdisciplinary studies.

Gisèle Freund (1908–2000) was a Berlin-born photographer who spent most of her professional life in Paris. A founding member of the photo agency Magnum, she published *Photography and Society* in 1974.

Darcy Grimaldo Grigsby is Associate Professor of the History of Art at the University of California, Berkeley. Her publications include *Extremities: Painting Empire in Post-Revolutionary France* (2002).

Tom Gunning is Edwin A. and Betty L. Bergman Distinguished Service Professor in the Humanities at the University of Chicago. He is the author of *D. W. Griffith and the Origins of American Film Narrative* (1991), *Fritz Lang* (2000), and countless influential articles on early film.

David Henkin is Associate Professor of History at UC, Berkeley. He is the author of *City Reading* (1998).

Anne Higonnet is Professor of Art History at Barnard College, New York. Her publications include *Berthe Morisot* (1990) and *Pictures of Innocence* (1998).

Joy S. Kasson is Bowman and Gordon Gray Professor of American Studies and English at the University of North Carolina, Chapel Hill. She is the author of *Buffalo Bill's Wild West* (2000).

Siegfried Kracauer (1889–1966) was the author of *From Caligari to Hitler* (1947) and essays collected as *The Mass Ornament* (1963).

Sharon Marcus is Associate Professor of English at Columbia University. She is the author of *Apartment Stories* (1999).

Karl Marx (1818–83) was one of the most influential thinkers of the nineteenth century. His magnum opus, *Capital* (1867), and his notion of "world literature" in *The Communist Manifesto* (1848) are of particular interest in this context.

Linda Nochlin is the Lila Acheson Wallace Professor of Modern Art at the Institute of Fine Arts, New York University. Her publications include *The Politics of Vision: Essays in Nineteenth-Century Art and Society* (1989), *The Body in Pieces* (1994), and *Representing Women* (1999).

Pierre Nora is Editorial Director at Editions Gallimard, editor of the journal *Le Débat*, and Directeur d'Etudes at the Ecole des Hautes Etudes en Sciences Sociales, Paris. He directed and edited the multi-volume series on French cultural memory, *Les Lieux de Mémoire*, which has had broad ramifications for the understanding of historical memory in general.

David Nye is Professor of American History at Odense University, Denmark. His most recent publication is *Narratives and Spaces: Technology and the Construction of American Culture* (1998).

Jeannene M. Przyblyski teaches in the graduate program at the San Francisco Art Institute and is executive director of the San Francisco Bureau of Urban Secrets. Her publications include *The Camera on the Barricades: Photography and the Paris Commune of 1871* (forthcoming).

Erika Rappaport is Associate Professor of History at the University of California, Santa Barbara. She is the author of *Shopping for Pleasure* (2000).

Alois Riegl (1858–1905) was one of the founding figures of art history. Important texts include *Problems of Style: Foundations for a History of Ornament* (1893), "The Dutch Group Portrait" (1902), and "The Modern Cult of Monuments" (1903).

James R. Ryan is Lecturer in Human Geography at Queen's University, Belfast, Northern Ireland. His publications include *Picturing Empire* (1997) and co-editor, with Joan Schwartz, of *Picturing Place* (2003).

Maurice Samuels is Assistant Professor of French at the University of Pennsylvania. His book on realism and the rise of the historical imagination is forthcoming from Cornell University Press, 2005.

Kirk Savage is Associate Professor of Art History at the University of Pittsburgh. He is the author of *Standing Soldiers, Kneeling Slaves* (1997).

Wolfgang Schivelbusch is a cultural historian who lives and works in Berlin and New York. He is the author of *The Railway Journey. The Industrialization of Time and Space in the Nineteenth Century* (1986).

Carl E. Schorske is Professor of History, Emeritus, at Princeton University. His many publications include *Fin-de-Siècle Vienna* (1981).

Vanessa R. Schwartz is Associate Professor of History at the University of Southern California. She is the author of *Spectacular Realities: Early Mass Culture in fin-de-siècle Paris* (1998) and co-editor, with Leo Charney, of *Cinema and the Invention of Modern Life* (1995).

Daniel J. Sherman is a Professor of History and Director of the Center for Twenty-First Century Studies at the University of Wisconsin-Milwaukee. His publications include *Worthy Monuments* (1989) and *The Construction of Memory in Interwar France* (1999).

Debora L. Silverman is Professor of Art History and History at UCLA. She is the author of *Art Nouveau in fin-de-siècle France* (1989) and *Van Gogh and Gauguin* (2000).

Georg Simmel (1858–1918) taught sociology and philosophy at the University of Berlin for most of his career. A seminal urban sociologist, he also wrote *The Philosophy of Money* (1900).

Shawn Michelle Smith is Associate Professor of American Studies at St. Louis University. Her publications include *American Archives* (1999).

Lisa Tickner is Professor of Art History at Middlesex University, London. She is the author of *The Spectacle of Women* (1988) and *Modern Life and Modern Subjects* (2001).

Marcus Verhagen received a Ph.D. in Art History from UC Berkeley and is an independent scholar and art curator in London. He has published many articles on the visual culture of fin-de-siècle France.

Judith Walkowitz is Professor of History at The Johns Hopkins University, Baltimore. Her publications include *City of Dreadful Delight* (1993) and she is now writing a book about the cultural geography of central London.

Jennifer Watts is Curator of Photography at the Huntington Library, in Pasadena, California. Her publications include *The Great Wide Open: Panoramic Photographs of the American West* (2001).

Michael L. Wilson is Associate Professor of Historical Studies at the University of Texas at Dallas and Associate Dean of the School of Arts and Humanities. His book, *Bohemian Montmartre: Art, Commerce and Community in Fin-de-Siècle Paris,* is forthcoming from The Johns Hopkins University Press.

Permissions

We gratefully acknowledge permission to reproduce the following essays:

Baudelaire, Charles, "The Painter of Modern Life." Reproduced from *The Painter of Modern Life and Other Essays* by Charles Baudelaire. © 1964 Phaidon Press Limited. Reprinted by permission of the publisher.

Benjamin, Walter, "The Work of Art in the Age of Mechanical Reproduction" from *Illuminations* by Walter Benjamin. © 1955 by Suhrkamp Verlag, Frankfurt a.M., English translation by Harry Zohn. © 1968 and renewed 1996 by Harcourt, Inc., reprinted by permission of Harcourt, Inc. Underlying work reprinted by permission of Suhrkamp Verlag.

Bennett, Tony, "The Exhibitionary Complex," from *The Birth of the Museum*, Routledge. © 1995 Tony Bennett. Reprinted by permission of Routledge and Tony Bennett.

Clark, T.J., "The View from Notre Dame," from *The Painting of Modern Life* by T.J. Clark. © 1984 by T.J. Clark. Used by permission of Alfred A. Knopf, a division of Random House, Inc., and the author. The text that appears in this volume is from the revised edition (1999).

Clayson, S. Hollis, "Painting the Traffic in Women," from *Painted Love: Prostitution in French Art of the Impressionist Era*, 1991. Reprinted by permission of the author.

Crary, Jonathan, "Techniques of the Observer," from *Techniques of the Observer*, The MIT Press. © 1990 Massachusetts Institute of Technology. Reprinted by permission of the publisher.

Foucault, Michel, "Panopticism," from *Discipline and Punish* by Michel Foucault. English translation. © 1977 by Alan Sheridan (New York: Pantheon). Originally published in French as *Surveiller et Punir*. © 1975 by Editions Gallimard. Reprinted by permission of Georges Borchardt, Inc., for Editions Gallimard. Also, reproduced by permission of Penguin Books Ltd, and Gallimard.

Freud, Sigmund, "The Dream-Work," *The Interpretation of Dreams*, from *The Basic Writings of Sigmund Freud*, A.A. Brill, ed. © 1938 Random House. Reprinted by permission of the Estate of A.A. Brill.

Freund, Gisèle, "Precursors of the Photographic Portrait," from *Photography & Society* by Gisèle Freund. Reprinted by permission of David R. Godine, Publisher, Inc. © 1980 by Gisèle Freund. Originally published as *Photographie et Société* © Editions du Seuil, 1974. Underlying work reprinted by permission of Editions du Seuil.

Grigsby, Darcy Grimaldo, "Revolutionary Sons, White Fathers and Creole Difference: Guillaume Guillon-Lethière's *Oath of the Ancestors* (1822)," from "Revolutionary Sons, White Fathers and Creole Difference: Guillaume Guillon-Lethière's *Oath of the Ancestors* (1822)," *Yale French Studies* 101 (2001), published by Yale French Studies. Reprinted by permission of the publisher.

Gunning, Tom, "'Animated Pictures': Tales of the Cinema's Forgotten Future, after 100 Years of Film," from Christine Gledhall and Linda Williams (eds), *Reinventing Film Studies*, Arnold Press, 2000. © 2000 Arnold. Reprinted by permission of Hodder Arnold.

Henkin, David, "Word on the Streets: Ephemeral Signage in Antebellum New York," from *City Reading* by David Henkin. © 1998 Columbia University Press. Reprinted with the permission of the publisher.

Kasson, Joy S., "Staking a Claim to History" and "The Wild West and The Frontier Thesis" from "At the Columbian Exposition: 1893" from *Buffalo Bill's Wild West: Celebrity, Memory and Popular History* by Joy S. Kasson. © 2000 by Joy S. Kasson. Reprinted by permission of Hill and Wang, a division of Farrar, Straus, and Giroux, LLC.

Kracauer, Siegfried, "Photography." Reprinted by permission of the publisher from "Photography" in *The Mass Ornament: Weimar Essays* by Siegfried Kracauer, translated, edited, and with an Introduction by Thomas Y. Levin, pp. 49–61, Cambridge, Mass.: Harvard University Press. © 1995 by the President and Fellows of Harvard College. Originally published as *Das Ornament der Masse: Essays by Suhrkamp Verlag* © 1963 by Suhrkamp Verlag. The underlying work reprinted by permission of Suhrkamp Verlag.

Marcus, Sharon, "The Portière and the Personification of Urban Observation," from *Apartment Stories* by Sharon Marcus, published by University of California Press. © 1999 by The Regents of the University of California. Reprinted by permission of the publisher.

Marx, Karl, "Part I. Commodities and Money," *Capital, Vol. I*. From *The Marx–Engels Reader, Second Edition* by Karl Marx and Friedrich Engels, edited by Robert C. Tucker. © 1978, 1972 by W. W. Norton & Company, Inc. Used by permission of W.W. Norton & Company, Inc.

Nochlin, Linda, "The Imaginary Orient," from *The Politics of Vision: Essays on Nineteenth-Century Art and Society* by Linda Nochlin. © 1991 by Perseus Books Group. Reproduced with permission of Perseus Books Group in the format Other Book via Copyright Clearance Center.

Nora, Pierre, "Between Memory and History: Les Lieux de Mémoire," from *Realms of Memory*; trans. Marc Roudebush. © 1989 by The Regents of the University of California. Reprinted from *Representations*, no. 26, issue: Spring 1989, pp. 7–25, by permission of the University of California Press Journals and the author.

Nye, David, "Electricity and Signs," *Electrifying America. Social Meanings of a New Technology (1880–1940)*, The MIT Press, 1990. © 1990 Massachusetts Institute of Technology. Reprinted by permission of the publisher.

Rappaport, Erika, "A New Era of Shopping," from Erika Rappaport, *Shopping for Pleasure*. © 2000 by Princeton University Press. Reprinted by permission of Princeton University Press.

Riegl, Alois, "The Modern Cult of Monuments: Its Character and Its Origin," *Oppositions*, Fall 1982: 25. Reprinted by permission of Mario Gandelosonas.

Ryan, James R., "On Visual Instruction," extracted from pp. 186–93 of *Picturing Empire: Photography and the Visualization of the British Empire* by James R. Ryan. First published by Reaktion Books, London, 1997. Reprinted by permission of the publisher.

Samuels, Maurice, "The Illustrated History Book: History Between Word and Image," from "The Illustrated History Book: History Between Word and Image," in *French Historical Studies*, vol. 26, no. 2, pp. 253–80. Copyright 2003, Social Science History Association. All rights reserved. Used by permission of Duke University Press.

Savage, Kirk, "Molding Emancipation: John Quincy Adams Ward's *The Freedman* and the Meaning of the Civil War." Based on "Molding Emancipation: John Quincy Adams Ward's *The Freedman* and the Meaning of the Civil War" in *Museum Studies*, vol. 27, no. 1 (2001), published by The Art Institute of Chicago. Reprinted by permission of the publisher.

Schivelbusch, Wolfgang, "Panoramic Travel" from *The Railway Journey. Trains and Travel in the 19th Century*. Translated by Anselm Hollo. © Wolfgang Schivelbusch 1977. Reprinted by permission of Wolfgang Schivelbusch.

Schorske, Carl E., "The Ringstrasse, its Critics, and the Birth of Urban Modernism." From *Fin-de-Siècle Vienna* by Carl E. Schorske, © 1979 by Carl E. Schorske. Used by permission of Alfred A. Knopf, a division of Random House, Inc.

Sherman, Daniel J., "The Bourgeoisie, Cultural Appropriation, and the Art Museum in Nineteenth-Century France, " from "The Bourgeoisie, Cultural Appropriation, and the Art Museum in Nineteenth-Century France," in *Radical History Review*, Volume 38, pp. 38–58. © 1987, MARHO, the Radical Historians' Organization, Inc. All rights reserved. Used by permission of the Duke University Press.

Silverman, Debora L., "*Psychologie Nouvelle*," from *Art Nouveau in Fin-de-Siècle France: Politics, Psychology and Style*, published by the University of California Press. © 1989 The Regents of the University of California. Reprinted by permission of the publisher.

Simmel, Georg, "The Metropolis and Mental Life." Reprinted with the permission of The Free Press, a division of Simon & Schuster Adult Publishing Group, from *The Sociology of Georg Simmel*, translated and edited by Kurt H. Wolff. © 1950 by The Free Press. © renewed 1978 by The Free Press.

Smith, Shawn Michelle, "'Baby's Picture Is Always Treasured': Eugenics and the Reproduction of Whiteness in the Family Photograph Album," from Shawn Michelle Smith, *American Archives: Gender, Race, and Class in Visual Culture*. © 1999 by Princeton University Press. Reprinted by permission of Princeton University Press. A longer version of this essay was published originally in *The Yale Journal of Criticism* 11:1 (Spring): 197–220.

Tickner, Lisa, "Banners and Banner-Making." Extract from *The Spectacle of Women: Imagery of the Suffrage Campaign, 1907–1914*. © 1988 by Lisa Tickner, published by Chatto & Windus, and The University of Chicago Press. Used by permission of The Random House Group Ltd, and The University of Chicago Press.

Walkowitz, Judith, "Urban Spectatorship," from *City of Dreadful Delight: Narratives of Sexual Danger in Late-Victorian London* by Judith Walkowitz, published by the University of Chicago Press and Time Warner Books UK. © 1992 by Judith R. Walkowitz. Reprinted by permission of the publishers.

Watts, Jennifer, "Picture taking in Paradise: Los Angeles and the Creation of Regional Identity, 1880–1920," *History of Photography* 24, no. 3 (2000), 243–50. Taylor & Francis Ltd, http://www.tandf.co.uk Reprinted by permission of the publisher.

Note

The text and/or notes of some contributions have been abridged.

Preface by the editors

TODAY, VISUAL CULTURE SEEMS TO BE EVERYWHERE in universities, a symptom of the seemingly endless saturation of the contemporary world by images. As Nicholas Mirzoeff states in his volume, *Visual Culture: An Introduction* (Routledge, 1999), "Modern life takes place onscreen." The self-evident nature of such an assertion, we believe, is contingent upon understanding our present moment in relation to a particular historical framework in which the nineteenth century forms an indispensable starting point. As much as we are guided by the notion that visual culture has a "history," we also believe it must be organized as an historical problem. The goal of a volume such as this is to provide a specific and historicized narrative for the kinds of questions and problems of visual culture today as outlined by Mirzoeff. In that way, it is not an "encyclopedia" of the visual for the nineteenth century but rather a volume in which "modernity" rather than "Modernism" becomes a primary way of conceiving the changes particular to visual culture of the nineteenth century.

We have each already begun to outline particular arguments about the experience of "modernity" as it emerged in the nineteenth century in our previously edited volumes, *Cinema and the Invention of Modern Life* (California, 1995) and *Making the News: Modernity and the Mass Press in Nineteenth-Century France* (Massachusetts, 1999). There are losses and gains to our approaches. Rather than a "global view," the volume will be centered on the Western experience (which of course includes encounters all around the world in the nineteenth century). As discussions of "Occidental" culture have made clear after September 11, 2001, one of the signal modes of Western culture is the modern mass media and the urban contexts from which they emerged in the nineteenth century, when such media were all too often focused on constructing a certain view of the "rest" by the West. In turn, a Reader about the twentieth century would be richer in such issues as appropriations of Western visual cultures by non-Western peoples or the emergence of a more syncretic visual culture in once-colonized settings. The gain of our narrower narrative commitment will be to solidify a history of visual culture that will then either generate more research about the nineteenth century (in which we will have more information about non-Western visual cultures that offer alternatives to "modernity") or in which the twentieth century will really be the arena for such investigation. In both cases, it will be imperative that scholars whose areas of expertise are

outside of the West and who have the historical training and linguistic skills take up this inquiry. We hope this volume will foster that new scholarship and that a new generation of researchers will be better positioned to write that history in dialogue precisely because a volume such as this has provided a clearly articulated and usable model of nineteenth-century visual culture and modernity in and of the West.

This Reader also foregrounds objects consumed for their image-value and the institutions that facilitated such looking. Hence, it will be more about such things as photographs, exhibitions, and advertising than the rich material culture of such things as quilts and tea cups which surely shaped visual experience as well. In this way, the Reader aspires to advance not just knowledge of the varieties of visual experiences in the nineteenth century but the very consciousness of vision and visuality in the period. A focus on objects consumed for their image-value highlights the very visuality of the historical moment that we argue is one of its distinguishing features. The focus in this Reader on objects consumed for their image-value is meant to hone the definition of visual culture so that we do not simply collapse everything that can be seen into "visual culture." The focus on the historical character of visuality is meant to distinguish visual culture from "Cultural Studies" most broadly speaking.

The Reader is divided into eight Parts; apart from Part One, each features a short introduction followed by selections that relate to the particular rubric. Part One starts with the inevitable discussions of defining visual culture as an object of study since it is a term whose precise definition is very much still up for grabs. The three original essays in this Part emphasize, to differing degrees, the twin elements of visual culture—an interdisciplinary mode of analysis and a concrete inventory of objects, institutions, and historically located observers. Part Two, "Genealogies," introduces key writings about culture from writers living in the nineteenth century itself or from those who scrutinized its visual culture from early in the twentieth century, such as Walter Benjamin and Siegfried Kracauer. The list is incomplete: what is represented here should be considered fundamental but not exhaustive in scope.

The rest of the volume is organized around themes: technologies and vision, practices of display and the circulation of images, cities and the built environment, visual representations of the past, visual representations of categories of racial, sexual, and social differences, and spatial configurations of inside and out, private and public. But there is inevitable overlap among the Parts. Put otherwise, one might reorganize the contributions to highlight particular methodological problems: the tensions and boundaries between media (especially when new ones such as photography and film appeared); the nineteenth-century penchant for reproduction, display, and collecting (especially with respect to the rise of the museum); the relation between perceptual and experiential modernity, and the emergence of aesthetic Modernism and its practices; the increasing circulation between elite and popular culture. We leave these inventive reorganizations to the students and teachers who we hope will use this volume.

Since the collection is a "Reader," it republishes what the editors consider vital pieces, but it also features new and unpublished essays that exemplify the next generation of research in the field. This makes the volume richer because students can identify the developments of the field from the foundational work of such figures as Linda Nochlin, T.J. Clark, and Jonathan Crary to younger scholars such as Eric Ames and Maurice Samuels. All volumes such as this walk a tightrope between coverage, quality, and establishing a sense of coherence. Each of us has already edited a more focused and narrower volume whose very success, we believe, can be attributed to the way the essays work together to create an argument that both affirms and exceeds relevance of the thematic focus of each essay. This Reader is bigger than those

volumes but takes a similar approach by attempting to summarize and present a coherent vision of a historical moment rather than a sampler whose component parts are bound together merely by their periodization. The number of images seemed enormous to the publisher and too few to us. In the end, what is represented should give students a genuine exposure to the range of visual materials from the period and their sources should guide students as they engage in further research into the history of visual culture. Given the range of materials, methods, and images, we hope the Reader can be used by instructors not only as a basis for courses in the history of visual culture in the nineteenth century, but also as a companion to art history surveys, to communications courses, literary and cultural studies courses, and history courses that emphasize the period between the French Revolution and World War I.

Despite its fairly hefty weight, we opted to sacrifice "coverage" for quality. The essays reprinted here can be characterized by their excellent research, their originality, and conceptual strength. Some selections are key excerpts from longer book chapters or articles, others (especially the new ones) are short essays distilled from larger studies that have been recently published or will eventually be published. The fact that many authors writing about the visual culture in the nineteenth century have already been anthologized in the Routledge Readers in other volumes also guided our selections—authors such as Anne Friedberg, Martin Jay, Mary Louise Pratt, and Timothy Mitchell are absent here because they are present elsewhere in the same series. What we miss in foregoing appearances by these "usual suspects," who are indispensable to any discussion of visual culture studies, we hope we more than make up for by the coherence and particularity of the nineteenth century that we have placed on offer.

As its contributors well know, this volume took a number of years to complete. We thank, first of all, our contributors for their forbearance and interest in the project, and also Nicholas Mirzoeff for his vision in editing Routledge's series of Visual Culture Readers. Margaret Cohen, Anne Higonnet, Sharon Marcus, and Michael Wilson were of particular help in discussing knottier moments of conceptualization and organization, and they deserve our special gratitude. David Prochaska and the group of scholars at the University of Illinois, Champagne-Urbana, who are interested in visual culture offered their reflections on the project, as did the students in Vanessa R. Schwartz's "Modernity and Its Visual Cultures" graduate seminar. Liz Willis and Megan Kendrick provided research assistance and the University of Southern California provided generous support for such assistance. Finally, we thank our families who have heard more about Visual Culture Studies over the last several years than any non-combatants in the field should be expected to tolerate.

PART ONE

Visual Culture and Disciplinary Practices

VANESSA R. SCHWARTZ AND
JEANNENE M. PRZYBLYSKI

VISUAL CULTURE'S HISTORY
Twenty-first century interdisciplinarity and its nineteenth-century objects

Tнis volume aims to contribute to the history of visual culture by giving shape to the notion that our contemporary understanding of it has a particular connection to modernity and the nineteenth century. We contend that the very notion of "visual culture" was made possible by many of the changes in image production in the nineteenth century and we take seriously the notion that the technological reproducibility of lithography and, more significantly, photography, forever altered our connection to such fundamentals as materiality, experience, and truth. The selections in this volume are testimony to the centrality of images, image-making, and vision in the nineteenth century.

It is also true that one might link these essays to early-modern continuities that go back to the Renaissance interest in "il vero;" to the fifteenth-century innovation of the printing press, or to the Scientific Revolution's trust in knowing through seeing, crystallized in the Enlightenment. These are important and ultimately more ambitious projects. Yet in the nineteenth century "modernity," we suggest, is an especially meaningful term precisely because it directs us to consider transformations that are at once about how visual culture studies have been conceptualized and how the history of visual culture has been and will continue to be written. As a conceptual field of study, visual culture has been shaped by our sense of a distinctively "modern" mode of perceptual/cognitive experience that begins its lineage in the reality-based entertainment and information technologies of nineteenth-century panoramas, wax museums, illustrated newspapers and the like, and subsumes forward-looking imaginings of the simulacrum from Disneyland to *The Matrix*. As an historical narrative, the history of visual culture asks us to interrogate the period boundaries, limits, and moments of paradigm shift accounting for our current sense of the centrality of images to belief-systems (capitalism, democracy, fascism, globalization, and its discontents) in contemporary society.

Moreover, the beginnings of this particular historical narrative (however preliminary and partial it might be) must begin by plotting the emergence of visual culture studies through the disciplines of history, art history, and literature and film studies. All of these disciplines are well represented in this volume and all contribute their distinctive strengths. Literary studies have been more than willing, in the words of W.J.T. Mitchell, to view vision as "a mode of cultural expression and human communication as fundamental and widespread as language," thereby opening visual practices and products to strategies of attentive reading

that have only deepened the possibilities for interpretation.[1] Art history has provided many of the tools of visual analysis and visual comparison informing visual culture studies, but it has also proved a site of useful resistance. This is not merely because it continues to hold in high regard qualitative judgments about relative aesthetic value and singular artistic achievement, but because it continues to distinguish, qualitatively, between the different material histories of production, distribution, and reception that are characteristic of any practice of image-making, whether in the realm of visual or verbal representations.[2] History has been uniquely well positioned to write some of the material accounts of these modes of production and media technologies, precisely because of its commitment to the archival record and its acute awareness of the problem of periodization in general. It remains a challenge to historians, however, to move beyond conventionally descriptive accounts. More often than not, as Michael L. Wilson notes in his essay for this volume, they remain more comfortable bringing images to the table only insofar as they serve as illustrative evidence for another kind of historical study (about politics, economics, everyday life, etc.).[3]

As will quickly become apparent to anyone reading this volume, the various disciplines may have contributed to the emergence of a field of scholarly practice we call "visual culture studies," but a history of visual culture is unthinkable without a willingness to transgress disciplinary boundaries. This is why we begin from a discussion of the contributions of art history, history, literary and film studies to the field, but we end with a partisan account of interdisciplinarity as the best roadmap for how visual culture studies and the history of visual culture will be written in the future. Likewise, in a similar vein, while we begin by attempting to define the particular objects of visual culture studies, we end by suggesting that visual culture studies is constituted less by its topical repertoire and more to the degree that it produces a discursive space where questions and materials that have been traditionally marginalized within the established disciplines become central. In turn, we continue to be optimistic that this discursive space has its own constitutive effect. As historians, art historians, literary and film critics, and others come together as scholars from different disciplinary perspectives and look at similar objects and problems, they begin to speak a hybridized discourse that not only elaborates the field of visual culture studies but also illuminates the productive resistances that lend each discipline, within its own areas of competency and interests, a continued currency.

Tracing the recent rise of visual culture

The fact that different disciplinary practitioners might find themselves with overlapping intellectual agendas is a product of radical changes and developments in the humanities in the last thirty years that may now seem easy to take for granted. As the history of visual culture begins to be written in our own time, we may find ourselves asking not so much "Why visual culture now?" as "Why did it take so long?" Beginning to answer this question requires remembering the institutional boundaries of disciplinary study in the mid-twentieth century, when, for the most part, those scholars who were primarily interested in the visual generally found themselves directed toward or niched into the history of art (itself a relative newcomer to academia). Rooted in practices of connoisseurship and framed by the hard realities of the art market, the field allowed art objects, such as paintings and sculptures, inevitably to occupy center stage, while prints, caricatures, fashion plates, advertising images, entertainments, visual ephemera generally, and other forms of visual experience played at most supporting roles.

The rise of the "Social History of Art" in the 1970s breached the art historical canon on a number of fronts, bringing fundamental changes. Inspired by a Marxist analysis that placed

art production and consumption within a larger ideological network of objects, images, and messages, at its best the social history of art made good on the assertion by the influential historian of medieval and modern art, Meyer Shapiro, that an "art built up out of other objects, that is, out of other interests and experience, would have another formal character," thereby reinscribing a sense of social urgency and contingency into the increasingly rarified and "universalist" realm of modernist/formalist artistic practice and visual analysis.[4] It also opened up discussions about the history of art institutions, the training of artists, the material conditions for the production and circulation of art, and the mutually constitutive dialogue between "art" and "craft."[5]

By shining a spotlight on this broader historical context, the social history of art paved the way to the history of visual culture—at times deliberately and at times by default. For example, the revisionist scrutinizing of canon formation—or how "good" art came to be considered "good"—especially by feminist art historians who understood the gendered nature of artistic production and distribution, both challenged aesthetic standards and broadened the categorical definitions of the objects that art historical scholars might study.[6] The subdiscipline of the history of photography began by making aesthetic claims about the medium that were deeply influenced by the history of painting, only to turn the tables and embrace an "instrumental" view of photography that ultimately argued that much of not only its cultural relevance but also its aesthetic stature stemmed from its early and ongoing uses as scientific document, judicial evidence, and topographic view, among other applications.[7] By these means and others, the history of art secured a claim of centrality to any history of visual culture. But its inevitably primary focus on the fine arts also ensured that, left to its own devices, art history itself would be inadequate to the task of providing an expanded view of the visual field.

At the same time that art history was changing into "the new art history," other fields in the humanities changed as well. Critiques of "top-down" history, similarly inspired by Marxist analysis of "social history," seemed to arrive everywhere to proclaim that we should study "history from below," paying special attention to the elements of infrastructure and material culture that embodied class relations at the level of everyday life.[8] Further complicating these revisionist interventions, historians and literary scholars in particular began in the 1980s to consider the problem of "representation" as a historically contingent construction. These scholars were deeply influenced by the anthropologist Clifford Geertz and his notion of culture as an assemblage of texts. All aspects of life now seemed ripe for cultural interpretation and anthropological "thick description."[9] This model for historical inquiry, loosely grouped under the rubrics of "the New Cultural History" or "the New Historicism," proceeded from "the possibility of treating all of the written and visual traces of a particular culture as a mutually intelligible network of signs."[10] Catherine Gallagher and Stephen Greenblatt, two of its foremost practitioners, described its focus on:

> representation as the central problem in which all of us—literary critic and art historian; historian and political scientist; Lacanian, Foucauldian, Freudian, neopragmatist; deconstructor and unreconstructed formalist—were engaged . . . Whatever progress we were likely to make in grappling with the contested status of representation would occur, we were convinced, only in close, detailed engagement with a multiplicity of historically embedded cultural performances: specific instances, images, and texts that offered some resistance to interpretation.[11]

In other words, regarding both textual utterances and visual artifacts as the material residue of social performances allows comparative readings across disciplinary boundaries (often

deploying, as is evident from this quotation, the most *au courant* theoretical methodologies). Attending to the opacity of these "specific instances" (their illegibility or apparent marginality within a broader view of the period) should be all the greater spur to historical—and archival— investigation.

Some might fault the New Cultural History for its proclivity for singular and strange events (including cat massacres, cases of mistaken identity, and foul-mouthed New World natives) and the tenuousness of their relationship to more generalizable patterns of historical circumstance, linking the practice in a peculiar way to the art historical taste for the exceptional and unique, rather than the quotidian and broadly representative.[12] Others might contend that the New Historicist emphasis on a synchronic cultural field in which different cultural forms and dis- courses are studied in the same historical moment has blurred the specific formal elements of the texts under consideration by privileging their sameness. This critique would characterize New Historicist studies as moving relatively effortlessly between high and low cultural forms, from paintings to crackpot medical writings to popular song, eliding the specificity of the texts and images under discussion in order to make aphoristic general claims about a cultural moment (London was a "city of Dreadful Delight," "Paris was deodorized at mid-century").[13] We would suggest instead that, in the best of cases, the juxtaposition of the literary text with a medical text or a visual image has clarified the edges of both texts and images, thus illuminating the particularities of each form, while also revealing shared attributes across a culture in time.[14] In addition, in the hands of the New Historicists, visual objects became not just illustrations of an historical assertion about say, religion or monarchy but the evidence itself. Rather, the history of the production and reception of images and the status and experience of the visual has started to become part of the historian's legitimate domain of inquiry.

These changes in art history, history, and literature also pushed them into closer prox- imity with the developing field of film studies. Because film presented a formal language akin to still photography in its effects of immanence and image-making, but distinct from it in its narrative drive, film scholars initially attempted to legitimate the study of this "popular amuse- ment" by discussing it in the terms cobbled together from those set out by critics for art and literature.[15] At the same time, the complex nature and hybrid qualities of film—was it art, entertainment, culture, or capitalist business-as-usual?—troubled the received categories of "art" and "literature" precisely to the degree that it seemed to prefigure the logic of the twen- tieth century, especially that of rationalized mass production and frenzied mass consumption. Another way of saying this is that the rise of film in the twentieth century as a paradigmatic cultural form has contributed greatly to the rise of visual culture as a field of study; film's own phenomenal success has led to a relentless casting backward into the nineteenth century to locate its origins. To no small degree this success has also led to a reevaluation of the history of the visual culture of the nineteenth century from the perspective of the media- saturated late twentieth century. The essays in this volume are gathered in a way that regis- ters this preoccupation with cinematic "prehistory" to the extent that they acknowledge the centrality of our own moment's questions and perspectives to our study of the nineteenth century, serving collectively as a genealogy for the present. Yet they also carefully guard the historical specificity of their own nineteenth-century moment and, as such, stand as a record of a different visual culture as well.

Defining and studying visual culture

Visual culture can be defined first by its objects of study, which are examined not for their aesthetic value per se but for their meaning as modes of making images and defining visual

experience in particular historical contexts. Visual culture has a particular investment in vision as a historically specific experience, mediated by new technologies and the individual and social formations they enable. Moreover, it identifies and underscores the status of the visual as a sensory experience that is itself conditioned by a historical understanding of physiology, optics, and cognitive science. Putting visual objects, image-production, and reception at the center of a historically based inquiry has also suggested a re-organization of historical periods which can be sorted as "scopic regimes" with distinct patterns of regulating the celebratory and repressive uses of particular objects, technologies, and ways of seeing.[16]

This last assertion marks the moment by which the history of the visual is unhinged definitively from the purview of the history of art and its conventions of stylistic periodization. In the Introduction to *The Visual Culture Reader*, the first in this series, editor Nicholas Mirzoeff suggests a move away from a certain kind of object-orientation: "Visual culture directs our attention away from structured, formal viewing settings like the cinema and the art gallery to the centrality of visual experience in everyday life."[17] Breaking down the boundaries between conventional sites for experiencing the visual and the world "out there" is fine as far as it goes, especially to the degree that it makes explicit the often problematic segregation of art "isms" from more apparently fashionable and faddish definitions of "style." Yet we would suggest that visual culture's alliance with everyday life should still emphasize objects produced and consumed primarily (if not exclusively) as images and their associated institutions and practices as culturally significant vectors of visual experience.

Another way of saying this might be that we acknowledge the hybridity of cultural forms in an expanded visual field. But, as we move outwards from the arenas of art galleries, museums, movie theatres, and the like, we would also maintain that the angle of historical approach to these forms should be fundamentally invested in their visual character. The great world's fairs of the nineteenth and early twentieth centuries would be one good example. Vast engines for showcasing material culture during the industrialist and imperialist age, they are not interesting to scholars of visual culture primarily as a catalogue of that culture (and as a point of entry for discussions of the use-value of such objects as steam locomotives, silk purses, and machine guns), but as a particular site for transforming such disparate elements into spectacles (of exoticism, commodity fetishism, or technological wizardry, to name just a few examples). The nineteenth-century invention of the department store would be another example. While an account of the changing experience of window-shopping as a consumerist, urban distraction certainly falls under the rubric of visual culture, a business history of retail shopping (on which the department store also had a significant impact) that did not include an interrogation of visual practices of commercial display among its examinations of sales figures, inventories, and vendor relations does not. In order to be a useful category of historical analysis, in other words, we believe that the *differences* as well as the similarities between visual culture and cultural history, or material cultural studies more broadly speaking, must be constantly and consistently interrogated.

Visual culture thus includes the study of image/objects and also reaches beyond them to include the history of vision, visual experience, and its historical construction. It constitutes its "subject" of reception as a viewer or a spectator (whether active or passive—and this in itself can be a point of dispute) rather than as a reader. Elaborating on Michael Baxandall's notion of "the period eye," historians of visual culture consider changes in both representational practices and in modes of observation.[18] Once again, the relation of sense perception to history had an early and articulate advocate in Walter Benjamin whose arguments about a nineteenth-century culture of the visual are built on the premise that "the mode of human sense perception changes with humanity's entire mode of existence."[19] But how and under

what conditions do we feel authorized to privilege the visual over other modes of sensory perception? Isn't this just falling into a trap that leaves unexamined our own contemporary sense of being bombarded by images? On the one hand, images are usually delivered in a multi-sensory package and are received in a multi-sensory way. In effect, a history of visual culture falsely describes what might be better expressed as a history of perception. Yet over time, a hierarchy of the senses became deeply embedded in the Western philosophical tradition of the Cartesian mind–body split. This hierarchy led to a celebration of sight as "the noblest of the senses," and much of the triumph of empiricism in the West can be traced to its door. In other words, the occularcentrism of the Occident turns out to be historically specific. Despite the fact that the five senses clearly work together, vision has been accorded a special status with respect to how we describe experience since the Enlightenment at least.[20]

Further, although formalism, and especially the brand of modernist formalism adduced from the late writings of the American art critic Clement Greenberg, has often been collapsed into a narrowly focused account of medium specificity (emphasizing, in the case of painting, for example, literal flatness, abstraction, and opticality over pictorial illusionism, figuration, and theatricality), we believe that historians of visual culture should nonetheless feel compelled to pay particular attention to the formal elements and conventions of the material objects and cultural performances they study.[21] In this way, scholars of visual culture should care deeply about the differences between media—painting and film, for example, or between forms of spectacle such as the world's fairs and wax museums—while insisting on the contextualization of these differences in a broader and historically specific cultural field. They should not confuse this contextual reading of form with a simple, generalized determinism (the seemingly inevitable and unconditional conjunction of photography and death, for example, or wax museums and ephemeral celebrity). Instead, what we suggest is an historically informed account of perceptions about the special and "essential," or *ontological*, character of a particular medium at a particular cultural moment.

Thus, our criteria for making selections in this volume proceeds from the conviction that media have no essence outside the contexts of their production and consumption, and that these contexts define and give shape and meaning to the formal conventions of each medium at particular moments in time. It does not escape our attention that key words for defining these contexts in the nineteenth century often include the vexed conceptual pairing of "modernity" and "Modernism" as ways of coming to terms with rapid technological change, urbanization, and capitalism as defining features of everyday life. In the following section we want to suggest that ongoing efforts to rethink their relation, of which several essays in this volume are outstanding examples, may help us to rethink the nineteenth-century's relevance for understanding our contemporary situation as well.

"Modernity," "Modernism," and the nineteenth century

Bringing together the terms "modernity," "Modernism," and the nineteenth century implies a particular story about a time, told from a particular perspective—that of Western culture. The narrative of "modernity" may not be the only way of conceptualizing the nineteenth century, but it has provided one of the most useful discursive frames for making sense of the relationship between visual experience and cultural hegemony in the nineteenth and twentieth centuries, and it continues to provide the most explicit genealogy for current discussions of visual culture in the twenty-first century.

While the era of formal empires in the West has all but come to an end, "the global era" has not yet produced a polyvalent web of interconnections. Instead, Western models of

democracy and capitalism still hold enormous sway. Under the thrall of these models, image-making techniques, technologies, and institutions emanating originally from the West may be the glue that binds any sense of a recognizable common global culture—whether one views that culture with horror, skepticism, or elation. In this sense, we can't help but admit that the Western visual tradition may well be the most widespread and durable legacy of the Western imperialism of the nineteenth century, while the increasing cross-fertilization of Western and non-Western visual conventions is a twenty-first century work-in-progress.

This anthology is intended not only to articulate the parameters of a visual culture of the nineteenth century, but also to provide a context for our current discussions of visual culture in general. Therefore, the volume foregrounds the problems, questions, and media that are indispensable in this genealogical sense, while also being sensitive to the ways in which Western images and "ways of seeing" not only circulated globally but also promoted and contributed to its uneven relations of power with peoples and their visual cultures all over the world. While using such terms as "modernity" and "Modernism" runs the risk of re-inscribing a Western perspective, a thorough-going investigation of their premises is a vital step toward grasping the shifting contours of today's virtual worlds. It is precisely out of this uneven experience that there exist such icons as the Coke bottle or golden arches which circulate globally but are made sense of within more localized and specific visual contexts, both Western and non-Western. The uneven development of modernity also provides a context for explorations of how such things as animé art from Japan, such as Pokéman, has influenced animation style all over the world.

When we speak of "modernity," then, usually we are referring to a set of political, economic, social, and cultural attributes that include such things as nationalism, democracy, imperialism, consumerism, and capitalism—each of which appear associated with the nineteenth century by virtue of their radical expansion during that period.[22] These elements of change may have resonated around the world but have come to stand as a shorthand for changes associated with "the West." To this list of attributes emerging from the watershed of the French Revolution, technologically reproducible image-making must be added. As William Ivins has noted, "the number of printed pictures between 1800 and 1901 was probably considerably greater than the total number of printed pictures before 1801."[23] This explosion led to what might be called "the image standard," which is among the fundamental developments of the nineteenth century.[24]

Such transformations in scale become transformations in kind and not simply ones of mere magnitude. While the French Revolution represents the triumph of the bourgeoisie and its new public sphere as pivotal benchmarks for defining the modern experience, scholars have only just begun to associate this narrative of the transformation of the social order with images.[25] Yet bourgeois society put a premium on the flow of information and trade (hence the proliferation of newspapers), esteemed objects for their exchange value (the rise of the art market is a case in point), and fostered new institutions such as museums and expositions that narrated their view of the world through the lessons of things. Industrialization and mechanization produced urbanization which appeared to expand the visual field especially by constituting formerly rural populations as a group through urban spectacle.

In short, the explosion of image-making made visual experience and visual literacy important elements in the rubric of modernity.[26] In the largest sense, one might claim that the transformations associated with modernity, both at the formal and the social historical level, can be generalized as having been waged along a central axis between investment in the positivist certainty of visual facts and ambivalence regarding the illusiveness of mere appearances. These contradictions served to position visual culture as both dominant culture and

contested culture, with key ideological disputes played out around issues of exhibition and display, reality and artifice, the impact of optical technologies promising enhanced visual mastery, and the implications of new processes of technological reproduction promising mass availability. There is no one over-arching causal factor; the story of nineteenth-century visual culture is a sort of alchemy of related problems and possibilities which can only be illuminated through historical investigation.

The Age of Mechanical Reproduction?

Nineteenth-century visual culture situates itself within and across the paradoxes of the "positive" and "positivist" late eighteenth-century Enlightenment investment in the mechanics of seeing and a growing culture of spectacle dependent on mechanical reproduction.[27] While the reproduction of images by such technologies as founding and stamping has been practiced since the time of ancient Greece, Walter Benjamin identified the nineteenth-century technologies of lithography and then photography and film as fundamental transformations, leading him to posit a watershed "Age of Mechanical Reproduction." Benjamin's intent was not to reduce explanations to technologies but to see in those technologies the crystallization and material embodiments of ways of imagining and experiencing the world. For us, no essay has more of a foundational status in the history of visual culture than his "The Work of Art in the Age of Mechanical Reproduction"[28] precisely because it frames the problems of visual culture as historical and material ones as opposed to universal and abstract ones. Benjamin proceeds by writing a history of visual culture that is both descriptive and methodologically self-conscious at the same time.[29]

Benjamin's "artwork" essay lays bare his interest in how forms of technology and media are social facts not just in their institutionalization, but also as embodiments and instantiations of social relations and experiences. A hallmark of this essay, which is reflected in many studies in the history of visual culture, is an interest in the relation between a period's visual technologies and its structures of understanding. Benjamin believed that every era has very specific techniques of reproduction that correspond to it.[30] He traced a lineage that began with lithography and moved from photography to what he believed was mechanical reproduction's fullest expression in film. These technologies as cultural forms also transformed practices of reception and spectatorship. Whereas art is conceived of as absorbing the spectator's attention, technologies such as film offer a new mode of reception in a state of distraction which better match the pace and scale of a public who fast became "absent-minded examiners." The new age altered the very ground of valuation in the arts, substituting the sheer quantity of images for quality. In mass culture, more is better. In the face of the distraction (and placation) of the masses by numbers, Benjamin posited film's effects of narrative fragmentation and montage, which activated spectators as "viewers" and hence compelled them to assume a more engaged, critical relation to the world of modern spectacle surrounding them.

Related as well to Benjamin's tendentious view of film as constitutive of newly politicized viewing subjects is the avant-garde construction of Modernism as a set of aesthetic postures and pictorial practices. Several selections in this volume acknowledge, as T.J. Clark has put it, that "Modernism is a form of testing—of modernity and its modes."[31] Modernism might be understood as a particular set of aesthetic responses, qualifications, priorities, and problems formulated with respect to the experience of modern life. What is interesting about the nineteenth century is the degree to which the two terms, modernity and the "Modern"— in painting and sculpture in particular—were constantly held in a close and deliberately

difficult, and provisional relationship to one another. As Modernism was consolidated as a narrower, more hermetic, and more besieged term in mid- to late-twentieth-century artistic practice and discourse, visual culture, along with (not coincidentally) post-modernism, became terms deployed to unsettle this dominant construction. While unseating Modernism's hegemony may have been an admirable goal on a number of fronts, without Modernism as a viable foil, visual culture threatens to become much less interesting as a category of both cultural intervention and analysis.

This is perhaps the point at which the concerns of art historians interested in visual culture most clearly diverge from historians, broadly speaking. If visual culture is only a "big tent" designed to include everything that the history of art (and especially Modern Art) had excluded, overlooked, or relegated to a second tier, then what can we usefully define as the critical priorities and qualifications of visual culture *for artists* (and others) as participants in the making and critiquing of that culture today? What are to be its resistances, contingencies, edges? While the predicament of much of early twenty-first-century art practice (its loss of common problems, unfocused pluralism, and difficulty in distinguishing between innovation and fashion) is certainly beyond the scope of this volume, suffice to say that yet another reason to look back at the nineteenth century is to recover this useful sense of a moment when visual artists had something vital to say about their different relation to visual culture precisely in order to move forward.

Finally, in Benjamin's view, it was not simply that the age of mechanical reproduction ushered in the culture of the copy, but that these copies had an impact on our definitions of authenticity and originality (what Benjamin referred to as an "aura" produced by the confrontation with actual presence) in unsettling and unexpected ways: "The desire of contemporary masses to bring things 'closer' spatially and humanly . . . is just as ardent as their bent toward overcoming the uniqueness of every reality by accepting its reproduction."[32] The world, in short, appears ever nearer and more "real" by virtue of these copies, even as the world "in reality" paradoxically recedes in the face of an onslaught of virtual representations. Or, to put it another way, aura does not necessarily wither away in the age of mechanical reproduction. Instead, it becomes just another (convincing) illusion.

Of contemporary scholars, Jonathan Crary has been one of the most precise in exploring the implications of this particular relationship of reality to representation in the nineteenth century—and the degree to which it is defined and not defined by photography as the mode of mechanical reproduction that loomed largest in the cultural imagination. Visual experience in the nineteenth century, he argues, did indeed look to the codes of monocular vision and geometrical perspective to structure reality through its photographic representations (by seeing the invention of the camera proceeding from the *camera obscura* as a device for picturing the landscape). But photographically based technologies such as stereoscopy and, eventually, cinema, ultimately annihilated the pretense of a single, consistent, and unified point of view inherent in these codes. While what he calls "the fictions of realism" continued to operate undisturbed, these technologies demanded a new kind of "observer-consumer," at home in a world already reconstituted (through reproductions) as free-floating illusions.[33]

Such fine-grained distinctions in models of spectatorship are richly suggestive for the future study of visual culture. Thus, this volume is everywhere saturated by the photographic as a key medium of mechanical reproduction, but also grapples with the differences between photography and other, proximate technologies. Even further, it imagines film as a sort of culminating point in the nineteenth-century history of visual culture, a claim that has already been thoroughly explored in *Cinema and the Invention of Modern Life*.[34] Simply put, cinematic culture seemed to mark a crossroads, emblematizing and transcending nineteenth-century

"modernity" as a realm of both experiences and representations. The advent of film represents a new phase but one that is not different in episteme from that of mechanical reproduction—certainly it is a phase with which we are not yet finished. Many scholars interested in identifying a postmodern moment will point to various key moments of rupture between modernity and postmodernity: the crisis of Modernism as a seemingly exhausted aesthetic discourse, the complete uncoupling of the copy from the original, virtuality versus referentiality, and the digital divide.

Of these facts as signs of epistemic rupture, we remain fairly skeptical. Is it really the fate of the history of visual culture to succumb to the decisive disembodiment of the image betokened by the digital age? Or is the time also ripe for visual culture studies to reconsider the degree to which the history of visual culture must rejoin and revise its relationship to the history of the corporeal senses in general? This is why phenomenological, cognitive approaches of early modernity studies such as those of Georg Simmel and Siegfried Kracauer have been included in this volume. Simmel and Kracauer offer compelling arguments for the need to make grounded claims about corporeal experience and the interaction of people, and a wide range of visual practices including, but not limited to, image-making. Their perspectives encourage us to use new tools that will need to be developed from the sorts of visual and formal analysis of art history and literary studies that go beyond verbal description and experience as "discourse."

Ultimately, these questions may lead us to reconsider the too-easy notion of the primacy of visual culture in modernity. This is why locating vision among the senses and writing a grounded history of that visual culture for the twentieth century should be foremost priorities as the field develops. Only then will we be able to address some of the primary issues on the visual culture agenda—especially the role that images play in contemporary globalization. This volume hopes to sharpen an historical genealogy of visual culture and the historical methodology of visual culture studies. Among other things, it asks readers to ask themselves whether we are in a new visual cultural epoch or whether what we think of as globalization is an extension of the French Revolution and the era of mechanical reproduction—for better and worse. Only the future will tell.

Notes

1 W.J.T. Mitchell, "Interdisciplinarity and Visual Culture," *Art Bulletin*, LXXVII (4) (December 1995): 543.

2 Carol Armstrong is particularly acute on this point in her response to the "Visual Culture Questionnaire" posed by the journal *October*. See *October* 77 (Summer 1996): 27–28. In general, the range of responses to this questionnaire by art and architectural historians, film theorists, literary critics, and artists are well worth reading.

3 For a recent overview of historians' uses of images, see Peter Burke, *Eyewitnessing. The Uses of Images as Historical Evidence* (Ithaca, N.Y.: Cornell University Press, 2001). The work of Neil Harris, and especially his influential essay "Iconography and Intellectual History: The Half-Tone Effect" in *New Directions in American Intellectual History*, edited by John Higham and Paul K. Conkins, 196–211 (Baltimore, Md.: The Johns Hopkins University Press, 1979), is essential reading. Other work on "the visual" by historians includes, Stephen Bann, *The Clothing of Clio* (Cambridge: Cambridge University Press, 1984); Paula Findlen: *Possessing Nature: Museums, Collecting and Scientific Culture in Early Modern Italy* (Berkeley, Calif.: University of California Press, 1994); Joshua Brown, *Beyond the Lines. Pictorial Reporting, Everyday Life, and the Crisis of Gilded Age America* (Berkeley, Calif.: University of California Press, 2002); Gregory M. Pfitzer, *Picturing the Past. Illustrated Histories and the American Imagination, 1840–1900* (Washington, D.C.: Smithsonian Press, 2002).

4 Meyer Shapiro, "The Social Bases of Art," *First American Artists' Congress Against War and Fascism* (New York: American Artists' Congress, 1936), reprinted in Charles Harrison and Paul Wood, *Art in Theory 1900–1990: An Anthology of Changing Ideas* (Oxford: Blackwell Publishers, 1993), p. 508.

5 This bibliography is by now voluminous and includes the work of many contributors to this volume. Other important contributions in the field of French painting, to make an example of just one area, include Albert Boime, *The Academy and French Painting in the Nineteenth Century* (London: Phaidon Press, 1971); Patricia Mainardi, *Art and Politics of the Second Empire: The Universal Expositions of 1855 and 1867* (New Haven, Conn. and London: Yale University Press, 1987); Nancy Troy, *Modernism and the Decorative Arts in France: From Art Nouveau to Le Corbusier* (New Haven, Conn. and London: Yale University Press, 1991); and Harrison C. White and Cynthia A. White, *Canvases and Careers: Institutional Change in the French Painting World* (Chicago and London: University of Chicago Press, 1965).

6 In the United States, the fundamental essay was Linda Nochlin's "Why Have There Been No Great Women Artists?" (*ARTnews* (January 1971): 22–39; 67–71). In England, crucial contributions to this debate were made by Griselda Pollock, a selection of whose essays has been published as *Vision and Difference: Femininity, Feminism and the Histories of Art* (London: Routledge, 1988) and Laura Mulvey, whose "Visual Pleasure and Narrative Cinema," originally published in 1975, became a fundamental cross-disciplinary reference for feminist art historians (reprinted in Mulvey, *Visual and Other Pleasures* (Bloomington, Minn.: Indiana University Press, 1989), pp. 14–28. A useful collection of early art historical interventions can be found in Norma Broude and Mary Garrard (eds.), *Feminism and Art History* (New York: HarperCollins, 1982).

7 The most notorious narrative of the "painterly" history of photography was advanced by Peter Galassi. See *Before Photography: Painting and the Invention of Photography* (Boston, Mass.: New York Graphic Society, 1981). The instrumental counterproposal to this narrative was argued most forcefully by Allan Sekula (see, for example, *Photography Against the Grain: Essays and Photoworks* (Nova Scotia: College of Art and Design, 1984) and "The Body and the Archive," *October* 39 (Winter 1986: 13–640) and John Tagg (*The Burden of Representation: Essays on Photographies and Histories* (Amherst, Mass.: University of Massachusetts Press, 1988)). See also Abigail Solomon-Godeau, *Photography at the Dock: Essays on Photogrpahic History, Institutions and Practices* (Minneapolis, Minn.: University of Minnesota Press, 1991) and the useful anthology edited by Richard Bolton, *The Contest of Meaning: Critical Histories of Photography* (Cambridge, Mass.: MIT Press, 1989). For more contextual and institutional approaches, see Anne McCauley, *Industrial Madness: Commercial Photography in Paris, 1848–1871* (New Haven, Conn.: Yale University Press, 1994) and James Ryan and Joan Schwartz, (eds.), *Picturing Place: Photography and the Geographical Imagination* (London: I.B. Tauris, 2003).

8 For an excellent survey of developments in historical methods, see Joyce Appleby, Lynn Hunt, and Margaret Jacob, *Telling the Truth about History* (New York: Norton, 1994).

9 Clifford Geertz, *The Interpretation of Cultures* (New York: Basic Books, 1973).

10 Catherine Gallagher and Stephen Greenblatt, *Practicing New Historicism*, p. 7.

11 Catherine Gallagher and Stephen Greenblatt, *Practicing New Historicism*, p. 4.

12 These references are to Robert Darnton, *The Great Cat Massacre* (New York, Basic, 1984), Natalie Davis, *The Return of Martin Guerre* (Cambridge, Mass.: Harvard University Press, 1983) and Stephen Greenblatt's essay about Caliban in *Learning to Curse* (New York: Routledge, 1999).

13 Judith Walkowitz, *City of Dreadful Delight. Narratives of Sexual Danger in Late-Victorian London* (Chicago: Chicago University Press, 1993); Alain Corbin, *The Foul and the Fragrant: Odor and the French Social Imagination* (Cambridge, Mass.: Harvard University Press, 1986).

14 Some of the best work about the nineteenth century in this mode includes: D.A. Miller, *The Novel and the Police* (Berkeley, Calif.: University of California Press, reprinted 1989); Mary Poovey, *Uneven Developments: The Ideological Work of Gender in Mid-Victorian England* (Chicago: University of Chicago Press, 1988); Catherine Gallagher, *The Industrial Reformation of English Fiction* (Chicago: University of Chicago Press, 1985); Alain Corbin, *The Foul and the Fragrant: Odor and the French Social Imagination* (Cambridge, Mass.: Harvard University Press, 1986); Judith Walkowitz, *City of Dreadful Delight. Narratives of Sexual Danger in Late-Victorian London* (Chicago: Chicago University Press, 1993).

15 David Bordwell's *On the History of Film Style* (Cambridge, Mass.: Harvard University Press, 1997) offers a concise history of this approach and is also one of the more recent examples of the same tradition. The more literature-oriented model of "auteurism" in which film directors replace writers as authors of texts had its first systematic champion in the United States in Andrew Sarris. Especially important is his essay, "Toward a Theory of Film History" in *The American Cinema. Directors and Directions, 1929–1968* (New York: DaCapo, 1996; originally 1968).

16 The term "scopic regime" is borrowed from Martin Jay's *Downcast Eyes. The Denigration of Vision in Twentieth-Century French Thought* (Berkeley, Calif.: University of California Press, 1993).

17 Nicholas Mirzoeff (ed.) *The Visual Culture Reader* (London: Routledge, 1998).

18 For the "period eye," see Michael Baxandall's *Painting and Experience in Fifteenth-Century Italy* (Oxford: Oxford University Press, 1972).

19 Walter Benjamin, "The Work of Art in the Age of Mechanical Reproduction" in this volume, pp. 63–70.

20 Martin Jay's *Downcast Eyes* is the best account of the rise of occularcentrism in the West. He argues ultimately for its decline, at least among intellectuals.

21 The most historically sensitive accounts of painting influenced by "Greenbergian" formalism have been produced by Michael Fried. See *Courbet's Realism* (Chicago and London: University of Chicago Press, 1990) and *Manet's Modernism or, The Face of Painting in the 1860s* (Chicago and London: University of Chicago Press, 1996).

22 See Stuart Hall, Kenneth W. Thompson, and David Held (eds.), *Modernity: An Introduction to Modern Societies* (Oxford: Blackwell, 1996) which is a thoughtful textbook in sociology that provides a useful synthesis. See also Arjun Appadurai, *Modernity at Large. Cultural Dimensions of Globalization* (Minneapolis, Minn.: University of Minnesota Press, 1996).

23 William M. Ivins, Jr, *Prints and Visual Communication* (Cambridge, Mass.: MIT Press, 1973, first published 1953) p. 94.

24 For a thorough explanation of the "image standard", see the essay "Complex Culture" by Margaret Cohen and Anne Higonnet in this volume.

25 See Jürgen Habermas, *The Structural Transformation of the Public Sphere* (Cambridge, Mass.: MIT Press, 1989) and Benedict Anderson, *Imagined Communities* (London: Verso, 1983) for general overviews of these transformations.

26 Jay, p. 122. For more on images and the French Revolution, see Lynn Hunt, *Politics, Culture and Class in the French Revolution* (Berkeley, Calif.: University of California Press, 1984) and Maurice Agulhon, *Marianne Into Battle. Republican Imagery and Symbolism in France, 1789–1880*, Janet Lloyd (trans.) (Cambridge: Cambridge University Press, 1981; originally 1979). For a useful CD-ROM of images, see Jack Censer and Lynn Hunt, *Liberty, Equality, Fraternity* (State College, Pa.: Penn State Press, 2000).

27 See especially the important work of Barbara Maria Stafford: *Artful Science: Enlightenment, Entertainment and the Eclipse of Visual Education* (Cambridge, Mass.: MIT Press, 1994); *Good Looking. Essays on the Virtue of Images* (Cambridge, Mass.: MIT Press, 1996); and, with Frances Terpak, *Devices of Wonder* (Los Angeles: Getty Research Institute, 2001).

28 See Benjamin's essay in this volume.

29 The editors make their individual case for Benjamin in two separate essays. See Jeannene M. Przyblyski, "History is Photography: The Afterimage of Walter Benjamin," *Afterimage* (September/October 1998): 8–11; and Vanessa R. Schwartz, "Walter Benjamin for Historians," *American Historical Review*, v.106, n.5 (December 2001): 1721–43.

30 This point is also elaborated in "Eduard Fuchs: Collector and Historian," *The Essential Frankfurt School Reader*, Andrew Arato and Eike Gebhardt (eds.) (New York, 1982), pp. 225–53.

31 T.J. Clark, "Origins of the Present Crisis," *New Left Review* 2, Second Series (March–April 2000): 85–96, 91.

32 See Benjamin's essay in this volume.

33 Jonathan Crary, *Techniques of the Observer: On Vision and Modernity in the Nineteenth Century* (Cambridge, Mass.: MIT Press, 1990), pp. 127–8.

34 Leo Charney and Vanessa R. Schwartz (eds.) *Cinema and the Invention of Modern Life* (Berkeley, Calif.: University of California Press, 1995).

MARGARET COHEN AND
ANNE HIGONNET

COMPLEX CULTURE

NOTHING HAS BETTER SHOWN both the appeal and the unresolved prob-
lems of studying culture in an expanded field than the cult of Walter Benjamin. His
Arcades Project remains a stunningly complex and suggestive approach to a history of repre-
sentations.[1] The *Arcades Project* (*Passagen-Werk*) took the form of a gigantic unfinished archive
of nascent modernity figured as the cultural history of Paris. Although he was thoroughly
familiar with the nineteenth-century's canonical images and texts, Benjamin trawled the then
obscure archives of everyday life, unrealized political and social theory, nascent technolo-
gies, popular culture, commercial culture, and urban entertainment, to leave us with the raw
material of a truly heterogeneous history whose rich diversity is encapsulated in the
rubrics of his research: A: "Arcades, Magasins de Nouveautés, Sales Clerks"; B: "Fashion"; C:
"Ancient Paris, Catacombs, Demolitions, Decline of Paris"; D: "Boredom, Eternal Return";
E: "Haussmannization, Barricade Fighting"; F: "Iron Construction"; G: "Exhibitions, Advertis-
ing, Grandville"; H: "The Collector"; I: "The Interior, the Trace"; and so on.[2]

Yet Benjamin did not leave the *Arcades Project* as an argument, but as the evidence for an
argument. For all its brilliance, it is raw material, so unwieldy it could not be edited, published,
or translated for decades. Shot through with implied methods of selection and critical struc-
ture, it nonetheless remains a disconcertingly chaotic field of information, as Adorno was
quick to point out when he considered Benjamin's first sketch of the project, *Paris, Capital of
the Nineteenth Century*, professing himself bewildered at Benjamin's unexplained assemblage
of "panorama and 'traces', *flâneur* and arcades, modernism and the unchanging, *without* a
theoretical interpretation."[3]

In late twentieth-century debates around whether interdisciplinary and cultural studies
have methodologies, it is the contours of the material under study that demand theorization.
How does one explain to one's discipline that a choice of topic is a contribution to one's
field? According to what criteria would one now teach the nineteenth century? The questions
are as much practical problems as theoretical issues. They involve specifying and justifying
what methods of analysis are suited to unfamiliar artifacts, and organizing the relationship of
those artifacts among one another. Do we still believe that some artifacts and paradigms have
more cultural value than others? If so, what kind of value, why, and how? A related problem
is both pedagogical and heuristic: what takes on exemplary value?

These questions are of particular relevance to visual culture studies, for visual culture, at
least in the nineteenth century, seems to be privileged material under scrutiny in the studies

of culture in an expanded field. This privilege dates at least to the time of Benjamin's *Arcades Project* which has been so influential in the recent flowering of the field of visual studies, propelled by critical works dedicated to the *Arcades Project* from the first writings on the subject, like Susan Buck-Morss's *The Dialectics of Seeing*.[4]

Benjamin opens the door to understanding the importance of visuality in recent inter-disciplinary studies of modernity when he raises the questions of the consequences for sensual perception of the fact that modernity is dominated by the commodity form. If, as Marx observed, the senses are not natural but rather historical, they must be affected by trans-formations in relations of production and exchange. One consequence of the commodification of all relations attending modernity is a heightened attention to visual appearance. When objects become commodities, they take on the power to stimulate the desire and fantasies of consumers on account of the human labor they both congeal and mask. This stimulus comes from their sensual aspect, and above all their visuality, that plays such an important role in how they are marketed and displayed.

The heightened importance of visuality in the phenomenology of commodity society stim-ulates a new society of the spectacle that in turn is propelled by industrialization, with its development of new mechanical techniques of visual representation. These techniques them-selves, moreover, have a specific effect on the authority accorded visual materials, with important consequences for the central role played by visual artifacts. With the inception and diffusion of mechanical technologies of visual reproduction dating to the middle decades of the nineteenth century, epitomized by the invention of photography, the capacity existed to minimize the visibility of the human hand in the manufacture of images. This erasure facili-tated the reception of visual material as "objective" phenomenon. Images appear to be a kind of degree zero of imitation, as they function as what might be called the image standard: one form of representation that itself becomes the common currency mediating among different forms of representation and thereby endowed with a seeming stabilizing effect. A good example of the image standard would be the power of lithography and photography to organize textual descriptions in nonfictional panoramic writings on social life around telling images that seem to get closer to "the thing itself," or the importance of visual appearance in the extensive description which was a hallmark of nineteenth-century French realism's ambitions to offer a "mirror" or "daguerreotype" of social relations. In our own present, the effect of the image standard is exacerbated by technological developments that make images increasingly manipul-able and transmissible. The high production values important to mobilizing an "objective" version of the image freed from the trace of its producer are no longer costly, nor do they require any great expense (imagine Walter Benjamin armed with a scanner, Photoshop, and PowerPoint).

Complexity, unevenness, mediation, and discourse

Any articulated model of culture as a complex system must build on two fundamental para-digms that currently underwrite materialist studies. Both these paradigms are all the more pertinent for us because they took shape in efforts to understand the cultural and social contours of nineteenth-century western Europe: the Marxian paradigm of society as a complex formation comprised of a range of different modes of production and the Foucauldian interest in the effects of power in structuring society across all manner of social boundaries.

Within the Marxian lineage, a great deal of attention has been devoted to how culture is determined in the last instance by the infrastructure, the realm of economic relations, and

how cultural products interact with the infrastructure in what are called processes of medi-ation. Across the twentieth century, the most important materialist critics have been concerned to complicate a vulgar binarism opposing economic/social relations to culture, and propose that we think of society instead as a complex formation comprised of levels or fields, modes of production which each operate according to their own internal logic, and thus have some measure of autonomy, even as they are simultaneously determined by each other and ultimately grounded in economic relations.[5]

Out of these post-Marxist conversations emerge several ideas key to the study of culture in an expanded field:

1 the notion that the critic looks for homologies: patterns and shifts that replicate them-selves across fields;
2 the importance of events and patterns specific to a field, exhibiting how cultural fields may be *uneven*, which is to say out of synch with one another at any one time;
3 the fact that events and transformations are *overdetermined*, propelled by multiple factors and kinds of causality on different levels of scale.[6]

The notion of unevenness was central to Foucault as well, who had a Nietzschean approach to the inequalities at issue in Marxian thought, establishing the relation among fields as occur-ring at the level of what he called discourse, and proposing that all such relationships are relationships of unequal power. As Foucault makes clear in *The Order of Things*, he developed his notion of discourse against traditional disciplinary paradigms, and even against the funda-mentally disciplinary assumption of cumulative knowledge. As he writes:

> I am not concerned, therefore, to describe the progress of knowledge towards an objectivity in which today's science can finally be recognized; what I am attempting to bring to light is the epistemological field, the *episteme* in which knowledge, envis-aged apart from all criteria having reference to its rational value or to its objective forms, grounds its positivity and thereby manifests a history which is not that of its growing perfection, but rather that of its conditions of possibility.[7]

In his desire to develop the notion of discourse and in his attention to the internal dynamics of these interdisciplinary discourses, Foucault emphasized the arbitrariness of all functioning cultural systems. On the one hand, Foucault convinced us that his nineteenth-century subjects—the prison, with its panopticon, the asylum, and bourgeois sexuality—were among the most pervasively powerful discourses of their time, far-reaching and internally coherent. Yet even in their coherence, Foucault's discourses appeared arbitrary. It seems, in retrospect, as if Foucault was attracted to his subjects precisely because their characteristically arbitrary exercises of power reinforced his belief in the cruel absurdity of all authority. While this remains an essential skepticism to feel in the face of any exercise of power, Foucault's work leave us with an association between discourse and arbitrariness that, in work less subtle than Foucault's, devolves into random designation.

More pertinently, for us, Foucault was not concerned with explaining the codes of repre-sentations, particularly elite representations. Although he begins the body of *The Order of Things* with one of the finest analyses of a painting ever written—of Velasquez's *Las Meninas*—his text seems to begin again immediately after that analysis, leaving it isolated. Foucault's choice to focus on practices rather than representations must be understood as part of his reaction

against traditional disciplinary formations and the accompanying value they assigned canonical objects, along with the attendant concepts of greatness and genius. This has advantages: Foucault's work makes us acutely aware of the passages from practice to representation that edge cultural studies. At the same time, Foucault relied on a contrast with traditional disciplines whose knowledge, we realize as their prestige fades, turn out to have been crucial to his project. They too were archaeologies of a sort. Without them, the passage from representation to practice, especially the passage between the objects of high culture and the expanded field of cultural studies, remains mysterious.

Implicitly at issue both in Marxian and Foucauldian models is some discomfort with the chaos of culture itself. In the former, this chaos must be dispelled and organized; in the latter, the complex forms of relations among different levels of cultural production are beside the point as we strive to attend to the murmur of discourse across these levels. In trying to find an alternative, cultural studies might well take a cue from recent developments in the natural sciences, where the word "chaos" is most frequently accompanied by the word "theory," and the word "complex" by the word "systems."[8] The natural sciences, of course, are not the same as the history of culture, nor can the methods of the natural sciences, understood in any detail, apply to the history of culture, which is, precisely, not natural and cumulatively not natural. But the most elementary principles of chaos theory and complex systems should inform anyone living in the present because they are the perceptual paradigms of our time, what Foucault would call our epistemes. Most fundamentally, chaos theory urges us to consider the multiple complexity of culture as its constitutive characteristic, not as our methodological failure. Just as the natural sciences had no choice but to meet the challenge of describing and theorizing a universe whose facts had come to include many objectively verifiable phenomena that could not be explained by traditional, linear, Newtonian physics, so interdisciplinary and cultural studies will find ways to describe and theorize all its artifacts.

The systems of visual culture

The very variety of objects, conditions, and practices now in the domain of visual studies allows us to see how individual objects belong within systems. The time has come to reassert difference and specificity, in contrast to structuralist models that posited a leveling textuality among objects, allowing the initial introduction of material alongside hallowed canonical texts or objects. The humanities have long had a type of analysis that treats object-types and objects as systems: genre theory.

The concept of genre has been pejoratively treated because it evacuates what aesthetic objects owe to the genius of the creator. Genre was also threateningly complex and chaotic, a quality that led critics to dismiss the notion for its lack of rigor because it entailed different criteria in different conditions. Viewed from the perspective of complex systems, however, this lack of rigor could be reclaimed as a useful flexibility. Genre in fact describes a historically located set of codes recognized and endowed with value by a particular audience at a historically specific moment. The nature of the codes will depend on the historical state of the field and the artifacts under consideration.[9] It will be shaped by such different levels of factors as preexisting formal patterns, authorial style (authorial specificity), medium (material), cultural and social function (where the object is positioned within the specific system), and the relation of this system to other systems. To grasp a structure of such complexity thus requires attention to a multilayered range of causes. It also requires a fluid approach to the artifact and object types. Criteria of description must be deduced according to the conditions

shaping an object rather than from any predetermined schema. Benjamin perhaps sensed this, quoting Goethe: "There is a delicate form of the empirical which identifies itself so intimately with its object that it becomes theory."[10] At the same time, it should be emphasized that no single object, even embedded in its contemporary reception, is likely to represent, summarize, or analyze the generic type. Rather, single objects are raw materials from the historical moment under consideration, which critics must synthesize into an analytic construct.

Ironically, the intellectual tools for the close analysis of artifacts necessary to establish genre are the most traditional tools of literary history and art history: the close analysis of form allied with rigorous archival research. These are skills that can be taught and honed; they are the province of traditional disciplinary knowledge. There have been many laments of late about the "deskilling" of the humanities. And yet, the skills once taught within the traditional disciplines of art history, literary history, and history can be rethought as adaptable to the study of many new subjects.

To define object-types that extend in time as well as space entails looking for what that artifact has in common with other artifacts, reading for patterns that cut across objects, even as it entails understanding how these patterns are located within culture. This is a very different kind of formal consideration from an appreciation of the uniqueness of an artifact. The goal of the critic will have been met, not when an adequate description of this uniqueness has been produced, but rather when the critic has described the range that makes up the object type. A very few objects might recapitulate an entire type, but no single description is revealing as an instance of the whole; the point is to provide an account of how it is situated within a larger pattern and what kind of variation the pattern displays.

This shift from uniqueness to variation within a range will certainly entail revising the traditional focus on describing objects in terms of form envisioned as individual style, working in tandem with the focus on an individual's biography as the social context framing an artifact. Correctly perceiving the primary characteristics of modern Western high art as its authorial individuality, in matters both of form and social context, art history concentrated its energies on understanding how and why objects look the way they do, and what the relationship might be between how they look and their makers' lives. To the extent that the art historical method called iconography elucidated the subject matter of artworks, subject matter was still considered as a function of the unique appearance of that subject matter and its author's experience at the moment of the object's making.

The first important departure from this attachment to style and biography was the study of reception, which showed how the meanings of any work of art were both synchronically and diachronically unstable. Collective factors, such as class, gender, race, nationality, religion, or political position, as well as any number of personal factors, could affect the perceived meanings of any work of art. From there it was only one step further to recognizing that those same sorts of factors could affect not just the reception of any one individual work of art, but the cultural climate within which any work of art could be made or would be understood. And this does mark a crucial step beyond genre theory, which, while it deals with how objects function, is not designed to cope with conditions or functions that operate independently of objects, or even with objects that are subordinate to conditions or functions of visuality.

This methodological step was achieved initially by feminist art historians who, impelled by their own gendered position in relation to art history, posited gender as a condition of visuality. What rules of etiquette, for instance, governed actual women's looking in public? What kinds of looking, therefore, could one expect to see ascribed to represented women?

It was then inevitable that cultural studies would be categorically broadened beyond the study of any and all objects to include all possible conditions of visuality. While some conditions of visuality might take forms that are not at all visual (often verbal, for instance, with the binding verbal force of law, perhaps even), others are visual, thus providing a link to visual objects. Furthermore, conditions of visuality raised issues of function. What practices governed the use of art objects? The first concerted, if often latent, answers to this kind of question were provided by histories of art institutions, and especially by histories of the art museum. The last decade has produced a small explosion in museum studies, all of which point to a crucial development in visual studies. While many museum histories treat institutions as if they were separate from the art objects they put into play, their underlying assumption has nonetheless been that art institutions matter because, in practice, art objects have been understood through them and in them, if not made for them. Art institutions exist to make art function, and so it does. And once art begins to function, it produces effects. Here is where we rejoin both Foucault and Bourdieu, with their interest in culture as lived practice. Visual representation is always and everywhere being put into practice and therefore producing actual, as opposed to representational, effects. This is why cultural studies meshes the disciplines of art history, literary history, and history.

And here we return to the systemic nature of visual culture. A systemic description of visual culture must deal with all its modalities. As far as objects go, this entails heeding the style, date, conditions, and functions of all forms of visual representation. If all these modalities are equally heeded, then visual studies may be paying attention to representational phenomena of very different sorts. Some phenomena will be more strongly characterized by some modalities than by others. Some may hardly be characterized by one or more modalities at all. Some phenomena may hardly even be objects. Traditional art history was all about objects characterized by style, about objects that could be described aesthetically. Art history, moreover, ranked objects according to their aesthetic characteristics, so that an aesthetically unremarkable object was judged inferior to one whose style was historically important. Such attention to form was, however, misleading because it designated only one aspect of a cultural artifact's representational properties. Content, condition, function, and effect are as important systems as formal structure. The difficulty of juggling all these factors is, admittedly, considerable. It has, however, been done. Very recently for instance, and at book length, Ann Bermingham has provided a model in her *Learning to Draw; Studies in the Cultural History of a Polite and Useful Art*.[11] Taking as her subject a practice, she investigates its texts, its institutions, its locations, and its players, as well as its objects. In every chapter, issues of form, class, gender, authority, and relationship to literature are intertwined as they evolve chronologically. Bermingham charts a cultural triage zone in which many means are deployed to decide where, how, and to whom access will be given to the powerful forms of culture and where, how, and to whom such access will be refused.

Visual culture as complex system

Different aspects of visual culture may each be locally described correctly and yet be incommensurable. Perhaps more confusingly, they can operate at the level of the particular and also at the level of a cultural totality. Not only may these aspects exist in different modalities, they may not obey the same rules macrocosmically as they do microcosmically. We rename as complex systems what Marxian criticism would call unevenness across the fields of cultural production to emphasize that this unevenness exists within the subsystems

of one field; it is not only a question of the relation between cultural superstructure and economic infrastructure, but of the complex nature of different aspects of the cultural superstructure itself.

One example of the way in which different aspects of visual culture may be internally uneven, or, as we put it, complex, is in the relation of Modernism to visual culture, or of the Modernist canon to cultural studies. Suppose the lineage of Modernist art were considered as one system, or what Adrian Rifkin has so aptly called the "art-series."[12] The art-series is primarily characterized by aesthetics, so much so that it has seemed, as it is so often said, aesthetically autonomous. In a dramatic reversal of fortunes, the very reason for its dominance of traditional art history is now all too often explained away as being at best seductive or at worst downright false. Yet this is historically absurd and the disappearance of a Modernist canon from visual culture would be seriously misleading. Modernism is what it always said it was and those are its terms. Moreover, it is historically true, as Modernist art historians always claimed, that those terms dominated the visual culture of the nineteenth century. Or rather, the formation of a Modernist canon is one of the, if not the single, most historically important phenomena of nineteenth-century visual culture.

Of course, there have always been canons: rosters of artworks prized most highly by their cultures, icons of cultural value. But a new canon was formed in the nineteenth century, one whose terms were organized around the concept of an authorship defined by optical stylistic evidence and secondarily around biography. It had been in the process of formation for decades and, by the late 1880s, it was established. The surest sign of its success was not so much the terms on which art was being made, but the terms on which older art was reevaluated. Some works that had been in previous canons, above all paintings by Raphael and Rembrandt, were included at the summit of the new canon, an overlap that masked a radical transformation in the criteria for their primacy. To accomplish such a transformation, a wide range of cultural practices had to be mobilized, ironically in order to make practices seem irrelevant. Nowhere is this more evident than in the massive efforts of pioneering art historians to constitute catalogs of canonical artists' paintings and to move their paintings through an art market into great private collections and from there into museum collections—two closely related enterprises. The connoisseurship of the late nineteenth century believed itself better able than ever before to see the difference between "genuine" and "false" authorship, when what was really happening was the triumph of a certain kind of seeing over other values. This development of an art series, at once actual and retroactive, is of the highest relevance to the historiography of cultural studies, for the conditions of the Modernist canon were the premise on which the academic field of art history could be separated from the fields of literature and history. Cultural studies reintroduces to the study of visuality many of the criteria and objects considered pertinent to the knowledge of visual culture prior to the nineteenth century.

To jettison the art-series is to deny what is locally true, and to deny the standard of power against which all other image-types—at least to some extent—measured themselves. The ability of the art-series to absorb other imagery and other practices and put them in the service of style is itself a history that must continue to be told accurately. To concede the power of an aesthetic canon cannot now be a tribute to some putatively transcendental aesthetic superiority, but rather an historical location. Centers and margins are functions of history, on whatever terms they stake out successfully. We need to understand how, why, and where centers hold or do not hold, how positions are realigned and on what terms. We need to reconstruct the genealogies that got us from how nineteenth-century audiences perceived

their culture—which may, moreover, vary from audience to audience—to how the field now looks to us today. This will entail a renewed interest in the question of aesthetic value. Yet aesthetic value will not return as the critic's task of connoisseurship and evaluation, but rather as the subject of inquiry, as a historically located discourse on culture, which must be understood in the historical specificity of its criteria. Only when we have a nuanced map of the make-up and transformations of these criteria, will we be able to address whether indeed there are transcendent aesthetic patterns whose value remains stable across time. Take the example of Christen Köbke. Early nineteenth-century Denmark produced an extraordinarily beautiful school of painting which the Danish call Golden Age, and whose most gifted artist was Köbke. Köbke is not a part of any Modernist canon. It might seem possible to point to the poetically luminous realism of Köbke's art and claim that he should, retroactively, be included in such a canon. That canon, however, was formed in its own time according to forces we need to recognize, not revise. Rather than undoing the past, Köbke's career and critical fortunes can help us to gauge how determinant the factors of institutional and geographic distance from the power center of Paris actually were. In Köbke's case, geography and institution trumped aesthetics. To acknowledge this, however, does not preclude discovering Köbke's qualities on our own terms, for our own time.

Conversely, cultural studies will have to turn away from making arguments for the importance of studying phenomena because they are marginal. No phenomenon is historically significant simply because it is marginal. (Köbke is not interesting because he is marginal, any more than he is interesting because he is canonical. From a historical point of view, what he illuminates is the power relationships among state-sponsored European art academies.) Nor is it inherently oppositional or liberating to study marginal phenomena. Marginal phenomena are as likely to be politically and socially conservative or intellectually elite as they are to be radical or popular. Marginal phenomena, just like central phenomena, are significant inasmuch as they allow the structure of a cultural situation to be understood. Rather than dwell on ideas of either margin or center, both of which are static, it would be more useful to think about location. Power operates neither at a center nor on a margin, but as systemic relationships.

Location calls into question both place and time. Complexity yokes not only systems with different characteristics, but also systems with different relations to temporality and temporal development. Some systems evolve on their own, tracing the possibilities of autonomy, and incidentally of occasional change. Other systems begin or end in a relationship with dominant modes of visuality but somewhere along the way develop a characteristic energy of their own. Some are short-lived, others durable, some widespread, others local; some diffuse, others clustered. Similarly, we must accept that the scale of these positions may vary radically. Culture entails the coexistence and interaction of systems operating on a number of different scales, just as the systems themselves contain phenomena of all sizes that might be called "scale free" (to borrow a term from chaos theory).

Yet to speak of a coexistence of different kinds of systems is not to imply that their relations cannot be studied. In this regard, attention to culture as a complex system offers a corrective to the utopian formulations of Deleuze and Guattari which have encouraged conceptualization of culture as a rhizome, as a sort of multidimensional complex formation through which energies take mutating forms. In applications of these notions, the emphasis is often put on celebrating transformation and mutation, but a complex systems approach to visual culture emphasizes the need to understand the specificity of the transformation and mutation, as well as the nature of the systems brought into relation.

More than ever before, then, chronology, geography, and consistency matter. This will be crucial in determining what energy moves the system. From what directions do its energies come? Where do they go? What ruptures or unions do they cause? In what ways are the energies of different systems like or unlike, compatible or incompatible? At what velocity does the system move? Do some parts move more rapidly than others? How, where, and when do systems encounter each other? Chronology, geography, and consistence will also be crucial in understanding how systems interface. The interface among systems involves two crucial issues: where systems are positioned in relation to each other, and how that relational position changes according to factors such as time, place, class, gender, race, or religion.

Edges

The reason to know the structures of systems is to be able to recognize when their pattern becomes disturbed enough to signal some change: the confluence of some other system (when travel-book prints reinforce the landscape painting movement), an obstacle encountered and perhaps surmounted (women achieving professional status), a technical problem long nagged at suddenly solved (photography becoming cinema). (Chaos theory would call such changes stochastic.) To describe a pattern as it replicates itself is the academic means, but to mark the moments and process of its transformation is the critical end. The transformations themselves are scale free, and at the horizon of attention to culture as a complex system is a better understanding of the different modalities of historical change itself. Of course, sudden flares are the most exciting: a single individual's invention, a head-on collision at full speed. We have long known, for instance, that Théodore Géricault made use of medical imagery and sensationalist journalism in his painting, as well making prints himself. But it has only been with the new work of Jonathan Crary on the ways in which the visual structures of the popular commercial panorama profoundly inform Géricault's 1819 masterpiece *The Raft of the Medusa* that we can understand Géricault as an artist who compulsively tried to hybridize academic and popular modes of visuality, leaving in his work the fierce traces of antagonistic clashes.[13] Scholars of culture will want to pay particular attention to the edges between systems because it is there that the different levels of factors structuring the interior of systems are most visible.

The edge is where systems change. Indeed, an emphasis on emergence is one way to rethink the importance of history, as it turns our attention for new reasons to change. These edges at times take on their own autonomy; here, we can usefully invoke the interest of thinkers like Deleuze and Guattari in the zone. The zone is a formation comprised of independent formations that overlap, opening a formation defined by its own rules, even as it is comprised of interacting formations. One example of such a rich zone would be the interface of visual and textual culture.

Shifts imply contiguity. Relationships among discontinuous systems are necessarily less coherent than what happens along edges. Analogies between separate systems may be curiously resonant, but they are bound to prove arbitrary and random. The strength of Debora L. Silverman's 1989 *Art Nouveau in Fin-de-Siècle France; Politics, Psychology, and Style* is her reconstruction of the forgotten edges between politics, psychology, and style.[14] Rather than posit a psychological dimension to the art criticism of the Goncourt brothers, for instance, she rediscovered which protopsychological texts the Goncourts actually knew and shows how one kind of text slips into another, and from there how texts about art affect art production.

Visual culture is structured by its contact zones.[15] What we need, therefore, are studies of the shared edges between textuality and visuality, and even more so between modes of visuality. In this respect, Andrew McClellan's work on the Louvre provides one model, with its careful reconstruction through prints of how the galleries of the Louvre presented paintings visually, which is to say how the Louvre, an institution devoted to making art function visually, did function visually.[16] We need many more such studies, for although the conditions and practices of visuality may not always and everywhere be lodged in objects, visual evidence for the conditions and practice of visuality will always be particularly convincing.

The importance of the edge extends to objects found within systems as well as those at their interface, for some objects make their external edges and positioning within a field the subject matter of their representations, as they stage within themselves the conditions of their position (or what phenomenology might call their horizon of possibility). Objects that thus carry within themselves the signs of their situation might be thought of as kinds of critical *mises en abyme*. They are objects that act as microcosms, designating the critical structures of visual culture. There are surprisingly many of these, some within traditional canons, and more of them elsewhere. While it was long believed that only intellectually elite objects were capable of such internal intricacy, it has been one of the important findings of cultural studies that all genres produce such intricacy. Indeed, one of the signs of culture being systemic is that there are so many objects that are self-conscious about this very fact. This way of conceptualizing culture cuts across the traditional non-canonical/canonical divide, as it does across the professional/amateur divide, and it can also be a way of reconceptualizing some canonical work. Some individuals repeatedly produce such works during their entire careers. Mary Ellen Best, for instance, a completely amateur feminine watercolor album maker, provides us with one of the most extensive catalogs of the conditions of image spectatorship in the first half of the nineteenth century. Almost obsessively, Best recorded an astonishing range of places in which images could be seen, bought, displayed, combined, or made, along with the sorts of people and activities that shared those exhibition and consumption spaces. Honoré Daumier provides another example of exceptionally sustained attention to relationships among images, complementary to Best's because he deals with the kinds of publicly commercial and political situations from which Best's feminine gender excluded her. Significantly, Daumier did this sort of critical image-making almost entirely within the mass-reproduced print medium, not in the paintings through which art history has tried to transform him into a "real" artist. Yet it would be a mistake to neglect the edges within canonical objects. Édouard Manet, for instance, constantly included other images within his paintings. Juxtaposed, conflated, elided, cited, overlapped, or slammed together, all the sorts of images then available to an artist are brilliantly forced by Manet into the service of Modernism.

Not all subjects are equally valuable. Only the most forceful trajectories will be perceptible from the kind of interdisciplinary distance that cultural studies aspires to. Scattered information or incompletely rendered systems will be invisible. It is the edges that will register, not only because of the activity that accelerates there, but because those zones of change are constituted by the meeting of systems whose differences create contrast. Contrary to the reputation of cultural studies, then, cultural studies depends more than its progenitors on a ruthless choice among subjects. Cultural studies must make evaluations based on multiple criteria, all of which add up to whether anything about a system, or even the entire system, plays a decisive macrosystemic historical role. The point to emphasize is, however, that such strenuous attention to context and specificity, which is essential to systemic thinking, is not disempowering to the critic and historian. Rather, it will allow them to control subjects of

greater scope than ever before. In today's academic climate, the temptation is to position oneself at a point of maximum diversity and exchange, to work as much on an edge as possible. Given the traditional organization of disciplines around a restrained set of fields of cultural production and around a body of inherited scholarship centered on this restrained notion of culture, and given the complexities of these restrained fields themselves, very few scholars come to the study of complex culture with the ability to work on edge. We need not be dismayed, however, by the challenge of working beyond our disciplinary homes as long as we maintain an interest in the edge and recognize the kinds of conflicts, as well as the excitement, that come from collaborative scholarship.

Collaboration, that is to say, preserves disciplinary expertise within an interdisciplinary context. While interdisciplinarity is sometimes given a nefarious role in promoting watered-down scholarship, our model of cultural complexity makes evident the importance of disciplinary expertise. This expertise is not treated complacently, but rather as needing to be defined against what it is not; as rethinking a vision of the internal consistency of the field as defined by its edges rather than as a traditional lineage of received scholarship. Collaboration has not, however, been a central model for scholarship in the humanities, above all in the disciplines of art history and literary studies, as if these disciplines' traditional focus on unique objects evaluated in terms of genius and greatness are extended to the work of the scholar as well. Until these criteria change to recognize the need for collaboration if we are to work on culture in an expanded field, however, the enabling power of collaboration will be accessible only to tenured scholars who no longer have to produce work affirming their creative individuality as the unique authors of their research. The humanities would do well to take a cue here from the natural sciences, where collaboration is a familiar model, recognized as the productive interface of the different kinds of skills that are necessary for the study of complex systems.

Notes

1 Vanessa R. Schwartz, "Walter Benjamin for Historians," *American Historical Review* (December 2001): 1721–43.

2 Walter Benjamin, *Das Passagen-Werk*, 2 vols. Rolf Tiedemann and Hermann Schweppen häusert, eds, with Theodore Adorno and Gershom Scholem (Frankfurt am Main, 1972–89); Walter Benjamin, *Paris, capitale du XIXᵉ siècle: Le livre des passages*, Jean Lacoste (trans.) (Paris, 1989); Walter Benjamin, *The Arcades Project*, Howard Eiland and Kevin McLaughlin (trans.) (Cambridge, Mass.: Belknap Press of Harvard University Press, 1999).

3 Theodor Adorno to Walter Benjamin, New York, 10 November 1938, in *Aesthetics and Politics* (London: New Left Books, 1979), p. 127.

4 Susan Buck-Morss, *The Dialectics of Seeing* (Cambridge, Mass.: MIT Press, 1989).

5 Thus, Althusser spoke of the "semi-autonomy" of different levels of social activity. Pierre Bourdieu has perhaps taken the farthest a systematization of Althusser's concept of "semi-autonomy," proposing that society might be thought of as organized into a number of different fields, defined by the specificity of their modes of producing economic and social value, and that the task of the cultural critic was to understand relations within and among them. For an example of this sytematization, see Bourdieu's *Les Règles de l'art*. Pierre Bourdieu, *The Field of Cultural Production: Essays on Art and Literature*, ed. and intro. Randal Johnson (New York: Columbia University Press, 1993); and *The Rules of Art: Genesis and Structure of the Literary Field*, trans. Susan Emanuel (Stanford, Calif.: Stanford University Press, 1992).

6 To use Bourdieu's model as an example, it lacks specific guidelines from how we relate one kind of cultural artifact to another, as well as a justification for his choice of objects on which to focus. Indicative of this lack is the inability of the model to account for the distinctive modality of the aesthetic artifact beyond Bourdieu's two crucial terms for organizing cultural products: as endowed either with economic or symbolic value. Whatever minimal formal analysis of the aesthetic Bourdieu engages in

turns form into practice, and into one kind of practice specifically: the foundational capitalist pursuit of surplus value. For Bourdieu, agents compete in social fields, as Bourdieu offers a model of the stakes of social activity that sits ambiguously between a Marxian model of society as driven by class struggle and a liberal model of society as driven by private individuals competing to maximize profit. Although Bourdieu complicates the nature of that value to include cultural as well as financial rewards, all aspects of an art work become subsumed to this competition whether it is the position-taking of individuals or aesthetic practices that become socially recognized and disseminated in positions.

7 Michel Foucault, *Les Mots et les choses; une archéologie des sciences humaines*. Paris: Gallimard, 1966, p. 13; tr.: Michel Foucault, Preface, *The Order of Things: An Archaeology of the Human Sciences* (New York: Random House, Inc., 1970), p. xxii.

8 Two good basic introductions to natural science models of complexity are Per Bak's *How Nature Works* (New York: Copernicus, 1996) and James Gleick's *Chaos: Making a New Science* (New York: Penguin Books, 1987).

9 For Pierre Bourdieu, genre was what he called a "position." Jameson grasped this aspect of genre in *The Political Unconscious* when he talked of it as a social contract, or what he also identified as a *combinatoire*. Frederic Jameson, *The Political Unconscious: Narrative as a Socially Symbolic Act* (Ithaca, N.Y.: Cornell University Press, 1981).

10 John Berger quoting Walter Benjamin quoting Goethe: "The Suit and the Photograph," *About Looking* (New York: Pantheon, 1980), p. 28.

11 Ann Bermingham, *Learning to Draw; Studies in the Cultural History of a Polite and Useful Art* (New Haven, Conn. and London: Yale University Press, 2000).

12 Adrian Rifkin, "Art's Histories," in *The New Art History*, A.L. Rees and F. Borzello (eds) (Atlantic Highlands: Humanities Press, 1988) pp. 157–63.

13 Jonathan Crary, "Géricault, the Panorama, and Sites of Reality in the Early Nineteenth Century," *Grey Room* 9 (Fall 2002): 6–25.

14 Debora L. Silverman, *Art Nouveau in Fin-de-Siècle France; Politics, Psychology, and Style* (Berkeley, Calif.: University of California Press, 1989).

15 Mary Louise Pratt defines this useful notion in *Imperial Eyes* (London and N.Y.: Routledge, 1992).

16 Andrew McClellan, *Inventing the Louvre: Art, Politics, and the Origins of the Modern Museum* (New York and Cambridge: Cambridge University Press, 1994).

Chapter 3

MICHAEL L. WILSON

VISUAL CULTURE
A useful category of historical analysis?

DO HISTORIANS NEED ANOTHER REMINDER to take seriously the pictorial traces of the past? More dogmatically, must we embrace yet another critical category of analysis, that of "visual culture"? The tempting answer is, of course, "No." Several long generations after Jakob Burckhardt, Johan Huizinga, and Aby Warburg argued for the crucial role of fine art in understanding the past, visual materials and issues of "representation"

seem firmly entrenched in historical practice.[1] Across geographical and chronological special-
izations, historical monographs, and major historical journals include illustrations and visual
sources on an increasingly regular basis. Historians now routinely examine images alongside
archival records, printed sources, and manuscripts. Textbooks, perhaps due to the common-
place assumption that each generation is more visually literate than the previous, are larded
with images; in the classroom many of us use overhead and digital projections, slides, television
programs, and movies to give our students a more vivid and concrete understanding of the
past. Film seems especially well integrated into not only teaching but professional scholarship.
The journal *Film & History* has been published for thirty years, the *American Historical Review* and
more specialized periodicals regularly review films, and a growing scholarly literature explores
relations between cinema and history.

In addition to finding a call for attention to visual culture redundant, historians may also
be dubious about the value to them of a field of study that is so vaguely and poorly demar-
cated. Scholars of visual culture seem unable to reach consensus on what, exactly, their
object of inquiry might be and how it is to be studied. Is "visual culture" best defined as an
expansion of the purview of traditional art history, to include popular and commercial forms
of pictorial representation, such as advertising, caricature and cartoons, postcards, snapshots,
and mass spectacles?[2] Should "visual culture" attend more broadly to the visible character-
istics or appearance of all products of culture and every social activity?[3] Should it focus instead,
as W.J.T. Mitchell has suggested, on the long history of interrelations between image and
idea?[4] Does this new field propose, in the words of the "Visual Culture Questionnaire" circu-
lated by *October*, a "newly wrought conception of the visual as disembodied *image*, re-created
in the virtual spaces of sign-exchange and phantasmatic projection."[5] Perhaps, as Chris Jenks
has posited, visual culture is to be grasped less as a particular range of objects than as a
process, a dynamic exploration of "the social context of both the 'seeing' and the 'seen' but
also . . . the intentionality of the practices that relate these two moments."[6] Or, as Irit Rogoff
has insisted, visual culture might be understood most importantly as a critical activity, a "ques-
tioning of the ways in which we inhabit and thereby constantly make and remake our own
culture" such that "the boundary lines between making, theorizing, and historicizing [are]
greatly eroded."[7] "Visual culture," then, is used by its advocates to refer to any number of
phenomena: a particular range of images, or the image as such, or relations between icons
and ideas, or the social process of visual perception, or a mode of criticism and analysis.

This range of possible definitions underlines that "visual culture" as an object of study
does not simply emerge from the effort to comprehend a contemporary world dominated by
the image. It also stems, at least in part, from the influence of recent historical writing upon
scholars of art, design, architecture, and mass media. That is, the successful efforts of these
analysts to make more *historical* their own practice—to trace the social histories and social
contexts of the "fine," "applied," and "commercial" arts—have themselves led in recent years
to this reconceptualization of the commonalities underlying forms of visual representation.
Art historians, for example, have since the 1970s explored in depth the specific social and
economic circumstances shaping the development of painting, sculpture, and photography
across the nineteenth century; social and economic historians, however, have not felt a reci-
procal impulse to investigate the pictorial arts in order to explain developments in their field
of inquiry. The advent of the field of visual culture, then, might be understood as confirma-
tion that scholars of the visual have a greater need for historical understanding than historians
have the need for greater attention to the pictorial.

Such skepticism may only be strengthened by an examination of some of the operational
assumptions that underpin scholarship in visual culture. One might point to the particularly

elastic and undifferentiated concept of "culture" which is often deployed in this literature, a framework expansive enough to include all "material artefacts, buildings and images, plus time-based media and performances, produced by human labour and imagination, which serve aesthetic, symbolic, ritualistic or ideological-political ends, and/or practical functions."[8] This notion of culture as a way of life was borrowed (as it was by historians) from twentieth-century anthropology. Here, though, the supposition that every detail of quotidian life is (to some degree) interconnected and (at least potentially) meaningful is taken as the basis of further assertions that culture is pervasively organized and integrated into a singular visual order. Whether cast as the Western "way of seeing", or the mode of "bourgeois perception", or the modern "scopic regime," the coherence of visual culture is privileged:

> [T]he weight of evidence certainly seems to convince us that the dramatic confluence of an empirical philosophical tradition, a realist aesthetic, a positivist attitude towards knowledge and a technoscientistic ideology through modernity have led to a common-sense cultural attitude of literal depiction in relation to vision.[9]

Such a model of visual culture as a closed, overdetermined system seems reductive, suspiciously static, and unnecessarily totalizing. Connections must be demonstrated (not merely assumed or asserted) between empiricism, aesthetics, practices of arts and crafts, ideologies, and common sense. What are the assumptions shared by different models of vision and perception—whether philosophical, physiological, or neuropsychological—formulated at any historical moment? How do such models change, gain prominence, and challenge one another? To what extent do prescriptive texts concerned with the production and reception of images influence practitioners or reflect their work? How widespread, how commonsensical are the conventions structuring different forms of visual culture, and how can we account for their development and change? Who are the different audiences within visual culture and to what extent can we determine how they do or do not make sense of what they see?

Let me draw particular attention to the last of these questions, since a flattened notion of culture is itself often at odds in visual cultural studies with a strong interest in *reception*. As in cultural studies more generally, analysts of the pictorial quite often stress the processes by which individuals and social groups perceive, appropriate, and transform the very materials of visual culture. In Rogoff's formulation, the attempt to analyze reception has at least three components:

> First there are the images that come into being and are claimed by various, and often contested histories. Second there are the viewing apparatuses that we have at our disposal that are guided by cultural models such as narrative or technology. Third, there are the subjectivities of identification or desire or abjection from which we view and by which we inform what we view.[10]

Rogoff's account plots a steady critical movement from material traces to the individual psyche, and places an emphasis on *how* people make sense of their experiences of images. However, a closer examination of how many scholars of visual culture work on questions of reception suggests that all three of these components are derived more from theoretical formulations than from whatever records might remain of how historical agents have participated in visual culture. Discussions of "the gaze," "surveillence," or "spectacle" often begin with the uncritical acceptance of assertions about how modern society is organized. Much of this scholarship depends on abstract, usually psychoanalytic mappings of the modern subject in which

the individual is as much constituted by, as he or she is a shaper of, larger, inflexible social forces. At its least convincing, scholarship in visual culture posits an iron cage of visuality in which universalized persons are subject to regimes of seeing over which they can exercise no significant influence.

Yet for all that is problematic in attempts to forge this new discipline and to delineate its aims and methods, the indifference (if not resistance) of historians to visual culture has more basic causes. Contemporary historians are, by and large, logocentric. In all the examples I proffered in my opening paragraph—and, I would argue, in the contemporary pursuit of history more generally—pictorial sources have value only to the degree that they *add to* the main work of historical knowledge. In practice, the visual (in both its broadest and narrowest manifestations) remains an addendum to the linguistic. Even so sympathetic a figure as Peter Burke, at the end of a recent book arguing for historical attention to pictorial evidence, writes, "the testimonies about the past offered by images are of real value, supplementing as well as supporting the evidence of written documents."[11] Historians regard images as *supplemental* in the sense that they augment a method of inquiry firmly grounded in language (and, to a limited degree, numbers). Visual sources are of interest insofar as they confirm what historians learn by examining other kinds of records. For example, newspaper illustrations, postcards, and photographs of theatrical presentations may show us the specific visual markers used in Victorian popular culture to stereotype Jews, gypsies, Africans, and Asians. However, historians are unlikely to see images of "exotic," "marginal," or inferior" peoples as having interest in themselves, or as having the power to generate ideas and preconceptions about those other groups. They are much more likely to cast these materials as illustrations or manifestations of Victorian social attitudes; and they are more likely to seek the motivations for and the meaning of these (mis)representations—the ground from which they arise—in political tracts, scientific treatises, travel literature, popular fiction, and other printed sources.

Historians' preference for working with written documents is not merely a matter of the comfort and familiarity of words; nor is it simply attributable to the ways in which historians are trained. Rather, historians prize the seeming transparency of language because their major concern lies not with textual questions but with the prior reality that written sources record. Despite what is often termed "the struggle with documents," historians are largely inclined to move *beyond* matters of representation (whether linguistic, numerical, or pictorial) to the agency and experience of people in the past.[12] The French, in the first half of the nineteenth century, produced an enormous archive of images and descriptions of the various social "types" inhabiting Paris, from the ragpicker to the financier, from the the milliner's delivery girl to the courtesan. Recent historians have generally explored only two aspects of these sources: how this proliferation of images signals widespread anxieties about cities and their inhabitants; and to what extent these images correspond to what Parisian life was "really" like.[13] These images are not considered of interest themselves. Instead, visual representations of urban life serve historians as an indirect route to the social, economic, and political realities that people experienced: the expansion of capitalism, urbanization, and fears of an urban underclass, transformations in gender norms, and so on. Such connections between iconography and social structure are, of course, there to be made; but historians habitually cast only social phenomena as analytically significant. Visual culture, then, is deemed inadequate for addressing the basic aims of historical research, which is reducible to attempts to document (and misdocument) people, social processes, and events already identified as having historical importance. Pictorial sources remain marginal to most historians because, as Stephen Bann has put it, "the visual image proves nothing—or whatever it does prove is too trivial to count as a component in the historical analysis."[14]

The presumption that visual is "trivial" becomes self-fulfilling. Those books and articles that do contain illustrations frequently treat these images as merely decorative, showing what a person or place "actually" looked like or adding a period "flavor." These works generally do not cite, much less analyze, any of the images included. Some books include extensive sections of illustrations whose relation to the printed text is never explained. Even those works that make mention of the images they contain may, for example, discuss caricatures only in terms of their captions or treat photographs as transparent documentary records. Often, authors offer no analysis of illustrations in terms of their visual content, their own history, the genre conventions in which they participate, or the manner in which they construct a representation of the world. Authors who use images in this reductive manner indicate to their readers that visual materials are outside the normal practice of historical inquiry.

Of course, not all historians are indifferent in their use of visual culture. Some have traced with great insight the institutions and material life of the fine and applied arts.[15] Others have explored the vital role of imagery in political life.[16] Two additional examples suggest how attentive historians are drawing on visual culture to enrich and expand their analyses. Douglas Mackaman, in his study of nineteenth-century French spa culture, uses architectural drawings alongside archival documents to investigate how the spatial organization of spas became decreasingly public and heterosocial in accordance with shifts in bourgeois notions of privacy and gender segregation. More provocatively, he examines the souvenir books of photographs and caricatures that could be purchased by spa-goers. Mackaman finds in these images an alternative to the archival and printed sources he examines, which are largely concerned with medical and therapeutic benefits. The souvenir books instead stress the discomforting and humiliating aspects of spa treatment, suggesting a dimension of the spa-going experience that the written sources do not document.[17]

Similarly, in her examination of the role of the nineteenth-century American women's periodical, *Godey's Lady's Book*, Isabelle Lehuu explores how the book's illustrations were frequently at odds with its printed texts. The didactic moralizing fiction and non-fiction that *Godey's* published has long been thought crucial to the shaping of middle-class norms of femininity in the antebellum period. Lehuu, though, traces the tensions between these proscriptive texts and the periodical's hand-colored engravings that show women displaying the latest fashion trends in public settings. While she demonstrates that over time the fashion plates came more and more to resemble sentimental genre scenes stressing domesticity and republican virtue, Lehuu posits that *Godey's* rendered the world of white middle-class Protestant women visible in a way that had not been possible before. Moreover, she suggests that the illustrations, which were frequently removed by readers and displayed in their homes, were more important to *Godey's* readership than its written texts. These engravings were not "direct representations of the image that nineteenth-century white middle-class women had of themselves," Lehuu argues, but images that readers were "appropriating, enjoying, and approving" in constructing their own identities.[18] By examining the complicated relations between text and image, and images and their referents, Lehuu demonstrates that even so "frivolous" and "trivial" a source as fashion illustrations can reveal competing notions of gender and class in operation.

Promising as such examples are, they remain the exception rather than the rule. All too often, historians' subordination of the visual to the linguistic and of representation to experience appears intractable. It is certainly (but not merely) another instance of historiography's methodological conservatism, of historians' valuing the documentary and reconstructive aspects of their work more highly than its interpretive dimensions. Historians have borrowed methods and even areas of research from any number of other disciplines over the past century, but this intellectual exchange has largely involved the social sciences. The insights

offered by economics, demography, or anthropology, for instance, have strengthened historians' ability to reconstruct the *experience* of the past in greater and greater *written* detail. Even after the much-vaunted "linguistic" and "cultural" turns, historiography remains firmly materialist in aim; and disciplines such as philosophy, literary criticism, and art history, whose objects and insights are not easily reducible to social, economic, and political generalizations, continue to be perceived as peripheral to the production of historical knowledge.

The tensions between the practice of historians and that of visual cultural studies, though, are not immutable. No matter how limited their mutual engagement and however uneven the exchange, the two fields have much to offer one another. At the very least, scholars with differing training can alert one another to new documents and sources, new archives, and alternative methods of criticism and interpretation. Mastering new skills as well as encountering a body of unfamiliar critical literature are unquestionably time-consuming undertakings, but they produce clear results. Historians would benefit from learning a range of modes of analysis of pictorial texts—from the rudiments of composition, to iconography, to film theory, to semiotics—for it would allow them to use a broader selection of sources with more flexibility and insight. With more methodological tools at their disposal, historians could distinguish more subtly between different practices and registers of meaning within visual culture and thereby make more effective use of them. Conversely, scholars of visual culture would benefit from exposure to the methods historians have established for the systematic interpretation and comparison of a variety of documents. Adapting some conventions of historical argument would also allow for analyses of visual culture that rely less on juxtaposition, analogy, and homology, and engage more with demonstrable linkage, contingency, and causality.

The interaction of historical and visual cultural studies would be especially productive with regard to several crucial methodological questions. How do we weigh the explanatory power of different bodies of evidence? (Sometimes an illustration is just an illustration.) How are we to apprehend and analyze the multiple relations between words and images, language and the pictorial? How autonomous are cultural phenomena with regard to given social, economic, and political structures?

Here I can treat only one such issue: the problem of periodization. Both fields tend to privilege chronological divisions derived either from political demarcations—Victorian, Second Empire, Wilheminian, Antebellum—that may not bear a significant relation to social or cultural developments, or from a conventional progression of aesthetic movements—Realism, Naturalism, Modernism—that may only account for a small segment of cultural production at any historical moment. Obviously, relations between cultural production, political activities, and the state are not negligible, particularly when discussing government-sponsored art institutions or instances of regulation and censorship. Similarly, the producers of visual culture—whether or not they were considered "artists"—were frequently knowledgeable and self-conscious about the relations between their work and that of their contemporaries and predecessors. Still, both ways of organizing the study of culture impute a false sense of coherence and homogeneity to the chronological units they create.

Of course, all attempts to carve time into manageable units are artificial and can only be heuristic. Practically, periodization serves to limit the number of possible relevant contexts that can be addressed in any particular investigation and to determine the range of possible explanations that can be proffered. The challenge facing scholars in history and in visual cultural studies lies in setting such limits in a manner that is appropriate to and commensurate with the phenomena they wish to examine. Political regimes and artistic movements may be of too brief a duration to have more than a glancing effect on cultural production; modernity may be a process too slow, uneven, and widely dispersed to explain the emergence

or transformation of specific forms of visuality. A number of different timescales, of varying and conflicting histories, might be required to account for the full range and significance of visual culture.

Consider, for instance, the early history of photography, with its cluster of "inventors," competing technical processes, transnational exchanges, and troubled aesthetics. Mid-nineteenth-century photography could be located within chronologies concerned with technologies of reproduction, burgeoning markets for consumer goods, the rise of a mass press, developments in popular science, ideologies of middle-class domesticity, and so on. It shares its implication in some—but not necessarily all—of these narratives with the history of the panorama and the diorama; these forms of representation were to some extent in competition with, influenced by and an influence upon photography, but had a different relationship to the fine arts and to popular entertainment. The potentially relevant contexts within which early photography might be examined proliferate as quickly as did contemporary media: posters, political caricatures, engravings of famous paintings and current events, wax museums, colonial exhibitions, world's fairs. According to what terms, though, do the similarities and the differences between all these practices become formally, ideologically, socially *significant*? How do we decide whether events occurring at more or less the same time have any *meaningful* correlation, much less common cause or causes? Or is the analytical imperative to make general claims itself dispensable? Concluding that these examples of visual culture are the products of industrial technology, tools of the imperial state, or constituents of a realist aesthetic (the list could go on) is a first step, but it is only a first step. We need now to formulate intermediary categories, ways of describing continuity and change that mediate between isolated artifacts, transient events or trends, chronicles of particular media, genres or traditions, and long-term transformations of social and economic organization. Periodization is one means of organizing our investigations of the past, but it may serve to obscure more than it does to reveal.

As this sketch suggests, encounters between historical practice and visual cultural studies can make uncomfortably explicit the assumptions and values of both fields. By designating pictorial sources as belonging to a particular "period," historians affirm the primacy of context over text, while scholars of visual culture insist that textuality is constitutive and pervasive. This in turn demonstrates just how dissimilar the explanatory models governing both fields can be, and returns our attention to the unsurprising fact that different disciplines (including those styled interdisciplinary) have differing objects and aims. Any productive exchange between historians and scholars of visual culture must begin with a recognition not only of what questions, methods, and materials they share, but of just how much separates them. That such a reckoning is challenging has not prevented scholars from moving between and among different disciplines, or from expanding and refining our knowledge of how the visual has functioned in past societies. The current collection provides ample testimony of just how fruitful such exploration can be. I imagine these interdisciplinary initiatives will continue and will increase in frequency and scope. To answer the rhetorical question posed at the start of this essay: historians need not adopt "visual culture" as a category of analysis, but if they fail to engage this new field, they risk intellectual and methodological impoverishment.

Notes

1 On European analyses of images as historical evidence from Petrarch through Huizinga, see Francis Haskell, *History and Its Images: Art and the Interpretation of the Past* (New Haven, Conn.: Yale University Press, 1993).

2 Norman Bryson, Michael Ann Holly, and Keith Moxey (eds.), *Visual Culture: Images and Interpretations* (Hanover: Wesleyan University Press, 1994).

3 John A. Walker and Sarah Chaplin, *Visual Culture: An Introduction* (Manchester: Manchester University Press, 1997), p. 2.

4 W.J.T. Mitchell, *Iconology: Image, Text, Ideology* (Chicago: University of Chicago Press, 1986) and *Picture Theory* (Chicago: University of Chicago Press, 1994).

5 "Visual Culture Questionnaire," *October* 77 (Summer 1996): 25.

6 Chris Jenks, "The Centrality of the Eye in Western Culture," in C. Jenks (ed.), *Visual Culture* (New York: Routledge, 1995), p. 16.

7 Irit Rogoff, "Studying Visual Culture," in Nicholas Mirzoeff (ed.), *The Visual Culture Reader* (New York: Routledge, 1998), p. 18.

8 Walker and Chaplin, p. 2.

9 Jenks, p. 14. See also John Berger, *Ways of Seeing* (New York: Viking Press, 1973); Donald Lowe, *History of Bourgeois Perception* (Chicago: University of Chicago Press, 1982); Martin Jay, "Scopic Regimes of Modernity" in Mirzoeff.

10 Rogoff, p. 18.

11 Peter Burke, *Eyewitnessing: The Uses of Images as Historical Evidence* (Ithaca, N.Y.: Cornell University Press, 2001), p. 184.

12 Historians have themselves critiqued this tendency. See Hayden White, *The Content of the Form* (Baltimore, Md.: The Johns Hopkins University Press, 1987); Dominick LaCapra, *History and Criticism* (Ithaca, N.Y.: Cornell University Press, 1985); Joan Wallach Scott, *Gender and the Politics of History* (New York: Columbia University Press, 1988); Robert Berkhofer, *Beyond the Great Story* (Cambridge, Mass.: Belknap Press, 1995).

13 The classic work on this topic, Louis Chevalier's *Laboring classes and dangerous classes in Paris during the first half of the nineteenth century* (Princeton, N.J.: Princeton University Press, 1981), demonstrates both tendencies.

14 Stephen Bann, *Under the Sign: John Bargrave as Collector, Traveler and Witness* (Ann Arbor, Mich.: University of Michigan Press, 1994), p. 122.

15 See, for example, Daniel J. Sherman, *Worthy Monuments: Art Museums and the Politics of Culture in Nineteenth-Century France* (Cambridge, Mass.: Harvard University Press, 1989); Debora Silverman, *Art Nouveau in Fin-de-Siècle France: Politics, Psychology and Style* (Berkeley, Calif.: University of California Press, 1989); Leora Auslander, *Taste and Power: Furnishing Modern France* (Berkeley, Calif.: University of California Press, 1996); F. Graeme Chalmers, *Women in the Nineteenth-Century Art World: Schools of Art and Design for Women in London and Philadelphia* (Westport, Conn.: Greenwood Press, 1998); James J. Sheehan, *Museums in the German Art World from the End of the Old Regime to the Rise of Modernism* (New York: Oxford University Press, 2000).

16 See, for example, Maurice Agulhon, *Marianne Into Battle: Republican Imagery and Symbolism in France, 1789–1880* (New York: Cambridge University Press, 1981); Peter Paret, *Art As History* (Princeton, N.J.: Princeton University Press, 1988); Lynn Hunt, *The Family Romance of the French Revolution* (Berkeley, Calif.: University of California Press, 1992).

17 Douglas Peter Mackaman, *Leisure Settings: Bourgeois Culture, Medicine, and the Spa in Modern France* (Chicago: University of Chicago Press, 1998).

18 Isabelle Lehuu, *Carnival on the Page: Popular Print Media in Antebellum America* (Chapel Hill, N.C.: University of North Carolina Press, 2000), p. 105.

PART TWO

Genealogies

VANESSA R. SCHWARTZ AND
JEANNENE M. PRZYBLYSKI

THIS SECTION BRINGS TOGETHER significant texts by authors of the late nineteenth and early twentieth centuries, whose works are cited and recited in the growing practice of visual culture studies. These authors are linked by their shared tendency toward an increasingly materialist account of historical change, coupled with a high degree of self-consciousness about distinctively modern modes of perception and experience. As will become quickly apparent, each of the case studies and theoretical analyses in the subsequent sections of the Reader are in one way or another in dialogue with one, some or all of these authors. The richness of this dialogue makes clear not only the centrality of these foundational texts, but also the degree to which the methodological foundations of visual culture studies in general are rooted in the nineteenth century. The continued relevance of this nineteenth-century perspective is why basic familiarity with these works is vital for any scholar entering the field.

The section opens with the nineteenth-century poet Charles Baudelaire, whose essay on the minor Parisian sketch artist Constantin Guys has been productively and chronically misread as an impassioned defense of the major French painter of modern life, Édouard Manet. This elision of popular and elite aesthetic discourse, and "low" and "high" forms of image production is fundamental to the practice of visual culture studies, and we are not sure that anyone since has managed it quite so seamlessly.

The nineteenth-century economist Karl Marx appears here for his linkage of the forms of material culture and image-making particular to the nineteenth century to the embourgeoisement of that culture and its embeddedness within the emergent structures of a capitalist economic system. The early twentieth-century sociologist Georg Simmel asks us to see this culture as a product of urbanization and the modes of "distracted" sensory experience imposed by the modern city. While it is certainly true that one could imagine a visual culture without cities, one cannot fathom modernity as anything but a product of urban experience—even in its most escapist, pastoral modes, modernity is always situating itself in tension with city life. Moreover, Simmel explicitly links cities and capital. "The metropolis," Simmel observed, "has always been the seat of a money economy."

In *The Interpretation of Dreams* and other texts, Sigmund Freud developed a way to read the disparate images of dreaming, providing the image of a collective unconsciousness that

could be used to analyze the pathology behind individual behavior. Not only are "waking" and "dream-sleeping" operative metaphors of modernity for Benjamin and others, but Freud's psychoanalysis of a cultural dreamscape is deeply suggestive of the ways in which modes of individual memory and dream recall can be productively elaborated as models of collective historical conscious. If Freud looked to dreams, then the late nineteenth-century art historian Alois Riegl looked to monuments (and ruins), and the early twentieth-century cultural critic Siegfried Kracauer looked to photography to find comparable materializations of the work-ings of memory and history. Riegl focuses on the nineteenth-century "cult of monuments" as the locus of a historical consciousness that admitted to both cycles of human production and cycles of inevitable destruction. Monuments tend to decline "naturally" into ruins, and the picturesqueness of decay is a vital critique of the ahistorical appearance of an eternal present. Kracauer, in turn, takes the image of photography to stand for the "go-for-broke" game of history, in part because of its already "ruined" status. Photography is the operative metaphor of a modern historical consciousness not merely because of what it shows, but because of what it does not show. "Memory's records," Kracauer observes, "are full of gaps."

And then there is Walter Benjamin. As our joint introduction to this Reader makes clear, we make no bones about our continuing engagement with Benjamin's writings on historical materialism and mechanical reproduction, his concept of aura and its decay, and the roadmap to the nineteenth century he provided in the *Arcades Project*. Benjamin seems to have been there first on so many fronts and, while some may tire of his arcane "theoretical" pronounce-ments, we continue to marvel at his commitment to the archive and his insistence on the possibility of a redemptive history, no matter how often hope for redemption might be fore-stalled.

There are two caveats: first, the following excerpts are meant to be merely tastes. Strategically lifted from longer essays and books, they should not be mistakenly assumed to represent those works in anything like their entirety, nor do they comprehensively represent the nuances and range of their author's thinking. For this reason, we have elected to elim-inate citations from this section. We hope that this editorial omission will serve as a spur to send the reader back to the unabridged version of each text.

The second caveat is more substantive and more cautionary: this genealogy is very much a lineage of father figures. While this patriarchal bias should give us pause, it is nevertheless true that these authors have had a significant impact on the decanonization of a lexicon of Modernism (think only of the Benjaminian juxtapositions of Baudelaire's poetry to consumer culture) and the elevation of everyday life as a category of historical analysis. By no stretch of the imagin-ation should Benjamin, Baudelaire, or anyone else in this section be recuperated as a feminist *avant la lettre*, for example. These authors all suffered from the prejudices of their times, and in many cases suffered for them as well (it is worth noting the number of early twentieth-century German–Jewish intellectuals whose work has been fundamental to postmodern strat-egies of cultural criticism, including visual culture studies). But their interest in apparently peripheral categories of cultural production such as fashion and ornament, their attention to the subtexts woven through the dominant histories of the nineteenth century, their focus on the unconscious return of the repressed, and their insistence upon the subjectivity of objectivity in all its historic guises has definitively splintered the authority of any pretense to a master narrative, opening up the field of historical inquiry to questions of modernity and visuality, and to feminist, postcolonial, and queer interventions, to name just a few.

CHARLES BAUDELAIRE

THE PAINTER OF MODERN LIFE (1863)

I Beauty, fashion and happiness

THE WORLD—AND EVEN the world of artists—is full of people who can go to
the Louvre, walk rapidly, without so much as a glance, past rows of very interesting,
though secondary, pictures, to come to a rapturous halt in front of a Titian or a Raphael—
one of those that have been most popularized by the engraver's art; then they will go home
happy, not a few saying to themselves, 'I know my Museum.' Just as there are people who,
having once read Bossuet and Racine, fancy that they have mastered the history of literature.

Fortunately from time to time there come forward righters of wrong, critics, amateurs,
curious enquirers, to declare that Raphael, or Racine, does not contain the whole secret, and
that the minor poets too have something good, solid and delightful to offer; and finally that
however much we may love *general* beauty, as it is expressed by classical poets and artists,
we are no less wrong to neglect *particular* beauty, the beauty of circumstance and the sketch
of manners.

It must be admitted that for some years now the world has been mending its ways a
little. The value which collectors today attach to the delightful coloured engravings of the last
century proves that a reaction has set in in the direction where it was required; Debucourt,
the Saint-Aubins and many others have found their places in the dictionary of artists who are
worthy of study. But these represent the past: my concern today is with the painting of
manners of the present. The past is interesting not only by reason of the beauty which could
be distilled from it by those artists for whom it was the present, but also precisely because
it is the past, for its historical value. It is the same with the present. The pleasure which we
derive from the representation of the present is due not only to the beauty with which it can
be invested, but also to its essential quality of being present.

I have before me a series of fashion-plates dating from the Revolution and finishing more
or less with the Consulate. These costumes, which seem laughable to many thoughtless
people—people who are grave without true gravity—have a double-natured charm, one both
artistic and historical. They are often very beautiful and drawn with wit; but what to me is
every bit as important, and what I am happy to find in all, or almost all of them, is the moral
and aesthetic feeling of their time. The idea of beauty which man creates for himself imprints
itself on his whole attire, crumples or stiffens his dress, rounds off or squares his gesture,
and in the long run even ends by subtly penetrating the very features of his face. Man ends
by looking like his ideal self. These engravings can be translated either into beauty or ugli-
ness; in one direction, they become caricatures, in the other, antique statues.

The women who wore these costumes were themselves more or less like one or the other type, according to the degree of poetry or vulgarity with which they were stamped. Living flesh imparted a flowing movement to what seems to us too stiff. It is still possible today for the spectator's imagination to give a stir and a rustle to this 'tunique' or that 'schall'. One day perhaps someone will put on a play in which we shall see a resurrection of those costumes in which our fathers found themselves every bit as fascinating as we do ourselves in our poor garments (which also have a grace of their own, it must be admitted, but rather of a moral and spiritual type). And then, if they are worn and given life by intelligent actors and actresses, we shall be astonished at ever having been able to mock them so stupidly. Without losing anything of its ghostly attraction, the past will recover the light and movement of life and will become present.

If an impartial student were to look through the *whole* range of French costume, from the origin of our country until the present day, he would find nothing to shock nor even to surprise him. The transitions would be as elaborately articulated as they are in the animal kingdom. There would not be a single gap: and thus, not a single surprise. And if to the fashion plate representing each age he were to add the philosophic thought with which that age was most preoccupied or concerned—the thought being inevitably suggested by the fashion-plate—he would see what a profound harmony controls all the components of history, and that even in those centuries which seem to us the most monstrous and the maddest, the immortal thirst for beauty has always found its satisfaction. [. . .]

II The sketch of manners

For the sketch of manners, the depiction of bourgeois life and the pageant of fashion, the technical means that is the most expeditious and the least costly will obviously be the best. The more beauty that the artist can put into it, the more valuable will be his work; but in trivial life, in the daily metamorphosis of external things, there is a rapidity of movement which calls for an equal speed of execution from the artist. The coloured engravings of the eighteenth century have once again won the plaudits of fashion, as I was saying a moment ago. Pastel, etching and aquatint have one by one contributed their quota to that vast dictionary of modern life whose leaves are distributed through the libraries, the portfolios of collectors and in the windows of the meanest of print shops. And then lithography appeared, at once to reveal itself as admirably fitted for this enormous, though apparently so frivolous a task. We have some veritable monuments in this medium. The works of Gavarni and Daumier have been justly described as complements to the *Comédie Humaine*. I am satisfied that Balzac himself would not have been averse from accepting this idea, which is all the more just in that the genius of the painter of manners is of a mixed nature, by which I mean that it contains a strong literary element. Observer, philosopher, *flâneur*—call him what you will; but whatever words you use in trying to define this kind of artist, you will certainly be led to bestow upon him some adjective which you could not apply to the painter of eternal, or at least more lasting things, of heroic or religious subjects. Sometimes he is a poet; more often he comes closer to the novelist or the moralist; he is the painter of the passing moment and of all the suggestions of eternity that it contains. Every country, to its pleasure and glory, has possessed a few men of this stamp. In the present age, to Daumier and Gavarni (the first names which occur to the memory) we may add Devéria, Maurin, Numa, historians of the more wanton charms of the Restoration; Wattier, Tassaert, Eugene Lami—the last of these almost an Englishman in virtue of his love for aristocratic elegance; and even Trimolet and Traviès, those chroniclers of poverty and the humble life.

III The artist, man of the world, man of the crowd, and child

Today I want to discourse to the public about a strange man, a man of so powerful and so decided an originality that it is sufficient unto itself and does not even seek approval. Not a single one of his drawings is signed, if by signature you mean that string of easily forgeable characters which spell a name and which so many other artists affix ostentatiously at the foot of their least important trifles. Yet all his works are signed—with his dazzling *soul*; and art-lovers who have seen and appreciated them will readily recognize them from the description that I am about to give. [. . .]

For ten years I had wanted to get to know Monsieur G. [artist Constantin Guys, 1802–92], who is by nature a great traveller and cosmopolitan. I knew that for some time he had been on the staff of an English illustrated journal, and that engravings after his travel-sketches, made in Spain, Turkey and the Crimea, had been published there. Since then I have seen a considerable quantity of those drawings, hastily sketched on the spot, and thus I have been able to *read*, so to speak, a detailed account of the Crimean campaign which is much prefer-able to any other that I know. The same paper had also published, always without signature, a great number of his illustrations of new ballets and operas. When at last I ran him to earth, I saw at once that it was not precisely an *artist*, but rather a man of the world with whom I had to do. I ask you to understand the word *artist* in a very restricted sense, and *man of the world* in a very broad one. By the second I mean a man of the whole world, a man who understands the world and the mysterious and lawful reasons for all its uses; by the first, a specialist, a man wedded to his palette like the serf to the soil. Monsieur G. does not like to be called an artist. Is he not perhaps a little right? His interest is the whole world; he wants to know, understand and appreciate everything that happens on the surface of our globe. The artist lives very little, if at all, in the world of morals and politics. If he lives in the Bréda district, he will be unaware of what is going on in the Faubourg Saint-Germain. Apart from one or two exceptions whom I need not name, it must be admitted that the majority of artists are no more than highly skilled animals, pure artisans, village intellects, cottage brains. Their conversation, which is necessarily limited to the narrowest of circles, becomes very quickly unbearable to the *man of the world*, to the spiritual citizen of the universe.

And so, as a first step towards an understanding of Monsieur G., I would ask you to note at once that the mainspring of his genius is *curiosity*.

Do you remember a picture (it really is a picture!), painted—or rather written—by the most powerful pen of our age, and entitled *The Man of the Crowd*? In the window of a coffee-house there sits a convalescent, pleasurably absorbed in gazing at the crowd, and mingling, through the medium of thought, in the turmoil of thought that surrounds him. But lately returned from the valley of the shadow of death, he is rapturously breathing in all the odours and essences of life; as he has been on the brink of total oblivion, he remembers, and fervently desires to remember, everything. Finally he hurls himself headlong into the midst of the throng, in pursuit of an unknown, half-glimpsed countenance that has, on an instant bewitched him. Curiosity has become a fatal, irresistible passion! [. . .]

The crowd is his element, as the air is that of birds and water of fishes. His passion and his profession are to become one flesh with the crowd. For the perfect *flâneur*, for the passionate spectator, it is an immense joy to set up house in the heart of the multitude, amid the ebb and flow of movement, in the midst of the fugitive and the infinite. To be away from home and yet to feel oneself everywhere at home; to see the world, to be at the centre of the world, and yet to remain hidden from the world—such are a few of the slightest pleasures of those independent, passionate, impartial natures which the tongue can but clumsily define.

The spectator is a *prince* who everywhere rejoices in his incognito. The lover of life makes the whole world his family, just like the lover of the fair sex who builds up his family from all the beautiful women that he has ever found, or that are—or are not—to be found; or the lover of pictures who lives in a magical society of dreams painted on canvas. Thus the lover of universal life enters into the crowd as though it were an immense reservoir of electrical energy. Or we might liken him to a mirror as vast as the crowd itself; or to a kaleidoscope gifted with consciousness, responding to each one of its movements and reproducing the multiplicity of life and the flickering grace of all the elements of life. He is an 'I' with an insatiable appetite for the 'non-I', at every instant rendering and explaining it in pictures more living than life itself, which is always unstable and fugitive. 'Any man,' he said one day, in the course of one of those conversations which he illumines with burning glance and evocative gesture, 'any man who is not crushed by one of those griefs whose nature is too real not to monopolize all his capacities, and who can yet be *bored in the heart of the multitude*, is a blockhead! a blockhead! and I despise him!' [. . .]

IV Modernity

And so away he goes, hurrying, searching. But searching for what? Be very sure that this man, such as I have depicted him—this solitary, gifted with an active imagination, ceaselessly journeying across the great human desert—has an aim loftier than that of a mere *flâneur*, an aim more general, something other than the fugitive pleasure of circumstance. He is looking for that quality which you must allow me to call 'modernity'; for I know of no better word to express the idea I have in mind. He makes it his business to extract from fashion whatever element it may contain of poetry within history, to distil the eternal from the transitory. Casting an eye over our exhibitions of modern pictures, we are struck by a general tendency among artists to dress all their subjects in the garments of the past. Almost all of them make use of the costumes and furnishings of the Renaissance, just as David employed the costumes and furnishings of Rome. There is however this difference, that David, by choosing subjects which were specifically Greek or Roman, had no alternative but to dress them in antique garb, whereas the painters of today, though choosing subjects of a general nature and applicable to all ages, nevertheless persist in rigging them out in the costumes of the Middle Ages, the Renaissance or the Orient. This is clearly symptomatic of a great degree of laziness; for it is much easier to decide outright that everything about the garb of an age is absolutely ugly than to devote oneself to the task of distilling from it the mysterious element of beauty that it may contain, however slight or minimal that element may be. By 'modernity' I mean the ephemeral, the fugitive, the contingent, the half of art whose other half is the eternal and the immutable. Every old master has had his own modernity; the great majority of fine portraits that have come down to us from former generations are clothed in the costume of their own period. They are perfectly harmonious, because everything—from costume and coiffure down to gesture, glance and smile (for each age has a deportment, a glance and a smile of its own)—everything, I say, combines to form a completely viable whole. This transitory, fugitive element, whose metamorphoses are so rapid, must on no account be despised or dispensed with. By neglecting it, you cannot fail to tumble into the abyss of an abstract and indeterminate beauty, like that of the first woman before the fall of man. If for the necessary and inevitable costume of the age you substitute another, you will be guilty of a mistranslation only to be excused in the case of a masquerade prescribed by fashion. (Thus, the goddesses, nymphs and sultanas of the eighteenth century are still convincing portraits, *morally* speaking.)

It is doubtless an excellent thing to study the old masters in order to learn how to paint; but it can be no more than a waste of labour if your aim is to understand the special nature of present-day beauty. The draperies of Rubens or Veronese will in no way teach you how to depict *moire antique*, *satin à la reine* or any other fabric of modern manufacture, which we see supported and hung over crinoline or starched muslin petticoat. In texture and weave these are quite different from the fabrics of ancient Venice or those worn at the court of Catherine. Furthermore the cut of skirt and bodice is by no means similar; the pleats are arranged according to a new system. Finally the gesture and the bearing of the woman of today give to her dress a life and a special character which are not those of the woman of the past. In short, for any 'modernity' to be worthy of one day taking its place as 'antiquity', it is necessary for the mysterious beauty which human life accidentally puts into it to be distilled from it. And it is to this task that Monsieur G. particularly addresses himself.

I have remarked that every age had its own gait, glance and gesture. The easiest way to verify this proposition would be to betake oneself to some vast portrait-gallery, such as the one at Versailles. But it has an even wider application. Within that unity which we call a Nation, the various professions and classes and the passing centuries all introduce variety, not only in manners and gesture, but even in the actual form of the face. Certain types of nose, mouth and brow will be found to dominate the scene for a period whose extent I have no intention of attempting to determine here, but which could certainly be subjected to a form of calculation. Considerations of this kind are not sufficiently familiar to our portrait-painters; the great failing of M. Ingres, in particular, is that he seeks to impose upon every type of sitter a more or less complete, by which I mean a more or less despotic, form of perfection, borrowed from the repertory of classical ideas.

In a matter of this kind it would be easy, and indeed legitimate, to argue *a priori*. The perpetual correlation between what is called the 'soul' and what is called the 'body' explains quite clearly how everything that is 'material', or in other words an emanation of the 'spiritual', mirrors, and will always mirror, the spiritual reality from which it derives. If a painstaking, scrupulous, but feebly imaginative artist has to paint a courtesan of today and takes his 'inspiration' (that is the accepted word) from a courtesan by Titian or Raphael, it is only too likely that he will produce a work which is false, ambiguous and obscure. From the study of a masterpiece of that time and type he will learn nothing of the bearing, the glance, the smile or the living 'style' of one of those creatures whom the dictionary of fashion has successively classified under the coarse or playful titles of 'doxies', 'kept women', *lorettes*, or *biches*.

The same criticism may be strictly applied to the study of the military man and the dandy, and even to that of animals, whether horses or dogs; in short, of everything that goes to make up the external life of this age. Woe to him who studies the antique for anything else but pure art, logic and general method! By steeping himself too thoroughly in it, he will lose all memory of the present; he will renounce the rights and privileges offered by circumstance— for almost all our originality comes from the seal which Time imprints on our sensations. I need hardly tell you that I could easily support my assertions with reference to many objects other than women. What would you say, for example, of a marine-painter (I am deliberately going to extremes) who, having to depict the sober and elegant beauty of a modern vessel, were to tire out his eyes by studying the overcharged, involved forms and the monumental poop of a galleon, or the complicated rigging of the sixteenth century? Again, what would you think if you had commissioned an artist to paint the portrait of a thoroughbred, famed in the annals of the turf, and he then proceeded to confine his researches to the Museums and contented himself with a study of the horse in the galleries of the past, in Van Dyck, Borgognone or Van der Meulen?

Under the direction of nature and the tyranny of circumstance, Monsieur G. has pursued an altogether different path. He began by being an observer of life, and only later set himself the task of acquiring the means of expressing it. This has resulted in a thrilling originality in which any remaining vestiges of barbarousness or *naïveté* appear only as new proofs of his faithfulness to the impression received, or as a flattering compliment paid to truth. For most of us, and particularly for men of affairs, for whom nature has no existence save by reference to utility, the fantastic reality of life has become singularly diluted. Monsieur G. never ceases to drink it in; his eyes and his memory are full of it. [. . .]

I am convinced that in a few years' time Monsieur G.'s drawings will have taken their place as precious archives of civilized life. His works will be sought after by collectors as much as those of the Debucourts, the Moreaus, the Saint-Aubins, the Carle Vernets, the Devérias, the Gavarnis, and all those other delightful artists who, though depicting nothing but the familiar and the charming, are in their own way no less of serious historians. A few of them have even sacrificed too much to charm, and have sometimes introduced into their compositions a classic style alien to the subject; some have deliberately rounded their angles, smoothed the rough edges of life and toned down its flashing highlights. Less skilful than they, Monsieur G. retains a remarkable excellence which is all his own; he has deliberately fulfilled a function which other artists have scorned and which it needed above all a man of the world to full. He has everywhere sought after the fugitive, fleeting beauty of present-day life, the distinguishing character of that quality which, with the reader's kind permission, we have called 'modernity'. Often weird, violent and excessive, he has contrived to concentrate in his drawings the acrid or heady bouquet of the wine of life.

Chapter 5

KARL MARX

COMMODITIES AND MONEY (1867)

The fetishism of commodities and the secret thereof

A COMMODITY APPEARS, AT FIRST SIGHT, a very trivial thing, and easily understood. Its analysis shows that it is, in reality, a very queer thing, abounding in metaphysical subtleties and theological niceties. So far as it is a value in use, there is nothing mysterious about it, whether we consider it from the point of view that by its properties it is capable of satisfying human wants, or from the point that those properties are the product of human labour. It is as clear as noon-day, that man, by his industry, changes the forms of the materials furnished by Nature, in such a way as to make them useful to him. The form of wood, for instance, is altered, by making a table out of it. Yet, for all that, the table

continues to be that common, every-day thing, wood. But, so soon as it steps forth as a commodity, it is changed into something transcendent. It not only stands with its feet on the ground, but, in relation to all other commodities, it stands on its head, and evolves out of its wooden brain grotesque ideas, far more wonderful than "table-turning" ever was.

The mystical character of commodities does not originate, therefore, in their use-value. Just as little does it proceed from the nature of the determining factors of value. For, in the first place, however varied the useful kinds of labour, or productive activities, may be, it is a physiological fact, that they are functions of the human organism, and that each such function, whatever may be its nature or form, is essentially the expenditure of human brain, nerves, muscles, &c. Secondly, with regard to that which forms the groundwork for the quantitative determination of value, namely, the duration of that expenditure, or the quantity of labour, it is quite clear that there is a palpable difference between its quantity and quality. In all states of society, the labour-time that it costs to produce the means of subsistence, must necessarily be an object of interest to mankind, though not of equal interest in different stages of development. And lastly, from the moment that men in any way work for one another, their labour assumes a social form.

Whence, then, arises the enigmatical character of the product of labour, so soon as it assumes the form of commodities? Clearly from this form itself. The equality of all sorts of human labour is expressed objectively by their products all being equally valued; the measure of the expenditure of labour-power by the duration of that expenditure, takes the form of the quantity of value of the products of labour; and finally, the mutual relations of the producers, within which the social character of their labour affirms itself, take the form of a social relation between the products.

A commodity is therefore a mysterious thing, simply because in it the social character of men's labour appears to them as an objective character stamped upon the product of that labour; because the relation of the producers to the sum total of their own labour is presented to them as a social relation, existing not between themselves, but between the products of their labour. This is the reason why the products of labour become commodities, social things whose qualities are at the same time perceptible and imperceptible by the senses. In the same way, the light from an object is perceived by us not as the subjective excitation of our optic nerve, but as the objective form of something outside the eye itself. But, in the act of seeing, there is at all events, an actual passage of light from one thing to another, from the external object to the eye. There is a physical relation between physical things. But it is different with commodities. There, the existence of the things quâ commodities, and the value-relation between the products of labour which stamps them as commodities, have absolutely no connexion with their physical properties and with the material relations arising therefrom. There it is a definite social relation between men, that assumes, in their eyes, the fantastic form of a relation between things. In order, therefore, to find an analogy, we must have recourse to the mist-enveloped regions of the religious world. In that world time productions of the human brain appear as independent beings endowed with life, and entering into relation both with one another and the human race. So it is in the world of commodities with the products of men's hands. This I call the Fetishism which attaches itself to the products of labour, so soon as they are produced as commodities, and which is therefore inseparable from the production of commodities.

This Fetishism of commodities has its origin, as the foregoing analysis has already shown, in the peculiar social character of the labour that produces them.

As a general rule, articles of utility become commodities, only because they are products of the labour of private individuals or groups of individuals who carry on their work

independently of each other. The sum total of the labour of all these private individuals forms the aggregate labour of society. Since the producers do not come into social contact with each other until they exchange their products, the specific social character of each producer's labour does not show itself except in the act of exchange. In other words, the labour of the individual asserts itself as a part of the labour of society, only by means of the relations which the act of exchange establishes directly between the products, and indirectly, through them, between the producers. To the latter, therefore, the relations connecting the labour of one individual with that of the rest appear, not as direct social relations between individuals at work, but as what they really are, material relations between persons and social relations between things. It is only by being exchanged that the products of labour acquire, as values, one uniform social status, distinct from their varied forms of existence as objects of utility. This division of a product into a useful thing and a value becomes practically important, only when exchange has acquired such an extension that useful articles are produced for the purpose of being exchanged, and their character as values has therefore to be taken into account, beforehand, during production. From this moment the labour of the individual producer acquires socially, a two-fold character. On the one hand, it must, as a definite useful kind of labour, satisfy a definite social want, and thus hold its place as part and parcel of the collective labour of all, as a branch of a social division of labour that has sprung up spontaneously. On the other hand, it can satisfy the manifold wants of the individual producer himself, only in so far as the mutual exchangeability of all kinds of useful private labour is an established social fact, and therefore the private useful labour of each producer ranks on an equality with that of all others. The equalisation of the most different kinds of labour can be the result only of an abstraction from their inequalities, or of reducing them to their common denominator, viz., expenditure of human labour-power or human labour in the abstract. The two-fold social character of the labour of the individual appears to him, when reflected in his brain, only under those forms which are impressed upon that labour in every-day practice by the exchange of products. In this way, the character that his own labour possesses of being socially useful takes the form of the condition, that the product must be not only useful, but useful for others, and the social character that his particular labour has of being the equal of all other particular kinds of labour, takes the form that all the physically different articles that are the products of labour, have one common quality, viz., that of having value.

Hence, when we bring the products of our labour into relation with each other as values, it is not because we see in these articles the material receptacles of homogeneous human labour. Quite the contrary: whenever, by an exchange, we equate as values our different products, by that very act, we also equate, as human labour, the different kinds of labour expended upon them. We are not aware of this, nevertheless we do it. Value, therefore, does not stalk about with a label describing what it is. It is value, rather, that converts every product into a social hieroglyphic. Later on, we try to decipher the hieroglyphic, to get behind the secret of our own social products; for to stamp an object of utility as a value, is just as much a social product as language. The recent scientific discovery, that the products of labour, so far as they are values, are but material expressions of the human labour spent in their production, marks, indeed, an epoch in the history of the development of the human race, but, by no means, dissipates the mist through which the social character of labour appears to us to be an objective character of the products themselves. The fact, that in the particular form of production with which we are, dealing, viz., the production of commodities, the specific social character of private labour carried on independently, consists in the equality of every kind of that labour, by virtue of its being human labour, which character, therefore, assumes in the product the form of value—this fact appears to the producers, notwithstanding

the discovery above referred to, to be just as real and final, as the fact, that, after the discovery by science of the component gases of air, the atmosphere itself remained unaltered.

What, first of all, practically concerns producers when they make an exchange, is the question, how much of some other product they get for their own? in what proportions the products are exchangeable? When these proportions have, by custom, attained a certain stability, they appear to result from the nature of the products, so that, for instance, one ton of iron and two ounces of gold appear as naturally to be of equal value as a pound of gold and a pound of iron in spite of their different physical and chemical qualities appear to be of equal weight. The character of having value, when once impressed upon products, obtains fixity only by reason of their acting and re-acting upon each other as quantities of value. These quantities vary continually, independently of the will, foresight and action of the producers. To them, their own social action takes the form of the action of objects, which rule the producers instead of being ruled by them. It requires a fully developed production of commodities before, from accumulated experience alone, the scientific conviction springs up, that all the different kinds of private labour, which are carried on independently of each other, and yet as spontaneously developed branches of the social division of labour, are continually being reduced to the quantitative proportions in which society requires them. And why? Because, in the midst of all the accidental and ever fluctuating exchange-relations between the products, the labour-time socially necessary for their production forcibly asserts itself like an over-riding law of Nature. The law of gravity thus asserts itself when a house falls about our ears.[1] The determination of the magnitude of value by labour-time is therefore a secret, hidden under the apparent fluctuations in the relative values of commodities. Its discovery, while removing all appearance of mere accidentality from the determination of the magnitude of the values of products, yet in no way alters the mode in which that determination takes place.

Man's reflections on the forms of social life, and consequently, also, his scientific analysis of those forms, take a course directly opposite to that of their actual historical development. He begins, post festum, with the results of the process of development ready to hand before him. The characters that stamp products as commodities, and whose establishment is a necessary preliminary to the circulation of commodities, have already acquired the stability of natural, self-understood forms of social life, before man seeks to decipher, not their historical character, for in his eyes they are immutable, but their meaning. Consequently it was the analysis of the prices of commodities that alone led to the determination of the magnitude of value, and it was the common expression of all commodities in money that alone led to the establishment of their characters as values. It is, however, just this ultimate money-form of the world of commodities that actually conceals, instead of disclosing, the social character of private labour, and the social relations between the individual producers. When I state that coats or boots stand in a relation to linen, because it is the universal incarnation of abstract human labour, the absurdity of the statement is self-evident. Nevertheless, when the producers of coats and boots compare those articles with linen, or, what is the same thing, with gold or silver, as the universal equivalent, they express the relation between their own private labour and the collective labour of society in the same absurd form.

The categories of bourgeois economy consist of such like forms. They are forms of thought expressing with social validity the conditions and relations of a definite, historically determined mode of production, viz., the production of commodities. The whole mystery of commodities, all the magic and necromancy that surrounds the products of labour as long as they take the form of commodities, vanishes therefore, so soon as we come to other forms of production. [. . .]

The life-process of society, which is based on the process of material production, does not strip off its mystical veil until it is treated as production by freely associated men, and is consciously regulated by them in accordance with a settled plan. This, however, demands for society a certain material ground-work or set of conditions of existence which in their turn are the spontaneous product of a long and painful process of development.

Political Economy has indeed analysed, however incompletely, value and its magnitude, and has discovered what lies beneath these forms. But it has never once asked the question why labour is represented by the value of its product and labour-time by the magnitude of that value. These formulæ, which bear it stamped upon them in unmistakeable letters that they belong to a state of society, in which the process of production has the mastery over man, instead of being controlled by him, such formulæ appear to the bourgeois intellect to be as much a self-evident necessity imposed by Nature as productive labour itself. Hence forms of social production that preceded the bourgeois form, are treated by the bourgeoisie in much the same way as the Fathers of the Church treated pre-Christian religions.

To what extent some economists are misled by the Fetishism inherent in commodities, or by the objective appearance of the social characteristics of labour, is shown, amongst other ways, by the dull and tedious quarrel over the part played by Nature in the formation of exchange-value. Since exchange-value is a definite social manner of expressing the amount of labour bestowed upon object, Nature has no more to do with it, than it has in fixing the course of exchange.

The mode of production in which the product takes the form of a commodity, or is produced directly for exchange, is the most general and most embryonic form of bourgeois production. It therefore makes its appearance at an early date in history, though not in the same predominating and characteristic manner as now-a-days. Hence its Fetish character is comparatively easy to be seen through. But when we come to more concrete forms, even this appearance of simplicity vanishes. Whence arose the illusions of the monetary system? To it gold and silver, when serving as money, did not represent a social relation between producers but were natural objects with strange social properties. And modern economy, which looks down with such disdain on the monetary system, does not its superstition come out as clear as noon-day, whenever it treats of capital? How long is it since economy discarded the physiocratic illusion, that rents grow out of the soil and not out of society?

But not to anticipate, we will content ourselves with yet another example relating to the commodity-form. Could commodities themselves speak, they would say: our use-value may be a thing that interests men. It is no part of us as objects. What, however, does belong to us as objects, is our value. Our natural intercourse as commodities proves it. In the eyes of each other we are nothing but exchange-values. Now listen how those commodities speak through the mouth of the economist. "Value"—(i.e., exchange-value) "is a property of things, riches"—(i.e., use-value) "of man. Value, in this sense, necessarily implies exchanges, riches do not." "Riches" (use-value) "are the attribute of men, value is the attribute of commodities. A man or a community is rich, a pearl or a diamond is valuable. . . . A pearl or a diamond is valuable" as a pearl or diamond. So far no chemist has ever discovered exchange-value either in a pearl or a diamond. The economic discoverers of this chemical element, who by-the-by lay special claim to critical acumen, find however that the use-value of objects belongs to them independently of their material properties, while their value, on the other hand, forms a part of them as objects. What confirms them in this view, is the peculiar circumstance that the use-value of objects is realised without exchange, by means of a direct relation between the objects and man, while, on the other hand, their value is realised only by exchange, that is, by means of a social process. Who fails here to call to mind our good

friend, Dogberry, who informs neighbour Seacoal, that, "To be a well-favoured man is the gift of fortune; but reading and writing comes by Nature." [. . .]

Note

1 "What are we to think of a law that asserts itself only by periodical revolutions? It is just nothing but a law of Nature, founded on the want of knowledge of those whose action is the subject of it." (Friedrich Engels: "Umrisse zu einer Kritik de Nationalökonomie," in the "Deutsch-Französische Jahrbücher," edited by Arnold Ruge, and Karl Marx. Paris, 1844.) [*Marx*]

Chapter 6

SIGMUND FREUD

THE DREAM-WORK (1990)

ALL OTHER PREVIOUS ATTEMPTS to solve the problems of dreams have concerned themselves directly with the manifest dream-content as it is retained in the memory. They have sought to obtain an interpretation of the dream from this content, or, if they dispensed with an interpretation, to base their conclusions concerning the dream on the evidence provided by this content. We, however, are confronted by a different set of data; for us a new psychic material interposes itself between the dream-content and the results of our investigations: the *latent* dream-content, or dream-thoughts, which are obtained only by our method. We develop the solution of the dream from this latent content, and not from the manifest dream-content. We are thus confronted with a new problem, an entirely novel task—that of examining and tracing the relations between the latent dream-thoughts and the manifest dream-content, and the processes by which the latter has grown out of the former.

The dream-thoughts and the dream-content present themselves as two descriptions of the same content in two different languages; or, to put it more clearly, the dream-content appears to us as a translation of the dream-thoughts into another mode of expression, whose symbols and laws of composition we must learn by comparing the origin with the translation. The dream-thoughts we can understand without further trouble the moment we have ascertained them. The dream-content is, as it were, presented in hieroglyphics, whose symbols must be translated, one by one, into the language of the dream-thoughts. It would of course, be incorrect to attempt to read these symbols in accordance with their values as pictures, instead of in accordance with their meaning as symbols. For instance, I have before me a picture-puzzle (rebus)—a house, upon whose roof there is a boat; then a single letter; then a running figure, whose head has been omitted, and so on. As a critic I might be tempted to judge this composition and its elements to be nonsensical. A boat is out of place on the roof of a house,

and a headless man cannot run; the man, too, is larger than the house, and if the whole thing is meant to represent a landscape the single letters of the alphabet have no right in it, since they do not occur in nature. A correct judgment of the picture-puzzle is possibly only if I make no such objections to the whole and its parts, and if, on the contrary, I take the trouble to replace each image by a syllable or word which it may represent by virtue of some allusion or relation. The words thus put together are no longer meaningless, but might constitute the most beautiful and pregnant aphorism. Now a dream is such a picture-puzzle, and our predecessors in the art of dream-interpretation have made the mistake of judging the rebus as an artistic composition. As such, of course, it appears nonsensical and worthless.

A Condensation

The first thing that becomes clear to the investigator when he compares the dream-content with the dream-thoughts is that a tremendous *work of condensation* has been accomplished. The dream is meagre, paltry and laconic in comparison with the range and copiousness of the dream thoughts. The dream, when written down, fills half a page; the analysis, which contains the dream-thoughts, requires six, eight, twelve times as much space. The ratio varies with different dreams; but in my experience it is always of the same order. As a rule, the extent of the compression which has been accomplished is under-estimated, owing to the fact that the dream-thoughts which have been brought to light are believed to be the whole of the material, whereas a continuation of the work of interpretation would reveal still further thoughts hidden in the dream. We have already found it necessary to remark that one can never be really sure that one has interpreted a dream completely; even if the solution seems satisfying and flawless, it is always possible that yet another meaning has been manifested by the same dream. Thus the *degree of condensation* is—strictly speaking—indeterminable. Exception may be taken—and at first sight the objection seems perfectly plausible—to the assertion that the disproportion between dream-content and dream-thoughts justifies the conclusion that a considerable condensation of psychic material occurs in the formation of dreams. For we often have the feeling that we have been dreaming a great deal all night, and have then forgotten most of what we have dreamed. The dream which we remember on waking would thus *appear* to be merely a remnant of the total dream-work, which would surely equal the dream-thoughts in range if only we could remember it completely. To a certain extent this is undoubtedly true; there is no getting away from the fact that a dream is most accurately reproduced if we try to remember it immediately after waking, and that the recollection of it becomes more and more defective as the day goes on. On the other hand, it has to be recognized that the impression that we have dreamed a good deal more than we are able to reproduce is very often based on an illusion, the origin of which we shall explain later on. Moreover, the assumption of a condensation in the dream-work is not affected by the possibility of forgetting a part of dreams, for it may be demonstrated by the multitude of ideas pertaining to those individual parts of the dream which do remain in the memory. If a large part of the dream has really escaped the memory, we are probably deprived of access to a new series of dream-thoughts. We have no justification for expecting that those portions of the dream which have been lost should likewise have referred only to those thoughts which we know from the analysis of the portions which have been preserved. [. . .]

But how, then, are we to imagine the psychic condition of the sleeper which precedes dreaming? Do all the dream-thoughts exist side by side, or do they pursue one another, or

are there several simultaneous trains of thought, proceeding from different centres, which sub-sequently meet? I do not think it is necessary at this point to form a plastic conception of the psychic condition at the time of dream-formation. But let us not forget that we are concerned with *unconscious* thinking, and that the process may easily be different from that which we observe in ourselves in deliberate contemplation accompanied by consciousness. [. . .]

B The work of displacement

Another and probably no less significant relation must have already forced itself upon our attention while we were collecting examples of dream-condensation. We may have noticed that these elements which obtrude themselves in the dream-content as its essential compo-nent not by any means play this same part in the dream-thoughts. As a corollary to this, the converse of this statement is also true. That which is obviously the essential content of the dream-thoughts need not be represented at all in the dream. The dream is, as it were, *centred elsewhere*; its content is arranged about elements which do not constitute the central point of the dream-thoughts. [. . .]

The recognition of this new and utterly inconstant relation between the dream-thoughts and the dream-content will probably astonish us at first. If we find in a psychic process of normal life that one idea has been selected from among a number of others, and has acquired a particular emphasis in our consciousness, we are wont to regard this as proof that a pecu-liar psychic value (a certain degree of interest) attaches to the victorious idea. We now dis-cover that this value of the individual element in the dream-thoughts is not retained in dream-formation, or is not taken into account. For there is no doubt which of the elements of the dream-thoughts are of the highest value; our judgment informs us immediately. In dream-formation the essential elements, those that are emphasized by intensive interest, may be treated as though they were subordinate, while they are replaced in the dream by other elements, which were certainly subordinate in the dream-thoughts. It seems at first as though the psychic intensity of individual ideas were of no account in their selection for dream-formation, but only their greater or lesser multiplicity of determination. One might be inclined to think that what gets into the dream is not what is important in the dream-thoughts, but what is contained in them several times over; but our understanding of dream-formation is not much advanced by this assumption; to begin with, we cannot believe that the two motives of multiple determination and intrinsic value can influence the selection of the dream other-wise than in the same direction. Those ideas in the dream-thoughts which are most important are probably also those which recur most frequently, since the individual dream-thoughts radiate from them as centres. And yet the dream may reject these intensively emphasized and extensively reinforced elements, and may take up into its content other elements which are only extensively reinforced.

This difficulty may be solved if we follow up yet another impression received during the investigation of the over-determination of the dream-content. Many readers of this investiga-tion may already have decided, in their own minds, that the discovery of the multiple determination of the dream-elements is of no great importance, because it is inevitable. Since in analysis we proceed from the dream-elements, and register all the ideas which associate themselves with these elements, is it any wonder that these elements should recur with pecu-liar frequency in the thought-material obtained in this manner? While I cannot admit the validity of this objection, I am now going to say something that sounds rather like it: Among the thoughts which analysis brings to light are many which are far removed from the nucleus

of the dream, and which stand out like artificial interpolations made for a definite purpose. Their purpose may readily be detected; they establish a connection, often a forced and farfetched connection, between the dream-content and the dream-thoughts, and in many cases, if these elements were weeded out of the analysis, the components of the dream-content would not only not be over-determined, but they would not be sufficiently determined. We are thus led to the conclusion that multiple determination, decisive as regards the selection made by the dream, is perhaps not always a primary factor in dream-formation, but is often a secondary product of a psychic force which is as yet unknown to us. Nevertheless, it must be of importance for the entrance of the individual elements into the dream, for we may observe that in cases where multiple determination does not proceed easily from the dream-material it is brought about with a certain effort.

It now becomes very probable that a psychic force expresses itself in the dream-work which, on the one hand, strips the elements of the high psychic value of their intensity and, on the other hand, *by means of over-determination*, creates new significant values from elements of slight value, which new values then make their way into the dream-content. Now if this is the method of procedure, there has occurred in the process of dream-formation a *transference and displacement of the psychic intensities* of the individual elements, from which results the textual difference between the dream-content and the thought-content. The process which we here assume to be operative is actually the most essential part of the dream-work; it may fitly be called *dream-displacement*. *Dream-displacement and dream-condensation* are the two craftsmen to whom we may chiefly ascribe the structure of the dream.

I think it will be easy to recognize the psychic force which expresses itself in dream-displacement. The result of this displacement is that the dream-content no longer has any likeness to the nucleus of the dream-thoughts, and the dream reproduces only a distorted form of the dream-wish in the unconscious. But we are already acquainted with dream-distortion; we have traced it back to the censorship which one psychic instance in the psychic life exercises over another. Dream-displacement is one of the chief means of achieving this distortion. *Is fecit, cui profuit*. We must assume that dream-displacement is brought about by the influence of this censorship, the endopsychic defence.

The manner in which the factors of displacement, condensation and over-determination interact with one another in dream-formation—which is the ruling factor and which the subordinate one—all this will be reserved as a subject for later investigation. In the meantime, we may state, as a second condition which the elements that find their way into the dream must satisfy, that *they must be withdrawn from the resistance of the censorship*. But henceforth, in the interpretation of dreams, we shall reckon with dream-displacement as an unquestionable fact.

Chapter 7

GEORG SIMMEL

THE METROPOLIS AND
MENTAL LIFE (1903)

T HE DEEPEST PROBLEMS OF MODERN LIFE derive from the claim of the
individual to preserve the autonomy and individuality of his existence in the face of over-
whelming social forces, of historical heritage, of external culture, and of the technique of life.
The fight with nature which primitive man has to wage for his *bodily* existence attains in this
modern form its latest transformation. The eighteenth century called upon man to free himself
of all the historical bonds in the state and in religion, in morals and in economics.
Man's nature, originally good and common to all, should develop unhampered. In addition
to more liberty, the nineteenth century demanded the functional specialization of man and
his work; this specialization makes one individual incomparable to another, and each of them
indispensable to the highest possible extent. However, this specialization makes each man
the more directly dependent upon the supplementary activities of all others. Nietzsche sees
the full development of the individual conditioned by the most ruthless struggle of individuals;
socialism believes in the suppression of all competition for the same reason. Be that as it
may, in all these positions the same basic motive is at work: the person resists to being leveled
down and worn out by a social-technological mechanism. An inquiry into the inner meaning
of specifically modern life and its products, into the soul of the cultural body, so to speak,
must seek to solve the equation which structures like the metropolis set up between the indi-
vidual and the super-individual contents of life. Such an inquiry must answer the question of
how the personality accommodates itself in the adjustments to external forces. This will be
my task today.

The psychological basis of the metropolitan type of individuality consists in the *intensifi-
cation of nervous stimulation* which results from the swift and uninterrupted change of outer
and inner stimuli. Man is a differentiating creature. His mind is stimulated by the differ-
ence between a momentary impression and the one which preceded it. Lasting impressions,
impressions which differ only slightly from one another, impressions which take a regular and
habitual course and show regular and habitual contrasts—all these use up, so to speak, less
consciousness than does the rapid crowding of changing images, the sharp discontinuity in the
grasp of a single glance, and the unexpectedness of onrushing impressions. These are the
psychological conditions which the metropolis creates. With each crossing of the street, with
the tempo and multiplicity of economic, occupational and social life, the city sets up a deep

Reprinted with the permission of The Free Press, a Division of Simon & Schuster Adult Publishing Group, from *The
Sociology of Georg Simmel*, translated and edited by Kurt H. Wolff. © 1950 by The Free Press. © renewed 1978 by
The Free Press.

contrast with small town and rural life with reference to the sensory foundations of psychic life. The metropolis exacts from man as a discriminating creature a different amount of consciousness than does rural life. Here the rhythm of life and sensory mental imagery flows more slowly, more habitually, and more evenly. Precisely in this connection the sophisticated character of metropolitan psychic life becomes understandable—as over against small town life which rests more upon deeply felt and emotional relationships. These latter are rooted in the more unconscious layers of the psyche and grow most readily in the steady rhythm of uninterrupted habituations. The intellect, however, has its locus in the transparent, conscious, higher layers of the psyche; it is the most adaptable of our inner forces. In order to accommodate to change and to the contrast of phenomena, the intellect does not require any shocks and inner upheavals; it is only through such upheavals that the more conservative mind could accommodate to the metropolitan rhythm of events. Thus the metropolitan type of man—which, of course, exists in a thousand individual variants—develops an organ protecting him against the threatening currents and discrepancies of his external environment which would uproot him. He reacts with his head instead of his heart. In this an increased awareness assumes the psychic prerogative. Metropolitan life, thus, underlies a heightened awareness and a predominance of intelligence in metropolitan man. The reaction to metropolitan phenomena is shifted to that organ which is least sensitive and quite remote from the depth of the personality. Intellectuality is thus seen to preserve subjective life against the overwhelming power of metropolitan life, and intellectuality branches out in many directions and is integrated with numerous discrete phenomena.

The metropolis has always been the seat of the money economy. Here the multiplicity and concentration of economic exchange gives an importance to the means of exchange which the scantiness of rural commerce would not have allowed. Money economy and the dominance of the intellect are intrinsically connected. They share a matter-of-fact attitude in dealing with men and with things; and, in this attitude, a formal justice is often coupled with an inconsiderate hardness. The intellectually sophisticated person is indifferent to all genuine individuality, because relationships and reactions result from it which cannot be exhausted with logical operations. In the same manner, the individuality of phenomena is not commensurate with the pecuniary principle. Money is concerned only with what is common to all: it asks for the exchange value, it reduces all quality and individuality to the question: How much? All intimate emotional relations between persons are founded in their individuality, whereas in rational relations man is reckoned with like a number, like an element which is in itself, indifferent. Only the objective measurable achievement is of interest. Thus metropolitan man reckons with his merchants and customers, his domestic servants and often even with persons with whom he is obliged to have social intercourse. These features of intellectuality contrast with the nature of the small circle in which the inevitable knowledge of individuality as inevitably produces a warmer tone of behavior, a behavior which is beyond a mere objective balancing of service and return. In the sphere of the economic psychology of the small group it is of importance that under primitive conditions production serves the customer who orders the good, so that the producer and the consumer are acquainted. The modern metropolis, however, is supplied almost entirely by production for the market, that is, for entirely unknown purchasers who never personally enter the producer's actual field of vision. Through this anonymity the interests of each party acquire an unmerciful matter-of-factness; and the intellectually calculating economic egoisms of both parties need not fear any deflection because of the imponderables of personal relationships. The money economy dominates the metropolis; it has displaced the last survivals of domestic production and the direct barter of goods; it

minimizes, from day to day, the amount of work ordered by customers. The matter-of-fact attitude is obviously so intimately interrelated with the money economy, which is dominant in the metropolis, that nobody can say whether the intellectualistic mentality first promoted the money economy or whether the latter determined the former. The metropolitan way of life is certainly the most fertile soil for this reciprocity, a point which I shall document merely by citing the dictum of the most eminent English constitutional historian: throughout the whole course of English history, London has never acted as England's heart but often as England's intellect and always as her moneybag!

In certain seemingly insignificant traits, which lie upon the surface of life, the same psychic currents characteristically unite. Modern mind has become more and more calculating. The calculative exactness of practical life which the money economy has brought about corresponds to the ideal of natural science: to transform the world into an arithmetic problem, to fix every part of the world by mathematical formulas. Only money economy has filled the days of so many people with weighing, calculating, with numerical determinations, with a reduction of qualitative values to quantitative ones. Through the calculative nature of money a new precision, a certainty in the definition of identities and differences, an unambiguousness in agreements and arrangements has been brought about in the relations of life-elements—just as externally this precision has been effected by the universal diffusion of pocket watches. However, the conditions of metropolitan life are at once cause and effect of this trait. The relationships and affairs of the typical metropolitan usually are so varied and complex that without the strictest punctuality in promises and services the whole structure would break down into an inextricable chaos. Above all, this necessity is brought about by the aggregation of so many people with such differentiated interests, who must integrate their relations and activities into a highly complex organism. If all clocks and watches in Berlin would suddenly go wrong in different ways, even if only by one hour, all economic life and communication of the city would be disrupted for a long time, in addition an apparently mere external factor: long distances, would make all waiting and broken appointments result in an ill-afforded waste of time. Thus, the technique of metropolitan life is unimaginable without the most punctual integration of all activities and mutual relations into a stable and impersonal time schedule. Here again the general conclusions of this entire task of reflection become obvious, namely, that from each point on the surface of existence—however closely attached to the surface alone—one may drop a sounding into the depth of the psyche so that all the most banal externalities of life finally are connected with the ultimate decisions concerning the meaning and style of life. Punctuality, calculability, exactness are forced upon life by the complexity and extension of metropolitan existence and are not only most intimately connected with its money economy and intellectualistic character. These traits must also color the contents of life and favor the exclusion of those irrational, instinctive, sovereign traits and impulses which aim at determining the mode of life from within, instead of receiving the general and precisely schematized form of life from without. Even though sovereign types of personality, characterized by irrational impulses, are by no means impossible in the city, they are, nevertheless, opposed to typical city life. The passionate hatred of men like Ruskin and Nietzsche for the metropolis is understandable in these terms. Their natures discovered the value of life alone in the unschematized existence which cannot be defined with precision for all alike. From the same source of this hatred of the metropolis surged their hatred of money economy and of the intellectualism of modern existence.

The same factors which have thus coalesced into the exactness and minute precision of the form of life have coalesced into a structure of the highest impersonality; on the other

hand, they have promoted a highly personal subjectivity. There is perhaps no psychic phenomenon which has been so unconditionally reserved to the metropolis as has the blasé attitude. The blasé attitude results first from the rapidly changing and closely compressed contrasting stimulations of the nerves. From this, the enhancement of metropolitan intellectuality, also, seems originally to stem. Therefore, stupid people who are not intellectually alive in the first place usually are not exactly blasé. A life in boundless pursuit of pleasure makes one blasé because it agitates the nerves to their strongest reactivity for such a long time that they finally cease to react at all. In the same way, through the rapidity and contradictoriness of their changes, more harmless impressions force such violent responses, tearing the nerves so brutally hither and thither that their last reserves of strength are spent; and if one remains in the same milieu they have no time to gather new strength. An incapacity thus emerges to react to new sensations with the appropriate energy. This constitutes that blasé attitude which, in fact, every metropolitan child shows when compared with children of quieter and less changeable milieus.

This physiological source of the metropolitan blasé attitude is joined by another source which flows from the money economy. The essence of the blasé attitude consists in the blunting of discrimination. This does not mean that the objects are not perceived, as is the case with the half-wit, but rather that the meaning and differing values of things, and thereby the things themselves, are experienced as insubstantial. They appear to the blasé person in an evenly flat and gray tone; no one object deserves preference over any other. This mood is the faithful subjective reflection of the completely internalized money economy. By being the equivalent to all the manifold things in one and the same way, money becomes the most frightful leveler. For money expresses all qualitative differences of things in terms of "how much?" Money, with all its colorlessness and indifference, becomes the common denominator of all values; irreparably it hollows out the core of things, their individuality, their specific value, and their incomparability. All things float with equal specific gravity in the constantly moving stream of money. All things lie on the same level and differ from one another only in the size of the area which they cover. In the individual case this coloration, or rather discoloration, of things through their money equivalence may be unnoticeably minute. However, through the relations of the rich to the objects to be had for money, perhaps even through the total character which the mentality of the contemporary public everywhere imparts to these objects, the exclusively pecuniary evaluation of objects has become quite considerable. The large cities, the main seats of the money exchange, bring the purchasability of things to the fore much more impressively than do smaller localities. That is why cities are also the genuine locale of the blasé attitude. In the blasé attitude the concentration of men and things stimulate the nervous system of the individual to its highest achievement so that it attains its peak. Through the mere quantitative intensification of the same conditioning factors this achievement is transformed into its opposite and appears in the peculiar adjustment of the blasé attitude. In this phenomenon the nerves find in the refusal to react to their stimulation the last possibility of accommodating to the contents and forms of metropolitan life. The self-preservation of certain personalities is brought at the price of devaluating the whole objective world, a devaluation which in the end unavoidably drags one's own personality down into a feeling of the same worthlessness. [. . .]

The most profound reason, however, why the metropolis conduces to the urge for the most individual personal existence—no matter whether justified and successful—appears to me to be the following: the development of modern culture is characterized by the preponderance of what one may call the "objective spirit" over the "subjective spirit." This is to say,

in language as well as in law, in the technique of production as well as in art, in science as well as in the objects of the domestic environment, there is embodied a sum of spirit. The individual in his intellectual development follows the growth of this spirit very imperfectly and at an ever increasing distance. If, for instance, we view the immense culture which for the last hundred years has been embodied in things and in knowledge, in institutions and in comforts, and if we compare all this with the cultural progress of the individual during the same period—at least in high status groups—a frightful disproportion in growth between the two becomes evident. Indeed, at some points we notice a retrogression in the culture of the individual with reference to spirituality, delicacy, and idealism. This discrepancy results essentially from the growing division of labor. For the division of labor demands from the individual an ever more one-sided accomplishment, and the greatest advance in a one-sided pursuit only too frequently means dearth to the personality of the individual. In any case, he can cope less and less with the overgrowth of objective culture. The individual is reduced to a negligible quantity, perhaps less in his consciousness than in his practice and in the totality of his obscure emotional states that are derived from this practice. The individual has become a mere cog in an enormous organization of things and powers which tear from his hands all progress, spirituality, and value in order to transform them from their subjective form into the form of a purely objective life. It needs merely to be pointed out that the metropolis is the genuine arena of this culture which outgrows all personal life. Here in buildings and educational institutions, in the wonders and comforts of space-conquering technology, in the formations of community life, and in the visible institutions of the state, is offered such an overwhelming fullness of crystallized and impersonalized spirit that the personality, so to speak, cannot maintain itself under its impact. On the one hand, life is made infinitely easy for the personality in that stimulations, interests, uses of time and consciousness are offered to it from all sides. They carry the person as if in a stream, and one needs hardly to swim for oneself. On the other hand, however, life is composed more and more of these impersonal contents and offerings which tend to displace the genuine personal colorations and incomparabilities. This results in the individual's summoning the utmost in uniqueness and particularization, in order to preserve his most personal core. He has to exaggerate this personal element in order to remain audible even to himself. The atrophy of individual culture through the hypertrophy of objective culture is one reason for the bitter hatred which the preachers of the most extreme individualism, above all Nietzsche, harbor against the metropolis. But it is, indeed, also a reason why these preachers are so passionately loved in the metropolis and why they appear to the metropolitan man as the prophets and saviors of his most unsatisfied yearnings. [. . .]

ALOIS RIEGL

THE MODERN CULT OF MONUMENTS
Its character and its origin (1928)

[. . .]

A **WORK OF ART IS GENERALLY DEFINED** as a palpable, visual, or audible creation by man which possesses an artistic value; a historical monument with the same physical basis will have a historical value. We will eliminate aural creations for our purposes, as they call be classified with written documents. With respect to the visual arts (and in the broadest sense, all artifacts), therefore, the question is what is artistic value and what is historical value?

Historical value is apparently the broader issue and therefore we will give it priority. Everything that has been and is no longer we call *historical*, in accordance with the modern notion that what has been can never be again, and that everything that has been constitutes an irreplaceable and irremovable link in a chain of development. In other words: each successive step implies its predecessor and could not have happened as it did without that earlier step. The essence of every modern perception of history is the idea of development. In these terms, every human activity and every human event of which we have knowledge or testimony may claim historical value; in principle every historical event is irreplaceable. But since it is not possible to consider the vast quantity of occurrences and events of which we have direct or indirect evidence and which multiply to infinity, we have of necessity limited our attention to that testimony which seems to represent a conspicuous phase in the development of a specific branch of human activity. This testimony could be written, activating a series of mental processes, or it could be a work of art whose content can be apprehended directly through the senses. It is important to realize that every work of art is at once and without exception a historical monument because it represents a specific stage in the development of the visual arts. In the strictest sense, no real equivalent can ever be substituted for it. Conversely, every historical monument is also an art monument, because even a secondary literary monument like a scrap of paper with a brief and insignificant note contains a whole series of artistic elements—the form of the piece of paper, the letters, and their composition—which apart from their historical value are relevant to the development of paper, writing, writing instruments, etc. To be sure, these are such insignificant elements that for the most part we neglect them in many cases because we have enough other monuments which convey much the same thing in a richer and more detailed manner. But were this scrap of paper the only surviving testimony to the art of its time, we would consider it, though trivial in itself, an utterly indispensable artifact. To the extent that it is present, the artistic element of such a document interests us only from a historical point of view: such monuments are

indispensable links in the development of art history. The "art monument" in this sense is really an "art-historical monument"; its value from this point of view is not so much artistic as historical. It follows that the differentiation of "artistic" and "historical" monuments is inappropriate because the latter at once contains and suspends the former.

But do we really appreciate only the historical value of a work of art? If this were so, then all the art from all epochs would have the same value in our view and would only increase in value by virtue of rarity or age. In reality we admire some recent works more than earlier ones, e.g., a Tiepolo of the eighteenth century more than Mannerist work of the sixteenth century. In addition to historical interest, there is, then, something else which resides in a work's specifically artistic properties, namely conceptual, formal, and coloristic qualities. Apart from the art-historical value, there is also in all earlier art a purely artistic value independent of the particular place a work of art occupies in the chain of historical development. Is this "art-value" equally as present as the historical value in the past, so that it may claim to be an essential and historically independent part of our notion of monument? Or is this art-value merely a subjective one, invented by and entirely dependent on the changing preferences of the modern viewer? Were this the case, would such art-value have no place in the definition of the monument as a commemorative work?

There are two fundamentally different responses to this question today: an older one which has not entirely disappeared, and a newer one. From the Renaissance—when, as we shall argue later, historical value was first recognized—until the nineteenth century, an inviolable artistic canon prevailed which claimed an absolute and objective validity to which all artists aspired but which they never achieved with complete success. Initially, ancient art seemed to conform to this canon most closely, even to the point of representing its very ideal. The nineteenth century definitively abolished this exclusive claim, allowing virtually all other periods of art to assume their own independent significance, but without entirely abandoning the belief in an objective artistic ideal. Only, around the beginning of the twentieth century have we come to recognize the necessary consequences of the theory of historical evolution, which declares that all artifacts of the past are irrecoverable and therefore in no way canonically binding. Even if we do not limit ourselves to appreciating modern works of art but also admire the concept, form, and color of older works, and even if we prefer the latter, we must realize that certain historic works of art correspond, if only in part, to the modern *Kunstwollen*. It is precisely this apparent correspondence of the modern *Kunstwollen* and certain aspects of historical art which, in its conflicting nature, exerts such power over the modern viewer. An entirely modern work, necessarily lacking this background, will never wield comparable power. According to current notions, there can be no absolute but only a relative, modern art-value. [. . .]

Historical value does not exhaust the interest and influence that artworks from the past arouse in us. Take, for instance, the ruins of a castle, which betray little of the original form, structure, internal disposition of rooms, and so forth, and with which the visitor has no sentimental association. The castle's historical value alone fails to account for the obvious interest which it excites in the modern observer. When we look at an old belfry we must make a similar distinction between our perception of the localized historical memories it contains and our more general awareness of the passage of time, the belfry's survival over time, and the visible traces of its age. The same distinction may be observed in a written testimony. A piece of parchment from the fifteenth century recording no more than the purchase of a horse evokes in us not only a dual commemorative value, but also, because of its written contents, a historical one established by the nature of the transaction (economic and legal history), by the names mentioned (political history, genealogy, land use) and so forth, and by the

unfamiliar language, the uncommon expressions, concepts, and decisions which even someone unschooled in history would immediately recognize as old-fashioned and belonging to the past. Modern interest in such an instance is undoubtedly rooted purely in its value as memory, that is, we consider the document an involuntary monument; however, its value as memory does not interfere with the work as such, but springs from our appreciation of the time which has elapsed since it was made and which has burdened it with traces of age. We have distinguished historical monuments from intentional ones as a more subjective category which remains nonetheless firmly bound up with objects, and now we recognize a third category of monuments in which the object has shrunk to a necessary evil. These monuments are nothing more than indispensable catalysts which trigger in the beholder a sense of the life cycle of the emergence of the particular from the general and its gradual but inevitable dissolution back into the general. This immediate emotional effect depends on neither scholarly knowledge nor historical education for its satisfaction, since it is evoked by mere sensory perception. Hence it is not restricted to the educated (to whom the task of caring for monuments necessarily has to be limited) but also touches the masses independent of their education. The general validity, which it shares with religious feelings, gives this new commemorative (monument) value a significance whose ultimate consequences cannot yet be assessed. We will henceforth call this the *age-value*. [. . .]

The nineteenth century is rightly called the historical one because, as we can see today, far more than before or after, it relished the search for and study of particulars, that is to say, it sought the most detailed rendering of individual human action and the way it has unfolded. The cherished goal was to acquire the fullest knowledge of historical facts. The so-called auxiliary fields of study were in fact not subsidiary at all, but rather the places where real historical research was engaged. The most unassuming narrative was read with pleasure and examined as to its authenticity. The postulate that issues about mankind, peoples, country, and church determined historical value became less important and was almost, but, not entirely, eliminated. Instead, *Kulturgeschichte*, cultural history, gained prominence, for which minutiae—and especially minutiae—were significant. The new postulate resided in the conviction that even the smallest particular within a developmental chain was irreplaceable and that within this chain even objective value adhered to objects wherein the material, manufacture, and purpose were otherwise negligible. With this unavoidable and constant dwindling of the objective value in monuments, the development itself became, as it were, the source of values which necessarily began to eclipse the individual monument. Historical value, which was tied to particulars, transformed itself slowly into developmental value, for which particulars were ultimately unimportant. This developmental value was none other than the age-value we have encountered before; it was the logical consequence of the historical value that preceded it by four centuries. Without historical value, there could not have been an age-value. If the nineteenth century was the age of historical value, then the twentieth century appears to be that of age-value. For the time being we are still in a period of transition, which is naturally also one of struggle. [. . .]

The nineteenth century not only dramatically increased appreciation of historical value, but it also sought to give it legal protection. The belief in an objective canon of art, which weakened again after the Renaissance, was now transferred to all artistic periods. This in turn gave rise to an unprecedented surge of art-historical research. According to nineteenth-century views, there was something of the eternal canon in every type of art; therefore each artifact deserved both perpetual conservation for the benefit of our aesthetic satisfaction and legal protection, since the values were often antithetical to contemporary ones. But

nineteenth-century laws were all tailored to the notion that the unintentional monument possessed only a historical value; with the rise of age-value, however, these laws became inadequate. [. . .]

An aesthetic axiom of our time based on age-value may be formulated as follows: from man we expect accomplished artifacts as symbols of a necessary process of human production; on the other hand, from nature acting over time, we expect their disintegration as the symbol of an equally necessary passing. We are as disturbed at the sight of decay in newly made artifacts (premature aging) as we are at the traces of fresh intervention into old artifacts (conspicuous restorations). In the twentieth century we appreciate particularly the purely natural cycle of becoming and passing away. Every artifact is thereby perceived as a natural entity whose development should not be disturbed, but should be allowed to live itself out with no more interference than necessary to prevent its premature demise. Thus modern man sees a bit of himself in a monument, and he will react to every intervention as he would to one on himself. Nature's reign, even in its destructive aspects—which also brings about the incessant renewal of life—claims equal right with man's creative power. What must be strictly avoided is interference with the action of nature's laws, be it the suppression of nature by man or the premature destruction of human creations by nature. If, from the standpoint of age-value, the traces of disintegration and decay are the source of a monument's effect, then the appreciation of this age-value cannot imply an interest in preserving monuments unaltered, and indeed such efforts would be found entirely inappropriate. Just as monuments pass away according to the workings of natural law—and it is precisely for this reason that they provide aesthetic satisfaction to the modern viewer—so preservation should not aim at stasis but ought to permit the monuments to submit to incessant transformation and steady decay, outside of sudden and violent destruction. Only one thing must be avoided: arbitrary interference by man in the way the monument has developed. There must be no additions or subtractions, no substitutions for what nature has undone, no removal of anything that nature has added to the original discrete form. The pure and redeeming impact of natural decay must not be arbitrarily disturbed by new additions. The cult of age-value condemns not only every willful destruction of monuments as a desecration of all-consuming nature but in principle also every effort at conservation, as restoration is an equally unjustified interference with nature. The cult of age-value, then, stands in ultimate opposition to the preservation of monuments. Without question, nature's unhampered processes will lead to the complete destruction of a monument. It is probably fair to say that ruins appear more picturesque the more advanced their state of decay: as decay progresses, age-value becomes less extensive, that is to say, evoked less and less by fewer and fewer remains, but is therefore all the more intensive in its impact on the beholder. Of course, this process has its limits. When finally nothing remains, then the effect vanishes completely. A shapeless pile of rubble is no longer able to convey age-value; there must be at least a recognizable trace of the original form, that is, of man's handiwork, whereas rubble alone reveals no trace of the original creation. [. . .]

SIEGFRIED KRACAUER

PHOTOGRAPHY (1927)

[. . .]

THE PRINCIPLE OF GOETHE PHILOLOGY is that of *historicist* thinking, which emerged at about the same time as modern photographic technology. On the whole, advocates of such historicist thinking[1] believe they can explain any phenomenon purely in terms of its genesis. That is, they believe in any case that they can grasp historical reality by reconstructing the course of events in their temporal succession without any gaps. Photography presents a spatial continuum; historicism seeks to provide the temporal continuum. According to historicism, the complete mirroring of an intratemporal sequence simultaneously contains the meaning of all that occurred within that time. [. . .] Historicism is concerned with the photography of time. The equivalent of its temporal photography would be a giant film depicting the temporally interconnected events from every vantage point.[2]

Memory encompasses neither the entire spatial appearance of a state of affairs nor its entire temporal course. Compared to photography, memory's records are full of gaps. The fact that the grandmother was at one time involved in a nasty story that is recounted time and again because people really do not like to talk about her—this does not mean much from the photographer's perspective. He knows every little wrinkle on her face and has noted every date. Memory does not pay much attention to dates—it skips years or stretches temporal distance. The selection of traits that it assembles must strike the photographer as arbitrary. The selection may have been made this way rather than another because dispositions and purposes required the repression, falsification, and emphasis of certain parts of the object; a virtually endless number of reasons determines the remains to be filtered. No matter which scenes an individual remembers, they all mean something relevant to that person, though he or she might not necessarily know what they mean. An individual retains memories because they are personally significant. Thus, they are organized according to a principle which is essentially different from the organizing principle of photography. Photography grasps what is given as a spatial (or temporal) continuum; memory images retain what is given only insofar as it has significance. Since what is significant is not reducible to either merely spatial or merely temporal terms, memory images are at odds with photographic representation. From the latter's perspective, memory images appear to be fragments—but only because photography does not encompass the meaning to which they refer and in relation to which they cease to be fragments. Similarly, from the perspective of memory, photography appears as a jumble that consists partly of garbage.

The meaning of memory images is linked to their truth content. So long as they are embedded in the uncontrolled life of the drives, they are inhabited by a demonic ambiguity;

they are opaque, like frosted glass which scarcely a ray of light can penetrate. Their transparency increases to the extent that insights thin out the vegetation of the soul and limit the compulsion of nature. Truth can be found only by a liberated consciousness which assesses the demonic nature of the drives. The traits that consciousness recollects stand in a relationship to what has been perceived as true, the latter being either manifest in these traits or excluded by them. The image in which these traits appear is distinguished from all other memory images, for unlike the latter it preserves not a multitude of opaque recollections but elements that touch upon what has been recognized as true. All memory images are bound to be reduced to this type of image, which may rightly he called the last image, since it alone preserves the unforgettable. The last image of a person is that person's actual *history*. This history omits all characteristics and determinations that do not relate in a significant sense to the truth intended by a liberated consciousness. How a person represents this history does not depend purely on his or her natural constitution or on the pseudo-coherence of his or her individuality; thus, only fragments of these assets are included in his or her history. This history is like a *monogram* that condenses the name into a single graphic figure which is meaningful as an ornament. [. . .]

Until well into the second half of the nineteenth century, the practice of photography was often in the hands of former painters. The not yet entirely depersonalized technology of this transition period corresponded to a spatial environment in which traces of meaning could still be trapped. With the increasing independence of the technology and the simultaneous evacuation of meaning from the objects, *artistic photography* loses its justification: it grows not into an artwork but into its imitation. Images of children are Zumbusches,[3] and the godfather of photographic landscape impressions was Monet. These pictorial arrangements—which do not go beyond a skillful emulation of familiar styles—fail to represent the very remnants of nature which, to a certain extent, advanced technology is capable of capturing. Modern painters have composed their images out of photographic fragments in order to highlight the side-by-side existence of reified appearances as they manifest themselves in spatial relations. This artistic intention is diametrically opposed to that of artistic photography. The latter does not explore the object assigned to photographic technology but rather wants to hide the technological essence by means of style. The artistic photographer is a dilettante artist who apes an artistic manner minus its substance, instead of capturing the very lack of substance. Similarly, rhythmic gymnastics wants to incorporate the soul about which it knows nothing. It shares with artistic photography the ambition to lay claim to a higher life in order to elevate an activity which is actually at its most elevated when it finds the object appropriate to its technology. The artistic photographers function like those social forces which are interested in the semblance of the spiritual because they fear the real spirit: it might explode the material base which the spiritual illusion serves to disguise. It would be well worth the effort to expose the close ties between the prevailing social order and artistic photography.

The photograph does not preserve the transparent aspects of an object but instead captures it as a spatial continuum from any one of a number of positions. The last memory image outlasts time because it is unforgettable; the photograph, which neither refers to nor encompasses such a memory image, must be essentially associated with the moment in time at which it came into existence. Referring to the average film whose subject matter is the normal photographable environment, E. A. Dupont remarked in his book on film that "the essence of film is, to some degree, the essence of time."[4] If photography is a *function of the flow of time*, then its substantive meaning will change depending upon whether it belongs to the domain of the present or to some phase of the past. [. . .]

The series of pictorial representations of which photography is the last historical stage begins with the *symbol*. The symbol, in turn, arises out of the "natural community," which man's consciousness was still entirely embedded in nature. [. . .]

For long stretches of history, imagistic representations have remained symbols. So long as human beings need them, they continue, in practice, to be dependent on natural conditions, a dependence that determines the visible and corporeal expression of consciousness. It is only with the increasing domination of nature that the image loses its symbolic power. Consciousness, which disengages itself from nature and stands against it, is no longer naïvely enveloped in its mythological cocoon: it thinks in concepts which, of course, can still be used in an altogether mythological way. In certain epochs the image retains its power; the symbolic presentation becomes *allegory*. "The latter signifies merely a general concept or an idea which is distinct from it; the former is the sensuous form, the incorporation of the idea itself." This is how old Creuzer defines the difference between the two types of images.[5] At the level of the symbol, what is thought is contained in the image; at the level of allegory, thought maintains and employs the image as if consciousness were hesitating to throw off its cocoon. This schematization is crude. Yet it suffices to illustrate the transformation of representations which is the sign that consciousness has departed from its natural contingency. The more decisively consciousness frees itself from this contingency in the course of the historical process, the more purely does its natural foundation present itself to consciousness. What is meant no longer appears to consciousness in images; rather, this meaning goes toward and through nature. To an ever-increasing degree, European painting during the last few centuries has represented nature stripped of symbolic and allegorical meanings. This certainly does not imply that the human features it depicts are bereft of meaning. Even as recently as the days of the old daguerreotypes, consciousness was so imbricated in nature that the faces bring to mind meanings which cannot be separated from natural life. Since nature changes in exact correspondence with the particular state of consciousness of a period, the foundation of nature devoid of meaning arises with modern photography. No different from earlier modes of representation, photography, too, is assigned to a particular developmental stage of practical and material life. It is a secretion of the capitalist mode of production. The same mere nature which appears in photography flourishes in the reality of the society produced by this capitalist mode of production. One can certainly imagine a society that has fallen prey to a mute nature which has no meaning no matter how abstract its silence. The contours of such a society emerge in the illustrated journals. Were it to endure, the emancipation of consciousness would result in the eradication of consciousness; the nature that it failed to penetrate would sit down at the very table that consciousness had abandoned. If this society failed to endure, however, then liberated consciousness would be given an incomparable opportunity. Less enmeshed in the natural bonds than ever before, it could prove its power in dealing with them. The turn to photography is the *go-for-broke game* of history. [. . .]

Notes

1 When this essay was first published in the *Frankfurter Zeitung* in 1927, Kracauer here explicitly named Wilhelm Dilthey as an exemplary advocate of such historicist thinking.

2 Kracauer refers to this passage in the introduction to *History: The Last Things Before the Last* (New York: Oxford University Press, 1969), when describing his surprising realization of the continuity between the work he had done on film and his present concern with history: "I realized in a flash the many existing parallels between history and the photographic media, historical reality and camera-reality. Lately I came across my piece on 'Photography' and was completely amazed at noticing that I had compared historicism with photography already in this article of the twenties" (3–4).

3 Ludwig von Zumbusch (1861–1927) was a German painter of naïve canvases, portraits, and pastel landscapes.
4 Ewald André Dupont, *Wie ein Film geschrieben wird und wie man ihn verwertet* (Berlin: Reinhold Kuhn, 1919), cited in Rudolf Harms, *Philosophie des Films* (Leipzig: Felix Meiner, 1926; facsimile rpt. Zurich: Hans Rohr, 1970), 142. Shortly after its publication, Kracauer reviewed Harms's study in the book review section of the *Frankfurter Zeitung* on July 10, 1927 (vol. 60, no. 28): 5.
5 Georg Friedrich Creuzer (1771–1858), *Symbolik und Mythologie der alten Völker, besonders der Griechen*, vol. 4 (Leipzig: Carl Wilhelm Leske, 1836–1843; rpt. Hildesheim: G. Olms, 1973), 540.

Chapter 10

WALTER BENJAMIN

THE WORK OF ART IN THE AGE OF MECHANICAL REPRODUCTION (1936)

[. . .]

Preface

WHEN MARX UNDERTOOK HIS CRITIQUE of the capitalistic mode of production, this mode was in its infancy. Marx directed his efforts in such a way as to give them prognostic value. He went back to the basic conditions underlying capitalistic production and through his presentation showed what could be expected of capitalism in the future. The result was that one could expect it not only to exploit the proletariat with increasing intensity, but ultimately to create conditions which would make it possible to abolish capitalism itself.

The transformation of the superstructure which takes place far more slowly than that of the substructure, has taken more than half a century to manifest in all areas of culture the change in the conditions of production. Only today can it be indicated what form this has taken. Certain prognostic requirements should be met by these statements. However, theses about the art of the proletariat after its assumption of power or about the art of a classless society would have less bearing on these demands than theses about the developmental tendencies of art under present conditions of production. Their dialectic is no less noticeable in the superstructure than in the economy. It would therefore be wrong to underestimate the value of such theses as a weapon. They brush aside a number of outmoded concepts, such as creativity and genius, eternal value and mystery–concepts whose uncontrolled (and at present almost uncontrollable) application would lead to a processing of data in the Fascist sense. The concepts which are introduced into the theory of art in what follows differ from the more familiar terms in that they are completely useless for the purposes of Fascism. They are, on the other hand, useful for the formulation of revolutionary demands in the politics of art.

I

In principle a work of art has always been reproducible. Manmade artifacts could always be imitated by men. Replicas were made by pupils in practice of their craft, by masters for diffusing their works, and, finally, by third parties in the pursuit of gain. Mechanical reproduction of a work of art, however, represents something new. Historically, it advanced intermittently and in leaps at long intervals, but with accelerated intensity. The Greeks knew only two procedures of technically reproducing works of art: founding and stamping. Bronzes, terra cottas, and coins were the only art works which they could produce in quantity. All others were unique and could not be mechanically reproduced. With the woodcut graphic art became mechanically reproducible for the first time, long before script became reproducible by print. The enormous changes which printing, the mechanical reproduction of writing, has brought about in literature are a familiar story. However, within the phenomenon which we are here examining from the perspective of world history, print is merely a special, though particularly important, case. During the Middle Ages engraving and etching were added to the woodcut; at the beginning of the nineteenth century lithography made its appearance.

With lithography the technique of reproduction reached an essentially new stage. This much more direct process was distinguished by the tracing of the design on a stone rather than its incision on a block of wood or its etching on a copperplate and permitted graphic art for the first time to put its products on the market, not only in large numbers as hitherto, but also in daily changing forms. Lithography enabled graphic art to illustrate everyday life, and it began to keep pace with printing. But only a few decades after its invention, lithography was surpassed by photography. For the first time in the process of pictorial reproduction, photography freed the hand of the most important artistic functions which henceforth devolved only upon the eye looking into a lens. Since the eye perceives more swiftly than the hand can draw, the process of pictorial reproduction was accelerated so enormously that it could keep pace with speech. A film operator shooting a scene in the studio captures the images at the speed of an actor's speech. Just as lithography virtually implied the illustrated newspaper, so did photography foreshadow the sound film. The technical reproduction of sound was tackled at the end of the last century. These convergent endeavors made predictable a situation which Paul Valéry pointed up in this sentence: "Just as water, gas, and electricity are brought into our houses from far off to satisfy our needs in response to a minimal effort, so we shall be supplied with visual or auditory images, which will appear and disappear at a simple movement of the hand, hardly more than a sign" [. . .]. Around 1900 technical reproduction had reached a standard that not only permitted it to reproduce all transmitted works of art and thus to cause the most profound change in their impact upon the public; it also had captured a place of its own among the artistic processes. For the study of this standard nothing is more revealing than the nature of the repercussions that these two different manifestations—the reproduction of works of art and the art of the film—have had on art in its traditional form.

II

Even the most perfect reproduction of a work of art is lacking in one element: its presence in time and space, its unique existence at the place where it happens to be. This unique existence of the work of art determined the history to which it was subject throughout the time of its existence. This includes the changes which it may have suffered in physical condition over the years as well as the various changes in its ownership. The traces of the first can be revealed only by chemical or physical analyses which it is impossible to perform on a

reproduction; changes of ownership are subject to a tradition which must be traced from the situation of the original.

The presence of the original is the prerequisite to the concept of authenticity. Chemical analyses of the patina of a bronze can help to establish this, as does the proof that a given manuscript of the Middle Ages stems from an archive of the fifteenth century. The whole sphere of authenticity is outside technical—and, of course, not only technical—reproducibility. Confronted with its manual reproduction, which was usually branded as a forgery, the original preserved all its authority; not so *vis-à-vis* technical reproduction. The reason is twofold. First, process reproduction is more independent of the original than manual reproduction. For example, in photography, process reproduction can bring out those aspects of the original that are unattainable to the naked eye yet accessible to the lens, which is adjustable and chooses its angle at will. And photographic reproduction, with the aid of certain processes, such as enlargement or slow motion, can capture images which escape natural vision. Secondly, technical reproduction can put the copy of the original into situations which would be out of reach for the original itself. Above all, it enables the original to meet the beholder halfway, be it in the form of a photograph or a phonograph record. The cathedral leaves its locale to be received in the studio of a lover of art; the choral production, performed in an auditorium or in the open air, resounds in the drawing room.

The situations into which the product of mechanical reproduction can be brought may not touch the actual work of art, yet the quality of its presence is always depreciated. This holds not only for the art work but also, for instance, for a landscape which passes in review before the spectator in a movie. In the case of the art object, a most sensitive nucleus—namely, its authenticity—is interfered with whereas no natural object is vulnerable on that score. The authenticity of a thing is the essence of all that is transmissible from its beginning, ranging from its substantive duration to its testimony to the history which it has experienced. Since the historical testimony rests on the authenticity, the former, too, is jeopardized by reproduction when substantive duration ceases to matter. And what is really jeopardized when the historical testimony is affected is the authority of the object.

One might subsume the eliminated element in the term "aura" and go on to say: that which withers in the age of mechanical reproduction is the aura of the work of art. This is a symptomatic process whose significance points beyond the realm of art. One might generalize by saying: the technique of reproduction detaches the reproduced object from the domain of tradition. By making many reproductions it substitutes a plurality of copies for a unique existence. And in permitting the reproduction to meet the beholder or listener in his own particular situation, it reactivates the object reproduced. These two processes lead to a tremendous shattering of tradition which is the obverse of the contemporary crisis and renewal of mankind. Both processes are intimately connected with the contemporary mass movements. Their most powerful agent is the film. Its social significance, particularly in its most positive form, is inconceivable without its destructive, cathartic aspect, that is, the liquidation of the traditional value of the cultural heritage. This phenomenon is most palpable in the great historical films. It extends to ever new positions. In 1927 Abel Gance exclaimed enthusiastically: "Shakespeare, Rembrandt, Beethoven will make films . . . all legends, all mythologies and all myths, all founders of religion, and the very religions . . . await their exposed resurrection, and the heroes crowd each other at the gate." Presumably without intending it, he issued an invitation to a far-reaching liquidation.

III

During long periods of history, the mode of human sense perception changes with humanity's entire mode of existence. The manner in which human sense perception is organized, the medium in which it is accomplished, is determined not only by nature but by historical circumstances as well. The fifth century, with its great shifts of population, saw the birth of the late Roman art industry and the Vienna Genesis, and there developed not only an art different from that of antiquity but also a new kind of perception. The scholars of the Viennese school, Riegl and Wickhoff, who resisted the weight of classical tradition under which these later art forms had been buried, were the first to draw conclusions from them concerning the organization of perception at the time. However far-reaching their insight, these scholars limited themselves to showing the significant, formal hallmark which characterized perception in late Roman times. They did not attempt—and, perhaps, saw no way—to show the social transformations expressed by these changes of perception. The conditions for an analogous insight are more favorable in the present. And if changes in the medium of contemporary perception can be comprehended as decay of the aura, it is possible to show its social causes.

The concept of aura which was proposed above with reference to historical objects may usefully be illustrated with reference to the aura of natural ones. We define the aura of the latter as the unique phenomenon of a distance, however close it may be. If, while resting on a summer afternoon, you follow with your eyes a mountain range on the horizon or a branch which casts its shadow over you, you experience the aura of those mountains, of that branch. This image makes it easy to comprehend the social bases of the contemporary decay of the aura. It rests on two circumstances, both of which are related to the increasing significance of the masses in contemporary life. Namely, the desire of contemporary masses to bring things "closer" spatially and humanly, which is just as ardent as their bent toward overcoming the uniqueness of every reality by accepting its reproduction. Every day the urge grows stronger to get hold of an object at very close range by way of its likeness, its reproduction. Unmistakably, reproduction as offered by picture magazines and newsreels differs from the image seen by the unarmed eye. Uniqueness and permanence are as closely linked in the latter as are transitoriness and reproducibility in the former. To pry an object from its shell, to destroy its aura, is the mark of a perception whose "sense of the universal equality of things" has increased to such a degree that it extracts it even from a unique object by means of reproduction. Thus is manifested in the field of perception what in the theoretical sphere is noticeable in the increasing importance of statistics. The adjustment of reality to the masses and of the masses to reality is a process of unlimited scope, as much for thinking as for perception.

IV

The uniqueness of a work of art is inseparable from its being imbedded in the fabric of tradition. This tradition itself is thoroughly alive and extremely changeable. An ancient statue of Venus, for example, stood in a different traditional context with the Greeks, who made it an object of veneration, than with the clerics of the Middle Ages, who viewed it as an ominous idol. Both of them, however, were equally confronted with its uniqueness, that is, its aura. Originally the contextual integration of art in tradition found its expression in the cult. We know that the earliest art works originated in the service of a ritual—first the magical, then the religious kind. It is significant that the existence of the work of art with reference to its aura is never entirely separated from its ritual function. In other words, the unique

value of the "authentic" work of art has its basis in ritual, the location of its original use value. This ritualistic basis, however remote, is still recognizable as secularized ritual even in the most profane forms of the cult of beauty. The secular cult of beauty, developed during the Renaissance and prevailing for three centuries, clearly showed that ritualistic basis in its decline and the first deep crisis which befell it. With the advent of the first truly revolutionary means of reproduction, photography, simultaneously with the rise of socialism, art sensed the approaching crisis which has become evident a century later. At the time, art reacted with the doctrine of l'*art pour l'art*, that is, with a theology of art. This gave rise to what might be called a negative theology in the form of the idea of "pure" art, which not only denied any social function of art but also any categorizing by subject matter. (In poetry, Mallarmé was the first to take this position.)

An analysis of art in the age of mechanical reproduction must do justice to these relationships, for they lead us to an all-important insight: for the first time in world history, mechanical reproduction emancipates the work of art from its parasitical dependence on ritual. To an ever greater degree the work of art reproduced becomes the work of art designed for reproducibility. From a photographic negative, for example, one can make any number of prints; to ask for the "authentic" print makes no sense. But the instant the criterion of authenticity ceases to be applicable to artistic production, the total function of art is reversed. Instead of being based on ritual, it begins to be based on another practice—politics.

V

Works of art are received and valued on different planes. Two polar types stand out: with one, the accent is on the cult value; with the other, on the exhibition value of the work. Artistic production begins with ceremonial objects destined to serve in a cult. One may assume that what mattered was their existence, not their being on view. The elk portrayed by the man of the Stone Age on the walls of his cave was an instrument of magic. He did expose it to his fellow men, but in the main it was meant for the spirits. Today the cult value would seem to demand that the work of art remain hidden. Certain statues of gods are accessible only to the priest in the cellar; certain Madonnas remain covered nearly all year round; certain sculptures on medieval cathedrals are invisible to the spectator on ground level. With the emancipation of the various art practices from ritual go increasing opportunities for the exhibition of their products. It is easier to exhibit a portrait bust that can be sent here and there than to exhibit the statue of a divinity that has its fixed place in the interior of a temple. The same holds for the painting as against the mosaic or fresco that preceded it. And even though the public presentability of a mass originally may have been just as great as that of a symphony, the latter originated at the moment when its public presentability promised to surpass that of the mass.

With the different methods of technical reproduction of a work of art, its fitness for exhibition increased to such an extent that the quantitative shift between its two poles turned into a qualitative transformation of its nature. This is comparable to the situation of the work of art in prehistoric times when, by the absolute emphasis on its cult value, it was, first and foremost, an instrument of magic. Only later did it come to be recognized as a work of art. In the same way today, by the absolute emphasis on its exhibition value the work of art becomes a creation with entirely new functions, among which the one we are conscious of, the artistic function, later may be recognized as incidental. This much is certain: today photography and the film are the most serviceable exemplifications of this new function.

VI

In photography, exhibition value begins to displace cult value all along the line. But cult value does not give way without resistance. It retires into an ultimate retrenchment: the human countenance. It is no accident that the portrait was the focal point of early photography. The cult of remembrance of loved ones, absent or dead, offers a last refuge for the cult value of the picture. For the last time the aura emanates from the early photographs in the fleeting expression of a human face. This is what constitutes their melancholy, incomparable beauty. But as man withdraws from the photographic image, the exhibition value for the first time shows its superiority to the ritual value. To have pinpointed this new stage constitutes the incomparable significance of Atget, who, around 1900, took photographs of deserted Paris streets. It has quite justly been said of him that he photographed them like scenes of crime. The scene of a crime, too, is deserted; it is photographed for the purpose of establishing evidence. With Atget, photographs become standard evidence for historical occurrences, and acquire a hidden political significance. They demand a specific kind of approach; free-floating contemplation is not appropriate to them. They stir the viewer; he feels challenged by them in a new way. At the same time picture magazines begin to put up signposts for him, right ones or wrong ones, no matter. For the first time, captions have become obligatory. And it is clear that they have an altogether different character than the title of a painting. The directives which the captions give to those looking at pictures in illustrated magazines soon become even more explicit and more imperative in the film where the meaning of each single picture appears to be prescribed by the sequence of all preceding ones. [. . .]

XV

The mass is a matrix from which all traditional behavior toward works of art issues today in a new form. Quantity has been transmuted into quality. The greatly increased mass of participants has produced a change in the mode of participation. The fact that the new mode of participation first appeared in a disreputable form must not confuse the spectator. Yet some people have launched spirited attacks against precisely this superficial aspect. Among these, Duhamel has expressed himself in the most radical manner. What he objects to most is the kind of participation which the movie elicits from the masses. Duhamel calls the movie "a pastime for helots, a diversion for uneducated, wretched, worn-out creatures who are consumed by their worries . . ., a spectacle which requires no concentration and presupposes no intelligence . . ., which kindles no light in the heart and awakens no hope other than the ridiculous one of someday becoming a 'star' in Los Angeles." Clearly, this is at bottom the same ancient lament that the masses seek distraction whereas art demands concentration from the spectator. That is a commonplace. The question remains whether it provides a platform for the analysis of the film. A closer look is needed here. Distraction and concentration form polar opposites which may be stated as follows: A man who concentrates before a work of art is absorbed by it. He enters into this work of art the way legend tells of the Chinese painter when he viewed his finished painting. In contrast, the distracted mass absorbs the work of art. This is most obvious with regard to buildings. Architecture has always represented the prototype of a work of art the reception of which is consummated by a collectivity in a state of distraction. The laws of its reception are most instructive.

Buildings have been man's companions since primeval times. Many art forms have developed and perished, tragedy begins with the Greeks, is extinguished with them, and after centuries its "rules" only are revived. The epic poem, which had its origin in the youth of

nations, expires in Europe at the end of the Renaissance. Panel painting is a creation of the Middle Ages, and nothing guarantees its uninterrupted existence. But the human need for shelter is lasting. Architecture has never been idle. Its history is more ancient than that of any other art, and its claim to being a living force has significance in every attempt to comprehend the relationship of the masses to art. Buildings are appropriated in a twofold manner: by use and by perception—or rather, by touch and sight. Such appropriation cannot be understood in terms of the attentive concentration of a tourist before a famous building. On the tactile side there is no counterpart to contemplation on the optical side. Tactile appropriation is accomplished not so much by attention as by habit. As regards architecture, habit determines to a large extent even optical reception. The latter, too, occurs much less through rapt attention than by noticing the object in incidental fashion. This mode of appropriation, developed with reference to architecture, in certain circumstances acquires canonical value. For the tasks which face the human apparatus of perception at the turning points of history cannot be solved by optical means, that is, by contemplation, alone. They are mastered gradually by habit, under the guidance of tactile appropriation.

The distracted person, too, can form habits. More, the ability to master certain tasks in a state of distraction proves that their solution has become a matter of habit. Distraction as provided by art presents a covert control of the extent to which new tasks have become soluble by apperception. Since, moreover, individuals are tempted to avoid such tasks, art will tackle the most difficult and most important ones where it is able to mobilize the masses. Today it does so in the film. Reception in a state of distraction, which is increasing noticeably in all fields of art and is symptomatic of profound changes in apperception, finds in the film its true means of exercise. The film with its shock effect meets this mode of reception halfway. The film makes the cult value recede into the background not only by putting the public in the position of the critic, but also by the fact that at the movies this position requires no attention. The public is an examiner, but an absent-minded one.

Epilogue

The growing proletarianization of modern man and the increasing formation of masses are two aspects of the same process. Fascism attempts to organize the newly created proletarian masses without affecting the property structure which the masses strive to eliminate. Fascism sees its salvation in giving these masses not their right, but instead a chance to express themselves. The masses have a right to change property relations; Fascism seeks to give them an expression while preserving property. The logical result of Fascism is the introduction of aesthetics into political life. The violation of the masses, whom Fascism, with its *Führer* cult, forces to their knees, has its counterpart in the violation of an apparatus which is pressed into the production of ritual values.

All efforts to render politics aesthetic culminate in one thing: war. War and war only can set a goal for mass movements on the largest scale while respecting the traditional property system. This is the political formula for the situation. The technological formula may be stated as follows: Only war makes it possible to mobilize all of today's technical resources while maintaining the property system. It goes without saying that the Fascist apotheosis of war does not employ such arguments. Still, Marinetti says in his manifesto on the Ethiopian colonial war: "For twenty-seven years we Futurists have rebelled against the branding of war as antiaesthetic . . . Accordingly we state: . . . War is beautiful because it establishes man's dominion over the subjugated machinery by means of gas masks, terrifying megaphones, flame throwers, and small tanks. War is beautiful because it initiates the dreamt-of metalization of

the human body. War is beautiful because it enriches a flowering meadow with the fiery orchids of machine guns. War is beautiful because it combines the gunfire, the cannonades, the cease-fire, the scents, and the stench of putrefaction into a symphony. War is beautiful because it creates new architecture, like that of the big tanks, the geometrical formation flights, the smoke spirals from burning villages, and many others. . . . Poets and artists of Futurism! . . . remember these principles of an aesthetics of war so that your struggle for a new literature and a new graphic art . . . may be illumined by them!"

This manifesto has the virtue of clarity, its formulations deserve to be accepted by dialecticians. To the latter, the aesthetics of today's war appears as follows: If the natural utilization of productive forces is impeded by the property system, the increase in technical devices, in speed, and in the sources of energy will press for an unnatural utilization, and this is found in war. The destructiveness of war furnishes proof that society has not been mature enough to incorporate technology as its organ, that, technology has not been sufficiently developed to cope with the elemental forces of society. The horrible features of imperialistic warfare are attributable to the discrepancy between the tremendous means of production and their inadequate utilization in the process of production–in other words, to unemployment and the lack of markets. Imperialistic war is a rebellion of technology which collects, in the form of "human material," the claims to which society has denied its natural material. Instead of draining rivers, society directs a human stream into a bed of trenches; instead of dropping seeds from airplanes, it drops incendiary bombs over cities; and through gas warfare the aura is abolished in a new way.

"*Fiat ars–pereat mundus*," says Fascism, and, as Marinetti admits, expects war to supply the artistic gratification of a sense perception that has been changed by technology. This is evidently the consummation of "*l'art pour l'art*." Mankind, which in Homer's time was an object of contemplation for the Olympian gods, now is one for itself. Its self-alienation has reached such a degree that it can experience its own destruction as an aesthetic pleasure of the first order. This is the situation of politics which Fascism is rendering aesthetic. Communism responds by politicizing art.

PART THREE

Technology and Vision

VANESSA R. SCHWARTZ AND
JEANNENE M. PRZYBLYSKI

WHILE THE INVENTION OF PHOTOGRAPHY in 1839 offered the period a defining image of rationalized and objective vision, its emergence dovetailed a host of different entertainment media in which vision was industrialized, commodified, and otherwise modernized. This section considers new viewing technologies and the ways they crystallized social organization and facilitated and transformed vision. From one perspective, this section offers readings that delineate the logic of the "era of mechanical reproducibility" and offers selections that treat dioramas, panoramas, photography, stereoscopes, and cinema, among other new or revitalized "image delivery systems" that mediated the popular understanding of optical perception and answered to the nineteenth-century taste for consuming visual illusions as if they were real.

Coupled with this history of technologies of vision, the section also connects these technologies to vision as a social and physiological experience. Michel Foucault's work on "panopticism" in the 1970s radically altered the way we thought about the connection between technologies and ways of seeing. His work operated at so general a level that scholars began to rethink "modern" bourgeois society as one in which individual bodies were rationalized and disciplined; we began to consider the connection between seeing and looking and social power. His observation that many institutions of the nineteenth century—the school, the hospital, and the prison shared an impulse toward surveillance, oriented scholarship to reconsider the connections between new technologies and the institutional, social, and individual organization of vision, opening a debate that is represented in the selections in this section and the next one which concentrates more on display and less on surveillance.

The selections here also contextualize technologies of vision such as photography, stereoscopy, magic lanterns, and film. Freund's view of the history of photography is important because she long ago championed (not unlike Walter Benjamin who she knew) that "art forms in their origin and evolution parallel contemporary developments in the social structure." Thus, her perspective on the history of photography is to understand it as the confluence of the trend toward mechanization, combined with the new status of the middle classes affirmed

through the democratization of portraiture. If Freund sees the social world crystallized in such new technologies as photography, others focus more explicitly on how vision itself is a way of understanding the crossroads of new technologies, the social structure, and the individual seeing the observer. Crary focuses on the act of the individual observing the subject as central in making the stereoscopic effect work and connects this to broad notions of vision as a subjective versus objective experience. Shivelbusch takes the experience of train travel as a fundamental reorientation of the way that individuals experienced the landscape and implies that this vision is found outside the train in such entertainments as panoramas. Gunning suggests that film emerges from a variety of technologies of images projected by light and the eventual, if not initial, idea of "instantaneity" associated with photography's ability to capture a moment. He makes clear that the history of film is a history of technologies, images and their particular reception. Film's appeal hinged on the public's simultaneous interest in the real and the uncanny pleasures produced by spectral illusions. Gunning's position reminds us that technology is a central element in the history of visual culture, but its experience and significance is not predetermined by virtue of its "essence" which is why careful historical scrutiny is needed.

MICHEL FOUCAULT

PANOPTICISM

THE FOLLOWING, ACCORDING TO an order published at the end of the seventeenth century, were the measures to be taken when the plague appeared in a town.[1] First, a strict spatial partitioning: the closing of the town and its outlying districts, a prohibition to leave the town on pain of death, the killing of all stray animals; the division of the town into distinct quarters, each governed by an intendant. Each street is placed under the authority of a syndic, who keeps it under surveillance; if he leaves the street, he will be condemned to death. On the appointed day, everyone is ordered to stay indoors: it is forbidden to leave on pain of death. The syndic himself comes to lock the door of each house from the outside; he takes the key with him and hands it over to the intendant of the quarter; the intendant keeps it until the end of the quarantine. [. . .]

This surveillance is based on a system of permanent registration: reports from the syndics to the intendants, from the intendants to the magistrates or mayor. At the beginning of the 'lock up', the role of each of the inhabitants present in the town is laid down, one by one; this document bears 'the name, age, sex of everyone, notwithstanding his conditions': a copy is sent to the intendant of the quarter, another to the office of the town hall, another to enable the syndic to make his daily roll call. Everything that may be observed during the course of the visits – deaths, illnesses, complaints, irregularities – is noted down and transmitted to the intendants and magistrates. The magistrates have complete control over medical treatment; they have appointed a physician in charge; no other practitioner may treat, no apothecary prepare medicine, no confessor visit a sick person without having received from him a written note 'to prevent anyone from concealing and dealing with those sick of the contagion, unknown to the magistrates'. The registration of the pathological must be constantly centralized. The relation of each individual to his disease and to his death passes through the representatives of power, the registration they make of it, the decisions they take on it. [. . .]

The plague is met by order; its function is to sort out every possible confusion: that of the disease, which is transmitted when bodies are mixed together; that of the evil, which is increased when fear and death overcome prohibitions. It lays down for each individual his place, his body, his disease and his death, his well-being, by means of an omnipresent and omniscient power that subdivides itself in a regular, uninterrupted way even to the ultimate determination of the individual, of what characterizes him, of what belongs to him, of what happens to him. Against the plague, which is a mixture, discipline brings into play its power, which is one of analysis. A whole literary fiction of the festival grew up around the plague: suspended laws, lifted prohibitions, the frenzy of passing time, bodies mingling together without respect, individuals unmasked, abandoning their statutory identity and the figure under which they had been recognized, allowing a quite different truth to appear. But there was also a political dream of the plague, which was exactly its reverse: not the collective festival,

but strict divisions; not laws transgressed, but the penetration of regulation into even the smallest details of everyday life through the mediation of the complete hierarchy that assured the capillary functioning of power; not masks that were put on and taken off, but the assignment to each individual of his 'true' name, his 'true' place, his 'true' body, his 'true' disease. The plague as a form, at once real and imaginary, of disorder had as its medical and political correlative discipline. [. . .]

If it is true that the leper gave rise to rituals of exclusion, which to a certain extent provided the model for and general form of the great Confinement, then the plague gave rise to disciplinary projects. Rather than the massive, binary division between one set of people and another, it called for multiple separations, individualizing distributions, an organization in depth of surveillance and control, as intensification and ramification of power. The leper was caught up in a practice of rejection, of exile-enclosure; he was left to his doom in a mass among which it was useless to differentiate; those sick of the plague were caught up in a meticulous tactical partitioning in which individual differentiations were the constricting effects of a power that multiplied, articulated and subdivided itself; the great confinement on the one hand; the correct training on the other. The leper and his separation; the plague and its segmentations. The first is marked; the second analysed and distributed. The exile of the leper and the arrest of the plague do not bring with them the same political dream. The first is that of a pure community, the second that of a disciplined society. Two ways of exercising power over men, of controlling their relations, of separating out their dangerous mixtures. The plague-stricken town, traversed throughout with hierarchy, surveillance, observation, writing; the town immobilized by the functioning of an extensive power that bears in a distinct way over all individual bodies – this is the utopia of the perfectly governed city. The plague (envisaged as a possibility at least) is the trial in the course of which one may define ideally the exercise of disciplinary power. In order to make rights and laws function according to pure theory, the jurists place themselves in imagination in the state of nature; in order to see perfect disciplines functioning, rulers dreamt of the state of plague. Underlying disciplinary projects the image of the plague stands for all forms of confusion and disorder; just as the image of the leper, cut off from all human contact, underlies projects of exclusion.

They are different projects, then, but not incompatible ones. We see them coming slowly together, and it is the peculiarity of the nineteenth century that it applied to the space of exclusion of which the leper was the symbolic inhabitant (beggars, vagbonds, madmen and the disorderly formed the real population) the technique of power proper to disciplinary partitioning. Treat lepers as 'plague victims', project the subtle segmentations of discipline onto the confused space of internment, combine it with the methods of analytical distribution proper to power, individualize the excluded, but use procedures of individualization to mark exclusion – this is what was operated regularly by disciplinary power from the beginning of the nineteenth century in the psychiatric asylum, the penitentiary, the reformatory, the approved school and, to some extent, the hospital. Generally speaking, all the authorities exercising individual control function according to a double mode; that of binary division and branding (mad/sane; dangerous/harmless; normal/abnormal); and that of coercive assignment, of differential distribution (who he is; where he must be; how he is to be characterized; how he is to be recognized; how a constant surveillance is to be exercised over him in an individual way, etc.). On the one hand, the lepers are treated as plague victims; the tactics of individualizing disciplines are imposed on the excluded; and, on the other hand, the universality of disciplinary controls makes it possible to brand the 'leper' and to bring into play against him the dualistic mechanisms of exclusion. The constant division between the normal and the abnormal, to which every individual is subjected, brings us back to our own time,

by applying the binary branding and exile of the leper to quite different objects; the existence of a whole set of techniques and institutions for measuring, supervising and correcting the abnormal brings into play the disciplinary mechanisms to which the fear of the plague gave rise. All the mechanisms of power which, even today, are disposed around the abnormal individual, to brand him and to alter him, are composed of those two forms from which they distantly derive.

Bentham's *Panopticon* is the architectural figure of this composition. We know the principle on which it was based: at the periphery, an annular building; at the centre, a tower; this tower is pierced with wide windows that open onto the inner side of the ring; the peripheric building is divided into cells, each of which extends the whole width of the building; they have two windows, one on the inside, corresponding to the windows of the tower; the other, on the outside, allows the light to cross the cell from one end to the other. All that is needed, then, is to place a supervisor in a central tower and to shut up in each cell a madman, a patient, a condemned man, a worker or a schoolboy. By the effect of backlighting, one can observe from the tower, standing out precisely, against the light, the small captive shadows in the cells of the periphery. They are like so many cages, so many small theatres, in which each actor is alone, perfectly individualized and constantly visible. The panoptic mechanism arranges spatial unities that make it possible to see constantly and to recognize immediately. In short, it reverses the principle of the dungeon; or rather of its three functions – to enclose, to deprive of light and to hide – it preserves only the first and eliminates the other two. Full lighting and the eye of a supervisor capture better than darkness, which ultimately protected. Visibility is a trap.

To begin with, this made it possible – as a negative effect – to avoid those compact, swarming, howling masses that were to be found in places of confinement, those painted by Goya or described by Howard. Each individual, in his place, is securely confined to a cell from which he is seen from the front by the supervisor; but the side walls prevent him from coming into contact with his companions. He is seen, but he does not see; he is the object of information, never a subject in communication. The arrangement of his room, opposite the central tower, imposes on him an axial visibility; but the divisions of the ring, those separated cells, imply a lateral invisibility. And this invisibility is a guarantee of order. If the inmates are convicts, there is no danger of a plot, an attempt at collective escape, the planning of new crimes for the future, bad reciprocal influences; if they are patients, there is no danger of contagion; if they are madmen there is no risk of their committing violence upon one another; if they are schoolchildren, there is no copying, no noise, no chatter, no waste of time; if they are workers, there are no disorders, no theft, no coalitions, none of those distractions that slow down the rate of work, make it less perfect or cause accidents. The crowd, a compact mass, a locus of multiple exchanges, individualities merging together, a collective effect, is abolished and replaced by a collection of separated individualities. From the point of view of the guardian, it is replaced by a multiplicity that can be numbered and supervised; from the point of view of the inmates, by a sequestered and observed solitude.[2]

Hence the major effect of the Panopticon: to induce in the inmate a state of conscious and permanent visibility that assures the automatic functioning of power. So to arrange things that the surveillance is permanent in its effects, even if it is discontinuous in its action; that the perfection of power should tend to render its actual exercise unnecessary; that this architectural apparatus should be a machine for creating and sustaining a power relation independent of the person who exercises it, in short, that the inmates should be caught up in a power situation of which they are themselves the bearers. To achieve this, it is at once too much and too little that the prisoner should be constantly observed by an inspector: too little, for

what matters is that he knows himself to be observed; too much, because he has no need in fact of being so. In view of this, Bentham laid down the principle that power should be visible and unverifiable. Visible: the inmate will constantly have before his eyes the tall outline of the central tower from which he is spied upon. Unverifiable: the inmate must never know whether he is being looked at at any one moment; but he must be sure that he may always be so. In order to make the presence or absence of the inspector unverifiable, so that the prisoners, in their cells, cannot even see a shadow, Bentham envisaged not only venetian blinds on the windows of the central observation hall, but, on the inside, partitions that inter-sected the hall at right angles and, in order to pass from one quarter to the other, not doors but zig-zag openings; for the slightest noise, a gleam of light, a brightness in a half-opened door would betray the presence of the guardian. The Panopticon is a machine for dissociating the see/being seen dyad: in the peripheric ring, one is totally seen, without ever seeing; in the central tower, one sees everything without ever being seen.

It is an important mechanism, for it automatizes and disindividualizes power. Power has its principle not so much in a person as in a certain concerted distribution of bodies, surfaces, lights, gazes; in an arrangement whose internal mechanisms produce the relation in which individuals are caught up. The ceremonies, the rituals, the marks by which the sovereign's surplus power was manifested are useless. There is a machinery that assures dissymmetry, disequilibrium, difference. Consequently, it does not matter who exercises power. Any indi-vidual, taken almost at random, can operate the machine: in the absence of the director, his family, his friends, his visitors, even his servants.[3] Similarly, it does not matter what motive animates him: the curiosity of the indiscreet, the malice of a child, the thirst for knowledge of a philosopher who wishes to visit this museum of human nature, or the perversity of those who take pleasure in spying and punishing. The more numerous those anonymous and tempo-rary observers are, the greater the risk for the inmate of being surprised and the greater his anxious awareness of being observed. The Panopticon is a marvellous machine which, what-ever use one may wish to put it to, produces homogeneous effects of power.

A real subjection is born mechanically from a fictitious relation. So it is not necessary to use force to constrain the convict to good behaviour, the madman to calm, the worker to work, the schoolboy to application, the patient to the observation of the regulations. Bentham was surprised that panoptic institutions could be so light: there were no more bars, no more chains, no more heavy locks; all that was needed was that the separations should be clear and the openings well arranged. The heaviness of the old 'houses of security', with their fortress-like architecture, could be replaced by the simple, economic geometry of a 'house of certainty'. The efficiency of power, its constraining force have, in a sense, passed over to the other side – to the side of its surface of application. He who is subjected to a field of visibility, and who knows it, assumes responsibility for the constraints of power; he makes them play spontan-eously upon himself; he inscribes in himself the power relation in which he simultaneously plays both roles; he becomes the principle of his own subjection. By this very fact, the external power may throw off its physical weight; it tends to the non-corporal; and, the more it approaches this limit, the more constant, profound and permanent are its effects: it is a perpetual victory that avoids any physical confrontation and which is always decided in advance.
[. . .]

The plague-stricken town, the panoptic establishment – the differences are important. They mark, at a distance of a century and a half, the transformations of the disciplinary programme. In the first case, there is an exceptional situation: against an extraordinary evil, power is mobilized; it makes itself everywhere present and visible; it invents new mechan-isms; it separates, it immobilizes, it partitions; it constructs for a time what is both a

counter-city and the perfect society; it imposes an ideal functioning, but one that is reduced, in the final analysis, like the evil that it combats, to a simple dualism of life and death: that which moves brings death, and one kills that which moves. The Panopticon, on the other hand, must be understood as a generalizable model of functioning; a way of defining power relations in terms of the everyday life of men. No doubt Bentham presents it as a particular institution, closed in upon itself. Utopias, perfectly closed in upon themselves, are common enough. As opposed to the ruined prisons, littered with mechanisms of torture, to be seen in Piranese's engravings, the Panopticon presents a cruel, ingenious cage. The fact that it should have given rise, even in our own time, to so many variations, projected or realized, is evidence of the imaginary intensity that it has possessed for almost two hundred years. But the Panopticon must not be understood as a dream building: it is the diagram of a mechanism of power reduced to its ideal form; its functioning, abstracted from any obstacle, resistance or friction, must be represented as a pure architectural and optical system: it is in fact a figure of political technology that may and must be detached from any specific use.

It is polyvalent in its applications; it serves to reform prisoners, but also to treat patients, to instruct schoolchildren, to confine the insane, to supervise workers, to put beggars and idlers to work. It is a type of location of bodies in space, of distribution of individuals in relation to one another, of hierarchical organization, of disposition of centres and channels of power, of definition of the instruments and modes of intervention of power, which can be implemented in hospitals, workshops, schools, prisons. [. . .]

In each of its applications, it makes it possible to perfect the exercise of power. It does this in several ways: because it can reduce the number of those who exercise it, while increasing the number of those on whom it is exercised. Because it is possible to intervene at any moment and because the constant pressure acts even before the offences, mistakes or crimes have been committed. Because, in these conditions, its strength is that it never intervenes, it is exercised spontaneously and without noise, it constitutes a mechanism whose effects follow from one another. Because, without any physical instrument other than architecture and geometry, it acts directly on individuals; it gives 'power of mind over mind'. The panoptic schema makes any apparatus of power more intense: it assures its economy (in material, in personnel, in time); it assures its efficacity by its preventative character, its continuous functioning and its automatic mechanisms. It is a way of obtaining from power 'in hitherto unexampled quantity', 'a great and new instrument of government . . . its great excellence consists in the great strength it is capable of giving to any institution it may be thought proper to apply it to.'[4]

[. . .]

How is power to be strengthened in such a way that, far from impeding progress, far from weighting upon it with its rules and regulations, it actually facilitates such progress? What intensificator of power will be able at the same time to be a multiplicator of production? How will power, by increasing its forces, be able to increase those of society instead of confiscating them or impeding them? The Panopticon's solution to this problem is that the productive increase of power can be assured only if, on the one hand, it can be exercised continuously in the very foundations of society, in the subtlest possible way, and if, on the other hand, it functions outside these sudden, violent, discontinuous forms that are bound up with the exercise of sovereignty. The body of the king, with its strange material and physical presence, with the force that he himself deploys or transmits to some few others, is at the opposite extreme of this new physics of power represented by panopticism; the domain of panopticism is, on the contrary, that whole lower region, that region of irregular bodies, with their details, their multiple movements, their heterogeneous forces, their spatial relations; what are required are mechanisms that analyse distributions, gaps, series, combinations, and

which use instruments that render visible, record, differentiate and compare: a physics of a relational and multiple power, which has its maximum intensity not in the person of the king, but in the bodies that can be individualized by these relations. At the theoretical level, Bentham defines another way of analysing the social body and the power relations that traverse it; in terms of practice, he defines a procedure of subordination of bodies and forces that must increase the utility of power while dispensing with the need for the prince. Panopticism is the general principle of a new 'political anatomy' whose object and end are not the relations of sovereignty but the relations of discipline.

The celebrated, transparent, circular cage, with its high tower, powerful, and knowing, may have been for Bentham a project of a perfect disciplinary institution; but he also set out to show how one may 'unlock' the disciplines and get them to function in a diffused, multiple, polyvalent way throughout the whole social body. These disciplines, which the classical age had elaborated in specific, relatively enclosed places – barracks, schools, workshops – and whose total implementation had been imagined only, at the limited and temporary scale of a plague-stricken town, Bentham dreamt of transforming into a network of mechanisms that would be everywhere and always alert, running through society without interruption in space or in time. The panoptic arrangement provides the formula for this generalization. It programmes, at the level of an elementary and easily transferable mechanism, the basic functioning of a society penetrated through and through with disciplinary mechanisms.

[. . .]

A few years after Bentham, Julius gave this society its birth certificate.[5] Speaking of the panoptic principle, he said that there was much more there than architectural ingenuity: it was an event in the 'history of the human mind'. In appearance, it is merely the solution of a technical problem; but, through it, a whole type of society emerges. Antiquity had been a civilization of spectacle. 'To render accessible to a multitude of men the inspection of a small number of objects': this was the problem to which the architecture of temples, theatres and circuses responded. With spectacle, there was a predominance of public life, the intensity of festivals, sensual proximity. In these rituals in which blood flowed, society found new vigour and formed for a moment a single great body. The modern age poses the opposite problem: 'To procure for a small number, or even for a single individual, the instantaneous view of a great multitude.' In a society in which the principal elements are no longer the community and public life, but, on the one hand, private individuals and, on the other, the state, relations can be regulated only in a form that is the exact reverse of the spectacle: 'It was to the modern age, to the ever-growing influence of the state, to its ever more profound intervention in all the details and all the relations of social life, that was reserved the task of increasing and perfecting its guarantees, by using and directing towards that great aim the building and distribution of buildings intended to observe a great multitude of men at the same time.'

Julius saw as a fulfilled historical process that which Bentham had described as a technical programme. Our society is one not of spectacle, but of surveillance; under the surface of images, one invests bodies in depth; behind the great abstraction of exchange, there continues the meticulous, concrete training of useful forces; the circuits of communication are the supports of an accumulation and a centralization of knowledge; the play of signs defines the anchorages of power; it is not that the beautiful totality of the individual is amputated, repressed, altered by our social order, it is rather that the individual is carefully fabricated in it, according to a whole technique of forces and bodies. We are much less Greeks than we believe. We are neither in the amphitheatre, nor on the stage, but in the panoptic machine, invested by its effects of power, which we bring to ourselves since we are part of

its mechanism. The importance, in historical mythology, of the Napoleonic character probably derives from the fact that it is at the point of junction of the monarchical, ritual exercise of sovereignty and the hierarchical, permanent exercise of indefinite discipline. He is the individual who looms over everything with a single gaze which no detail, however minute, can escape. [. . .] At the moment of its full blossoming, the disciplinary society still assumes with the Emperor the old aspect of the power of spectacle. As a monarch who is at one and the same time a usurper of the ancient throne and the organizer of the new state, he combined into a single symbolic, ultimate figure the whole of the long process by which the pomp of sovereignty, the necessarily spectacular manifestations of power, were extinguished one by one in the daily exercise of surveillance, in a panopticism in which the vigilance of intersecting gazes was soon to render useless both the eagle and the sun.

Notes

1 Archives militaires de Vincennes, A 1,516 91 sc. Pièce. This regulation is broadly similar to a whole series of others that date from the same period and earlier.
2 J. Bentham, *Works*, ed. Bowring (1843), iv, pp. 60–4.
3 Ibid., p. 45.
4 Ibid., pp. 66.
5 N. H. Julius, *Leçons sur les prisons*, I (1831., Fr. Trans) pp. 384–6.

Chapter 12

GISÈLE FREUND

PRECURSORS OF THE PHOTOGRAPHIC PORTRAIT

T HE DEVELOPMENT OF THE PHOTOGRAPHIC PORTRAIT corresponds to an important phase in the social development of Western Europe: the rise of the middle classes when for the first time, fairly large segments of the population attained political and economic power. To meet their resulting demand for goods, nearly everything had to be produced in greater quantities. The portrait was no exception: By having one's portrait done an individual of the ascending classes could visually affirm his new social status both to himself and to the world at large. To meet the increased demand for portraits, the art became more and more mechanized. The photographic portrait was the final stage in this trend toward mechanization.

Around 1750 the nascent middle classes began pushing into areas that were formerly the sole domain of the aristocracy. For centuries the privilege of aristocratic circles, the portrait began to yield to democratization. Even before the French Revolution the bourgeoisie had already manifested its profound need for self-glorification, a need which provoked the development of new forms and techniques of portraiture. Photography, which entered the public domain in 1839, owes much of its popularity and rapid social development to the continuing vogue of the portrait.

During this period of transition, however, when constant political upheaval and new production methods in all industries were dissolving the remains of the feudal system in France, the rising classes had not found a characteristic means of artistic expression because they had not yet formed a clear self-image. The bourgeoisie still modeled itself after the aristocracy, which continued to set standards of taste even though it was no longer the dominant economic or political force. The rising classes adopted the artistic conventions favored by the nobility, modifying them according to their own needs.

The nobility were difficult clients. They demanded technical perfection. To suit the tastes of the day, the painter tried to avoid all bold colors in favor of more delicate ones. Canvas alone could not satisfy the aristocracy: painters experimented with any material which might better render the rich textures of velvet or silk. The miniature portrait became a favorite of the nobility. It underlined the aristocracy's delight in personal charm. On powder boxes and pendants one could always carry about these tiny portraits of friends, lovers, or faraway members of the family.

The miniature was also one of the first portrait forms to be coveted by the bourgeoisie for the expression of its new cult of individualism. In dealing with this new clientele, the portrait painter faced a double task: he must imitate the style of the court painters, and bring down his prices. [. . .] Easily adapted to its new clientele, the miniature became one of the most successful minor arts. A miniaturist could support himself by turning out thirty to fifty portraits a year and selling them at moderate prices. But even though it was popular among the middle classes for a time, it still retained its aristocratic elements, and eventually, as the middle classes became more secure, it died out.

By 1850, when the bourgeoisie had become firmly established, the miniature portrait had all but disappeared and photography deprived the last of the miniaturists of their livelihood. In Marseille, for example, there were no more than four or five miniaturists by 1850, only two of whom enjoyed enough of a reputation to be turning out fifty portraits a year. These artists earned just enough to support themselves and their families. Within a few years, there were nearly fifty photographers in town, most of whom devoted themselves to portrait photography and earned a good deal more than the best-known miniaturists. The photographers turned out an average of twelve hundred pictures annually. Sold at 15 gold francs apiece, these brought a yearly total of 18,000 francs and a combined income of nearly one million. Equally dramatic changes took place in all the large cities in France and abroad.[1] For one-tenth the price of a painted portrait, the photographer could furnish a likeness which satisfied the taste of the bourgeois as well as the needs of his pocketbook.

Art forms in their origin and evolution parallel contemporary developments in the social structure. The artistic efforts of the era with which we are concerned reflect the democratic ideals of the French Revolution of 1789, which demanded 'the rights of man and of the citizen.' The revolutionary citizen who helped take the Bastille and who defended the rights of his class at the National Assembly reflected the same ideals in posing for the physiono-tracists of Paris. [. . .]

The physionotrace was based on the well-known principle of the pantograph, an instrument which mechanically reproduces a drawing or diagram. The pantograph is made of rods in the shape of two joined parallelograms. The device moves in a horizontal plane, one parallelogram passing over a design, the other over a blank paper ready to receive the design. With a dry stylus attached to the corner of the first parallelogram, the operator follows the contours of the design. An inked stylus, attached to the second, automatically reproduces the design on the blank page at a scale determined by the distance between each stylus. The physionotrace was much larger than the pantograph and differed in two other respects: the device was held upright so that the features of a seated model could be traced, and it was fitted with an eyepiece in place of the dry stylus which could pick out the outlines of an object in space. After posing his model, the physionotracist, seated on a stepladder behind the apparatus, maneuvered it by aiming his eye at the features to be reproduced. The distance from the model to the device, as well as the position of the stylus, determined the relative scale of the final image.[2] [. . .]

Physionotrace portraits had an increasingly detrimental effect on miniature painting and engraving. At the Salon of 1793, one hundred physionotrace portraits were exhibited. Just three years later, there were twelve rooms showing fifty physionotrace portraits each.[3]

The physionotracists, especially the three best known, Quenedey, Gonord, and Chrétien, maintained a bitter rivalry. Each accused the others of having stolen his most recent improvements, and they publicized their disputes in the Paris newspapers.[4] Hoping to win the favor of the public, each claimed to be the sole inventor of the various technical processes. Realizing that there were many interested amateurs, Gonord began to manufacture sets of equipment as well. All the physionotracists made a good deal of money from the invention. Eager to have their portraits made, but unwilling to spend much time or money, most people preferred to go to the physionotracist who, after only a short sitting, could produce a portrait that was very similar to a painted miniature for a low price. Soon, the physionotrace portrait replaced the miniature.

The same tendencies were evident throughout the French business world. The type and quality of merchandise on hand varied with the number of buyers; merchandise of poorer quality at a lower price replaced more expensive merchandise of superior quality. Luxury, bought cheaply, became the best guarantee of good business. [. . .]

The physionotrace can be considered the symbol of a period of transition between the old regime and the new. It is the predecessor of the camera in the technical evolution that has led to the coin-operated portrait machines and Polaroids of today. There will always be a sector in the art world which is more concerned with speed and quantity than with art; the physionotracist of 1790 is not far removed from the passport photographer of the twentieth century.

Thanks to the physionotrace, a large portion of the French bourgeoisie gained access to portraits. But the process did not necessarily capture the *interest* of the majority of the middle class, much less the lower class. It does not, for example, seem to have been practiced in the provinces. Individual labor was still dominant there in the execution of a portrait. It was not until a totally impersonal technique came into use with the advent of photography that the portrait could be completely democratized.

Although the physionotrace had nothing to do with the technical development of photography, it can be argued that it was its ideological predecessor.

Notes

1 Vidal, 'Mémoire de la séance du 15 novembre 1868 de la société statistique de Marseille,' *Bulletin de la société française de photographie*, 1871, pp. 37, 38, 40.
2 Cf. Cromer, 'Le secret du physionotrace,' *Bulletin de la société archéologique, historique et artistique*, 'Le Vieux Papier,' 26th year, October 1925.
3 Cf. Vivarez, *Le physionotrace*.
4 Cf. *Journal de Paris*, 21 July 1788.

Chapter 13

JONATHAN CRARY

TECHNIQUES OF THE OBSERVER

T HE MOST SIGNIFICANT FORM of visual imagery in the nineteenth century, with the exception of photographs, was the stereoscope.[1] It is easily forgotten now how pervasive was the experience of the stereoscope and how for decades it defined a major mode of experiencing photographically produced images. This too is a form whose history has thus far been confounded with that of another phenomenon, in this case photography. [. . .] Its conceptual structure and the historical circumstances of its invention are thoroughly independent of photography. Although distinct from the optical devices that represented the illusion of movement, the stereoscope is nonetheless part of the same reorganization of the observer, the same relations of knowledge and power, that those devices implied.

Of primary concern here is the period during which the technical and theoretical principles of the stereoscope were developed, rather than the issue of its effects once it was distributed throughout a sociocultural field. Only after 1850 did its wide commercial diffusion throughout North America and Europe occur.[2] The origins of the stereoscope are intertwined with research in the 1820s and 1830s on subjective vision and more generally within the field of nineteenth-century physiology already discussed. The two figures most closely associated with its invention, Charles Wheatstone and Sir David Brewster, had already written extensively on optical illusions, color theory, afterimages and other visual phenomena. Wheatstone was in fact the translator of Purkinje's major 1823 dissertation on afterimages and subjective vision, published in English in 1830. A few years later Brewster summarized available research on optical devices and subjective vision.

The stereoscope is also inseparable from early nineteenth-century debates about the perception of space, which were to continue unresolved indefinitely. Was space an innate form or was it something recognized through the learning of cues after birth? The Molyneux

problem had been transposed to a different century for very different solutions. But the question that troubled the nineteenth century had never really been a central problem before.

Binocular disparity, the self-evident fact that each eye sees a slightly different image, had been a familiar phenomenon since antiquity. Only in the 1830s does it become crucial for scientists to define the seeing body as essentially binocular, to quantify precisely the angular differential of the optical axis of each eye, and to specify the physiological basis for disparity. The question that preoccupied researchers was this: given that an observer perceives with each eye a different image, *how* are they experienced as single or unitary? Before 1800, even when the question was asked it was more as a curiosity, never a central problem. Two alternative explanations had been offered for centuries: one proposed that we never saw anything except with one eye at a time; the other was a projection theory articulated by Kepler, and proposed as late as the 1750s, which asserted that each eye projects an object to its actual location.[3] But in the nineteenth century the unity of the visual field could not be so easily predicated.

By the late 1820s physiologists were seeking anatomical evidence in the structure of the optical chiasma, the point behind the eyes where the nerve fibers leading from the retina to the brain cross each other, carrying half of the nerves from each retina to each side of the brain.[4] But such physiological evidence was relatively inconclusive at that time. Wheatstone's conclusions in 1833 came out of the successful measurement of binocular parallax, or the degree to which the angle of the axis of each eye differed when focused on the same point. The human organism, he claimed, had the capacity under most conditions to synthesize retinal disparity into a single unitary image. While this seems obvious from our own standpoint, Wheatstone's work marked a major break from older explanations (or often disregard) of the binocular body.

The form of the stereoscope is linked to some of Wheatstone's initial findings: his research concerned the visual experience of objects relatively close to the eye.

> When an object is viewed at so great a distance that the optic axes of both eyes are sensibly parallel when directed towards it, the perspective projections of it, seen by each eye separately; and the appearance to the two eyes is precisely the same as when the object is seen by one eye only.[5]

Instead Wheatstone was preoccupied with objects close enough to the observer so that the optic axes had *different* angles.

> When the object is placed so near the eyes that to view it the optic axes must converge. . . a different perspective projection of it is seen by each eye, and these perspectives are more dissimilar as the convergence of the optic axes becomes greater.[6]

Thus physical proximity brings binocular vision into play as an operation of reconciling disparity, of making two distinct views appear as one. This is what links the stereoscope with other devices in the 1830s like the phenakistiscope. Its "realism" presupposes perceptual experience to be essentially an apprehension of differences. The relation of the observer to the object is not one of identity but an experience of disjunct or divergent images. Helmholtz's influential epistemology was based on such a "differential hypothesis."[7] Both Wheatstone and Brewster indicated that the fusion of pictures viewed in a stereoscope took place over time and that their convergence might not actually be secure. According to Brewster,

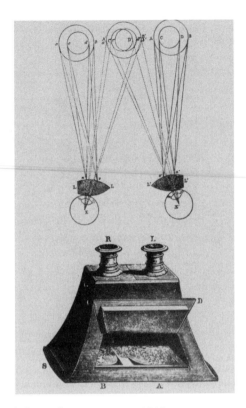

Figure 13.1 David Brewster's lenticular stereoscope, 1849.

the relief is not obtained from the mere combination or superposition of the two dissimilar pictures. The superposition is effected by turning each eye upon the object, but the relief is given by the play of the optic axes in uniting, in rapid *succession*, similar points of the two pictures . . . Though the pictures apparently coalesce, yet the relief is given by the subsequent play of the optic axes varying themselves successively upon, and unifying, the similar points in each picture that correspond to different distances from the observer.[8]

Brewster thus confirms there never really is a stereoscopic image, that it is a conjuration, an effect of the observer's experience of the differential between two other images.

In devising the stereoscope, Wheatstone aimed to simulate the actual presence of a physical object or scene, not to discover another way to exhibit a print or drawing [Figure 13.1]. Painting had been an adequate form of representation, he asserts, but only for images of objects at a great distance. When a landscape is presented to a viewer, "if those circumstances which would disturb the illusion are excluded," we could mistake the representation for reality. He declares that up to this point in history it is impossible for an artist to give a faithful representation of any *near* solid object.

When the painting and the object are seen with both eyes, in the case of the painting two similar objects are projected on the retina, in the case of the solid object the pictures are dissimilar; there is therefore an essential difference between the impressions

on the organs of sensation in the two cases, and consequently between the percep-
tions formed in the mind; the painting therefore cannot be confounded with the
solid object.[9]

What he seeks, then, is a complete equivalence of stereoscopic image and object. Not only
will the invention of the stereoscope overcome the deficiencies of painting but also those of
the diorama, which Wheatstone singles out. The diorama, he believed, was too bound up in
the techniques of painting, which depended for their illusory effects on the depiction of distant
subjects. The stereoscope, on the contrary, provided a form in which "vividness" of effect
increased with the apparent proximity of the object to the viewer, and the impression of
three-dimensional solidity became greater as the optic axes of each diverged. Thus the desired
effect of the stereoscope was not simply likeness, but immediate, apparent *tangibility*. But
it is a tangibility that has been transformed into a purely visual experience, of a kind that
Diderot could never have imagined. The "reciprocal assistance" between sight and touch
Diderot specified in *Letters on the Blind* is no longer operative. Even as sophisticated a student
of vision as Helmholtz could write, in the 1850s,

> these stereoscopic photographs are so true to nature and so lifelike in their portrayal
> of material things, that after viewing such a picture and recognizing in it some object
> like a house, for instance, we get the impression, when we actually do see the object,
> that we have already seen it before and are more or less familiar with it. In cases of
> this kind, the actual view of the thing itself does not add anything new or more accu-
> rate to the previous apperception we got from the picture, so far at least as mere
> form relations are concerned.[10]

No other form of representation in the nineteenth century had so conflated the real with the
optical. We will never really know what the stereoscope looked like to a nineteenth-century
viewer or recover a stance from which it could seem an equivalent for a "natural vision."
There is even something "uncanny" in Helmholtz's conviction that a picture of a house could
be so real that we feel "we have already seen it before." Since it is obviously impossible to
reproduce stereoscopic effects here on a printed page, it is necessary to analyze closely the
nature of this illusion for which such claims were made, to look through the lenses of the
device itself.

First it must be emphasized that the "reality effect" of the stereoscope was highly variable.
Some stereoscopic images produce little or no three-dimensional effect: for instance, a view
across an empty plaza of a building facade, or a view of a distant landscape with few inter-
vening elements. Also, images that elsewhere are standard demonstrations of perspectival
recession, such as a road or a railroad track extending to a centrally located vanishing point,
produce little impression of depth. Pronounced stereoscopic effects depend on the presence
of objects or obtrusive forms in the near or middle ground; that is, there must be enough
points in the image that require significant changes in the angle of convergence of the optical
axes. Thus the most intense experience of the stereoscopic image coincides with an object-
filled space, with a material plenitude that bespeaks a nineteenth-century bourgeois horror of
the void; and there are endless quantities of stereo cards showing interiors crammed with
bric-a-brac, densely filled museum sculpture galleries, and congested city views.

But in such images the depth is essentially different from anything in painting or photog-
raphy. We are given an insistent sense of "in front of" and "in back of" that seems to organize
the image as a sequence of receding planes. And in fact the fundamental organization of the

stereoscopic image is *planar*.[11] We perceive individual elements as flat, cutout forms arrayed either nearer or further from us. But the experience of space between these objects (planes) is not one of gradual and predictable recession: rather, there is a vertiginous uncertainty about the distance separating forms. Compared to the strange insubstantiality of objects and figures located in the middle ground, the absolutely airless space surrounding them has a disturbing palpability. There are some superficial similarities between the stereoscope and classical stage design, which synthesizes flats and real extensive space into an illusory scene. But theatrical space is still perspectival in that the movement of actors on a stage generally rationalizes the relation between points.

In the stereoscopic image there is a derangement of the conventional functioning of optical cues. Certain planes or surfaces, even though composed of indications of light or shade that normally designate volume, are perceived as flat; other planes that normally would be read as two-dimensional, such as a fence in a foreground, seem to occupy space aggressively. Thus stereoscopic relief or depth has no unifying logic or order. If perspective implied a homogeneous and potentially metric space, the stereoscope discloses a fundamentally disunified and aggregate field of disjunct elements. Our eyes never traverse the image in a full apprehension of the three-dimensionality of the entire field, but in terms of a localized experience of separate areas. When we look head-on at a photograph or painting our eyes remain at a single angle of convergence, thus endowing the image surface with an optical unity. The reading or scanning of a stereo image, however, is an accumulation of differences in the degree of optical convergence, thereby producing a perceptual effect of a patchwork of different intensities of relief within a single image. Our eyes follow a choppy and erratic path into its depth: it is an assemblage of local zones of three-dimensionality, zones imbued with a hallucinatory clarity, but which when taken together never coalesce into a homogeneous field. It is a world that simply does not communicate with that which produced baroque scenography or the city views of Canaletto and Bellotto. Part of the fascination of these images is due to this immanent disorder, to the fissures that disrupt its coherence. The stereoscope could be said to constitute what Gilles Deleuze calls a "Riemann space," after the German mathematician Georg Riemann (1826–1866). "Each vicinity in a Riemann space is like a shred of Euclidian space but the linkage between one vicinity and the next is not defined. . . . Riemann space at its most general thus presents itself as an amorphous collection of pieces that are juxtaposed but not attached to each other."[12]

A range of nineteenth-century painting also manifests some of these features of stereoscopic imagery. Courbet's *Ladies of the Village* (1851), with its much-noted discontinuity of groups and planes, suggests the aggregate space of the stereoscope, as do similar elements of *The Meeting (Bonjour, M Courbet)* (1854). Works by Manet, such as *The Execution of Maximillian* (1867) and *View of the International Exhibition* (1867), and certainly Seurat's *Sunday Afternoon on the Island of La Grande Jatte* (1884–86) also are built up piecemeal out of local and disjunct areas of spatial coherence, of both modeled depth and cutout flatness. Numerous other examples could be mentioned, perhaps going back as early as the landscapes of Wilhelm von Köbell, with their unsettling hyperclarity and abrupt adjacency of foreground and distant background. I am certainly not proposing a causal relation of *any* sort between these two forms, and I would be dismayed if I prompted anyone to determine if Courbet owned a stereoscope. Instead I am suggesting that *both* the "realism" of the stereoscope and the "experiments" of certain painters were equally bound up in a much broader transformation of the observer that allowed the emergence of this new optically constructed space. The stereoscope and Cézanne have far more in common than one might assume. Painting, and early modernism in particular, had no special claims in the renovation of vision in the nineteenth century.

The stereoscope as a means of representation was inherently *obscene*, in the most literal sense. It shattered the *scenic* relationship between viewer and object that was intrinsic to the fundamentally theatrical setup of the camera obscura. The very functioning of the stereoscope depended, as indicated above, on the visual priority of the object closest to the viewer and on the absence of any mediation between eye and image.[13] It was a fulfillment of what Walter Benjamin saw as central in the visual culture of modernity: "Day by day the need becomes greater to take possession of the object—from the closest proximity—in an image and the reproduction of an image."[14] It is no coincidence that the stereoscope became increasingly synonymous with erotic and pornographic imagery in the course of the nineteenth century. The very effects of tangibility that Wheatstone had sought from the beginning were quickly turned into a mass form of ocular possession. Some have speculated that the very close association of the stereoscope with pornography was in part responsible for its social demise as a mode of visual consumption. Around the turn of the century sales of the device supposedly dwindled because it became linked with "indecent" subject matter. Although the reasons for the collapse of the stereoscope lie elsewhere, as I will suggest shortly, the simulation of tangible three-dimensionality hovers uneasily at the limits of acceptable verisimilitude.[15]

If photography preserved an ambivalent (and superficial) relation to the codes of monocular space and geometrical perspective, the relation of the stereoscope to these older forms was one of annihilation, not compromise. Charles Wheatstone's question in 1838 was: "What would be the visual effect of simultaneously presenting to each eye, instead of the object itself, its projection on a plane surface as it appears to that eye?" The stereoscopic spectator sees neither the identity of a copy nor the coherence guaranteed by the frame of a window. Rather, what appears is the technical reconstitution of an already reproduced world fragmented into *two* nonidentical models, models that precede any experience of their subsequent perception as unified or tangible. It is a radical repositioning of the observer's relation to visual representation. The institutionalization of this decentered observer and the stereoscope's dispersed and multiplied sign severed from a point of external reference indicate a greater break with a classical observer than that which occurs later in the century in the realm of painting. The stereoscope signals an eradication of "the point of view" around which, for several centuries, meanings had been assigned reciprocally to an observer and the object of his or her vision. There is no longer the possibility of perspective under such a technique of beholding. The relation of observer to image is no longer to an object quantified in relation to a position in space, but rather to two dissimilar images whose position simulates the anatomical structure of the observer's body [Figure 13.2].

To fully appreciate the rupture signified by the stereoscope it is important to consider the original device, the so-called Wheatstone stereoscope. In order to view images with this device, an observer placed his eyes directly in front of two plane mirrors set ninety degrees to one another. The images to be viewed were held in slots on either side of the observer, and thus were spatially completely separated from each other. Unlike the Brewster stereoscope, invented in the late 1840s, or the familiar Holmes viewer, invented in 1861, the Wheatstone model made clear the atopic nature of the perceived stereoscopic image, the disjunction between experience and its cause. The later models allowed the viewer to believe that he or she was looking forward *at* something "out there." But the Wheatstone model left the hallucinatory and fabricated nature of the experience undisguised. It did not support what Roland Barthes called "the referential illusion."[16] There simply was nothing "out there." The illusion of relief or depth was thus a subjective event and the observer coupled with the apparatus was the agent of synthesis or fusion.

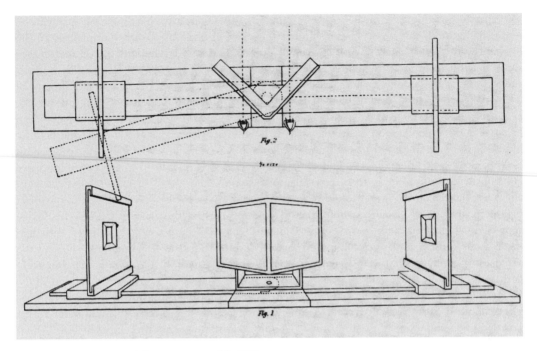

Figure 13.2 Diagram of the operation of the Wheatstone stereoscope.

Like the phenakistiscope and other nonprojective optical devices, the stereoscope also required the corporeal adjacency and immobility of the observer. They are part of a nineteenth-century modulation in the relation between eye and optical apparatus. During the seventeenth and eighteenth centuries that relationship had been essentially metaphoric: the eye and the camera obscura or the eye and the telescope or microscope were allied by a conceptual similarity, in which the authority of an ideal eye remained unchallenged.[17] Beginning in the nineteenth century, the relation between eye and optical apparatus becomes one of metonymy: both were now contiguous instruments on the same plane of operation, with varying capabilities and features.[18] The limits and deficiencies of one will be complemented by the capacities of the other and vice versa. The optical apparatus undergoes a shift comparable to that of the tool as described by Marx: "From the moment that the tool proper is taken from man, and fitted into a mechanism, a machine takes the place of a mere implement."[19] In this sense, other optical instruments of the seventeenth and eighteenth centuries, like peep-shows, Claude glasses, and print viewing boxes had the status of tools. In the older handicraft-based work, Marx explained, a workman "makes use of a tool," that is, the tool had a metaphoric relation to the innate powers of the human subject.[20] In the factory, Marx contended, the machine makes use of man by subjecting him to a relation of contiguity, of part to other parts, and of exchangeability. He is quite specific about the new metonymic status of the human subject: "As soon as man, instead of working with an implement on the subject of his labour, becomes merely the motive power of an implement-machine, it is a mere accident that motive power takes the disguise of human muscle; and it may equally well take the form of wind, water, or steam."[21] Georges Canguilhem makes an important distinction between eighteenth-century utilitarianism, which derived its idea of utility from its definition of man as toolmaker, and the instrumentalism of the human sciences in the

nineteenth century, which is based on "one implicit postulate: that the nature of man is to be a tool, that his vocation is to be set in his place and to be set to work."[22] Although "set to work" may sound inappropriate in a discussion of optical devices, the apparently passive observer of the stereoscope and phenakistiscope, by virtue of specific physiological capacities, was in fact made into a producer of forms of verisimilitude. And what the observer produced, again and again, was the effortless transformation of the dreary parallel images of flat stereo cards into a tantalizing apparition of depth. The content of the images is far less important than the inexhaustible routine of moving from one card to the next and producing the same effect, repeatedly, mechanically. And each time, the mass-produced and monotonous cards are transubstantiated into a compulsory and seductive vision of the "real."

A crucial feature of these optical devices of the 1830s and 1840s is the undisguised nature of their operational structure and the form of subjection they entail. Even though they provide access to "the real," they make no claim that the real is anything other than a mechanical production. The optical experiences they manufacture are clearly disjunct from the images used in the device. They refer as much to the functional interaction of body and machine as they do to external objects, no matter how "vivid" the quality of the illusion. So when the phenakistiscope and the stereoscope eventually disappeared, it was not as part of a smooth process of invention and improvement, but rather because these earlier forms were no longer adequate to current needs and uses.

One reason for their obsolescence was that they were insufficiently "phantasmagoric," a word that Adorno, Benjamin, and others have used to describe forms of representation after 1850. Phantasmagoria was a name for a specific type of magic-lantern performance in the 1790s and early 1800s, one that used back projection to keep an audience unaware of the lanterns [Figure 13.3]. Adorno takes the word to indicate

> the occultation of production by means of the outward appearance of the product . . . this outer appearance can lay claim to the status of being. Its perfection is at the same time the perfection of the illusion that the work of art is a reality *sui generis* that constitutes itself in the realm of the absolute without having to renounce its claim to image the world.[23]

But the effacement or mystification of a machine's operation was precisely what David Brewster hoped to overcome with his kaleidoscope and stereoscope. He optimistically saw the spread of scientific ideas in the nineteenth century undermining the possibility of phantasmagoric effects, and he overlapped the history of civilization with the development of technologies of illusion and apparition.[24] For Brewster, a Scottish Calvinist, the maintenance of barbarism, tyranny, and popery had always been founded on closely guarded knowledge of optics and acoustics, the secrets by which priestly and higher castes ruled. But his implied program, the democratization and mass dissemination of techniques of illusion, simply collapsed that older model of power onto a single human subject, transforming each observer into simultaneously the magician and the deceived.

Even in the later Holmes stereoscope, the "concealment of the process of production" did not fully occur.[25] Clearly the stereoscope was dependent on a physical engagement with the apparatus that became increasingly unacceptable, and the composite, synthetic nature of the stereoscopic image could never be fully effaced. An apparatus openly based on a principle of disparity, on a "binocular" body, and on an illusion patently derived from the binary referent of the stereoscopic card of paired images, gave way to a form that preserved the referential illusion more fully than anything before it. Photography defeated the stereoscope

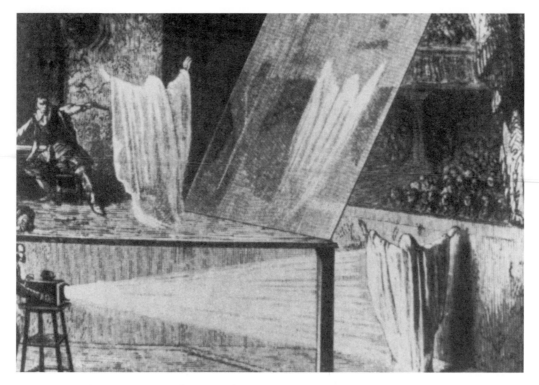

Figure 13.3 Phantasmagoria, mid-nineteenth century.

as a mode of visual consumption as well because it recreated and perpetuated the fiction that the "free" subject of the camera obscura was still viable. Photographs seemed to be a continuation of older "naturalistic" pictorial codes, but only because their dominant conventions were restricted to a narrow range of technical possibilities (that is, shutter speeds and lens openings that rendered elapsed time invisible and recorded objects in focus).[26] But photography had already abolished the inseparability of observer and camera obscura, bound together by a single point of view, and made the new camera an apparatus fundamentally independent of the spectator, yet which masqueraded as a transparent and incorporeal intermediary between observer and world. The prehistory of the spectacle *and* the "pure perception" of modernism are lodged in the newly discovered territory of a fully embodied viewer, but the eventual triumph of both depends on the denial of the body, its pulsings and phantasms, as the ground of vision.[27]

Notes

1 There are few serious cultural or historical studies of the stereoscope. Some helpful works are: Edward W. Earle, ed., *Points of View: The Stereograph in America: A Cultural History* (Rochester, 1979); A. T. Gill, "Early Stereoscopes," *The Photographic Journal* 109 (1969), pp. 545–599, 606–614, 641–651; and Rosalind Krauss, "Photography's Discursive Spaces: Landscape/View," *Art Journal* 42 (Winter 1982), pp. 311–319.

2 By 1856, two years after its founding, the London Stereoscopic Company alone had sold over half a million viewers. See Helmut and Alison Gernsheim, *The History of Photography* (London, 1969), p. 191.

3 See, for example, William Porterfield, *A Treatise on the Eye, the Manner and Phenomena of Vision* (Edinburgh, 1759), p. 285.

4 See R. L. Gregory, *Eye and Brain: The Psychology of Seeing*, 3rd ed. (New York, 1979), p. 45.

5 Charles Wheatstone, "Contributions to a physiology of vision—Part the first. On some remarkable, and hitherto unobserved, phenomena of binocular vision," in *Brewster and Wheatstone on Vision*, ed. Nicholas J. Wade (London, 1983), p. 65.

6 Wheatstone, "Contributions to a physiology of vision," p. 65.

7 Hermann von Helmholtz, "The Facts in Perception," *Epistemological Writings*, ed. Moritz Schlick (Boston, 1977), p. 133: "Our acquaintance with the visual field can be acquired by observation of the images during the movements of our eyes, provided only that there exists, between otherwise qualitatively alike retinal sensations, some or other perceptible difference corresponding to the difference between distinct places on the retina."

8 Sir David Brewster, *The Stereoscope: Its History, Theory, and Construction* (London, 1856), p. 53 (emphasis in original).

9 Charles Wheatstone, "Contributions to the Physiology of Vision," in *Brewster and Wheatstone on Vision*, p. 66.

10 Helmholtz, *Physiological Optics*, vol. 3, p. 303.

11 See Krauss. "Photography's Discursive Spaces," p. 313.

12 Gilles Deleuze and Félix Guattari, *A Thousand Plateaus*, p. 485.

13 See Florence de Mèredieu. "De l'obscénité photographique," *Traverses* 29 (October 1983), pp. 86–94.

14 Walter Benjamin, "A Small History of Photography," in *One Way Street*, trans. Edmund Jephcott and Kingsley Shorter (London, 1979), pp. 240–257.

15 The ambivalence with which twentieth-century audiences have received 3-D movies and holography suggests the enduring problematic nature of such techniques. Christian Metz discusses the idea of an optimal point on either side of which the impression of reality tends to decrease, in his *Film Language* (New York, 1974), pp. 3–15.

16 See Roland Barthes, "The Reality Effect," in *The Rustle of Language*, trans. Richard Howard (New York, 1986), pp. 141–148.

17 On the telescope as metaphor in Galileo, Kepler, and others see Timothy J. Riess, *The Discourse of Modernism* (Ithaca, 1980), pp. 25–29.

18 "In Metonymy, phenomena are implicitly apprehended as bearing relationships to one another in the modality of part-part relationships, on the basis of which one can effect a *reduction* of one of the parts to the status of an aspect or function of the other." Hayden White, *Metahistory: The Historical Imagination in Nineteenth Century Europe* (Baltimore, 1973), p. 35.

19 Karl Marx, *Capital*, vol. 1, trans. Samuel Moore and Edward Aveling (New York, 1967), p. 374.

20 Marx, *Capital*, vol. 1, p. 422. J. D. Bernal has noted that the instrumental capacities of the telescope and microscope remained remarkably undeveloped during the seventeenth and eighteenth centuries. Until the nineteenth century, the microscope "remained more amusing and instructive, in the philosophical sense, than of scientific and practical value." *Science in History, Vol. 2: The Scientific and Industrial Revolutions* (Cambridge, Mass., 1971), pp. 464–469.

21 Marx, *Capital*, vol. 1, p. 375.

22 Georges Canguilhem. "Qu'est-ce que la psychologie," *Etudes d'histoire et de philosophie des sciences* (Paris, 1983), p. 378. See also Gilles Deleuze and Félix Guattari, *A Thousand Plateaus*, p. 490: "During the nineteenth century a two-fold elaboration was undertaken: of a physioscientific concept of Work (weight-height, force-displacement), and of a socioeconomic concept of labor-power or abstract labor (a homogenous abstract quantity applicable to all work and susceptible to multiplication and division). There was a profound link between physics and sociology: society furnished an economic standard of measure for work, and physics as 'mechanical currency' for it. . . . Impose the Work Model upon every activity, translate every act into possible or virtual work, discipline free action, or else (which amounts to the same thing) relegate it to 'leisure,' which exists only by reference to work."

23 Theodor Adorno, *In Search of Wagner*, trans. Rodney Livingstone (London, 1981), p. 85. On Adorno and the phantasmagoria, see Andreas Huyssen, *After the Great Divide: Modernism, Mass Culture, Postmodernism* (Bloomington, 1986), pp. 34–42. See also Rolf Tiedemann, "Dialectics at a Standstill: Approaches to the Passagen-Werk," in *On Walter Benjamin: Critical Essays and Recollections*, ed. Gary Smith (Cambridge, Mass., 1988), pp. 276–279. For the technical and cultural history of the original phantasmagoria, see Terry Castle, "Phantasmagoria: Spectral Technology and the Metaphorics of Modern Reverie," *Critical Inquiry* 15 (Autumn 1988), pp. 26–61; Erik Barnouw, *The Magician and the Cinema* (Oxford, 1981); and Martin Quigley, Jr., *Magic Shadows: The Story of the Origin of Motion Pictures*, pp. 75–79.

24 Sir David Brewster, *Letters on Natural Magic* (New York, 1832), pp. 15–21.

25 This device is described by its inventor in Oliver Wendell Holmes, "The Stereoscope and the Stereo-graph," *Atlantic Monthly* 3, no. 20 (June 1859), pp. 738–748.

26 For the disruptive effect of Muybridge and Marey on nineteenth-century codes of "naturalistic" repre-sentation, see Noël Burch, "Charles Baudelaire versus Doctor Frankenstein," *Afterimage* 8–9 (Spring 1981), pp. 4–21.

27 On the problem of modernism, vision, and the body, see the recent work of Rosalind Krauss: "Antivision," *October* 36 (Spring 1986), pp. 147–154; "The Blink of an Eye," in *The States of Theory: History, Art, and Critical Discourse*, ed. David Caroll (New York, 1990), pp. 175–199; and "The Impulse to See," in *Vision and Visuality*, ed. Hal Foster (Seattle, 1988), pp. 51–75.

Chapter 14

WOLFGANG SCHIVELBUSCH

PANORAMIC TRAVEL

Dreamlike travelling on the railroad. The towns which I pass between Philadelphia and New York make no distinct impression. They are like pictures on a wall. The more, that you can read all the way in a car a French novel.

> Emerson, *Journals*, February 7, 1843

IN GOETHE'S JOURNAL on his trip to Switzerland in 1797, we find the following entry:

Left Frankfurt shortly after 7:00 A.M. On the Sachsenhausen mountain, many well-kept vineyards; foggy, cloudy, pleasant weather. The highway pavement has been improved with limestone. Woods in back of the watchtower. A man climbing up the great tall beech trees with a rope and iron cleats on his shoes. What a village! A deadfall by the road, from the hills by Langen. *Sprendlingen*. Basalt in the pavement and on the highway up to Langen; the surface must break very often on this plateau, as near Frankfurt. Sandy, fertile, flat land; a lot of agriculture, but meager . . .[1]

As Goethe tells Eckermann, this journal was "merely jotted down as given by the moment." Thus it is no poetic text, but a description of a journey by coach in the late eighteenth century, a record of impressions received on that journey. Goethe's trip from Frankfurt to Heidelberg consists of a continuous sequence of impressions that demonstrates how intense the experi-ence of the traversed space has been. Not only the villages and towns on the way are noted,

not only the formations of the terrain, but even details of the material consistency of the pavement of the highway are incorporated into his perceptions.

The railway puts an end to this intensity of travel, which reached its peak in the eighteenth century and found its cultural expression in the genre of the "novel of travels." The speed and mathematical directness with which the railroad proceeds through the terrain destroy the close relationship between the traveler and the traveled space. The space of *landscape* becomes, to apply Erwin Straus' concept, *geographical* space. "In a landscape," says Straus, "we always get to one place from another place; each location is determined only by its relation to the neighboring place within the circle of visibility. But geographical space is closed, and is therefore in its entire structure transparent. Every place in such a space is determined by its position with respect to the whole and ultimately by its relation to the null point of the coordinate system by which this space obtains its order. Geographical space is systematized."[2] Straus sees the railroad as the essential agent of the transformation of landscape into geographical space:

> The modern forms of traveling in which intervening spaces are, as it were, skipped over or even slept through, strikingly illustrate the systematically closed and constructed character of the geographical space in which we live as human beings. Before the advent of the railroad, geographical connections evolved, for the traveler, from the change in landscape. True, today the traveler also goes from place to place. But now we can get on a French train in the morning, and then, after twelve hours on the train (which is really being nowhere), we can get out in Rome. The old form of traveling provided for a more and better balanced relationship between landscape and geography.[3]

The nineteenth century found a fitting metaphor for this loss of continuity: repeatedly, the train is described as a projectile. First, the projectile metaphor is used to emphasize the train's speed, as in Lardner: a train moving at seventy-five miles an hour "would have a velocity only four times less than a cannon ball."[4] Then, as Greenhow points out, there is the cumulative power and impact that turns a speeding train into a missile: "when a body is moving at very high velocity, it then, to all intents and purposes, becomes a projectile, and is subject to the laws attending projectiles."[5] In 1889, after the complete cultural assimilation of the railroad, the projectile metaphor is still quite attractive. "Seventy-five miles an hour," says a technical text published in that year, "is one hundred and ten feet a second, and the energy of four hundred tons moving at that rate is nearly twice as great as that of a 2,000-pound shot fired from a 100-ton Armstrong gun."[6]

The train is experienced as a projectile, and traveling on it, as being shot through the landscape — thus losing control of one's senses. "In travelling on most of the railways . . . ," says an anonymous author of the year 1844, "the face of nature, the beautiful prospects of hill and dale, are lost or distorted to our view. The alternation of high and low ground, the healthful breeze, and all those exhilarating associations connected with 'the Road,' are lost or changed to doleful cuttings, dismal tunnels, and the noxious effluvia of the screaming engine."[7] Thus the rails, cuttings, and tunnels appear as the barrel through which the projectile of the train passes. The traveler who sits inside that projectile ceases to be a traveler and becomes, as noted in a popular metaphor of the century, a mere parcel.[8] "It matters not whether you have eyes or are asleep or blind, intelligent or dull," says Ruskin, "all that you can know, at best, of the country you pass is its geological structure and general clothing."[9]

This loss of landscape affects all the senses. Realizing Newton's mechanics in the realm of transportation, the railroad creates conditions that will also "mechanize" the travelers's perceptions. According to Newton, "size, shape, quantity, and motion" are the only qualities that can be objectively perceived in the physical world. Indeed, those become the only qualities that the railroad traveler is now able to observe in the landscape he travels through. Smells, sounds, not to mention the synesthetic perceptions that were part of travel in Goethe's time, simply disappear.

The change effected in the traveler's relationship to the landscape becomes most evident in regard to his sense of sight: visual perception is diminished by velocity. George Stephenson testifies to this in a statement given at a parliamentary hearing on safety problems on the railways in 1841: when asked for his estimation of the engine-driver's ability to see obstacles, he replies, "If his attention is drawn to any object before he arrives at the place, he may have a pretty correct view of it; but if he only turns himself round as he is passing, he will see it very imperfectly."[10]

Unlike the driver, the travelers have only a very limited chance to look *ahead*: thus all they can see is an evanescent landscape. All early descriptions of railroad travel testify to the difficulty of recognizing any but the broadest outlines of the traversed landscape. Victor Hugo describes the view from a train window in a letter dated August 22, 1837: "The flowers by the side of the road are no longer flowers but flecks, or rather streaks, of red or white; there are no longer any points, everything becomes a streak; the grainfields are great shocks of yellow hair; fields of alfalfa, long green tresses; the towns, the steeples, and the trees perform a crazy mingling dance on the horizon; from time to time, a shadow, a shape, a spectre appears and disappears with lightning speed behind the window: it's a railway guard." (Quoted in Baroli, *Le Train dans la Littérature Française*, Paris, 1964, p. 58). And Jacob Burckhardt writes in 1840: "It is no longer possible to really distinguish the objects closest to one — trees, shacks, and such: as soon as one turns to take a look at them, they already are long gone.[11] [. . .]

The recommendation to look at things "from a certain distance" does not seem entirely realistic, in view of the traveler's situation in train compartment: enclosed in it, the traveler has no way of distancing himself from the objects — all he can do is to ignore the objects and portions of the landscape that are closer to him, and to direct his gaze to the more distant objects that seem to pass by more slowly. If he does not modify his old way of observing things while traveling — if he still tries to perceive proximity and distance in equal measure — the result, as noted in 1862 by the *Lancet*, a medical journal, is fatigue:

> The rapidity and variety of the impressions necessarily fatigue both the eye and the brain. The constantly varying distance at which the objects are placed involves an incessant shifting of the adaptive apparatus by which they are focused upon the retina; and the mental effort by which the brain takes cognizance of them is scarcely less productive of cerebral wear because it is unconscious: for no fact in physiology is more clearly established than that excessive functional activity always implies destruction of material and organic change of substance.[12]

Increased velocity calls forth a greater number of visual impressions for the sense of sight to deal with. This multiplication of visual impressions is an aspect of the process peculiar to modern times that George Simmel has called the development of urban perception. He characterizes it as an "*intensification of nervous stimulation* which results from the swift and uninterrupted change of outer and inner stimuli."[13] (Italics in original.) "Lasting impressions,"

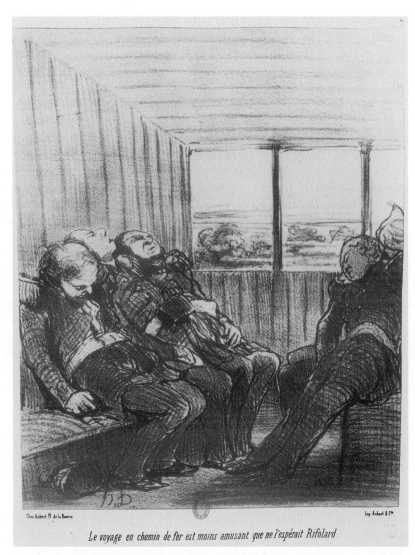

Le voyage en chemin de fer est moins amusant que ne l'espérait Rifolard.

Figure 14.1 Monotony of railway journey, *Sleeping Travelers*, Honoré Daumier. © Collection Roger-Viollet.

Simmel says, "impressions which take a regular and habitual course and show regular and habitual contrasts — all these use up, so to speak, less consciousness than does the rapid crowding of changing images, the sharp discontinuity in the grasp of a single glance and the unexpectedness of onrushing impressions." [. . .]

John Ruskin, whose dislike of the railways created the most sensitive descriptions of the peculiar traits of preindustrial travel, proposes an almost mathematical negative correlation between the number of objects that are perceived in a given period of time and the *quality* of that perception: "I say, first, to be content with as little change as possible. If the attention is awake, and the feelings in proper train, a turn of a country road, with a cottage beside it, which we have not seen before, is as much as we need for refreshment; if we hurry past it, and take two cottages at a time, it is already too much: hence to any person who has all

his senses about him, a quiet walk along not more than ten or twelve miles of road a day, is the most amusing of all travelling; and all travelling becomes dull in exact proportion to its rapidity."[14]

That final statement — "travelling becomes dull in exact proportion to its rapidity" — represents the evaluation of railroad travel made by all those nineteenth-century travelers who were still accustomed to preindustrial travel and thus not able to develop modes of perception appropriate to the new form of transportation. Dullness and boredom result from attempts to carry the perceptual apparatus of traditional travel, with its intense appreciation of landscape, over to the railway. The inability to acquire a mode of perception adequate to technological travel crosses all political, ideological, and esthetic lines, appearing among the most disparate personalities of the nineteenth century. Flaubert writes to a friend in 1864: "I get so bored on the train that I am about to howl with tedium after five minutes of it. One might think that it's a dog someone has forgotten in the compartment; not at all, it is M. Flaubert, groaning."[15] Before a railway journey, Flaubert stays up all night in order to be able to sleep through the journey and not experience it at all: he can do nothing with the vista offered to him by the compartment window.[16] [Figure 14.1] [. . .]

While the consciousness molded by traditional travel finds itself in a mounting crisis, another kind of perception starts developing which does not try to fight the effects of the new technology of travel but, on the contrary, assimilates them entirely. For such a pair of eyes staring out of the compartment window, all the things that the old consciousness experiences as losses become sources of enrichment. The velocity and linearity with which the train traverses the landscape no longer destroys it — not at all; only now is it possible to fully appreciate that landscape. Thus, a description of a trip from Manchester to Liverpool in the year 1830:

> The passenger by this new line of route having to traverse the deepest recesses where the natural surface of the ground is the highest, and being mounted on the loftiest ridges and highest embankments, riding above the tops of the trees, and overlooking the surrounding country, where the natural surface of the ground is the *lowest* — this peculiarity and this variety being occasioned by that essential requisite in a well-constructed Railway — a level line — imposing the necessity of cutting through the high lands and embanking across the low; thus in effect, presenting to the traveller all the variety of mountain and ravine in pleasing succession, whilst in reality he is moving almost on a level plane and while the natural face of the country scarcely exhibits even those slight undulations which are necessary to relieve it from tameness and insipidity.[17]

That is not a picturesque landscape destroyed by the railroad; on the contrary, it is an intrinsically monotonous landscape brought into an esthetically pleasing perspective by the railroad. The railroad creates a new landscape. The velocity that atomizes the objects of Ruskin's perception, and thus deprives them of their contemplative value, becomes a stimulus for the new perception. Now it is the velocity that makes the objects of the visible world attractive. [. . .]

To Benjamin Gastineau, whose newspaper essays on travel were collected in 1861 in book form as *La Vie en chemin de fer*, the motion of the train through the landscape appears as the motion of the landscape itself. The railroad choreographs the landscape. The motion of the train shrinks space, and thus displays in immediate succession objects and pieces of scenery

that in their original spatiality belonged to separate realms. The traveler, gazing through the compartment window at such successive scenes, has acquired a novel ability that Gastineau calls "la philosophie synthetique du coup d'oeil" (the synthetic philosophy of the glance). It is the ability to perceive the discrete, as it rolls past the window, indiscriminately. The scenery that the railroad presents in rapid motion appears in Gastineau's text as a panorama, without being explicitly referred to as such: "Devouring distance at the rate of fifteen leagues an hour, the steam engine, that powerful stage manager, throws the switches, changes the decor, and shifts the point of view every moment; in quick succession it presents the astonished traveler with happy scenes, sad scenes, burlesque interludes, brilliant fireworks, all visions that disappear as soon as they are seen: it sets in motion nature clad in all its light and dark costumes, showing us skeletons and lovers, clouds and rays of light, happy vistas and somber views, nuptials, baptisms, and cemeteries."[18]

In another, roughly contemporary, French text we find all three essential characteristics of the panorama described. Jules Clarétie, a Parisian journalist and publicist, characterizes the view from the train window as an evanescent landscape whose rapid motion makes it possible to grasp the whole, to get an *overview*; defining the process, he makes specific use of the concept of panorama: "In a few hours, it [the railway] shows you all of France, and before your eyes it unrolls its infinite panorama, a vast succession of charming tableaux, of novel surprises. Of a landscape it shows you only the great outlines, being an artist versed in the ways of the masters. Don't ask it for details, but for the living whole. Then, after having charmed you thus with its painterly skills, it suddenly stops and quite simply lets you get off where you wanted to go."[19]

What, exactly, does this new perception that we are referring to as "panoramic" consist of? Dolf Sternberger uses this concept of the panorama and the panoramic to describe European modes of perception in the nineteenth century — the tendency to see the discrete indiscriminately. "The views from the windows of Europe," Sternberger says, "have entirely lost their dimension of depth and have become mere particles of one and the same panoramic world that stretches all around and is, at each and every point, merely a painted surface."[20] In Sternberger's view, modern transportation, the railroad first and foremost, is the main cause for such panoramization of the world: "The railroad transformed the world of lands and seas into a panorama that could be experienced. Not only did it join previously distant localities by eliminating all resistance, difference, and adventure from the journey: now that traveling had become so comfortable and common, it turned the travelers' eyes outward and offered them the opulent nourishment of ever changing images that were the only possible thing that could be experienced during the journey."[21]

What the opening of major railroads provides in reality — the easy accessibility of distant places — was attempted in illusion, in the decades immediately preceding that opening, by the "panoramic" and "dioramic" shows and gadgets. These were designed to provide, by showing views of faraway landscapes, cities, and exotic scenes, "a substitute for those still expensive and onerous journeys."[22] A newspaper of the year 1843 describes the Parisian public "reclining on well-upholstered seats and letting the five continents roll by at its pleasure without having to leave the city and without having to risk bad weather, thirst, hunger, cold, heat, or any danger whatsoever."[23] That the diorama fad dies out in Paris around 1840[24], more or less at the same time that the first great railways are opened (lines from Paris to Orléans and Rouen appearing in 1843) would seem corroborative evidence for the presumed connection. The simultaneous rise of photography provides more support for the thesis. According to Buddemeier, the public became fascinated, at first,

Not by the taking of a picture of any specific object, but by the way in which any random object could be made to appear on the photographic plate. This was something of such unheard-of novelty that the photographer was delighted by each and every shot he took, and it awakened unknown and overwhelming emotions in him, as Gaudin points out. . . . Indeed, the question arises: why did the exact repetition of reality excite people more than the reality itself? Gaudin hints at an answer: he describes how intensely the first photographs were scrutinized, and what people were mostly looking for. For instance: looking at a picture of the building across the street from one's own window, one first started counting the roof shingles and the bricks out of which the chimney was constructed. It was a delight to be able to observe how the mason had applied the mortar between the individual stones. Similar instances occur in other texts dealing with photographs. Tiny, until then unnoticed details are stressed continuously: paving stones, scattered leaves, the shape of a branch, the traces of rain on the wall.[25]

Thus the intensive experience of the sensuous world, terminated by the industrial revolution, undergoes a resurrection in the new institution of photography. Since immediacy, close-ups, and foreground have been lost in reality, they appear particularly attractive in the new medium.

Sternberger observes that the vistas seen from Europe's windows had lost their dimension of depth; this happened first with the vistas seen from the train compartment window. There the depth perception of preindustrial consciousness is literally lost: velocity blurs all foreground objects, which means that there no longer is a foreground — exactly the range in which most of the experience of preindustrial travel was located. The foreground enabled the traveler to relate to the landscape through which he was moving. He saw himself as part of the foreground, and that perception *joined* him to the landscape, included him in it, regardless of all further distant views that the landscape presented. Now velocity dissolves the foreground, and the traveler loses that aspect. He is removed from that "total space" which combines proximity and distance: he becomes separated from the landscape he sees by what Richard Lucae, speaking of ferrovitreous architecture, has called an "almost immaterial barrier." The glass separates the interior space of the Crystal Palace from the natural space outside without actually changing the atmospheric quality of the latter in any visible manner, just as the train's speed separates the traveler from the space that he had previously been a part of. As the traveler steps out of that space, it becomes a stage setting, or a series of such pictures or scenes created by the continuously changing perspective. Panoramic perception, in contrast to traditional perception, no longer belongs to the same space as the perceived objects: the traveler sees the objects, landscapes, etc. *through* the apparatus which moves him through the world. That machine and the motion it creates become integrated into his visual perception: thus he can only see things in motion. That mobility of vision — for a traditionally oriented sensorium, such as Ruskin's, an agent for the dissolution of reality — becomes a prerequisite for the "normality" of panoramic vision. This vision no longer experiences evanescence: evanescent reality has become the new reality. [. . .]

Notes

1 *Werke*, East Berlin ed., vol. 15, pp. 348 ff.; the complete journal of the Swiss journey in *Werke*, Sophia ed., vol. 2, sec. 3.
2 Erwin Straus, *The Primary World of the Senses* (New York and London, 1963), p. 319.

3 Op. cit., p. 320.

4 D. Lardner, *Railway Economy*, p. 179.

5 C. H. Greenhow, *An Exposition of the Danger and Deficiencies of the Present Mode of Railway Construction* (London, 1846), p. 6.

6 H. G. Prout, "Safety in Railroad Travel," in *The American Railway*, ed. T. M. Cooley (New York, 1889), p. 187.

7 *Horse-Power Applied to Railways At Higher Rates of Speed than by Ordinary Draught* (London, 1844), p. 48.

8 "It [the railway] transmutes a man from a traveller into a living parcel." (Ruskin, *The Complete Works*, vol. 8, p. 159.) Manfred Riedel provides the two following quotes from lesser authors. For Ida Hahn-Hahn, the traveler "demotes himself to a parcel of goods and relinquishes his senses, his independence" (Manfred Riedel, "Vom Biedermeier zum Maschinenzeitalter,"*Archiv für Kulturgeschichte*, vol. 43 (1961), fascicle 1, p. 119). And, according to Joseph Maria von Radowitz: "For the duration of such transportation one ceases to be a person and becomes an object, a piece of freight." (Op. cit., p. 120.)

9 Ruskin, vol. 36, p. 62; this is essentially echoed by a French medical author: "He [the traveler] hardly knows the names of the principal cities through which he passes, and only recognizes them, if at all, by the steeples of the best-known cathedrals which appear like trees by some faraway road." (A. Aulagnier, in *L'Union médicale de la Gironde* [Bordeaus, 1857], p. 525.)

10 Great Britain, *Parliamentary Papers*, "Report from the Select Committee on Railways," vol. 5 of the section "Transport and Communications" (reprint ed., Shannon, Ireland, 1968), p. 125.

11 From Manfred Riedel, 'Von Deidermeier zum Maschinen zeitalter.' *Archiv für Kulturgeschicte*, v. 43 (1961) fascile 1, p. 112.

12 *The Influence of Railway Travelling on Public Health* (London, 1862), p. 44. (This is a compendium of articles previously published in the journal the *Lancet*.)

13 *The Sociology of Georg Simmel*, ed. Kurt M. Wolff (Glencoe, Ill., 1950), p. 410.

14 Ruskin, vol. 5, p. 370. Elsewhere, Ruskin speaks of the travelers "who once in their necessarily prolonged travel were subjected to an influence, from the silent sky and slumbering fields, more effectual than known or confessed." (Vol. 8, p. 246.)

15 *Correspondance* (Paris, 1929), vol. 5, pp. 153–54.

16 Op. cit.; Letter dated 30 October 1873, quoted in Marc Baroli, *Le Train dans la littérature Française* (Paris, 1964), p. 201. People sleep in their train compartments not only out of boredom; an equally strong motivation is the need to escape from the tiring influx of stimuli by means of sleep: "There are people, hurried by their business, who . . . in the course of one day have to cast their eyes upon the panoramas of several hundreds of places. They arrive at their destination overwhelmed by a previously unknown fatigue. Just ask these victims of velocity to tell you about the locations they have traveled through, to describe the perspectives whose rapid images have imprinted themselves, one after another, on the mirror of their brain. They will not be able to answer you. The agitated mind has called sleep to its rescue, to put an end to its overexcitation." (Gustave Claudin, *Paris* [Paris, 1867], pp. 71–72.)

17 Henry Booth, *An Account of the Liverpool and Manchester Railway* (Liverpool, 1830), pp. 47–48.

18 Benjamin Gastineau, *La Vie en chemin de fer* (Paris, 1861), p. 31.

19 Jules Clarétie, *Voyages d'un parisien* (Paris, 1865), p. 4.

20 Dolf Sternberger, *Panorama, oder Ansichten vom 19. Jahrhundert*, 3rd ed. (Hamburg, 1955), p. 57.

21 Op. cit., p. 50.

22 Heins Buddemeier, *Panorama, Diorama, Photographie: Entstehung und Wirkung neuer Medien im 19. Jahrhundert* (Origin and effect of new media in the nineteenth century) Munich, 1970, p. 41.

23 Ibid., p. 45.

24 Ibid., p. 48.

25 Ibid., p. 78.

TOM GUNNING

'ANIMATED PICTURES'
Tales of the cinema's forgotten future, after 100 years of film

A visit to the kingdom of shadows

> If you only knew how strange it is to be there.

<div align="right">Maxim Gorky, 1896</div>

IN 1896 MAXIM GORKY ATTENDED a showing of the latest novelty from France at the All Russia Nizhni-Novgorod Fair – motion pictures produced and exhibited by the Lumière brothers, Auguste and Louis. The films were shown at Charles Aumont's Theatre-concert Parisian, a recreation of a *café chantant* touring Russia, offering the delights of Parisian life.[1] A patron could enjoy the films in the company of any lady he chose from the 120 French chorus girls Aumont featured (and who reportedly offered less novel forms of entertainment to customers on the upper floors). Gorky remarked a strong discrepancy between the films shown and their 'debauched' surroundings, displaying family scenes and images of the 'clean toiling life' of workers in a place where 'vice alone is being encouraged and popularized'.[2] However, he predicted that the cinema would soon adapt to such surroundings and offer 'piquant scenes of the life of the Parisian demi-monde'.[3]

But it was not the place of exhibition alone that made Gorky uneasy about his first experience of motion pictures. The spectre-like monochrome and silent films themselves disturbed him, appearing like harbingers of an uncertain future: 'It is terrifying to see this gray movement of gray shadows, noiseless and silent. Mayn't this already be an intimation of life in the future? Say what you will – but this is a strain on the nerves.'[4]

The cinema made a strong impression on Gorky, but he did not display the reaction often assumed to be common for the first viewers of cinema – gaping astonishment at this new mastery of realism and technology. Instead Gorky experienced the first films as powerful in their uncanny and disturbing effect:

> This mute gray life finally begins to disturb and depress you. It seems as though it carries a warning, fraught with a vague but sinister meaning that makes your heart grow faint. You are forgetting where you are. Strange imaginings invade your mind and your consciousness begins to wane and grow dim.[5]

A century later, this record of cinema's origins recalls a time when cinema possessed a future rather than a past. Cinema as a commercial industry has always been founded on novelty (one early film magnate even compared the industry to the ice business, selling goods whose value lessened every minute).[6] Consequently, its past has not only been neglected but systematically discarded and destroyed. We now possess only a fragment of our film culture, with less than 20 per cent of silent cinema existing. No art form has ever been placed so directly in harm's way, the result of a combination of material fragility (the celluloid film base itself, as well as emulsion and color dyes) and institutional indifference. But excavating the first years of cinema history uncovers not only a neglected past, but a forgotten future,[7] an often troubling vision of its potentials and perils. If there is a rationale for celebrating cinema's centennial, remembering the complexities of an earlier imagined future may supply one. [. . .]

Cinema at this present moment, the culmination of its first complete century, hardly stands in a position of institutional power or economic stability. Flux and uncertainty seem to threaten not only film's continued existence but its very definition. While the technological prophets of cinema's demise by the turn of the twentieth century seem to have been premature, there is no question that cinema now means something very different than it did even a generation ago. Is video a form entirely different from cinema, or simply a new means of distribution of what now might be best referred to generically as 'motion pictures'? Are the technological differences between film and video strong enough to determine an aesthetic disparity or do they simply represent alternate modes of exhibition? Certainly, a technological essentialist position seems harder to support today when so much of the film industry's profits come from the video market. However, an enormous transformation of movie watching has taken place – from a public theatrical event to an increasingly private act of domestic consumption. In the first half of the twentieth century film theory labored to endow cinema with a unique identity, to differentiate it from the older arts and provide it with a new aesthetics. At the beginning of cinema's second century we find this identity fraying, dispersed into a number of new image technologies. The last modern art form seems to be dissolving into a postmodern haze.

I will not exercise dubious gifts of prophecy by attempting to foresee cinema's second century. Instead I claim the historian's privilege of retrospection and point out that cinema's apparently chaotic present recalls in many respects its origins about a century ago. This *déjà vu* goes beyond recognizing the recurrence of historical cycles (whether tragical or farcical). Recalling cinema's origins at this point in time should open up a non-linear conception of film history within which a chaotic and protean identity holds utopian possibilities and uncanny premonitions. In place of a well-rounded century of film history, this approach to cinema's centennial aspires to Walter Benjamin's description of true historical thinking: 'to seize hold of a memory as it flashes up in a moment of danger'. To do this one must, as Benjamin demands, 'blast open the continuum of history'[8] and discover in the past the shards of a future discarded or disavowed.

This centennial marks not only the first century of film history, but also the first century of history captured by motion pictures. In a sense motion pictures literally embody Benjamin's description of the historical imperative, seizing hold of the flash of memory in a century of danger. But the danger inherent in modern life derives from cinema as well. The proliferation of moving images threatens, as in the myth of the invention of writing offered in Plato's *Phaedrus*, to destroy rather than preserve memory, substituting widely circulated institutional images for the most personal resources of imagistic recall. Images in their mass-produced form recall less those 'honeycombs of memory'[9] that Proust sought, than recycled discards of the all-too-familiar. It may well be that the warnings offered by the ghost-like flickering

images Gorky watched in 1896, downstairs from a bordello, included this eclipse of authentic memory by a barrage of stock footage. The forgotten future of cinema that we seek must take seriously the unease Gorky experienced when first viewing film's spectral world, an unease partly due to the uncanny presence of realistic detail within an insubstantial fleeting imagery composed of shadow and light. Cinema has always pirouetted about the poles of providing a new standard of realist representation and (simultaneously) projecting a sense of unreality, a realm of impalpable phantoms.

Lanterna magica: images edged in light

> I pretend to be neither priest nor magician; I have no wish to deceive you; but I know how to astonish you.
>
> Paul Philidor, inventor of the Fantasmagoria, 1793

At its appearance, cinema was often referred to as 'animated pictures'. Cinema seemed to add the surplus of life-like movement to images previously experienced as static. While this animation supplied the innovation offered by the inventions of Edison, Lumière, Skladanowsky and others at the end of the nineteenth century, it also related cinema to a host of technologies of vision that had already gained popularity during the nineteenth century, all of which manipulated images to make them more intense and more exciting, whether by the addition of motion, color, three-dimensionality or intense illumination. The century-long pursuit of 'animated pictures' reveals cinema's imbrication within new experiences of technology, time and visual representation.

In other words, the identity of cinema which theorists took pains to define from the 1910s to the 1960s has its origin in a morass of modern modes of perception and new technologies which coalesced in the nineteenth century. To trace back cinema's origins leads not to a warranted pedigree but to the chaotic curiosity shop of early modern life. The genealogy of cinema (from the magic lanterns of the seventeenth century through the 'philosophical toys', experiments with vision and still photography of the nineteenth century) takes on a tidy appearance when these diverse threads are spun together teleologically to culminate in the invention of cinema. However, if we follow the thread backward into the labyrinth of the nineteenth century, it unravels into a disparate series of obsessions and fascinations. What has commonly been called the 'archaeology of the cinema' fragments into multiple scenarios.

Images projected by light are one trajectory in this ancestry of motion pictures. While projected images can be traced back to the shadow and light plays of antiquity, an actual historical filiation only appears with sixteenth-century experiments with optics and light. Ahistorical theories may find the source of cinema in the shadow play exhibited in Plato's cave, but the historical genesis of the light play of cinema derives from an intersection between a Renaissance preoccupation with the magical power of images (typified by Guilio Camillo's and Giordano Bruno's theaters of memory[10]) and a secular discovery of the processes of light and vision.

This extraordinary confluence of an ancient magical imagistic tradition and a nascent scientific enlightenment seesaws between a desire to produce thaumaturgic wonder and an equally novel interest in dissolving the superstitious mystification of charlatans via the demonstrations of science. Although the Enlightenment contributed a scientific purpose and method to these optical experiments, it is often difficult to separate a naïve sense of wonder from learned awe at the demonstration of the laws of nature. The magic lantern (as well as earlier optical

devices which preoccupied scholars in the seventeenth century, such as the catoptric mirror and camera obscura) derives from the tradition of natural magic, an intersection between earlier occult traditions and the new spirit of the late Renaissance and dawning Enlightenment. For Giambatista della Porta, whose *Magiae naturalis sive de miraculis rerum naturalium* was published in Naples in 1589, the realm of natural magic included not only the magical powers of images, stones and plants and descriptions of the celestial influences which bathe our planet but also chemical and optical experiments. Among these, della Porta offered a plan for an optical theater using the camera obscura to create a shifting and varied visual entertainment whose magical effects were attributable entirely to the laws of optics.[11]

Optics became increasingly popular as a form of scientiflc entertainment during the seventeenth century. The Jesuit polymath Athaneus Kircher devoted a whole volume to the *Ars magna lucis et umbrae*, a work completed in 1644. Describing a variety of optical phenomena, natural and artificial, Kircher followed della Porta in envisioning spectacles created by a camera obscura or reflections from focused and inscribed catoptric mirrors. As Charles Musser has pointed out in his sketch of the history of 'screen entertainment' in his book *The emergence of cinema*, Kircher demanded that impresarios of such entertainment explain their scientific basis and demystify any appearance of sorcery or magic that might cling to them.[12] In the era of the Inquisition (which had burned Bruno at the stake for his devotion to imagistic magic), such advice indicates not only a growing scientific spirit but also a strong sense of self-preservation. By 1833 David Brewster (himself the inventor of two important visual devices – the kaleidoscope and the stereoscope) in his *Letters on natural magic* had abandoned any reference to celestial influence or magical images and explained optical illusions and the wonders of natural magic from a purely scientific viewpoint.[13]

But optical entertainments retained a powerful uncanny effect despite their rationally explainable processes of light and vision. This may explain why Christian Huygens, who invented the magic lantern (the first projection device using both an artificial light source and a lens, and therefore cinema's first direct ancestor) in 1659, chose not to display it publicly and even avoided association with it, preferring to be known for his astronomical discoveries via the telescope or his perfection of accurate clocks.[14] As Laurent Mannoni has shown in the most recent (and best) description of cinema's archaeology, *Le grand art de la lumière et de l'ombre*, the magic lantern spread across the globe as a device of entertainment and instruction. With a modest beginning at the end of the seventeenth century, it became a highly commercialized form of public and home entertainment by the nineteenth century. However, the great familiarity that followed the commercial expansion of this optical toy did not entirely overcome its uncanny associations. Pierre Petit, one of the lantern's first public exhibitors, called it, in fact, the *'lanterne du peur'*.[15]

The most elaborate visual entertainment using the magic lantern, the fantasmagoria of Philidor and Robertson, invoked the supernatural by projecting images of spirits of the dead in highly stage-managed eerie surroundings while simultaneously obeying Kircher's dictum on demystification.[16] Robertson (who offered his spectral entertainment in Paris at the end of the eighteenth century, nearly in the shadow of the guillotine) repeatedly stressed that his phantoms were merely applications of the laws of optics and perspective. He portrayed himself as one of the *'physicien-philosophes'* of the Enlightenment, dedicated to destroying the old enchanted world of superstition. Fantasmagoria productions of mysterious projected images appeared throughout the Western world during the first half of the nineteenth century. A show of projected spirits in Cincinnati, Ohio, in 1811, for instance, maintained the seemingly contradictory attractions of Robertson's spectacle, advertising itself as 'scientific, rational and astounding'.[17]

The ghost-raising spectacles of the fantasmagoria could only have appeared in the wake of the Enlightenment and subsequent secularization. Formerly sacred concepts, stripped of official sanction, could now serve as entertainment. But the residue of faith produced the uncanny shudder which these projected apparitions drew from spectators. The magic lantern of the fantasmagoria, with its powerfully illuminated images which seemed to move and float in mid-air, discovered the fissure between skepticism and belief as a new realm of fascination. These optical entertainments exemplify the state of suspended disbelief Octave Mannoni describes as 'I know very well, but nonetheless . . .'.[18] In a new realm of visual entertainment this psychic state might best be described as 'I know very well, and yet I see . . .'. The purveyors of magical illusions learned that attributing their tricks to explainable scientific processes did not make them any less astounding, because the visual illusion still loomed before the viewer, however demystified by rational knowledge that illusion might be.

Although any connection of the magic lantern with the supernatural had been officially repressed by the nineteenth century, it returned in the memory of adults recounting their childhood experiences of projections on bedroom walls or sheets hung in the family parlor. Marcel Proust found that his delight in the magic lantern slide shows projected in his bedroom and narrated by his great-aunt was undercut by the sudden uncanny unfamiliarity it introduced into the center of his domestic environment:

> it substituted for the opaqueness of my walls, an impalpable iridescence, supernatural phenomenon of many colors, in which legends were depicted as on a shifting transitory window. But my sorrows were only increased thereby, because this mere change of lighting was enough to destroy the familiar impression I had of my room, thanks to which, save for the torture of going to bed, it had become quite endurable. Now I no longer recognized it and felt uneasy in it.[19]

Harriet Martineau in her autobiography records a similar childhood reaction in which rational daytime knowledge was overthrown by the irrational power of the projected image:

> I used to see it [the magic lantern] cleaned by daylight, and to handle all its parts – understanding its whole structure; yet such was my terror of the white circle on the wall, and of the moving slides, that, to speak the plain truth, the first apparition always brought on bowel-complaint.[20]

Although polite, Martineau's Victorian terminology clearly expresses the plain truth that even a domesticated 'lanterne de peur' scared the shit out of well-bred children. Such memories were not restricted to decadent aesthetes or Victorian neurasthenics. In 1897 the pioneering San Francisco woman journalist who wrote under the pseudonym Alice Rix (a tough cookie who had undertaken exposés of white slavery in Chinatown and reported on Sausalito pool rooms) concluded her review of the Veriscope, an early motion picture projector which exhibited films of prizefights, with her childhood memory of magic lantern shows:

> I am reminded suddenly of a long-forgotten childish terror of the Magic Lantern show. The drawing-room in darkness, the ghastly white plain [sic] stretching away into the unknown world of shadows. It was all very well to call it a linen sheet, to say it was stretched between innocent familiar folding doors, it nevertheless divided the known and safe from the mysterious beyond where awful shadows lived and moved with a fearful rapidity and made no sounds at all.

And they were always awful, no matter how grotesquely amusing the shape they took, and they followed me to the nursery in after hours and sat on my heart and soul the black night through. And sometimes even morning light could not drive them quite away. And now, forsooth, it seems they have withstood the years.[21]

Even a tough and modern 'new woman' at the dawn of the twentieth century retained this memory of the ontological instability of projected images and the terror they could inspire, a memory that surfaced on her first exposure to the modern motion pictures.

If the tradition of optics and projected images provides one branch of cinema's ancestors, another aspect displays even less coherence and includes a wide variety of devices which attempted to endow images with a surplus of lifelikeness, ranging from three-dimensionality to effects of transformation and movement. Many of these, such as Daguerre's diorama, wedded traditional perspectival arts to the control of light mastered in the magic lantern tradition. Daguerre's huge paintings on transparent materials were presented in darkened theaters and illuminated from behind, giving them an intensely virtual nature, as if the viewer were gazing into an actual landscape. Manipulation of the light behind the picture could give the effect of changing light and shade or even of complete transformation from daylight to night.

The famous story that a spellbound child observing one of Daguerre's dioramas declared that it 'was more beautiful than nature itself'[22] accents the contradictory aspect of these enhanced realist illusions, their 'more than real' effect. If the recreation were powerful enough it could surpass reality in intensity and animation. These images with their carefully devised effects were successively (or perhaps even simultaneously) experienced as mere images, as accurate simulacra of reality and as images more perfect or more pleasing than reality itself. While avoiding supernatural content, such enhanced images partook of the magical effect of the fantasmagoria, creating images so real they seemed to blur the distinction between model and copy, or even render the original source inferior to its imagistic realization. We encounter here again the spectral nature of cinema's sources, not only creating detailed realist images but also fashioning a world of images that threaten to replace the actual experiences they represent.

The image of an instant

Horses in the air
Feet on the ground
Never seen
This picture before.
 Philip Glass, 'The photographer'[23]

The invention of photography (partly through Daguerre's next innovation, the daguerreotype) derives directly from other nineteenth-century optical devices which shared this obsession with enhanced images endowed with a surplus of realism. Nowhere is this better demonstrated than in the stereoscope, one of the most popular forms of nineteenth-century photography. The stereoscope was an optical device which gave specially made photographs (known as stereographs) an illusion of three-dimensionality. Creating an image with the appearance of relief and recession, the stereoscope caused its enthusiasts to claim it provided the perfect image of reality.[24] However, as Jonathan Crary has pointed out, the fascination of the stereoscope seems to outrun its realist claims, or to redefine them. The strangely layered

three-dimensional image it offers strikes the viewer precisely as an illusion – something which exceeds common sense and perception. Again, the reality effect functions as a surplus, a magical addition to an image, rather than an integrated mode of representation. We see an image endowed with three-dimensionality through an optical illusion rooted in the physiology of human vision, an illusion which in fact frequently takes a moment or two to swim into focus before the viewer's eyes.[25]

However, the form of photography that led directly to the cinema differed greatly from the daguerreotypes or other forms of still photography possible for most of the nineteenth century. The long exposure time required for early photographs (an hour or longer for the first photographic images and several seconds through the 1860s) meant that photography for most of the nineteenth century lagged behind the accelerating pace of modern life. Charles Baudelaire praised the quickly sketching crayon of illustrators such as Constantin Guys for capturing the smack of the instant, but the ephemeral moment of modernity initially eluded the camera.[26] Film theorists (including André Bazin and Siegfried Kracauer) have often derived essential aspects of cinema's identity from its dependence on photography. But the major debt cinema owes to photography must be credited to a very specific practice that appeared only in the 1870s: instantaneous photography.

It is not clear that when Fox Talbot, Niepce and Daguerre conceived of photography in the first half of the nineteenth century they were concerned about capturing a brief instant of time.[27] Early photography seemed more suited to what Baudelaire (rather slightingly) called its 'secretary' function, capturing with unprecedented accuracy the forms of works of art (engravings and sculpture), recording the multitude of hieroglyphics on an ancient monument or even providing an inventory of a shelf of books.[28] Still photography was initially confined to still subjects. Rather than seizing an instant on the wing, photography was vaunted as a hedge against time, a souvenir preserving an accurate memory of those things – relatives, landscapes or works of art – which time would decay. While the goal of freezing a moment of time, of capturing a subject in full flight, became increasingly seductive after mid-century, it remained technically elusive. The motion studies Eadweard Muybridge began in 1873 did not anticipate the cinema simply because they consisted of a series of images recording the stages of a motion, like the succession of frames in a motion picture film. Even as single images Muybridge's photographs announced the unique ability of cinema, capturing the impression of an instant of time beyond the capacity of the human eye to retain it.[29]

If cinema derives from this diverse genealogy of optical fascinations which twine about the separate poles of optical entertainment and scientific demonstration, the actual invention of moving picture devices in the late nineteenth century by Marey, Demeny, Edison and Lumière rehearsed this *pas de deux* with compressed elegance. Once again the rival claims of scientific demonstration and visual wonder came together. This time, however, the contest no longer pitted a waning occultism against a dawning secular science. Instead, an empirical science, increasingly suspicious of visual evidence, confronted a popular culture reaching constantly expanding audiences through a mechanical reproduction of visual attractions.

The career of Étienne-Jules Marey, the man who can best claim the title of inventor of the cinema, re-enacted this conflict with instructive clarity (including dramas of personal betrayal). As Marta Braun demonstrates in her authoritative study of this French physiologist, the center of Marey's research lay in a search for precision machines sensitive enough to record the processes of the body which are too subtle for direct perceptual observation.[30] Marey's 'obsession with the trace' initially led to a series of mechanisms which could provide an objective record of bodily processes through time, whether the pulse of circulating blood

or the rhythm of the muscles. These apparatuses replaced direct visual observation with precise graph-like diagrams of those processes the human body has always performed but which no one had previously recorded accurately.[31] Marey's curiosity extended to patterns of movement beyond the human, including the flight of birds and insects, the gait of horses and other animals and the currents of liquid and air.

At first Marey must have regarded photography with some suspicion. He made no use of the medium until new thresholds of film sensitivity transformed this clumsy visual simulacrum into a new form of observation – instantaneous photography. Photography's new receptivity and speed transformed its relation to human knowledge. Photography no longer was restricted to the role of secretary and *aide-mémoire* but could provide a glimpse of a new realm of temporality beyond direct human perception. Before the 1870s photography was basically limited to reproducing the already seen, the *déjà vu* of sights already available to the human eye. With the mastery of the instant, photography left human vision behind and opened up a world from which the naked eye had been excluded. The enormous controversy that greeted Muybridge's first publication of his instantaneous photographs of galloping horses heralded a new era in representation, a visual image simultaneously concretely recognizable and intellectually confounding. No one had seen what Muybridge showed and therefore no one could believe it. Visual wonder once again confounded common perceptual sense, but in this case no illusion was involved. Instead an unfamiliar accuracy loomed before the viewer.

A much more thoroughly trained and serious scientist than Muybridge, Marey already had obtained evidence of the patterns of a horse's strides from his pressure-sensitive motion recorders. Marey had preferred these non-imagistic devices because they avoided the fallibility of sensual representation with evidence presented in an abstract quasi-mathematical manner. But Muybridge's photographs presented an image that seemed to contradict human habits of seeing by means of a new scientific vision that Marey could countenance. Marey's own chronophotographic images strove to overcome the chaotically overspecific imagery of ordinary photography. Cloaking his photographic subjects in black tights and hoods, decorated with white strips outlining the basic limbs, Marey converted human beings into abstract stick figures. Even animals submitted to this passion for the essential over the anecdotal. Heroic chargers were spangled with dots marking key joints, converting galloping horse flesh into a series of points describing an arc of motion. To obtain these graph-like streaks of motion, Marcy effaced photography's visual icons, privileging its new ability to retain the trace of the smallest increments of time.

The analysis of motion which Marey's chronophotography allowed could also be regathered into a synthesis, a recreation of motion providing proof of the accuracy of his process of recording. But for Marey the reproduction of motion was decidedly secondary. After all, such reproduction merely presented what the eye already saw – a walking man, the galloping horse – rather than the transformation of vision which the non-human sensitivity of instantaneous photography allowed. Edison and the Lumière brothers observed demonstrations of Muybridge's and Marey's breakdown of the visual continuum and decided to reverse the process. This photographic analysis could be adapted to a series of visual toys which had reproduced motion since the 1830s, including the phenakistiscope, the zootrope and Reynauld's praxinoscope. All these visual devices had taken advantage of discoveries in the physiology of vision (and especially in the possibility of tricking the eye into seeing something that did not exist, as in the stereoscope's illusion of depth) to produce illusions of motion. However, these devices had previously depended on drawings for their images, since photography had not been able to capture the stages of motion (unless artificially posed). If Marey saw

instantaneous photography as a penetration into what Benjamin has called 'unconscious optics',[32] Edison and Lumière saw a new means for fooling the eye, astounding viewers with illusions produced by scientific means.

Marey recognized this difference between his work and that of purveyors of scientific entertainment. The popularity of the new inventions founded on his work which reproduced movement photographically did not surprise him, but their effects did not interest him greatly, because of their lack of scientific observation, 'however satisfying and astonishing that resurrection of movement may be'.[33] Motion pictures may fascinate audiences, but:

> What they show the eye can see directly. They add nothing to the power of our vision, they banish none of sight's illusions. Whereas the true character of a scientific method is to supplement the weakness of our senses and to correct our errors.[34]

The bitter split between Marey and his chief assistant Georges Demeny emerged partly from his protégé's desire to exploit chronophotography as a means of entertainment, a project which filled Marey with grave suspicion and even distaste. When Edison's kinetoscope appeared in Paris a few years later as the first widespread commercial utilization of motion picture photography, one journalist described the innovation it represented in terms of its deviation from Marey:

> M. Marey had only a scientific end in view, he applied himself to research in physiology or physics. . . . Examining his films in a zootrope is extremely instructive and interesting, but it isn't amusing. Mr. Edison, on the other hand, desires nothing but to give pleasure, science being not the end, but the means.[35]

Myths of total illusion

> It is precisely when it appears most truthful, most faithful and most in conformity to reality that the image is most diabolical.
>
> Jean Baudrillard, 'The evil demon of images', 1987[36]

Ultimately, however, the testimony of Gorky and others makes us wonder how familiar and ordinary the sight of projected motion pictures really was. If nineteenth-century viewers of the cinema were rarely the unsophisticated gawkers before a totally new invention some accounts of early cinema would like us to imagine, nonetheless the première of moving photographic images represented a new move in a long-existing game of fooling the senses and the uncanny pleasures it evoked. André Bazin, in his famous essay (in fact a review of the first volumes of Georges Sadoul's *Histoire générale du cinéma*), declared that the invention of cinema was simply a partial realization of a 'myth of total cinema' which appeared in various forms throughout the nineteenth century, 'a total and complete representation of reality . . . a perfect illusion of the outside world in sound, color and relief'.[37] In one sense, I have been surveying in this chapter precisely that tradition. However, for Bazin, writing in the 1950s (a decade which saw a resurgence of realist illusions in the cinema, including three-dimensional films, Cinerama and Cinemascope), it seemed this myth was on the verge of completion, hence his reassuring and idealist understanding of cinema's relation to reality and illusion.[38]

Myths, as Bazin well knew, always express ambivalence. There is no question that cinema at the end of the nineteenth century appeared amidst a welter of hyper-realistic forms of

representation, which included not only the devices of projection and photography I have discussed, but other forms of mass entertainment, such as the wax museum and the world expositions. What are we to make of this obsession with realism?

I believe it would be simplistic to treat such an obsession as naïve belief in the efficacy of representation. I have tried to demonstrate in this sketch of cinema's origins that the appearance of animated images, while frequently invoking accuracy and the methods of science, also provoked effects of astonishment and uncanny wonder. Innovations in realist representation did not necessarily anchor viewers in a stable and reassuring situation. Rather, this obsession with animation, with super-lifelike imagery, carries a profound ambivalence and even a sense of disorientation.

The discourse surrounding all these realist modes of visual attraction balanced claims of realism with proclamations of wonder, dazzling effects, reactions verging on disbelief. Audiences could not believe their eyes and were dazzled by these displays of alternative realities. Gorky's unease before motion pictures may be of a peculiarly sophisticated sort, but it expresses an ambivalent experience of animated pictures that was shared by many early viewers.[39] The more real such illusions were, the more their deficiencies were evident (the lack of sound or color, the disappearance of moving figures at the border of the screen). The more perfect the illusion, the more unreal and phantom-like such illusion seemed, reflecting back on the viewer's sense of her or his deluded perception as much as on the referent portrayed.

Could it be that the nineteenth century became obsessed with this task of an ever-progressive and always elusive total and complete illusion precisely from an anxiety about the loss of concrete experience? Edgar Allan Poe offered in his story 'The oval portrait' (written in 1842, three years after the first public discussions of the daguerreotype – and two years after Poe himself wrote several brief articles on this new invention)[40] a fable of the pursuit of realist representation that serves as a cautionary tale. In this brief story Poe first describes a painting whose 'life-likeliness of expression' first startled and 'finally confounded, subdued and appalled' a viewer, and then tells the tale of its creation. A young artist obsessed with his craft paints a portrait of his wife, shutting her up in a turret as he paints her, unaware of the debilitating effect this has on her. The portrait at length completed, the artist stands before it and proclaims, 'This is indeed Life itself.' He turns 'to regard his beloved – She was dead'.

From the perspective of the end of the first century of cinema, one might wonder whether ever-increasing powers of realist illusion are not counterbalanced by, and indeed a response to, a constantly increasing sense of a loss of a shared reality. I believe that it is only during periods of a temporary stability that the ambivalence of such representations can be forgotten. Perhaps fortuitously, the full cycle of the century brings us back to this sense of crisis in representation and medium. Cinema was devised as the medium that could not only deliver the most intense impression of animated pictures but also serve as a record of the most aleatory and instantaneous events. It should not surprise us that in both its form and history cinema reflects this mercurial and ambiguous mission.

A century ago cinema emerged from various strands of visual entertainments and new forms of intensified visual representation. Curiously, when film began to define its own aesthetic identity in the teens and twenties, the extreme variety of its origins most often was reduced to a differentiation from theater. Now, a century later, cinema seems to define itself in relation to another evil twin, the specter of television. But if cinema is now inconceivable on many levels without television (as a component in financing production and as a dominant mode of distribution and exhibition), this should not produce the illusion that this new medium

has a stable identity. It is a grave mistake to analyse television primarily in terms of the material produced for it (the game shows, news reports, soap operas, etc.) rather than as a domestic form of access to a range of various programs offered simultaneously.

As Wim Wenders has said, anywhere a television set is turned on automatically becomes the center of the world.[41] Television seems less involved with intensifying vision than with providing immediate access to anything whatsoever. Clearly, this drive for access and coverage emerges as one of the extreme points in the spectralization of reality. But television itself possesses no solid identity beyond this dream (or nightmare) of immediate access to all of time and space. Movies remain one of the things carried by television, and watching movies on television is not just watching television. In spite of widespread predictions of cannibalization and total absorption, the two forms remain distinct; they seem to articulate in different ways the crisis of image and representation that an age of information brings to light.

Benjamin demonstrated half a century ago that cinema, as a mode of mechanical reproduction, could never be treated as a traditional form of high art. The elusive nature of the film commodity deprives it of a traditional aura of uniqueness. Unlike the traditional high arts, as an industrial product film depends less on individual ownership and unique artifacts than on circuits of distribution. Film culture is based less on objects than on the intangible effects of memory and shared experiences. It is important that the accumulated thickness of film history does not make us assume that cinema is simply an art like all the others, and that its contemporary crisis threatens an established sacral identity. In fact, there is no single identity to guard, and cinema in its origins was founded on the transformation of sacred rituals into irreverent entertainments.

I do not want to indicate that we should react either passively or optimistically to the current adulteration of the film image by video technology, to the loss of public experiences and discourse that the eclipse of the film theater implies or to the irreparable loss of film prints through corporate greed or bureaucratic inaction. However, in defending our film culture we need to recognize that cinema itself was conceived as a protean form and its permutations are far from played out. The crisis of cinema does not consist in the passing away of a century-long fashion in popular entertainment but embodies a crisis in our way of life in the age of information. It was as a harbinger of this crisis that film emerged about a century ago; now it once again focuses our understanding of this situation with greater clarity. Cinema has long been a skeleton at a feast, but at the same time, as in a fantasmagoria program, a Méliès trick film or a Disney cartoon, cinema is also a feast of skeletons, a carnival which simultaneously acknowledges our progressive loss of shared realities and provides a festive ground on which this loss can be anticipated, celebrated, mourned and perhaps even transcended. There is still a future, even if only an apocalyptic one, for this century-old illusion.

Acknowledgment

A version of this chapter has previously been published in *Michigan Quarterly*, vol. 34, no. 4 (1995).

Notes

1 Gorky wrote two reviews of these films. One, signed with the pseudonym I. M. Pacatus appeared in *Nizhegorodski listok* on 4 July 1896. This review is translated in Jay Leyda, *Kino: a history of the Russian and Soviet film* (London, George Allen & Unwin, 1960), pp. 407–9, translated by 'Leda Swan'. The

other review apparently appeared in an Odessa newspaper and is translated as 'Gorky on the Films, 1896', ed. Herbert Kline *New theater and film: 1934 to 1937, an anthology* translated by Leonard Mins (San Diego, Harcourt Brace Jovanovich, 1985), pp. 227–31. I have quoted from both reviews. Gorky also wrote a short story about this screening, entitled 'Revenge'. Background on these reviews and the story, as well as an insightful discussion of them, can be found in Yuri Tsivian, *Early cinema in Russia and its cultural reception*, translated by Alan Bodger (London, Routledge, 1994), pp. 36–7.

2 Gorky, *Kino*, p. 409.

3 Gorky, *New theater and film*, p. 229. Gorky was actually slightly behind the times here. Henri Joly, working for Charles Pathé, had already shot *Le Bain d'une mondaine* in October 1895. See Laurent Mannoni, *Le grand art de la lumière et de l'ombre* (Paris, Éditions Nathan, 1994), p. 402.

4 Gorky, *New theater and film*, p. 229.

5 Gorky, *Kino*, p. 408.

6 This was Frank Dyer, head of the Edison film interests, testifying in the government anti-trust suit against the MPPC in 1914. *United States v. Motion Picture Patents Company*. 225 F. 800 (E.D. Pa., 1915) Record, 1627.

7 By this phrase I pay tribute to the series of super-8 films made by Lewis Klahr known as 'Tales of the forgotten future'. But Miriam Hansen points out to me that the phrase was also used by Walter Benjamin.

8 Walter Benjamin. 'Theses on the philosophy of history', ed. Hannah Arendt, *Illuminations* (New York, Schocken Books, 1969), p. 255.

9 The phrase is Benjamin's, in 'The image of Proust', *Illuminations*, p. 203.

10 This tradition is discussed by Frances Yates in her controversial works, such as *The art of memory* (Chicago, IL, University of Chicago Press, 1966) and in Ioan P. Couliano, *Eros and magic in the Renaissance* (Chicago, IL, University of Chicago Press, 1987).

11 For a discussion of natural magic and of della Porta (whose name is also often given as Giovanni Battista della Porta) see Lynn Thorndike, *History of magic and experimental science* (New York, Columbia University Press, 1941), vol. vi, especially pp. 418–23. Della Porta published an earlier edition of this book in 1558, but this theater is described in the later edition. My summary comes from the section quoted in Mannoni, *Le grand art de la lumière et de l'ombre*, p. 20.

12 The best discussions of Kirchner's optical works in relation to the cinema appear in Mannoni, *Le grand art de la lumière et de l'ombre*, pp. 29–35, 61–63, and in Charles Musser, *The emergence of cinema; the American screen to 1907* (New York, Charles Scribner's Sons, 1990), pp. 17–22.

13 David Brewster, *Letters on natural magic* (London, John Murray, 1933).

14 Mannoni supplies a detailed and focused treatment of Huygens's invention of the magic lantern as well as his near disowning of it, in *Le grand art de la lumière et de l'ombre*, pp. 44–52. See, as well, his article 'Christian Huygenes et la "lanterne de peur"', in *1895* no. 11 (December, 1992), pp. 49–78. Perhaps the first scholar to indicate Huygens' priority in the invention of the magic lantern was H. Mark Gosser, in 'Kircher and the magic lantern – a re-examination', *Journal of the Society of Motion Picture and Television Engineers*, 90 (October 1981), pp. 972–8.

15 See Mannoni, *Le grand art de la lumière et de l'ombre*, p. 55, and 'Christian Huygens', p. 69.

16 There are many descriptions of the fantasmagoria (sometimes spelled 'phantasmagoria'). The best are Mannoni, *Le grand art de la lumière et de l'ombre*, pp. 135–68; X. Theodore Barber, 'Phantasmagorical wonders: the magic lantern ghost show in nineteenth century America', *Film History*, 3, no. 2 (1989), pp. 73–86; Richard Altick, *The shows of London* (Cambridge, MA, Harvard University Press, 1978), pp. 217–19 (focused on the version presented in London); Olive Cook, *Movement in two dimensions* (London, Hutchinson, 1963), pp. 19–21.

17 Barber, 'Phantasmagorical wonders', p. 82.

18 Octave Mannoni, 'Je sais bien, mais quand même . . .', in *Clefs pour l'imaginaire ou l'autre scène* (Paris, Éditions du Seuil, 1969). This idea is founded upon Freud's concept of 'disavowal'. See 'Fetishism', *The standard edition of the complete psychological works of Sigmund Freud*, edited and translated by James Strachey, vol. XXII, pp. 152–7.

19 Marcel Proust, *Remembrance of things past; vol. I: Swann's Way*, translated by C.K. Scott Moncrieff and Terence Kilmartin (New York, Vintage Books, 1982), pp. 9–10.

20 Quoted in Altick, *The shows of London*, p. 233.

21 Alice Rix is quoted in the dissertation by Daniel Gene Streible, 'A history of the prizefight film, 1894–1915' (Austin, TX, University of Texas at Austin, 1994). Mr Streible is the first, I believe, to have unearthed this fascinating account. My information on Ms Rix comes from this excellent dissertation.

22 Helmut Gernstein and Alison Gernsheim, *L.J.M Daguerre: the history of the diorama and the daguerreotype*, p. 18. On the diorama see also Mannoni, *Le grand art de la lumière et de l'ombre*, pp. 177–82; Altick *The shows of London*, pp. 163–74; and Cook, *Movement in two dimensions*, pp. 36–43.

23 Philip Glass, 'The photographer', 'A Gentleman's Honor' (New York: CBS Records, 1983).

24 See, for instance, Oliver Wendell Holmes's famous essay, 'The stereoscope and the stereograph', ed. Alan Trachtenberg, *Classic essays on photography* (New Haven, CT, Leete's Island Books, 1980), pp. 71–82.

25 Jonathan Crary, *Techniques of the observer: on vision and modernity in the nineteenth century* (Cambridge, MA, MIT Press, 1990), especially pp. 116–35. This important book has had a strong influence on this chapter.

26 Charles Baudelaire, 'The painter of modern life', edited and translated by Jonathan Mayne, *The painter of modern life and other essays* (London, Phaidon, 1965), p. 13.

27 Geoffrey Batchen, *Burning with desire: the conception of photography* (Cambridge, MA, MIT Press, 1997), pp. 90–1, indicates that the early photographers were greatly interested in the temporal nature of photography, but this seems to me primarily to indicate an interest in preserving, by fixing them in a photograph, phenomenon that are ephemeral, that fade quickly, such as Talbot's shadows, rather than the brief instant which exceeds human perception.

28 Baudelaire, 'The salon of 1859', edited and translated by Jonathan Mayne, *Art in Paris 1845–1862* (London: Phaidon, 1965), p. 154. The use of photography in recording hieroglyphics is suggested in Arago's 1839 'Report to the French Commissioner of Deputies on the daguerreotype', reprinted in Trachtenberg, p. 17.

29 The bibliography on Muybridge is extensive. Besides Muybridge's own books of plates, *The human figure in motion and animals in motion*, both reprinted by Dover Press, the most thorough works are Robert Haas, *Muybridge: man in motion* (Berkeley, CA, University of California Press, 1976); and Gordon Hendricks, *Muybridge: the father of the motion picture* (New York, Grossman, 1975). Brian Coe's *Muybridge and the chronophotographers* (London, Museum of the Moving Image, 1992) provides a more recent and an excellent condensed contextual account. Muybridge's relation to the development of motion pictures is sketched well in both Mannoni, *Le grand art de la lumière et de l'ombre*, and Musser, *The emergence of cinema*.

30 Marta Braun, *Picturing time: the work of Étienne-Jules Marey (1830–1904)* (Chicago, IL, University of Chicago Press, 1992). This is not only the definitive work on Marey but an extremely careful placement of his work within cultural history. Braun provides a thorough discussion of Marey's relation to motion pictures. In addition, Marcy's work is discussed in relation to motion pictures in Coe, *Muybridge and the chronophotographers*, Jacques Deslandes, *Histoire comparée du cinéma* (Paris, Casterman, 1966), vol. I, pp. 107–77; and Mannoni, *Le grand art de la lumière et de l'ombre*, pp. 299–337. See as well Francois Dagognet's excellent book-length essay on Marey, *Étienne-Jules Marey: a passion for the trace* (New York, Zone Books, 1992).

31 Both Braun, *Picturing time*, and Dagognet, *Étienne-Jules Marey*, provide descriptions of these devices. They include the sphygmograph for recording the pulse, the cardiograph for measuring the heart beat, and the myograph for recording muscular contractions. These are illustrated in Braun on pages 17, 20 and 25.

32 Walter Benjamin; 'The work of art in the age of mechanical reproduction', *Illuminations*, p. 237.

33 Quoted in Braun, *Picturing time*, p. 196.

34 Quoted in Deslandes, *Histoire comparée du cinéma*, p. 144, my translation.

35 Quoted in Mannoni, *Le grand art de la lumière et de l'ombre*, p. 372, my translation.

36 Jean Baudrillard, 'The evil demon of images', *Powers Institute Publication* no. 3 (Sydney: Powers Institute, 1987), p. 13.

37 André Bazin, 'The myth of total cinema', *What is cinema?*, vol I (Berkeley, CA, and Los Angeles, CA, University of California Press, 1967), p. 20.

38 However, Bazin is always more subtle than his detractors make out. Notice his comment in a footnote in 'The myth of total myth of total cinema':

> Besides, just as the word indicates, the aesthetic of trompe-l'oeil in the eighteenth century resided more in illusion than in realism, that is to say, in a lie rather than the truth . . . To some extent, this is what the early cinema was aiming at, but this operation of cheating quickly gave way to an ontogenetic realism.
>
> (1967: 19)

39 In a previous essay, '"Primitive cinema", a frame-up? or The trick's on us' (anthologized in Thomas Elsaesser, *Early cinema: space, frame, narrative* (London, British Film Institute, 1990), I have discussed the following scene from Frank Norris's novel *McTeague* in which Mack and Trina accompany Trina's mother, Mrs Sieppe, to an early projection of motion pictures. After the younger couple express amazement, the older immigrant woman intervenes:

> 'It's all a drick', exclaimed Mrs. Sieppe with sudden conviction. 'I ain't no fool; dot's nothun but a drick'.
> 'Well, of course, Mamma', exclaimed Trina; 'it's –'.
> But Mrs. Sieppe put her head in the air. 'I'm too old to be fooled', she persisted. 'It's a drick'. Nothing more could be got out of her than this.
>
> [*McTeague* (New York, New American Library, 1964), p. 79]

This admittedly fictional exchange (written only a couple of years after Gorky's piece – *McTeague* was published in 1899) portrays an unsophisticated reaction that is as aware as Gorky is of the ambiguous nature of the image.

40 Edgar Allan Poe, 'The oval portrait', *Poe: poetry and tales*, ed. Patrick F. Quinn (New York: Library of America, 1984), p. 484.

41 Wim Wenders, 'Soundtrack of film', *Tokyo Ga* (1984).

PART FOUR

Practices of Display and the Circulation of Images

VANESSA R. SCHWARTZ AND
JEANNENE M. PRZYBLYSKI

I F WE NOW UNDERSTAND THAT TECHNOLOGIES of vision are socially and
culturally specific, and that seeing and looking can be considered in the broadest of social
and historical terms, we next consider the explosion of new institutions of visual display during
the nineteenth century. Introducing this section is Tony Bennett's important revision of
Foucault's thesis of the panoptic society. Instead of characterizing the nineteenth century and
its institutions as confining, Bennett underscores the fact that such paradigmatic sites as the
museum and the exhibition were actually "sites for sight." Bennett focuses on the open spaces
of exhibition and introduces the notion of the "exhibitionary complex" which combined the
effect of the panopticon with that of the panorama. If the panopticon made the individual
always visible to the eye of power, the increasingly large and undifferentiated publics called
into being by the institutions of exhibition were organized around the crowd as viewers. The
crowd participated as spectators and the institutions also made the audience recognizable to
itself as a social group. The establishment of the institutions of the exhibitionary complex
and the status of the spectator within them are taken up in the selections below.

There is a large and important literature on these new institutions of display: museums,
scientific exhibitions, world's fairs, department stores, entertainment venues such as wax
museums. The selections in this section introduce readers both to the variety of the institu-
tions that emerged and to the centrality of class, race, and gender in the construction of
exhibiting and viewing. The museum literature is particularly well developed and rich. In fact,
there are volumes such as Daniel J. Sherman's and Irit Rogoff's *Museum Culture* (University
of Minnesota, 1994) dedicated to the exploration of the parameters of that "modern" insti-
tution. We have selected Daniel J. Sherman's essay on museums in France because it contains
within it the many avenues of investigation that looking at museums suggests. His essay makes
more than clear what can be gained in writing an archivally based history of museums.
Sherman examines the art museum as an institution that legitimated the authority of the

ascendant middle class, especially in provincial cities in France. Sherman also suggests that the museum served as an important dumping ground for a certain kind of painting and, in fact, led to the rise of what might be thought of as the "museum picture" – in that way shaping art production as well as representing it.

The didactic nature of these institutions is not lost on James R. Ryan whose essay takes up the history of visual instruction and the centrality of the visualization of geography through photographic slides as a key part of the imperial project, and its construction of racial and cultural otherness. The imperial project was promoted and made concrete through these image lessons. Bennett, Sherman, and Ryan concentrate on the "official" state-sponsored organization of display, but private enterprise also contributed to promoting exhibition.

The centrality of consumer culture and capitalism in the story of display cannot be over-emphasized. The imposing visual spectacle of Selfridge's department store in London and the theatricality of its windows and advertising made "eye appeal" the key lubricant in the machine of consumption. Erika Rappaport also emphasizes the important role that women played as consumers. Department stores also made possible a viewing culture that seemed self-consciously designed for women and opened up new spaces for women in the city. Rappaport's essay ends the section because it makes quite clear the overlap between the institutions of display and the nineteenth-century city. Institutions of display were also part and parcel of the "modernization" of the urban landscape.

TONY BENNETT

THE EXHIBITIONARY COMPLEX

I N REVIEWING FOUCAULT ON THE ASYLUM, the clinic, and the prison as institutional articulations of power and knowledge relations, Douglas Crimp suggests that there 'is another such institution of confinement ripe for analysis in Foucault's terms – the museum – and another discipline – art history'[1]. Crimp is no doubt right, although the terms of his proposal are misleadingly restrictive. For the emergence of the art museum was closely related to that of a wider range of institutions – history and natural science museums, dioramas and panoramas, national and, later, international exhibitions, arcades and department stores – which served as linked sites for the development and circulation of new disciplines (history, biology, art history, anthropology) and their discursive formations (the past, evolution, aesthetics, man) as well as for the development of new technologies of vision. Furthermore, while these comprised an intersecting set of institutional and disciplinary relations which might be productively analysed as particular articulations of power and knowledge, the suggestion that they should be construed as institutions of confinement is curious. It seems to imply that works of art had previously wandered through the streets of Europe like the Ships of Fools in Foucault's *Madness and Civilisation*; or that geological and natural history specimens had been displayed before the world, like the condemned on the scaffold, rather than being withheld from public gaze, secreted in the *studiolo* of princes, or made accessible only to the limited gaze of high society in the *cabinets des curieux* of the aristocracy [Figure 16.1]. Museums may have enclosed objects within walls, but the nineteenth century saw their doors opened to the general public – witnesses whose presence was just as essential to a display of power as had been that of the people before the spectacle of punishment in the eighteenth century.

Institutions, then, not of confinement but of exhibition, forming a complex of disciplinary and power relations whose development might more fruitfully be juxtaposed to, rather than aligned with, the formation of Foucault's '*carceral archipelago*'. For the movement Foucault traces in *Discipline and Punish* is one in which objects and bodies – the scaffold and the body of the condemned – which had previously formed a part of the public display of power were withdrawn from the public gaze as punishment increasingly took the form of incarceration. No longer inscribed within a public dramaturgy of power, the body of the condemned comes to be caught up within an inward-looking web of power relations. Subjected to omnipresent forms of surveillance through which the message of power was carried directly to it so as to render it docile, the body no longer served as the surface on which, through the system of retaliatory marks inflicted on it in the name of the sovereign, the lessons of power were written for others to read:

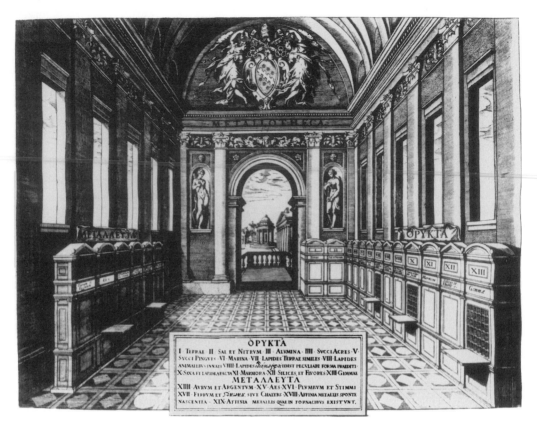

Figure 16.1 The cabinet of curiosities: the *Metallotheca* of Michele Mercati in the Vatican, 1719.
Courtesy of House of Stratus Ltd.

The scaffold, where the body of the tortured criminal had been exposed to the ritually manifest force of the sovereign, the punitive theatre in which the representation of punishment was permanently available to the social body, was replaced by a great enclosed, complex and hierarchised structure that was integrated into the very body of the state apparatus.[2]

The institutions comprising 'the exhibitionary complex', by contrast, were involved in the transfer of objects and bodies from the enclosed and private domains in which they had previously been displayed (but to a restricted public) into progressively more open and public arenas where, through the representations to which they were subjected, they formed vehicles for inscribing and broadcasting the messages of power (but of a different type) throughout society.

Two different sets of institutions and their accompanying knowledge/power relations, then, whose histories, in these respects, run in opposing directions. Yet they are also parallel histories. The exhibitionary complex and the carceral archipelago develop over roughly the same period – the late eighteenth to the mid-nineteenth century – and achieve developed articulations of the new principles they embodied within a decade or so of one another. Foucault regards the opening of the new prison at Mettray in 1840 as a key moment in the

development of the carceral system. Why Mettray? Because, Foucault argues, 'it is the disciplinary form at its most extreme, the model in which are concentrated all the coercive technologies of behaviour previously found in the cloister, prison, school or regiment and which, in being brought together in one place, served as a guide for the future development of carceral institutions' (Foucault 1977[3]). In Britain, the opening of Pentonville Model Prison in 1842 is often viewed in a similar light. Less than a decade later the Great Exhibition of 1851 [. . .] brought together an ensemble of disciplines and techniques of display that had been developed within the previous histories of museums, panoramas, Mechanics' Institute exhibitions, art galleries, and arcades. In doing so, it translated these into exhibitionary forms which, in simultaneously ordering objects for public inspection and ordering the public that inspected, were to have a profound and lasting influence on the subsequent development of museums, art galleries, expositions, and department stores.

Nor are these entirely separate histories. At certain points they overlap, often with a transfer of meanings and effects between them. To understand their interrelations, however, it will be necessary, in borrowing from Foucault, to qualify the terms he proposes for investigating the development of power/knowledge relations during the formation of the modern period. For the set of such relations associated with the development of the exhibitionary complex serves as a check to the generalizing conclusions Foucault derives from his examination of the carceral system. In particular, it calls into question his suggestion that the penitentiary merely perfected the individualizing and normalizing technologies associated with a veritable swarming of forms of surveillance and disciplinary mechanisms which came to suffuse society with a new – and all pervasive – political economy of power. This is not to suggest that technologies of surveillance had no place in the exhibitionary complex but rather that their intrication with new forms of spectacle produced a more complex and nuanced set of relations through which power was exercised and relayed to – and, in part, through and by – the populace than the Foucaultian account allows.

Foucault's primary concern, of course, is with the problem of order. He conceives the development of new forms of discipline and surveillance, as Jeffrey Minson puts it, as an 'attempt to reduce an ungovernable populace to a multiply differentiated *population*', parts of 'an historical movement aimed at transforming highly disruptive economic conflicts and political forms of disorder into quasi-technical or moral problems for social administration'. These mechanisms assumed, Minson continues, 'that the key to the populace's social and political unruliness and also the means of combatting it lies in the "opacity" of the populace to the forces of order'[4]. The exhibitionary complex was also a response to the problem of order, but one which worked differently in seeking to transform that problem into one of culture – a question of winning hearts and minds as well as the disciplining and training of bodies. As such, its constituent institutions reversed the orientations of the disciplinary apparatuses in seeking to render the forces and principles of order visible to the populace – transformed, here, into a people, a citizenry – rather than vice versa. They sought not to map the social body in order to know the populace by rendering it visible to power. Instead, through the provision of object lessons in power – the power to command and arrange things and bodies for public display – they sought to allow the people, and *en masse* rather than individually, to know rather than be known, to become the subjects rather than the objects of knowledge. Yet, ideally, they sought also to allow the people to know and thence to regulate themselves; to become, in seeing themselves from the side of power, both the subjects and the objects of knowledge, knowing power and what power knows, and knowing themselves as (ideally) known by power, interiorizing its gaze as a principle of self-surveillance and, hence, self-regulation.

It is, then, as a set of cultural technologies concerned to organize a voluntarily self-regulating citizenry that I propose to examine the formation of the exhibitionary complex. In doing so, I shall draw on the Gramscian perspective of the ethical and educative function of the modern state to account for the relations of this complex to the development of the bourgeois democratic polity. Yet, while wishing to resist a tendency in Foucault towards misplaced generalizations, it is to Foucault's work that I shall look to unravel the relations between knowledge and power effected by the technologies of vision embodied in the architectural forms of the exhibitionary complex.

Discipline, surveillance, spectacle

In discussing the proposals of late eighteenth-century penal reformers, Foucault remarks that punishment,while remaining a 'legible lesson' organized in relation to the body of the offended, was envisioned as 'a school rather than festival; an ever-open book rather than a ceremony' (Foucault 1977[5]). Hence, in schemes to use convict labour in public contexts, it was envisaged that the convict would repay society twice: once by the labour he provided, and a second time by the signs he produced, a focus of both profit and signification in serving as an ever-present reminder of the connection between crime and punishment:

> Children should be allowed to come to the places where the penalty is being carried out: there they will attend their classes in civics. And grown men will periodically relearn the laws. Let us conceive of places of punishment as a Garden of the Laws that families would visit on Sundays.[6]

In the event, punishment took a different path with the development of the carceral system. Under both the *ancien régime* and the projects of the late eighteenth-century reformers, punishment had formed part of a public system of representation. Both regimes obeyed a logic according to which 'secret punishment is a punishment half-wasted' (Foucault 1977[7]). With the development of the carceral system, by contrast, punishment was removed from the public gaze in being enacted behind the closed walls of the penitentiary, and had in view not the production of signs for society but the correction of the offender. No longer an art of public effects, punishment aimed at a calculated transformation in the behaviour of the convicted. The body of the offender, no longer a medium for the relay of signs of power, was zoned as the target for disciplinary technologies which sought to modify the behaviour through repetition.

> The body and the soul, as principles of behaviour, form the element that is now proposed for punitive intervention. Rather than on an art of representation, this punitive intervention must rest on a studied manipulation of the individual. . . . As for the instruments used, these are no longer complexes of representation, reinforced and circulated, but forms of coercion, schemata of restraint, applied and repeated. Exercises, not signs . . .[8]

It is not this account itself that is in question here but some of the more general claims Foucault elaborates on its basis. In his discussion of 'the swarming of disciplinary mechanisms', Foucault argues that the disciplinary technologies and forms of observation developed in the carceral system – and especially the principle of panopticism, rendering everything

visible to the eye of power – display a tendency 'to become "de-institutionalised", to emerge from the closed fortresses in which they once functioned and to circulate in a "free" state'[9]. These new systems of surveillance, mapping the social body so as to render it knowable and amenable to social regulation, mean, Foucault argues, that 'one can speak of the formation of a disciplinary society . . . that stretches from the enclosed disciplines, a sort of social "quarantine" to an indefinitely generalisable mechanism of "panopticism"'[10]. A society, according to Foucault in his approving quotation of Julius, that 'is one not of spectacle, but of surveillance':

> Antiquity had been a civilisation of spectacle. 'To render accessible to a multitude of men the inspection of a small number of objects': this was the problem to which the architecture of temples, theatres and circuses responded . . . In a society in which the principal elements are no longer the community and public life, but, on the one hand, private individuals and, on the other, the state, relations can be regulated only in a form that is the exact reverse of the spectacle. It was to the modern age, to the ever-growing influence of the state, to its ever more profound intervention in all the details and all the relations of social life, that was reserved the task of increasing and perfecting its guarantees, by using and directing towards that great aim the building and distribution of buildings intended to observe a great multitude of men at the same time.[11]

A disciplinary society: this general characterization of the modality of power in modern societies has proved one of the more influential aspects of Foucault's work. Yet it is an incautious generalization and one produced by a peculiar kind of misattention. For it by no means follows from the fact that punishment had ceased to be a spectacle that the function of displaying power – of making it visible for all to see – had itself fallen into abeyance.[12] Indeed, as Graeme Davison suggests, the Crystal Palace might serve as the emblem of an architectural series which could be ranged against that of the asylum, school, and prison in its continuing concern with the display of objects to a great multitude:

> The Crystal Palace reversed the panoptical principle by fixing the eyes of the multitude upon an assemblage of glamorous commodities. The Panopticon was designed so that everyone could be seen: the Crystal Palace was designed so that everyone could see.[13]

This opposition is a little overstated in that one of the architectural innovations of the Crystal Palace consisted in the arrangement of relations between the public and exhibits so that, while everyone could see, there were also vantage points from which everyone could be seen, thus combining the functions of spectacle and surveillance. None the less, the shift of emphasis is worth preserving for the moment, particularly as its force is by no means limited to the Great Exhibition. Even a cursory glance through Richard Altick's *The Shows of London* convinces that the nineteenth century was quite unprecedented in the social effort it devoted to the organization of spectacles arranged for increasingly large and undifferentiated publics.[14] Several aspects of these developments merit a preliminary consideration.

First, the tendency for society itself – in its constituent parts and as a whole – to be rendered as a spectacle. This was especially clear in attempts to render the city visible, and hence knowable, as a totality. While the depths of city life were penetrated by developing

networks of surveillance, cities increasingly opened up their processes to public inspection, laying their secrets open not merely to the gaze of power but, in principle, to that of everyone; indeed, making the specular dominance of the eye of power available to all. By the turn of the century, Dean MacCannell notes, sightseers in Paris 'were given tours of the sewers, the morgue, a slaughterhouse, a tobacco factory, the government printing office, a tapestry works, the mint, the stock exchange and the supreme court in session'[15]. No doubt such tours conferred only an imaginary dominance over the city, an illusory rather than substantive controlling vision, as Dana Brand suggests was the case with earlier panoramas[16]. Yet the principle they embodied was real enough and, in seeking to render cities knowable in exhibiting the workings of their organizing institutions, they are without parallel in the spectacles of earlier regimes where the view of power was always 'from below'. This ambition towards a specular dominance over a totality was even more evident in the conception of international exhibitions which, in their heyday, sought to make the whole world, past and present, metonymically available in the assemblages of objects and peoples they brought together and, from their towers, to lay it before a controlling vision.

Second, the increasing involvement of the state in the provision of such spectacles. In the British case, and even more so the American, such involvement was typically indirect[17]. Nicholas Pearson notes that while the sphere of culture fell increasingly under governmental regulation in the second half of the nineteenth century, the preferred form of administration for museums, art galleries, and exhibitions was (and remains) via boards of trustees. Through these, the state could retain effective direction over policy by virtue of its control over appointments but without involving itself in the day-to-day conduct of affairs and so, seemingly, violating the Kantian imperative in subordinating culture to practical requirements (Pearson 1982[18]). Although the state was initially prodded only reluctantly into this sphere of activity, there should be no doubt of the importance it eventually assumed. Museums, galleries, and, more intermittently, exhibitions played a pivotal role in the formation of the modern state and are fundamental to its conception as, among other things, a set of educative and civilizing agencies. Since the late nineteenth century, they have been ranked highly in the funding priorities of all developed nation-states and have proved remarkably influential cultural technologies in the degree to which they have recruited the interest and participation of their citizenries.

Finally, the exhibitionary complex provided a context for the *permanent* display of power/knowledge. In his discussion of the display of power in the *ancien régime*, Foucault stresses its episodic quality. The spectacle of the scaffold formed part of a system of power which 'in the absence of continual supervision, sought a renewal of its effect in the spectacle of its individual manifestations: of a power that was recharged in the ritual display of its reality as "super-power"[19]. It is not that the nineteenth century dispensed entirely with the need for the periodic magnification of power through its excessive display, for the expositions played this role. They did so, however, in relation to a network of institutions which provided mechanisms for the permanent display of power. And for a power which was not reduced to periodic effects but which, to the contrary, manifested itself precisely in continually displaying its ability to command, order, and control objects and bodies, living or dead.

There is, then, another series from the one Foucault examines in tracing the shift from the ceremony of the scaffold to the disciplinary rigours of the penitentiary. Yet it is a series which has its echo and, in some respects, model in another section of the socio-juridical apparatus: the trial. The scene of the trial and that of punishment traversed one another as they

moved in opposite directions during the early modern period. As punishment was withdrawn from the public gaze and transferred to the enclosed space of the penitentiary, the procedures of trial and sentencing – which, except for England, had hitherto been mostly conducted in secret, 'opaque not only to the public but also to the accused himself'[20] – were made public as part of a new system of judicial truth which, in order to function as truth, needed to be made known to all. If the asymmetry of these movements is compelling, it is no more so than the symmetry of the movement traced by the trial and the museum in the transition they make from closed and restricted to open and public contexts. And, as a part of a profound transformation in their social functioning, it was ultimately to these institutions – and not by witnessing punishment enacted in the streets nor, as Bentham had envisaged, by making the penitentiaries open to public inspection – that children, and their parents, were invited to attend their lessons in civics.

Moreover, such lessons consisted not in a display of power which, in seeking to terrorize, positioned the people on the other side of power as its potential recipients but sought rather to place the people – conceived as a nationalized citizenry – on this side of power, both its subject and its beneficiary. To identify with power, to see it as, if not directly theirs, then indirectly so, a force regulated and channelled by society's ruling groups but for the good of all: this was the rhetoric of power embodied in the exhibitionary complex – a power made manifest not in its ability to inflict pain but by its ability to organize and co-ordinate an order of things and to produce a place for the people in relation to that order. Detailed studies of nineteenth-century expositions thus consistently highlight the ideological economy of their organizing principles, transforming displays of machinery and industrial processes, of finished products and *objets d'art*, into material signifiers of progress – but of progress as a collective national achievement with capital as the great co-ordinator[21]. This power thus subjugated by flattery, placing itself on the side of the people by affording them a place within its workings; a power, which placed the people behind it, inveigled into complicity with it rather than cowed into submission before it. And this power marked out the distinction between the subjects and the objects of power not within the national body but, as organized by the many rhetorics of imperialism, between that body and other, 'non-civilized' peoples upon whose bodies the effects of power were unleashed with as much force and theatricality as had been manifest on the scaffold. This was, in other words, a power which aimed at a rhetorical effect through its representation of otherness rather than at any disciplinary effects.

Yet it is not merely in terms of its ideological economy that the exhibitionary complex must be assessed. While museums and expositions may have set out to win the hearts and minds of their visitors, these also brought their bodies with them creating architectural problems as vexed as any posed by the development of the carceral archipelago. The birth of the latter, Foucault argues, required a new architectural problematic:

> that of an architecture that is no longer built simply to be seen (as with the ostentation of palaces), or to observe the external space (cf. the geometry of fortresses), but to permit an internal, articulated and detailed control – to render visible those who are inside it; in more general terms, an architecture that would operate to transform individuals: to act on those it shelters, to provide a hold on their conduct, to carry the effects of power right to them, to make it possible to know them, to alter them.[22]

As Davison notes, the development of the exhibitionary complex also posed a new demand: that everyone should see, and not just the ostentation of imposing façades but their contents

too. This, too, created a series of architectural problems which were ultimately resolved only through a 'political economy of detail' similar to that applied to the regulation of the relations between bodies, space, and time within the penitentiary. In Britain, France, and Germany, the late eighteenth and early nineteenth centuries witnessed a spate of state-sponsored architectural competitions for the design of museums in which the emphasis shifted progressively away from organizing spaces of display for the private pleasure of the prince or aristocrat and towards an organization of space and vision that would enable museums to function as organs of public instruction[23]. Yet, as I have already suggested, it is misleading to view the architectural problematics of the exhibitionary complex as simply reversing the principles of panopticism. The effect of these principles, Foucault argues, was to abolish the crowd conceived as a 'compact mass, a locus of multiple exchanges, individualities merging together, a collective effect' and to replace it with 'a collection of separated individualities'[24]. However, as John MacArthur notes, the Panopticon is simply a technique, not itself a disciplinary regime or essentially a part of one, and, like all techniques, its potential effects are not exhausted by its deployment within any of the regimes in which it happens to be used[25]. The peculiarity of the exhibitionary complex is not to be found in its reversal of the principles of the Panopticon. Rather, it consists in its incorporation of aspects of those principles together with those of the panorama, forming a technology of vision which served not to atomize and disperse the crowd but to regulate it, and to do so by rendering it visible to itself, by making the crowd itself the ultimate spectacle.

An instruction from a 'Short Sermon to Sightseers' at the 1901 Pan American Exposition enjoined: 'Please remember when you get inside the gates you are part of the show'[26]. This was also true of museums and department stores which, like many of the main exhibition halls of expositions, frequently contained galleries affording a superior vantage point from which the layout of the whole and the activities of other visitors could also be observed.[27] It was, however, the expositions which developed this characteristic furthest in constructing viewing positions from which they could be surveyed as totalities: the function of the Eiffel Tower at the 1889 Paris exposition, for example. To see and be seen, to survey yet always be under surveillance, the object of an unknown but controlling look: in these ways, as micro-worlds rendered constantly visible to themselves, expositions realized some of the ideals of panopticism in transforming the crowd into a constantly surveyed, self-watching, self-regulating, and, as the historical record suggests, consistently orderly public – a society watching over itself.

Within the hierarchically organized system of looks of the penitentiary in which each level of looking is monitored by a higher one, the inmate constitutes the point at which all these looks culminate but he is unable to return a look of his own or move to a higher level of vision. The exhibitionary complex, by contrast, perfected a self-monitoring system of looks in which the subject and object positions can be exchanged, in which the crowd comes to commune with and regulate itself through interiorizing the ideal and ordered view of itself as seen from the controlling vision of power – a site of sight accessible to all. It was in thus democratizing the eye of power that the expositions realized Bentham's aspiration for a system of looks within which the central position would be available to the public at all times, a model lesson in civics in which a society regulated itself through self-observation. But, of course, self-observation from a certain perspective. As Manfredo Tafuri puts it:

> The arcades and the department stores of Paris, like the great expositions, were certainly the places in which the crowd, itself become a spectacle, found the spatial and visual means for a self-education from the point of view of capital.[28]

However, this was not an achievement of architecture alone. Account must also be taken of the forces which, in shaping the exhibitionary complex, formed both its publics and its rhetorics. [. . .]

Exhibitionary apparatuses

The space of representation constituted by the exhibitionary disciplines, while conferring a degree of unity on the exhibitionary complex, was also somewhat differently occupied – and to different effect – by the institutions comprising that complex. If museums gave this space a solidity and permanence, this was achieved at the price of a lack of ideological flexibility. Public museums instituted an order of things that was meant to last. In doing so, they provided the modern state with a deep and continuous ideological backdrop but one which, if it was to play this role, could not be adjusted to respond to shorter-term ideological require-ments. Exhibitions met this need, injecting new life into the exhibitionary complex and rendering its ideological configurations more pliable in bending them to serve the conjunc-turally specific hegemonic strategies of different national bourgeoisies. They made the order of things dynamic, mobilizing it strategically in relation to the more immediate ideological and political exigencies of the particular moment.

This was partly an effect of the secondary discourses which accompanied exhibitions. Ranging from the state pageantry of their opening and closing ceremonies through newspaper reports to the veritable swarming of pedagogic initiatives organized by religious, philanthropic and scientific associations to take advantage of the publics which exhibitions produced, these often forged very direct and specific connections between the exhibitionary rhetoric of progress and the claims to leadership of particular social and political forces. The distinctive influence of the exhibitions themselves, however, consisted in their articulation of the rhetoric of progress to the rhetorics of nationalism and imperialism and in producing, via their control over their adjoining popular fairs, an expanded cultural sphere for the deployment of the exhibitionary disciplines.

The basic signifying currency of the exhibitions, of course, consisted in their arrangement of displays of manufacturing processes and products. Prior to the Great Exhibition, the message of progress had been carried by the arrangement of exhibits in, as Davison puts it, 'a series of classes and sub-classes ascending from raw products of nature, through various manufactured goods and mechanical devices, to the "highest" forms of applied and fine art'[29]. As such, the class articulations of this rhetoric were subject to some variation. Mechanics Institutes' exhibitions placed considerable stress on the centrality of labour's contributions to the processes of production which, at times, allowed a radical appropriation of their message. 'The machinery of wealth, here displayed,' the *Leeds Times* noted in reporting an 1839 exhibition, 'has been created by the men of hammers and papercaps; more honourable than all the sceptres and coro-nets in the world'[30]. The Great Exhibition introduced two changes which decisively influenced the future development of the form.

First, the stress was shifted from the *processes* to the *products* of production, divested of the marks of their making and ushered forth as signs of the productive and co-ordinating power of capital and the state. After 1851, world fairs were to function less as vehicles for the technical education of the working classes than as instruments for their stupefaction before the reified products of their own labour, 'places of pilgrimage', as Benjamin put it, 'to the fetish Commodity'[31].

Second, while not entirely abandoned, the earlier progressivist taxonomy based on stages of production was subordinated to the dominating influence of principles of classification

based on nations and the supra-national constructs of empires and races. Embodied, at the Crystal Palace, in the form of national courts or display areas, this principle was subsequently developed into that of separate pavilions for each participating country. Moreover, following an innovation of the Centennial Exhibition held at Philadelphia in 1876, these pavilions were typically zoned into racial groups: the Latin, Teutonic, Anglo-Saxon, American, and Oriental being the most favoured classifications, with black peoples and the aboriginal populations of conquered territories, denied any space of their own, being represented as subordinate adjuncts to the imperial displays of the major powers. The effect of these developments was to transfer the rhetoric of progress from the relations between stages of production to the relations between races and nations by superimposing the associations of the former on to the latter. In the context of imperial displays, subject peoples were thus represented as occupying the lowest levels of manufacturing civilization. Reduced to displays of 'primitive' handicrafts and the like, they were represented as cultures without momentum except for that benignly bestowed on them from without through the improving mission of the imperialist powers. Oriental civilizations were allotted an intermediate position in being represented either as having at one time been subject to development but subsequently degenerating into stasis or as embodying achievements of civilization which, while developed by their own lights, were judged inferior to the standards set by Europe[32]. In brief, a progressivist taxonomy for the classification of goods and manufacturing processes was laminated on to a crudely racist teleological conception of the relations between peoples and races which culminated in the achievements of the metropolitan powers, invariably most impressively displayed in the pavilions of the host country.

Exhibitions thus located their preferred audiences at the very pinnacle of the exhibitionary order of things they constructed. They also installed them at the threshold of greater things to come. Here, too, the Great Exhibition led the way in sponsoring a display of architectural projects for the amelioration of working-class housing conditions. This principle was to be developed, in subsequent exhibitions, into displays of elaborate projects for the improvement of social conditions in the areas of health, sanitation, education, and welfare – promissory notes that the engines of progress would be harnessed for the general good. Indeed, exhibitions came to function as promissory notes in their totalities, embodying, if just for a season, utopian principles of social organization which, when the time came for the notes to be redeemed, would eventually be realized in perpetuity. As world fairs fell increasingly under the influence of modernism, the rhetoric of progress tended as Rydell puts it, to be 'translated into a utopian statement about the future', promising the imminent dissipation of social tensions once progress had reached the point where its benefits might be generalized[33].

Iain Chambers has argued that working- and middle-class cultures became sharply distinct in late nineteenth-century Britain as an urban commercial popular culture developed beyond the reach of the moral economy of religion and respectability. As a consequence, he argues. 'official culture was publicly limited to the rhetoric of monuments in the centre of town: the university, the museum, the theatre, the concert hall; otherwise it was reserved for the "private" space of the Victorian residence'[34]. While not disputing the general terms of this argument, it does omit any consideration of the role of exhibitions in providing official culture with powerful bridgeheads into the newly developing popular culture. Most obviously, the official zones of exhibitions offered a context for the deployment of the exhibitionary disciplines which reached a more extended public than that ordinarily reached by the public museum system. The exchange of both staff and exhibits between museums and

exhibitions was a regular and recurrent aspect of their relations, furnishing an institutional axis for the extended social deployment of a distinctively new ensemble of disciplines. Even within the official zones of exhibitions, the exhibitionary disciplines thus achieved an exposure to publics as large as any to which even the most commercialized forms of popular culture could lay claim: 32 million people attended the Paris Exposition of 1889; 27.5 million went to Chicago's Columbian Exposition in 1893 and nearly 49 million to Chicago's 1933/4 Century of Progress Exposition; the Glasgow Empire Exhibition of 1938 attracted 12 million visitors, and over 27 million attended the Empire Exhibition at Wembley in 1924/5[35]. However, the ideological reach of exhibitions often extended significantly further as they established their influence over the popular entertainment zones which, while initially deplored by exhibition authorities, were subsequently to be managed as planned adjuncts to the official exhibition zones and, sometimes, incorporated into the latter. It was through this network of relations that the official public culture of museums reached into the developing urban popular culture, shaping and directing its development in subjecting the ideological thematics of popular entertainments to the rhetoric of progress.

The most critical development in this respect consisted in the extension of anthropology's disciplinary ambit into the entertainment zones, for it was here that the crucial work of transforming non-white peoples themselves – and not just their remains or artefacts – into object lessons of evolutionary theory was accomplished. Paris led the way here in the colonial city it constructed as part of its 1889 Exposition. Populated by Asian and African peoples in simulated 'native' villages, the colonial city functioned as the showpiece of French anthropology and, through its influence on delegates to the tenth Congrès Internationale d'Anthropologie et d'Archéologie Préhistorique held in association with the exposition, had a decisive bearing on the future modes of the discipline's social deployment. While this was true internationally, Rydell's study of American world fairs provides the most detailed demonstration of the active role played by museum anthropologists in transforming the Midways into living demonstrations of evolutionary theory by arranging non-white peoples into a 'sliding-scale of humanity', from the barbaric to the nearly civilized, thus underlining the exhibitionary rhetoric of progress by serving as visible counterpoints to its triumphal achievements. It was here that relations of knowledge and power continued to be invested in the public display of bodies, colonizing the space of earlier freak and monstrosity shows in order to personify the truths of a new regime of representation.

In their interrelations, then, the expositions and their fair zones constituted an order of things and of peoples which, reaching back into the depths of prehistoric time as well as encompassing all corners of the globe, rendered the whole world metonymically present, subordinated to the dominating gaze of the white, bourgeois, and (although this is another story) male eye of the metropolitan powers. But an eye of power which, through the development of the technology of vision associated with exposition towers and the positions for seeing these produced in relation to the miniature ideal cities of the expositions themselves, was democratized in being made available to all. Earlier attempts to establish a specular dominance over the city had, of course, been legion – the camera obscura, the panorama – and often fantastic in their technological imaginings. Moreover, the ambition to render the whole world, as represented in assemblages of commodities, subordinate to the controlling vision of the spectator was present in world exhibitions from the outset. This was represented synecdochically at the Great Exhibition by Wylde's Great Globe, a brick rotunda which the visitor entered to see plaster casts of the world's continents and oceans. The principles embodied in the Eiffel Tower, built for the 1889 Paris Exposition and repeated in countless

subsequent expositions, brought these two series together, rendering the project of specular dominance feasible in affording an elevated vantage point over a micro-world which claimed to be representative of a larger totality.

Barthes has aptly summarized the effects of the technology of vision embodied in the Eiffel Tower. Remarking that the tower overcomes 'the habitual divorce between *seeing* and *being seen*', Barthes argues that it acquires a distinctive power from its ability to circulate between these two functions of sight:

> An object when we look at it, it becomes a lookout in its turn when we visit it. and now constitutes as an object, simultaneously extended and collected beneath it, that Paris which just now was looking at it.[36]

A sight itself, it becomes the site for a sight: a place both to see and be seen from, which allows the individual to circulate between the object and subject positions of the dominating vision it affords over the city and its inhabitants. In this, its distancing effect. Barthes argues 'the Tower makes the city into a kind of nature; it constitutes the swarming of men into a landscape, it adds to the frequently grim urban myth a romantic dimension, a harmony, a mitigation', offering 'an immediate consumption of a humanity made natural by that glance which transforms it into space'[37]. It is because of the dominating vision it affords, Barthes continues, that, for the visitor, 'the Tower is the first obligatory monument; it is a Gateway, it marks the transition to a knowledge'[38]. And to the power associated with that knowledge: the power to order objects and persons into a world to be known and to lay it out before a vision capable of encompassing it as a totality.

In *The Prelude*, Wordsworth, seeking a vantage point from which to quell the tumultuousness of the city, invites his reader to ascend with him 'Above the press and danger of the crowd/Upon some showman's platform' at St Bartholomew's Fair, likened to mobs, riotings, and executions as occasions when the passions of the city's populace break forth into unbridled expression. The vantage point, however, affords no control:

> All moveables of wonder, from all parts,
> All here – Albinos, painted Indians, Dwarfs,
> The Horse of knowledge, and the learned Pig,
> The Stone-eater, the man that swallows fire,
> Giants, Ventriloquists, the Invisible Girl,
> The Bust that speaks and moves its goggling eyes,
> The Wax-work, Clock-work, all the marvellous craft
> Of modern Merlins, Wild Beasts. Puppet-shows,
> All out-o' -the-way, far-fetched, perverted things,
> All freaks of nature, all Promethean thoughts
> of man, his dullness, madness, and their feats
> All jumbled up together, to compose
> A Parliament of Monsters.

Stallybrass and White argue that this Wordsworthian perspective was typical of the early nineteenth-century tendency for the educated public, in withdrawing from participation in popular fairs, also to distance itself from, and seek some ideological control over, the fair by the literary production of elevated vantage points from which it might be observed. By the

end of the century, the imaginary dominance over the city afforded by the showman's platform had been transformed into a cast-iron reality while the fair, no longer a symbol of chaos, had become the ultimate spectacle of an ordered totality. And the substitution of observation for participation was a possibility open to all. The principle of spectacle – that, as Foucault summarizes it, of rendering a small number of objects accessible to the inspection of a multitude of men – did not fall into abeyance in the nineteenth century: it was surpassed through the development of technologies of vision which rendered the multitude accessible to its own inspection. [. . .]

Notes

1 Douglas Crimp. "On the museum's ruins," in Hal Foster, ed., *The Anti-Aesthetic: Essays on Postmodern Culture* (Washington: Bay Press, 1985), p. 45.
2 Michel Foucault. *Discipline and Punish: The Birth of the Prison* (London: Allen Lane, 1977), pp. 115–16.
3 Ibid., p. 293.
4 Jeffrey Minson. *Geneaologies of Morals: Nietzsche, Foucault, Donzelot and the Eccentricity of Ethics* (London: Macmillan, 1985) p. 24.
5 Foucault, p. 111.
6 Ibid.
7 Ibid.
8 Ibid., p. 128.
9 Ibid., p. 211.
10 Ibid., p. 216.
11 Ibid., pp. 216–17.
12 This point is well made by MacArthur who sees this aspect of Foucault's argument as inimical to the overall spirit of his work in suggesting a "historical division which places theater and spectacle as past". John MacArthur, "Foucault, Tafuri, Utopia: Essays in the History and Theory of Architecture", M.Phil. thesis, University of Queensland, 1983, p. 192.
13 Graeme Davison. 'Exhibitions', *Australian Cultural History*, no. 2, 1982/3 (Canberra: Australian Academy of the Humanities and the History of Ideas Unit, ANU), p. 7.
14 Richard Altick. *The Shows of London* (Cambridge, Mass., and London: The Belknap Press of Harvard University Press, 1978).
15 Dean MacCannell. *The Tourist: A New Theory of the Leisure Class* (New York: Schocken Press, 1976), p. 57.
16 Dana Brand. *The Spectator and the City: Fantasies of Urban Legibility in Nineteenth-Century England and America* (Ann Arbor, Mich.: University Microforms International, 1986).
17 For discussion of the role of the American state in relation to museums and expositions, see, respectively, K. E. Meyer *The Art Museum: Power, Money, Ethics* (New York: William Morrow & Co., 1979) and Badger R. Reid, *The Great American Fair: The World's Columbian Exposition and American Culture* (Chicago: Nelson Hall, 1979).
18 Nicholas Pearson. *The State and the Visual Arts: A Discussion of State Intervention in the Visual Arts in Britain, 1780–1981* (Milton Keynes: Open University Press, 1982), pp. 8–13, 46–7.
19 Foucault, p. 57.
20 Ibid., p. 35.
21 Debora Silverman. "The 1889 exhibition: the crisis of bourgeois individualism," *Oppositions: A Journal of Ideas and Criticism in Architecture*, no. 45, 1977, Robert W. Rydell. *All the World's a Fair: Visions of Empire at American International Expositions, 1876–1916* (Chicago: University of Chicago Press, 1984).
22 Foucault, p. 172.
23 H. Seling. 'The genesis of the museum', *Architectural Review*, no. 131, 1967.
24 Foucault, p. 201.
25 John MacArthur. 'Foucault, Tafuri, Utopia: Essays in the History and Theory of Architecture', M.Phil. thesis, University of Queensland, 1983.
26 Cited in Neil Harris. 'Museums, merchandising and popular taste: the struggle for influence', in I. M. G. Quimby, ed., *Material Culture and the Study of American Life* (New York: W. W. Norton, 1978), p. 144.

27 For details of the use of rotunda and galleries to this effect in department stores, see John William Ferry, *A History of the Department Store* (New York: Macmillan, 1960).

28 Manfredo Tafuri. *Architecture and Utopia: Design and Capitalist Development* (Cambridge, Mass.: MIT Press, 1976), p. 83.

29 Davison, p. 8.

30 Cited in Toshio Kusamitsu. "Great exhibitions before 1851," *History Workshop*, no. 9, 1980, p. 79.

31 Walter Benjamin. *Charles Baudelaire: A Lyric Poet in the Era of High Capitalism* (Cambridge, Mass.: Harvard University Press, 1973), p. 165.

32 Neil Harris. "All the world a melting pot? Japan at American fairs, 1876–1904," in Iriye Akira, ed., *Mutual Images: Essays in American-Japanese Relations* (Cambridge, Mass.: Harvard University Press, 1975).

33 Rydell, p. 4.

34 Iain Chambers. 'The obscured metropolis', *Australian Journal of Cultural Studies*, vol.3, no. 2, 1985, p. 9.

35 John M. MacKenzie. *Propaganda and Empire: The Manipulation of British Public Opinion, 1880–1960* (Manchester: Manchester University Press, 1984), p. 101.

36 Roland Barthes. *The Eiffel Tower and Other Mythologies* (New York: Hill and Wang, 1979), p. 4.

37 Ibid., p. 8.

38 Ibid., p. 14.

Chapter 17

DANIEL J. SHERMAN

THE BOURGEOISIE, CULTURAL APPROPRIATION, AND THE ART MUSEUM IN NINETEENTH-CENTURY FRANCE

R**ECENT SCHOLARSHIP ON ART MUSEUMS** has shown a laudable determination to replace parochialism and the anecdotal, characteristic of so much previous work in the field, with a new conceptual and theoretical rigor. This new work, in addition to clarifying the internal logic of museums' functions, also constitutes a brief against them, one consisting, with some variants, of two main charges. First, the argument runs, museums by their very nature remove works of art from the context that makes them meaningful, thus rendering them "lifeless, as in a vacuum." In response to such perceptions of sterility and boredom, museum administrators have in recent years made a concerted attempt to enhance their public appeal, through such means as "blockbuster" exhibitions, a dramatically expanded line of reproductions, and a wide variety of ancillary services. But, according to the second charge, this effort has trivialized and commercialized art rather than restoring its cultural significance.[1]

In a sense, the scholarly critique has provided an intellectual formulation of popular estrangement from art museums. The most acute of the new studies, notably those of Carol

Duncan and Alan Wallach, have pointed to museums' effective constitution as ideological systems as the source of much of the disquiet they provoke.[2] In their seminal article "The Universal Survey Museum," Duncan and Wallach offer a lucid and convincing analysis of the ways in which museums convey ideological meaning through a symbolic structuring of visitors' experiences and perceptions. For Duncan and Wallach, the elements that order the museum experience—spatial arrangements, decorative features, inscriptions—constitute a kind of residue of museums' history. Yet they offer a theoretical outline, rather than empirical analysis, of the processes out of which these elements emerged. History, in this view, worked on museums at one original moment, providing them with an organizing principle around which their constituent parts would cohere, and which continues to determine their relationship. In terms of Duncan and Wallach's problematic, further analysis of that relationship would be not only superfluous but unavailing.

This essay, in contrast, seeks to demonstrate that the apparent internal coherence of the art museum is itself a construction, the result of a complex historical evolution shaped as much by contingency as by system. In the process of its construction, the museum invests its constituent elements—art, buildings, administrators, public—with new cultural significances, both particular to its enterprise and more broadly resonant. It can, for example, grant ideological sanction to the political power of its administrators, materially assist the careers of those artists whose production it appropriates, and provide an aesthetic justification for the social attitudes of its visitors. The nature of an institution is such that its creators can best achieve such ends by merging and subsuming them into a new and separate identity—by transforming them into the elements of something larger, thus making the museum literally greater than the sum of its parts. The temptation, in analyzing museums, to reduce their significance to one of these elements constitutes only one measure of the solidity of its construction.

The risks of ignoring the complexity of museums' development can be readily seen in examining one such reduction. For Duncan and Wallach, "the sudden flowering of art museums all over Europe in the late eighteenth and early nineteenth centuries testifies to the bourgeoisie's growing social and political power." The museum, in this view, serves to "institutionalize the bourgeois claim to speak for the interests of all mankind," and in doing so helps the bourgeoisie both to "secure power" over the state and to represent that domination. On the basis of the same general evidence, however, Arno Mayer has argued that "the museum's principal social function was to further the integration of the aspirant bourgeoisie into these [the old] ruling classes on terms favorable to the old elites."[3] This disparity of emphasis makes clear that, without sustained research and analysis of questions of motivation, procedure, and circumstance, no single interpretive framework can claim validity over any other. A number of monographic studies in the areas of status definition, consumption, and private life, moreover, make a strong theoretical and empirical case for distinguishing between the two concepts that both Duncan and Wallach and Mayer effectively conflate: bourgeois culture and national ideology.[4] The former may be broadly conceived as both the values that the class holds in common and their external signifiers, the latter as the constitutive and guiding principles of the secular nation-state; their relationship bears further examination even if one identifies the bourgeoisie as a ruling elite. We need, in other words, to investigate who these bourgeois were, why and in what context they chose to actualize their "growing . . . power" in a wholly new institutional form, how (assuming this explanation is correct) they carried out this enterprise, and how the methods they employed relate to other, contemporaneous efforts. Conceptually as well as empirically, the complexity of historical process cannot be circumvented.

On the surface, admittedly, the history of French art museums lends a certain plausibility to the conflation of bourgeois culture and national ideology. Although proposals to turn the

Louvre, long disused as a royal residence, into a public gallery had been in the air since the 1770s, it took the upheaval of the Revolution to turn the palace into Europe's first national art museum. Not only the circumstances but the rhetoric surrounding the creation of this institution thus infused it with the ideology of the Revolution: the museum was intended, wrote the Minister of the Interior, Garat, in the spring of 1793, to serve "public instruction and the glory of the arts." In January 1794 the painter Jacques-Louis David, whose connections to Robespierre had propelled him to the leadership of national cultural affairs under the Jacobins, made the connections between the just-opened museum and revolutionary politics even clearer:

> . . . to place everything under the revivifying eye of the people, to illuminate every object in the light of public attention, with that share of glory that it can rightfully claim, to establish in the museum, at last, an order worthy of the objects it houses, let us neglect nothing, citizen colleagues, and let us not forget that the culture of art is one more weapon we can use to awe our enemies.[5]

Many previous regimes, including the old French monarchy, had used the visual arts as a field of ideological commitment, but revolutionary France was the first to do so self-consciously. The heirs (or, depending on one's perspective, the betrayers) of the Revolution did not hesitate to continue in this commitment: Napoleon gave the Louvre his own name, the Musée Napoléon, used it as a showcase for the artistic plunder of various military campaigns, and even staged his marriage to Marie-Louise there in 1810.[6] From all this visible national ideology to bourgeois culture is an easy step, albeit one that summons up the bourgeoisie as a construct, a theoretical rather than a vital actor: the identification of the French Revolution, and of the state that issued from it, as "bourgeois" in nature. But this step is, to say the least, problematic from a historiographical point of view, and from a methodological point of view it is perhaps worse than that. Recent scholarship has cast considerable doubt on the orthodox interpretation of the French Revolution as a "bourgeois revolution," so that the identification of the power of the post-revolutionary state with that of the French bourgeoisie can no longer be sustained as a historical position.[7] Methodologically, to base a study of French museums as bourgeois institutions only on the Louvre would entail not only such an identification but also the assumption that the central state alone promulgates ideology. Paris alone can tell only part of the story. A full understanding of the complexity of the art museum's development in France entails extending the field of investigation beyond the capital and beyond the national museum.

Of course the state did play a role in the development of provincial museums, but one much smaller than the standard image of centralized state power in France would suggest. In 1801 a Napoleonic decree provided for the transfer to fifteen provincial cities works of art, largely acquired during the previous decade's military campaigns, for which the Louvre had no more room. This decree concerned only works of art, chiefly paintings, and left to the cities concerned the responsibility for founding and developing institutions to house them. This arrangement continued after the Restoration, with the important difference that the state now sent to provincial museums works of art, commonly known as envois, that it had purchased at the Paris Salon. Whereas in the first half of the century the state had devoted the majority of its expenditures on the arts to commissions, in the Second Empire it came increasingly to rely on these Salon purchases. In sheer numbers, annual purchases of paintings more than quadrupled from 1858 to 1869, and the proportion of expenditures devoted to purchases nearly tripled. Since 1818 the government had used a gallery adjacent to the Luxembourg

Palace as a museum for contemporary art, but this cramped facility could not possibly accommodate such a rapidly growing collection. Thus provincial art museums received an increasing share of the state's purchases and thereby came to play a crucial role in the system of state patronage of the arts.

The state's growing emphasis on purchases had important repercussions on both the ideology and the practice of its art patronage. Ideologically, this choice signified its acceptance of the primacy of the marketplace, with the concomitant openness and impersonality of its relationships, in the production and diffusion of art. To the extent that the nexus between art and commerce seemed inconsistent with the "higher values" in which it continued to frame the arts, the state sought to insulate the Salon from the traffic in art. Thus official rhetoric continued to emphasize the Salon's role as a prestigious forum for the presentation of the best recent creations of the French school, and to ignore its simultaneous function as a massive art bazaar. Yet the tremendous increase in the size of the Salon over the course of the nineteenth century, together with persistent complaints about conditions of admission and the quality of the works exhibited, both resulted from and focused attention on its crucial place in the art market.[8] Nor did the state confine its role to organizing the Salons—indeed, in 1880 it abandoned that task to the artists themselves—it used them as its primary point of purchase.

Beyond its symbolic importance, the state's identification with the Salon thus had certain practical consequences, including, as Jon Whiteley has pointed out, the privileging in artists' minds of a certain kind of painting calculated to attract the attention of the government commission in charge of making official purchases. Works that aimed for official purchases needed to combine large size, conventional standards of execution, and a certain facile distinctiveness, with the result that they virtually cried out for exhibition in a large public space. For the aspiring artist, the Luxembourg represented the acme of success, but, faced with the alternative of no sale at all, the possibility of consignment to a provincial museum had its attractions.

Provincial museums had to deal with the consequences of the envoi system on a number of levels. Some of the works sent from Paris were so enormous they severely taxed museums' ability to hang them, so that curators dreaded the periodic arrival of envois as a moment of considerable disruption to their installations. More seriously, the envoi system epitomized a peculiar and problematic dialectic between art as transcendent and the art object as commodity. Put simply, museums needed to evoke a conception of art as embodying civilization's highest values. For this they needed actual works of art, but the very act of acquiring them, even if not involving a direct transaction, called attention to their market value as commodities as well as to their moral value as cultural signifiers. The need to resolve, or at any rate to bypass this dialectic would condition the entire process of institutional definition of the art museum; as the dialectic's terms of reference changed—such contingencies as the state of the art market and shifting conceptions of the purpose of artistic creation—so too did the process. What needs to be stressed here, however, is that this process was a *local* one, in which neither the envois as objects nor the state as their institutional progenitor played a preponderant role. In assigning such centrality to the envoi system, the standard history of provincial art museums fails to distinguish between collections, which envois were indeed instrumental in developing, and institutions, which emerged largely through local efforts.[9]

The state's disregard for the actual conditions of provincial museums, which lasted until the first decade of the Third Republic, makes clear that it regarded the envoi system as a way of disposing of pictures and had little interest in what happened to them afterwards. While as early as the 1820s various well-connected notables were given the resonant-sounding title

of "Inspector of Departmental Museums," they had no real functions, and the positions were generally regarded as sinecures. Published reports of visitors to provincial museums before about 1860 hardly provided much reassurance about the safety of the works sent to them, to say nothing of any purpose they might have been serving the public. Toulouse paid so little attention to its collections that in 1857 several paintings seemed about to disintegrate, while in Strasbourg, where popular militia had used the museum for shooting practice in 1848, ten years later paintings lay in piles against the still unrepaired walls. Stendhal in 1838 called the Marseille museum "venerable in its obscurity"; twenty years later another observer found it "in almost complete darkness . . . a confused mass of gilded frames." Critics at about the same time disparaged the lighting, and the general conditions, in the Bordeaux and Grenoble museums as well.[10]

Such situations arose from the origins and early organization of provincial museums. Administratively, most functioned as appendages of the municipal art schools, whose students, rather than the infrequently admitted general public, formed their primary constituency. Curators usually served as directors of the art schools as well, and naturally devoted most of their attention and energies to this more familiar institution. The collections assembled at the Revolution, a combination of confiscated religious and noble property and the initial envois, thus tended to remain in the cold, dark, drafty buildings, often former churches or conventual buildings, in which they had first found refuge. Worse, some cities, like Bordeaux, continually shunted their museums around from one inadequate facility to another in order to make room for other municipal offices.[11]

Museums in small provincial centers for the most part remained in such deplorable conditions for most of the nineteenth century. In large provincial cities, however—usually left out of the familiar dichotomy that treats Paris as the only true city and equates the provinces with rural France—museums did change profoundly in the second half of the century. There the dusty depots and neglected attics beloved of cartoonists were becoming the temples of art that the word "museum," stripped of the qualifying attribute of provinciality, now so readily connotes. For museums emerged from the neglectful tutelage of drawing schools only when local elites took notice of them and began to feel that public collections of works of art had a significant role to play in the life of the city. This new perception can be documented in the formulation, beginning in the 1840s and 1850s, of coherent acquisition policies, and, a decade or two later, in the construction of new museum buildings. These developments took place during precisely the period in which historians have situated the ascendancy of the first sectors of the bourgeoisie to local political power. The July Monarchy, which instituted the first popularly elected city councils since the early days of the Revolution, laid the groundwork for this passage to power, and what Theodore Zeldin has called the political system of Napoleon III, though initially less democratic, in inadvertently fomenting local centers of opposition to the imperial regime helped to cement it.[12]

The significance of this political transformation lies in its cast of characters: lawyers, merchants, ship-owners in the port cities, manufacturers in Rouen and Marseille, a sprinkling of bankers and real estate developers. New to the political authority they exercised as city councilors, these municipal elites evinced a keen awareness of charges that their power derived from wealth alone, that they lacked the element of cultural prowess to which their predecessors had laid claim in the past.[13] Culture thus constituted a crucial element in legitimating their authority, so that they constantly sought concrete, specific ways in which the city could manifest its greatness in the artistic sphere, not merely in commerce and industry. In the context of the massive urban renewal that many cities were undertaking in the mid-nineteenth century, municipal leaders' discussions typically came to focus on the need to go

beyond street widening, renovation of housing stock, and the modernization of infrastructure to provide cities with "monuments" to embody both their past achievements and the grandeur of their current aspirations.[14]

A monument, in contemporary terms, could be almost any large civic structure with an aesthetic presence going beyond the strict needs of its functions: it could be a stock exchange or a theatre, a government building or a library, as well as an art museum. That so many major cities came to regard art museums as essential to their monument construction campaigns illustrates how museums in particular bespoke that concern for higher values that the new municipal elites wished to link to their leadership of the city.[15] Yet the realization of museums' symbolic potential did not emerge from any abstract considerations, but rather from a concrete process of institution-building that centered on the acquisition of new works of art for museum collections. Since this process effectively defined the terms that cities would eventually try to actualize in museum buildings, it demands a brief examination.

In museums' early days, few cities made a regular practice of purchasing works of art. On rare occasions a city might avail itself of the opportunity to acquire from a private collector a painting or even a collection attributed (dubiously) to a well-known master or masters.[16] Cities lacked, however, the two ingredients essential to a concerted acquisitions policy: commitment and regular budget items. The catalyst to these came largely from the private associations, or Sociétés des Amis des Arts, that appeared in a number of provincial cities in the 1840s and 1850s. The societies were run by well-to-do bourgeois with good connections to municipal leaders, and indeed counted many of them among their members; most societies concentrated their efforts on an annual exposition, or local version of the Salon, where they hoped to show the works of noted Paris artists as well as local products. The exposition organizers strongly encouraged city governments to follow the example of the state and to make annual acquisitions of works at these shows for their museums. Without the prospect of such a purchase the societies argued, the major Paris artists would not submit a work of the importance they considered crucial to the success or éclat—meaning essentially a good draw and good sales—of their shows.[17]

To the extent that they regarded annual municipal purchases as crucial to their efforts, the societies met with varying success, but they nonetheless played a vital role in the emergence of provincial cities as cultural centers. The availability of works of art in regular local exhibitions, and the stimulus these provided to local interest in the arts and to the market for art, represented a happy confluence of circumstances for most cities and had certain important consequences for the practice of municipal patronage. First, although they continued to acquire works by old masters whenever they could do so advantageously, provincial cities simply did not have the resources, either financial or technical, to do so on a regular basis. Local salons provided them with an opportunity to demonstrate their interest in and regard for the arts if not exactly cheaply—Bordeaux paid 20,000 francs for Cogniet's *Tintoretto Painting his Dead Daughter* in 1853—at least in relative security, that is without having to worry about attributions. The obvious resemblance to the state's practices, moreover, ensured, if not universally favorable publicity, at least an identification of municipal purchases with a model of patronage of which the fundamental nobility of purpose could not be doubted.

But the connection with the state and the Paris Salon was not merely a conceptual one; it also played a role in determining the kind of work cities would support with their patronage. Provincial exhibitions could expect from prominent, Paris-based artists only those works they had not been able to sell in Paris, in all likelihood at the Salon. Thus the paintings that cities were purchasing during the Second Empire inevitably fell into the category of the exhibition picture discussed above: large, technically accomplished, and flashy. Indeed discussions of these

purchases in city councils drew on a conventional vocabulary that shows the emergence of a more or less standardized concept of a "museum picture." The elements of such a picture most frequently mentioned included size—anything too large for a "bourgeois salon," as many correspondents put it—and authenticity (for an old master) or quality (for a contemporary work), which in turn encompassed both technical skill and an identifiable seriousness of purpose, and a certain "elevated" sensibility. Whatever its other merits, the museum picture, imbued with the aura these characteristics could together provide, constructed a readily conceivable link to the great tradition of Western painting generally taken to have begun with the Italian Renaissance, without the necessity of having the more highly valued objects of this tradition actually at hand.

The elements of size, quality, and "elevation" constructed a notion of the museum picture sufficiently clear and suggestive that it needed no restrictions on subject matter or (within certain broad limits) on technique. While traditional history paintings, including, according to the contemporary definition, religious scenes as well as those drawn from literature, retained some of their appeal, the majority of purchases of contemporary paintings in Bordeaux and Marseille from 1850 to 1870 went to landscapes and genre scenes.[18] City officials could find evidence of both technical accomplishment and such qualities as "penetrating grace," an "elevated style" and "deep feeling" in works as various as a *Sunset* by Antoine Viot, which Marseille acquired in 1865, a Corot *Bathers*, purchased by Bordeaux in 1858, or *L'Ora del Pianto*, an Italian genre scene by Benjamin Ulmann (Marseille, 1868). There seemed little essential difference between the conception of these works and the rhetoric surrounding Antony Serres' *The Sentence of Joan of Arc*, even though "this great history painting," acquired for the Bordeaux museum in 1868, was touted as providing historical and moral lessons that the others presumably could not offer.[19]

There is a sense, indeed, in which almost any work, no matter how unlikely at first glance, could become a museum picture by virtue of an external process of definition. We can see that process at work in the discussions that preceded Marseille's 1869 decision to purchase Jean-François Millet's *La Bouillie*, a modest painting of a peasant woman spoon-feeding an infant and the first canvas by this artist to enter a French public collection. The deputy mayor in charge of the fine arts had to admit that Millet had "pitched his tent in the realist camp," but he then quickly bypassed the association. "One sees," the official said, "that Millet looks to style and imagination for effect and prestige; unlike Courbet, who goes so far as to slander nature, he does not systematically seek out ugliness, but he does not flee nature when he finds it." The use of the word "ugliness" is crucial, for a critic who saw the picture at its first showing at the Salon of 1861 described it as a study in "the mannerism of ugliness."[20] When *La Bouillie* had come before the Bordeaux city council in 1866, proponents of the purchase, dealing with the picture on its own terms, argued that the museum *ought* to have representatives of all schools, but the council rejected it by a vote of 14 to 10. In Marseille, the spokesman for the purchase did not confront the problem of "ugliness," he simply denied its existence. Like his Bordeaux counterparts with regard to a rather too nubile nymph by Alexandre Antigna they acquired in 1865, he was saying in effect that a museum picture is what we say it is—and, perhaps more significantly, is not what we say it is not.[21]

This is tautology, of course, but it is tautology of a very deliberate kind. Each of these paintings constituted, to some degree, a problem for prevailing notions of cultural propriety: Antigna's *Mirror of the Woods* because it depicted nubility (and not merely nudity) without the exculpating frame of mythological or historical allusion, *La Bouillie* in portraying a peasant woman without any attempt either to prettify or to moralize. The acquisitions of these two pictures exemplify more tellingly than most the process of appropriation inherent in each

purchase. The particularities of the individual work mattered less than the act of acquiring it, for the act of patronage connected the city with the cultural tradition it wished to evoke, and, indeed, claimed for the city the position of legitimate heir to that tradition.[22] Not surprisingly, the models that civic leaders most frequently invoked occupied privileged positions in the tradition they were trying to appropriate: not only the cities of pre-revolutionary France, renowned for their cultural richness and diversity, as well as for their greater autonomy from centralized power, but also the city-states of the ancient world and of Renaissance Italy. The genius of these civic societies lay, according to a common interpretation, in their ability to "unite, in such fortunate concord, the commercial instinct with a love of the arts."[23] For the bourgeoisie of provincial France, this achievement constituted both end and means. As an end, it represented unqualified recognition of the legitimacy of their power; as a means, it could be regarded as perhaps the most spectacularly successful example of the kind of cultural appropriation in which they were engaged.

Practical men, the new civic leaders probably recognized that they had little chance of finding a new Raphael or Michelangelo to reappropriate the Renaissance for them as these artists had, in the standard view, appropriated the ancient world in their own day. Thus they settled, reasonably gamely, for the rhetorical appropriation of such of their own artists as they could afford. As a consequence, however, they found themselves forming collections that made their existing homes more and more untenable. In this way the art museum emerged as a necessary monument for the image, their own image, that bourgeois elites were trying to impress on their cities. As one Marseille city councillor put it, in successfully arguing for a sizeable supplementary credit for the new museum building then under construction, "the visitor going through the rooms, the gardens, the walks, must be able to say: This is truly the work of a great city! It is a creation that honors Marseille!"[24]

The means cities used to achieve these goals included lavish expenditure on ornamentation, which they emphasized occasionally at the expense of space, though not to the detriment of technical innovations, like steel-frame construction and skylights, that they regarded as important to their image as forward-looking and progressive cities. Cities generally selected a monumental architecture that made specific references to buildings from past eras of glory, although the vigorous eclecticism of mid-nineteenth century architecture gave them a wide range of precedents from which to choose.[25] The results ranged from the exuberant, frankly opulent Palais de Longchamp in Marseille [Figure 17.1] with its references to French Renaissance châteaux, to the more severely classicizing, understated, but still clearly monumental museum in Rouen, whose city fathers consciously wished to avoid creating "a rival to the older monuments of which our city is justly proud."[26] The shared historicist impulse merged with certain other common elements of museum design to create a standard image of the art museum that transcended differences in architectural style. These elements included a proximity to a park or gardens, designed to provide a tranquil setting for contemplation and reflection, clearly separated from quotidian distractions,[27] the commemoration of artists from the great tradition, either with inscriptions (as in Marseille, Dijon, and Montpellier) or with busts (Rouen),[28] and some kind of grand entrance and ceremonial stairway, to symbolize the visitor's passage into a sanctuary of art.

To adorn these spaces, a number of museums, including those of Marseille and Rouen, turned to France's most celebrated decorator of public spaces, Pierre Puvis de Chavannes (1824–1898). Known for the extraordinary stillness, dignity and almost other-worldly quality of his frieze-like figures, Puvis excelled in the painting of allegorical programs, including, among the best known, the series in the Pantheon in Paris and the Boston Public Library.[29] Yet his special appeal to the builders of the new provincial museums had other bases as well,

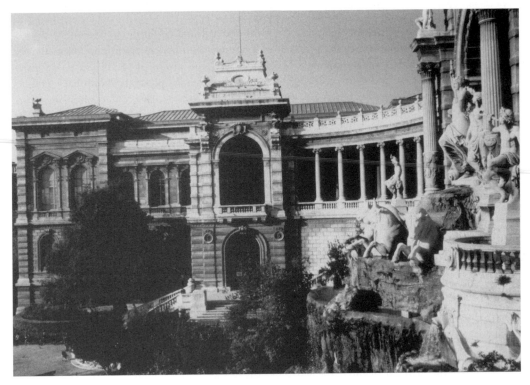

Figure 17.1 Palais de Longchamp, Marseille, 1862–9. Postcard, *c.* 1900. Courtesy of Daniel J. Sherman.

not least in his remarkable talent for creating works on canvas—the transportability of which can be regarded as essential to the functioning of the modern art market, and indeed to the very treatment of art as a commodity—that, when attached to the walls of suitably monumental spaces, assumed the timeless aura of the mural.

Moreover, the two paintings he executed for Marseille, *Marseille, Greek Colony* [Figure 17.2] and *Marseille, Gateway to the Orient* [Figure 17.3], and the centerpiece the Rouen program, *Inter Artes et Naturam*, are not allegories in the conventional sense. Those in Marseille depict, in a highly stylized form, actual events in the history of the city as a center of commerce. *Inter Artes et Naturam*, set on the heights of Bonsecours with the modern city of Rouen in the background, with the aid of two side panels, *Pottery* and *Ceramics*, comments on a craft industry strongly associated with Rouen. Yet Puvis' conscious classicism and initially radical simplification of figures transform the subjects of these scenes so that, without being either minimized or denied, they lose their centrality. In the sense that the act-or the fact-of representing has assumed primacy over the object represented, these paintings are no longer *about* that object, broadly speaking, commerce or some aspect of it. Their subject has become the representation of commerce, or, in terms Puvis' first public would have recognized, the "fortunate concord" between the arts and commerce. The brilliance of Puvis' contribution lies in the way his paintings manage not simply to represent or to comment on the process of appropriation, but in fact to enact it.

On one level, of course, the new museums made themselves available for general admiration, and the most spectacular of them, the Palais de Longchamp in Marseille, attracted a great deal of it. But at the same time, the ornamental details, the decorative paintings and

however, professional advertisers had begun to theorize about this shopping spectator. As Stuart Culver, Jackson Lears, William Leach, and others have argued, by the 1890s professional advertisers placed their faith in the persuasive force of "eye appeal."[37] English advertisers and retailers, particularly those interested in attracting female consumers, also believed in the psychological force of images. An article in the *Retail Trader* in 1910, for example, compared the window dresser to a stage manager: "Just as the stage manager of a new play rehearses and tries and retries and fusses until he has exactly the right lights and shades and shadows and appeals to his audience, so the merchant goes to work, analyzing his line and his audience, until he hits on the right scheme that brings the public flocking to his doors."[38] Trade journals emphasized women's supposed aesthetic sense, love of music,[39] enjoyment of "attractive" illustrations,[40] "artistic" packaging, and "dainty surroundings."[41] One "specialist" summarized: "We are beginning to see that people are influenced more through the eye than any other organ of the body."[42] While reporting on Selfridge's opening-week window displays, the *Daily Chronicle* put it simply: "The Modern Shop is run on the principle that the public buys not what it wants but what it sees."[43] Although Gordon Selfridge stimulated consumers' visual pleasures, he also asked them to associate shopping with an almost inconceivable range of other sensual and social pleasures.

"A time of profit, recreation, and enjoyment"

The most striking aspect of Selfridge's advertising, especially the opening week cartoons, was that it fit so perfectly within already accepted understandings of gender, shopping, and the Edwardian West End.[44] In reading Selfridge's advertisements and the publicity that the store generated, one can almost hear the voices of William Whiteley, Frances Power Cobbe, Edith Davis, and the countless other men and women who had characterized all or part of the West End as a female territory. When journalists wrote about the store's opening and its advertisements, they incorporated Selfridge's idiom because in some sense they already spoke the same language. In many respects, Gordon Selfridge had himself learned to talk about shopping and shoppers from reading the papers. He often adopted the excessive verbiage of the advertorial, as well as the tropes of the urban sketch, the guidebook, and the feminist tract. Thus, Selfridge departed from his English competitors not in specific arguments, but in his ability to weave together what were by now orthodox beliefs and make them his own. Advertising and newspaper publicity paralleled each other in such a way that whatever Selfridge said appeared as the truth.

At their most basic level, the opening week ads worked upon an association between femininity, visual pleasure, and abundance.[45] The feeling of abundance emanated not from the campaign's subject matter, but its volume, repetition, and cost. For months newspaper reports had told the British public that Selfridge had spent an enormous sum on his building and his advertising. The thirty-two initial cartoons that appeared in nearly all the daily and evening papers during the middle week of March in 1909 gave the impression that Selfridge's message was simply everywhere and addressed to everyone. Though Selfridge often advertised in the ladies' papers, this campaign targeted all types of readers. It did not include *The Times*; however, though Lord Northcliffe admired Selfridge, he refused to participate in this advertising extravaganza.[46]

The visual pleasures of shopping were derived from the ads' form as much as their content. They were considered, as already mentioned, works of art, something to look at as much as read. At the same time, since many of the illustrations incorporated images of the store, the idea of looking at the ad and looking at the store became conflated. These two forms of

pleasurable looking gave way to a third in those cartoons which prominently displayed the shopper or shopping crowd. In many but not all of the ads the newspaper reader gazed upon a female body. Selfridge's ads thus asked both men and women to look at a "beautiful" store, a lovely woman, and a compelling ad. An example of this dynamic appeared in "Lady London," one of the opening week ads illustrated by F. V. Poole [Figure 19.1]. Poole's design transformed the already tight relationship between women, the department store, and the city into an enticing image. He represented "London receiving her Newest Institution" by drawing London as a statuesque goddess protectively holding the new department store.[47] As Rachel Bowlby has pointed out, this image implied that the store's success was literally in women's hands.[48] Yet here London is no ordinary British matron, but rather a combination of Nike and her secularized version, Fame. Crowned with a garland of buildings and wearing wings of flying drapery, this allegorical female frequently symbolized, according to Marina Warner, the desire for success.[49] Lady London personified the metropolis as a female shopper and endowed her with tremendous power.

 Advertisements such as Lady London cannot be said to mean one thing to everyone at any one moment. Yet by 1909 the newspaper reading public would have been so familiar with the idea of shopping as a female pursuit and with the department store as the shoppers favorite stomping ground, that few could have avoided reading Poole's ad in this way. If they had any doubts about the ad's meaning, though, they needed only to turn to the editorial pages; nearly all of the papers in which Selfridge advertised, and a good many in which he did not, felt compelled to comment upon and rework the themes developed in the opening campaign.

Figure 19.1 Selfridge's advertisement, "Lady London," March 1909, F.V. Poole. Courtesy of the Selfridge's Collection held at The History of Advertising Trust Archive.

Selfridge asked women to travel to the city, become part of the urban crowd, and to experience the store as a public place. Indeed, the department store became newsworthy not because of the commodities it sold, but because of its definition as a social and cultural institution for women. Advertising and newspaper publicity promoted Selfridge's as a "sight" and shopping as female entertainment. Within days, Selfridge's had become, trumpeted the *Daily Telegraph*, "one of the sights of London."[50] A reporter for the *Church Daily Newspaper* tersely captured Selfridge's agenda by proclaiming that, at Selfridge's, "Shopping" had become "An Amusement."[51] Whether imagined as an absolute need, a luxurious treat, a housewife's duty, a social event, or a feminist demand, shopping was now always a pleasure.

In writing about the new emporium, the *European Mail* exclaimed that Selfridge's was quite simply "Modernity's Creation."[52] This headline picked up upon one of Selfridge's main strategies: to define consumer pleasure as in itself a "modern" phenomenon. He claimed that his store offered amusements that had supposedly not existed in the past. In Selfridge's vision of history, Victorian shopping had once been work because shops had been dark, their windows had been cluttered and ugly, and shop assistants had been rude. In contrast, Selfridge's had launched a "new era" in which shopping became an amusement. The "repressive" spirit of Victorian shopkeeping had not died, however. Selfridge's ads implied that most West End shops still lived in this unpleasant and uncomfortable past.

Selfridge's early advertising, therefore, tended to undermine the claims of pre-existing urban commercial culture in order to heighten the excitement for and enjoyment of his new enterprise. The earliest advertisements often asserted that Selfridge's had transformed shopping from labor into leisure. A typical advertisement loudly proclaimed that the emporium influenced the "shopping habit of the public." "Previous to its opening . . . shopping was merely part of the days WORK . . . To-day, shopping—at Selfridge's . . . is an important part of the day's PLEASURE, a time of PROFIT, RECREATION, and ENJOYMENT, that no Lady who has once experienced it will willingly forgo."[53] Another emphasized that "not until Selfridge's opened had English ladies understood the full meaning of 'shopping made easy.' Never had it been quite such a delightful pastime."[54]

Most of Selfridge's ads, especially the opening cartoons, set out to teach readers how to enjoy this "delightful pastime." They did not all do so, however. At least four of the initial advertisements, for example, pictured idealized images of male construction workers, with each declaring that the store was "a monument to British labor" and a sign of the "strong endurance . . . indomitable grit and pluck" of the "British Workman."[55] Others claimed that Selfridges demonstrated "honest" business practices such as "Integrity, Sincerity, Courtesy and Value."[56] Children were also asked to visit "Babyland" or to eat something "really nice" in the Luncheon Hall.[57] Perhaps some of the most curious advertisements implied that Selfridge's brought the "world" to London. Using the graphic styles associated with Germany, France, and Ireland, a series of ads told foreign shoppers they would find a bit of their homeland in Oxford Street. Each of these drew upon different artistic traditions and no doubt created diverse responses in their readers. However, their collective effect suggested that the store offered something for everyone, and that, although it was brand new and had no established traditions, Selfridge's was a trustworthy enterprise.

The most common theme, however, was the transformation of shopping into leisure. Several ads observed that shopping at Selfridge's offered women access to publicly oriented social life. These pictured shopping as a female pleasure but one associated with a newly emerging consumer-based heterosocial urban culture. Its romantic possibilities, for example, were subtly encoded in the imagery of the opening day advertisement, "Herald Announcing the Opening," drawn by Bernard Partridge. In this cartoon the department store/Gordon

Selfridge is figured not as a modern institution but as a medieval prince mounted atop a faithful steed. The powerful muscles and overwhelming size of the animal underscored the handsome herald's appeal. Not unlike Selfridge himself, the messenger rides into the countryside to summon ladies and their spending power to the urban center. The economic and international aspects of the buyer-seller relationship were encoded in the store's symbol, a capital S that appeared as a combination of a pound and dollar sign, emblazoned on the breastplate of the herald's armor. Yet this illustration also obscures the "foreign" background of the owner and his business methods by linking the venture to a representation of ancient English "tradition" and currently popular images of empire.[58] Novelty and tradition, sensuality and consumption, America and England were thus bound together in a pastiche of medieval and Edwardian romantic imagery.[59]

A second cartoon, "Leisurely Shopping," emphasized the romantic pleasures shopping by representing a fashionably dressed couple enjoying tea together [Figure19.2]. The attractive couple is less interested in each other, however, than in the viewer, who as the object of their gaze is also invited to enjoy looking at the couple. Man or woman, the reader becomes both object and subject of a desiring gaze. The pleasures of shopping are symbolized by the sexual exchange of the couple and in the voyeuristic pleasures of the reader. In contrast to this somewhat provocative drawing, the written text just hints at this sexual interplay. "Shopping at Selfridge's," it claims, is "A Pleasure—A Pastime—A Recreation [. . .] something more than merely shopping."[60] The advertisement constructed heterosexual and consumer desire in relation to each other and linked both to a public culture of display.[61]

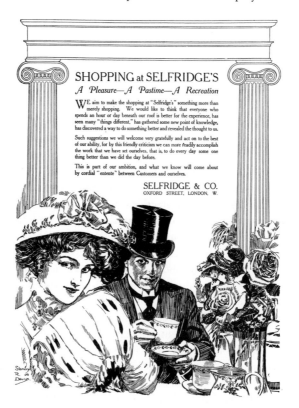

Figure 19.2 "Leisurely Shopping," advertisement, March 1909, Stanley Davis. Courtesy of the Selfridge's Collection held at The History of Advertising Trust Archive.

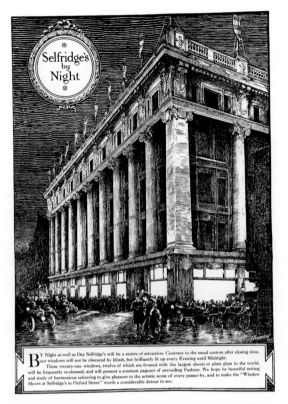

Figure 19.3 "Selfridge's by Night," advertisement, March 1909, T. Friedleson. Courtesy of the Selfridge's Collection held at The History of Advertising Trust Archive.

T. Friedelson also united consumption with heterosocial culture and modern upper-class Society by promoting the visual and social pleasures of window shopping after hours. In "Selfridge's by Night," Friedelson illustrated a fashionable crowd streaming out of motorcars and carriages to gaze at the store's brightly lit windows [Figure 19.3]. Together the image and text implied that window shopping was an exciting but respectable evening entertainment. "By Night as well as Day, Selfridge's will be a centre of attraction," the copy boasted. The "brilliantly lit" and "frequently re-dressed" windows promised "to give pleasure to the artistic sense of every passer-by, and to make the 'Window Shows at Selfridge's in Oxford Street' worth a considerable detour to see."[62] This picture of evening street life encouraged shopping by suppressing the better-known image of the West End after dark.

The notion of the public realm as a romantic space was in part a calculated attack on the reigning portrayal of the urban center as host to prostitution, gambling, and other illicit activities. Like the managers of West End restaurants, hotels, and theaters, Selfridge rebuilt the city's image as a modern, heterosocial, commercial pleasure center. These were, however, "respectable" or "licit" pleasures. Peter Bailey has observed that during this period capitalist managers promoted a new form of open, licit sexuality.[63] A distinct form of modernity was constructed then through the promotion of a capitalist-inspired heterosexual culture.

Both store advertisements and newspaper publicity situated the department store within the commercial spaces of the metropolis. For example, in 1912 a Callisthenes column explained that "abroad, it is the cafés, which are the familiar, lovable places where the populace resort

to . . . to meet their friends, to watch the world and his wife, to take a cup of coffee, or drink a glass of lager or absinthe." However, in London "it is the Big Stores which are beginning to play the part of the charming foreign café; and . . . it was Selfridge's who deliberately began to create the necessary atmosphere."[64] Department stores, these ads implied, offered middle-class women a simulacrum of social spaces they had rarely entered and that had been until recently tinged with associations of the sexual marketplace.

Gordon Selfridge went further, however, and encouraged bourgeois women to experience city life by themselves, to take up the position of that modern urban character the *flâneur*, or, in this case, the *flâneuse*. Advertising drew upon the portrait of female urban explorer that had been developed in novels, magazines, and newspapers since at least the mid-nineteenth century, but then argued that the *flâneuse* should always include the department store in her ramble. "What a wonderful street is Oxford-street," claimed one ad, for "it compels the biggest crowds of any street in London." "When people come here, they feel they are in the centre of things. . . . Oxford Street is the most important highway of commerce in the world."[65] Advertising itself was characterized as the modern manifestation of *flânerie* in "An Ode to London in the Spring, The Gentle Art of Advertisement." This "ode" privileged the pleasures of an urban walk over a country stroll:

> Although the country lanes are sweet
> And though the blossom bloss,
> Yet what are these to Regent Street
> Or even Charing Cross?
> So catch a train, and thank your stars
> That there are trains to catch
> And make your way this very day
> To London, with dispatch . . .[66]

Selfridge's advertising adopted the idea of the *flâneuse* developed elsewhere, but unlike her other manifestations, she typically meandered through the different departments at Selfridge's and gained her distanced bird's-eye view of London and its swarming tide from the store's roof garden.

She was also asked to come home. In the department store women could enjoy the pleasure of men's company, could experience the pleasures of *flânerie*, but could also experience social and yet domestic pleasures of the aristocracy and wealthy bourgeoisie. These ads represented the department store as both a public and private place. For example, in Lewis Baumer's opening-week advertisement, "At Home," middle-class shoppers were invited to a gathering of fur-wrapped and elegantly coiffed Society ladies. The picture and caption played on the two meanings of being at home. The illustration represented the formal ritualized sense of the term as a social event, while the text reminded readers of the comfortable domestic connotation of feeling "at home."[67] Other ads similarly portrayed Selfridge's as a formal "event" in the Season's calendar. "Shopping," at Selfridge's, one ad explained, "has all the appearance of a Society gathering. . . . It holds a recognised position on the programme of events, and is responsible sartorially for much of the success of each function that takes place."[68] These sorts of advertisements drew readers into the "private" sphere of West End elite culture. They implied one could be a part of Society if one consumed the right goods at the right shop.[69]

Gordon Selfridge and his commercial artists designed and publicized the department store, then, as a blend of elite and mass culture, mirroring the world of Ascot and the amuse-

ment park.[70] Ads and articles described the store as a carnival, a fair, a public festival, a tourist sight, a women's club, and a pantomime. Several pieces compared Selfridge's to the Crystal Palace or the Franco-British Exhibition. The *Daily News* even touted the department store as a "new White City . . . especially for women."[71] This carnivalesque atmosphere heightened in July, when Selfridge displayed the Bleriot airplane, the first to fly between France and England, on the roof of his store. Despite his competitors' accusation that he was engaging in a cheap American publicity stunt, huge crowds rushed to his rooftop.[72] The *Daily Telegraph* reported that "the public interest in the monoplane yesterday was immense. Throughout the entire day, without cessation or diminution, a constant stream of visitors passed into Selfridge's and circled round the historic implement."[73] The stunt proved so successful that Selfridge eventually opened a rifle range, putting ground, and skating rink on the top of the store.

Shopping was exciting and thrilling because it was "modern," but also because it could carry shoppers back in time. Selfridge even claimed that his emporium recaptured the sociability of the early-modern marketplace with its mixed-class and mixed-sex culture. In 1913, for example, Selfridge discussed his store as a modern reincarnation of "the great Fairs" that flourished before "small shops began to do business behind thick walls and closed doors." With his own romantic vision of the history of commerce, he continued:

> We have lately emerged from a period when merchandising and merrymaking were kept strictly separate. "Business was Business." . . . But to-day . . . stores—the modern form of market—are gaining something of the atmosphere of the old-time fair at its best; that is, before it became boisterous and degenerate. The sociability of Selfridge's is the sociability of the fair. It draws its visitors from far and near . . . to sell to them or merely to amuse and interest them.[74]

Selfridge posited that mass retailing reunited elite and popular culture, which he argued had been separated during the Victorian era. This rift had limited the pleasures of shopping and urban culture. This argument might be said to have been part of the larger denigration of all things Victorian that so marked early-twentieth-century culture. [. . .]

Notes

1 The company was initially registered on June 19, 1906, as Selfridge and Waring, Ltd., with a capital of a million pounds divided into 100,000 five-pound reference shares and 500,000 ordinary shares at one pound each. When Waring dropped out of the deal, Selfridge set up Selfridge and Co., Ltd., investing approximately £200,000 more of his own money. On Selfridge's finances, see Pound, *Selfridge*, 33.

2 Lawrence, "Steel Frame Architecture," 23–46. Selfridge and his lawyers spent a great deal of time in Portman's estate offices, but he evidently felt that the estate officers were a bit less obstructionist than others. Pound, *Selfridge*, 35.

3 *Daily Chronicle*, March 15, 1909.

4 Honeycombe, *Selfridge*, 9.

5 *Daily Express*, March 16, 1909. Also see *Builder*, March 20, 1909. This issue published photographs of Selfridge's and the newly rebuilt Debenham and Freebody's. Selfridge's classical design used more glass, and its strong vertical lines emphasized the store's height.

6 *Black and White*, March 20, 1909.

7 *Daily Chronicle*, March 15, 1909.

8 *Daily Chronicle*, March 16, 1909.

9 *Christian World*, March 18, 1909. On the comparison between American and English display techniques, see the *Drapers' Record*, April 3 and 10, 1909. Around 1910 American print ads and show windows began to use more empty space in order to appear less cluttered. Leonard Marcus, *The American Store*

Window (London: Architectural Press, 1978), 18–19. Yet American window dressers still had diverse opinions about how best to excite the passersby. Leach, *Land of Desire*, 59–69. Before Selfridge arrived in London, architects and shopkeepers were already rethinking the function of the store window. For an example of English techniques, see Horace Dan and E. C. Morgan, *English Shop Fronts Old and New* (London: B. T. Batsford, 1907).

10 *Drapery Times*, March 20, 1909.

11 Haug has suggested that this perception of the shop as a stage is still present in the late-twentieth-century understandings of the department store. Wolfgang F. Haug, *Critique of Commodity Aesthetics: Appearance, Sexuality, and Advertising in Capitalist Society*, 8th ed. (Minneapolis: University of Minnesota Press, 1986), 68–69. Of course, goods take on value or meanings in many different ways. Appadurai's introduction to *The Social Life of Things* is a particularly useful overview of many of the key theorists in this field. For critical studies of contemporary advertising, see Sut Jhally, Stephen Kline, and William Leiss, eds., *Social Communication in Advertising: Persons, Products, and Images of Well-Being* (New York and London: Routledge, 1986); Sut Jhally, *The Codes of Advertising: Fetishism and the Political Economy of Meaning in the Consumer Society* (London: Frances Pinter, 1987); Kathy Myers, *Understains: The Sense and Seduction of Advertising* (London: Comedia, 1986); and Judith Williamson, *Decoding Advertisements: Ideology and Meaning in Advertising* (London: Marion Boyars, 1978); and her *Consuming Passions: The Dynamics of Popular Culture* (London: Marion Boyars, 1986).

12 For an analysis of the themes that were most commonly developed in these ads, see Richards, *The Commodity Culture of Victorian England*; and Loch, *Consuming Angels*. In "Advertising: The Magic System," in *Problems in Materialism and Culture* (London: Verso, 1980), Raymond Williams provides a short history of print advertising and the advertising profession.

13 On retailers' refusal to advertise in newspapers, see Nevett, *Advertising in Britain*, 74. On the store catalog, see Turner, *The Shocking History of Advertising!* 198. Also see Alison Adburgham, *Yesterday's Shopping: The Army and Navy Store's Catalogue, 1907*, facsimile ed. (Devon: David and Charles Reprints, 1969). Many catalogs did not match this example, however. Edward Maxwell wrote in 1904 that most were "marvels of typographical imperfection. . . . They cry Cheap! Cheap! Cheap!" "A Matter-of-Fact Talk on Advertising," *Magazine of Commerce* 4 (February 1904): 120. By 1912 the *Evening Standard* announced that newspaper advertising had replaced the "inanimate" catalogs as the medium of choice for London retailers. January 2, 1912.

14 Berthe Fortesque Harrison, "Advertising from the Woman's Point of View," *Modern Business* 2 (December 1908): 512.

15 On catalogs and American consumer culture, see Alexandra Keller, "Disseminations of Modernity: Representation and Consumer Desire in Early Mail-Order Catalogs," in Charney and Schwartz, *Cinema and the Invention of Modern Life*, 156–82.

16 Turner, *Shocking History of Advertising!* 198. On the alliance between American newspapers and department stores, Michael Schudson, *Advertising, the Uneasy Persuasion: Its Dubious Impact on American Society* (New York: Basic Books, 1984), 4.

17 Maxwell, "Matter-of-Fact Talk on Advertising," 117. On Wanamaker's use of newspaper publicity, see Simon J. Bronner, "Reading Consumer Culture," in *Consuming Visions*, 13–53. In addition to Lears's recent *Fables of Abundance*, another helpful study of American advertising is Roland Marchand, *Advertising the American Dream: Making Way for Modernity, 1920-1940* (Berkeley: University of California Press, 1985).

18 *American Register*, May 1, 1909.

19 Of course, Selfridge did not limit himself to the newspapers. In 1909 London's buses also asked, "Why Not Spend the Day at Selfridge's?" *Rialto*, April 7, 1909.

20 Artists signed their individual drawings, and their names were also republished when the designs were bound into a souvenir booklet. The artists were: Lewis Baumer, R. Anning Bell, Walter Crane, John Campbell, Stanley R. Davis, J. T Friedelson, E. Grasset, H. A. Hogg, Garth Jones, Will Lendon, Ellis Martin, John Mills, Harold Nelson, Bernard Partridge, Fred Pegram, F. V. Poole, Tony Sarge, E. J. Sullivan, S. E. Scott, Linley Sanbourne, Fred Taylor, Howard Van Dusen, Frank Wiles, J. F. Woolrich. Two women, Miss B. Ascough and Miss S. B. Pearse, drew the two cartoons promoting "Children's Day."

21 Green, *Underground Art*; Barmen, *The Man Who Built London Transport*.

22 *The Times*, March 14, 1909.

23 *Newsbasket*, May 1909. One of the most famous of his opening week cartoons should be well known to scholars of consumer culture, for Rachel Bowlby published it on the cover her book *Just Looking*.

24 *Advertising World*, November 26, 1910, 551.

25 A typical budget was about £500 a month. Nevett, *Advertising in Britain*, 74.

26 Raymond Blathwayt, "Mr. H. Gordon Selfridge: A Character Sketch," *Modern Business* 2 (August 1908–January 1909): 338, 335–343.

27 Lears, *Fables of Abundance*, 219. Also see Garvey, *The Adman in the Parlor*

28 Williams, *No Name on the Door*, 28.

29 Some of the many papers in which notices of the new store appeared include: *Barrow News, Belfast Evening Telegraph, Bolton Evening News, Bolton Journal, Bristol Times, Burton Daily Mail, Cork Constitution, Cork Examiner, Coventry Herald, Derby Daily Telegraph, Dublin Express, Dundee Courier, East Anglian Daily Times, Leicester Chronicle, Manchester Guardian, Midland Counties Express, Nottingham Echo*, and others. The foreign papers included: *African World, Egyptian Morning News, Gold Coast Leader, Indian Engineering, Toronto Evening Telegram, Transvaal Critic, Brisbane Telegraph*, and numerous German, French, American, and Commonwealth papers. Papers from different Christian faiths such as *Catholic Weekly, Christian Commonwealth, Christian World, Church Daily Newspaper*, and *British Congregationalist* praised the new shop and the pleasures of shopping, as did the *Jewish Chronicle, British Journal of Nursing, Car*, and *Co-operative News*.

30 George Warrington criticized Selfridge for not continuing the spectacular style of his opening week ads. See "If I Were Selfridge," *Modern Business*, August 4, 1909, 38.

31 Although readers thought Callisthenes was a composite of many English authors, it was a pseudonym for Selfridge and the employees whose copy he revised. Some of these were rebound under the title *Selfridge's of London: A Five-Year Retrospect* (London: Selfridge and Co., 1913).

32 Honeycombe, *Selfridges*, 172.

33 Bonavia, *London before I Forget*, 77.

34 *London Opinion*, March 27, 1909.

35 *Shoe and Leather Record*, March 19, 1909.

36 *Anglo-Continental*, March 20, 1909.

37 Leach, *Land of Desire*, 43; Lears, *Fables of Abundance*; and Stuart Culver, "What Manikins Want: *The Wonderful Wizard of Oz* and *The Art of Decorating Dry Goods Windows*," *Representations* 21 (Winter 1988): 106.

38 "The Show Window," *Retail Trader*, October 25, 1910, 18.

39 Maxwell, "A Matter-of-Fact Talk on Advertising," 118.

40 Harrison, "Advertising from the Woman's Point of View", 511.

41 R. Strauss, "Original Retailers: Mr. W. B. Fuller," *Modern Business* 3 (June 1909): 452.

42 "The Reign of the Artistic," *Success Magazine*, reprinted in *Retail Trader*, May 19, 1910, 16.

43 *Daily Chronicle*, March 16, 1909.

44 Williamson has argued that advertisements are not a "'single' language"; they "provide a structure which is capable of transforming the language of objects to that of people and vice versa." *Decoding Advertisements*, 12. For an excellent study of how advertising draws upon and reworks "prior meanings," see Timothy Burke, *Lifebuoy Men, Lux Women: Commodification, Consumption, and Cleanliness in Modern Zimbabwe* (Durham, N.C.: Duke University Press 1996), 3.

45 A female image conveying fertility and abundance was a recurrent trope in advertising of the period. Lears, *Fables of Abundance*, especially 101–10.

46 Pound, *Selfridge*, 60.

47 *Evening Standard*, March 16, 1909.

48 Bowlby, *Just Looking*, 20.

49 Marina Warner, *Monuments and Maidens: The Allegory of the Female Form* (New York: Atheneum, 1985), 140. For an analysis of how the classical female worked in other Victorian advertisements, see Loeb, *Consuming Angels*, 34–42.

50 *Daily Telegraph*, March 16, 1909.

51 *Church Daily Newspaper*, March 19, 1909.

52 *European Mail*, March 22, 1909.

53 *Daily Telegraph*, April 11, 1910.

54 *Daily Chronicle*, March 17, 1909.

55 See, for example, the ad entitled "Labor Omnia Vincit," drawn by Harold Nelson.

56 H. A. Hogg's advertisement, "Of Foundation Stones."

57 "Children's Day at Selfridge's," drawn by Bessie Ascough.

58 Mark Girouard, *The Return to Camelot: Chivalry and the English Gentleman* (New Haven: Yale University Press, 1981).

59 This foreshadowed the "capitalist realism" style described by Schudson in *Advertising, the Uneasy Persuasion*, 214–15. Such ads illuminate Haug's argument that "commodities borrow their aesthetic language from human courtship; but then the relationship is reversed and people borrow their aesthetic expression from the world of the commodity." Haug, *Critique of Commodity Aesthetics*, 19.

60 *Daily News*, *Telegraph*, and *Westminster Gazette*, March 19, 1909.

61 Selfridge's advertising illuminates how the consumer was identified as having a "polymorphous potential to desire everything." Birken, *Consuming Desire*, 50.

62 *Daily Chronicle*, March 20, 1909.

63 Bailey, "Parasexuality and Glamour."

64 *Evening Standard*, January 22, 1912.

65 *Evening Standard*, December 11, 1915.

66 *Evening Standard*, May 1912 (specific date not available).

67 *Standard*, March 20, 1909.

68 *Evening Standard* and *Pall Mall Gazette*, May 13, 1912.

69 Various journals debated whether or not Selfridge's fulfilled this goal. The *Lady*, for example, believed that the store made the average woman feel "at home," while *Truth* thought there was a world of difference between the crowd invited to a private social event and that invited to Selfridge's. *Lady*, March 18, 1909; and *Truth*, May 5, 1909.

70 For parallel examples, see Lauren Rabinovitz, "Temptations of Pleasure: Nickelodeons, Amusement Parks, and the Sights of Female Sexuality," *Camera Obscura* 23 (May 1990): 71–89; Tony Bennett, "A Thousand and One Troubles: Blackpool Pleasure Beach," in Jameson, *Formations of Pleasure*, 138–55.

71 *Daily News*, March 22, 1909. See also *Justice*, March 20, 1909.

72 Honeycombe, *Selfridges*, 39.

73 *Daily Telegraph*, July 27, 1909.

74 *Hardware Trade Journal*, March 3, 1913. On the interplay between the market and the theater in the early-modern period, see Agnew, *Worlds Apart*.

PART FIVE

Cities and the Built Environment

VANESSA R. SCHWARTZ AND
JEANNENE M. PRZYBLYSKI

T HE EMPHASIS ON DISPLAY and novel technologies of vision has been linked to new consuming publics. The density of these crowds is embedded in one of the main transformations of the nineteenth century: urbanization. While the existence of cities stretches back to antiquity, the nineteenth century is fundamentally associated with urban life. This is due in part to the demographic phenomenon in which the countryside in Western Europe witnessed enormous out-migration into old cities and also helped form new industrial ones. Representations of urban life became an essential part of this social historical development. Seeing the city and seeing in the city became a preoccupation of the urban experience. City life saturated old forms of representation in new ways (Impressionist painting), offered entirely novel forms such as posters on city buildings, and made city planning and design a central part of the way that political regimes represented their agendas in the face of increasing democratization. In short, Part Five presents multiple points of view for discussing the ways in which cities in the nineteenth century became the crystallization of the spectacle of modern life.

In particular, the essays in this section suggest the fundamentally visual character of nineteenth-century urbanization. City spaces and their design and planning could represent the visual expression of social values as demonstrated by Carl E. Schorske's examination of the Ringstrasse in Vienna. T.J. Clark's consideration of the classic urban modernization—the "Haussmannization" of Paris—connects the design of the city and its effects to the painting of the period. Clark's signal contribution is that he does more than simply see in paintings a reflection of urban changes. He points to the need to represent the city itself and the ambivalence of these images to suggest that painting underscored the fact that the city, after its modernization, belonged to its inhabitants only as an image. Images of Paris replaced actual social relations among inhabitants.

Other contributions seek to understand the ways that novel representational forms and practices shaped new urban audiences and their identity as urban dwellers. While the buildings and paintings discussed in Schorske and Clark rely on fairly traditional visual objects,

David Henkin turns to billboards and banners, David Nye to electric illumination and Jennifer Watts to amateur photographs to identify the way that new modes of display and new media changed the look of the city and also contributed to the constitution of new audiences based on the anonymity of urban life. Although many scholars have pointed to the emergence of "flânerie" as a mode of elite male observation through which the city and the urban landscape became "legible" and coherent, several of the selections also acknowledge a more open and fluid urban practice of observation. Judith Walkowitz suggests that a new urban geography also opened up communities to urban observation and that the earlier interest in urban pathology and decline was matched by a new commercialized landscape.

So much of the peculiarly visual culture of the nineteenth century is so centrally related to urban culture that readers will find examples of urban institutions and practices throughout the collection. What distinguishes these contributions is that they not only transpire in the city, but they take the issue of the city and its visual representation as their primary axis of consideration.

CARL E. SCHORSKE

THE RINGSTRASSE, ITS CRITICS, AND THE BIRTH OF URBAN MODERNISM

IN 1860, THE LIBERALS OF AUSTRIA took their first great stride toward political power in the western portion of the Habsburg Empire and transformed the institutions of the state in accordance with the principles of constitutionalism and the cultural values of the middle class. At the same time, they assumed power over the city of Vienna. It became their political bastion, their economic capital, and the radiating center of their intellectual life. From the moment of their accession to power, the liberals began to reshape the city in their own image, and by the time they were extruded from power at the century's close, they had largely succeeded: the face of Vienna was transformed. The center of this urban reconstruction was the Ringstrasse. A vast complex of public buildings and private dwellings, it occupied a broad belt of land separating the old inner city from its suburbs. Thanks to its stylistic homogeneity and scale, "Ringstrasse Vienna" has become a concept to Austrians, a way of summoning to mind the characteristics of an era, equivalent to the notion "Victorian" to Englishmen, "*Gründerzeit*" to Germans, or "Second Empire" to the French.

Toward the close of the nineteenth century, when the intellectuals of Austria began to develop doubts about the culture of liberalism in which they had been raised, the Ringstrasse became a symbolic focus of their critique. Like "Victorianism" in England, "*Ringstrassenstil*" became a quite general term of opprobrium by which a generation of doubting, critical, and aesthetically sensitive sons rejected their self-confident, parvenu fathers. More specifically, however, it was against the anvil of the Ringstrasse that two pioneers of modern thought about the city and its architecture, Camillo Sitte and Otto Wagner, hammered out ideas of urban life and form whose influence is still at work among us. Sitte's critique has won him a place in the pantheon of communitarian urban theorists, where he is revered by such recent creative reformers as Lewis Mumford and Jane Jacobs. Wagner's conceptions, radically utilitarian in their basic premises, have earned him the praises of modern functionalists and their critical allies, the Pevsners and the Giedions. In their contrasting views, Sitte and Wagner brought to thought about the city the archaistic and modernistic objections to nineteenth-century civilization that appeared in other areas of Austrian life. They manifested in their urban theory and spatial design two salient features of emergent twentieth-century Austrian higher culture—a sensitivity to psychic states, and a concern with the penalties as well as the possibilities of rationality as the guide of life.

I shall first consider the Ringstrasse itself as a visual expression of the values of a social class. It is important to remember, however, that there was more to municipal development than the projection of values into space and stone. The liberals who ruled Vienna put some of their most successful efforts into the undramatic technical work which made the city capable of accommodating in relative health and safety a rapidly increasing population. They developed

with remarkable dispatch those public services common to the expanding modern metropolis throughout the world. The Danube was channeled to protect the city against the floods that had plagued it for centuries. The city's experts developed in the sixties a superb water supply. In 1873, with the opening of the first city hospital, the liberal municipality assumed, in the name of medical science, the traditional responsibilities which previously the church had discharged in the name of charity. A public health system banished major epidemics, though tuberculosis remained a problem in the working-class districts.[1] Unlike Berlin and the industrial cities of the north, expanding Vienna generally retained its Baroque commitment to open space. To be sure, parks were conceived no longer exclusively in the language of geometry, but also in the physiological, organic terms favored by the nineteenth century: "Parks," said Mayor Kajetan Felder, "are the lungs of a megalopolis."[2] In the provision of parks, utilities, and public services, the liberals of Vienna established a respectable record.[3] By contrast, those features of city planning for which Vienna later became famous—the provision of low-cost housing and the social planning of urban expansion—were altogether absent in the Ringstrasse era.* The planning of the Ringstrasse was controlled by the professional and the well-to-do for whose accommodation and glorification it was essentially designed. The imperial decree governing its development program exempted the rest of the city from the purview of the City Expansion Commission and thus left it to the tender mercies of the private construction industry. Public planning was based on an undifferentiated grid system, with control applied only to the height of buildings and the width of streets.[4]

Whatever the strengths and weaknesses of the liberal city fathers in defining and developing the public services which are the bone and muscle of the modern city, they took their greatest pride in transforming the city's face. The new development of Vienna, by virtue of its geographical concentration, surpassed in visual impact any urban reconstruction of the nineteenth century—even that of Paris. In the new Vienna, the fathers "projected their image" no less consciously than the managers of the Chase Manhattan Bank a few years ago proclaimed their character in what they called the "soaring angularity" of their New York modular skyscraper. The practical objectives which redesigning the city might accomplish were firmly subordinated to the symbolic function of representation. Not utility but cultural self-projection dominated the Ringstrasse. The term most commonly used to describe the great program of the sixties was not "renovation" or "redevelopment," but "beautification of the city's image [*Verschönerung des Stadtbildes*]."[5] More economically than any other single source, the great forum built along Vienna's Ringstrasse, with its monuments and its dwellings, gives us an iconographic index to the mind of ascendant Austrian liberalism.

That Vienna should have had at its center a huge tract of open land available for modern development was, ironically, a consequence of the city's historical backwardness. Well after other European capitals had razed their fortifications, Vienna had maintained them. The massive defense works and the broad glacis which had protected the imperial capital against the marauding Turk had long since ceased to define the city limits. [. . .] The inner city remained insulated from its suburbs by the vast belt of open land. Joseph II, the benevolent "people's emperor," developed much of the glacis as a recreational area, but the Revolution of 1848 redefined, both politically and militarily, the place of the glacis in the life of the city. The abolition of feudal political jurisdiction led to the incorporation of the suburbs fully into the city.

* There were two exceptions: the establishment of a single public housing project by a foundation created for Francis Joseph's Jubilee in 1898; and a commercial project of 1912. See Hans Bobek and Elisabeth Lichtenberger, *Wien* (Graz-Cologne, 1966), pp. 56–7.

At the same time, the liberals extracted from the emperor the right to municipal self-government after three centuries of direct imperial rule. The new municipal statute of March 6, 1850, although not fully implemented until the introduction of constitutional government for all Austria in 1860, provided a political framework for advancing civilian claims to the glacis. Behind the political pressure lay the rapid economic growth of the 1850's, which created for the city of half-a-million both a population influx and a severe housing shortage.*[6]

The Revolution of 1848, while issuing in increased political and economic demands for the civilian utilization of the defense zone, also revitalized its strategic importance. The enemy in question was now not a foreign invader but a revolutionary people. Through most of the 1850's, the Austrian army, smarting from having had to withdraw from Vienna in 1848, opposed plans for civilian development of the glacis. The Central Military Chancellery took as its major premise the persistence of a revolutionary threat. The imperial court must be secure against possible attacks "from the proletariat in the suburbs and outlying localities. Only the army could be relied upon to defend the imperial government," Generaladjutant Karl Grünne maintained, arguing as late as 1857 against the proposal to scrap the fortifications. In a period of "revolutionary swindle," he said, even the conservatives would remain passive in the face of "tumult."[7]

As the fifties progressed, economic needs proved stronger than counterrevolutionary fears in the highest councils of government. On December 20, 1857, Emperor Francis Joseph proclaimed his intention to open the military space to civilian uses, and established a City Expansion Commission to plan and execute its development. The liberal *Neue Freie Presse* later interpreted the symbolic import of the event in the language of fairy tale: "The imperial command broke the old cincture of stone which for many centuries kept Vienna's noble limbs imprisoned in an evil spell."[8] Yet the author of these lines, writing in 1873 when the liberals had taken over the Ringstrasse, distorted the beginnings of the development. In fact, during the first three years (1857–60), the allocation of space and especially the priorities for monumental building still expressed the values of dynastic neo-absolutism. First came a great church, the Votivkirche (1856–79)—"a monument of patriotism and of devotion of the people of Austria to the imperial House"—built to celebrate the emperor's escape from the bullet of a Hungarian nationalist assassin. Financed by public subscription under the leadership of the royal family and the higher clergy, the Votivkirche expressed the unbreakable unity of throne and altar against what Vienna's Archbishop, Joseph Cardinal von Rauscher, called at the cornerstone-laying ceremonies "the mortally wounded tiger of Revolution."[9] The fact that the Votivkirche was intended to serve simultaneously as church for the garrison of Vienna and as a Westminster Abbey for Austria's greatest men made it, in the words of the *Neue Freie Presse*, a symbol of the "*Säbel- und Kultenregiment* [the rule of the sabre and religion]."

The military for its part, although it lost the battle for the walls and fortifications, received favored treatment in the first Ringstrasse plans. To complete its chain of modernized counterinsurgency facilities, a program already well advanced by 1858, an imposing new arsenal complex and two barracks were strategically constructed near railway stations that could feed reinforcements into the capital from the provinces. Huge tracts of land adjacent to the Hofburg continued to be reserved as protective fields of fire against the suburbs.†[10] Finally, the military

* Between 1840 and 1870, both the population of Vienna and the number of economic enterprises doubled.

† The Arsenal near the South Station was built to house three regiments and an artillery workshop in 1849–55. The architects Siccardsburg and van der Nüll participated in the work, although both had been officers in the Academic Legion, the main military force defying the Army in 1848. The Arsenal was supplemented by the sumptuous Military Museum, the first "cultural institution" built on the glacis. Its architect was Theophil Hansen, an, enthusiast for the

left its imprint on the Ringstrasse as a thoroughfare. With fortifications gone, Austrian army spokesmen, like their contemporary counterparts in the construction of the boulevards of Paris, favored the broadest possible street to maximize mobility for troops and to minimize barricading opportunities for potential rebels.*[11] Hence the street was designed as a broad artery totally surrounding the inner city in order to facilitate the swift movement of men and matériel to any point of danger. Military considerations thus converged with civilian desires for an imposing boulevard to give the Ringstrasse both its circular form and its monumental scale.

Within a decade of the imperial decree of 1857, political developments had transformed the neo-absolutist régime into a constitutional monarchy. The army, defeated by France and Piedmont in 1859 and by Prussia in 1866, lost its decisive voice in the councils of state, and liberals took the helm. As a consequence, the substance and meaning of the Ringstrasse program changed, responding to the will of a new ruling class to erect a series of public buildings expressing the values of a *pax liberalis*. [. . .]

The contrast between the old inner city, and the Ring area inevitably widened as a result of the political change. The inner city was dominated architecturally by the symbols of the first and second estates: the Baroque Hofburg, residence of the emperor; the elegant palais of the aristocracy; the Gothic Cathedral of St. Stephen and a host of smaller churches scattered through the narrow streets. In the new Ringstrasse development, the third estate celebrated in architecture the triumph of constitutional *Recht* over imperial *Macht*, of secular culture over religious faith. Not palaces, garrisons, and churches, but centers of constitutional government and higher culture dominated the Ring. The art of building, used in the old city to express aristocratic grandeur and ecclesiastical pomp, now became the communal property of the citizenry, expressing the various aspects of the bourgeois cultural ideal in a series of so-called *Prachtbauten* (buildings of splendor).

Although the scale and grandeur of the Ring suggest the persistent power of the Baroque, the spatial conception which inspired its design was original and new. Baroque planners had organized space to carry the viewer to a central focus: space served as a magnifying setting to the buildings which encompassed or dominated it. The Ringstrasse designers virtually inverted Baroque procedure, using the buildings to magnify the horizontal space. They organized all the elements in relation to a central broad avenue or corso, without architectonic containment and without visible destination. The street, polyhedral in shape, is literally the only element in the vast complex that leads an independent life, unsubordinated to any other spatial entity. Where a Baroque planner would have sought to join suburb and city—to organize vast vistas oriented toward the central, monumental features—the plan adopted in 1859, with few exceptions, suppressed the vistas in favor of stress on the circular flow. Thus the Ring cut the old center off from the new suburbs. ". . . [T]he inner city," wrote Ludwig von Förster, one of the chief planners, "acquired a closed and regular form by filling in its irregular edges as a seven-sided figure around which one of the most lordly promenades, the corso, could run [*ziehen*], and could separate the inner city from the outer suburbs."[12] Instead of a strong radial system, which one would expect to link the outer parts and the city center, most of the streets that enter the Ring area from either inner city or suburb have little or no prominence. They debouche in the circular flow without crossing it. The old city was thus

Greek Revolution who later designed the Austrian Parliament building. The largest of the barracks was the Franz-Josef Kaserne (1854–57), which was torn down at the century's end to make way for a new War Ministry, seat of the new-style bureaucratized army.

*The army pressed in vain for the street itself to be still wider than the 82 feet stipulated for it.

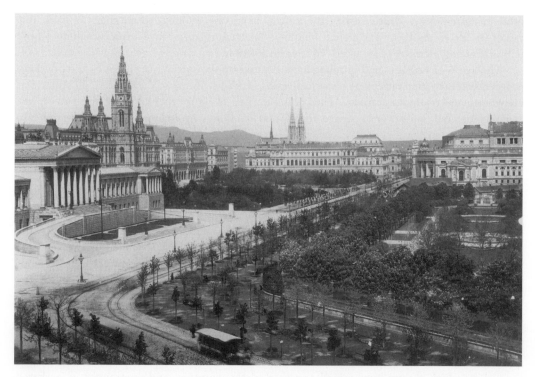

Figure 20.1 Ringstrasse, showing (left to right) Parliament, Rathaus, University, and Burgtheater, *c.* 1888. Courtesy of the Austrian National Library, Picture Archive, Vienna (111.800-C).

enclosed by the Ring—reduced, as one critic has observed, to something museum-like.[13] What had been a military insulation belt became a sociological isolation belt.

In the vast, continuous circular space of the Ring, the great representational buildings of the bourgeoisie were placed sometimes in clusters, sometimes in isolation. Only rarely were they oriented to each other under some principle of subordination or primacy. The broad avenue does not focus upon them; rather, the buildings are separately oriented toward the avenue, which serves as the sole principle of organizational coherence. The photograph in Figure 20.1, taken where the Ringstrasse rounds one of its corners at the Parliament building, reveals the linear power generated by the street. The University at center right does not face the Parliament at left, which is separated from it by the park. Like the Parliament itself and like the Rathaus rising at center left, the University fronts the Ringstrasse quite independent of its neighbors' weighty presence.* Trees running along the entire length of the Ringstrasse only serve to heighten the primacy of the street and the isolation of the buildings. Vertical mass is subordinated to the flat, horizontal movement of the street. No wonder that the "ring *street*" gave the whole development its name.

The several functions represented in the buildings—political, educational, and cultural— are expressed in spatial organization as equivalents. Alternate centers of visual interest, they are related to each other not in any direct way but only in their lonely confrontation of the

* Notable exceptions to street-centered placement are the two major museums, of Art History and Natural History, which face each other across a space conceived by its planners as a square.

great circular artery, which carries the citizen from one building to another, as from one aspect of life to another. The public buildings float unorganized in a spatial medium whose only stabilizing element is an artery of men in motion.

The sense of isolation and unrelatedness created by the spatial placement of the buildings is accentuated by the variety of historical styles in which they were executed. In Austria as elsewhere, the triumphant middle class was assertive in its independence of the past in law and science. But whenever it strove to express its values in architecture, it retreated into history. As Förster had observed early in his career (1836), when he set out to bring the treasures of the past to the attention of modern builders in his journal, *Die Bauzeitung*, ". . . [T]he genius of the nineteenth century is unable to proceed on its own road. . . . The century has no decisive color."[14] Hence it expressed itself in the visual idiom of the past, borrowing that style whose historical associations were most appropriate to the representational purpose of a given building.

The so-called Rathaus Quarter also exemplifies the pluralism of architectural styles and its ideational significance. The four public buildings of this sector together form a veritable quadrilateral of *Recht* and *Kultur*. They represent as in a wind rose liberalism's value system: parliamentary government in the Reichsrat building, municipal autonomy in the Rathaus, the higher learning in the University, and dramatic art in the Burgtheater. Each building was executed in the historical style felt to be appropriate to its function. Thus to evoke its origins as a free medieval commune, now reborn after a long night of absolutist rule, liberal Vienna built its Rathaus in massive Gothic [Figure 20.2]. The Burgtheater, housing the traditional queen of Austria's arts [Figure 20.3], was conceived in early Baroque style, commemorating the era in which theater first joined together cleric, courtier, and commoner in a shared aesthetic enthusiasm. On the grand staircase within, one of the youngest masters of Ringstrasse

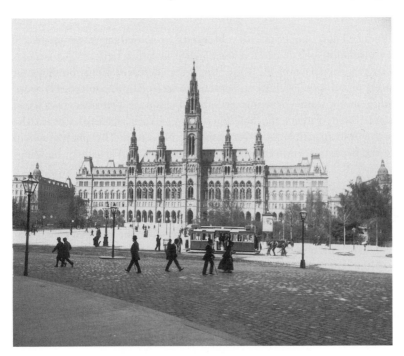

Figure 20.2 Rathaus, Friedrich Schmidt, architect, 1872–83. Courtesy of the Austrian National Library, Picture Archive, Vienna (138968B).

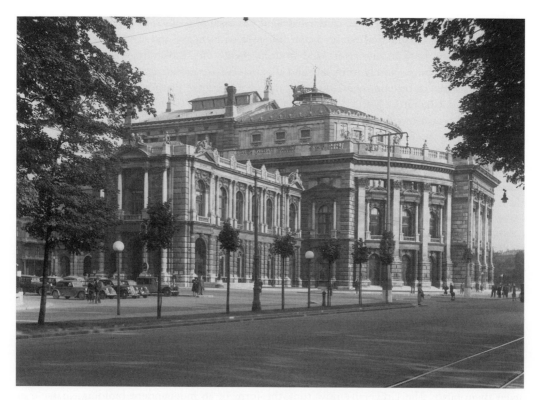

Figure 20.3 Hofburgtheater, Gottfried Semper and Carl Hasenauer, architects, 1874–88. Courtesy of the Austrian National Library, Picture Archive, Vienna (39704B).

painting, Gustav Klimt, won his spurs in decorating the ceiling with canvases depicting the history of the theater. Like the Opera and the Museum of Art History, the Burgtheater provided a meeting ground for the old aristocratic and new bourgeois élites, where differences of caste and politics could be, if not expunged, at least attenuated by a shared aesthetic culture. The imperial court (*Hof*) could comfortably extend itself to the newly widened public in the institutes of the performing arts—the *Hof*burgtheater, *Hof*oper, *Hof*museen—while the new bourgeoisie could eagerly absorb traditional culture in those arts without surrendering its proud sense of separateness in religion, politics, and science.

The Renaissance-style University, in contrast to the Burgtheater, was an unequivocal symbol of liberal culture. Accordingly, it had long to wait to realize its claims to a significant building site on the Ringstrasse. As the citadel of secular rationalism, the University was the last to win recognition from the diehard forces of the Old Right, and suffered first from the rise of a populist, anti-Semitic New Right. The siting of the University and even its architectural style occasioned years of conflict within the government and among its shifting constituent social interest groups. For years the University dwelt under the shadow of its role in the Revolution of 1848. The Academic Legion, composed of faculty and students of the University and other institutions of higher learning, had been the heart of revolutionary Vienna's organized fighting force. The imperial army could neither forget nor forgive its own ignominious withdrawal in the face of the intelligentsia-in-arms. After the suppression of the revolution, the military occupied the old University in the inner city, and forced the dispersion of its functions

in buildings scattered through the outer districts. On assuming office in July 1849, the aristocratic, pious, but enlightened conservative Minister of Religion and Instruction, Count Leo Thun, had sought both to modernize and to domesticate the University, to restore its autonomy yet to link it more closely to throne and altar. He strove in vain against the army and other political objectors to bringing the University out of its punitive diaspora. From 1853 to 1868, Thun and his collaborators worked to create a new English- and Gothic-style University quarter which would be clustered around the Votivkirche—to no avail.[15]

The University problem was resolved only when the liberals came to power. At that time, the three public institutions most important to the liberals—University, Parliament, and Rathaus—were still housed in quarters either temporary, or inadequate, while the army held on to the parade ground, the last open tract (over 500 acres) of the old glacis. Immediately after its formation in 1868, the new *Bürgerministerium* (Citizens' Ministry) petitioned the emperor for that plot, without success. Mayor Kajetan Felder finally broke the deadlock by setting up a commission consisting of the three architects for Parliament, Rathaus, and University to draw site plans to accommodate all three buildings on the parade ground. In April 1870, with the enthusiastic support of the liberal-dominated city council, Felder won the emperor's approval for the triple building plan. Against a large compensatory payment from the City Expansion Fund, the army finally surrendered its *champ de Mars* to the champions of liberal politics and learning.[16]

The political change that made possible the location of the University in a place of highest honor on the Ringstrasse was reflected also in the form and style of the building itself. Count Thun's plans for a medievalizing *cité universitaire*, with Gothic buildings huddled about the Votivkirche like chicks around a mother hen, faded with the neo-absolutist politics that had given them birth. The University now took the form of an independent building, massive in feeling and monumental in scale. Not Gothic, but Renaissance was the style chosen for it, to proclaim the historical affiliation between modern, rational culture and the revival of secular learning after the long night of medieval superstition.

Its designer, Heinrich Ferstel (1828–1883), a Vicar of Bray even among the politically flexible architects of the day, commanded all the varieties of historical "style-architecture," as it was called, ready to meet the changes in preference that accompanied changes in political power. The son of a banker, Ferstel had had his youthful moment as a revolutionary in the Academic Legion in 1848, but soon retrieved this blighted start as architect for the Bohemian aristocracy in the conservative fifties. With the patronage of one of these aristocrats, Count Thun, Ferstel soared to fame as architect of the Votivkirche.[17] But when the liberal phase of University planning finally began, Ferstel was commissioned to design a building in Renaissance style. He went to the cradle of modern humanist learning, Italy, to study the universities of Padua, Genoa, Bologna, and Rome. To be sure, certain natural scientists objected to Ferstel's seeking to outdo in his imposing structure the models of the Renaissance past. Those venerable buildings, their petition ran, did not serve the purpose of furthering the natural sciences. These flowered elsewhere—in the universities of Berlin and Munich, the Collège de France, the University of London. In their simple buildings, "better suited to sober requirements . . . the exact sciences can feel comfortable." But even these critics advanced their functional views somewhat apologetically, accommodating themselves in the end to the prevailing emphasis on representational considerations: "When everyone is marvelling at the style of the Italian universities, then surely we shall gain great glory if we outdo them." Renaissance thus won the day as the proper style for Vienna's monumental center of liberal learning.

Perhaps the most imposing building in the quadrilateral of *Recht* and *Kultur* was the Reichsrat or Parliament [Figure 20.4]. Its Danish architect, Theophil Hansen (1813–1891),

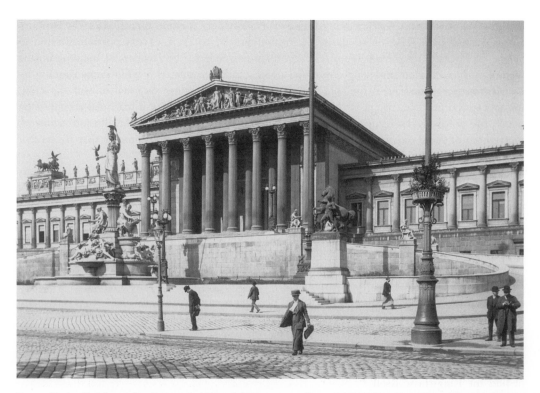

Figure 20.4 Reichsrat (Parliament), Theophil Hansen, architect, 1874–83. Courtesy of the Austrian National Library, Picture Archive, Vienna (144751-B).

built five of the public buildings in the Ringstrasse complex,* but it was on the Parliament that he lavished his greatest effort. He selected the style he most revered—the classical Greek—to dress the exterior of the building, even though its articulated, blocklike volumes had greater affinity with the Baroque. A true Philhellene, Hansen believed that his "noble, classical forms would produce with irresistible force an edifying and idealizing effect on the representatives of the people."[19] As in the case of the University, the plans for the form, style, and location of the Parliament changed as the power of the liberals grew. At first the two houses of the legislature were to be in separate buildings executed in different styles. In his original plans Hansen projected the House of Lords in classical Greek, the "nobler" style. For the House of Representatives, he contemplated Roman Renaissance. But all plans were suspended with the Austro-Prussian War and the ensuing internal crisis in 1866. When the smoke cleared and a more liberal constitution was established, it was decided in 1869 to unite the two houses in "a single monumental building of splendor [*Prachtbau*]," with a wing for each House. A shared central hall, shared reception rooms for the presidents of both chambers, and the adoption of the "nobler" Greek style for the whole symbolized the hoped-for parliamentary integration of peers and people.[20] No expense was spared to provide the richest materials for the execution of Hansen's sumptuous plans.

 The liberation of the parade ground from the army also gave the Parliament a site befitting its new political importance. Instead of the modest location originally contemplated,†

* Hall of the Music Society, Academy of Fine Arts, Stock Exchange, Evangelical School, and Parliament.
† On the present Schillerplatz.

the building now assumed prime Ringstrasse frontage, where it could directly face the Hofburg across a small park. Hansen so designed the building as to create every possible illusion of height, as Figure 20.4 shows. He placed the main entrance to the Parliament building on the second story within an imposing columned porch, and constructed a wide ramp running up to it from the ground level for vehicles. The vigorous ascending diagonal line of the ramp imparts to the massive, rough-textured ground floor the character of a masoned acropolis on which the polished classic upper stories rest. Yet, however ingenious the illusion achieved, the temple of *Recht* did not secure the effect of dominating its environment that its creator seems to have wished for it.

The statuary gracing the ramp betrayed the degree to which Austrian parliamentary liberalism sensed its lack of anchorage in the past. Having no past, it had no political heroes of its own to memorialize in sculpture. It borrowed a pair of "tamers of horses" from Rome's Capitol Hill to guard the entrance to the ramp. Along the ramp itself were placed the figures of eight classical historians—Thucydides, Polybius, and other worthies. Where historical tradition was lacking, historical erudition had thus to fill the void. Finally Athena was chosen as central symbol to stand at the front of the new building. Here myth stepped in where history failed to serve. The Austrian parliamentarians did not gravitate toward a figure as freighted with a revolutionary past as Liberty. Athena, protectrix of the polis, goddess of wisdom, was a safer symbol. She was an appropriate deity, too, to represent the liberal unity of politics and rational culture, a unity expressed in the oft-repeated Enlightenment slogan, "Wissen macht frei" (Knowledge makes [us] free). Despite her grand scale, Athena is no more able to dominate the scene than Hansen's Reichsrat. She stares stonily across the windswept center of life: the Ringstrasse itself.*

The primacy of the stylistically imposing over the functionally useful, which is present even in the well-designed Parliament building, did not always appeal to the practical men who sat on the building committees. In 1867, when the architects Ferstel and Hansen submitted plans for the museums of Art History and Natural History that provided inadequate interior space in the interest of the facades, one of the committee members countered by drawing an engineer's sketch of "a functional structure [*Nutzbau*], with a usable floor plan and an unusable facade." A new architect, Gottfried Semper, who advocated in principle the unity of utility and splendor, had to be brought in from Germany to reconcile the conflicting demands.[21] Interestingly enough, it was only in urban building that the bourgeois fathers felt impelled to assert the primacy of the aesthetic. In the countryside, they felt no need to screen their businesslike identity. Thus when the city councilmen had to select a style for the Baden aqueduct of the new Vienna water supply system, they rejected a suggestion for "something with decoration [*etwas mit Schmuck*]." Instead, they followed the advice of one of the architects, who averred that for such a practical structure in the countryside, there was only one appropriate style, "which is called the style of Adam; namely, naked and strong."[22] In the city, such a baring of muscle would have been considered gross. There the truth of industrial and commercial society had to be screened in the decent draperies of pre-industrial artistic styles. Science and law were modern truth, but beauty came from history.

Taken as a whole, the monumental buildings of the Ringstrasse expressed well the highest values of regnant liberal culture. On the remnants of a *champ de Mars* its votaries had reared the political institutions of a constitutional state, the schools to educate the élite of a free people, and the museums and theaters to bring to all the culture that would redeem the *novi*

* Kundmann's statue of Athena, though a part of Hansen's plan, was erected only in 1902, nearly twenty years after the completion of the building, and long after the spirit of rationality had abandoned the Reichsrat.

homines from their lowly origins. If entry into the old aristocracy of the genealogical table was difficult, the aristocracy of the spirit was theoretically open to everyone through the new cultural institutions. They helped forge the link with the older culture and the imperial tradition, to strengthen that "second society," sometimes called "the mezzanine," where the bourgeois on the way up met the aristocrats willing to accommodate to new forms of social and economic power, a mezzanine where victory and defeat were transmuted into social compromise and cultural synthesis.

The contemporary liberal historian Heinrich Friedjung interpreted the Ringstrasse development as a whole as a redeemed pledge of history, the realization of the labors and sufferings of generations of ordinary Viennese burghers, whose buried wealth and talent were finally exhumed in the late nineteenth century "like huge coal beds lying under the earth." "In the liberal epoch," Friedjung wrote, "power passed, at least in part, to the bourgeoisie; and in no area did this attain fuller and purer life than in the reconstruction of Vienna."[23]

One young provincial, Adolf Hitler, who came to Vienna because, as he said, he "wanted to be something," fell under the Ringstrasse's spell no less than Friedjung: "From morning until late at night," he wrote of his first visit, "I ran from one object of interest to another, but it was always the buildings that held my primary interest. For hours I could stand in front of the Opera, for hours I could gaze at the Parliament; the whole Ring Boulevard seemed to me like an enchantment out of 'The Thousand-and-One Nights.'"*[24] As an aspiring artist and architect, Hitler soon learned in frustration that the magical world of *Recht* and *Kultur* was not easy to penetrate.[25] Three decades later he would return to the Ring as the conqueror of all it stood for.

Notes

1 Hans Bobek and Elisabeth Lichtenberger, *Wien* (Graz-Cologne, 1966), pp. 60–1.
2 Karl Glossy, "Kajetan Felder," *Neue Oesterreichische Biographie*, IV, 215–17. (Hereafter *N.O.B.*)
3 For a detailed account of Vienna's administrative history, see Rudolf Till, *Geschichte der Wiener Stadtverwaltung* (Vienna, 1957), pp. 38–99.
4 Bobek and Lichtenberger, *Wien*, pp. 45–7.
5 Eduard Suess, *Erinnerungen* (Leipzig, 1916), p. 171.
6 For the generative structure behind the transformation of the city in the nineteenth century, see Bobek and Lichtenberger, *Wien*, pp. 30–41.
7 For the complex evolution of the military attitude toward the city's expansion plans, see Walter Wagner, "Die Stellungnahme der Militärbehörden zur Wiener Stadterweiterung in den Jahren 1848–1857," *Jahrbuch des Vereines für Geschichte der Stadt Wien*, XVII/XVIII (1961–2), 216–85. For Grünne's final position on the eve of the emperor's approval of the opening of the glacis, see *ibid.*, 282–4.
8 *Neue Freie Presse*, Dec. 2, 1873 (Morgenblatt).
9 Reinhold Lorenz, "Politische Geschichte der Wiener Ringstrasse," *Drei Jahrhunderte Volk, Staat und Reich* (Vienna, 1944), pp. 487–9. The allocation of glacis land for the church anticipates, of course, the general edict of 1857 releasing the area.
10 Heinrich Friedjung, *Oesterreich von 1848 bis 1860* (3rd ed.; Stuttgart and Berlin, 1912), II, i, 424–6.
11 Wagner, *Jahrbuch . . . Wiens*, XVII/XVIII, 284.
12 Quoted in Bruno Grimschitz, *Die Wiener Ringstrasse* (Bremen and Berlin, 1938), p. 6. See also Renate Wagner-Rieger, ed., *Die Wiener Ringstrasse, Bild einer Epoche* (Vienna-Cologne-Graz, 1969 *et seq.*), I. *Das Kunstwerk im Bild* (1969), 87.
13 Grimschitz, *Ringstrasse*, p. 6. The best discussion of the radial communication pattern is that of the geographer Elisabeth Lichtenberger, *Wirtschaftsfunktion und Sozialstruktur der Wiener Ringstrasse*, in Wagner-Rieger, ed., *Die Wiener Ringstrasse*, VI, 24–6.

* Hitler's close, personal, and often perceptive criticism of the Ringstasse makes clear its power and vitality as symbol of a way of life.

14 Quoted in Grimschitz, *Ringstrasse*, p. 8.
15 Norbert Wibiral and Renata Mikula, *Heinrich von Ferstel*, in Wagner-Rieger, ed., *Wiener Ringstrasse*, VIII, iii, 44–9.
16 Lorenz, *Drei Jahrhunderte*, pp. 497–9; Friedjung, *Oesterreich*, 1848–1860, II, i, 426–7; Wibiral and Mikula, *Ferstel*, pp. 55–7.
17 A true man of the "second society," in which bourgeois-aristocratic fusion was accomplished, Ferstel built not only great public buildings but palaces for members of the imperial family and bankers, and also apartment houses for speculative construction companies. For Ferstel's career, see Wibiral and Mikula, *Ferstel, passim*; on his involvement with the various University projects, pp. 44–75.
18 Quoted from a faculty petition of Aug. 4, 1871, in *ibid.*, p. 61.
19 Conversation with Hansen reported by Suess in *Erinnerungen*, pp. 171–2. Hansen had served as teacher and architect in the young Greek monarchy from 1838 to 1846 and had designed the Greek Academy of Sciences in 1861.
20 These and other details in the history of the planning were included by the joint parliamentary planning commission in its *Bericht zur Begutachtung der Pläne für das neue vereinigte Parlaments-gebäude zu Wien eingesetzten gemischten Kommission*, March 5, 1873, Baron Kübeck, *Berichterstatter* (Vienna, 1873). See also Renate Wagner-Rieger, *Wiens Architektur im 19. Jahrhundert* (Vienna, 1970), pp. 177–8.
21 Suess, *Erinnerungen*, pp. 171–2. For the great debate over the museum competition, see *Festschrift des historischen Museums zur Feier des fünfzig-jährigen Bestandes*. Part I. Alphons Lhotsky, *Die Baugeschichte der Museen und der neuen Burg* (Vienna, 1941), pp. 53–92.
22 Suess, *Erinnerungen*, p. 216.
23 Friedjung, *Oesterreich*, II, i, 427–8.
24 Adolf Hitler, *Mein Kampf*, tr. Ralph Mannheim (Boston, 1943), p. 19.
25 *Ibid.*, chs. II and III, *passim*.

Chapter 21

T.J. CLARK

THE VIEW FROM NOTRE-DAME

[. . .]

IT MIGHT BE BEST TO BEGIN a description of Haussmannization at the edge of Paris, after the baron's work was done. Some time in 1886—let us assume it was subsequent to seeing Seurat's *Dimanche après-midi à l'île de La Grande Jatte* in the artist's studio or the Impressionist exhibition—Vincent van Gogh painted a small picture of the city's northern outskirts [Figure 21.1]. We cannot be sure whether the tract of land he shows us stretches away to the north or the south, but it must be roughly one point of the compass or the other, for we are somewhere in the brief interval of open country between the working suburbs of Clignancourt and the iron-and-steel town of Saint-Denis to the north.

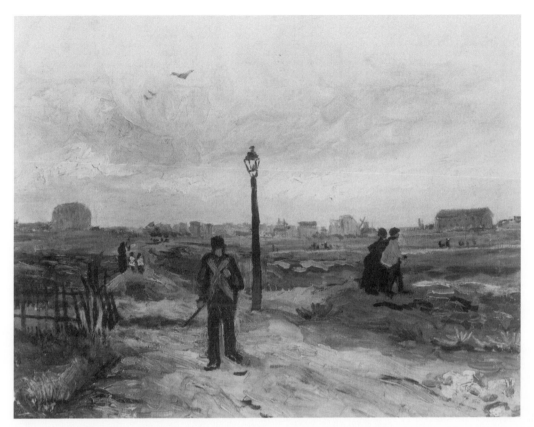

Figure 21.1 The Outskirts of Paris, Vincent van Gogh, 1886. Private collection.

It was not unusual in the 1880s for a painter to choose a subject like this and believe it to be modern and poetical. There was a notion in the nineteenth century that the city divulged its secrets in such places, and that the curious ground between town and country—the *banlieue*, as Parisians called it—had its own poetry and sharpened the dreaming onlooker's sense of what it meant to be bourgeois or *campagnard*. Victor Hugo put it as follows, in a passage he added to his novel *Les Misérables* for the new edition of 1861:

> To wander in a kind of reverie, to take a stroll as they call it, is a good way for a philosopher to spend his time: particularly in that kind of bastard countryside, somewhat ugly but bizarre, made up of two different natures, which surrounds certain great cities, notably Paris. To observe the *banlieue* is to observe an amphibian. End of trees, beginning of roofs, end of grass, beginning of paving stones, end of ploughed fields, beginning of shops, the end of the beaten track, the beginning of the passions, the end of the murmur or things divine, the beginning of the noise of humankind—all of this holds an extraordinary interest.
>
> And thus, in these unattractive places, forever marked by the passer-by with the epithet *sad*, the promenades, apparently aimless, of the dreamer.[1]

These paragraphs may have left their traces in van Gogh's elaborate, bookish mind. In any case he would have known for certain that the *banlieue* was meant to be melancholy, and

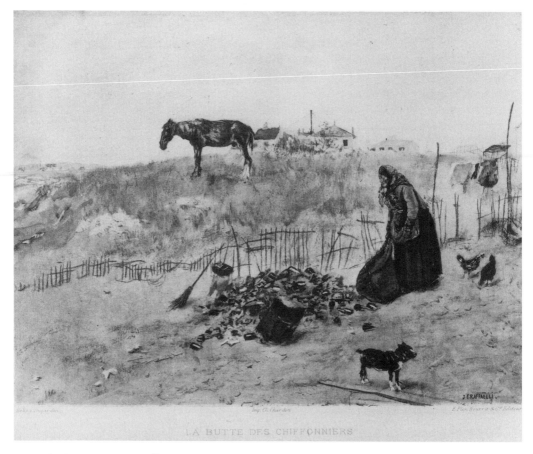

Figure 21.2 La Butte des chiffonniers, Jean-François Raffaëlli, 1889. By permission of the British Library; shelfmark 12330.k.45. opp. pg. 120.

that by 1886 there were even specialists—poets and painters—in the new commodity. The *banlieue* was the place where autumn was always ending on an empty boulevard, and the last traces of Haussmann's city—a kiosk, a lamppost, a cast-iron *pissotière*—petered out in the snow. It was the territory of ragpickers, gypsies, and gasometers, the property of painters like Jean-François Raffaëlli [Figure 21.2] and Luigi Loir. The best insult to *La Grande Jatte* that Armand Guillaumin could devise in 1886 was to tell Seurat he was "doing a Raffaëlli."[2] So van Gogh would have known that there were various *banlieues* to be avoided if one wished to stay part of the avant-garde.

We might suspect van Gogh of wanting to maintain Hugo's attitude, but of realizing that it would have to be reworked by a consciousness that all the epithets applied to the *banlieue*—sad, grey, desolate, ruined, even the *vague* of *terrain vague*—had been used too often, at least by bourgeois passers-by. Put them in the mouths of a laundress and a metalworker, as Zola did in chapter 8 of *L'Assommoir*, and they might be allowed to rekindle for a moment. Gervaise and Goujet climb the north side of Montmartre:

> With their heads lowered, they made their way along the well-worn path, amid the
> rumbling of the factories. Then, after two hundred yards, without thinking, as if they

had known the place all along, they turned left, still keeping silent, and came out into an empty terrain. There, between a mechanical sawmill and a button works, was a strip of meadow still remaining, with patches of scorched yellow grass; a goat, tied to a post, walked round in circles bleating; further on a dead tree crumbled in the hot sun.

"Really," Gervaise murmured, "you'd believe you were in the countryside." . . .

The two of them said nothing. In the sky, a flock of white clouds swam past as slowly as a swan. In the corner of the field, the goat had turned in their direction and looked at them; from time to time, at regular intervals, it bleated softly. And holding hands, their eyes brimming with tenderness, they looked into the distance, lost in thought, on the pallid slopes of Montmartre, surrounded by the great forest of factory chimneys blocking out the horizon, in that chalky and desolate *banlieue*, where the green trees shading the cheap taverns moved them to the edge of tears. . . .[3]

It is all hedged in by a sense of absurdity, and the reader is given the option perhaps too grossly in that final phrase—of finding Gervaise's vision merely foolish. But the vision and the emotion are not there in the novel simply to be denied; Gervaise and Goujet have their moment of freedom, and the landscape of the *banlieue* is the setting that confirms it and marks its limits.

L'Assommoir was part of van Gogh's reading too. He had read it first in The Hague four years earlier, and he may have looked at it again in Paris. But the picture he finally did of the *banlieue* is not a composite image; my network of possible points of reference is not meant to suggest it is. On the contrary, the image he made is saved from merely belonging to one artistic *banlieue* or another by its very emptiness, and the literalness with which the signs of change are spelt out in it unobtrusively.

Of course the picture has its share of desolation. It is mostly laid on or suggested by the unrelieved drabness of the colours, and by having objects and persons reduced to fluid, approximate, almost apologetic smears of paint. The paint is as slippery as the rained-on clay at the crossroads in the foreground, and as liquid as the cloud cover—that waterlogged, tumescent grey in which the very birds seem bloated and lumbering. The *banlieue* was supposed to look like this: the weather is suitably hopeless, and the brushwork insists on the mud-caked, deliquescent character of everything, even the lamppost. Whatever separate forms there are seem half embedded in the general ooze, but nonetheless van Gogh has been at pains to make them readable, and by means of them he draws up a kind of inventory of the edge of Paris—he does so matter-of-factly, bit by bit. There are the birds and the gaslight; there is a windmill in the distance and two or three tall narrow houses with red-tiled roofs, and on either side of the horizon large, lumpish grey buildings with rows of identical windows. There is some ragged grass, a broken fence, weeds, a line which changes from ochre to pink at the right which may be wheat or barley, or perhaps another path, and a trace of vermilion at the left which might be meant for poppies growing on fallow ground. Two men are dressed in workers' smocks, one near, one far, the nearer keeping company with a woman in black; two children dressed in white are being taken for a walk through the fields, and there are half a dozen other figures, tiny, to the right, working or walking in the distance. On the path in front of the gaslight stands a character with a stick and a cap, a shapeless brown jacket, and a face which is one unworked block of grey paint.

None of these details are innocent, and most of them tell the same story. The factories—for that is what those lumpish buildings are—will replace the windmill, and the villas will march across the mud and cornfields until they reach the premonitory gas standard. This is

a working landscape, with anonymous citizens mostly moving fast, going about their business, not stopping or sauntering, not sitting on the grass. There are no dreamers here. It does not appear to be Sunday afternoon, and the Plaine Saint-Denis is not arranged or proffered to the viewer as a *prospect*: neither the dingy line of buildings nor the edges of fields, nor even the five retreating figures on the path, establish much of a sense of scale or demarcation: things are seeping into one another, and the landscape is taking on a single, indiscriminate shape. It is much like the action of water on chalk and clay in the foreground.

There are those who blamed Baron Haussmann directly for all of this—the factories, the mess of fields and paths and stranded gaslights. As early as 1870 the grandest of Haussmann's enemies, Louis Lazare, had accused the baron of building a second industrial Paris on the edge of the old, and waiting for low rents and the promise of work to lure the working class out to it.

> Artisans and workers [wrote Lazare] are shut up in veritable Siberias, criss-crossed with winding, unpaved paths, without lights, without shops, with no water laid on, where everything is lacking. . . .
>
> We have sewn rags onto the purple robe of a queen; we have built within Paris two cities, quite different and hostile: the city of luxury, surrounded, besieged by the city of misery. . . . You have put temptation and covetousness side by side.[4]

As a matter of fact Haussmann had taken a personal hand in selling the Plaine Saint-Denis. He had called the great capitalists Cail and Say into his office and had showed them the open land on the map, free from the city's normal taxes, with new sewers and cheap coal guaranteed.[5] He most certainly thought that factories should get out of the imperial city. In time the tax laws and the baron's promises had the intended effect: Monsieur Say moved his refinery from Ivry, Monsieur Cail his steel mill from Grenelle. Others followed, and during the 1870s the plain was steadily filling up: Haussmann had had his way with industry, as with so much else.

It is unquestionably too glib to read van Gogh's picture as simply an image of Lazare's new Siberia. In describing the painting I have been obliged to move between the language of the melancholic *banlieue*—for some such discourse is still present here, determining the picture's general look—and another language, more pedestrian and empirical, in which the disparate, provisional character of the place is rehearsed quite soberly. This is not to say that the sobriety does not end up producing something pointed, even chilling—it seems to me it does. But the picture is small and in a sense prosaic; it avoids the sociologist's high moral tone. And yet Lazare is after all probably closer to van Gogh's purpose than Victor Hugo. We could say that the landscape in van Gogh's work—and here is the difference from Hugo and Zola—is no longer envisaged as the edge of something else, the definite city of Paris. The plain is not presented, like Hugo's *banlieue*, as the end of one form of life and the beginning of another; there is no town in van Gogh's picture, and no country; the broken line of factories, villas, and warehouses is no more a marker of the city's edge than the gaslight in the field; and our reading of the open land and its agriculture is determined, surely, by the sea of mud in the foreground—it stands for the casual disrepair of this whole territory.

How different it is from van Gogh's sense of town and country a year or so later, when he paints the plain at the edge of Arles! There the fields are crammed with wheat; the picture's foreground is the rich, dry, stippled yellow of the stubble; and the factories and railway line beside the old city are drawn as a single bounding line—beyond them towers and churches, packed together [Figure 21.3].

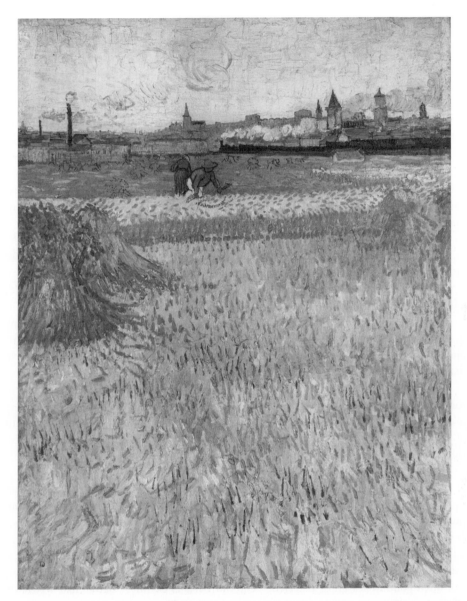

Figure 21.3 The Mowers, Arles in the Background, P.7304, Vincent van Gogh, 1888. © Musée Rodin, Paris.

What van Gogh was depicting in 1886 was the aftermath of Haussmannization. I do not think, as I said, that we should make the picture out to be too doom-laden; but there is some doom in it, especially if the edge of Paris is compared with that of Arles. The atmosphere of dissolution and misuse seems unmistakeable, and the suggestion strong that the modern may add up to not much more than the vague misappropriation of things. This, we shall see, is not to be explained as the mere bewilderment of a Dutchman in the big city: it is a characteristic note struck by Parisians when they deal with what had happened to Paris in their own time.

The word most often used to describe that process was "Haussmannization," and it was meant to convey the brutality (the Germanic thoroughness) with which the city has been transformed. At the edges of Paris there might be muddle and suburban sprawls but these were the obverse—the ancillary conditions— of a city which for the most part was hideously well ordered. The reader should immediately beware, however, of the fiction that modernity, brutal or not, had been achieved once and for all by the baron's rebuilding. Certainly there were Parisians who believed as much, but the things they blamed on Haussmann—the blankness, the sameness, the regularity of the new buildings and streets—had been held to be true of the capital for thirty years or more before the baron took power. They had been extrapolated, always with a sense of doom, from the merest signs of interruption or drift. In 1830, for example, swooping over Paris from the towers of Notre-Dame and fixing on the repetitious architecture of the Bourse and the Rue de Rivoli, Victor Hugo had dreamt Haussmann's city and conjured up a bitter image of its plan:

> Let us add that if it is right that the architecture of an edifice be adapted to its purpose in such a way that the purpose be readable from the edifice's exterior alone, we can never be sufficiently amazed at a monument which can equally well be a royal palace, a house of commons, a town hall, a college, a riding school, an academy, an entrepôt, a tribunal, a museum, a barracks, a sepulchre, a temple, a theatre. For the time being it is a Stock Exchange. . . . We have that colonnade going round the monument, under which on the great days of religious observance there can be developed in majestic style the theories of stockbrokers and commission agents.
>
> Without a doubt these are quite superb monuments. Add to them a quantity of handsome streets, amusing and varied like the Rue de Rivoli, and I do not one day present that richness of line, that opulence of detail, that diversity of aspect, that hint of the grandiose in the simple and the unexpected in the beautiful, which characterizes a checkerboard.[6]

Hugo's metaphor would be borrowed regularly later, when the battle with Haussmann was on. By the 1840s there were plenty of town councillors and Saint-Simonians to moderate the poet's apocalyptic sarcasms and put his objection in reasonable, practical terms. The problem with Paris, the experts thought, was that its inner core was on the move to the west, following the drift of commerce towards the Bourse and the *grands boulevards*.[7] If something drastic was not done, the city would be left with a dead centre, its streets too narrow, its tradesmen gone in search of the rich. "The old Paris is passing," Balzac had written in *Les Petits Bourgeois*, "following the kings who have passed."[8] The new Paris was struggling to be born; and once again what is striking is the commentators' wish to have it there already, fully fledged.

> Let me tell you what threatens everything in Paris: this abrupt efflorescence of bricks and slate, this profusion of building timbers and ashlar, this exuberant vegetation of casement windows, shutters, and *portes cochères*. . . . A craze for building reigns like an epidemic: the tide of houses rises as we look, overflowing the *barrières*, invading the *banlieue* and making its first assault on the outworks of the city's fortifications [in other words, spreading out to the land round Porte de Clichy and Porte de la Chapelle: no more than a stone's throw from van Gogh's path and lamppost]. Can we stop this fever, this mania for piling stone on stone?[9]

This was Texier's verdict in 1852, before Haussmann had even entered the prefecture; and this was the diagnosis two years earlier in a pamphlet entitled *De la décentralisation des Halles*:

> As a result of the transformation of the old Paris, the opening of new streets, the widening of narrow ones, the high price of land, the extension of commerce and industry, with the old slums giving way each day to apartment houses, vast stores, and workshops, the poor and working population finds itself, and will find itself more and more, forced out to the extremities of Paris; which means that the centre is destined to be inhabited in future only by the well-to-do. . . .[10]

None of these descriptions is arbitrary, still less straightforwardly untrue. Paris was drifting west in the 1840s; the Bourse was a special kind of architecture and would have progeny; there was undoubtedly a building boom before Haussmann. (One of the baron's first problems in the western *faubourgs* was that he was obliged, in order to build his new boulevards, to pull down so many fine houses which had been standing for only a handful of years—and whose owners had influence at court.[11]) But all the same these texts, especially Hugo's, *anticipate* modernity: it is as if the various authors needed it to be there, and made believe it was, in order to anathematize it. The most effective conjuration was certainly that hurled from the towers of Notre-Dame, and it should give us pause straightaway that the best description of Haussmannization was written thirty years before the event. Pamphleteers in the 1860s liked to take Hugo's tour de force for an epigraph,[12] and then go on to repeat its basic imagery—discovering a city of straight lines and unreadable façades, in which the stockbroker and commission agent still waxed theoretical on feast days. We might say of these writers that they seem to *want* the city to have a shape—a logic and a uniformity—and therefore construct one from the signs they have, however sparse and unsystematic. They see or sense a process and want it finished, for then the terms in which one might oppose it will at least be clear. The ultimate horror would be to have modernity (or at any rate not to have what had preceded it), to know it was hateful, but not to know what it was.

It is just that latter condition which haunts the most intense of these forebodings—the one in which prediction finally fuses with description—the entry in the Goncourts' journal of 18 November 1860:

> I go in the evenings to the Eldorado, a big café-concert on the Boulevard de Strasbourg, a room with columns and very luxurious decor and paintings, something rather like Kroll's in Berlin.
>
> Our Paris, the Paris where we were born, the Paris of the way of life of 1830 to 1848, is passing away. Its passing is not material but moral. Social life is going through a great evolution, which is beginning. I see women, children, households, families in this café. The interior is passing away. Life turns back to become public. The club for those on high, the café for those below, that is what society and the people are come to. All of this makes me feel, in this country so dear to my heart, like a traveller. I am a stranger to what is coming, to what is, as I am to these new boulevards, which no longer smack of the world of Balzac, which smack of London, some Babylon of the future. It is idiotic to arrive in an age under construction: the soul has discomforts as a result, like a man who lives in a newly built house.[13]

Again the date of the entry is important. By the winter of 1860 the new city was manifestly in the making. The Goncourts were seated in a café-concert on the enormous boulevard

which Haussmann had laid out a year or so earlier to connect the Cité to the Gare de l'Est. But the baron's improvements were still in progress, and the shape of the *deuxième réseau*— the second, decisive instalment of street improvements and public works—was still not clear. The Rue de Rivoli had been finished, to Hugo's chagrin, in 1858, and the Boulevard Saint-Michel; but the network of grand avenues to the west, which would exacerbate the city's drift in that direction, was only just begun; the spinal cord of the new West End, the great Boulevard Malesherbes, was a wilderness of mud and scaffolding; and the subjection of the eastern, working-class *faubourgs* was mapped out but not yet put into practice. There was some understandable confusion, therefore, about Haussmann's purposes and their effect on Parisian life; the battle against Haussmannization had hardly started, and the word itself was not yet in circulation.

The Goncourts' verdict on this state of affairs is unfriendly but elusive; and whatever splenetic certainty it appears to have at first reading tends to dissipate the more one pays heed to the elliptical imagery and the indecisive tense of so many of the crucial verbs. When Edmond tidied up the text of the *Journal* for publication in 1891, he tried to make the imagery more concrete—or at least more vivid—and to mend his original uncertainty as to what was happening, what had happened, and what the future might hold in store:

> I am going this evening to the Eldorado, a café-concert on the Boulevard de Strasbourg, a room with columns and very luxurious decor and paintings.
>
> My Paris, the Paris where I was born, the Paris of the way of life of 1830 to 1848, is passing away. If it is passing in material terms, it is passing in terms of morality. Social life is going through a great evolution, which is beginning. I see women, children, households, families in this café. The interior is going to die. Life threatens to become public. The club for those on high, the café for those below, that is what society and the people will come to . . . From this an impression of passing through these things, like a traveller. I am a stranger to what is coming, to what is, as I am to these new boulevards without turnings, without chance perspectives, implacable in their straight lines, which no longer smack of the world of Balzac, which make one think of some American Babylon of the future.[14]

London would no longer quite do as a point of reference for what Haussmann was attempting: it was replaced by New York and Chicago. Paris, after all, was passing away materially as well as morally. The contradictory double time implied in the original phrase, *"La vie retourne à devenir publique"*—it is as if the present public life was a regression from the fierce privacy which had hitherto characterized bourgeois existence, but also the form of the future—was rewritten as simple threat, *"La vie menace de devenir publique."* And the clichés of Haussmann's critics were now given room in the text: the boulevards as usual became things "without turnings, without chance perspectives, implacable in their straight lines." (There was joke after joke on this theme in the 1860s, the best being Edmond About's: his old soldier Colonel Fougas saw the way things were going in Paris and dreamt of the day when the Seine itself would be straightened, "because its irregular curve is really rather shocking."[15])

The original version of the Goncourts' text was less formulaic than this. It did not *have* a Paris, in the way the Hugo had, or the other writers I have quoted. It was on the verge of recognizing in itself—through deployment of tenses, and production of the narrator as a kind of ghostly, idiot intruder in the text, having nothing to do with the forms of life he attempts to describe—the very work of extrapolation which the other commentators took for granted. Of course the Goncourts' entry amounts in the end to an offer of knowledge, a picture of

Paris, and one made almost coherent by the simple pressure of disgust—the interior is dying, whatever was once of value in bourgeois existence is sabotaged or travestied, and life spills out into the streets and the Eldorados. But "picture" here is not quite the right word: the Goncourts' Paris—this is its originality—is only incompletely an image. It is not really visualized, and that reticence seems to have been exactly true to what was going on in 1860: a city was being made, vigorously and well, but with no forms of visualization provided, or none the Goncourts could believe in.

We seem to have reached an impasse. Did Hausmannization give the city form or not? To many contemporaries the question would have seemed entirely odd; for what were the boulevards, the squares, and the new street furniture if not an attempt to make Paris look a certain way—to make it the image the critics had been anticipating? But it was possible to say—Lazare said it, and Haussmann sued him for doing so—that the attempt was turning out a failure.[16] The city was eluding its various forms and furnishings, and perhaps what Haussmann would prove to have done was to provide a framework in which another order of urban life—an order without an imagery—would be allowed its mere existence. (The real doom comes, the Goncourts might have agreed, when there are no images of it, and therefore no sense of it much.) In this perspective—and I suppose its very grimness means that it is not maintained very often, or for long—the whole debate about Haussmann's *aesthetics* has a nostalgic ring. So the baron pined for long straight lines and striking "points of view," and his critics for chance perspectives! But what had either to do with the winding paths of Lazare's Siberia, or the mute efficiency of the speculators around the Parc Monceau? Capital did not need to have a representation of itself laid out upon the ground in bricks and mortar, or inscribed as a map in the minds of its city-dwellers. One might even say that capital preferred the city not to be an image—not to have form, not to be accessible to the imagination, to readings and misreadings, to a conflict of claims on its space—in order that it might mass-produce an image of its own to put in place of those it destroyed. On the face of things, the new image did not look entirely different from the old ones. It still seemed to propose that the city was one place, in some sense belonging to those who lived in it. But it belonged to them now simply *as an image*, something occasionally and casually consumed in spaces expressly designed for the purpose—promenades, panoramas, outings on Sundays, great exhibitions, and official parades. It could not be had elsewhere, apparently; it was no longer part of those patterns of action and appropriation which made up the spectators' everyday lives.

I shall call that last achievement the spectacle; and it seems to me clear that Haussmann's rebuilding was spectacular in the most oppressive sense of the word. We look back at Haussmanization now and see the various ways in which it let the city be consumed in the abstract, as one convenient fiction. But we should beware of too much teleology: the truth is that Haussmann's purposes were many and contradictory, and that the spectacle arrived, one might say, against the grain of the empire's transformations, and incompletely. (The spectacle is never an image mounted securely and finally in place; it is always an account of the world competing with others, and meeting the resistance of different, sometimes tenacious forms of social practice.) Pay heed to the Goncourts' casting round for an image of Paris and not finding one—it points very well to the limits of Haussmannization. [. . .]

What those limits amounted to essentially, is suggested well by Manet's painting of the empire's *Exposition Universelle de 1867* [Figure 21.4]. The exhibition's assorted halls and towers are put down in summary notation in the painting's middle distance on the Champ de Mars, and the viewer looks across to them, or up at a tethered balloon in the sky, from the summit of a convenient nearby hill, the Butte de Chaillot. In the foreground, seemingly below us,

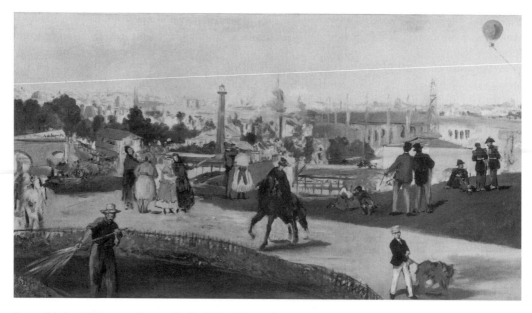

Figure 21.4 L'Exposition Universelle de 1867, Edouard Manet, 1867. Photo: J. Lathion
© Nasjonalgalleriet 03. Courtesy of the National Gallery, Norway.

are a strip of lawn, a flower bed, and a gardener in a straw hat with a hose; a path along which a dandified small boy is being pulled by a dog; a woman on horseback; soldiers standing or sitting on the grass; tourists; a man with binoculars surveying the view; ladies in assorted sizes; and a glimpse of the river at the left, with a crush of people crossing a bridge and a steamboat beside them disgorging still more.

This is all Haussmann's doing, of course: it is how the imperial city was supposed to present itself that year. (The exhibition was, while it lasted, a popular invention, at least with the middle classes. Reports agreed that the war scares and general despondency of the spring abated in the summer months while the show was on, though they revived soon enough when it was over.[17]) Three months before, the exhibition organizers had decided that the Butte de Chaillot was "irregular" and wild, and that therefore the view across the river from the exhibition grounds lacked harmony. They ordered the baron to lower the hill by twenty feet or so and make its profile less untidy.[18] It was a large demand to make with so little time left before the emperor was to cut the scarlet ribbon. Haussmann brought in squads of navvies and paid them to work under arc lights through the night; he built a special railway line to cart off the rubble, and used two hundred cars and half a dozen locomotives for the job. The operation attracted sightseers in its own right, and was duly mentioned in *Le Magasin Pittoresque*: "On one side of the river a swarming mass of men, all bent over and armed with picks, was digging trenches and levelling a mountain; on the other was the Champ de Mars, invaded by thousands more workers." . . .[19] So the hill in the round of Manet's painting was built specifically to be regular and provide a view. It was finished just in time and no doubt the geraniums are doing well under the gardener's watchful eye.

I want to sound a comic note somehow, because it seems to me that that is partly what the picture is doing, with its fat ladies, silhouettes of soldiers, and stray balloons. Its subject is festive and topical—the city containing the world. People are taking their ease on top of the hill, enjoying the exhibition and making sure their enjoyment is noticed; gaping, strolling,

sprawling on makeshift grass, pointing things out to one another with umbrellas, looking well on a horse, showing off pets and wearing (they hope) outlandish shades of yellow. This is a comedy of sorts: a picture of people and things in fashion, of crowds crossing bridges in search of the universal, of the power of binoculars and the size of bows. It is a parade of "types" on a suitable stage. The lawns and flower beds may have been planted somewhat hastily, but at least they are not scheduled for dismantling in the fall; most of the picture's middle ground, on the other hand, was not intended to outlast the festivities; the actors move about in front of it as if it were all painted, and what they are pointing to with their umbrellas is no more than a plausible likeness, rattling a bit in the wind—but whose freedom of handling they choose to admire. (No one exactly *believes* in an exhibition, at least not in its claims to represent the world. And yet the illusion is often effective and fetching, the suspension of disbelief quite possible for an afternoon. Some such attitude seems to apply here, not just to the exhibition but to Paris and Parisians in general.)

There are clearly rather different kinds of comedy, mixed up in this occasion, and the way they fit together or fail to is the picture's sharpest subject. We are expected to enjoy the gallery of tourists and *cocottes*, and register the details of class, profession, and up-to-dateness. But what is comic in the painting exceeds that pantomime, and has to do with what these figures are engaged in and how it relates to the painter's presentation of the scene. The comedy quite often comes from the business of seeing itself, in its various aspects: not just how people look as they look at the view, but what that looking consists of—the artifice involved in having a city thus available to vision, focussed and framed as a unity for the man with binoculars:

> Meantime you gain the height, from whose fair brow
> The bursting prospect spreads immense around.[20]

The man with binoculars abstracts and selects with his small machine; the painter gains some further height, outside the scene itself (hovering above it, apparently), and puts the bursting prospect into order.

The city does look well from here; that lost twenty feet makes all the difference. Yet its looking well, as we have seen, is a fragile achievement on the empire's part, something put together in the nick of time. The painting itself—in its general makeup and handling—provides a kind of equivalent for that fact. It is a large-scale piece of work, over six feet wide and three feet high, but—uniquely, I think, for a painting this size by Manet—it is quite insistently *sketchy*. The sketch may be improbably big and overfull of matter, but it pretends all the same to be not quite a picture, not quite finished. The paint is put on in discriminate, sparse patches which show off their abbreviation—puffs of smoke eat into the dome of Les Invalides, streamers and flags blend with the foliage, the shape of a dog is left shadowed and blurred, water hisses from the gardener's hosepipe in neat, dry strokes of colour (as if the hose were the handle of a giant paintbrush), and the hooves of the Amazon's horse are moving just too fast for us to see them. There is even a passage at the left-hand side, between the geraniums and the river, where abbreviation frankly becomes absence of sense, and a sequence of scratchy blue-grey strokes on primed canvas fails to become an image, however hard the viewer tries to make it one.

The picture presented of Paris is approximate, therefore, but not vague. The strollers on the hill would not settle for vagueness; their minimum requirement is that Paris have landmarks and offer up, as cities ought to, some definite and reassuring points of reference—social as well as topographic. Part of the pleasure in taking a walk is to be reminded, in the course

of it, of what it means to be Parisian—to see other Parisians and be able to spot their type. These people want the Paris that goes with such transparent citizens; they want it spread out in front of them, a stone's throw away, like a gas-lit picture in a diorama.

And so it is in Manet's painting. The types in the park are drawn for easy reading and do not seem to detain one another's attention too long; they are spiky, dapper, and articulate, picked out on a neutral ground, floating past one another slightly out of scale. The city beyond is these persons' property; the distance between the hilltop and the view is simply declared not to exist or not to matter: it is a part of the image that does not interest the painter or the pedestrians. The path in the foreground supports its dogs and horses, and then grows tenuous—it peters out into the river at the left and is last seen sliding unresistant through the Pont de l'Alma. The great open space which lies between the Butte de Chaillot and the Champ de Mars—the Seine itself, and the long hinterland leading down to the Pont d'Iéna—is hidden behind the brow of the hill. The grass ends sharply, with soldiers, children, and horses silhouetted along its edge; behind them the exhibition begins, equally brightly: the one world passes into the other without a break. There is a glimpse of the Pont d'Iéna, in fact, on either side of the man with binoculars and his companion: two unmodulated patches of grey, and some dashes and squiggles which stand for the bridge's equestrian statues on their plinths. These are the strongest indices of a middle ground that the viewer is provided. They are too few and too cryptic, and even when—or if—they are recognized for what they are, they do not make the exhibition seem farther off. The towers and pavilions still overlap the bridge, and the distant flags and foliage blend in with Antoine-Auguste Préault's *Gallic Horseman*, perched there at the picture's centre as a noble (and illegible) reminder of the republic.[21] These things are all part of the same disembodied flat show, the same spectacle.

What is meant by the word "spectacle" should be coming into focus by now. Part of its meaning is obvious: it points to the ways in which the city (and social life in general) was presented as a unity in the later nineteenth century, as a separate something made to be looked at—an image, a pantomime, a panorama. But this should straightaway be qualified if we wish to prevent the notion of spectacle from declining into a half-baked means of "understanding media" or anathematizing the society of leisure. To call the city "spectacular" is not to describe it as possessing or improvising entertainments, as all cities do, or even to be impressed unduly by its electing times and places for the fashionable to congregate and eye one another. These things can be done—and still were in the 1860s—as *part* of a city's more substantial life; they can derive what intensity they have from the crush of signs, the exchange of signals, in a special overcrowded space. When a city has a public life in this sense—it is regularly organized around entertainments—what mostly impresses the observer is the sheer density of signals conveyed and understood, and the highly coded nature of the conveyance. Public life of this kind is both elliptical and formalized, and also risky: it involves contact and transaction, contests of nuance and misreading, the kind Proust chronicled in his surviving "society." Everything depends on the lady and gentleman's skill with the signs of class, sex, age, and individual character; there is no surer path to ridicule or oblivion than not to understand, in such places, the way these previous kinds of belonging inflect the comedy of manners.

The behaviour that derives from such dealings can be odious or grand (and surely Proust's description does not incline one to enthusiasm over its normal achievements), but it cannot be called "spectacular" because social identities are still a matter for complex negotiation in the public realm. The essential separation of public life from private, and the thorough invasion of both by capital, has not yet been effected. The public idiom is not standardized satisfactorily, not yet available to anyone with the price of a newspaper or this season's hat. In this sense the 1860s are notably an epoch of transition. The great categories of collective

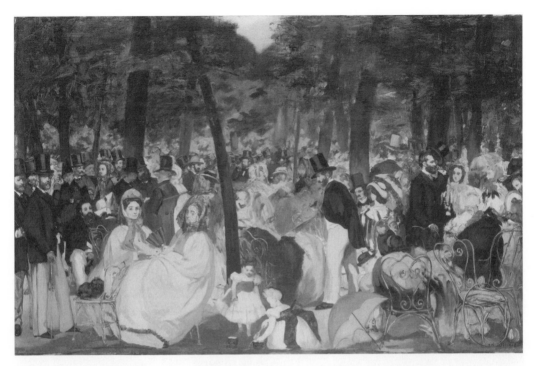

Figure 21.5 La Musique aux Tuileries (Music in the Tuileries Gardens), Edouard Manet, 1862.
© National Gallery, London.

life—for instance, class, city, neighbourhood, sex, nation, place on the "occupational ladder"
—have not yet been made over into commodity form, though the effort to do so is impres-
sive. And therefore the spectacle is disorganized, almost hybrid: it is too often mixed up with
older, more particular forms of sociability and too likely to collapse back into them. It lacks
its own machinery; its structures look flimsy alongside the orders and means of representa-
tion they are trying to replace.

This seems to me the implication of Manet's earlier picture of public gathering, *La Musique
aux Tuileries*, most likely painted in 1862 [Figure 21.5].[22] If we put this curious half-miniature
alongside *L'Exposition Universelle*—it is just over half the later picture's size—it will appear,
in what it shows and how it shows it, to be strikingly the opposite of its companion: hardly
a picture of modernity at all, as it is sometimes supposed to be, but, rather, a description of
"society's" resilience in the face of empire.

The public realm in the Jardin des Tuileries is still narrow and definite, composed of
particular portraits, professions, and uniforms. It is a realm in which one recognizes friends
and relations, and knows precisely how they would wish to be shown. Such knowledge depends
in turn on the great protocols of class, which everyone here obeys scrupulously: and it is class
itself—the pure category, the disembodied order of appearances—which ends up invading
every square inch between the trees. The music is pretext for this more serious counterpoint:
the raising of hats, the lifting of veils (if one is a young lady) and the lowering of them
(if one is not), the minding of children, the exchange of literary judgements, the saying hello
to one's aunt.

Likewise the lithograph entitled *Le Ballon* [Figure 21.6] done the same year, depicting the
Esplanade des Invalides. The distractions in this case are more obtrusive than music from a

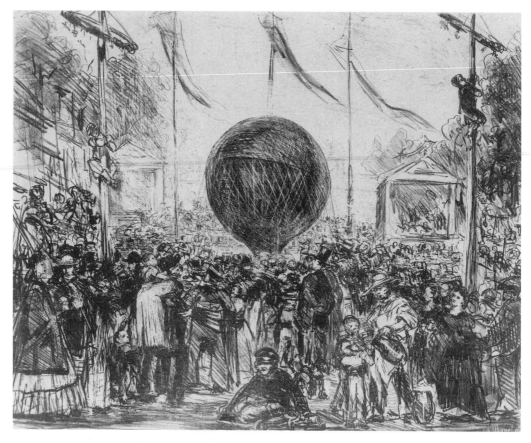

Figure 21.6 Le Ballon, lithograph, Edouard Manet, 1862. Courtesy of the Fogg Art Museum, Harvard University Art Museums, Program for Harvard College Fund. Photo: Photographic Services © 2003, President and Fellows of Harvard College.

bandstand, but even so, what matters—what the painter takes as the subject to be faced—is less the balloon and the puppet shows than the greasy press of people in the foreground, lined up across the narrow stage, usurping it, embarrassing the spectacle behind—ladies in crinolines having to come in contact with legless beggarboys on trolleys.

In the picture of the exposition, by contrast, there is no embarrassment because there is no contact; that is what makes it modern. The crowd is thinned out into individual, slightly vulgar (or slightly elegant) consumers; the marks of class and sex and so forth are broadly handled, and meant as amusement. Everything is held in place by mere vision and design, as opposed to the actual, stifling crush among the iron chairs in the Tuileries—those people obliged to touch one another and recoil, listening, jostling, being polite, pushing their trolleys, making mud pies out of the real earth, taking frightened little ones on their knees, selling lemonade, and climbing flagpoles—as much for the fun of it as for a better view of the balloonist.

That list of activities amounts, as Manet's images do, to a description of a *crowd*: it suggests the way its view of things is necessarily bound up with other kinds of interest and behaviour. The view in *L'Exposition Universelle*, we could almost say, might as well be the balloonist's: does not the neat hypotenuse of his guy rope serve to tie down the image as a whole, and is he not

seated in a gondola which looks on second glance like nothing so much as a giant camera, swinging full circle over the Champ de Mars—giving back the gaze of the man with binoculars? The balloon in both cases most probably belonged to the photographer Nadar. Thus the conceit could be pursued one step further, bearing in mind that photograph and spectacle go together (though the one does not amount to the other). It is as if Manet's lithograph is out to show us everything that is supposed not to register on the photographer's plate—the press of relations and identities that cannot be stopped by a shutter (that cannot simply be "seen"); and as if *L'Exposition Universelle* concedes on the contrary that a city exists—it may be temporary, it may be here to stay—which the camera can show quite adequately. There are parts of Paris in which it appears that there *are* no relations, only images arranged in their place. [. . .]

Notes

1 Victor Hugo, *Les Misérables*, 3 vols. (Paris, 1967), 2: 108.
2 George Seurat, letter to Signac, 16 June 1886; cited in Henry Dorra and John Rewald, *Seurat: L'Oeuvre peint, biographie et catalogue critique* (Paris, 1959).
3 Emile Zola, *L'Assommoir* (Paris, 1969), pp. 267, 269.
4 Louis Lazare, *Les Quartiers de l'est de Paris et les communes suburbaines* (Paris, 1870), pp. 62–63, 142; cited in P. Lavedan, *Histoire de l'urbanisme à Paris* (Paris, 1975), p. 482.
5 The story is told in Jeanne Gaillard, *Paris, La Ville: 1852–1870* (Paris, 1977), pp. 57–59.
6 Victor Hugo, *Notre-Dame de Paris, 1482* (Paris, 1967), pp. 157–58.
7 See Pierre Lavedan, *Histoire de l'urbanisme*, pp. 398–403.
8 A. Morizet, *Du vieux Paris au Paris moderne: Haussmann et ses prédécesseurs* (Paris, 1932), p. 201.
9 Edmond Texier, *Tableau de Paris*, 2 vols. (Paris, 1852), 1: 75; cited in G.N. Lameyre, *Haussmann: "Préfet de Paris"* (Paris, 1958).
10 L. Marie, *De la décentralisation des Halles* (Paris, 1850); cited in *Histoire de l'urbanisme*, by Lavedan, p. 403.
11 See H. Malet, *Le Baron Haussmann* (Paris, 1973), pp. 191–93.
12 See, for instance, Victor Fournel, *Paris nouveau et Paris futur* (Paris, 1865).
13 Edmund and Jules de Goncourt, *Mémoires de la vie littéraire*, 4 vols. (Monaco, 1956), 1: 835.
14 Edmond and Jules de Goncourt, *Journal des Goncourts*, 9 vols. (Paris, 1912), 1: 345–46.
15 Edmond About, *L'Homme à l'oreille cassée* (Paris, 1862), p. 196; cited in *Histoire de l'urbanisme*, by Lavedan, p. 450.
16 Lazare first attacked Haussmann in *La Revue Municipale* in October 1861. Haussmann took Lazare to court for his article and had the magazine suppressed. See Lavedan, *Histoire de l'urbanisme*, p. 477.
17 The war scare and its temporary abatement are discussed in P. Sorlin, *Waldeck-Rousseau* (Paris, 1966), p. 112. For a different reading of the relation between Manet's picture and its public occasion, see P. Mainardi, "Edouard Manet's *View of the Universal Exposition of 1867*," *Arts Magazine*, January 1980.
18 See Malet, *Le Baron Haussmann*, pp. 248–49.
19 Cited ibid., p. 249.
20 James Thomson, "Spring," in *The Seasons* (lines 950–1, describing the view from Hagley); cited in J. Barrell, *The Idea of Landscape and the Sense of Place: An Approach to the Poetry of John Clare* (London, 1972), p. 14.
21 Préault's sculpture was one of the more successful public commissions of the Bureau des Beaux-Arts in 1848, done originally in plaster for a Fête de la Concorde. See T. J. Clark, *The Absolute Bourgeois: Artists and Politics in France, 1848–51* (London, 1973), p. 61.
22 The best discussion of the picture is still in N. G. Sandblad, *Manet: Three Studies in Artistic Conception* (Lund, 1954), pp. 17–68. It is important for my account that the picture is full of particular portraits of friends and relations: Mme. Lejosne, wife of the commandant of the imperial guard (an old family friend); Mme. Loubens, wife of a distinguished headmaster; Jacques Offenbach; Lord Taylor; the society columnist Aurélien Scholl; Théophile Gautier; the monocled Albert de Balleroy; Baudelaire and Champfleury; Fantin-Latour and Manet's brother Eugène; Manet himself at the extreme left. One should recall that Manet came from an impeccable haut-bourgeois background (his father was *chef du personnel* at the Ministry of Justice) and even after notoriety struck was described as "one of the five or six men in present-day Paris who still know how to make conversation with a woman" (Paul Alexis, "Manet," *La Revue Moderne et Naturaliste*, 1880, p. 289).

DAVID HENKIN

WORD ON THE STREETS
Ephemeral signage in antebellum New York

IN RECENT DECADES, studies of the nineteenth-century city have become increasingly preoccupied with its visual culture. Earlier scholarship had emphasized the sounds and smells of early industrial urban space, calling attention to the wide gap separating the modern metropolis of cars, electricity, and plumbing from its noisome, slow-paced ancestor. But with the shift in sensory emphasis has come a new appreciation for what was prototypically and crucially modern about urban life in Europe and the United States before World War I (especially in the fifty years preceding 1914). For a whole generation of students, scholars, and critics, what makes the nineteenth-century city such a compelling symbol of modernity is the cluster of visual practices and attractions associated with urban life—practices linked to such developments as explosive population growth, residential mobility, mass transportation, commercial entertainment, the availability of ready-made clothing, and the introduction of new techniques of visual representation and reproduction (including photography, chromolithography, and motion pictures). Re-envisioned as a revolutionary moment in the history of looking and seeing, nineteenth-century urban culture has come to represent modernity with all of its spectacular distraction and spectatorial detachment.[1]

Somewhat overlooked in this reassessment of urban modernity is the fact that much of what city people spent their time looking at in the nineteenth century (and subsequently) appeared in verbal form. On street signs, advertising billboards, building walls, and newspaper stands, texts loomed large in the visual landscape of the metropolis, and their proliferation both epitomized and encouraged the spread of the modern practices of seeing the city. As much as flashy poster-images, towering skyscrapers, or nickelodeon features, publicly posted words drew attention to the transitions and disjunctions of city life and dramatized the circulation of strangers within unfamiliar environments. Nowhere was this phenomenon more conspicuous than in New York City, which grew during the course of the nineteenth century from a small port town of 60,000 inhabitants to a bustling multicultural metropolis with a population close to 3.5 million. And while historians often associate the rise of New York's dense verbal cityscape with the electrified skyline of the end of the century, already by the time of the Civil War a network of public signage was firmly in place in the streets of Manhattan. It is to that period that we must look to explore the origins of the public reading (and seeing) practices that shape modern urban living.

Like buildings, paintings, and panoramas, urban texts are part of modern visual culture. Yet there are several shared features that distinguish texts from nonverbal artifacts and images.[2] First, the proliferation of written and printed words in public space reflected and reinforced the rise of mass literacy. In antebellum New York, literacy rates were extraordinarily high, even by modern standards. Street signs, posters, and newspapers, and even paper money

provided incentives to maintain and improve rudimentary reading skills in the English language, and thus belong to the larger history of literacy education in the nineteenth-century West.[3] Second, texts signify differently from icons or monuments (though texts can, of course, be icons and monuments themselves), labeling space and addressing passersby in an apparently (if deceptively) more direct manner. Moreover, urban texts share a common set of elements and symbols—both with one another and with such other forms of human communication as law, contract, sermon, bawdy humor, and literary art—which allows them to perform a variety of social functions less available to nonverbal artifacts. This common field of reference also facilitates two forms of reception that characterize urban modernity: browsing and quoting. Urban texts are susceptible both to quick, casual, and silent consumption, and to various forms of cross-reference and reappropriation. Writing and print were thus singularly apt objects and symbols of the new visual culture of the modern city.

Among the countless texts New Yorkers encountered during their daily negotiations of public space—on street lamps, building facades, newspaper racks, bulletin boards, parade floats, and sidewalks—ephemeral signs best evoked the transitions and juxtapositions of urban life. Light and flimsy, handbills and posters were mobile, exchangeable, and had an ambiguous relation to the surfaces upon which they appeared. A vast array of ephemeral texts could be seen in the public spaces of antebellum New York, including cards passed from hand to hand, advertisements suspended over the shoulders of human beings, and banners draped across buildings during moments of civic celebration. The posters, banners, sandwich boards, and handbills that contributed to both the hubbub and the pageantry of daily life were material artifacts deeply imbedded into the fabric of the built environment as well as impersonal texts addressed to a mass readership. They reinforced some of the impact of sturdy, monumental signage (street signs, storefront advertisements), and orderly, serial publications (daily newspapers) in facilitating the anonymous circulation of strangers and mediating their interactions in New York bustling streets, but extended that sign system democratically to embrace a broader range of people, everyday circumstances, and political purposes. This essay takes a brief look at the culture of bills, boards, and banners in mid-century New York as a window into the meaning of urban modernity.

Perhaps the most mobile and ephemeral texts appearing in the public spaces of the growing city were cards and bills passed from person to person in the streets. Most of these notices and announcements were commercial advertisements, trade cards, or handbills promoting everything from patent medicines to daguerreotype studios. Trade cards (which could run as small as 2 by 3 inches but were often more than twice that size) had been used by merchants and craftsmen in urban North America for more than a century, but with the spread of lithography in the 1820s, these cards became a more viable form of large-scale advertising. While in the first two decades of the century trade cards generally restricted their content to neoclassical emblems and the name and trade of an individual proprietor, the trend thereafter was toward the kind of verbose and detailed advertising messages exemplified in the 1851 dollar-bill style card of Baker, Godwin, & Co. Steam Printers [Figure 22.1]. Trade bills designed to resemble paper money (an increasingly common strategy among New York tradesmen in the late antebellum period) were obviously intended to catch the eye and induce a reader to take a closer look. At the same time, the resemblance is broadly suggestive of the way trade cards circulated as public texts. Like currency (and newspapers as well), these "circulars" traveled from person to person in the form of numerous identical copies, each one implicitly referring to its wider public distribution.[4]

Beyond its role as cheap public advertising, the passing of paper from hand to hand also constituted a particular act of urban self-presentation. A written notice could transform a chance

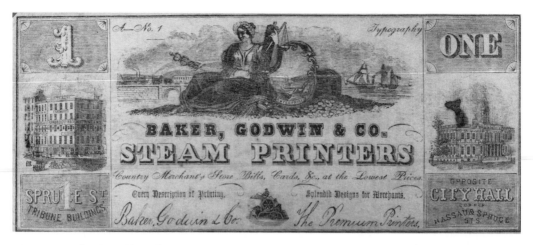

Figure 22.1 "1851 Dollar-Bill Style Card," Baker and Godwin Steam Printers, 1851. © Collection of the New York Historical Society.

and silent encounter in the streets into a meaningful communicative act. Unlike signs attached to buildings or lampposts, handbills and circulars bore the stamp of a physical confrontation between two people, though the fact that the same text was being distributed to countless others in plain view compromised the personal quality of that stamp. A newspaper article from the 1850s describes a German festival in which an energetic woman, having impressed and exhausted her dance partner, presents him with a card "similar to the following: M. Klopfel/ LAGERBIER AND OYSTER SALOON/ No. _____ Delancey Street/ New York."[5] The card appears to cheapen an erotic moment at the festival (or perhaps raises its price), and to hint at further links between sex and commerce in the growing city. The indifferent distribution of paper advertisements to strangers in the streets evoked the promiscuity of urban life, and it is fitting that prostitutes advertised their services on cards passed out in the streets by peddler boys.[6] Nonetheless, many trade notices (which in this period still advertised businesses owned by individuals rather than corporations) bore significant substantive and rhetorical resemblance to more personal forms of correspondence, such as the social card, at the same time as they extended the public discourse of commercial signs. The distributed trade card was thus personal and impersonal at the same time, requiring and registering a moment of one-on-one contact while constructing its readership as a group of largely undifferentiated consumers.

As the city grew, such gestures of written self-presentation, however dependent on the physical presence of their authors, typically relied on anonymity for their effect. Cartman Isaac Lyon recalled an 1848 encounter with a young beggar girl on Broadway who wore "a thick piece of white pasteboard, about 12 × 16 inches in size," hanging around her neck by a string. The sign read "To a Generous Public—Please Help a Poor Blind Girl," and Lyon noted that the girl "bore every appearance of being in reality what she professed to be." A few days later, however, Lyon spotted her dressed elegantly in the streets, and when their eyes met, the girl dashed off.[7] Henry Southworth, who was employed as a millinery clerk at mid-century, described in his diary an encounter with a young boy who sought alms with a printed "circular 'to the benevolent.'" The boy, Southworth noted, "was sent out by some person, as I am informed that there are persons in this City who make it their business to supply these beggars with circulars, and who live upon the proceeds of their begging."[8]

Handbills and circulars may have presupposed some physical contact between individuals

in the streets, but in most cases individual people were simply vehicles for the distribution of signs expressing the authority and promoting the interests of others. In the expanding mobile sign discourse of antebellum New York, individuals tended to function as messengers, or simply as advertising space. With the explosion of commerce and the growth of the population, any visible surface might become a forum for transmitting messages and getting attention. "There seems to be no end to the new advertising projects which are daily springing up in all directions," observed a commercial reference book published during the Civil War. Noting with surprise that umbrellas were still left blank, "their ample and conspicuous surface bearing no announcement of any new pill, new adhesive gum, bankrupt's sale, or What is it?," the author half-seriously predicted that this oversight would soon be corrected, allowing the umbrella to realize its destiny as "a tremendous vehicle for information."[9]

Enlisted into the cause of commercial promotion, the written word began to appear on wagons, personal accessories, clothing, and, most dramatically, on sandwich boards—what one visitor described as "huge boards pasted with gigantic posters . . . carried on their shoulders by men and women hired for this purpose."[10] Marked umbrellas and moving billboards may not seem too strange from the perspective of a culture in which T-shirts, lapels, backpacks, hats, and jackets are appropriate and commonplace sites for displaying messages of all kinds. But advertising signs worn on one's person did not project an individual's fashion statements or political postures. In extreme contrast to Hester Prynne's scarlet letter, which was to be read as revealing her character (or her character type), sandwich boards effectively buried their bearers' identities under the weight of someone else's words.

Sandwich boards offered a uniquely suggestive representation of how people could be used for advertising, a vivid reminder of the essentially impersonal character of sign communication. But most temporary signs eliminated all appearance of the human middleman, addressing readers from the largely anonymous spaces of building fronts and walls. Though the term "handbill" suggests a particular mode of circulation, bills were usually posters or "show cards" (larger versions of trade cards intended for display rather than distribution) and were generally attached to surfaces that bore no particular relation (proprietary or otherwise) to the authors or distributors of the posted text.[11] In this respect, bills were even further severed from personal authority than fixed signboards; if a store sign appeared to speak for a building, a handbill appeared to speak for itself. This kind of anonymous, free-floating text represented an important and potentially subversive medium of urban communication. Posting a bill—which could offend readers, slander the powerful, or instigate political passions—within the view of substantial numbers of city residents did not require owning or renting property, gaining expensive access to printing devices, or even assuming much responsibility for its words. Efforts to regulate this medium of communication with legal penalties or with famous and ironically self-defying signs advising "Post no Bills" proved largely unsuccessful, especially in the face of a torrent of anonymous postings.

Whether or not posters identified their producers or distributors, it was hard to assert authority over spaces whose publicity value lay precisely in the suspension of authority. Numerous fascinating uses of the free-floating handbill illustrate the subversive potential of ephemeral signage, perhaps none so dramatically as the case of Martha Clements, a teenager who was prosecuted for indecency in 1830. According to a neighbor on Greenwich Street, Clements was in the habit of "cutting out large capital letters from play and hand or posting bills, and arranging the said letters together in grammatical order so as to read vulgar and indecent words . . . [and] pasting them on the fences, & places in the yard." Because the rearranged letters were placed "within sight and view of divers other citizens through the said yard," Clements was charged with corrupting the morals of neighbors and passers-by, acting "in

contempt of the people of [New York] and their laws, to the evil example of all others in like case offending, and against the peace of the people of the state of New York and their dignity."[12] Of course the ostensible essence of the indecent act lay simply in the public use of language, an offense for which any kind of posted sign could have qualified. Yet the image of cutting and pasting evoked in Horton's testimony seems somehow crucial to the indecency of Clements's action and to the symbolic transgression it achieves. Not only was she displaying dirty words in public, not only was she cloaking her identity in the anonymity of a posted sign, but by enlisting other people's publicly circulated words toward her ends, Martha Clements's scandalous prank calls attention to the emerging power of the city's public texts, severed from their original authors and expressive contexts, broken down and refashioned before a promiscuous urban readership.[13]

If a particular poster might shock to the point of prosecution, most temporary signs blended inoffensively and unobtrusively into the vast and increasingly familiar spectacle of writing and print that had become part of everyday life in the city by the 40s and 50s. As several observers noted, however, the seamless surface of this verbal collage papered over many discontinuities in urban life. An 1862 lithographic advertisement depicts a wall plastered completely with overlapping bills promoting everything from esteemed ministers to Tammany Hall politicians to popular actresses [Figure 22.2]. Read "downwards," as the original caption to "The Bill-Posters Dream" instructs its readers to do, the notices form such amusing messages as "$100 BOUNTY WANTED A JEWESS FOR ONE NIGHT ONLY," "THE AMERICAN BIBLE SOCIETY WILL MEET AT THE GAIETIES CONCERT SALOON," "GREAT SPARRING EXHIBITION BY THE SIAMESE TWINS AT BARNUM'S MUSEUM," and "RESTORATIVE FOR THE HAIR USE SPAULDING'S PREPARED GLUE." The humor in this drawing lies, of course, in the characteristically urban juxtaposition of unlikely combinations of people and events, in which physical proximity forces the promiscuous intermingling of a community's disparate elements. More specifically, the cartoon calls attention to several central features of New York's ephemeral sign discourse as it emerged in the antebellum period. First, "The Bill-Posters Dream" seems to make the point that as signs became too numerous, their individual purposes were to a certain extent undermined as the notices buried one another in an avalanche of competing messages. At the same time, the signs blended smoothly into a shared language of publicity encompassing everything from politics to entertainment to religion—it is because of their superficial graphic and discursive resemblances as well as their spatial contiguity that the overlapping words lend themselves to humorous misreadings. In addition, the effectiveness of the collage depends on what was the crucially *public* element in the emerging urban sign system: once a sign was placed in the public domain it became radically severed from the control and intentions of its author and acquired a life of its own. Finally, the framing of the plastered wall by a small sign reading "Post No Bills!" in the upper left corner and the sleeping bill poster (whose fantasy of an exhaustively papered wall seems like more than just a dream of day's work completed) in the lower left dramatizes the clash between a barely conspicuous and patently ineffective public authority and an unwieldy commercial culture intent on leaving no vertical space unmarked.

In depicting the ironies and excesses of New York's collage of signage, "The Bill-Posters Dream" joined a chorus of cultural commentary on what was a central development in the history of the city. The man who had the job of covering public walls with printed notices provided a compelling figure for the confusions and collisions of life in antebellum New York. A contemporary compendium of business lore celebrates the bill-sticker as a "definite, genuine distinct character—one who keeps alive other trades—and who may also be said to live in the public eye as literally as any other man of his day."[14] In the mid-century urban exposés

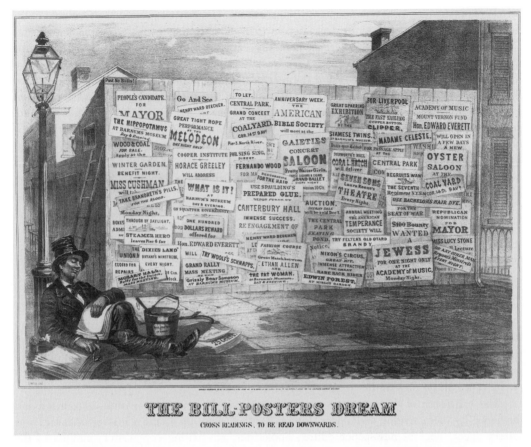

Figure 22.2 "The Bill-Posters Dream," 1862. Courtesy of the Eno Collection, Miriam and
Ira D. Wallach Division of Art, Prints and Photographs, The New York Public Library, Astor,
Lenox and Tilden Foundations.

of popular journalist George G. Foster, the bill-poster appears as an intrepid connoisseur of
the city, much like the author himself. "With his hieroglyphic paper bed-blankets over one
arm and his paste-bucket hanging upon the other," the bill-poster makes the rounds late at
night when only a handful of drunks are left in the street, and "with nice discrimination" spots
the fresh posters of his rivals and "neatly plasters them over with his own."[15] Elsewhere,
Foster describes the spectacle of a wall papered with ads in a manner much like that of the
1862 cartoon:

> Go to the tumbling dead-walls of the Park Theater . . . and see what is written there.
> You will perhaps, after scanning its calicoed surface, reply: "Steamer Ali–Sugar-Coat–
> and Pantaloons for–the Great Anaconda–Whig Nominations–Panorama of Principles–
> Democrats Rally to the–American Museum"–and so on, reading interminably from the
> handbills lying like scales (or like political editors) one upon another.[16]

Though such contrived illustrations may present an exaggerated picture, posters and show
bills were in fact plastered all over the city . . ., "stuck upon every wall," as one foreign observer
noted during the Civil War—"with an utterly English disregard of artistic proprieties"—and

banners hung from awnings, announcing special sales and merchandise arrivals. "One sees nothing but waving banners, monstrous sign-boards, flamboyant finery," complained Ernest Duvergier de Hauranne in 1864 after a stroll down Broadway. "There isn't enough room for the advertisements," the Frenchman noted, "and they overflow into the street, on the edge of the sidewalks, between the gutter and the feet of the passers-by." Travel writer Isabella Lucy Bird, who visited from England in the 1850s, wrote of "large squares of calico, with names in scarlet or black upon them, hang[ing] across the streets, to denote the whereabouts of some popular candidate or 'puffing' storekeeper."[17] The streets were the site of countless verbal publicity campaigns whose promotional strategies remained essentially the same, as Bird's comment suggests, whether their purposes were political or commercial. The effect of these campaigns could, of course, be trivializing. Duvergier de Hauranne expressed outrage at the juxtaposition and homogenization of such varied concerns.

> Then I came upon this emphatic advertisement: 'Books at Tremendous low prices;' then a majestic array of signs all alike: 'We need ten thousand volunteers,' with details of the bounties offered and the drinks promised, or else a big flag upon which the picture of a fantastic bottle is displayed in brilliant colors. Everything is done in this way, even serious things, even the purchase of human blood!

Seen together, this collage of paper and ink served, much like the city's store signs and street signs, to provide a familiar space for staging and receiving public messages. Due to their visibly transitory character, though, they called even more attention to the rapidity of urban change. "That which is really written there is but a single word," Foster observed of the sign collage outside the theater, "MUTABILITY."[18]

The expansion of this style of street advertising in New York was both epitomized and furthered by the activities of Phineas Taylor Barnum. Barnum's entire masterful career—as lottery agent, libelous newspaper editor, bookseller, advertising copywriter, curator of the curious and the freakish, concert impresario, circus director, bank president, and autobiographer—traces the trajectory and highlights the dominant themes of the history of print in nineteenth-century America. While various scholars have offered convincing readings of Barnum as the classic Yankee performer, the classic con artist, and the classic self-made man, it is important to appreciate his status as, quite literally, an urban man of letters.[19]

Beyond the general and oft-remarked fact that Barnum recognized and exploited the power of the press and of print advertising to stimulate mass interest in previously unknown persons (such as Swedish opera singer Jenny Lind, whose fantastically successful concerts he presented in New York in 1850) or largely unremarkable events and exhibitions (such as his 1842 discovery of a dwarf in Connecticut whom he dubbed General Tom Thumb), Barnum understood two important features of the written word. First, Barnum appreciated the material qualities of a sign, and was often as attentive to the physical appearance of an advertisement as he was to its semantic content. Second, Barnum thrived on the sparseness of the written sign, on its ability to make a brief and enigmatic statement without having to elaborate or respond to queries.[20] Of course Barnum was not beyond making patently false claims in his printed ads—he once cautioned the Water Commission not "to interpret my show bills too literally."[21] In general, though, Barnum's strategic deployment of writing and print tended to revel in an intensely literal and close reading. He preferred to rope in customers with advertising messages that remained within the bounds of technical accuracy while refusing to satisfy any further the curiosity they aroused. "The cold type," one of Barnum's friendly critics explained in another context, concealed "the twinkling of the author's eye."[22]

If Barnum's promotional uses of the written word were, as he saw it, more "audacious" and more "glaring" than those of his neighbors,[23] they were by no means out of place in an urban culture in which public signs and posters were scattered throughout the streets, addressing their readers with brief slogans and enticing hooks. Political posters and broadsides were of course part of this public culture, and placards posted around the city before an election, such as an 1861 sign on the corner of Broadway and Duane Street reading "For Sheriff, William M. Tweed,"[24] or a striking Jacksonian summons for voters to "Go the Whole Hog" (in what one visitor dubbed "sesquipedalian characters"),[25] clearly had more in common with Barnum's commercial posters than with the idealized political broadside literature associated with the development of the public sphere in the eighteenth century. But far from trivializing politics, the continuities between political and commercial sign discourse intensified and underscored the broadly popular character of public debate and action in the antebellum city.

Throughout the antebellum era, in campaign advertisements and political broadsides distributed in the streets and posted on trees and buildings, New Yorkers of different ideological commitments and agendas took full advantage of the handbill medium, especially in the staging of rallies and riots. Though such collective political actions appear in the historical imagination as events dominated by the spoken (or shouted) word, writing and print occupy a central position in the history of street protest in antebellum New York. Temporary signs extended opportunities for public address to a broad range of people, they rendered the views and tactics of those people visible in public space, and they facilitated and orchestrated mass action in a city whose size curtailed the logistical efficacy of traditional modes of face-to-face political organization. For these reasons, ephemeral signage figured prominently in virtually every major political demonstration of the period, from flour riots to partisan parades.

Perhaps the most impressive evidence of the role of street posters in the organization of political protest comes earlier from the famous Astor Place Riots of 1849, in which a rivalry between two stage actors became the focal point for cultural and economic anxieties among New York's artisans and journeymen and led to a massacre. The clash between the English actor William Macready at the Astor Place Opera House and the American Edwin Forrest, at the Broadway Theatre, was dramatized quite visibly by the appearance on May 7th of two posters announcing two different performances of *Macbeth* that evening. The juxtaposition of the competing plays was represented in the familiar spectacle of commercial advertising—the tone and style of the posters were identical (only the names of the cast members differed)—but the seriousness of the conflict was clear enough. That night Macready was greeted with boos and rotten eggs by the Bowery B'hoys, and was forced to leave the theater. Three days later, on the occasion of Macready's infamously well-guarded repeat performance, bills pasted to walls all over town asked "SHALL AMERICANS OR ENGLISH RULE IN THIS CITY?" and alleged some threats made by English sailors against "all Americans who shall dare to express their opinion this night at the English Aristocratic Opera House!!" The poster, which seems to have been distributed by popular author Ned Buntline (E.Z.C. Judson) and by Isaiah Rynders's Tammany gang the Empire Club, received considerable attention in the papers after that evening's unrest culminated in the killing of twenty-two people. When Buntline was tried for his participation in the riots, presiding Judge Daly recognized the significance of the defendant's "words, signs, and gestures."[26]

The day after the violence, several other signs sprouted up, attempting to organize a response to the previous night's massacre. "TO THE PARK!" one poster urged New Yorkers "opposed to the destruction of human life," while a more inflammatory bill summoned American patriots, "whose fathers once compelled the base-born miscreants to succumb," to

fight the aristocratic English oppressors and defend "the liberty of opinion—so dear to every true American heart."[27] Another notice, signed by the coroner William Walters, invited "persons who witnessed the wounding or death of individuals during the riot at the Opera House Theatre" to meet the next day at his office, and Mayor Caleb Woodhull's proclamation "deploring the loss of life" while reminding "all the citizens that the peace of the City must be maintained" was posted that afternoon.[28] As much as the newspaper, which required a greater time lag and operated on different principles of personal accountability, posted signs served as a primary conductor of mass communication during the 1849 tragedy.

Events such as the Astor Place Riots remind us how important bills and posters were in the network of urban communication that (among other things) made large-scale political action possible in antebellum New York. The place of signs in the dissemination of news and information frequently escapes the notice of historians who are (quite properly) impressed by the spread of the newspaper in the nineteenth century. It is easy to overlook the fact that, first of all, since newspapers were hawked in the streets, they themselves could function as a kind of public handbill, and that, moreover, newspaper companies often engaged in sign-posting activities to supplement and promote their paper sales. Especially after the introduction of the telegraph, newspaper offices became frequent sites of public reading where New Yorkers gathered to learn the latest bits of important information as they were posted for general view. The power of temporary signs extended beyond their capacity to transmit information, however. Signs were well suited for political mobilization because they circulated anonymously. New Yorkers could appear and interact in public unanchored and uncompromised by the burdens and responsibilities of mutual personal recognition. In the realm of politics, this situation had profound implications. Much like the broadside literature of the Revolutionary period, antebellum posters could claim the public interest (or in some cases class or regional interest) not simply by addressing an abstract readership, but by bracketing the personal identity of their composers.[29] Standing freely in public space or floating swiftly from hand to hand, bills often claimed an impersonal authority irreducible to the private or ambivalent interests of an author. In addition, anonymous authors and distributors could attribute their words to other parties and could intervene in political debates without any personal liability.

The political culture of antebellum New York depended on both the logistical utility and the radical publicity of posted signs to recruit participants and create an audience. Signs helped publicize and promote most of the major riots, rallies, parades, and celebrations of the middle of the century, and they also served as pivotal communication devices within the context of crowd activity. Signs helped orchestrate group behavior by speaking over the noise of the assembled, and provided visible symbols and pithy captions for the cause for which a crowd had gathered. Writing and print were ubiquitous in the political theater of the antebellum and Civil War eras, even in those scenes we tend to imagine as most spontaneous, rowdy, and beyond the reaches of literate communication. During the Draft Riots of 1863, for example, rioters strung a blinded black man to a lamppost and covered his chest with a sign reading: "We will be back for you tomorrow."[30] The signs posted at rallies exerted a disproportionate impact on popular understandings of these events, and the slogans lofted at processions and meetings (which were dutifully reproduced or quoted in the newspapers) shaped political rhetoric by publicizing a set of pithy aphorisms that became campaign shibboleths.

By the end of the Civil War, New Yorkers had grown accustomed to reading the city by consulting the constantly changing collage of publicly posted words. Walking down Wall Street on April 3, 1865, the prominent lawyer George Templeton Strong noticed the announcement "PETERSBURG IS TAKEN" on the *Commercial Advertiser* bulletin board and went

inside the office for more information. As he recorded in his famous diary: "The man behind the counter was slowly painting in large letters on a large sheet of brown paper another annunciation for the board outside: 'RICHMOND IS'—'What's that about Richmond?' said I. 'Anything more?' He was too busy for speech, but he went on with a capital C, a capital A, and so on, till I read the word CAPTURED!!!"[31] Though the surrender of the Confederate Army was hardly a typical news item, and though the author's dramatic rendering of the event emphasizes the fortuitous nature of his discovery, Strong's encounter took place on a stage familiarly and legibly cluttered with outdoor texts.

The emergence of such urban reading practices is difficult to appreciate from our historical perspective. We have come to expect cityscapes to be legible, much as we expect consumer goods to come with labels, instructions, legal disclaimers, and promotional copy. But there was once something novel in the spectacle of so many words, and something radical in the notion that buildings and streets ought to be marked for the viewing of strangers. The process by which different groups of New Yorkers constructed and adjusted to the texts that marked their city unfolded unevenly and in complex ways, reflecting, among other things, changing patterns of residence, work, commerce, education, social control, and visual representation. The impact of this collage of signs, newspapers, banners, and bills was equally complex, but tended to reinforce the anonymous and impersonal forms of interaction that fill Strong's account. The man behind the counter is, significantly, "too busy for speech," and the well-connected lawyer gets his information by virtue of his physical location in public space, rather than his social position in the community. In the increasingly anonymous, heterogeneous, and transitory public spaces of the nineteenth-century city, momentous wartime messages shared a common public stage with more mundane communications and more quotidian pleasures. The disjointed encounters between this public stage and new generations of city readers mark the advent of some our most basic modes of urban spectatorship. While urbanites in nineteenth-century America and Europe celebrated the visual pleasures associated with dioramas, photographs, illusionist paintings, they also fixed their gaze on written and printed texts, though often with less fanfare and dimmer self-consciousness. If the subsequent history of big city life has reaffirmed, in Georg Simmel's evocative formulation, the preponderance of visual over aural experience, the ordinary texts of urban life remain highly evocative symbols of modernity.

Notes

1 See, for example, Marshall Berman, *All That is Solid Melts into Air* (New York, 1988); T.J. Clark, *The Painting of Modern Life* (Princeton, N.J., 1986); Vanessa R. Schwartz, *Spectacular Realities: Early Mass Culture in Fin-de-Siècle Paris* (Berkeley, Calif., 1998); Leo Charney and Vanessa R. Schwartz (eds.), *Cinema and the Invention of Modern Life* (Berkeley, Calif., 1996); William R. Taylor, *In Search of Gotham* (New York, 1996); Dana Brand, *The Spectator and the City in Nineteenth-Century American Literature* (Cambridge, Mass., 1991). Much of this literature is informed by or responding to Guy Debord's *Society of the Spectacle* (Cambridge, Mass., 1994), trans. Donald Nicholson-Smith.

2 For an extended discussion of the distinctiveness of words within the cityscape, see David Henkin, *City Reading* (New York, 1998), pp. 17–22.

3 According to the 1840 census, for example, the literacy rate in New York State exceeded 90 per cent. See Henkin, pp. 20–2.

4 Robert Jay, *The Trade Card in Nineteenth-Century America* (Columbia, Missouri, 1987), especially 13–33; Adele Jenny, *Early American Trade Cards from the Collection of Bella C. Landauer* (New York, 1927); Thomas J. Schlereth, *Cultural History and Material Culture: Everyday Life, Landscapes, Museums* (Charlottesville, 1990), pp. 125–6.

5 *New York Herald*, quoted in Stanley Nadel, *Little Germany: Ethnicity, Religion, and Class in New York City, 1845–1880* (Urbana, 1990): 108–9.

6 Timothy J. Gilfoyle, *City of Eros: New York City, Prostitution, and the Commercialization of Sex, 1790–1920* (New York, 1992), p. 174.
7 Isaac Lyon, *Recollections of an Old Cartman* (New York 1984 [1872]), pp. 28–9.
8 "Journal of Henry C. Southworth," July 5, 1850, New York Historical Society, MSS.
9 Frazar Kirkland, *Cyclopaedia of Commercial and Business Anecdotes* (New York, 1864), pp. 309–10.
10 Arnold Schrier (ed.), *A Russian Looks at America: The Journey of Aleksandr Borisovich Laieir in 1857* (Chicago, 1979), p. 66. According to Clarence P. Hornung, sandwich boards first appeared in New York in the 1820s, followed shortly thereafter by wagons draped with banners. *Handbook of Early Advertising Art: Pictorial Volume* (New York, 1856), p. xxxi.
11 See Jay, *Trade Card in Nineteenth-Century America*, p. 22.
12 *People v. Moses Clements et al.*, Court of General Sessions, September, 13, 1830. Court of General Sessions, Indictment Papers, Municipal Archives, City of New York.
13 As Susan Stewart has argued in an essay on graffiti, "Writing and figuration in the wrong time and place fall into the category of obscenity," in a manner analogous to public displays of sexuality – even when the content of the graffiti is beyond reproach. "Ceci Tuera Cela: Graffiti as Crime and Art," in John Fekete (ed.), *Life After Postmodernism: Essays on Value and Culture* (New York, 1987), p. 169.
14 Kirkland, *Cyclopaedia of Commercial and Business Anecdotes*, p. 323.
15 George G. Foster, *New York by Gaslight and Other Urban Sketches* (Berkeley, Calif. 1990), p. 75.
16 Ibid., p. 152. The theme of overlapping or strikingly juxtaposed public notices is developed in Thomas La Clear's 1845 painting *Looking for Fun*. Melville adopts a related strategy and invokes a similarly urban trope for organizing information and events in the beginning of Moby-Dick (1851), when Ishmael imagines his whaling voyage as an item in the "grand programme of Providence," sandwiched between a contested presidential election and a battle in "Affghansitan." Herman Melville, *Moby-Dick* (New York, 1957), p. 15.
17 Edward Dicey, *Spectator of America* (Chicago, 1971 [1863]), p. 10; Ernest Duvergier de Hauranne in Ralph Bowen (ed.), *A Frenchman in Lincoln's America: Huit Mois en Amerique: Lettres et Notes de Voyages, 1864–1865* (Chicago, 1974), I, pp. 21–2; Isabella Lucy Bird, *The Englishwoman in America* (Madison, 1966 [1856]), pp. 386–7.
18 Foster, p. 152.
19 P.T. Barnum, *Struggles and Triumphs* (New York, 1981 [1855]); Barnum, *P.T. Barnum: The Greatest Showman on Earth* (New York, 1983 [1855]); Neil Harris, *Humbug: The Art of P.T. Barnum* (Boston, Mass., 1973); Bluford Adams, *E Pluribus Barnum: The Great Showman and the Making of U.S. Popular Culture* (Minneapolis, Minn., 1997); Peter Buckley, "To the Opera House: Culture and Society in New York, 1820–1860," Ph.D. diss., SUNY Stony Brook, 1984, 469–540; Constance Mayfield Rourke, *Trumpets of Jubilee* (London, 1927), 369–426; Leo Braudy, *The Frenzy of Renown: Fame and its History* (New York, 1986), 498–506; Jennifer Wicke, *Advertising Fictions: Literature, Advertisement, and Social Reading* (New York, 1988), 55–72; A.H. Saxon, *P.T. Barnum: The Legend and the Man* (New York, 1989).
20 His legendary use of a large canvas bearing the words "TO THE EGRESS" as a device to reduce crowds at his American Museum on Broadway by directing unsuspecting patrons to the exit typified Barnum's strategic use of writing to mislead readers into believing something he didn't actually say; significantly, in Barnum's retelling of the "egress" story his patrons (especially Irish ones) appear to fall for the ruse in part because they *mispronounce* the word egress – they supplement the sparse written word with a misleading vocalization (suggestive of a wild animal) for which Barnum need not assume legal responsibility. Barnum, *Struggles and Triumphs*, p. 119. Adams, *E Pluribus Barnum*, p. 96.
21 Barnum, *Struggles and Triumphs*, p. 108.
22 Quoted in Rourke, *Trumpets of Jubilee*, p. 369.
23 Barnum, *Struggles and Triumphs*, p. 107.
24 Leo Hershkowitz, *Tweed's New York: Another Look* (Garden City, N.Y., 1977), p. 85.
25 [Thomas Hamilton,] *Men and Manners in America* (New York, 1964 [1833]), p. 18.
26 Robert Moody, *The Astor Place Riot* (Bloomington, 1958), p. 130; Buckley, "To the Opera House," pp. 315, 417; Headley, *The Great Riots of New York: 1712–1873* (Indianapolis, 1970 [1873]), pp. 111–28.
27 Moody, *The Astor Place Riot*, p. 178.
28 Ibid., p. 184.
29 As Michael Warner argues, republican political discourse valorized an abnegation of the personal identity of individual authors. The kind of authority claimed by Benjamin Franklin's Mrs Dogood or the framers of the Constitution defined itself in opposition to and above individual identity and interest.

Warner, *Letters of the Republic: Publication and the Public Sphere in Eighteenth-Century America* (Cambridge, Mass., 1990).

30 Frederick Van Wyck, *Recollections of an Old New Yorker* (New York, 1932), p. 30.

31 Allan Nevins and Milton Halsey Thomas (eds.), *The Diary of George Templeton Strong* (New York, 1952), III, p. 574 (April 3, 1865).

Chapter 23

JUDITH WALKOWITZ

URBAN SPECTATORSHIP

WHEN HENRY JAMES ARRIVED IN LONDON in 1876, he found the city "not a pleasant place" nor "agreeable, or cheerful, or easy, or exempt from reproach." He found it "only magnificent . . . the biggest aggregation of human life, the most complete compendium in the world." It was also the "largest chapter of human accidents," scarred by "thousands of acres covered by low black houses of the cheapest construction" as well as by "unlimited vagueness as to the line of division between centre and circumference." "London is so clumsy and brutal, and has gathered together so many of the darkest sides of life," that it would be "frivolous to ignore her deformities." The city itself had become a "strangely mingled monster," the principal character in its own drama: an "ogress who devours human flesh to keep herself alive to do her tremendous work."[1]

Despite its brutalities, London offered James an oasis of personal freedom, a place of floating possibilities as well as dangers. Alone in lodgings, James first experienced himself in London as "an impersonal black hole in the huge general blackness." But the streets of London offered him freedom and imaginative delights. "I had complete liberty, and the prospect of profitable work; I used to take long walks in the rain. I took possession of London; I felt it to be the right place." As an artist, bachelor, and outsider, James aestheticized this "world city," the "center of the race," into a grand operatic panorama of movement, atmosphere, labyrinthine secrets and mysteries. London's "immeasurable circumference," argued James, gave him a "sense of social and intellectual elbow room"; its "friendly fogs," which made "everything brown, rich, dim, vague," protected and enriched "adventure." For the "sympathetic resident," such as James, the social ease of anonymity was matched by an ease of access to and imaginative command of the whole: one may live in one "quarter" or "plot" but in "imagination and by a constant mental act of reference . . . [inhabit] the whole."[2]

James celebrated the traditional prerogatives of the privileged urban spectator to act, in Baudelaire's phrase, as *flâneur*, to stroll across the divided spaces of the metropolis, whether it was London, Paris, or New York, to experience the city as a whole. The fact and fantasy of urban exploration had long been an informing feature of nineteenth-century bourgeois male

subjectivity. Cosmopolitanism, "the experience of diversity in the city as opposed to a relatively confined localism," argues Richard Sennett, was a bourgeois male pleasure. It established a right to the city—a right not traditionally available to, often not even part of, the imaginative repertoire of the less advantaged. In literary and visual terms, observes Griselda Pollock, "being at home in the city" was represented as a privileged gaze, betokening possession and distance, that structured "a range of disparate texts and heterogeneous practices which emerge in the nineteenth-century city—tourism, exploration/discovery, social investigation, social policy."[3]

A powerful streak of voyeurism marked all these activities; the "zeal for reform" was often accompanied "by a prolonged, fascinated gaze" from the bourgeoisie. These practices presupposed a privileged male subject whose identity was stable, coherent, autonomous; who was, moreover, capable through reason and its "science" of establishing a reliable and universal knowledge of "man" and his world.[4] It was these powers of spectatorship that Henry James ascribed to his "sympathetic resident" who, while residing in one quarter of town, was capable "in imagination" of inhabiting "the whole" of it.

At odds with this rationalist sensibility was the *flâneur*'s propensity for fantasy. As illusionist, the *flâneur* transformed the city into a landscape of strangers and secrets. At the center of his art, argues Susan Buck-Morss, was the capacity to present things in fortuitous juxtapositions, in "mysterious and mystical connection." Linear time became, to quote Walter Benjamin, "a dream-web where the most ancient occurrences are attached to those of today." Always scanning the gritty street scene for good copy and anecdote, his was quintessentially "consumerist" mode of being-in-the-world, one that transformed exploitation and suffering into vivid individual psychological experience.[5]

James's affectionate portrait of London, that "dreadfully delightful city," is dominated by the *flâneur*'s attention to the viewer's subjectivity and by the capacity of the city to stimulate. In James's "strangely mingled monster," activities of manufacture, trade, and exchange were overshadowed by rituals of consumption and display. Extremes of wealth and poverty aroused the senses, for "the impression of suffering was part of the general vibration," while London's status as repository of continuous culture and national heritage—its "great towers, great names, great memories"—served as a further stimulant to his own consciousness and memory: "All history appeared to live again and the continuity of things to vibrate through my mind."[6]

The literary construct of the metropolis as a dark, powerful, and seductive labyrinth held a powerful sway over the social imagination of educated readers. It remained the dominant representation of London in the 1880s, conveyed to many reading publics through high and low literary forms, from Charles Booth's surveys of London poverty to the fictional stories of Stevenson, Gissing, and James, to the sensational newspaper exposés by W. T. Stead and G. R. Sims. These late-Victorian writers built on an earlier tradition of Victorian urban exploration, adding some new perspectives of their own. Some rigidified the hierarchical divisions of London into a geographic separation, organized around the opposition of East and West. Others stressed the growing complexity and differentiation of the world of London, moving beyond the opposition of rich and poor, palace and hovels, to investigate the many class cultures in between. Still others among them repudiated a fixed, totalistic interpretive image altogether, and emphasized instead a fragmented, disunified, atomistic social universe that was not easily decipherable.

Historians and cultural critics have linked this contest over and "crisis" in representation to a range of psychological and social crises troubling literary men and their social peers in the 1880s: religious self-doubt, social unrest, radical challenges to liberalism and science, anxiety over imperial and national decline, as well as an imaginative confrontation with the

defamiliarized world of consumer culture "where values and perception seem in constant flux."[7] Equally crucial may have been the psychic difficulties produced by the imperatives of a "hard" physical manliness, first developed in the mid- and late-nineteenth century public schools and then diffused among the propertied classes of the Anglo-Saxon world. The hallmarks of this "virile" ethos were self-control, self-discipline, and the absence of emotional expression.[8] Whatever the precipitating causes, the public landscape of the privileged urban *flâneur* of the period had become an unstable construct: threatened internally by contradictions and tensions and constantly challenged from without by social forces that pressed these dominant representations to be reworked, shorn up, reconstructed.

Middle-class men were not the sole explorers and interpreters of the city in the volatile decade of the 1880s. On the contrary, as the end of the century approached, this "dreadfully delightful city" became a contested terrain, where new commercial spaces, new journalistic practices, and a range of public spectacles and reform activities inspired a different set of social actors to assert their own claims to self-creation in the public domain. Thanks to the material changes and cultural contests of the late-Victorian city, protesting workers and "gents" of marginal class position, female philanthropists and "platform women," Salvation Army lasses and match girls, as well as glamorized "girls in business," made their public appearances and established places and viewpoints in relation to the urban panorama. These new entrants to the urban scene produced new stories of the city that competed, intersected with, appropriated, and revised the dominant imaginative mappings of London.

Before tracking the progress of these new urban travelers and their social visions, let us first examine the tradition of urban spectatorship embodied in Henry James's alter ego, the "sympathetic resident." As a cosmopolitan, the "sympathetic resident" could take up nightwalking, a male pursuit immortalized in urban accounts since Elizabethan times, but one that acquired a more active moral and emotional meaning for intrepid urban explorers in the Victorian period. Whereas Regency dandies of the 1880s like Pierce Egan's characters, Tom and Jerry, had experienced the streets of London as a playground for the upper classes, and interpreted streets sights and characters as passing shows, engaged urban investigators of the mid- and late-Victorian era roamed the city with more earnest (if still voyeuristic) intent to explain and resolve social problems. Frederick Engels, Charles Dickens, and Henry Mayhew were the most distinguished among a throng of missionaries and explorers, men who tried to read the "illegible" city, transforming what appeared to be a chaotic, haphazard environment into a social text that was "integrated, knowable, and ordered." To realize their subject, their travel narratives incorporated a mixture of fact and fancy: a melange of moralized and religious sentiment, imperialist rhetoric, dramatized characterization, graphic descriptions of poverty, and statistics culled from Parliamentary Blue Books.[9]

As early as the 1840s, these urban explorers adapted the language of imperialism to evoke features of their own cities. Imperialist rhetoric transformed the unexplored territory of the London poor into an alien place, both exciting and dangerous. As Peter Keating notes, urban explorers never seemed to walk or ride into the slums, but to penetrate inaccessible places where the poor lived, in dark and noisy courts, thieves' "dens," foul-smelling "swamps," and the black "abyss." To buttress their own "eye of power," these explorers were frequently accompanied by the state representative of order, a trusty policeman: in the 1860s, the journalist George Sims made excursions to East End taverns frequented by sailors and prostitutes, accompanied by a detective or professional "minder." As a master of disguise, the journalist James Greenwood felt comfortable enough to dispense with this latter precaution: "A private individual," he insisted, "suitably attired and of modest mien, may safely venture where a policeman dare not show his head."[10]

The literature of urban exploration also emulated the privileged gaze of anthropology in constituting the poor as a race apart, outside the national community.[11] Mayhew, for example, introduced his investigation in *London Labour and the London Poor* by linking the street folks of London to the ethnographic study of "wandering tribes in general," arguing that, like all nomads, costermongers had big muscles and small brains, and were prone to be promiscuous, irreligious, and lazy;[12] even Engels, who went to great lengths to expose the "culpability" of the bourgeoisie for the slums, still retained, according to Peter Stallybrass and Allon White, "an essentialist category of the sub-human nomad: the Irish."[13]

Mid-Victorian investigators represented the urban topography of the "gaslight era" as a series of social Juxtapositions of "high" and "low" life. Observers in the 1860s and 1870s frequently reproduced a Dickensian cityscape of dirty, crowded, disorganized clusters of urban villages, each with its own peculiar flavor and eccentricity, where the Great Unwashed lived in chaotic alleys, courts, and hovels just off the grand thoroughfares. In the 1860s, for instance, James Greenwood began his tour of "Low Life Deeps" with a visit to the "notorious Tiger Bay" of the East End's Radcliffe Highway, but he soon moved westward to "Jack Ketch's Warren" in Frying Pan Alley, Clerkenwell, and then to a "West End Cholera Stronghold." Henry Mayhew also moved from place to place in his study of the urban poor, although he noticed a difference between the laboring classes in the East and the West: "In passing from the skilled operative of the West-end, to the unskilled workman of the Eastern quarter, the moral and intellectual change is so great, that it seems as if we were in a new land, and among another race."[14]

Mayhew's observations portended an important reconfiguration of London as a city divided into East and West. Mid-Victorian explorations into the *terra incognita* of the London poor increasingly relied on the East/West opposition to assess the connecting links between seemingly unrelated parts of society. One of the most powerful and enduring realizations of this opposition, Doré and Jerrold's *London: A Pilgrimage* (1872), envisioned London as two distinct cities, not of capital and labor, but of the *rentier* and the impoverished criminal. It juxtaposed a West End of glittering leisure and consumption and national spectacle to an East End of obscure density, indigence, sinister foreign aliens, and potential crime.[15]

This bifurcated cityscape reinforced an imaginative distance between investigators and their subjects, a distance that many urban explorers felt nonetheless compelled to transgress. Cultural critics Stallybrass and White offer a Bakhtinian explanation of the cultural dynamics at work in this "poetics" of transgression. In class society, they argue, the repudiation of the "low" by the dominant "top" of society was paradoxically accompanied by a heightened symbolic importance of the "low Other" in the imaginative repertoire of the dominant culture.

> A recurrent pattern emerges: the "top" attempts to reject and eliminate the "bottom" for reasons of prestige and status, only to discover not only that it is in some way frequently dependent on the low-Other . . ., but also that the top *includes* that low symbolically as a primary eroticized constituent of its own fantasy life. The result is a mobile, conflictual fusion of power, fear and desire in the construction of subjectivity.

For this reason, Stallybrass and White argue, "what is *socially* peripheral is so frequently *symbolically* central. . . . The low-Other is despised, denied at the level of political organization and social being whilst it is instrumentally constitutive of the shared imaginary repertoire of the dominant culture."[16] [. . .]

By, the 1880s, most of the salient features of London's imaginary landscape, which writers like Dickens, Mayhew, and Greenwood had helped to construct, had formalized into a conception

of London as an immense world-city, culturally and economically important, yet socially and geographically divided and politically incoherent. Social and political developments of the mid- and late-Victorian period materially reinforced this complex image. London was the largest city in the world, totalling four million inhabitants in the 1880s. Since the first half of the nineteenth century, it had reclaimed its status as the cultural and nerve center of the nation and empire, overshadowing Manchester and Liverpool as the embodiment of the "modern city."[17]

In the second half of the century, the West End of Mayfair and St. James had undergone considerable renovation; from a wealthy residential area it had been transformed and diversified into the bureaucratic center of empire, the hub of communications, transportation, commercial display, entertainment, and finance. In the process, a modern landscape had been constructed—of office buildings, shops, department stores, museums, opera, concert halls, music halls, restaurants, and hotels—to service not only the traditional rich of Mayfair but a new middle class of civil servants and clerks, living in such areas as Bayswater and the nearby suburbs.[18] New figures appeared in this urban landscape, most significantly "girls in business," neither ladies nor prostitutes, but working women employed in the tertiary sector of the economy, there to assist the large numbers of "shopping ladies," attracted to the new feminized world of department stores that had been created for them in the center. In late-Victorian London, the West End was not just the home and fixed reference of the urban *flâneur*; it had become a new commercial landscape, used by men and women of different classes. [. . .]

Notes

1 Henry James, "London," in *Essays in London and Elsewhere* (Freeport, N.Y.: Books for Libraries, 1922 [first pub. 1893]) pp. 27, 32. See "City of Dreadful Delight," review of James's "London," in *PMG* (London), 15 Sept. 1888.

2 Henry James, *The Complete Notebooks of Henry James*, ed. Leon Edel (New York: Oxford University Press, 1987), pp. 215–18; James, "London," pp. 7, 14.

3 Richard Sennett, *The Fall of Public Man* (Cambridge: Cambridge University Press, 1973), pp. 135–37; Peter Stallybrass and Allon White, *The Politics and Poetics of Transgression* (Ithaca: Cornell University Press, 1986), p. 139; Griselda Pollock, "Vicarious Excitements: *London: A Pilgrimage* by Gustave Doré and Blanchard Jerrold, 1872," *New Formations* 2 (Spring 1988): 28.

4 Jane Flax, "Postmodernism and Gender Relations in Feminist Theory," *Signs* 12, no. 4 (Summer 1987): 624.

5 Susan Buck-Morss, "The Flâneur, the Sandwichman, and the Whore: The Politics of Loitering," *New German Critique* 13, no. 39 (1986): 106; Walter Benjamin, quoted in ibid., 106; ibid., 105.

6 James, "London," p. 27.

7 Gareth Stedman Jones, *Outcast London: A Study in the Relationship Between Classes in Victorian Society* (Oxford: Clarendon Press, 1971); Frank Miller Turner, *Between Science and Religion: The Reaction to Scientific Naturalism in Late-Victorian England* (New Haven: Yale University Press, 1974); Colin Ford and Brian Harrison, *A Hundred Years Ago: Britain in the 1880s in Words and Photographs* (Cambridge: Harvard University Press, 1983); Norman MacKenzie and Jeanne MacKenzie, *The Fabians* (New York: Simon and Schuster, 1977); T. J. Jackson Lears, *No Place of Grace: Anti-modernism and the Transformation of American Culture, 1880–1920* (New York: Pantheon, 1981); Richard Wightman Fox and T. J. Jackson Lears, eds., *The Culture of Consumption: Critical Essays in American History, 1880–1980* (New York: Pantheon, 1983).

8 This norm involved the merger of aristocratic and middle-class norms; it was a secularized version of "muscular Christianity" with a decidedly greater emphasis on the muscular than the Christian. As historians note, it may have subjected men to a greater degree of emotional deprivation than the moral strictures of evangelical Christianity, which at least offered an outlet of intense emotion in religious expression. See J. A. Mangan and James Walvin, eds., *Manliness and Morality: Middle-Class Masculinity in Britain and America, 1800–1940* (New York: St. Martin's Press, 1987); Ronald Hyam, *Empire and Sexuality: The British Experience* (Manchester: Manchester University Press, 1990), pp. 71–73; Janet

Oppenheim, *"Shattered Nerves": Doctors, Patients, and Depression in Victorian England* (New York: Oxford University Press, 1991), pp. 146–51.

9 On Tom and Jerry, see Deborah Epstein Nord, "The City as Theater: From Georgian to Early Victorian London," *Victorian Studies* 31, no. 2 (Winter 1988): 159–88. On reading the city, see William Sharpe and Leonard Wallock, "From 'Great Town' to 'Nonplace Urban Realm': Reading the Modern City," in *Visions of the Modern City: Essays in History, Art, and Literature*, ed. William Sharpe and Leonard Wallock (Baltimore: Johns Hopkins University Press, 1987), p. 9.

10 Peter Keating, ed., Introduction, *Into Unknown England, 1866–1913: Selections from the Social Explorers* (Glasgow: William Collins and Sons, 1976), p. 16; Pollock, "Vicarious Excitements," p. 28; George R. Sims, *My Life: Sixty Years' Recollections of Bohemian London* (London: Eveleigh Nash, 1917), p. 101; James Greenwood, *The Wilds of London* (1874; rpt., New York: Garland, 1985).

11 See Deborah Epstein Nord, "The Social Explorer as Anthropologist: Victorian Travellers among the Urban Poor," in *Visions of the Modern City*, ed. Sharp and Wallock, pp. 122–34; George W. Stocking, *Victorian Anthropology* (New York: The Free Press, 1987); Adam Kuper, *The Invention of Primitive Society* (London and New York: Routledge and Kegan Paul, 1988).

12 They did not always sustain this separation throughout the texts: as Mayhew detailed the lives of his street folk, observes Catherine Gallagher, "these charges evaporate." Mayhew's ethnography of wandering tribes conflicted with what Gareth Stedman Jones describes as Mayhew's understanding "in embryo" of the "specificity of the London economy," its prevalence of casual trades, low wages, under-employment, that explained the "improvident" habits of the London worker. Catherine Gallagher, "The Body versus the Social Body in the Works of Thomas Malthus and Henry Mayhew," in *The Making of the Modern Body: Sexuality and Society in the Nineteenth Century*, ed. Catherine Gallagher and Thomas Laqueur (Berkeley: University of California Press, 1987), pp. 83–106; Jones, *Outcast London*.

13 "By condensing the 'abnormal' practices of the slum in the figure of the savage Irishman," Engels attempted to protect the English proletariat from conflation with the filth and squalor of their environment (Stallybrass and White, *Politics and Poetics of Transgression*, p. 132). As Gertrude Himmelfarb observes, Mayhew imagined the costermongers more as "a species in the Darwinian sense than a class in the Marxian." As urban primitives, they were likened to the Bushmen and Hottentots of Africa, subjected to the same anthropological scrutiny and classification as subhuman. Commentators often fixed on their animalistic bodies; in Mayhew's case, on the unnaturally robust health of the street traders who parasitically lived off the labor of the productive poor; or, in the cases of Engels and Dickens, the starving, enfeebled bodies of the industrial classes. Gertrude Himmelfarb, "The Culture of Poverty" in *The Victorian City: Images and Realities*, 2 vols., ed. H. J. Dyos and Michael Wolff (London and Boston: Routledge and Kegan Paul, 1973), 2: 712; Gertrude Himmelfarb, *The Idea of Poverty: England in the Early Industrial Age* (New York: Vintage, 1985).

14 James Greenwood, *Low Life Deeps: An Account of the Strange Fish to be Found There* (London: Chatto and Windus, 1876); Henry Mayhew, *London Labour and the London Poor*, four vols. (1861; rpt, New York: Dover, 1968), 3: 233, quoted by Jones, *Outcast London*, p. 30.

15 Visual interpretations like *London: A Pilgrimage* helped to sustain nostalgic and anachronistic representations of London in the last decades of the century. See Pollock, "Vicarious Excitements."

16 Stallybrass and White, *Politics and Poetics of Transgression*, pp. 5–6.

17 Asa Briggs, *Victorian Cities* (New York and Evanston: Harper and Row, 1963), chap. 8.

18 Gavin Weightman and Steve Humphries, *The Making of Modern London, 1815–1914* (London: Sidgwick and Jackson, 1983).

DAVID NYE

ELECTRICITY AND SIGNS

I

IN 1885 *ELECTRICAL WORLD* REPORTED a scheme for lighting the entire city of Paris with an artificial sun mounted on one central tower in the Tuileries Garden. The 1,100-foot tower was to have one hundred lamps of 200,000 candle power each, turning night into day.[1] This grandiose idea was impossible because such powerful lights had not yet been invented, and it was also impractical because such an installation could illuminate only one side of most buildings. [. . .] [A]n artificial sun in the Tuileries would proclaim French cultural superiority. From its inception the public has understood lighting as a powerful symbolic medium, and yet the history of lighting usually has been presented as the triumph of science in providing the useful. Before gas and electric streetlights people had to find their way with lanterns, and the city at night seemed fraught with danger. Certainly public lighting made the city safer, more recognizable, and easier to negotiate. But such a functionalist approach cannot begin to explain why electric lighting had its origins in the theater or why spectacular lighting emerged as a central cultural practice in the United States between 1885 and 1915, when promoters and public alike demanded ever-greater public displays. America's use far exceeded necessity, employing light as a form of symbolic expression in world's fairs, theaters, public events, and electrical advertising signs. Within a single generation after 1885 Americans transformed their main streets into "Great White Ways," and by the 1920s photographers and painters had made electric lighting a central part of the representation of the city. [. . .]

III

World fairs modeled an idealized future, projecting a man-made universe where every object was in harmonious relationship with an overarching theme. They were middle-class visions of order, cast in the imported Beaux Arts style and sponsored by the same cultural elite that built up the new museums of history and art. Their ideal was a horizontal monumentality, and their object was to expose the ugliness of late nineteenth-century American cities, with their chaotic traffic, irregular lighting, and immigrants crowded into tenements that often had no running water and little fresh air. The cities had been built rapidly after the Civil War on a monotonous grid pattern, and they lacked the aesthetic unity of the great expositions. They were discordant environments, indiscriminately mixing a great variety of styles, juxtaposing new towers with two-story buildings and squalid apartments. Electricity did not improve conditions, but rather intensified the contrast. It was far easier for a single business to adopt eye-catching technologies from the exposition midway than it was for a group of civic leaders to impose a single style on a district. Instead of the stately "white city" of Chicago, or the pastel impressionism of the

Pan-American Exposition with its unified color scheme, American cities emerged as a visual babble, a vital confusion of forms that was the despair of early city planners.[2]

One obvious problem was the tangle of wires and poles erected for the telephone, telegraph, street lighting, and private power that disfigured most downtown streets. In New York, "there was a vast and intricate network of wires over all the city, especially in the business sections; and the avenues and streets showed a forest of tall poles, many of them carrying several hundred wires." The city's Board of Electrical Control reported in 1888 that "as these poles necessarily differ in height the wires upon them form a complete network, rendering the efficient use of the hooks and ladders and life saving apparatus of the fire department almost impossible."[3] Many communities with this problem, like Muncie, were unable to muster the political consensus needed to pass laws against this danger and aesthetic blight, and even if they did utility companies sometimes ignored ordinances requiring that wires be buried under the street. In the 1890s, when the utilities of New York serenely ignored a law requiring that their lines must be buried, the mayor finally ordered that public officials chop down the unsightly poles, though they were laden with wires; when the order was carried out, citizens stood at a prudent distance and applauded.

If the emerging city was discordant, theaters were developing powerful illusions in electrical spectacles that would soon move out-of-doors. Theaters, which had developed "impractical" electric lighting long before Edison, were among his earliest customers. In 1885 he personally supervised installation of an electrical system in Steele McKaye's Lyceum, and by the late 1880s Adolphe Appia and David Belasco also had adapted electric lighting to the stage. Indeed, Belasco became known as "the wizard of the switchboard," a title that belonged equally to his full time electrician, Louis Hartmann. Both Appia and Belasco "regarded light as the unifying principle which would link the actor and the stage setting in an artistic entity." Indeed, "Belasco's lighting always served a distinct purpose. In his view the lighting of a performance—its color, its stress, its comment—must be revealing in the fullest sense." Moving away from footlights, which he abolished altogether for some performances Belasco was one of the first to employ a flexible system of moving projectors and spotlights, which he "used to achieve an atmospheric, plastic illumination of the scenery by means of constantly varying, delicately natural shades of brightness and shadow." By 1900, Belasco could stage a long scene in *Madame Butterfly* that represented the hours from dusk to dawn, in which no one spoke; he maintained dramatic intensity through manipulation of lighting alone. Reviewers saw in this and other productions the emergence of a new kind of theater that relied less on language and more on stagecraft. Belasco himself called Madame Butterfly "the first play to develop electricity in its use for stage effects, from the merely practical to the picturesque and poetical." He was perhaps the first to hold lighting rehearsals. In later years Livingston Pratt and Joseph Urban continued Belasco's innovations in the New Movement.[4]

Just as electrical corporations sold stage designers on the safety, flexibility, and variety of effects possible with electrical lighting, they also marketed the lighting techniques they had pioneered at world's fairs to private customers, and began to transform the urban night landscape. In *The Titan* Theodore Dreiser describes a saloon that "was the finest in all Wentworth Avenue. It fairly glittered with the newly introduced incandescent lamp reflected in a perfect world of beveled and faceted mirrors."[5] Electricity made such a business up-to-date; as a symbol of modernity light bulbs were ostentatiously displayed in windows, redoubled in mirrors, or reflected on polished surfaces. By the 1890s restaurants, hotels, and department stores regarded elaborate lighting as essential to competition. Their displays began to transform the city's visual organization and texture; if in the full glare of the sun it was drab, after dark it seemed close to the ideal. Many sensed this gradual redefinition of the city after dark.

Dreiser's Carrie Meeber was fascinated by Chicago's bright lights when she first arrived. Like other small-town visitors, she admired the world of monumental buildings, rushing electric trains, brightly lighted shop windows, and flashing signs. At the turn of the century, this urban electrification was still located at the pedestrian's level, either as street lighting or as advertising. It served the vision of the horizontal city, making the city legible.[6]

Because advertising signs intruded so noticeably into the streets, they became a matter of controversy. In London three hundred architects presented a petition to the county council, demanding the repression of "the evils of monstrous letter and illuminated advertising," and in Edinburgh the Bovril Company was forced by a great public outcry to abandon plans to erect an illuminated sign overlooking Princess Street. By comparison, there was far less resistance to electric signs in the United States, although some private organizations fitfully protested against them, including the American Park and Outdoor Art Association and the American League for Civic Improvement.[7] But downtown American streets were destined to combine the eye-catching effects of the midway with the Beaux Art visions of the world's fairs. While merchant associations, in a combination of self-interest and desire to make the city beautiful, at times bought streetlighting systems and then turned them over to their city, such coordinated efforts were the exception, and individualism the rule. Every business developed its own displays and advertising, creating lively but discordant streets where the level of lighting rapidly intensified, so that American cities soon were far more brightly lighted than their European counterparts. As early as 1903 Chicago, New York, and Boston had five times as many electric lights per inhabitant as Paris, London, or Berlin, and by 1910 the electrical displays stunned foreign visitors.[8]

New York took an early lead as the most brightly lighted urban center, and by the 1890s Americans began to hear Broadway described as "the Great White Way," where huge electric signs made the night into day. This fame depended almost entirely upon illuminated advertising, the most conspicuous form of urban lighting. In the middle 1890s the first large electric sign appeared on Broadway. Fifty feet high and eighty feet wide, it used fifteen hundred lights. Dreiser recalled reading this sign:

SWEPT BY OCEAN BREEZES
THREE GREAT HOTELS
PAIN'S FIREWORKS
SOUSA'S BAND
SEIDL'S GREAT ORCHESTRA
THE RACES
NOW——MANHATTAN BEACH——NOW

In this early sign, "each line was done in a different color of lights, light green for the ocean breezes, white for Manhattan Beach and the great hotels, red for Pain's fireworks and the races, blue and yellow for the orchestra and band." When one line was illuminated the others were dark, until each had flashed its message separately. Then the whole sign came on at once and stayed on for a moment before repeating the display. For Dreiser as for others, "Walking up or down Broadway of a hot summer night, this sign was an inspiration and an invitation. It made one long to go to Manhattan Beach."[9] The sign was not automatic. A man operated it from a shanty on a nearby roof.

The first sign that blinked off and on spelled out "EDISON" at the London 1882 International Exhibition in the Crystal Palace, and was designed by Hammer.[10] The following year he made a similar sign that was automatic rather than hand-operated. Its blinking was

achieved through the use of a commutator or "flasher" that interrupted the electrical circuit. His commutator, which became the model for many others, took the form of a metal drum or wheel rotated by a small motor. Along the side of the drum, metal alternated with either nonconductors or holes arranged so that in rotation they alternately opened and closed electrical circuits. More complex signs that simulated movement employed a commutator that resembled the cylinder of a music box. With this technology well-developed by 1900, it was possible not only to spell words, but to change the words within a space by shifting letters either suddenly or by fading from one to the other. Careful organization of the sequence could give the illusion of motion; the persistence of human vision that film also relies upon would create the appearance of movement.

As Broadway between Madison and Herald Square was covered with such displays, it became known as the Great White Way, at a time when Times Square still remained in obscurity. H. J. Heinz bought the space Manhattan Beach had used in Madison Square and placed there a 45-foot-long pickle in green bulbs. Below it other bulbs spelled out "57 varieties," followed by the names of products—tomato catsup, vinegar, and sweet pickles—each in a different color. In 1900 this sign confronted the enormous Dewey Arch, built in the best Beaux Arts tradition to commemorate the naval victories against Spain. At night Dewey Arch was brightly illuminated with electric bulbs and was visible for a mile up Fifth Avenue, but the bright green Heinz pickle against an orange background was just as visible, leading one reformer to write "Advertising Run Mad" where he complained that "the dancing flash light of the 57 varieties of beans, pickles, etc [is] thrown in the faces of all who throng Madison Square."[11] Such protests had no effect, however, and the sign remained until the building was torn down in 1901. Heinz memorialized the occasion in lights:[12]

Here at the death of the wall of fame
We must inscribe a well-known name
The man whose varieties your palate did tickle.
Whose name is emblazoned in the big green pickle.
HEINZ

As such signs proliferated, they forced other institutions to use electricity too. As early as the 1890s some New York churches felt compelled to install electric advertising because they were being ignored. The Methodist Hohn Street Church took the lead because its "somber little building was almost buried between towering skyscrapers, and hundreds passed it daily without realizing that it was a church at all." An electric cross and "a glowing display on the front of the building" proved such a success that another Methodist congregation did the same thing, but for different reasons. The Union Methodist Episcopal Church stood on Forty-eighth Street in the heart of New York's entertainment district across from the Long Acre Square Theater and surrounded by "amusement places that line the Great White Way, all ablaze with electric signs. With these to attract the attention of the public, the church was hardly noticed by passing pleasure seekers" until it erected an electric sign.[13]

By 1910 more than twenty blocks on Broadway were covered with electric advertisements, including one that many tourists felt to be the most interesting sight in New York—an illuminated Roman chariot race. Designed by Elwood Rice and erected in ninety days on top of the Hotel Normandie at Thirty-eighth Street and Broadway, it was 72 feet high and 90 feet wide. It created the illusion of galloping horses, straining drivers, furiously spinning chariots' wheels, and snapping whips. Movement was also suggested by the changing shape of the track and alternation of the stadium walls in the background, giving viewers an illusion some-

thing like that provided by a motion picture camera that follows a race. *The Strand Magazine* reported, "It is more perfect and natural in its movement than the finest colored cinematograph picture," a nearly perfect illusion.[14] The "race" lasted a full thirty seconds, followed by thirty seconds of darkness before the next "performance." Few spectators were content to watch the race only once. When the sign was first turned on, crowds halted traffic, and for weeks a special squad of police was detailed to handle them. Seen by millions of people a year, this seven-story-high sign required twenty thousand light bulbs.[15]

The sign used seventy thousand electrical connections, five hundred thousand feet of wire, and thirty-five hundred switches, and its lights made twenty-five hundred flashes a minute. The galloping effect was produced by outlining the legs of the horses in eight different positions and using flashing sequences of more than thirty times a second, far faster than the eye can follow, rendering their gallop perfectly. Rice gave equal care to the movement of the clothing, the flags, and the horses' manes and tails. To make whirls of dust beneath the horses' feet, he put tan-colored lights behind semitransparent glass. The official name of his sign was Leaders of the World, and it was designed not for a single corporation, but as a vehicle for many. Above the chariot race was space for 54 four-foot-high letters, which could spell out any corporation's name and message. This portion of the sign operated on a ten-minute cycle, allowing up to ten different corporations to advertise.

Not every American city could boast such gigantic attractions, but even smaller cities and towns had imitations, as salesmen systematically canvassed the nation. These men met regularly at conventions of the National Electric Light Association. In 1908 one salesman claimed that even in a town of only twenty thousand people an electric utility could average ninety-five cents per capita each year on electric signs. He also remarked, "There is no question in my mind but that these large and beautiful signs on Broadway have been multiplied tenfold on the lines of central stations throughout the country." Salesmen also agreed that the effectiveness of signs resulted from a combination of their striking appearance and the propitious time of day when they were seen. As another speaker at the NELA convention put it, "The electrical-sign advertisement catches a man after he has left his office. It takes him in the best part of the day, when he has shaken off business affairs and is seeking recreation. He is in the best possible mood for persuasion. . . . The thing is flashed in his eye. Bright colors depict the letters in such a fitting manner that the truth is sent home quickly . . . It may be a remedy for his cough—a well-fitting shoe—a fine brand of cigar—an easy chair. It is the most opportune moment of the day for these insinuations to bear fruit."[16]

The largest electric advertising signs were one-of-a-kind items, labor-intensive products created by small companies or by specialists. The Federal Sign Company of Chicago operated in many cities, buying electricity wholesale from utilities at a slight discount and selling to advertisers this current, its services, and individually designed signs. In Detroit alone during 1911 the company purchased $20,000 in electricity.[17] The large electrical manufacturers were also active in this market, selling standardized signs to thousands of customers. General Electric published a detailed bulletin called "Electrical Advertising," listing exposed and enclosed lamp signs, silhouette signs, lighted posters and billboards, and building display installations with flood lighting or outline lighting. The company included mathematical formulas that allowed the customer to calculate how far away a message could be read with letters of a given size, how powerful bulbs of different colors had to be so that they would seem to have the same intensity, and how close together the bulbs had to be placed to achieve a desired effect.[18]

General Electric and Westinghouse also concentrated on selling streetlighting systems to smaller cities and towns that wanted to emulate the Great White Way. To develop new systems of illumination General Electric built a full-time laboratory in 1899 at its Lynn,

Massachusetts, plant, and soon had additional laboratories in Cleveland, Schenectady, and Harrison, New Jersey. Under the direction of Walter D'Arcy Ryan, these facilities made scientific studies of lighting, often employing model streets and miniaturized cities where new lights could be tested.[19] Both General Electric and Westinghouse developed new arc lights, different kinds of poles and globes, special spotlights, and floodlights to illuminate the sides of buildings. These products were displayed at national electric fairs and advertised in appropriate journals.

Such corporate research and advertising only partially account for the great popularity of street lighting in the United States, however, which also developed as a response to local demands for symbols of progress. In *Main Street* Sinclair Lewis describes how the leaders of Gopher Prairie decided to buy a set of streetlights to prove that it was as good as New York, Chicago, or Minneapolis. "Then, glory of glories, the town put in a White Way. White Ways were in fashion in the Middlewest. They were composed of ornamental posts with clusters of high-powered electric lights along two or three blocks on Main Street. The [town paper] *Dauntless* confessed: 'White Way Is Installed—Town Lit Up Like Broadway—Speech by Hon. James Blausser—Come On You Twin Cities—Our Hat Is In the Ring.'"[20] Many small towns, such as Nyack, New York, and Bellefontaine, Ohio, emulated the larger cities by installing White Ways. To them electrification was a form of conspicuous consumption that said, "We are progressive and growing." As a town booster in Lewis's Gopher Prairie declared: "Now the point of this is: I'm not only insisting Gopher Prairie is going to be Minnesota's pride, the brightest ray in the glory of the North Star State, but also and furthermore that it is right now."[21] Intensive lighting seemed to actualize dreams of greatness. For such towns lighting was more than a mere functional necessity or a convenience; it emerged as, a glamorous symbol of progress and cultural advancement.

Moreover, electrification offered clear economic incentives for many groups with access to the levers of power, with the upper middle class usually providing leadership. Merchants found that better lighting drew more trade to their stores; the new breed of city managers and civil servants wanted brighter cities as a safety measure that improved traffic conditions, deterred crime and boosted civic pride. Other powerful constituencies in each community also stood to profit by installing electrical systems. Property owners expected electrification to increase the value of their real estate. Contractors and labor unions vied for the chance to work on the projects. Ward politicians and city councilmen could grant franchises as a valuable political favor. Given this powerful combination of property owners, progressive reformers, business and labor interests, and political opportunists united under the banner of civic pride, utilities found it, easy to sell and install better electric lighting systems in most American cities.

Between 1900 and 1920 almost every city improved its system, and many chose to install a White Way. In some, such as Wichita and Cincinnati, merchants themselves paid for the new system. Often when a business district's popularity began to decline in favor of newer streets, the merchants in the older center bought lighting to attract customers. By 1910, however, New Haven, Philadelphia, and other cities upgraded their existing systems at public expense.[22] The inauguration of each new White Way became a community event with speeches, a parade, and extensive newspaper coverage. Lighting specialists and important citizens of nearby communities often then decided to emulate or surpass it. Once White Ways had been widely adopted, General Electric brought out the Intensive White Way, which used incandescent lights instead of the carbon-burning arc lights common in many older systems. San Francisco was the first customer for this "Path of Gold" in 1916, followed by Atlanta and many others.[23] Each city imagined that it was imitating Broadway and Times Square, but both

of these sites were so thoroughly lighted by advertising signs that little public lighting had ever been installed. By 1925 the lights of Broadway together had a candle power of more than twenty-five million paid for by private advertisers.[24] Spectacular lighting, begun as a device to attract crowds to world's fairs, had become an essential part of commerce and the life of the street. [. . .]

Notes

1 Farfetched as such a project might seem today, tower lights of more modest dimensions enjoyed a vogue in the 1880s and were installed in Detroit by the Brush Electric Company and at the New Orleans Cotton Centennial Exhibition of 1884. *Electrical World*, March 14, 1885.

2 See M. Christine Boyer, *Dreaming the Rational City: The Myth of American Planning*. Cambridge, MA: MIT Press, 1983, pp. 44–66.

3 First Report of the Board of Electrical Control, City of New York, Jan. 25, 1888, p. 13. Copy in Henry Ford Museum Library, unaccessioned papers.

4 Lise-Lone Marker, *David Belasco: Naturalism in the American Theater*. Princeton: Princeton University Press, 1975, pp. 78–79, 82, citation, p. 88. Also see Mary C. Henderson, *Theater in America*. New York: Harry N. Abrams, 1986, pp. 230–235.

5 Theodore Dreiser, *The Titan*. New York: World Publishing Company, 1946, p. 288.

6 I am relying upon the notions of vertical and horizontal monumentality developed by Thomas Bender and William R. Taylor in "Culture and Architecture: Some Aesthetic Tensions in the Shaping of Modern New York City," in William Sharpe, *Visions of the Modern City*. Baltimore: Johns Hopkins, 1987. Theodore Dreiser, *Sister Carrie*. New York: Holt, Rinehart, and Winston, 1957, first chapters and passim.

7 Charles Mulford Robinson, *The Improvement of Towns and Cities, or The Practical Basis of Civic Æsthetics*. New York: G.P. Putnam's Sons, 1902, pp. 80, 86–87. Also see the same author's *Modern Civic Art*. New York: G.P. Putnam's Sons, 1901, for his protest against "hideous advertisements," p. 132.

8 "Electric Lighting in Boston," *General Electric Review*, vol. I, Nov. 1903, p. 12.

9 Theodore Dreiser, *The Color of a Great City*. New York: Boni and Liveright, 1923, p. 119. Also see Hammer Collection, Archives of Museum of American History, Box 14.

10 E.A. Mills, "The Development of Electric Sign Lighting, *Transactions of the Illuminating Engineering Society*. Vol. XV, No. 6, Aug. 30, 1920, pp. 370–371. Also see J.A. Goldberg, "The Development of Motion Effects in Electrical Signs," Hammer Collection, Box 14.

11 John DeWitt Warner, "Advertising Run Mad," *Municipal Affairs* 4, no. 2, June 1900, p. 276.

12 Frank Presbury, *The History and Development of Advertising*. Garden City, New York: Doubleday, 1929, p. 505.

13 "Advertising the Church," *The Literary Digest*, vol. 47, Dec. 27, 1913, p. 1279.

14 Francis Arthur Jones, "The Most Wonderful Electric Sign in the World," *The Strand Magazine*, and "Largest Electric Sign in the World," clippings in Hammer Collection, Box 14.

15 Frederick A. Talbot, "Electric Sky Signs," in *Electrical Wonders of the World*, vol. II, London: Cassell, 1921, pp. 686–687.

16 National Electric Light Association, *Proceedings, Thirty-First Convention*, 1908, pp. 750–751. Quote from George Williams, a salesman.

17 Ibid., p. 27.

18 Copy in Hammond Papers, W 4047.

19 Ibid., L 1038–1050.

20 Sinclair Lewis, *Main Street*. London: Jonathan Cape, 1923, p. 413.

21 "Fond du Lac's Great White Way," *American City*, Sept. 1912, p. 246; "How the Different Cities are Promoting the Cause of More and Better Light," *The Illuminating Engineer*, Aug. 1910, pp. 314–316.

22 "New Public Lighting An Incentive to Other Reforms," *The Illuminating Engineer*, Oct. 1910, pp. 425–428. See Westinghouse Electric and Manufacturing Company, "Lighting St. Louis," Special Publication 1823A, n.d., c. 1925.

23 "The General Electric Company's Contribution to Outdoor Lighting," typescript, Hammond Papers, L 3352; also see ibid., L 1908.

24 "The Great White Way." Pamphlet, Hammond Papers, L 6615.

JENNIFER WATTS

PICTURE TAKING IN PARADISE
Los Angeles and the creation of
regional identity, 1880–1920

From the photographer's point of view, the City of Los Angeles is as interesting as
any in the United States.

(Henry Workman Keller, c. 1885)[1]

W HEN HENRY WORKMAN KELLER trained his camera's lens on the dusty,
tree-lined streets and spanking new residences of 1885 Los Angeles, the city was crest-
ing the wave of a real-estate boom that would change it irrevocably. The teenaged son of a well-
to-do pioneer family, Keller had taken to photography with enthusiasm. His zeal for the craft
moved him to pen a handsome little treatise called 'The Amateur in Los Angeles' [Figure 25.1].
In it, Keller praised his hometown as an ideal environment for the photographer, a place where
diverse scenery and a 'mixed population' provided a vast array of photo opportunities.[2] Young
Mr Keller's prescription for the most interesting views included many of those places especially
vulnerable to change: 'the old adobes, the pepper and palm avenues, and the Chinese quarters'.[3]
The album's illustrations demonstrate that Keller heeded his own advice.

Henry Keller was only one voice of a Southern California chorus. Los Angeles civic élites
and regional pitchmen of the late nineteenth century burst into promotional song: the city
was a paradise, an exceptional place at the edge of the nation and the new century, its urban
greatness assured. Keller's schoolboy prose fits the genre, and his claims about Los Angeles's
distinctiveness, beauty, and promise have the ring of booster-speak to them. But he also let
his pictures do the talking, and in so doing presaged the future.

Henry Keller's photographs echo a distinct vernacular of visual language. Southern
California's advocates *needed* photography to help make words real, to demonstrate (or at
least suggest) the authenticity of exaggerated claims about the future of a place like Los
Angeles. Photography would be the rose-coloured glasses through which the country could
glimpse this new city or, as some even claimed, this new civilization. A flood of photographic
imagery flowed from the region and around the globe in snapshot albums, postcards, and the
illustrated press. By the late 1880s, amidst surging population, photographers — resident and
tourist, amateur and professional — became a ubiquitous presence. As the photographic
products of hobby and profession dramatically increased, a dynamic relationship emerged
between the image created for commerce and that for keepsake pleasure. Photographers
worked in tandem to create and disseminate a strikingly fixed visual narrative of the region.
And the themes of this photographic vernacular looked very much like those quietly outlined
by seventeen-year-old Henry Keller.

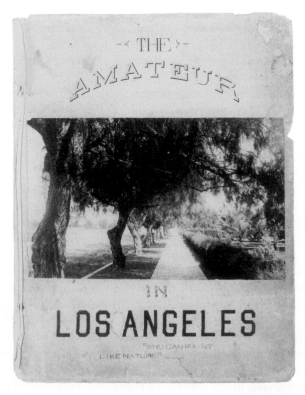

Figure 25.1 The Amateur in Los Angeles, handwritten manuscript with albumen photographs, Henry Workman Keller, *c.* 1885. This item (Matthew Keller Coll. Box 4[3]) is reproduced by permission of The Huntington Library, San Marino, California.

These visual tropes centred on a salubrious climate that gave rise to a peculiarly fecund, even exotic, landscape; a graceful antiquity characterized by architectural relics (particularly missions); and the quaint appeal of the 'ethnic other'.[4] As such, the photographs of the era attempt to come to terms with a new environment by rendering the unfamiliar as worthy. But they are also formulaic constructions appealing to the potential consumer, settler, investor, émigré. In abbreviated form, this essay will examine aspects of this regional identity-building project as performed through photography.

The 1880s put Los Angeles on the map. By virtue of the arrival of the Southern Pacific and Santa Fe transcontinental railroads, and the resulting rate wars, population exploded. A powerful advertising machine composed of civic elites, boards of trade, real-estate concerns, railroad corporations, and entrepreneurs (all of whom fall under the broad label of 'booster') disseminated a colourful array of material highlighting the Edenic and exotic qualities of the region. The siren call of commerce was wildly successful; health seekers, travellers, tourists, and settlers streamed into the area in record numbers. Seemingly overnight, a small cow town of a few thousand became a metropolis of busy residential streets, civic buildings, churches, and schools.[5]

The transformation of Los Angeles into the self-appointed 'Queen of the Southwest' occurred simultaneously with two revolutionary technological advances. In 1888, George Eastman unveiled his 'push-button' camera and made picture taking available to anyone with

a modicum of interest and some money to spare. Coincidentally, the perfection of halftone engraving enabled the popular press to fill its pages with photographs. Readers loved it, and thus began the golden age of the illustrated press.[6]

The timing of it all proved propitious. Regional advertising campaigns formerly rested on hyperbolic prose augmented by a variety of graphics. Now, in the last decade of the nineteenth century, the photographic image became widely and cheaply available. A new, lightweight, and virtually foolproof camera enabled the novice to frame the scene for him/herself, and the illustrated press (largely the domain of the professional camera operator) disseminated images more effectively and broadly than ever before. By 1900, *Camera Craft* could boast: 'It is only through photography that the beauties of [California] can be displayed for the admiration of the East and the rest of the world'.[7] Photographs became visual exclamation points to enthusiasts' claims, and in doing so, they pushed aside conventional methods and forms of visual representation.

The photography community grew with Los Angeles. Few professional photographers operated prior to 1870, and even those with studios needed to find additional sources of revenue to remain solvent.[8] But as the city increased in size and fame, more professionals arrived to exploit the expanding pool of clients. One venue for their wares was the thematic 'picture book'. These compilations, with titles such as *Picturesque Southern California* and *Los Angeles: The Queen of the City of Angels*, were marketed as keepsakes for tourists and mementoes for local residents. The books were light on text and featured halftone reproductions showcasing idyllic landscapes and grand residences, often in lurid colour.[9] Photographers continued their bread-and-butter business of portrait work, but a new world was emerging, one with an insatiable demand for photographic imagery. Mastery of halftone processing meant boosters wanted photographs by the bushel. Photographers documented real-estate developments and new industries, supplied postcard manufacturers with pictures both dramatic and prosaic, and sent their work off to newspapers and magazines at home and afar.

The promoters who clamoured for imagery had a target audience in mind, bracketed both by race and class. The ideal resident of or visitor to, Los Angeles was a 'cultured' person of northern European extraction from the midwestern or eastern sections of the United States. As one local journal declared, Los Angeles 'is a city of lovely homes, of cultured well-to-do people; with Eastern education and Western cordiality. . . . It is the country of a new art for the Saxon'.[10] This genteel 'Saxon' was the person whom the campaigns — and the photographs — sought to entice. And when these people of Boston or Cleveland or New York answered the call, they frequently brought their cameras with them. Such ethnic and class parameters of image production must be stated overtly, as they account for the inclusion, as well as the conspicuous absence, of certain types of photographs within this visual record. It is clear that photographic themes emerging from the camerawork of professional and amateur tell the story of particular people every bit as much as they do of a time or place.[11]

Resident amateur photographers acted as vibrant adjuncts to the professional community. Hobbyists, like young Henry Keller went out singly or in small groups, on foot or on bicycle to capture the varied aspects of their surroundings with trusty box cameras. Entranced by the Mediterranean climate, the quality of the light and the sheer variety of subject-matter — both vegetative and human — the amateur had a wide field from which to choose. These snapshooters varied in levels of intensity and interest (not to mention skill), but, like Keller, they had time and resources.[12] For the more serious among them, newspaper and journal articles addressed form and technique in practicums and lessons.[13]

The 1899 establishment of the Los Angeles Camera Club legitimized the amateurs and provided a social network for the hobbyist. Within the first six months of its founding, the

organization boasted a membership of 250, and plans were under way to construct a plush headquarters on the top floor of a fashionable building in the city's business district.[14] The club organized outings to local sites, sponsored lantern-slide shows and lectures — both humorous and instructional — and exhibited members' prints in the clubhouse gallery. The educational side was balanced by an active calendar of dramatic readings, tea parties, and musical entertainment. Photography fever was in the air, so much so that *Camera Craft* reported: 'Los Angeles is thoroughly embued with the photographic spirit. Every daily and weekly news-paper is devoting page after page to photography, and the Los Angeles club is booming as it never did before'.[15]

To be sure, that 'photographic spirit' existed outside club boundaries as well, among those Angelenos content to practise the craft without affiliation. Furthermore, the Southern California tourist, whether on a short excursion or a winter's stay of several months, proved as avid a shutterbug as the local amateur. Lured by pictures in the first place, visitors created photographic keepsakes of their own once they arrived, filling their scrapbooks and albums to bursting. The vernacular connection between these amateur and 'official' views is striking.

Before examining the constituent parts of this dialogue, a critical forum in which it occurred merits introduction. The visual message of the city's sublimity and attractiveness was most widely portrayed through the medium of the illustrated press. In this realm, there was one contemporary journal in which the photograph reigned supreme. Aptly named *The Land of Sunshine*, this magazine became a distinct force in the promotion of Los Angeles, relying on photography to drive home its editorial and narrative points far more than any such publication of the time.

The Land of Sunshine first appeared on Los Angeles news-stands in 1894. A quarto-sized journal with thick glossy pages and skilful photo illustrations, its stated purpose was to be 'a monthly paper, handsomely illustrated, artistically printed, containing well written matter on Southern California topics'.[16] The magazine was the brainchild of a small group of men with strong ties to the Los Angeles Chamber of Commerce. They aimed their publication at their ideal reader: a desirable sort of Easterner, the type who travelled to warmer climes for pleasure and health and who (most of all) might consider taking up residency under Southern California skies.

The Land of Sunshine needed a genuine editor with a literary or journalistic background if it was to make a go. Within the year publishers found their man in the person of Charles Fletcher Lummis. A Harvard-educated easterner, Lummis had become famous, at least in Southern California, by walking from Chilicothe, Ohio to Los Angeles in 1884–85.[17] His infatuation with the area proved instantaneous and dramatic, and he soon became an advocate for all things Southwestern. Yet Lummis had real qualifications for *The Land of Sunshine* job. A recognized journalist (he became city editor of the *Los Angeles Times* upon his arrival), he had also written a number of books on the Southwest.[18] Thrown into the bargain was Lummis's love of photography. Himself an avid and talented photographer, Lummis well understood the power of imagery to entice, narrate, and persuade. The published photograph, of the amateur as well as the professional, would be one of the hallmarks of his editorship. Given that this publication had thousands of subscribers across the country and the world — readers who delighted in expressing their appreciation of the illustrations — the impact of the photographs cannot be overstated.

Charles Lummis's stamp on *The Land of Sunshine* was as obvious as it was immediate. While he did not jettison the publication's booster ethos, he nonetheless tempered regional enthusi-asms by adding intellectual and cultural pretensions. 'Southern California', he wrote, 'grows brains as well as oranges'.[19] By the end of its first year in circulation, *The Land of Sunshine* had

eight thousand subscribers, and the magazine could be seen in public libraries, resorts, chambers of commerce, on steamships, and aboard overland railroads stretching from New York to Chicago, and from Denver to San Francisco.[20] Lummis kept photographic illustrations front and centre, publishing, on average, a hefty thirty-five per issue. A new column, 'The Land We Love (And Hints of Why)' was purely photographic, with four to six captioned images in each issue. Subscribers loved it. 'You have increased our interest [in Southern California]', wrote one, adding that 'the pictures in the May number only make [us] cry for more!'.[21]

While the magazine depended in large part on local studio photographers, Lummis quickly substantiated the importance he placed on the amateur practitioner. 'There is nowhere else in the United States so broad and pleasant a field for the amateur photographer as Southern California', he declared in an article announcing a regular competition designed to draw local talent.[22] Judged by Lummis himself ('an amateur of eight years' practice and many thousands of negatives in North and South America') and Herve Friend, a commercial photographer and photoengraver, the winning efforts would be showcased in future issues. While a cynic imagines the money saved by relying on amateurs to illustrate the journal, Lummis insisted that he wished to 'arouse such interest among these scattered enthusiasts as will focus their zeal and their talents'.[23]

The winning photographs in the inaugural contest are telling. A view of cherubic Anglo children reposing in a garden is entitled 'The Children's Paradise'. Another winner depicts two stately palms at the San Fernando Mission, while 'A Bit of Sonorotown' focuses on a crumbling adobe structure. Finally, the stated 'gem of the whole competition' is 'a portrait of an ancient Mexican by Mr. Smith', an image Lummis considered extraordinary 'both as a type and as a photographic triumph'.[24] These few images — as with the adobe, the palms, and the ethnic types of Henry Keller's treatise point to the visual themes that show up repeatedly in *The Land of Sunshine* (as well as elsewhere) in the period.

A Semi-tropic Garden of Eden

[A] chief charm of Southern California is that a new home can be framed in its own little Eden in time so short that it seems magic. Three years, with care and slight labor, and at almost no cost, will turn a bare lot into such a semi-tropic garden as a century and a million could not duplicate in the East.
(Charles F. Lummis, 'Gardens of Eden While You Wait')[25]

Late nineteenth- and early twentieth-century pictures of Los Angeles tell a tale of paradise created, if not paradise found. The professional views and the amateur efforts march lockstep with the travel accounts, brochures, and novels that depict Southern California as a semi-tropic Garden of Eden, a 'New Italy', a 'Land of the Golden Mean'. Los Angeles was ballyhooed as an oasis where the Mediterranean temperatures acted as a palliative to the sick and a refreshing balm to the well. It was a place where grateful pilgrims paid homage to a climate of perfection.

But promoters were not content merely to catalogue the climatological assets of the region. They asserted that this idyll was an incubator for a better humanity, with kinship ties to the civilizations of ancient Greece and Rome. As Pasadena horticulturist Jeanne Carr wrote in *A Southern California Paradise*, 'It was in a climate like this that the Greek cities clustered richly together, and Art was born. It was beside the waters of an untroubled sea, beneath just such cloudless skies, where the myrtle, the orange, the olive, and the vine flourished and were fed by living mountain streams, that a greater than the Greek civilization gave law and

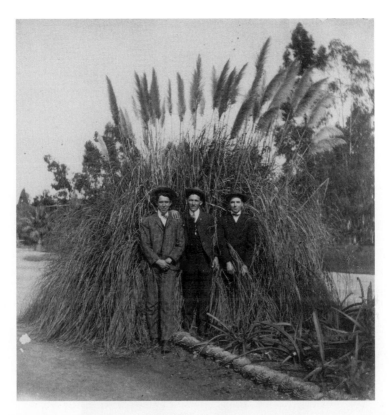

Figure 25.2 Boys in Front of Pampas Grass in Southern California, gelatin silver photograph, unidentified, c. 1905. This item (photCL 254[54]) is reproduced by permission of The Huntington Library, San Marino, California.

order to a barbarous world'.[26] Here at the Pacific's edge, Saxon Americans would create their rightful civilization, as much a 'city on a hill' as a 'city under the sun'.

But how could such weighty allusion and metaphor about climactic promise be illustrated? Promoters and believers had to make do with the climate's tangible effects, by reference to, for instance, the variety of vegetation and the rapidity of its growth. Climate could be demonstrated, after which viewers had to make the cultural connections to complete the equation. Not surprisingly, the visual components of the narrative hinged on what was most available to the cadre of local photographers: the home garden and the public park. Photographers of all stripes focused their lenses on the fecundity of the land, a self-contained Eden (or, better yet, Athens) of perpetually lush lawns and flowering, plants that bloomed year round. There is no hint of an encroaching desert but miles away in these pictures of vegetative abundance. On the contrary, scene after scene of verdant growth implies an endless supply of water. And as in the Eden of old, Nature's bounty appears without the sweat of one's brow. Nowhere does the viewer see the laborious process of creating the earthly paradise, of carving a city from the brush and sycamore and arid sweeps of the Los Angeles basin.

Hand in hand with visual expressions of 'the fecund' came those of 'the exotic'. The plants that appeared otherworldly to migrants from Iowa and New York — the palm tree, the blooming yucca, the banana and orange trees, the calla lilies, and the ubiquitous pampas grass — were a favourite landscaping choice of nineteenth-century settlers. As a consequence,

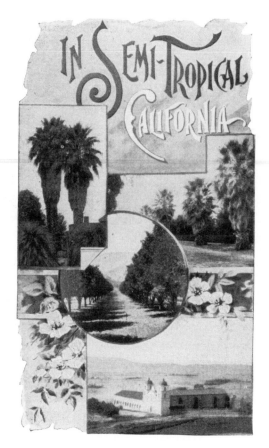

Figure 25.3 In Semi-Tropical California, halftone photographs from cover of promotional booklet, 1895. This item (photEph Uncat.) is reproduced by permission of The Huntington Library, San Marino, California.

they appear everywhere in the visual record. Visitors are dwarfed by a cactus hedge, a house is rendered puny by the blossoms of a rose bush that climb up and over the rooftop and people of all ages pose next to the overarching plumes of the giant pampas [Figure 25.2]. Published pictures show a landscape of domesticated flowers, trees, even cacti, all foregrounded against palatial residences captioned as 'typical views' of Southern California living.[27] While the booster sought to embellish the truth and flatter the viewer, the amateur snapshooter went about aiming at more documentary purposes. Yet the effects were remarkably similar and mutually reinforcing.

Advertisers and amateurs mimicked one another, equally entranced by this 'semi-tropic' landscape of plenty. For instance, a subject considered inherently 'photographable' was the palm tree, that most Edenic of icons [Figure 25.3].[28] The ancient palms of downtown's San Pedro Street, purportedly over a hundred years old, as well as the palm-lined drive of the notable residence of Colonel Longstreet, appear repeatedly; no commercial publication was complete without these stock views. But, neither, apparently, was many a family scrapbook. These scenes show up nearly as often in the personal album of the tourist or local as they do in the picture book of the booster.[29] In the quotidian setting of the garden and park, climate and its influence was 'made real' through the reportage of the photograph.

The Mission of Antiquity

The antiquity of California is represented by her Missions. Before their time there was naught of civilization . . . but today it is conceded that the advent of the Spanish friars more than a century ago marks the beginning of a civilization that has . . . culminated in a period that will for all time be recalled as the brightest in scientific achievements of the Caucasian race.

(F. Weber Benton, 1914)[30]

In July 1900, members of the Los Angeles Camera Club boarded a train for the old Spanish mission at San Juan Capistrano. Weekend excursions were popular among the membership, and outings to the missions all the more so. 'The old mission at San Juan is probably the most picturesque to be found in Southern California', a participant remembered. 'The arches, broken columns, long corridors and ruined altar affording opportunities for the photographer which fills his soul with great joy and empties his pockets of loose change in the endeavor to secure sufficient plates and film'.[31]

Spain established the 21 missions of California in the eighteenth and early nineteenth centuries to colonize and Christianize the native peoples. Once Spain ceded control of the territory to Mexico, and Mexico in turn to the United States, a long period of mission secularization and decline followed. By the last third of the century, many of the once-imposing edifices had become little more than broken timbers and adobe rubble. In the 1880s, these dilapidated structures received unexpected publicity from novelist Helen Hunt Jackson. Her historical romance novel *Ramona*, set amidst the missions of Southern California, was designed to focus attention on the injustices faced by Native Americans under Anglo-American rule.[32] Far from being the call to Indian reform that Jackson intended, however, the story instead helped ignite a regional love affair with the Spanish mission and 'things Spanish'. The missions, and not the mission Indians, became symbols of a heroic and mythic past. Before long, photographers descended on the crumbling ruins.[33]

California's missions had been a favoured subject of artists for decades.[34] But in the romantic wake of Jackson's novel, commercial photographers flocked to the missions to provide illustrations for the inevitable books and guides. Such publications cast the mission in the hazy glow of nostalgia, equating this aspect of California history with that of a proud and ancient civilization. On the one hand, chamber of commerce types used mission ruins to legitimize California as a place of 'authentic' history.[35] At the very least, the missions were championed as the cultural equivalent to historically resonant sites of colonial New England.[36] In the final analysis, missions fitted the booster project most efficiently not as landmarks of heritage so much as tourist destinations, and an entire industry sprang up around their preservation and promotion.[37]

Photography played a critical role in this agenda. Books such as *In and Out of the Old Missions* by George Wharton James, which contained '142 illustrations from photographs', provided detailed histories of the missions, directions for reaching the sites, even figures for the correct train fare.[38] Mr. James, a colourful advocate for Southern California (detractors referred to him as George 'Snortin' James) and an avid amateur photographer, stated proudly that he had taken 'thousands of photographs of the missions'. As halftone pictures of mission ruins standing stark and imposing on barren landscapes became the focal point of innumerable publications, photographers made pilgrimages of commercial, as opposed to spiritual, purpose.

The inherently picturesque quality of the mission as ruin, and its seemingly ephemeral condition, acted as a photography magnet. While professional photographers marketed sets of mission views, the amateur combed the area for worthy material.[39] Articles encouraged

the amateur to shoot the 'fast disappearing relics' before time ran out.[40] Groups of serious hobbyists, such as the Los Angeles Camera Club and one led by Pasadenan Adam Clark Vroman, made systematic mission surveys.[41] Those who fancied themselves artists of the craft, or Pictorialists, saw in the crumbling mission façade the perfect subject for their atmospheric prints.[42] In short, as the image record attests, the mission (any mission) was the destination for the regional photographer.

An aesthetic of the 'best view' soon emerged. In the astonishing repetition of vantage points and scenes, it becomes evident that photographers saw some aspects of the missions as more photogenic than others. In the case of the Mission San Gabriel, an especially popular destination because of its streetcar proximity to downtown Los Angeles, a triptych of views are seen almost exclusively: the mission stairs, the bell tower, and a long shot of the south building façade. Cyanotype snapshots by Edward Earle, reproduced here, are notable for the divergent scene of the grave marker, while shots of the bell tower and the south facade fit the code of prescribed views [Figure 25.4]. Such mimicry suggests that hobbyists the likes of Mr Earle came to the missions to replicate the images that had already been imprinted on their minds. Creative vision seems to have taken a back seat in this call-and-response conversation between booster and amateur. Drawn, in part, to document the missions for posterity, the image-maker added to a visual narrative that rendered the mission a nostalgic symbol of a glorious past and, in the process, appropriated it as a sentimentalized marker for a distinctly Anglo future.

Ethnicity and Exoticism

Great, in the last decade, is our indebtedness to the camera, which has fought gallantly with the destructive rainy season for the possession of crumbling mission arches

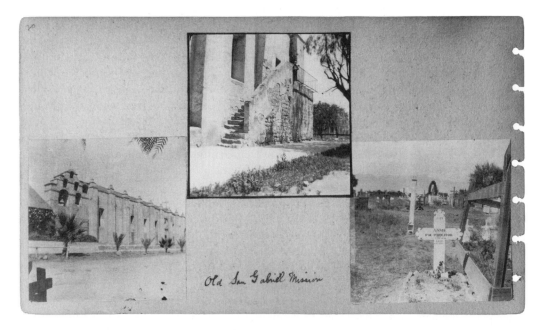

Figure 25.4 Old San Gabriel Mission, page of cyanotype photographs in personal album, Edward Earle, *c.* 1890. This item (photCL 89[20]) is reproduced by permission of The Huntington Library, San Marino, California.

[. . .] of a past which is never to return. Grave ethnological possibilities lie in this same camera.

(Auguste Wey, 1892)[43]

The Anglo population of camera enthusiasts saw Los Angeles as a field of ethnic types ripe for the picking. Stock characters emerge from the nineteenth century like players in a region-wide drama. The Mexican dancer, the Chinese merchant, and the Indian basket-maker were reminders, in this case human ones, of a colourful, but supposedly fading, past. Numerous writings targeting the amateur mentioned these types that Los Angeles so generously provided as subjects for the camera's gaze.[44] But again, as with scenes of semi-tropic abundance and the mission ruin, these subjects were limited to a rigid set of categories, in this instance determined by the intersection of racial attitudes and photographic practice. Certain groups, considered more 'picturesque', appear repeatedly, while others remain conspicuously absent from the record. The 'Spanish' senorita in all her finery was a favourite advertising trope, a photogenic reminder of the city's exoticism and European roots. Yet a generalized Mexican resident is seen — if at all — at the margins of photography, a footnote to the primary subject. The ancient Native American, captioned as a person over one hundred years of age, became a preferred character, suggesting none too subtly that there were no longer any youthful counterparts to a dying race. These 'centenarians' performed the dual role of testifying to the salutary effects of the climate while rendering their race obsolete, a wrinkled remnant of the past. Like the palm and the cacti, human examples of racial difference (strictly confined to innocuous occupational categories) exuded that exotic tinge that made them suitable subjects of document and art.

Among the various ethnic groups available to the photographer, the Chinese were prized subjects. Residents of nineteenth-century Chinatown, confined to a few square blocks near downtown Los Angeles, were, at least by common understanding, notoriously camera shy. This only seemed to add to the thrill of the photographic chase. One story in the *Los Angeles Times* recounted the antics of a journalist and Kodak salesman on an evening foray to 'shoot' Chinese with the new Kodak Instantaneous Camera. In amused tones the journalist recalled the befuddled and dazed response of the unsuspecting subjects and the general hilarity of the 'hunters'.[45]

Despite the supposed roadblocks to securing images, scenes from Los Angeles Chinatown appear in personal albums and the stock of numerous commercial companies. The Garden City Photo Company included photomontages of 'Scenes in Chinatown' in its catalogue, and *The Land of Sunshine* published several illustrated articles on the Chinese quarter. Descriptive passages highlighted scenes of supposed representativeness: an opium den, a Chinese doctor's hand (with long, curling fingernails), and various Chinese 'types' in traditional dress. One view of three women crossing the street is captioned, 'Three Little Maids from School. Dodging the Camera'.[46] Tourists and residents took up both the challenge and their cameras.

The prevailing sentiment was summed up by a writer who offered that, 'if there are uncomfortable odors in the Chinese quarter, nothing can exceed its picturesqueness. Chinatown is the Mecca of tourists'.[47] An unidentified, bowler-hatted photographer travelling through Southern California around 1890 took in all the usual sights: the beaches of San Diego, the luxuriant gardens of Pasadena, and Chinatown and its inhabitants [Figure 25.5]. Olive Percival, a resident of Pasadena and a bookkeeper by trade, was bewitched by the Chinese district and took her camera there on many occasions.[48] Other Angelenos, such as Charles James Fox, a member of the Los Angeles Camera Club, snapped the Chinese vegetable peddler as he made the rounds in Fox's affluent neighbourhood.[49] To the Anglo newcomer, the polyglot society of Los Angeles provided the optimum photo opportunity. These people

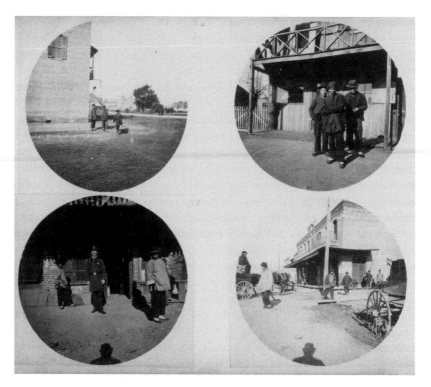

Figure 25.5 Scenes in Los Angeles Chinatown, page of snapshots from amateur album, *Scenes of Altadena, Los Angeles, and South California*, unidentified, *c.* 1889. This item (photCL 403[2]) is reproduced by permission of The Huntington Library, San Marino, California.

with their strange habits and fanciful dress could be neatly contained within the photograph's borders; they, like the missions and the weird plants, were markers of the strange and unique landscape in which the new arrival found himself. Images like those of the vegetable peddler and the ancient Indian create a regional narrative that typifies and thus marginalizes entire groups of people. As with the palm tree, the 'exotic' is rendered familiar, typical, and thus non-threatening, a colourful attraction for the visual consumption of the new arrival or the folks back home.

Subject-matter, not pictorial form, distinguishes the visual vernacular characterizing Los Angeles of this era. The amateur aesthetic engendered by the box camera — blurred views, oddly cropped scenes, the mistaken inclusion of a shadow, and lack of formal arrangement — crosses regional boundaries. The well-executed pictures of the professional or serious hobbyist do not reveal distinctive formalist tendencies of space, light, or expression that would classify them as uniquely 'Southern Californian'. The postcards, the brochure illustrations, and the resale views exhibit the 'tall-tale' quality of commercial illustration everywhere: they focus on the biggest, the best, the 'most' to drive home advertisers' claims. It is the choice and, more specifically, the combination of themes within the visual narrative — horticultural, architectural, and ethnological — that tie Southern Californian photographs to a specific cultural and social milieu.

Photography changed Los Angeles at the close of the nineteenth century. Not only could civic élites utilize the power of the photograph in their advertising campaigns, but George Eastman saw to it that a camera was within the grasp of virtually everyone. Technological

advances in printing produced similarly democratic results. Tossed like lures into waters teeming with tourist fish, photographs did their work well. They seduced, they enticed, and they narrated a story of regional growth and pride. Thousands of people, liking what they saw, came West and took their places in the pictures.

New arrivals felt compelled to replicate the images that brought them to Southern California in the first place. In the sea of picture books and illustrated magazines, family scrapbooks and personal albums, the strikingly similar themes stand out. Wishing to make sense of a foreign landscape, the amateur and the professional photographer did so in ways that amplified the hyperbolic prose of the booster. The 'big picture' that emerges from these views is a semi-tropical garden, lush and overflowing with exotic plants, a heroic regional antiquity embodied by the mission ruin, and an ethnic other safely contained (and fast disappearing) within boundaries of space and class. This constructed reality pictured Los Angeles within narrow visual confines. Consumers demanded a certain kind of city and photography obliged, imaging Los Angeles as a commodity of manufactured paradise.

Notes

1 'The Amateur in Los Angeles', unpublished manuscript by Henry Workman Keller. Henry Workman Keller Collection, Box 4 (3), The Henry E. Huntington Library.

2 Ibid., 1.

3 Ibid., 1.

4 These are only three of the themes that surfaced as I studied the personal photograph albums, postcards, illustrated periodicals, and stereographs from the period. The field is wide open for study, and any one of these formats could be mined for additional analysis. For an overview of commercial and amateur photography of California in this era see Gary F. Kurutz, *California Pastorale: Selected Photographs, 1860–1925*, Sausalito, CA: Windgate Press 1997. See also Monica Highland, *Greetings from Southern California: A Look at the Past Through Postcards*, Portland, Oregon: Graphic Arts Center Publishing Company 1988.

5 Population in Los Angeles County tripled in the decade 1880–90; the city of Los Angeles grew nearly five times larger in the same period. By 1900, the county had 170 000 people (more than 10% of the entire state population), and the city was home to just over 100 000 residents. From Leonard Pitt and Dale Pitt, *Los Angeles A to Z: An Encyclopedia of the City and County*, Berkeley: University of California Press 1997. See also Glenn S. Dumke, *The Boom of the Eighties in Southern California*, San Marino: Huntington Library 1944; John E. Barr, *The Health Seekers of Southern California, 1870–1900*, San Marino: Huntington Library 1959; Carey McWilliams, *Southern California Country: An Island on the Land*, New York: Duell, Sloan & Pearce 1946, esp. ch. 1. For an introduction to regional boosterism, see Kevin Starr, *Material Dreams: Southern California through the 1920s*, New York: Oxford University Press 1990; William F. Deverell, 'Privileging the mission over the Mexican: the rise of regional identity in Southern California', in *Many Wests: Place, Culture, and Regional Identity*, eds. David Wrobel and Michael Steiner, Lawrence: University Press of Kansas 1997, 235–28; Robert Fogelson, *The Fragmented Metropolis: Los Angeles, 1850–1930*, Berkeley: University of California Press 1993, esp. ch. 3; Mike Davis, *City of Quartz: Excavating the Future in Los Angeles*, London: Verso Press 1992.

6 For further reading on the revolution caused by halftone technology, see Estelle Jussim, *Visual Communication and the Graphic Arts: Photographic Technologies in the Nineteenth Century*, New York & London: R. R. Bowker 1974; and Neil Harris, *Cultural Excursions: Marketing Appetites and Cultural Tastes in Modern America*, Chicago: University of Chicago Press 1990, 304–18.

7 *Camera Craft* 2: 1 (November 1900), 47.

8 For a brief overview of the subject, see Nancy Dustin Wall Moure, *Loners, Mavericks, and Dreamers: Art in Los Angeles before 1900*, Laguna, CA: Laguna Art Museum 1993, 91–3; Barbara Dye Callarman, *Photographers of Nineteenth Century Los Angeles County: a Directory*, Los Angeles: Hacienda Gateway Press 1993. For two examples of pioneer photographers from the period, see John Dewar, *Adios Mr Penelon: Henri Penelon, 1827–1885, Painter, Photographer, El Pueblo de Los Angeles*, Los Angeles: History Division, Los Angeles County Museum of Natural History 1968, and Frank Q. Newton, Jr., 'William M. Godfrey: early California photographer, 1825–1900', *Los Angeles Corral* (Summer 1992), 1–8.

9 E. C. Kropp, *Picturesque Southern California*, Los Angeles: M. Rieder 1903; and *Los Angeles: the Queen City of the Angels*, Los Angeles: M. Rieder 1907 are but two of the hundreds of such publications produced to show the region to full advantage. The sheer number of these illustrated books is daunting. However, an analysis of these books — their contents, circulation, and audience — is a rich and untapped area for further research.

10 'Los Angeles, queen of the Southwest', *The Land of Sunshine* (December 1896), 49.

11 The reason for examining these particular sources is, first, that they comprise the bulk of the photographic materials available for research. There are few significant bodies of work from this era available in regional archives produced, by, for instance, Mexican-Americans and African-Americans. The notable exception is the recent acquisition of photographs from ethnic family albums at the Los Angeles Public Library. See Carolyn Kozo Cole and Kathy Kobayashi, *Shades of L.A.: Pictures from Ethnic Family Albums*, New York: New Press 1996. For the purposes of this article, I am interested in looking at the photographic construction of regional identity produced by and for civic élites.

12 There has been very little work done on the community of photographers in Los Angeles at the turn of the century, particularly the many amateur photographers of the region. See section on the 'Pasadena Eight' in Lee Clark Mitchell, *Witnesses to a Vanishing America: The Nineteenth-Century Response*, Princeton: Princeton University Press 1981, 140–5. See, also Jennifer A. Watts, 'Wayfarer in Italy: The Photography of Marian Osgood Hooker', author's files.

13 Additionally, a Camera Section was organized under the auspices of the Academy of Sciences in 1896. Moure, 92.

14 *Camera Craft* 1: 1 (May 1900), 32; Helen L. Davie, 'New home of the Los Angeles Camera Club', *Camera Craft* 1: 3 (September 1900), 238–9.

15 *Camera Craft* 3: 1 (May 1901), 26. Even with an enthusiastic membership and well-appointed quarters, the Club's future was uncertain; LACC dissolved and was reconstituted several times before it inexplicably faded from the scene in 1915. Dennis Reed, 'Southern California Pictorialism: its modern aspects', in *Pictorialism in California: Photographs 1900–1940*, Michael G. Wilson and Dennis Reed, Malibu, California: J. Paul Getty Museum 1994, 67–86.

16 *The Land of Sunshine* 1: 1 (June 1894), 1. For an excellent and thorough analysis of the history of *The Land of Sunshine* and Charles Lummis's role as editor, see Edwin F. Bingham, *Charles F. Lummis: Editor of the Southwest*, San Marino, CA: Huntington Library 1955.

17 Lummis wrote melodramatically of this cross-country exploit in weekly dispatches to the *Los Angeles Times*. When he finally arrived in February 1885, the *Times* hired him on the spot as the paper's first city editor. From that point forward, well into the twentieth century, Charles Lummis became a vital, if enigmatic and often misunderstood, figure in the region's literary and cultural life. See Charles F. Lummis, *A Tramp Across the Continent*, New York: C. Scribner's Sons 1892.

18 For additional information on the colourful and varied career of Charles Lummis see Turbese Lummis Fiske and Keith Lummis, *Charles F. Lummis: The Man and His West*, Norman: University of Oklahoma Press 1975; Dudley Gordon, *Charles F. Lummis: Crusader in Corduroy*, Cultural Assets Press 1972; Daniela P. Moneta (ed.), *Charles F. Lummis: The Centennial Exhibition Commemorating His Tramp Across the Continent*, Los Angeles: Southwest Museum 1985.

19 Lummis set out to prove his statement by assembling a talented stable of writers and journalists. Bingham, 49.

20 Ibid., 62.

21 Letter from Gove Family, Bellows Fall, Vermont, 28 May 1900. Charles F. Lummis Papers, Southwest Museum.

22 'Our Amateur Photographs', *The Land of Sunshine* (January 1895), 28.

23 Ibid., 29.

24 Ibid., 29.

25 Charles Lummis, 'Gardens of Eden While You Wait', *The Land of Sunshine* (March 1895),63.

26 R. W. C. Farnsworth (ed.), *A Southern California Paradise*, Pasadena, CA: R. W. C. Farnsworth 1883. F. Weber Benton also expounded on the topic of climate and civilization saying, 'Southern California is destined to become the seat of civilization in America'. F. Weber Benton, *Semi-Tropic California, The Garden of the World*, Los Angeles: Benton & Co. 1914, 30.

27 Picture books also captioned scenes of prolific vegetation with the phrase 'in winter'. In one example, the accompanying text of an image titled 'Los Angeles Street Scene in Winter' explains: 'The, profusion of flowers, green lawns, magnolia, palm, banana and pepper, trees, the cactus plants, the fir trees, the dark green orange trees, all combine to form a scene which charms every visitor to

California'. *As Seen from the Southern Pacific*, San Francisco: Passenger Department, Southern Pacific Company 1904, n.p.

28 See David Alan Karnes, 'Modern metropolis: mass culture and the transformation of Los Angeles, 1890–1950', PhD dissertation, University of California, Berkeley 1991. The rhapsodies evoked by palm trees are indicated by Harriet Tolman, who collected many views of palms on an 1888 trip to Southern California. Under a commercial view of a date palm at the San Gabriel Mission she wrote: 'No single tree ever gave me such a thrill as this solitary palm standing erect and graceful. Like a strange being in an atmosphere of its own — a goddess with serenity, grace & dignity of the Venus de Milo'. Harriet S. Tolman Collection, *A Trip to California, 1888–1889*, Volume 2, Bancroft Library, University of California, Berkeley.

29 For an amateur view see 'Los Angeles. Palm Drive. 7/14/[18]99', in The Bolt Collection, Bancroft Library, University of California, Berkeley. Images of Longstreet's palm-lined drive as well as views of palms appear in — among others — *Los Angeles*, Brooklyn: Albertype Co. n.d.; *Scenes in Southern California*, Denver: Williamson-Haffner Co. 1903; *Southern California*, Philadelphia: J. Howard Avil 1903; Kropp, 22.

30 Benton, 39.

31 *Camera Craft* 1: 4 (August 1900), 200.

32 See Valerie Sherer Mathes, *Helen Hunt Jackson and Her Indian Reform Legacy*, Austin: University of Texas Press 1990.

33 For an excellent overview of the 'Ramona Phenomenon', see David Hurst Thomas, 'Harvesting Ramona's garden: life in California's mythical mission past', in *The Spanish Borderlands, in Pan-American Perspective, Columbian Consequences*, ed. David Hurst Thomas, Washington, DC: Smithsonian Institution Press 1991, vol 3, 119–57. See also Errol Wayne Stevens, 'Helen Hunt Jackson's Ramona: social problem novel as tourist guide', *California History* (Fall 1998), 158–67.

34 Moure, 22–4. See also Claire Perry, 'Pacific Arcadia: images of California, 1600–1915', PhD dissertation, Stanford University 1993, esp. ch.4.

35 As historian James Rawls notes, the missions 'became symbols of an ancient and heroic past for California, a beginning of European civilization that antedated the Gold Rush'. James Rawls, 'The California Mission as symbol and myth', *California History* (Fall 1992), 342–61.

36 In the foreword to one of the many picture books devoted to the missions, Ben Truman wrote: 'They [the missions] represent an energy as forceful, a courage as unfaltering, a devotion as true as that manifested by the Puritan fathers upon the bleak and unhospitable [sic] shores of New England'. Ben C. Truman, *Missions of California*, Los Angeles: M. Reider 1903.

37 In 1895, Charles Lummis founded the Landmarks Club for the purpose of preserving the missions. A visit to restored California missions became a planned excursion in and of itself and an entire infrastructure grew up around marking and mapping the missions for the visitor. See Patricia A. Butz, 'Landmarks Club', in Moneta, 68–73; Bingham, 103–11.

38 George Wharton James, *In and Out of the Old Missions of California: An Historical and Pictorial Account of the Franciscan Missions*, Boston: Little, Brown, 1910, 100.

39 W. H. Fletcher was one such professional photographer who marketed an 'Old Mission Series' as part of his 'California Views'. This series included scenes from San Luis Rey, San Juan Capistrano, San Gabriel, San Fernando, and the Santa Barbara Mission.

40 What Shall the Amateur Do?', *Camera Craft* 5: 4 (August 1902), 159.

41 Adam Clark Vroman and his 'Club of Four' took many camera excursions to the missions. Vroman's photographic documentation of California's missions was published in 1903 in a book called *Mission Memories: the Franciscan Missions of California*, Los Angeles: Out West Co. 1903. His photographs were also used to illustrate a 1913 edition of *Ramona*. See Jane Apostol, *Vroman's of Pasadena: A Century of Books 1894–1994*. Pasadena, CA: A. C. Vroman 1994. See also Ruth I. Mahood (ed.), *Photographers of the Southwest: Adam Clark Vroman, 1856–1916*, Los Angeles: Ward Ritchie Press 1961.

42 Louis Fleckenstein is one Pictorialist who produced a series of all 21 of the missions. Louis Fleckenstein, 'Photographs of California Missions', n.d., Huntington Library.

43 Auguste Wey, 'A California Loan Exhibition', *The Californian* 2: 4 (September 1892), 505.

44 Charles Lummis claimed that the numerous 'human types' made Southern California an excellent locale for the photographer: 'From the undeniable specific beauty of the higher type of Spanish-American ladies down through the quaint variants of the Mestizos and Indians, there is a remarkable scope for valuable and artistic work'. 'Our Amateur Photographers', 29.

45 'A trip through Chinatown with a Kodak camera', reproduced in *The Photographist* (Winter 1979), 29–30. That the 'hunting trip' took place within memory of the notorious massacre of Chinese in Los Angeles' Chinatown seems not to have troubled either journalist or salesman. At the first-birthday celebration of the Los Angeles Camera Club, the evening's entertainment included a humorous lecture by one of the members on 'some of the difficulties attendant upon procuring photos of the inhabitants of Chinatown'. *Camera Craft* 2: 3 (January 1901), 256.

46 Ng Poon Chew, 'The Chinese in Los Angeles', *The Land of Sunshine* 1: 5 (October 1894), 102–3.

47 J. Torrey Connor, 'Only John', *The Land of Sunshine* 4: 3 (February 1896), 111.

48 Olive Percival's collection of photographs resides at the Huntington Library and contains many scenes of Chinatown. See Linda Popp Di Biase, 'Forgotten Woman of the Arroyo: Olive Percival', *Southern California Quarterly* (Fall 1984), 207–19. See also Jane Apostal, *Olive Percival: Los Angeles Author and Bibliophile*, Los Angeles: Department of Special Collections, University Research Library, University of California Los Angeles 1992.

49 Mary Beatrice Fox Photograph Collection, Huntington Library.

PART SIX

Visualizing the Past

VANESSA R. SCHWARTZ AND
JEANNENE M. PRZYBLYSKI

I F MODERNITY CELEBRATED NOVELTY, techonology, and the present, it also transformed how people thought about and represented the past. Yet the visual culture of modernity has eroded our sense of the past, its contemporary critics maintain. Contributors to this section consider how representations of historical events served as building-blocks in the nineteenth-century project of nation-building. Visual representations of the past, especially the national past, exploded in the nineteenth century. The nation and its history needed to be "visualized." The representation of the past may seem as old as antiquity, but the forms and their meanings have changed over time. This section addresses some of the challenges and innovations in nineteenth-century historical representation. Together, they suggest not only that notions of the past are represented through these various modes—engravings, painting, monumental sculpture, photographs—but also that these very modes have come to shape our understanding of and expectation for the narrative structure of the past itself.

Pierre Nora's lament about modern historical consciousness centers on the foregrounding of outward signs of the past; on the symbolic and "retinal" elements that he argues have come to stand in for actual collective memories. It sets the stage for distinguishing between memory and history and gives a framework through which we might understand the partic- ular examples gathered in the section. While each selection addresses the representation of a national past, the essays differ not only by nation—France, Haiti, and the United States— but also over the role of image-making in their stories. Samuels argues that images become integrated into the historical narratives of Napoleon's France as a means of gaining control over a turbulent past. Savage underscores a figurative first—the first African-American bronze—in the broader immediate post-emancipation visual culture to explain the terms by which it failed to become an emblem of the end of slavery in the context of the US Civil War. Darcy Grimaldo Grigsby introduces several important elements in decoding the repre- sentation of the past—the complex status of colonial liberation, the personal histories of an artist (in this case, the hybrid identity of a Creole painter), and the connection between indi- vidual and national pasts as they are represented visually. Conventions of figuration, such as

God, the white father, stand out as testimony to the powerful legacy of representation that seemed to contradict a nation's and a painter's actual experience.

Each of the essays also confronts the role that imagery and performance play in negotiating the delicate frontier between history and myth. Joy S. Kasson addresses the paradigmatic American mythology of the Wild West by looking at the performance of history in Buffalo Bill's shows and in the program books sold as part of the spectacle. Kasson's essay introduces such important questions as the slippage between fiction and authenticity in historical representation; the borders between popular and academic history, and the modern penchant for nostalgia produced by and through modern image culture.

PIERRE NORA

BETWEEN MEMORY AND HISTORY
Les Lieux de Mémoire

T**HE ACCELERATION OF HISTORY**: let us try to gauge the significance, beyond metaphor, of this phrase. An increasingly rapid slippage of the present into a historical past that is gone for good, a general perception that anything and everything may disappear—these indicate a rupture of equilibrium. The remnants of experience still lived in the warmth of tradition, in the silence of custom, in the repetition of the ancestral, have been displaced under the pressure of a fundamentally historical sensibility. Self-consciousness emerges under the sign of that which has already happened, as the fulfillment of something always already begun. We speak so much of memory because there is so little of it left.

Our interest in *lieux de mémoire* where memory crystallizes and secretes itself has occurred at a particular historical moment, a turning point where consciousness of a break with the past is bound up with the sense that memory has been torn—but torn in such a way as to pose the problem of the embodiment of memory in certain sites where a sense of historical continuity persists. There are *lieux de mémoire*, sites of memory, because there are no longer *milieux de mémoire*, real environments of memory.

Consider, for example, the irrevocable break marked by the disappearance of peasant culture, that quintessential repository of collective memory whose recent vogue as an object of historical study coincided with the apogee of industrial growth. Such a fundamental collapse of memory is but one familiar example of a movement toward democratization and mass culture on a global scale. Among the new nations, independence has swept into history societies newly awakened from their ethnological slumbers by colonial violation. Similarly, a process of interior decolonization has affected ethnic minorities, families, and groups that until now have possessed reserves of memory but little or no historical capital. We have seen the end of societies that had long assured the transmission and conservation of collectively remembered values, whether through churches or schools, the family or the state; the end too of ideologies that prepared a smooth passage from the past to the future or that had indicated what the future should keep from the past—whether for reaction, progress, or even revolution. Indeed, we have seen the tremendous dilation of our very mode of historical perception, which, with the help of the media, has substituted for a memory entwined in the intimacy of a collective heritage the ephemeral film of current events.

The "acceleration of history," then, confronts us with the brutal realization of the difference between real memory—social and unviolated, exemplified in but also retained as the secret of so-called primitive or archaic societies—and history, which is how our hopelessly forgetful modern societies, propelled by change, organize the past. On the one hand, we find an integrated, dictatorial memory—unself-conscious, commanding, all-powerful, spontaneously actualizing, a memory without a past that ceaselessly reinvents tradition, linking the

history of its ancestors to the undifferentiated time of heroes, origins, and myth—and on the other hand, our memory, nothing more in fact than sifted and sorted historical traces. The gulf between the two has deepened in modern times with the growing belief in a right, a capacity, and even a duty to change. Today, this distance has been stretched to its convulsive limit. [. . .]

Memory and history, far from being synonymous, appear now to be in fundamental opposition. Memory is life, borne by living societies founded in its name. It remains in permanent evolution, open to the dialectic of remembering and forgetting, unconscious of its successive deformations, vulnerable to manipulation and appropriation, susceptible to being long dormant and periodically revived. History, on the other hand, is the reconstruction, always problematic and incomplete, of what is no longer. Memory is a perpetually actual phenomenon, a bond tying us to the eternal present; history is a representation of the past. Memory, insofar as it is affective and magical, only accommodates those facts that suit it; it nourishes recollections that may be out of focus or telescopic, global or detached, particular or symbolic—responsive to each avenue of conveyance or phenomenal screen, to every censorship or projection. History, because it is an intellectual and secular production, calls for analysis and criticism. Memory installs remembrance within the sacred; history, always prosaic, releases it again. Memory is blind to all but the group it binds—which is to say, as Maurice Halbwachs has said, that there are as many memories as there are groups, that memory is by nature multiple and yet specific; collective, plural, and yet individual. History, on the other hand, belongs to everyone and to no one, whence its claim to universal authority. Memory takes root in the concrete, in spaces, gestures, images, and objects; history binds itself strictly to temporal continuities, to progressions and to relations between things. Memory is absolute, while history can only conceive the relative.

At the heart of history is a critical discourse that is antithetical to spontaneous memory. History is perpetually suspicious of memory, and its true mission is to suppress and destroy it. At the horizon of historical societies, at the limits of the completely historicized world, there would occur a permanent secularization. History's goal and ambition is not to exalt but to annihilate what has in reality taken place. A generalized critical history would no doubt preserve some museums, some medallions and monuments—that is to say, the materials necessary for its work—but it would empty them of what, to us, would make them *lieux de mémoire*. In the end, a society living wholly under the sign of history could not, any more than could a traditional society, conceive such sites for anchoring its memory. [. . .]

The study of *lieux de mémoires*, then, lies at the intersection of two developments that in France today give it meaning: one a purely historiographical movement, the reflexive turning of history upon itself, the other a movement that is, properly speaking, historical: the end of a tradition of memory. The moment of *lieux de mémoire* occurs at the same time that an immense and intimate fund of memory disappears, surviving only as a reconstituted object beneath the gaze of critical history. This period sees, on the one hand, the decisive deepening of historical study and, on the other hand, a heritage consolidated. The critical principle follows an internal dynamic: our intellectual, political, historical frameworks are exhausted but remain powerful enough not to leave us indifferent; whatever vitality they retain impresses us only in their most spectacular symbols. Combined, these two movements send us at once to history's most elementary tools and to the most symbolic objects of our memory: to the archives as well as to the tricolor; to the libraries, dictionaries, and museums as well, as to commemorations, celebrations, the Pantheon, and the Arc de Triomphe; to the *Dictionnaire Larousse* as well as to the Wall of the *Fédérés*, where the last defenders of the Paris commune were massacred in 1870. [. . .]

Modern memory is, above all, archival. It relies entirely on the materiality of the trace, the immediacy of the recording, the visibility of the image. What began as writing ends as high fidelity and tape recording. The less memory is experienced from the inside the more it exists only through its exterior scaffolding and outward signs—hence the obsession with the archive that marks our age attempting at once the complete conservation of the present as well as the total preservation of the past. Fear of a rapid and final disappearance combines with anxiety about the meaning of the present and uncertainty about the future to give even the most humble testimony, the most modest vestige, the potential dignity of the memorable. Have we not sufficiently regretted and deplored the loss or destruction, by our predecessors, of potentially informative sources to avoid opening ourselves to the same reproach from our successors? Memory has been wholly absorbed by its meticulous reconstitution. Its new vocation is to record; delegating to the archive the responsibility of remembering, it sheds its signs upon depositing them there, as a snake sheds its skin. [. . .]

Representation proceeds by strategic highlighting, selecting samples and multiplying examples. Ours is an intensely retinal and powerfully televisual memory. [. . .]

Lieux de mémoire are simple and ambiguous, natural and artificial, at once immediately available in concrete sensual experience and susceptible to the most abstract elaboration. Indeed, they are *lieux* in three senses of the word—material, symbolic, and functional. Even an apparently purely material site, like an archive, becomes a *lieux de mémoire* only if the imagination invests it with a symbolic aura. A purely functional site, like a classroom manual, a testament, or a veterans' reunion belongs to the category only inasmuch as it is also the object of a ritual. And the observance of a commemorative minute of silence, an extreme example of a strictly symbolic action, serves as a concentrated appeal to memory by literally breaking a temporal continuity. Moreover, the three aspects always coexist. Take, for example, the notion of a historical generation: it is material by its demographic content and supposedly functional—since memories are crystallized and transmitted from one generation to the next— but it is also symbolic, since it characterizes, by referring to events or experiences shared by a small minority, a larger group that may not have participated in them.

Lieux de mémoire are created by a play of memory and history, an interaction of two factors that results in their reciprocal overdetermination. To begin with, there must be a will to remember. If we were to abandon this criterion, we would quickly drift into admitting virtually everything as worthy of remembrance. One is reminded of the prudent rules of old-fashioned historical criticism, which distinguished between "direct sources," intentionally produced by society with a view to their future reproduction—a law or a work of art, for example—and the indiscriminate mass of "indirect sources," comprising all the testimony an epoch inadvertently leaves to historians. Without the intention to remember, *lieux de mémoire* would be indistinguishable from *lieux d'histoire*. [. . .]

One simple but decisive trait of *lieux de mémoire* sets them apart from every type of history to which we have become accustomed, ancient or modern. Every previous historical or scientific approach to memory, whether national or social, has concerned itself with *realia*, with things in themselves and in their immediate reality. Contrary to historical objects, however, *lieux de mémoire* have no referent in reality; or, rather, they are their own referent: pure, exclusively self-referential signs. This is not to say that they are without content, physical presence, or history; it is to suggest that what makes them *lieux de mémoire* is precisely that by which they escape from history. In this sense, the *lieu de mémoire* is double: a site of excess closed upon itself, concentrated in its own name, but also forever open to the full range of its possible significations. [. . .]

MAURICE SAMUELS

THE ILLUSTRATED HISTORY BOOK
History between word and image

I N THE FIRST HALF OF THE NINETEENTH CENTURY in France, a new
type of illustrated history changed the look of the past. Struggling to make sense of the
Revolution of 1789, and the political and economic forces it unleashed, the French increas-
ingly came to rely on the image as a vehicle for historical understanding at the beginning of
the period we label as "modern." As the past came to seem more remote because of the rapid
pace of historical change, and as the need to understand the nature of this change became
more pressing, illustrated histories began offering pictures of historical people, places, and
events by the score.[1] This essay positions the rise of illustrated history in its nineteenth-century
French context in order to explore the connection between new conceptions of the histor-
ical image and the new social formation of modernity.

The prominence of illustrated histories in the 1830s and 1840s, of course, parallels the
development of a much more well-known phenomenon, Romantic historiography.[2] Pierre
Nora and Richard Terdiman have argued that the French experienced the ongoing political
instability (seven different forms of government between 1789 and 1848) and economic trans-
formation (the rise of industrial capitalism driving large numbers of people from the countryside
to the city) as a "memory crisis" in which links to the past, including traditional rituals, were
suddenly and irrevocably severed. The rise of Romantic historiography and of history as a
discipline during this period, they explain, filled the gap left by the loss of more organic forms
of memory.[3] I would like to suggest that the development of visual or spectacular modes of
historical representation in popular culture during this period, such as illustrated history,
helped the French cope with historical change by making it seem more "real." In what follows,
I describe the visual and textual strategies by which the new forms of historical illustration
produced this illusion.

The image of history

In the 1830s and 1840s, at the same time that the Romantic historians began to gain renown
for their picturesque descriptions, actual pictures came to occupy an increasingly large place
on the historiographic horizon. As I will detail below, this expanded use of the image resulted
in part from innovations in printing and engraving technology, but a general shift in attitudes
toward the role of the image as a pedagogical tool also contributed to its triumph in a variety
of genres in France during this period. As in the eighteenth-century *Encyclopédie*, which made
use of the image to diffuse technological and philosophical knowledge, nineteenth-century
newspapers, school textbooks, travel guides, and social commentaries employed the image to
disseminate ideas necessary for the economic and social development of the new century.[4]

The nineteenth century, however, did not inaugurate the use of visual imagery in historical representation. As Francis Haskell has shown, the Bayeux Tapestry elaborated a visual vocabulary for historical representation in the Middle Ages.[5] And as Maurice Agulhon, Lynn Hunt, and Ronald Paulson have demonstrated, images played an important role in reflecting shifts in popular sentiment toward political change during the French Revolution.[6] Renaissance and Neo-Classical histories in Italy and France, moreover, had incorporated portraits of famous monarchs from the sixteenth century onward.[7] But if the historical image was hardly new in the nineteenth century, it was radically transformed. While *ancien régime* historiography incorporated primarily iconography produced during the period being represented, nineteenth-century illustrated historiography favored "retrospective" representation, images depicting past rather than current events.[8] This shift away from the exclusive use of "authentic" iconography freed the nineteenth-century illustrated editions to explore a wide range of subject matter in their images: the new illustrations did not confine themselves to portraiture, but rather tended to focus on historical actions or events.[9]

The work of the Romantic historians produced during the 1820s proved ideal for this kind of illustration because of its emphasis on visual description. Adolphe Thiers' enormously influential *History of the French Revolution,* first published in 1823, was reissued in illustrated editions in 1834, 1836, 1837, and 1838.[10] Augustin Thierry's *History of the Conquest of England by the Normans,* another major work of Romantic historiography, first published in 1825, was reissued in 1838 in an edition adorned with engraved images by such prominent artists as Ary and Henri Scheffer, Horace Vernet, and Tony Johannot.[11] In addition to images of the eleventh-century Norman invasion, readers in 1838 could also see imaginative representations of the fifteenth century in the new fifth edition of Prosper de Barante's *History of the Dukes of Burgundy of the House of Valois,* illustrated by many of the same artists who worked on the Thierry volume.

The images in these works were metal engravings. First drawn on paper, they were then engraved (by a separate hand) onto copper or steel plates which were then inked and used for printing. Unlike traditional woodcuts, which were popular during the Renaissance but had fallen out of favor by the eighteenth century, metal engraving allowed for multiple impressions without the loss of detail. But metal engravings, unlike woodcuts, could not be printed on the same press as typographical characters. Expensive to produce, metal engravings had to appear on separate pages from printed text ("*hors texte*"), and were often shrouded by a thin layer of tissue-like paper to prevent the ink from staining the facing page, but also to shield the image from what Madeleine Rébérioux has called "*[le] regard brutal du lecteur.*"[12] Invented in Germany at the end of the eighteenth century and brought to France between 1809 and 1816, lithography, in which artists drew images directly onto a stone which was then used for printing, saved time by eliminating the need for engraving. But lithographic images, which frequently adorned illustrated historiography during the 1820s, also had to be printed separately from type and thus appeared "*hors texte.*"[13]

In the early 1830s, the perfection of a new technique of wood engraving brought image and text together. Unlike traditional woodcuts, in which an image was carved on a plank with the grain running horizontal to the surface ("*bois de fil*"), the new technique, pioneered in England in the eighteenth century, used a harder wood (boxwood), cut the engraving into the end of the wood ("*bois de bout*"), with the grain perpendicular to the surface, and used a burin instead of a knife.[14] This process allowed for greater precision than the traditional woodcut and for a greater number of impressions without the loss of detail. And unlike metal engraving or lithography, wood engravings could be printed along with typographical characters, allowing for the first time a high-quality image to appear on the same page as the text.

It also allowed for lower production costs, and hence less expensive editions, since an entire stage of the printing process was eliminated (although unlike lithography, it still required the skills of an engraver).

Among the first historiographic works to incorporate wood engravings, certainly the most celebrated was Théodose Burette's 1840 *Histoire de France,* which contained 500 drawings by Jules David of all periods of French history. "The text is elegant and colorful; the form is brilliant," enthused the Romantic journal *L'Artiste* in a review that reproduced examples of the remarkable illustrations; "it flatters at once the intelligence and the eye."[15] Unsurprisingly, given the cult that had grown up around Napoleon since his death in exile in 1821, a host of histories marshalled wood engraving in worship of the fallen hero. The discussion that follows focuses on two primary examples, both published in 1839: a re-edition of Jacques de Norvins' *Histoire de Napoléon,* with illustrations by the celebrated military artist Denis Auguste Marie Raffet,[16] and Paul Mathieu Laurent de l'Ardèche's new *Histoire de L'Empereur Napoléon,* illustrated by another renowned military artist, Horace Vernet.[17]

Identical in price (20 francs), these two works were vigorously advertised in the press of the period and vied with each other for readership.[18] They are remarkably alike in appearance and format: both are in octavo volumes, bound luxuriously in gold-embossed leather, and both run over six-hundred pages—quite substantial for the time, though commonplace by today's standards for biography. Several kinds of images adorn these volumes. In addition to the hundreds of wood-engraved illustrations ("*vignettes*") found alongside the text, the books feature wood-engraved still-life images at the start of chapters ("*tête de page*") and at the end ("*cul de lampe*") showing various Napoleonic accoutrements, as well as decorated first letters likewise adorned with Imperial symbols, including eagles, crowns, mantles, etc.[19]

Just as the form of these two books is quite similar, so too is their content. Following an introduction or preface announcing the works' more or less hagiographic intentions, both books divide Napoleon's life into chapters, beginning with his birth on the island of Corsica and ending with his death on the island of Saint-Helena. The history by Laurent, written expressly for this illustrated edition, tends to highlight the mythic moments of Napoleon's life, and quotes liberally from other sources, including the *Bulletins de la Grande-Armée,* Napoleon's own memoirs, and especially the account of Napoleon's life in exile, Las Cases' *Mémorial de Saint-Hélène.* Famous anecdotes or sayings associated with the great man structure the narrative, with Laurent confining himself to commentary on the authenticity or significance of the event or *bon mot.* The Norvins biography, which was first published in 1827, and which would go through 22 editions by 1854, some illustrated, some not, is perhaps the more serious historical work, featuring more original source material and more subtle analyses of events, their causes and effects.[20] As the prospectus advertising the wood-engraved illustrated edition admits, however, the analyses in this edition have been shortened to make room for more familiar anecdotes and famous events ("*hauts faits*"). By focusing on specific historical moments, often those that had attained legendary status, and by describing these in vivid and colorful detail, the texts facilitated the task of the illustrator.

The wood-engraved images relate to the narrative both metaphorically and metonymically. A metaphoric illustration presents a visual equivalent of the anecdote recounted by the text. For example, the description of the emperor's marriage to Marie-Louise in the Laurent volume is accompanied by a picture of the ceremony, which effectively translates the written content into a parallel visual form. Immediately after the narrative of the ceremony, however, the text produces a "close up" picture of Napoleon's hand placing the ring on his bride's finger, an action not specifically mentioned by the text [Figure 27.1]. As in the classic example of the metonymical device of synecdoche, "I'll take her hand in marriage," here the part stands

for the whole, allowing for a kind of visual shorthand or abbreviation, summarizing the action by summoning its (unrecounted) climactic moment. This visual insert at the conclusion of the description of the wedding thus goes beyond the narrative, directing the reader/viewer's attention to a detail that the written text could not summon without sagging under the weight of excessive specificity. The function of this image as a decorative "*cul de lampe*," moreover, allows it to disrupt the forward progression of the narrative, providing a space outside the strict chronology in which the history unfolds for contemplation of this sentimental and symbolic moment. The illustration thus allows for multiple and simultaneous levels of discourse, in which the visual relates to but does not entirely mirror the verbal.

498 HISTOIRE DE NAPOLÉON.

Au milieu de ces transports universels et de ces réjouissances splen-
dides, l'ambassadeur d'Autriche devait avoir son jour pour étaler sa
joie officielle et son faste diplomatique. Il choisit le 1ᵉʳ juillet, et la fête
fut marquée par un sinistre événement. Le feu prit à la salle du bal;
la femme du ministre autrichien et plusieurs autres personnes périrent
dans l'incendie. Napoléon ne laissa pas à une main étrangère le soin et
l'honneur de sauver son épouse; il la saisit vivement et l'emporta lui-
même hors des pièces embrasées. On se rappela alors que les fêtes pour
le mariage de Louis XVI et de Marie-Antoinette avaient été troublées
aussi par de graves accidents.

Figure 27.1 Horace Vernet, illustration in Laurent de l'Ardèche, *L'Histoire de l'Empereur Napoléon* (Paris, 1839). Courtesy of the President and Fellows of Harvard College.

Such a use of the historical image, of course, was hardly new in the nineteenth century: the real innovation of these works lay in their spatial conjunction of image and text. As I described above, prior illustrated histories had confined their images to separate pages or separate volumes, forcing the reader to pause and turn her head, sometimes even to turn the whole book if the image were printed horizontally, as was usually the case, causing an interruption in the flow of the narrative. In such works, there was no way to determine at what point the reader would choose to look at the image, and these images seldom referenced specific anecdotes recounted by the text. Instead, they often merely reproduced pre-existing images (sometimes famous paintings) of battles, people, or places.[21] The wood engravings in the new illustrated editions, on the other hand, were always created expressly for the text, and punctuate the narrative at precisely defined moments.

Perfectly suited to the anecdotal character of these works, the images focus on particularities in the narrative, picking out telling or colorful details. In the Laurent volume, for example, a description of Napoleon's notorious retreat from Moscow through the freezing Russian winter focuses on a picturesque, though gory, aspect of the scene: "The horses of the cavalry and the artillery perished every night." In the middle of the word "artillery," the text cuts away to an image of a dead horse [Figure 27.2]. The word itself is not completely uttered before the image intrudes. The layout of the page thus forces the reader to encounter word and picture simultaneously, offering a visual representation of the events before a mental picture can be formed. In this case, the page is dominated by image rather than written text, and the words seem almost to intrude upon the flow of images.

The Norvins volume employs the same technique. Describing the same episode of the Russian debacle, the text reads: "The unhappy ones, surprised on all sides by the Cossacks, perished from lance, hatchet or axe blows, or stayed exposed and naked on the snow, slowly awaiting death at the will of cannibals." An image dividing the word "Cossacks" shows French soldiers and their horses lying dying in the snow alongside an exposed naked female body [Figure 27.3]. The text, of course, does not specify the sex of the naked bodies—indeed there's no specific mention of women or children accompanying the soldiers at all. The image thus illustrates the specific anecdote while adding its own layer of meaning and in this case prurient interest.[22] While earlier "*hors-texte*" illustrated editions also, to be sure, juxtaposed image and text to produce meaning, wood-engraved histories achieve their effect through the new proximity of the two levels of discourse: the *mise-en-page* breaks down the barrier between the visual and the verbal, creating a mode of symphonic signification in which parallels—and disjunctures—between image and text register simultaneously.

The images blend into the text visually as well as textually. As we have seen, the traditional "*hors-texte*" image remains external to the narrative, a supplement whose status as luxury or even fetish object is signalled by the paratextual apparatus, such as the tissue-paper "veil." Unlike metal engravings, which leave a plate-mark around the image, wood engravings are not set off by a border of any kind. The wood-engraved image thus fuses with the text surrounding it, aided by the centrifugal mode of composition in which the most intense contrasts of light and dark appear in the center of the image and tend to fade out toward the edges.[23] The effect is an almost seamless transition from text to image and back again to text, allowing the reader to assimilate both levels of content, the graphic and the scriptural, simultaneously and, as it were, effortlessly.

Here we see one of the defining features of the new illustrated editions of the 1830s and 1840s, and one of the primary ways in which they differ not only from prior forms of illustration but also from history painting. Like illustrated historiography, history painting underwent a radical transformation in the early nineteenth century. The canvases of such

Figure 27.2 Horace Vernet, illustration in Laurent de l'Ardèche, *L'Histoire de l'Empereur Napoléon* (Paris, 1839). Courtesy of the President and Fellows of Harvard College.

painters as Paul Delaroche, Charles Steuben, and Horace Vernet (all of whom also contributed to illustrated historiographies) depicted the material aspects of the past with a new attention to detail, endowing what had formerly been the most "noble" genre of painting with what some saw as a trivial, journalistic function.[24] These paintings, however, depict the past as fundamentally separate from the viewer. The process whereby the picture breaks free of its frame in wood-engraved editions effectively alters this classical conception of the image as a "window onto the world"—as a picture that remains discrete, distinct, and compartmentalized. If the framing of paintings and traditional, metal engravings serves to signal the status of the picture as representation, here the distinction between art and reality is blurred.[25] The

troupeau sans défense, où se répandent dans toutes les directions pour chercher du pain et un abri. Les malheureux, surpris de tous côtés par les Cosa-

ques, périssent à coups de lance, de pique et de hache, ou restent exposés

Figure 27.3 Raffet, illustration in Norvins, *L'Histoire de Napoléon* (Paris, 1839). Courtesy of the President and Fellows of Harvard College.

image no longer keeps to its place, but rather reaches out of the text and out to the viewer, who finds herself drawn in, bodily, to the picture. Just as in the panorama,[26] which exploited optical illusions to give the viewer a sense of being "part of the scene," or the wax display, which allowed viewers to circulate among life-size historical figures,[27] the new illustrated histories incorporated the spectator into the spectacular text. The result was a historical experience of a different nature, one that allowed viewers to declare, as did one critic of the Panorama of the Battle of the Moskowa from 1835, "I forgot I was in front of a canvas."[28]

During the *ancien régime*, history had served either as a model for conduct or, in Voltaire, as pretext for social and political critique.[29] In the nineteenth century, however, historical representation began to function less as a means of influencing the present than as a vehicle for transcending it. "Our album has the inappreciable advantage of offering the most exact, the most loyal, the most complete, and the most true representation of the time of the Consulate and the Empire," boasted the prospectus for a collection of engravings destined to

accompany a popular work of Romantic historiography. "You would think you were present at a battle, or in the honor guard as the victorious French enter the capital of Austria or Prussia."[30] These illustrations offer themselves as a time-machine, capable of transporting the viewer to the historical scene. The image, if executed with sufficient illusionistic skill, promises to erase the distance separating the viewer from history, providing a quasi-mystical communion with the very events that had caused such profound changes in French society.

Evoked visually, with a material specificity, disorienting episodes like the Revolution and Napoleonic Wars could more easily be assimilated by viewers. In reaching out to spectators, in inviting them to enter into the image, the new forms of spectacular history provided viewers with a sense of historical agency: nineteenth-century subjects could experience the feeling of participating first-hand in events whose effects had previously been felt but not seen. By "transporting" the viewer to the scene of a battle, by making the spectator "witness" Napoleon's trimphant entrance into Vienna or the tragic Russian retreat, the historical image of the nineteenth century creates the illusion of power guaranteed by presence. The testimony to the realism of these images in the prospectuses used to market them and in contemporary criticism, I would like to suggest, betrays a wish on the part of nineteenth-century viewers to gain control over a turbulent past (and, by extension, of a still uncertain future).

Of course, this sense of control was meant to be experienced by those that could afford to pay for it. Indeed, the new visual forms of historical representation appealed primarily to the early nineteenth-century bourgeoisie, a heterogeneous class marked by varying levels of educational and economic advantage. *Ancien régime* historiography had reached only a very restricted elite of educated and affluent readers—not only those with the leisure to read and the resources to gain access to books, but those whose educational levels allowed them to make sense of the material. By rendering the past in visual form, the new spectacular forms of history, such as illustrated historiography, reached a much larger audience. Though still out of the reach of common workers,[31] illustrated editions helped make historiography available to the growing numbers of the semi-literate—poorly-educated, but newly affluent subjects produced by industrial capitalism, who relied on the image as a comprehension aid, as well as children.[32] By making the past accessible to a wide range of bourgeois subjects, the illustrated histories thus reproduced on a material level the revolution they depicted on a narrative level: they represented the bourgeoisie's rise to power both *in* the past and *over* the past.

The image and its discontents

For some observers at the time, however, the historical image posed grave dangers. Indeed, critics from both the Right and Left of the political spectrum worried that the image promoted an unhealthy obsession with Napoleon, whose likeness dominated all forms of visual historiography, from the illustrated histories to the panorama to the Boulevard stage. Bonapartism, a political movement that sought the restoration of a Napoleonic heir to the throne, and combined authoritarianism with populism, remained a real political option—or threat—throughout the July Monarchy.[33] As Michael Marrinan has shown, Louis-Philippe would try to co-opt the energy of this movement for his own political ends precisely by appropriating Napoleon's *image:* the museum of French history at Versailles, opened by the "citizen-king" in 1837, contained hundreds of paintings of Napoleon and his famous battles.[34]

Others were less willing to sanction the image, however, and their critiques provide a vantage point from which to evaluate the larger implications of history's spectacularization in the nineteenth century. For Alfred Nettement, a legitimist[35] critic who wrote a series of articles attacking Romantic historiography during the mid-1830s, the historian should invoke

dangerous periods like the Revolution and the Napoleonic Wars only in order to condemn them. Any free-floating description of Revolutionary or Napoleonic history, unattached to condemnation—and the picturesque historiography of the Romantics abounded in such descriptions, as did real images in the panorama and the illustrated histories—ran the risk of promoting Revolutionary or Imperial sentiment by enflaming the imaginations of readers/viewers. For Nettement, the historical image of the nineteenth century, by divorcing description from judgment, by shifting responsibility for deciphering the meaning of the past from the historian to the "viewer," promoted passion without knowledge. The problem with the Romantic historians, for a reactionary like Nettement, lay exactly here, in their transformation of the past into what he termed, in a review of the fifth edition of Barante's *History of the Dukes of Burgundy,* "a series of pictures."[36] Nettement was not talking about actual visual images, but he might as well have been: the fifth edition of Barante's work, we remember, was illustrated.

Contemporary observers on the Left of the political spectrum, however, also saw certain dangers in the attempt to turn the past into a picture. An example of this anxiety emerges in the criticism directed against the large-scale historical canvases exhibited by Paul Delaroche in the *salons* of the 1830s. Delaroche's paintings of English history—of Lady Jane Grey moments before her execution, and of the children of King Edward awaiting death in the Tower of London—fascinated French spectators in the early years of the July Monarchy with their illusionistic representation of emotionally-laden moments from the past. These paintings present history as a dramatic scene: frozen in a moment of maximum pathos, Delaroche's historical images arouse the pity of viewers, especially those inclined to sympathize with suffering and soon-to-be-murdered monarchs. But as contemporary Left-wing commentators noted, such representations deny the complexity of the past, and prevent a true understanding of history.[37] By reducing history to a single scene, images prevent viewers from understanding the social and political causes underlying historical events. By rendering the past as spectacle, they encourage viewers to thrill in the moment, and perhaps to identify with the beautiful victims of Revolutionary violence, but they do not provide an accurate picture of the past.

Criticisms such as these take on particular relevance when viewed from the other end of the century that would follow, an era in which the image would triumph, along with modern forms of popular dictatorship. If visual history in the early nineteenth century helped the bourgeois individual assert a new, post-Revolutionary identity, it also contributed to modernity's darker side, in which the individual surrendered that identity to irrational passions and hero worship. The propaganda machines of twentieth-century mass culture proved particularly adept at using the image as an instrument of manipulation, in ways that go beyond the worst fears of nineteenth-century critics. How, we need to ask, does our "postmodern" historical imagination remain linked to these modern ways of looking at the past? To what extent is the legacy of the illustrated history still with us, even if our historical gaze no longer remains fixated on Napoleon?

While photographic images proliferate in twentieth-century history books, film represents the most illustrious descendent of the illustrated histories. Indeed, cinema employs the same techniques of cut away, insert, and closeup first used in the biographies of Napoleon and other wood-engraved editions from the time. Silent cinema, especially, would harness word and image in much the same way to engage multiple senses and multiple faculties of perception simultaneously, aiming to produce a total, and realistic, experience of the past. And it is not a coincidence that Napoleon's biography would go on to become the subject of one of the classics of the silent cinema: Abel Gance's *Napoléon* of 1927 adapts not only the techniques of the illustrated histories, but reproduces much of their content as well. Recent cinema has only accelerated the spectacularization of the past. The reality effects (now produced by

computers rather than engraving) viewers and critics admire (or deplore) in such films as Steven Spielberg's *Saving Private Ryan* and Michael Bay's *Pearl Harbor* are only the latest manifestation of a process that has been underway since the early nineteenth century. The impact of such representations on the way postmodern culture views its past, and the political uses to which this spectacular past is put, remain to be studied. Like the critics in the nineteenth century, viewers today need to recognize that there is more to the way we look at history than first meets the eye.

Acknowledgments

I am indebted to Diane Brown, Jann Matlock, Catherine Nesci, Naomi Schor, Vanessa Schwartz, Mary Sheriff, Daniel J. Sherman, Susan Suleiman, Richard Terdiman, and Beth S. Wright, as well as to several anonymous readers, for their helpful comments on versions of this essay. I am also grateful to Dalia Judovitz and Marshall Brown for the opportunity to present this material at the 2000 MLA convention, and to Peter Stallybrass for the invitation to present it at the History of the Material Text seminar at the University of Pennsylvania in 2001.

Notes

1 Illustrated editions were only part of a vast expansion of historiographic production in this period. According to the *Bibliographie de la France,* 140 works of history, excluding geographies and genealogies, were published in 1815. By 1830 this number would rise to 240.

2 The school of Romantic historians includes Prosper de Barante, François Guizot, Jules Michelet, Augustin Thierry, and Adolphe Thiers.

3 See Nora, "Between Memory and History: *Lieux de Mémoire,"* trans. Marc Roudebush, *Representations* 26 (1989) and this volume, Chapter 26; and Terdiman, *Present Past: Modernity and the Memory Crisis* (Ithaca, N.Y.: Cornell University Press, 1993).

4 For a general account of the use of images in various genres in nineteenth-century France, see Michel Melot, "Le texte et l'image," in Roger Chartier and Henri-Jean Martin, eds., *Histoire de l'édition française: Le temps des éditeurs* (Paris: Fayard/Promodis, 1990). Also see Gordon N. Ray, *The Art of the French Illustrated Book, 1700 to 1914* (New York: The Pierpont Morgan Library, 1982).

5 In *History and its Images* (New Haven, Conn.: Yale University Press, 1993), Francis Haskell provides a magisterial overview of the use of visual imagery in the representation of the past from the Middle Ages to the present.

6 The work of these scholars has focused on the allegorical representation of political or historical events, whereas I am interested in representations that treat the historical referent in a more literal manner. See Agulhon, *Marianne au combat: L'imagerie et la symbolique républicaines de 1789 à 1880* (Paris: Flammarion, 1979); Hunt, "Engraving the Republic," *History Today,* 30 (1980), 11–17; and Paulson, *Representations of Revolution (1789–1820)* (New Haven, Conn.: Yale University Press, 1983). Also see Hunt, *The Family Romance of the French Revolution* (Berkeley, Calif.: University of California Press, 1992) for a discussion of the role of popular engravings (especially of the Royal Family) during the Revolution.

7 See Jean Adhémar, "L'enseignement par l'image," *Gazette des Beaux-Arts,* 97 (1981), 53–60; and Adhémar, "L'éducation visuelle des fils de France et l'origine du Musée de Versailles," *La Revue des arts* (6 March 1956): 29.

8 While some of the events depicted in the new histories, such as the Napoleonic Wars, belonged to a quite recent past, the new images maintained a different ontological relation to their subject: they no longer purported to be "eye witness" representations, produced from a living model. Haskell dismisses such "retrospective" images as "fanciful and romantic drawings" (p. 288) and does not discuss them in detail.

9 Among the very few scholarly treatments of nineteenth-century illustrated historiography, see Madeleine Rebérioux, "L'illustration des Histoires de la Révolution française au XIXe siècle: esquisse d'une problématique," in Stéphane Michaud, Jean-Yves Mollier et Nicole Savy (eds), *Usages de l'image* (Paris: Editions Créaphis, 1992). Also see Marie Claude Chaudonneret, "Les représentations des événements

et des hommes illustres de la Révolution Française de 1830 à 1848" and Rémi Mallet, "L'iconographie de la Révolution Française dans les livres d'histoire du XIXe siècle," in Michel Vovelle (ed.), *Les Images de la Révolution Française* (Paris: Publications de la Sorbonne, 1988); as well as Beth S. Wright, "'That Other Historian, the Illustrator': Voices and Vignettes in Mid-Nineteenth Century France," *Oxford Art Journal* 23.1 (2000): 113–136.

10 On the illustrated editions of Thiers, see Rebérioux and Mallet.

11 The atlas volume containing the illustrations bears the date 1839.

12 Rebérioux, 21. This and all subsequent translations from the French are my own.

13 A.V. Arnault's *Vie politique et militaire de Napoléon,* first published in 1822, provides a stunning example of the use made of lithography by enterprising historiographic editors. Capitalizing on interest in the emperor following his death in 1821, this edition of two luxuriously leather-bound, in-folio volumes contained 120 full-page lithographs. The cost of this collector's edition, however, was as monumental as its format: twelve francs for each of the thirty parts ("livraisons"), each containing four images, that made up the completed volume.

14 Thomas Bewick (1753–1826) was responsible for reviving wood engraving during this period in England. On the "modern" technique of wood engraving, see William Andrew Chatto, *A Treatise on Wood Engraving* (London: Chatto and Windus, 1861). On its uses in nineteenth-century France, see Henri Zerner, "La Gravure sur bois romantique," *Médecine de France,* 150 (1964): 17–32; and Henri Zerner and Charles Rosen, *Romanticism and Realism* (London: Faber and Faber, 1984), Chapter Three. Other classic studies of wood engraving include Champfleury, *Les Vignettes romantiques, 1825–1840,* and Pierre Gusman, *La Gravure sur bois en France au XIXe siècle.*

15 *L'Artiste,* tome 6 (1840), 138–44. Beth S. Wright discusses this edition of Burette and its review in *L'Artiste* in her essay "That Other Historian, the Illustrator." She argues for the primacy of the "aural metaphor" over the spectacular in these works, suggesting that the text-image relationships in Burette's history "engaged reader-viewers more actively, enabling them to 'hear' rather than see the past,": 117.

16 For more on Raffet, see the catalogue to the recent exhibition of his work held at the Bibliothèque Marmottan, March 24–July 10, 1999: *Raffet (1804–1860)* (Editions Herscher, 1999), especially the articles by Ségolène Le Men, "Raffet, illustrateur de la Révolution," and Bruno Foucart, "Napoléon et l'inspiration napoléonienne."

17 For more on Horace Vernet, see the catalogue of the exhibition held at the Académie de France à Rome in 1980, *Horace Vernet (1789–1863)* (Rome: De Luca, 1980).

18 The wood-engraved editions were aggressively advertised in all the major Parisian daily newspapers as ideal presents for the New Year (Étrennes). In these ads, the illustrator's name figures in as large (or larger) typeface than the author of the work he is illustrating, suggesting the degree to which the image was essential in the tranformation of history into a commodity during this period.

19 Such an arrangement of small images was typical of illustrated editions at the time. See Margaret Cohen, "Panoramic Literature and the Invention of Everyday Genres," in Leo Charney and Vanessa R. Schwartz (eds.), *Cinema and the Invention of Modern Life* (Berkeley, Calif.: University of California Press, 1995), p. 240, for a description of such images in the contemporary *physiologies.*

20 See James Smith Allen, *Popular French Romanticism: Authors, Readers, and Books in the 19th Century* (Syracuse: Syracuse University Press, 1981), pp. 4–6, for a discussion of the popularity of the Norvins history in the nineteenth century. According to Allen, production runs of this work ran into the tens of thousands.

21 Rebérioux describes how Charles Furne, who edited illustrated histories of the Revolution by Thiers, Lamartine, and Louis Blanc, reprinted many of the same images from one work to the next (p. 18). This "reuse of graphic material" was typical of the nineteenth century.

22 Michel Melot highlights the way image and text also could contradict each other in these editions, p. 338.

23 The same was true of lithography, which also did not leave a plate mark. See Zerner and Rosen, p. 78.

24 Recent studies of changes in history painting in the early nineteenth century include Christopher Prendergast, *Napoleon and History Painting: Antoine-Jean Gros's* La Bataille d'Eylau (Clarendon Press, Oxford, 1997); and Beth S. Wright, *Painting and History During the French Restoration* (Cambridge: Cambridge University Press, 1997).

25 See Zerner and Rosen, p. 81.

26 Vanessa Schwartz describes how the panorama "had to fit. [. . .] the entire bodily experience of its viewers into the spectacle," *Spectacular Realities* (Berkeley, Calif.: University of California Press, 1998), p. 157. On the position of the observer in relation to such new modes of spectatorship in the nineteenth

century as the panorama, also see Jonathan Crary, *Techniques of the Observer* (Cambridge, Mass.: MIT Press, 1990), 112–13.

27 The Curtius wax display, begun in the eighteenth century, remained open into the 1840s. On the phenomenon of the wax display, see Schwartz, Chapter Three.

28 *Journal des artistes,* August 30, 1835.

29 See Voltaire's *Essai sur les moeurs et l'esprit des nations* (1765).

30 Anon., "Prospectus" in *Album de la Revolution Française 1789–1793* (n.p., n.d.), 2.

31 While an average work of illustrated history cost upwards of 20 francs, in 1830 the wages of a skilled male worker ranged from 2.50 francs to 6 francs a day. The average wage for a female worker in 1840, moreover, had only attained 0.80 francs. Public reading rooms, *cabinets de lecture,* of course, provided access to books at a cheaper rate, but reading still required the kind of leisure unavailable to common workers in the period. On wages, see Jacques Rougerie, "Remarques sur l'histoire des salaires à Paris au XIXe siècle," *Le Mouvement social,* 63 (1968): 98–101.

32 James Smith Allen points out that if as many as 85 percent of men and 60 percent of women could at least sign their names in the period, certainly many fewer had the intellectual ability to sustain the reading of a historical work (p. 155).

33 The threat was real: Louis-Napoleon Bonaparte, the nephew of Napoleon I, would declare himself emperor following a *coup-d'état* in 1851.

34 See Michael Marrinan, "Historical Vision and the Writing of History at Louis-Philippe's Versailles," *The Popularization of Images: Visual Culture under the July Monarchy,* Petra Ten-Doesschate Chu and Gabriel P. Weisberg (eds) (Princeton, N.J.: Princeton University Press, 1994), pp. 113–43.

35 Legitimists sought the restoration of the Bourbon monarchs to the throne.

36 *La Gazette de France,* January 3, 1837.

37 For a discussion of critical reactions to nineteenth-century history painting, see Wright, *Painting and History During the French Restoration.* She sums up the critique of the detailed, illusionistic paintings of the period: "they are embodiments of historical presence, rather than enactments of historical meaning" (p. 47).

Chapter 28

DARCY GRIMALDO GRIGSBY

REVOLUTIONARY SONS, WHITE FATHERS AND CREOLE DIFFERENCE
Guillaume Guillon-Lethière's *Oath of the Ancestors* (1822)

THE SCENE IS TEARFUL [Figure 28.1]. Revolutionary soldiers swear their loyalty to France with a clamor of upraised swords. Some take leave of their wives and children. Guillaume Guillon-Lethière's picture of 1799 undoubtedly refers to—and rewrites—David's *Oath of the Horatii* exhibited fourteen years earlier. In both pictures, the fatherland is menaced and the brothers rally with arms held high on its behalf. In Lethière's painting, we see the

Figure 28.1 Guillaume Guillon-Lethière, *The Fatherland in Danger*, 1789. Courtesy of Musée de la Révolution française, Vizelle (inv. No. MRF 1985–14).

pose of the Horatii reiterated (in reverse) in numerous vignettes: at center middleground, the fanning left hands of the soldiers who with their right hand lift spiking swords; at left foreground, the two men who extend a long sheathed sword and open hands towards the official on a step above them; at right, the rhyming, ornate soldiers (in uniforms designed by David), two of whom gesture to the ship while another momentarily advances from their lockstep in order to embrace his wife. As the latter detail suggests, Lethière's picture deviates from the *Horatii* in the prominence (and activity) accorded to France's female family members. It also deviates from David's picture in its absenting of the father. This, despite the fact that the painting is entitled *La Patrie en danger* (The Fatherland in Danger).[1] Even in the late days of the Republic, the land of the father is imagined as a land of citizens unified by a founding absence, the elimination of the King in 1792, as well as by a perpetual external threat: foreign enemies. Absent fathers and absent but imperiling enemies. Herein lay preconditions for revolutionary fraternity and self-sacrifice.

The liveliness and sheer competency of Lethière's picture distract us from the quandary of founding a nation upon absences, but the animation of the scene attests to the pictorial as well as political ramifications of parricide: the dispersal of loci of attention. Without the simple patriarchal structure of oath-taking in the *Horatii*, without a symbolic center, Lethière's sons swear allegiance to multiple substitutes; the magistrate on the step, for example, but most prominently, the immense, elevated female personification which presides—impassive and unmoved—over the scene of pathos. In Lethière's celebration of the French revolution, as in much revolutionary iconography, the "fatherland" to which men pledge loyalty is a woman rendered inanimate and monumental. But in order to take such an oath, the crowd of men at the picture's center must look over and beyond a thick wall of persons, representatives of the French polity of a different sort: the row of strangely diminutive, seated government officials, partly obscured in shadow; the brightly lit and oversized naked pink babies; and the

large women who hold them aloft. The oath of France's soldiers must leap over these persons. Loyalty to France is presumably sworn on their behalf but also requires an overlooking. Lethière's picture is therefore not so unlike David's *Oath of the Horatii*. It recapitulates that devotion to *la patrie* entails sacrifice, or a refusal to privilege—in some cases, even to recognize—the competing claims that individuals, including family members, may embody.

Among those overlooked is the black deputy who sits at the center of the row of government representatives. Such deputies of African descent had indeed sat in the revolutionary assemblies after Jean-Baptiste Belley, former military captain, had arrived as elected official from Saint-Domingue in 1794, and Lethière could very well have depicted Belley's replacement, the dashing young officer Etienne Mentor.[2] Lethière's registration of the presence of colonial deputies of African descent in the revolutionary body politic is at once accurate, unusual among French pictures of the 1790s—Girodet's 1797 portrait of Belley stands as the other, more well-known, exception to the rule—and explicable because of his origins. Guillaume Lethière was born in the French colony of Guadeloupe.[3] The painter of *The Fatherland in Danger* was the illegitimate son of a French royal official, Pierre Guillon, and a black slave named Marie-Françoise "*dite*" Pepayë. Although he had lived in France since the age of fourteen—that is, for some twenty-five years in 1799—Lethière would have been known in Paris as a "man of color" or a *sang-mêlé* (mixed-blood) and also as a colonial or creole: a man, in other words, marked by racial difference as well as by birth in the colonies. He was nicknamed "*l'Américain*" by fellow artists.

With everything to win and not much to lose, the politically disenfranchised "men of color" had enthusiastically embraced the revolution of 1789. Their bid for political rights was especially threatening to those in favor of sustaining the colonial slave economy because many were educated, affluent, tax-paying landowners; some possessed slaves. Given their wealth, the only basis for their continued disenfranchisement was racial difference. This issue was hotly debated in 1791 and led to a series of contradictory legislative decisions. It is worth stressing that free men of color, not black slaves, forced many (proslavery) Frenchmen to turn to race to legitimate the disenfranchisement of dark-skinned persons. The possibility that *sang-mêlés* could "pass" into the French polity of active citizens drew more rather than less attention to their differences.

Lethière responded to the revolution as did other "men of color." Twenty-nine years old in 1789, he became an ardent revolutionary patriot and would sustain his revolutionary politics until his death in 1832. His charisma, poise, and considerable talent must have contributed to successes achieved despite the reactionary politics of subsequent regimes (and despite his temper which at one point led to the temporary closure of his studio after he killed an officer in a duel). Ultimately, Lethière's color, foreign birth, and Republicanism did not stop him from receiving the highest honors on offer to painters during the Napoleonic Empire and Bourbon Restoration: Directorship of the Academy in Rome from 1807–1816, membership in the Legion of Honor in 1818, appointment to the Institute in 1818; Professorship in the Ecole des Beaux-Arts in 1819. These successes are all the more remarkable given evidence that Louis XVIII may have been disinclined to honor him. The King refused to approve his first election to the Institute in 1816; significantly the monarch had also declined the nomination of another *sang-mêlé*, the composer Saint Georges, as Opera director.

Traces of Lethière's difference are few in his pictures. Here clearly was an assimilated "man of color," integrated not only within France's official institutions but within its artistic community, actual and pictured. He is included, for example, in Louis-Léopold Boilly's clubbish portrait of elegant artists gathered in Isabey's studio in 1798. Tall and handsome, he

Figure 28.2 Guillaume Guillon-Lethière, *Philoctetes on the Island of Lemnos*, 1798.
© Photo RMN – Gérard Blot.

stands wrapped in a cape at the picture's center; charismatic but not the least bit disruptive. Lethière was presumed by Boilly to belong, a presumption Lethière seems to have shared. And Lethière's pictures declare that belonging as well. The man who had visited David in prison[4] and who was repeatedly portrayed, along with his entire family, by his good friend Ingres, produced a series of respectable if unexciting neoclassical pictures over his career, often several years after the subjects had been painted by David and his students. David painted *Brutus* in 1789; Lethière painted versions of *Brutus* in 1801 and 1811; Drouais painted *Philoctetes* in 1788; Lethière painted versions of *Philoctetes* in 1788, 1795 and 1798 [Figure 28.2]. France's classical canon of exemplarity with its cast of Greek and Roman heroes was his own. The black deputy in *The Fatherland in Danger* is as outnumbered by heroic white protagonists in his oeuvre as he is within that painting.

There is one remarkable exception among Lethière's pictures, however, and it is another scene of revolutionary oath-taking [Figure 28.3]. The solitary painting within which Lethière chose to inscribe his foreign birth—"*né à Guadeloupe*"—takes as its subject not the revolution

in France but the revolution in another French colony in the West Indies, Saint-Domingue (present-day Haiti); the revolution, that is, that transformed France's most lucrative slave colony into the first independent nation created by slaves turned revolutionaries. The Haitian revolution was the black revolution that haunted France's white one; the black revolution that erupted as a consequence of France's white revolution but quickly exceeded its control; the black revolution that defeated Napoleon's troops in 1802 and culminated in the declaration of the independence of Haiti in 1804. White/Black: the Haitian revolution was racially polarized in ways that required that persons of color—those persons who were, to cite Werner Sollors, "neither white nor black yet both"—be subsumed under one rubric or another.[5] *Sang-mêlés* had to choose. That choice of alliance—in which racial allegiances and self-definitions could exist in tension with personal and economic interests—made persons of color the most unpredictable, potentially decisive constituency during the Haitian revolution. Swinging

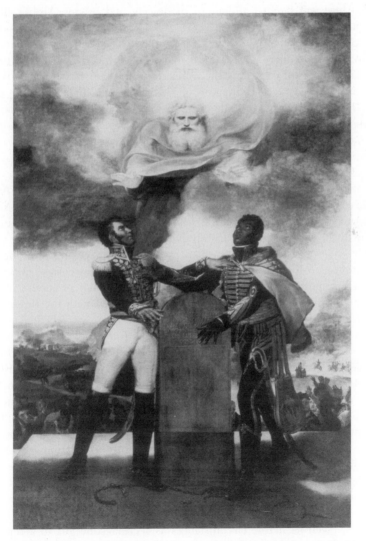

Figure 28.3 Guillaume Guillon-Lethière, *Oath of the Ancestors*, 1822. Courtesy of le Musée du Panthéon National Haitien.

between strategic alliances with white colonists and with black rebels, men of color ultimately joined forces with the latter: this is the moment celebrated in Lethière's remarkable picture of 1822. The painting depicts the alliance between the mulatto officer Alexandre Pétion—significantly, in half black and half white—and the black slave leader Jean-Jacques Dessalines—all in black. The mulatto Pétion had chosen, along with his troops, to defect from Bonaparte's army in 1802.[6] The fact that the alliance of mulatto and black leaders ultimately led to their victory and the founding of the Haitian nation is signalled within the picture by the stele over which the two men swear their oath. It is inscribed with the words of the Haitian constitution: "*L'union fait la force. Vivre libre ou mourir. Il n'y a de veritable liberté qu'avec la religion . . . les loix . . . La Constitution.*" ("Union makes strength. To live free or to die. There is no true liberty except with religion . . . laws . . . The Constitution.")

Significantly, Lethière, the Guadeloupan-born, Parisian painter "of color" made a picture called *Oath of the Ancestors*. The emphasis on ancestors suggests that the picture was a personal gesture of allegiance and familial affiliation, of descent and origins. Unlike his neoclassical pictures, and unlike *The Fatherland in Danger*, *Oath of the Ancestors* was intended not for a French audience—it was never shown in Paris—but for a Haitian one. The painting was personally delivered by Lethière's son Lucien to Port-au-Prince where it still hangs. The son delivered the father's gesture towards their ancestors in 1823, two years before Charles X finally and punitively recognized the nation of Haiti in return for a crippling debt intended to compensate France for its losses. Lethière's painting of 1822 was therefore an act of recognition, a tribute, made in advance of the French nation and against the Restoration government and offered as a gift rather than as an incurred debt. Lucien's transport of the picture was a covert act, noted by a French "secret agent" in Port-au-Prince when the ship, aptly named the "Alliance," first arrived from France.[7]

Lethière, the Institute member, Legionnaire of Honor, Ecole-des-Beaux-Arts professor, and former Director of the Roman Academy, was smuggling a representation of his ancestry out of France and into the nation that had successfully rebelled against it. The loss of Saint-Domingue was, even in 1822, a loss acutely felt by the French. The debates as to whether France should recognize Haiti fully betrayed a pervasive nostalgic and futile desire to return to a pre-revolutionary colonial age when gold from slave labor piled high. *Oath of the Ancestors* was therefore a surreptitious revolutionary picture made in honor of another revolution won at France's expense. In this painting, Lethière aligned himself with the foreign enemies not figured in *The Fatherland in Danger*—the black and mulatto men who rebelled as soldiers rather than sitting decorously as deputies. In 1799 when *The Fatherland in Danger* was painted, in those late days of the Directory immediately prior to Bonaparte's seizure of power in a coup-d'état, revolutionary France and revolutionary men of color were not necessarily at war, but they soon would be. *Oath of the Ancestors* depicts that later moment when French and Haitian interests were no longer reconcilable; when the brave young deputy Etienne Mentor was killed; when the patriot deputy Jean-Baptiste Belley was betrayed and died, like the black rebel leader Toussaint L'Ouverture, in a French prison. Lethière's painting bravely refuses to repress the war—the conflict—that brought Haiti into existence. Pétion and Dessalines stand on the chains of slavery in full military uniform and in the distance troops are visible and so too is the rising smoke. Slavery, the picture declares, was only abolished because of these Haitians' valor as military leaders, because of their alliance, and because of their determination "to live free or to die."

Nevertheless, given its heroic circumstances as a clandestine gift to a repressed revolutionary past, Lethière's painting is, I feel, strange and heart-breaking. The heartbreak stems, of course, from the figure of God. The French patriarch missing from *The Fatherland in Danger*

has not only returned but has returned more omnipotent than ever before: a billowing emana-
tion of light surmounting the pyramidal composition (the word Jehovah written in Hebrew
above his head). Blanched, symmetrical, white-haired, circled by an aureole of bright, icy
blue drapery, the figure belongs to another coloristic and pictorial universe and leaves the
persons and land below him dark and obscure, shadowy earth tones. Indeed the white Godhead
is depicted as the light source in the picture, illuminating the far edge of the platform on
which Pétion and Dessalines stand and casting the foreground and the stele itself in deep
shadow. Of course, this was the Restoration and, yes, the Haitian constitution referred to
God and, yes, the picture would come to hang in the Cathedral at Port-au-Prince. But the
intensely racialized politics of Haitian revolution made the choice to include a figure of God
impossibly compromising. What color could he be other than white? Was not Lethière a well-
trained French painter who rightly turned to sanctioned precedents, among them, altarpieces
like Guido Reni's in the Quirinal Chapel, pictures he would have known very well because
of his long residence in Rome?

Lethière offered a gift of recognition to the Haitian people, but within his picture, he
depicted that gift as the beneficent blessing of a white patriarchal Godhead. This clandestine,
indeed rebellious, act by a man of color sadly reinscribed the ultimate authority of the white
patriarch. Lethière's painting relied on the patronizing structure deployed in abolitionist
imagery and recycled three years later in prints commemorating France's official recognition
of Haiti: Charles X, hand raised, blessing a grateful personification of Haiti. At least Lethière
showed standing military men rather than kneeling naked slaves or, still worse, in the prints
of 1825, female personifications of the Americas. (Those latter commemorative images insid-
iously implied that France recognized an indigenous native people—America—rather than an
African population that it had displaced and enslaved). But the syntax of condescension in
Lethière's picture and the prints is the same. Recognition is a gift, not an accomplishment;
recognition represents benevolence towards a subordinate rather than surrender to a victor.
Moreover, the Haitian revolution, this picture implies, remains incomplete without the recog-
nition of the white French father. The alliance between Pétion and Dessalines, the symmetry
that makes their union as equals visible, requires their rhyming poses of attentive deferral to
the third term. As in David's *Oath of the Horatii*, the brothers unite by responding identically
to the patriarch who organizes them.

It is far too easy to account for and to dismiss the failures of Lethière's picture. The
templates offered by Franco-Italian pictorial traditions made the representation of radical
Haitian revolution difficult—necessarily cobbled together. The very success of Lethière's assim-
ilation as a French painter and citizen made his strange picture probable: half altarpiece, half
revolutionary manifesto; half white, half black—like Pétion's uniform, like Lethière's colonial
origins. But I would like to pause over the picture's weirdness, to delay its dismissal (or its
celebration) as all that may have been possible. The strangeness of the picture stems not only
from its hybrid iconography but from the double gesture it enacts: *Oath of the Ancestors* is a
picture pointing back to the revolutionary birth of a black nation two decades earlier (1802–4),
but also back to Lethière's colonial origins—to a pre-revolutionary past in the West Indies
which the sixty-two year old painter had left behind in 1774, almost half a century earlier.
Its retrospection is multiple: revolution and pre-revolution; its geographical displacements are
also: Haiti and Guadeloupe. But the picture is also a picture of 1822, of Bourbon Restoration,
and of Paris. Why after all did Lethière paint *Oath of the Ancesors* in 1822, eighteen years after
the founding of Haiti?

Partly because of recent events in Haiti. In 1811, the black leader Christophe had declared
himself King Henry I and ruled the north with the lavish accoutrements of monarchy, while

the "mixed-blood" President Pétion and his successor Boyer had sustained Republicanism in the South. Lethière sustains the contrast between the monarchical opulence of black rulers like Dessalines and Christophe and the Republican simplicity of mulatto leaders like Pétion and Boyer. Note the juxtaposition of the military uniforms of the black leader Dessalines at right and the mulatto Pétion at left; while both are highly ornamented, Pétions elaborate jacket is relieved by the empty expanse of his white pants; Dessalines' costume, by contrast, is everywhere elaborately decorated, the billowing jacket and hanging bag suggesting a cape. In 1820, two years before Lethière painted his picture, the black monarch Christophe had died and the mulatto president Boyer had immediately declared the unification of northern and southern Haiti. 1820 thus marked the reintegration of (black and mulatto, north and south) Haiti as a Republic. Lethière, the ardent *sang-mêlé* revolutionary and republican, would have been pleased. In 1822, moreover, Boyer had temporarily seized control of the Spanish half of the island, Santo-Domingo, uniting the entire island as the Republic of Haiti. 1822 was therefore an important date in Haiti's history as an autonomous Republican nation ruled by a mulatto president.

But Lethière's decision to paint *Oath of the Ancestors* in 1822 may also have stemmed from more personal events. Lethière had recently been forced, in Paris, to confront and to represent his Creole past as well as his racial identity. In fact, his difference and his origins had become a matter of public record. *Oath of the Ancestors* is signed "G. Guillon Le Thière, né à la Guadeloupe, An 1760, Paris, 1822, 7bre." Lethière thus inscribes the painting with both his origins and his picture's; his birth and, during the act of signing, his present. It is the name, "G. Guillon Lethière," that unifies and connects the dates, that makes the gap between 1760 and 1822 (and the space between Guadeloupe and Paris) continuous—a life. The name of this *sang-mêlé* painter was, however, as disjunctive a bricolage as his 1822 picture. At his birth, Lethière had been given a homonym of his father's withheld surname as his first name: not "Guillon" (fils) but, bastardized, "Guillaume." "Guillaume" was the extent to which the slave's son inherited a paternal name. Only fourteen years later, when his father brought him to France, was the future painter given a surname. France, not Guadeloupe, required a proper name, but it would not be his father's. In 1774, Pierre Guillon enrolled his illegitimate son Guillaume in art school and chose to call him "Le Tiers" because he was his third such "enfant naturel." Lethière's surname was therefore at once fabricated and a record of his position in his father's sequence of illegitimate children. The painter's name was produced by his illegitimacy and, at least for the son and the father, continued to signal it. The "Guillon" signed at the bottom of the *Oath of the Ancestors* marked, therefore, a later achievement: the legal recognition by Pierre Guillon of his illegitimate thirty-nine year old son in 1799, a recognition only made possible by recent revolutionary legislation of 12 Brumaire an II (1794) which attempted to extend equality before the law even to France's bastards. Pierre Guillon's recognition of Lethière also likely depended on the death of Guillon's two legitimate children—-his lack, that is, of an heir to bear his name.[8] In 1799 Guillaume Lethière added Guillon to the name by which he was already well-known.

Evidence suggests that the father and son were close despite the fact that they lived most of their lives apart from one another. Their letters indicate, for instance, that Guillon's legal recognition of Lethière was an act they had long discussed and carefully considered. A letter of 1797 written by Guillon from Washington D.C. indicates what he believed was at stake:

> This title announces to you my friend, the certainty of my paternity, the desire to transmit my name and my properties [*biens*] to he whom nature designates should possess them and who by his social virtues merits them as much as you do: for a

long time, I have wanted to render this justice if the exclusive laws of the Ancien Regime relative to your primitive condition had not taken the power away from me; and if those now repealing the former laws, and without a particular rule concerning this, had given me the power in a sensible fashion not susceptible to contradictions; which I did not believe to be the case with the Code of Civil Laws of the new legislation. The first question that must be resolved immediately because the nullity of this application would engender incidents more prejudicial than profitable to your happiness, your satisfaction and your fortune, the objects of my paternal solicitude— is whether it is necessary to provide besides the name of the mother, her status, her condition at the time of the birth of her son, and if, an omission would lead to difficulties capable of rendering null the effects of the adoption [. . . and also] if the laws apply to an individual over the age of 14 . . . Concerning [the condition of the mother], I fear as I said above that reticence on this subject will give birth to contestations, [whether] well or badly founded, and that these would imprint [on you] the humiliation of publicity. From all of this comes the desire to know if the Code on adoption is made and promulgated and, if valid, whether it is possible to keep the secret [*garder le tacet*] concerning the status of the condition of she who brought you into the light of day. Finally what would be the real advantages you would derive from this?[9]

Guillon claimed that he had always wanted legally to recognize his illegitimate son. Lethière deserved to be recognized because he was indeed his son—nature designated him to be so— and because he was worthy. But Guillon had not been able to do what he wished because of the law (which deemed Lethière's status to be "primitive"). Now revolutionary legislation might permit the legal transmission of his name and properties to his son, but the advantages of proceeding still might not outweigh the risks, "the humiliation of publicity." Could the white father recognize his illegitimate son without exposing what he called "the secret"? Lethière's mother may have "brought him into the light of day" but she herself needed to remain in darkness. The question was whether Lethière's paternal origins could now come into the light of law while leaving his humiliating maternal origins obscure. Pierre Guillon's anxieties were not his alone. The revolutionary legislation and the debates it engendered repeated again and again that the illegitimacy in question was only that resulting from the sexual union of parents who were both free at the time of their child's birth.

Despite Guillon's concerns, Lethière was legally recognized by his father in 1799. Nevertheless, twenty years later, Lethière's mother would become the subject of public inquiry. In 1819, when the painter was fifty-nine, his right to inherit Pierre Guillon's estate was contested in French court by a collateral relative. A man named Delpeyron claimed that he was Pierre Guillon's lawful heir, not because Guillaume Lethière's mother had been a slave, not because Guillaume Lethière was "mixed-blood," not because Guillaume Lethière was illegitimate—a bastard—but because he was an "adulterin," the child of an adulterous liaison who was indeed excluded from the legislation concerning illegitimacy. Delpeyron's case pivoted on the contestation of Guillaume Lethière's date of birth and the fact that neither son nor father had produced a birth certificate in 1799. Because Pierre Guillon had been married in 1762, Delpeyron insisted Guillaume had not been born in 1760. He even produced a birth certificate for a boy named Guillaume born in 1765 to a "mulatta" named Marie-Jeanne (instead of Marie-Françoise). The fact that both mothers, in all likelihood both slaves, lacked surnames as did their sons—named only Guillaume—made Delpeyron's charges more difficult for Lethière and his lawyer to dismiss. To have only first names was to have less certain

legal identities. Lethière was in a bind. He needed the recognition by Pierre Guillon that Delpeyron contested as illegal. He required, it seems, perpetual confirmation by his father, in this case, confirmation of his date of birth, in order to protect himself from the confiscation of his inheritance and the "humiliation of publicity." Short of that, he needed the sanction of France's courts.

He ultimately won the latter, but not without the publication in the *Gazette de France* and the *Moniteur Universel* of his lawyer's statement. His story became public. Lethière's lawyer referred to the painter's origins and name as a "modest and naïve geneaology." Since Marie-Jeanne was a mulatta, the lawyer needed to admit that Lethière's mother was black, not mulatta, but he would not say so explicitly. Instead he referred to her only as "a woman of color." The lawyer pointed out that while this fact might have clinched Delpeyron's case if Lethière had been born in Paris, such circumstances were "far from sufficient to establish a perfect identity" in Guadeloupe. There, women of color were as numerous as white women. The lawyer also admitted that if Pierre Guillon had given Lethière life alone, he may not have chosen to honor him with legitimacy. However,

> a lively and tender friendship united [father and son]; even absence itself could not alter their sympathy, an uninterrupted correspondance brought them proofs, across the oceans, of their mutual attachment. Pierre Guillon came to France; his son received him in his domicile at the Louvre; it was in this noble asylum, given by our Kings to the beaux-arts, that Letiers closed his father's eyes. Thus, Sirs, was purified the relationship whose origin was vicious.[10]

The lawyer's statement is deft and it is revealing. Neither Lethière's mother's blackness nor her status as slave are stated. The term "woman of color" leaves vague and unspecified her social and racial identity, although it makes clear that she was not white. Her identity, he underscores, was far from certain; in a fundamental way, it was insufficient. Instead, paternal affection plays an important role in the lawyer's defense and so too does Lethière's profession. The deathbed scene of filial piety occurs in the Louvre, the "noble asylum" of the arts given by the King to France's artists. Just as Pierre Guillon had recognized Lethière so too had Louis XVIII: the artist was a worthy son whose "vicious origins" were purified by his noble feeling and by the fact that his merit and his loyalty had been recognized, recognized by France's fathers.

"G. Guillon Le Thière, né à la Guadeloupe, An 1760, Paris, 1822, 7bre.": the signature on *Oath of the Ancestors* can be understood to serve as a legal document. The first name Guillaume, which had failed to distinguish Lethière from Marie-Jeanne's son of the same name, is truncated to "G." It was, one might argue, redundant with Guillon in any case and it is his father's surname that Lethière chooses to claim, along with his colonial birthplace, Guadeloupe and just as significantly, his birthdate. G. Guillon Lethière, the third illegitimate son of Guillon, was born in 1760 in Guadeloupe not in 1765. He was illegitimate but not "adulterin." His father's benificent act of recognition was legal and the painting implies, binding—the truth before God, the truth as if his Father was God. No wonder that the figure of Pétion is so much more animated and well-illuminated than Dessalines; the light of the Father brings him into light, the light of recognition in law as in history and as in pictures. This painting initiated by the unification of Haiti under a Republican mulatto president privileges the *sang-mêlé* over the opulently ornamented (read monarchical) black. This is not to minimize the alliance the picture expresses with Dessalines, the former black slave become rebel leader and founder of Haiti. This is a picture not just of a father and a son but also of

revolutionary brothers. The problem is the difficulty in imagining from where and from whom Dessalines could come. God does not appear to be his father. The diagonal edge where black and white clouds meet at the picture's very center, descends from God the Father towards Pétion, not towards Dessalines. The black military officer is cast in a more ambiguous, hushed shadow. His only possible parent is even less visible. She stands at the far right of the picture, behind the platform, arms upraised, holding directly before her a naked baby, like the women in *The Fatherland in Danger*, but she and her child are dark-skinned. The black slave mother makes her appearance in Lethière's homage to his colonial past and to black revolution, but she is noticed only tangentially, late and circuitously, when the viewer succeeds in turning away from the blinding light of the white patriarch and accustoms his/her eyes to the darkness.

Illegitimate sons and illegitimate revolutions required their father's recognition. The paradox is that they required it in order to sustain their autonomy in the world, as painters and as nations. And even under revolutionary law, illegitimate sons, like illegitimate nations, could not sue the patriarch for recognition. Instead, legitimacy and paternal lineage were gifts that needed—by law—to be freely given. French revolutionaries wanted to incorporate bastards into the body politic, but not to unleash paternity suits. Paternal recognition was a legal act that had to be initiated by the father, not the son, not the mother. Herein lay the structure reproduced in Lethière's picture of the founding of the Haitian nation. We witness the gift. To the deserving but not the demanding. We witness their legitimation. So far from revolution and yet legislated by it.

Paternity is, of course, a tenuous, uncertain relation. Perhaps this is why revolutionaries defined it as a gift, fundamentally an adoption. Biological paternity could be as easily disclaimed as claimed. By fathers, by mothers or by sons. Paternity might be where one least expected it and not where one did. Men of color may have been particularly alert to such questions as well as their stakes. And they may have seen them in pictures where we see none. General Alexandre Dumas was Lethière's close friend and shared his circumstances. Two years Lethière's junior, Dumas was also born in the West Indies, in his case, Haiti, and he too was brought to France at the age of fourteen by a white French father who bore another name. General Dumas would die young, poor, injured by war, and betrayed by Bonaparte (who could not forgive him for abandoning Egypt), but his novelist son would frequent Lethière's fashionable salon throughout the Restoration, delighting in the painter's tafia from Guadeloupe as well as his attractive republican French mistress. In his *Mémoires*, the writer Alexandre Dumas would pay homage to the painter's generosity as well as his talent. And he would also rewrite, from the perspective of a man of color, Lethière's far-from-original neoclassical pictures. According to the novelist Dumas, Lethière's Philoctetes was none other than Dumas's beautiful, mortally wounded, Herculean father—a *sang-mêlé* who posed as an antique hero and "passed" so well only son and painter could see him still. Brutus, the Republican father who sacrificed his sons because they conspired against the Republic, was also not what he seemed. Dumas recounts:

> The famous painter Lethière [was] author of *Brutus condemning his sons*, a heroism which always seemed to me a bit Spartan, until it was explained to me later by Ponsard's *Lucretia*. Monsieur Ponsard first revealed this great conjugal mystery, that the sons of Brutus were, not the sons of Brutus, but only the children of adultery: in having their heads cut off, Brutus did not sacrifice himself, he avenged himself![11]

Dumas shockingly rewrites the tale of the virtuous self-sacrifice of a Republican patriarch. The very sacrifice of sons that made Brutus the most severe and patriotic Republican is

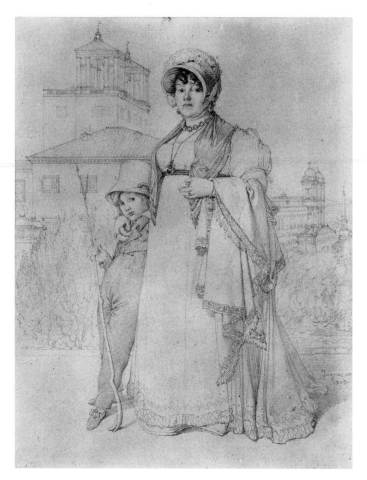

Figure 28.4 Jean-Auguste-Dominique Ingres, *Madame Guillaume Guillon Lethière and her Son*, 1808. Courtesy of The Metropolitan Museum of Art, H.O. Havemeyer Collection. Bequest of Mrs H.O. Havemeyer, 1929 (29.100.191). All rights reserved, The Metropolitan Museum of Art.

rescripted by the "mixed-blood" author as a form of self-interest and vengeance against his wife's adultery: "The sons of Brutus were, not the sons of Brutus." Nevertheless, in Dumas' lurid scenario, the sons could be recognized by Brutus—as sons. And as sons they could also be killed by him. Ultimately, the father did not control paternity (Dumas's comma is devastating), but he enjoyed the prerogative of choosing to recognize or not to recognize, to let live or to let die those he chose to claim as sons. Brutus was the patriarch who wielded this control. Whether he was biological father or not.

Sons, in turn, could choose revolution and also murder. Parricide was enacted again and again in Haiti as well as in France. Or sons could direct their longing for revolution and also for their fathers into their art. They could imagine their fathers as Philoctetes and as God the Father, martyr fathers, and deity fathers. Absences both. In the arts of men of color, familial lineage was at stake but so too were absences and compensatory recognitions. Looking back at the *Fatherland in Danger*, it is worth noting that it is a picture not only of revolutionary oath-taking but also of departures, of voyages and of families separated by ships which take men elsewhere, away from wives, away from mothers, away from children. In Lethière's life,

he had been the revolutionary son who had entered France rather than left it, but his arrival entailed leaving behind not only his slave mother but his French father. Lethière's departures and displacements were not easy ones nor were they entirely predictable. The white Father was in the colonies, but the white Fatherland was France where Lethière would reside for 58 of his 72 years.

In 1822, Lethière sent a gift back to his colonial past and to his father's, and he sent it with his twenty-one year old son who departed from his father and his birth country to travel to Haiti. The small, shy, fair boy pictured behind his French mother's skirt in Ingres' line drawing [Figure 28.4] bravely defined himself as "a man of color"—the secret agent in Port-au-Prince tells us so—and as his father's son, and returned to the colonies of his father's birth. Lucien stayed in Haiti and married a Haitian woman. He died only a few years later, leaving behind a young daughter for whom Lethière would provide (as he provided for his eldest son Alexandre's children after his early death). Familial recognition and adoption were important acts in Lethière's history. While Alexandre (possibly named after his friend General Dumas) would remain illegitimate, Lethière had married his younger son's mother only months after his own father, Pierre Guillon, had finally legally adopted him. For this creole man of color, the chain of lineage, of paternal succession, could not be taken for granted but needed to be made, by French law—the law of the father, and of the fatherland, but also of the revolution. Revolution, in Haiti as in France, could entail parricide, yet it also promised recognition, incorporation, and adoption into the lawful body politic. Those contradictory desires—for revolution, for parricide, and for paternal succession—could be inscribed, strangely and uncomfortably, in paintings like Lethière's where the expelled white father returns, but not as a man on the earth, and bestows his recognition upon his deserving dark-skinned sons.

Acknowledgments

For our son Wilgens Pierre.

I would like to thank Geneviève Marcel Capy, France's expert on Lethière and founder along with G.-Florent Laballe of the *Association des Amis de Lethière*, for her extraordinary generosity in sharing her knowledge and work with me. This article could not have been written without her scholarship. *Oath of the Ancestors* is only available as an object of study for scholars outside Haiti because she and Laballe rediscovered it in the cathedral at Port-au-Prince in 1991 and succeeded in getting it restored by Musées de France conservators between 1995 and 1997. I also thank Jessica Dandona for her invaluable work as my research assistant in Paris and Matthew Gerber, who is writing a dissertation on Revolutionary legislation on illegitimacy at U.C. Berkeley, for directing me to appropriate sources including his own scholarship.

Notes

1 Philippe Bordes, "*La Patrie en danger* par Lethière et l'esprit militaire," *La Revue du Louvre et des Musées de France*: 4–5 (1986), 301–6. Of course, in its foregrounding of female protagonists, Lethière's painting of 1799 resembles David's *Intervention of the Sabines* of the same year. The latter painting, however, valorizes the ending rather than the perpetuation of war. Concerning David's *Sabines*, see my "Nudity à la grecque in 1799," *Art Bulletin*, LXXX: 2 (June 1998), 311–335.

2 On the politics of race during the Revolutionary period and on Belley as well as Girodet's portrait, see my *Extremities in Paint. Embodying Empire in Post-Revolutionary France* (London: Yale University Press, 2002), Chapter 1.

3 On Lethière, see G. Florent-Laballe and Geneviève Capy, *Guillaume Guillon Lethière. Peintre d'histoire 1760–1832* (Point-à-Pitre: Centre des Arts et de la Culture, 1991); Geneviève Madec-Capy, "Guillaume Guillon-Lethière, peintre d'histoire (1760–1832)," Thèse de Doctorat d'histoire de l'art, Université de Paris IV, 1997; and G. Florent-Laballe and Geneviève Capy, *1848–1998. Cent Cinquantenaire de l'Abolition de l'esclavage. Le Serment des Ancêtres de Guillaume Guillon-Lethière* (Fort-Delgrès, Basse-Terre, 1998); Hans Naef, *Die Bildniszeichnungen von J.-A.-D.-Ingres* (Bern: Benteli Verlag, 1977) I, 403–420.

4 Lethière also testified against David when he was imprisoned after the fall of Robespierre; see J. L. Jules David, *Le Peintre Louis David 1748–1825. Souvenirs et Documents inédits* (Paris: Victor Havard, 1880), pp. 221, 257–8, 285–7.

5 *Neither Black nor White Yet Both. Thematic Explorations of Interracial Literature* (Oxford: Oxford University Press, 1997).

6 On the history of the Haitian revolution, see Thomas Madiou, *Histoire d'Haiti* (Port-au-Prince, Editions Henri Deschamps, 1988).

7 Archives Nationales OM/CC/9a/52.

8 See Laurence Boudouard and Florence Bellivier, "Des droits pour les bâtards, l'enfant naturel dans les débats révolutionnaires," in Irène Thiry and Christian Biet (eds), *La famille, la loi, l'état de la Revolution au Code Civil* (Paris: Centre Georges Pompidou, 1989), 122–44.

9 Archives Nationales/476/AP/12; cited in Capy, 1997, pp. 181–6.

10 *Gazette de France*, February 28, 1819; cited in Naef, pp. 405–6.

11 *Mes Mémoires* (Paris, Gallimard, 1967), III, pp. 14–15. The son of the General, the novelist Alexandre Dumas is known as Alexandre Dumas *père* to distinguish him from his son (the General's grandson) who also became a writer.

Chapter 29

KIRK SAVAGE

MOLDING EMANCIPATION
John Quincy Adams Ward's *The Freedman* and the Meaning of the Civil War

By the spring of 1863, the bloodiest war in the history of the U.S. had been dragging on for two full years. But the moral stakes of the conflict had changed profoundly, thanks to a wartime measure advanced by Abraham Lincoln. On January 1, 1863, the Emancipation Proclamation had taken effect, officially transforming the Union war effort into a crusade against slavery. That same year at the annual spring exhibition of the National Academy of Design in New York City, a smattering of patriotic art work dealt with this momentous event. New York painter Henry Peters Gray showed his *America in 1862*, an allegorical image featuring a personification of America breaking the chains of a kneeling slave with one hand and giving the slave a sword with the other hand. While the painting is now lost, accounts in the contemporary press make it clear that the picture was little more than a piece of Union propaganda, cloaked in the elevated language of nineteenth-century academic art.[1]

Gray's allegorical image of the Emancipation Proclamation, like many others of the period, created an oversimplified and indeed misleading picture of the government's policy. Not "all slaves were made freedmen by Abraham Lincoln," as military recruiting posters aimed at African Americans claimed. In fact, Lincoln's proclamation did not free any slaves in Union territory, but rather promised freedom to those slaves in Confederate hands who could reach Union-controlled territory, or who could wait for the Union to reach them. Lincoln reasoned that the male slaves that could be drained from the Confederacy would become an important source of new manpower for the Union army, which is why Gray's figure of America hands the freed slave a sword. But unlike Gray's mythical figure, who accomplished all this simultaneously with two bold strokes of the hand, Lincoln's proclamation merely accelerated a process that had already been set in motion by the slaves themselves. Months before Lincoln signed the proclamation, slaves began taking their destiny in their own hands, escaping in increasing numbers to the Union lines and offering their services to the Union army in the cause of liberation.[2]

Gray's painting was not the only work in the exhibition inspired by the Emancipation Proclamation. In a dimly lit corner of the exhibition rooms, there was a striking plaster statuette, not quite two feet high, by a little known sculptor named John Quincy Adams Ward. This was the *Freedman*, known to us today by several bronze casts probably produced from the original plaster model [Figure 29.1].[3] Word of the piece soon got around, and critics hailed it in local and national press. Unlike Gray's painting which was couched in the more abstract language of allegory and myth, Ward's *Freedman* seemed to the critics astonishingly realistic and direct, even more so because it was in the three-dimensional medium of sculpture—a medium in which African Americans had been nearly invisible.[4] The *Freedman* was probably the first image of an African American ever cast in bronze, and it may have been the first African American figure in any sculptural medium to be shown in a U.S. art exhibition. It isn't surprising that the organizers of the exhibition put it in an inconspicuous corner; they must have been rather nervous about what reaction there would be to such an unprecedented work.[5]

The *Freedman* belonged to a well-established sculptural genre, that of the small-scale statuette purchased for display on a desk or a parlor mantel. Usually these works represented the great white men whose lives embodied the dominant culture's idea of its own moral purpose. In their cheaper plaster form, such statuettes were often called "images" and were sold door to door by Italian artisans throughout the Northeast. One such image, John Rogers's 1859 plaster *Slave Auction*, is the only real precursor of Ward's *Freedman*. But Rogers's piece, literally sold on the streets of New York, stayed in the humble universe of the image-peddlers and did not find its way into the high-art realm of the gallery and the bronze foundry, as Ward's piece succeeded in doing.[6]

For several years after the National Academy exhibition, critics remembered the *Freedman* and singled it out. James Jackson Jarves, in his enormously popular book of 1864 called the *Art-Idea*, suggested that the piece might be enlarged and placed inside the Capitol building alongside Horatio Greenough's statue of Washington, where it would "commemorate the crowning virtue of democratic institutions in the final liberty of the slave."[7] And in 1866, in an essay in *Atlantic* magazine pondering the question of what Civil War monuments should look like, the literary critic William Dean Howells could find only one acceptable prototype for the new kind of monument he wanted to see: the *Freedman*. Later, the popular critic Henry Tuckerman suggested that it be reproduced small-scale in a cheap material so that it could be "seen and possessed by the great mass of the people."[8] And yet despite all this attention and lavish praise, Ward's piece eventually lapsed into obscurity. It never did become

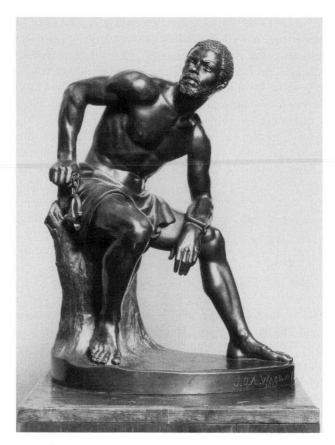

Figure 29.1 John Quincy Adams Ward, *The Freedman*, 1863. Acc.no. 45.5. Sculpture, height 49.5 cm, 1863. Gift of Mr Ernest Kanzler, courtesy of The Detroit Institute of Arts. Photograph © 2001 The Detroit Institute of Arts.

enlarged to monumental size, nor was it reproduced in mass quantities. Ward managed to sell a few high-quality bronze casts, the exact number of which is unknown, and some pirated casts also circulated. But it never became the kind of cultural icon that critics such as Howells and Tuckerman envisioned.

This essay will focus on two key questions raised by this intriguing and important piece. The first is what made the *Freedman* so special, so meaningful in its own time—the period of the Civil War and its immediate aftermath. The second, perhaps more urgent to us in the early twenty-first century, is why Ward's work ultimately failed to become the great emblem of American liberty that so many critics hoped it would be. As we shall see, the answers to these two questions are linked. For what made the *Freedman* unconventional and innovative also made it problematic, at a time when the underlying issue of freedom was itself an unresolved dilemma.

To account for its power in the 1860s, we must first recognize that the *Freedman* departed dramatically from the standard visual formula for representing emancipation. In the conventional depictions, a standing figure representing white power symbolically frees a kneeling or crouching black slave below. Gray's *America in 1862* was an allegorical version of this formula, but by the time of the Emancipation Proclamation a more common solution was to personalize the act

by putting Abraham Lincoln in the standing position of power [Figure 29.2], as if Lincoln himself were a master personally freeing his own slave. The formula actually has its roots in Roman antiquity and the ceremony of manumission, the act by which a master voluntarily freed a slave. In the ceremony, a magistrate would touch a kneeling slave with a rod while the master stood above. The act of the slave crouching in obeisance, and indeed the point of the ceremony itself, was to reaffirm that the power relations between slave and master had not changed. Although nominally free, the ex-slave was still indebted to and subordinate to his master; in fact, most freed slaves in antiquity continued to remain dependent on their masters for work and for protection.

While it is highly unlikely that those who designed the images of Lincoln emancipating slaves were aware of what the ancient Roman rite of manumission looked like, they came up with a visual conceit that was remarkably similar and conveyed much of the same sentiment. This formula made the slave appear a passive recipient of Lincoln's generosity, and in so doing encouraged viewers to see the slave as forever indebted to and dependent on Lincoln. Historically speaking, this imagery is nonsense: we know that slaves played a decisive role in

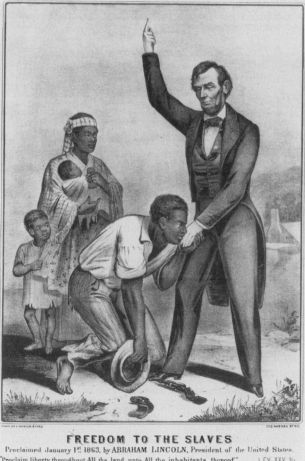

Figure 29.2 Currier and Ives, *Freedom to the Slaves*, 1863. Reproduced from the collections of the Library of Congress.

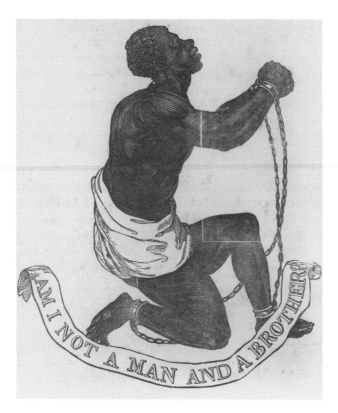

Figure 29.3 John Greenleaf Whitter, *Our Countryman in Chains! Am I Not a Man and a Brother?*, *c.* 1837. Reproduced from the collections of the Library of Congress.

their own liberation during the Civil War, and that Lincoln was probably more dependent on them for helping to erode the Confederacy's strength than they were on him. The many thousands of slaves who fled their Confederate masters during the war aided the Union cause in two crucial ways: first, by diminishing the labor force needed to run the South's civilian economy; and second, by joining the Union army and fighting against their former masters.[9]

The conventional image of emancipation came most directly from the imagery of abolitionism. The basic abolitionist emblem was the figure of a kneeling black man in chains, his upraised arms imploring "Am I not a man and a brother?" [Figure 29.3]. This was certainly the most common image of African Americans before the Civil War, and one of the most common images of any kind—printed all over the country, embroidered on pincushions, stitched into quilts, stamped on medals, and so on. The black slave in the image appears lowly and powerless, his pose and his physical contact with the ground emphasizing his abject state. Unable to help himself, he implores us, the audience, to notice and free him. The image, in effect, cried out for a savior, and artists were eager to oblige, readily combining the kneeling slave with a variety of standing saviors, such as Christ, America, or Lincoln.[10]

Even more than other Americans of his era, Ward would have been deeply familiar with this pervasive abolitionist imagery. His teacher and mentor was Henry Kirke Brown, a sculptor with strong abolitionist leanings. In 1855, when Ward was still working in Brown's studio, Brown had created his own melancholy image of a slave, seated on a cotton bale, looking downcast. The slave figure was part of a large model for a pediment that Brown had had the

audacity to propose for the U.S. Capitol, at a time when the slaveholder Jefferson Davis was the cabinet secretary in charge of the building's construction.[11] Ward must have known Brown's slave figure quite well, for the *Freedman* seems to be a response to it. Both seated men lean forward, with torso twisted to the right and left leg thrust out. But in Ward's figure the limbs are untangled and released to act: the right arm, bent behind the back in Brown's design, pressed down firmly in Ward's piece; the right leg, crossed behind the other leg in the earlier work, now pushes against the stump too; and the left arm, poised on the elbow in Brown's model, slides down to allow the *Freedman* to tilt his head upward. It is as if Brown's downcast figure suddenly comes to life in Ward's hands, taking on energy and purpose. Ward's figure breaks decisively from the abolitionist tradition, followed by Brown, of representing slaves as abject, dependent beings. The *Freedman* does not beg or despair. He has gotten off the ground and broken his own chains, which he still clenches in one fist. He turns his head alertly, his brows knit, his gaze intent on something in the distance. No longer passively awaiting salvation from above, this figure exudes an active force shaping his own destiny. He does this without an implied savior; this is his story alone, not the story of white charity.

It was not only its departure from the standard imagery of emancipation that made the *Freedman* so remarkable in 1863: the sculpture was also striking in its realism. Abandoning the trappings of allegory, the *Freedman* told a more straightforward and familiar narrative, one based on the repeated experiences of real slaves. This was the common wartime story of fugitive slaves fleeing the Confederacy and seeking freedom behind Union lines—the very act that Lincoln's Emancipation Proclamation was trying to capitalize on. The few cues that Ward's sculpture gives—the tree stump, the broken chain, his searching look into the distance—suggest that this man is pausing in his flight from slavery.

Even as he enacts this familiar wartime narrative, however, it is less than clear what Wards's figure is actually doing. At first glance he appears to be resting easily on the tree stump; his pose, however, is by no means so simple. Bent forward, his body balances edgily between repose and movement. His taut right forearm, veins bulging from the skin, pushes down on the stump in a strong vertical, transferring the brunt of his weight through the other arm to the leg planted in front. At the same time his abdomen is pulled in and tensed, keeping the weight of his body from sinking down into the seat. It is impossible to tell whether the figure is sitting down or getting up: his body is not resting or moving forward, but suspended in an in-between state, coiled in anticipation—just as the broken chains still attached to his body suggest that he occupies a liminal state, neither completely beyond the realm of slavery nor entirely within the world of freedom. Ward's subject remains in the fugitive's state of limbo, where his fate is not yet clear.

Another question raised by Ward's realism is why the figure is nude. Obviously, real fugitive slaves did not embark on their arduous journeys unclothed. Popular representations of fugitive slaves in the news magazines tended to emphasize the tattered clothing of the fugitive as he arrived in Union territory [Figure 29.4], rags that were then replaced by the crisp uniform of a Union soldier. If the former slave was shown undressed, it was to display the scars that gave witness to slavery's cruelty—scars that Ward's flawless figure certainly does not bear.[12]

The *Freedman*, of course, was not a throwaway magazine illustration but a work of sculpture, and the nude body was thought to be the most venerable subject a sculptor could undertake. For Ward, making the figure nude allowed him to model the minutiae of joint, muscle, and vein, just the sort of realistic detail that was usually absent in the more smooth and doughy surfaces of the typical "ideal" marble sculpture of the day. (When Ward copied the figure from plaster to bronze, the superior surface detail of cast metal made this "naturalism"

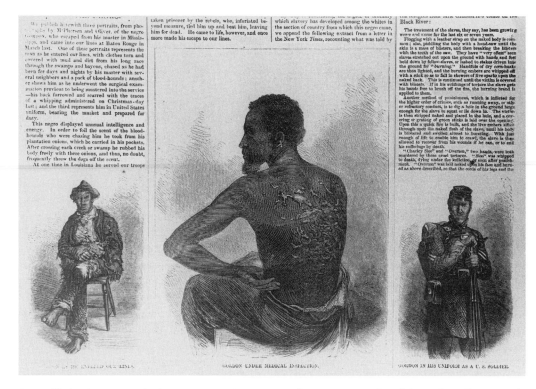

Figure 29.4 American, *Gordon as He Entered Our Lines*, July 1863. Reproduced from the collections of the Library of Congress.

of the body even more apparent.) The scrupulous rendering of vein and flexed muscle is precisely what allows the viewer to grasp the exact tension of the pose, to see it as a specific moment in a specific man's life.

Indeed, the nude body did have a peculiar logic in Ward's narrative. As a subject, the fugitive slave did not have a fixed social identity that demanded a certain sort of clothing. No longer on the plantation, he did not need or want the slave laborer's garb; but not yet a free man, he could not assume the uniform of a citizen or a soldier. In the before-and-after images of escaped slaves that were common at the time [Figure 29.4], the replacement of the slave's tattered clothes with the starched military uniform registered most clearly the black man's new social identity. By removing his freedman's clothes, Ward situated the figure in between these two states—after the before, and before the after. Thus the *Freedman's* nudity functions as a kind of double sign, pointing in one direction to the man's vulnerability (as a slave on the run) and in another direction to his heroic potential (as a free man). In one respect, the lack of clothing does not compromise the subject's realism, for the revealed body does indeed look real in every way. But in his glorious nudity, the figure is lifted from the real world of tired, sweating, bruised, and scarred bodies into an idealized, heroic register.

This is why most contemporary critics responded so strongly to Ward's sculpture: for them the *Freedman* seamlessly combined the real and the ideal. The figure appeared to be a study from life of an actual man, yet it resembled the best of Greek sculpture; in fact Ward did probably model the torso on a well-known fragment of ancient sculpture, the *Torso Belvedere*. That this classicized figure was a black man—a subject that had barely even been

attempted in sculpture in the U.S.—made it all the more remarkable. African Americans had already been subject to decades of caricature in popular prints, so the fact that Ward could pull off this combination of intense realism and idealizing classicism in the figure of a black man was astonishing to the white critics of the day. "It is a negro, and nothing more," wrote the abolitionist newspaper the *Independent*, yet "it makes the nearest approach . . . to the statuary of the Greeks of any modern piece of sculpture we have seen."[13]

At least one critic, the editor of the art journal *The New Path*, argued in January 1864 that the perfection of Ward's figure was its moral undoing. Far from upsetting the pro-slavery men, this critic asserted, the *Freedmen's* splendid physique would have pleased them. "With such a model on his mantel-piece how [the slave owner's] imagination would have glowed over the fancy price to be obtained for such a display of bone and muscle."[14] Great black bodies did have obvious value as human property in the world of slavery, but this critic failed to mention that there is not a single example of a black slave in sculpture in any art collection in the ante-bellum South. Why were slaves absent in sculpture when they had such high value as human property? For the same that the *Freedman* would never sit comfortably on a slave owner's mantel-piece: its idealized sculptural nudity had a moral dimension, a heroic cast.[15]

What viewers encounter in the *Freedman*, therefore, is not so much a portrait of a "real" slave or freedman, as the magazines showed, but an idealized representative of black manhood poised on the threshold of freedom. His prospects remain undetermined. While he lacks almost everything—clothes, material goods, and, by extension, political rights and social standing—his powerful frame and his look of determination reveal a heroic potential, the potential for transformation into a fully formed, fully acting social being. As Ward himself wrote when he entered the sculpture into the 1863 National Academy exhibition in New York, his subject has not yet won the struggle for freedom, he has not yet lost it either:

> I shall send tomorrow or next day a plaster model of a figure which we call the "Freedman" for want of a better name, but I intended it to express not one set free by any proclamation so much as by his own love of freedom and a conscious *power* to brake things—the struggle is not over with him (as it never is in this life) yet I have tried to express a degree of hope in his undertaking.[16]

Ward's remarks reveal how consciously he set about to craft a sculptural narrative that resists any clear ending, and refuses to offer an easy answer to the problem of freedom. "The struggle is not over with him," Ward wrote, "yet I have tried to express a degree of hope in his under-taking." This deliberate ambiguity is perhaps the most striking difference between the *Freedman* and more typical celebratory representations of emancipation. The standard images framed emancipation as a closed episode, an achievement already accomplished and finalized: Lincoln frees the slaves—end of story. This is not surprising given that these images were made by white artists and represented a white point of view on history: their whole point was to make the white nation look good, to applaud white leaders for bringing freedom to abject black slaves. Artists had every reason to make emancipation look decisive and conclusive; the more there was to celebrate, the less there was to fret about.

With the *Freedman* Ward turned this whole approach on its head: he did not celebrate the moral achievement of white leadership, but instead concentrated on the experience of emancipation from the perspective of the slave. And from that perspective, emancipation was only just beginning. Lincoln's proclamation was merely one step in a long historical struggle that African Americans knew was far from over. The plight of Ward's fugitive can be read as a metaphor for the plight of all African Americans, at least all African American men: even

if nominally freed, they had still not achieved liberty in the full sense. They had not yet secured their position in American society as citizens with the same rights and responsibilities as their white counterparts enjoyed. This is why Ward was not satisfied with his title, *Freedman*, because it suggested misleadingly that freedom had already been secured, when, in fact, the outcome was still in doubt, for both this individual fugitive and for the race and gender he represented.[17]

If it was in fact such a revolutionary portrayal of emancipation, why did the *Freedman* fail to become the great cultural icon, the great emblem of American liberty, that some of its critics hoped it would? Our discussion already contains the seeds of an answer. For, as we have just seen, the *Freedman* did not in fact declare the black man's liberty. Instead, the sculpture was a declaration of the *possibility* of liberty, and of the black man's determination to make that possibility a reality. Ward conceived the piece in a moment of great historical transition, and he didn't flinch from it. The *Freedman* was located in that paradoxical space between slavery and freedom in which many African Americans found themselves in during the Civil War. But as the war came to an end, that space seemed to disappear as events overtook the *Freedman*'s story and made it seem it obsolete. Shortly after Ward first exhibited the piece in the spring of 1863, the Confederate army lost at Gettysburg and the South's military fortunes began to sour. A few weeks later black soldiers began to fight for the Union in their first major battles and displayed their heroism to a skeptical white public. The black man, it seemed, was no longer suspended between worlds; he was standing tall, in uniform, and fighting for his freedom [Figure 29.5]. And as more and more African Americans joined the Union army, slavery crumbled ever more rapidly, until it was finally abolished by the Thirteenth Amendment in 1865.

Perhaps this is why the *Freedman* underwent a curious title change when it was exhibited in Chicago in June 1865, shortly after the war had ended. There, at a benefit for the U.S. Sanitary Commission, the figure appeared as *The Slave*, the exact opposite of its original title.[18] This odd slippage points to a structural ambiguity within Ward's sculpture. Since his figure of the black fugitive occupies an uncertain space between slavery and freedom, the specific historical context in which the figure was displayed and viewed might easily shift its meaning in one direction or the other. In the context of its original 1863 exhibition, with the institution of slavery just beginning to disintegrate, viewers naturally focused on the figure's act of liberation: having broken his own chains, he became a metaphor for the larger drama of emancipation. But in 1865—with slavery now destroyed by the war, and with nearly 200,000 African Americans having served in uniform—it was easier to focus on what the figure lacked. At that moment, the *Freedman* looked more slave than free.

This ambiguity within the *Freedman* suggests an even deeper ambivalence that characterizes the concept of freedom itself. Freedom is not a static or a unitary concept. To a person who is bound and gagged in a chair, for instance, the simple act of breaking those restraints will seem like complete freedom. But to a person who is used to sitting comfortably in her own chair, the freedom to get up at will may well seem insignificant; for her, freedom will probably be defined quite differently, perhaps as the right to speak openly or to get equal opportunity in the workplace. Freedom is measured on a continuum with many different variables.

In 1865, former slaves were in the process of negotiating freedom's protean meanings, as they struggled to define and secure freedom on their own terms. Although no longer suffering the obvious legal restraints of slavery, their ability to participate in the life of the nation was by no means assured. This was what Reconstruction was all about—a battle over what freedom would actually mean for the millions of slaves who had been emancipated during and after the war. Would they have the right to vote, for example? Would they have access

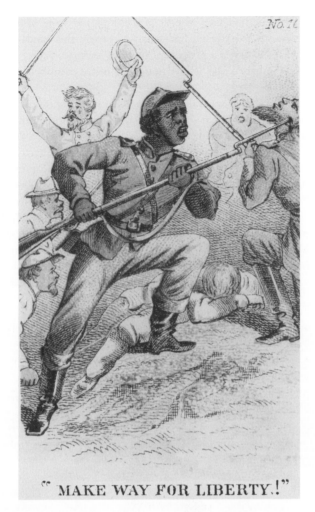

Figure 29.5 H.L. Stephens, "Make Way for Liberty!" 1863. Lithograph. Reproduced from the collections of the Library of Congress.

to education and to land on which to farm? As Ward had predicted in 1863, the struggle was "not over"; it was, in fact, only beginning.[19]

Given the ongoing struggles of Reconstruction, it is not so surprising that even in the mid-to-late 1860s, years after the last escapes of fugitive slaves, the *Freedman* still had a compelling story to tell. It was during this period that Howells proposed that the work be transformed into a public monument. Critics such as Howells were still so amazed by its combination of realism and idealism that the piece continued to function for them as a kind of model for representing the new black man. But in fact, the *Freedman* was virtually the opposite of what a nineteenth-century public monument was expected to be. Public monuments were not supposed to pose questions; they were supposed to provide answers. Monuments to heroes and events were not meant to continue old struggles and debates, but instead to show how great men and deeds made the nation better and stronger than it was before. The purpose of a public monument was to condense history's moral lessons and fix them in place for all time; this meant that what was being commemorated, whether it be a

person or an event, had to be imagined as part of a completed stage of history, nestled safely in a sealed past. The *Freedman* quite clearly fails to convey this kind of historical closure: indeed, by suggesting that history is a process of ongoing struggle rather than a simple record of great achievements, it subverts the whole notion of history implicit in public monuments of its time.[20]

During the mid-to-late 1860s, several sculptors were working on public monuments dealing with emancipation, and all of them sought in one way or another to bring the subject to closure. Harriet Hosmer's grand, unrealized proposal for the Freedmen's Memorial to Lincoln in Washington, D.C. was the most optimistic of the bunch, with its cycle of African American history that culminated in the confident figure of an African American citizen-soldier [Figure 29.6]. Far more common were designs that reproduced the earlier imagery of Lincoln freeing a subservient slave. Produced by white artists working for white monument committees, these designs fit squarely within the standard self-congratulatory view of emancipation as an inspired act of great white moral leadership. The only one actually built was Thomas Ball's proposal for the Freedmen's Memorial to Lincoln, unveiled in Washington, D.C. in 1876 [Figure 29.7]. Ironically, while African Americans funded the monument with voluntary contributions, they had no control over its design, which was decided by the Western Sanitary Commission, the

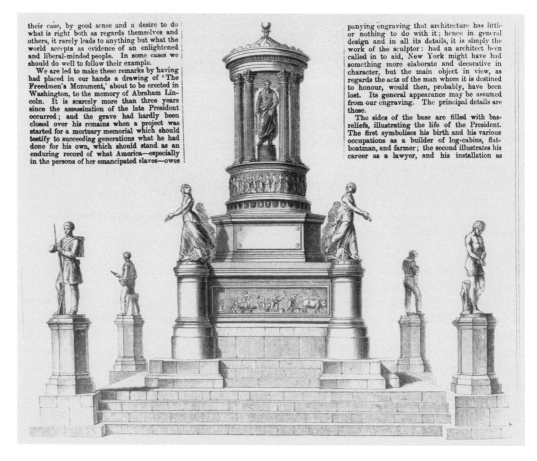

their case, by good sense and a desire to do what is right both as regards themselves and others, it rarely leads to anything but what the world accepts as evidence of an enlightened and liberal-minded people. In some cases we should do well to follow their example.

We are led to make these remarks by having had placed in our hands a drawing of 'The Freedmen's Monument,' about to be erected in Washington, to the memory of Abraham Lincoln. It is scarcely more than three years since the assassination of the late President occurred; and the grave had hardly been closed over his remains when a project was started for a mortuary memorial which should testify to succeeding generations what he had done for his own, which should stand as an enduring record of what America—especially in the persons of her emancipated slaves—owes

panying engraving that architecture has little or nothing to do with it; hence in general design and in all its details, it is simply the work of the sculptor: had an architect been called in to aid, New York might have had something more elaborate and decorative in character, but the main object in view, as regards the acts of the man whom it is destined to honour, would then, probably, have been lost. Its general appearance may be assumed from our engraving. The principal details are these.

The sides of the base are filled with bas-reliefs, illustrating the life of the President. The first symbolises his birth and his various occupations as a builder of log-cabins, flat-boatman, and farmer; the second illustrates his career as a lawyer, and his installation as

Figure 29.6 Harriet Hosmer, *Freedman's Memorial to Lincoln*, 1867, from *Art-Journal*, new series v.7, 1868. Photography courtesy of The Art Institute of Chicago.

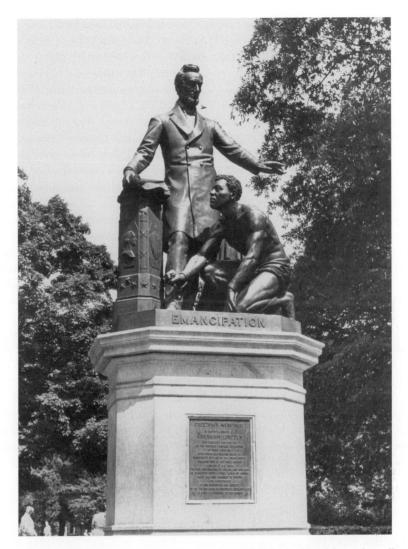

Figure 29.7 Thomas Ball, *Freedman's Memorial to Lincoln*, 1876. Reproduced from the collections of the Library of Congress.

white philanthropic organization put in charge of the money; another hundred years would go by before Africans Americans gained any measure of control over their representation in public space.[21]

The Freedmen's Memorial came to be known as the Emancipation Monument, and for many decades it served as the standard image of emancipation in the U.S. This was unfortunate not only because it made the slave the passive recipient of Lincoln's gift of freedom, but also because it fixed in bronze forever the master-servant relationship that so clearly encoded racial hierarchy. While the point of the narrative is that Lincoln's act will enable the black man to rise, he never does because the monument, in its very permanence, fixes him literally and figuratively in his place. "Shine, Sir?" was how many African Americans referred to this disastrous work. Even so, the monument was used recently as the backdrop for Washington, D.C.'s revived Emancipation Day celebration, although not without controversy.[22]

By now it should be clear that the *Freedman* was unsuitable in almost every way for the kind of public monument preferred in the U.S. As we have seen, there is no white person in the image; it does not congratulate white society, even indirectly; and it does not even suggest that emancipation was definitive or successful. But these are all reasons why the *Freedman* spoke so insightfully and truthfully about the historical experience of emancipation. Even after the Radical-Republican Congress had passed the Fourteenth Amendment declaring racial equality before the law, emancipation was still by no means real and complete. During Reconstruction, African Americans struggled against great odds for economic self-determination even as southern whites were fighting to deprive them of their newly won political rights. As we now know, this was a battle that African Americans eventually lost, much to the nation's shame. By the end of the nineteenth century, segregation and structural inequality (social, political, and economic) were the norm throughout the South and much of the North as well. While nominally free, African Americans were certainly not the full citizens they had expected to become when they took up arms for the Union cause in 1863–65.

This is why the *Freedman* would have made a powerful national monument. Not for the reason Jarves gave in the *Art-Idea*—he thought it would crown democracy by showing the "final liberty of the slave"—but for quite the opposite reason. Because it deliberately did not show the final liberty of the slave, the *Freedman* would have stood as a challenge to the nation to complete the process of emancipation which had been started during the war. Just imagine for a moment the *Freedman* enlarged to over life-size and erected in place of Ball design for the Freedmen's Memorial, or even better yet, installed under the great dome of the Capital Rotunda as Jarves had suggested in 1864. If Ward's figure were greatly enlarged, its heroism magnified by the increase in scale, its tense alertness all the more striking, a typical reaction might be, "Why isn't this man free? Doesn't he deserve to be? Hasn't he risked everything for the chance to take his rightful place in the nation?" No matter how determined this fugitive seemed to be to escape the bonds of slavery, no matter how heroic his tale of flight from persecution, his final fate depended on one essential question: whether the nation would choose to accept him into its fold. And that is the great problem that the *Freedman* would have posed to white America as the nation retreated from the great promise of racial equality made immediately after the war.

Of course this never did happen. The *Freedman* never did find its way into the Capitol building, or anywhere else into public space. Ward himself never again represented African Americans in this way. He went on to become a famous sculptor, executing the stock-in-trade subjects that most every sculptor hoped to get, namely white heroes. In fact, he was one of the first sculptors to design the new kind of war memorial that appeared after the Civil War, the standing soldier monument that appeared on innumerable town greens and squares to commemorate the ordinary white infantryman who served. Howells had hoped that such military monuments would disappear from the landscape, and that Americans would choose instead to commemorate the war with images like the *Freedman* in order to evoke the conflict's moral purpose.[23] In retrospect, Howells's thought seems wildly naive; he was swimming against the tide.

Ward, however, decided to swim with the tide. He abandoned the experimental, subversive mode of the *Freedman* and produced the kind of celebratory monuments that most of his contemporaries seemed to want. The only other African American figure he ever made was the figure of an adolescent girl who appears properly grateful on the base of a monument in Brooklyn to the abolitionist preacher Henry Ward Beecher. It is a national misfortune that Ward didn't continue in the vein of the *Freedman*, for there was precious little public sculpture in the nineteenth century (or even the twentieth) that did any justice to African Americans.

Only in the fairly recent past have artists and their publics in the U.S. begun to negotiate the problem of creating an interracial space of representation. Yet, in my view, the experiment of the *Freedman* still has not been surpassed. Nothing so immediate and direct, yet so challenging, has appeared in our own time to open up the prospect, as the *Freedman* once did, of a new and better world.

Notes

1 *Harper's Weekly* 7 (May 2, 1863): 274. See also "A Letter to a Subscriber," *The New Path*, 9 (January 1864): 118. Many thanks to Andrew Walker for drawing this reference to my attention.

2 A good selection of contemporary documents relating to the proclamation and its meaning can be found in Ira Berlin (ed.), *Free at Last* (New York: New Press, 1992), 95–129 and C. Peter Ripley (ed.), *Witness for Freedom: African-American Voices on Race, Slavery, and Emancipation* (Chapel Hill, N.C.: 1993), 221–31. The quote is from a recruiting poster, *Freedom to the Slave*, in the Chicago Historical Society.

3 A plaster model of the *Freedman*, perhaps the original, is in the collection of the Pennsylvania Academy of Fine Arts, Philadelphia, and is reproduced in Jacolyn A. Mott and Linda Bantel (eds.), *American Sculpture in the Museum of American Art of the Pennsylvania Academy of Fine Arts* (Philadelphia, 1997), p. 81. Ward began to make bronze casts as early as 1864; see Lewis Sharp, *John Quincy Adams Ward: Dean of American Sculpture* (Newark, Del., 1985), pp. 153–56.

4 There are three portraits of African Americans on slate gravestones in an eighteenth-century graveyard in Newport, R.I., a group of African Americans depicted in a marble panel on a tomb erected in Pittsburgh in 1860, and a handful of plaster images dating from the 1850s, including John Rogers's *Slave Auction*. See Kirk Savage, *Standing Soldiers, Kneeling Slaves: Race, War, and Monument in Nineteenth-Century America* (Princeton, 1997), pp. 15–17, 70–2.

5 *Independent*, June 11, 1863, p. 6.

6 Savage, *Standing Soldiers, Kneeling Slaves*, pp. 16–17.

7 James Jackson Jarves, *The Art-Idea* (Cambridge: Belknap Press, 1960; originally 1864), 225–26.

8 William Dean Howells, "Question of Monuments," *Atlantic Monthly*, 18 (May 1866): 648. Henry Tuckerman, *Book of the Artists* (New York: G.P. Putnam & Son, 1867), p. 582. Tuckerman attributes this suggestion to Jarves's *Art-Idea* but it does not appear there.

9 Kirk Savage, "Manumission and Black Masculinity in a Monument to Lincoln," in Reynolds Scott-Childress (ed.), *Race and the Production of Modern American Nationalism* (New York: Garland, 1999), pp. 32–4. For more on Lincoln's mixed reputation among African Americans after the Civil War, see Ripley, *Witness for Freedom*, pp. 221–31.

10 Savage, *Standing Soldiers, Kneeling Slaves*, 21–3.

11 Ibid., 31–5.

12 "A Typical Negro," *Harper's Weekly*, 7 (July 4, 1863): 429; see also William A. Gladstone, *United States Colored Troops 1863–1867* (Gettysburg, Pa., 1990), 44. In the published notices of runaway slaves, identifying scars and brands figured routinely.

13 *Independent*, June 11, 1863, p. 6. See also *New York Times*, May 3, 1863, p. 5 and June 24, 1863, p. 2. A more comprehensive selection of press clippings can be found in the John Quincy Adams Ward Scrapbook [hereafter Ward Scrapbook] in the Ward Papers, Albany Institute of History and Art; see especially New York *Evening Post*, November 3, 1865.

14 "A Letter to a Subscriber," *The New Path*, 9 (January 1864): 118.

15 For more on the moral dimension of sculpture, see Savage, *Standing Soldiers, Kneeling Slaves*, pp. 8–15.

16 Ward to J.R. Lambdin, April 2, 1863, in Albert Rosenthal Papers, Archives of American Art, Roll D34, frame 1302.

17 It would not have occurred to Ward to make the figure a freed *woman*, even though women were also escaping slavery. The reason is that the metaphorical content of the sculpture would have been entirely different. Women, no matter what color, could not become full citizens in the nineteenth-century US. The figure of a fugitive woman would have probably been understood by audiences as a victim—most likely a sexual victim—rather than a person capable of assuming freedom and citizenship.

18 *Catalogue of Paintings, Statuary, Etc. of the Art Department in the Great North-Western Fair* (Chicago, 1865), 8. My thanks again to Andrew Walker for bringing this to my attention.

19 The now standard work on this period is Eric Foner, *Reconstruction: America's Unfinished Revolution* (New York, Harper & Row, 1988).

20 For more extended reflections on the function of monuments in the nineteenth century, see Kirk Savage, "The Past in the Present: The Life of Memorials," *Harvard Design Magazine* (Fall 1999): 14–19; and Savage, *Standing Soldiers, Kneeling Slaves*, pp. 4–8, 64–70.

21 Savage, *Standing Soldiers, Kneeling Slaves*, pp. 72–122.

22 Aaron Lloyd, "Statue of Limitations: Why Does D.C. Celebrate Emancipation in Front of a Statue That Celebrates 19th-century Racism?" *Washington City Paper*, April 28, 2000: 19.

23 Howells, "Question of Monuments," p. 647.

Chapter 30

JOY S. KASSON

STAKING A CLAIM TO HISTORY

THE CLEAREST ARTICULATION OF THE WILD WEST'S aspirations was, of course, always found in the program booklet. By 1893, Burke and his team were producing a booklet sixty-four pages long (twice the size of that for 1885), crammed with articles on virtually every aspect of the show. Together they made the case for Buffalo Bill's importance as an authentic American hero and expressed the delicate balance between fictionality and authenticity in the Wild West's performance.

The cover for the booklet features colorful lithographs placing Buffalo Bill in the center of a sequence of authentic-looking frontier scenes. [Figure 30.1]. On the front, a head-and-shoulders portrait of Cody is surrounded by three vignettes: a hunter shooting two buffalo, Buffalo Bill aiming a pistol from a running horse, and, across the bottom of the page, the Deadwood stage under attack by Indians, with Buffalo Bill and the cowboys riding up to save it. These three dramatic scenes could be interpreted as actual occurrences in Cody's own history and also as scenes from the Wild West performance. A dignified Buffalo Bill is presiding over the sort of historically evocative "action pictures" the Wild West's advertisements promised.[1] The back cover [Figure 30.2] shows a very different scene, one that could not be duplicated in the arena: a rocky landscape seen from a distance, with an Indian encampment on a plateau, and two tiny figures starting up a long, steep path toward it. The caption credits a periodical source, the *Illustrated American* of January 10, 1891, and identifies this scene as "Sioux on the War-Path: Stronghold in the Bad Lands of the Hostile Indians, Chiefs, 'Short Bull' and 'Kicking Bear.'" So the back cover represents the "real" West that exists independent of its fictional enactment. These lithographs stake strong claims for their own representational power. The show that had convinced Europeans they had seen the authentic West and inspired Rosa Bonheur to paint as if she had visited the Great Plains framed

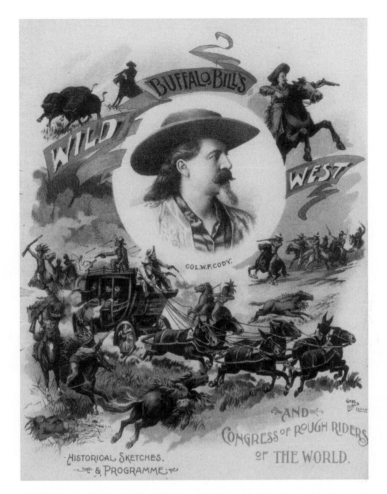

Figure 30.1 1893 Wild West Show program, front cover. From *Buffalo Bill's Wild West and Congress of Rough Riders of the World, Historical Sketches and Programme*, Chicago, Ill.: The Blakely Printing Company, 1893. From the collection of John and Joy S. Kasson.

its program booklet with images that linked staged representation with the "real" Wild West.

The text embraces both performance and the world outside the arena, and the language of fiction jostles against the apparatus of authentication. Burke's opening message, "Salutatory," written for the first season in 1883 and reprised with only a few changes, mobilizes the extravagant formulations of frontier romance. Extolling "the little vanguard of pioneers, trappers, and scouts, who, moving always in front, have paved the way – frequently with their own bodies – for the safe approach of the masses behind," it echoes the closing lines of James Fenimore Cooper's *The Pioneers*, which had helped to create the frontier myth in 1823 when it described Natty Bumppo as "the foremost in that band of Pioneers, who are opening the way for the march of our nation across the continent."[2] The booklet also includes romanticized poetry, such as "Cody's Corral; or, the Scouts and the Sioux," reprinted from the dime-novel publication *Beadle's Weekly* and part of the program booklet since at least 1885: "And loudly rings the war-cry of fearless Buffalo Bill/And loudly rings [sic] the savage yells,

Figure 30.2 1893 Wild West Show program, back cover. From *Buffalo Bill's Wild West and Congress of Rough Riders of the World, Historical Sketches and Programme*, Chicago, Ill.: The Blakely Printing Company, 1893. From the collection of John and Joy S. Kasson.

which make the blood run chill!" But the sensational tone of these passages is juxtaposed with the serious-minded items documenting Buffalo Bill's offstage importance: facsimiles of Cody's 1889 commission as brigadier general in the National Guard of Nebraska and of a set of letters from January 1891 in which the governor of Nebraska orders Cody to undertake special service and Major General Nelson Miles of the U.S. Army informs him about the state of Indian hostilities. The letters of recommendation solicited by Burke before Cody's departure for London are quoted at length, and newspapers and books about the frontier are cited to authenticate Cody's service on the plains. The booklet draws on the resources of both romance and realism, showing Buffalo Bill is an unabashedly fictionalized hero yet at the same time documenting his place in history.

The copious illustrations reflect this blend of highly colored romance and solemnly invoked claims to factuality. Some of the images are line engravings in the exuberant spirit of novel illustration, while others are dignified, posed photographs. A few of the engravings had been part of Cody's repertory for nearly fifteen years: for example, an illustration showing Cody pursuing a running buffalo amid covered wagons and tents is a slight reworking of 'Bringing Meat into Camp," an illustration in his *Autobiography* (1879). An image of an Indian on horseback peering into the distance was taken from a poster circulated as early as 1885 [Figure 30.3]. The booklet also contains some very familiar visual materials in slightly altered versions,

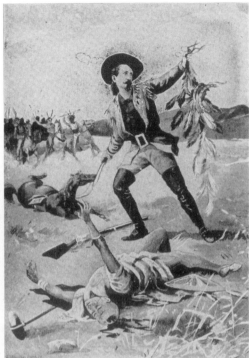

THE FORMER FOE—PRESENT FRIEND, THE AMERICAN.

Figure 30.3 The Former Foe – Present Friend, The
American, 1893 program. From Buffalo Bill's Wild
West and Congress of Rough Riders of the World,
Historical Sketches and Programme, Chicago, Ill.:
The Blakely Printing Company, 1893. From the
collection of John and Joy S. Kasson.

Figure 30.4 Buffalo Bill Scalping Yellow Hand,
1893 program. From Buffalo Bill's Wild West and
Congress of Rough Riders of the World, Historical
Sketches and Programme, Chicago, Ill.: The Blakely
Printing Company, 1893. From the collection of
John and Joy S. Kasson.

including the scalping of Yellow Hand [Figure 30.4], the image of Cody on a running horse
shooting glass balls tossed in the air by an Indian, and the attack on a stagecoach. Such images
connect the Wild West performance with its sources in the dime novel and other forms of
popular literature.

But photographs in the program booklet also connect the Wild West spectacle with an
emerging documentary tradition. Cody had used souvenir and carte de visite photographs for
publicity since his earliest days as an entertainer, but when the Wild West returned from
Europe, photographs blossomed in the program booklet as well. The halftone process, which
made it possible to print photographs and words on the same page, had revolutionized American
publishing starting in the 1880s, and by the 1890s many books and popular magazines included
illustrative photographs. Photographs emphasized the "real" in books as diverse as Civil
War albums and travel books, while urban reformers were using photographs to authenticate
the claims of their texts. Harper's Monthly, Century, and Collier's included many photographs,
especially accompanying nonfiction articles.[3] The photographs in the Wild West booklet follow
this same logic: portraits of show personnel, a view of cattle and horses grazing at Cody's
Scout's Rest Ranch [Figure 30.5], a full-page photograph of Cody on horseback with General

"BUFFALO BILL'S" HOME AND HORSE RANCH ON THE OLD FIGHTING GROUND OF THE PAWNEE AND SIOUX.

Figure 30.5 Buffalo Bill's Home, 1893 program. From *Buffalo Bill's Wild West and Congress of Rough Riders of the World, Historical Sketches and Programme,* Chicago, Ill.: The Blakely Printing Company, 1893. From the collection of John and Joy S. Kasson.

Miles. A lengthy section on American Indian culture is illustrated with posed photographs of carefully identified individuals, including chiefs and children. The last few pages are filled with photographs from the Wild West's European tour. The remarkable picture of Cody and several of his costumed Indian performers in a gondola in Venice receives a full page, and a photograph of the encampment at Earl's Court in London is also included.

But this deployment of images blurs the boundaries between "real" photographs and "imaginary" drawings. Some of the illustrations combine the two in a manipulated "realistic" image. Sketches of the Wild West performers are added to what appears to be a photograph of the Colosseum in Rome, and similarly, the company is drawn into a photographic image of St. Peter's. Like the show itself, the images lay claim to overlapping realms of fictionality and "truth," insisting on the interrelatedness of performance and the "real" West.

The program booklet also blended fact and fiction in its portrayal of the show's growing international element. By 1893, the Wild West proudly advertised a wide variety of acts from around the globe. The Congress of Rough Riders of the World included an impressive number of riding and military acts: Mexican vaqueros, Syrian and Arabian horsemen, Russian cossacks, Argentinean gauchos, and military units from Germany, England, and France. The booklet gave educational, historical, and descriptive information about these performers in words transplanted, perhaps, from press releases. At the same time, the international horsemen enacted a romantic and theatrical extravaganza that became ever more central to the show. When these colorful riders galloped into the arena, audiences were treated to a dream of exotic lands, and perhaps also a vision of American imperialism extending, not just across the Western plains, but throughout the world as well.

The very structure of the Wild West's program projected this careful balance between romance and fact. The content had remained remarkably consistent since Cody and Salsbury filed their copyright papers in 1883: a processional introducing the show's personnel was followed by the different acts – races, demonstrations of skill, and narrative segments that embedded fictional representations of historical events in an authenticating frame of real animals, real guns, real frontier characters. Annie Oakley's shooting act was now firmly placed at the beginning of the show, for experience had proved that audiences who felt nervous when confronted with the noise and smoke of gunfire felt reassured when they saw a petite, attractive woman shooting first. Furthermore, both her shooting skill and her physical presence helped to establish the show's credibility, as if to vouch for the fictive acts to follow. Several other segments claimed historical and ethnographic authenticity, including a demonstration of pony-express riding techniques, a buffalo hunt, and a demonstration of "Life Customs of the Indians." In the last two, American Indian performers appeared in a sympathetic light, but at least three other segments cast them as villains in staged narratives: the "Prairie Emigrant Train Crossing the Plains," the "Capture of the Deadwood Mail Coach by the Indians," and the "Attack on a Settler's Cabin."

In the midst of the 1893 season, Cody and his managers made one change in the program that intensified the Wild West's claim to historical significance and at the same time complicated its promise of a happy ending to the civilizing process. In August, the Wild West replaced the standard "Attack on a Settler's Cabin" with "The Battle of Little Big Horn, or Custer's Last Charge." Cody had always traded on the powerful emotions stirred up by Custer's death. He had mounted an enactment of this incident in London, and now he added it to the Chicago season, perhaps to stimulate a burst of return visitors halfway through his six-month engagement. Publicity releases announced that the act would include three Indians who had actually been in the fight, Plenty Horses, Painted Horse, and Rocky Bear; and a large party of army officers attended its first performance. By presenting an episode from frontier history that did not end happily, the Wild West risked contradicting its promise of triumphant conquest. Yet in the show as in the battle itself, the death of Custer gave advocates of expansionism a martyr whose death could justify their cause. And Custer's death did not end the performance: Buffalo Bill galloped in, too late to rescue Custer but poised to continue the work of conquest.

Reviews of this new Custer sequence, like those for the Wild West as a whole, reinforced the show's historical claims. An enthusiast reported, "those who had 'been thar' said it was a faithful representation of the scene." The conjunction of Custer and Cody, which came solely from dime-novel accounts and not from the historical record, seemed by 1893 to be entirely appropriate. "Colonel Cody rode down to the grandstand, waved his hat, his old army friends whooped for him and the satisfied crowd filed out of the arena."[4] The stage Custer was fictional, the army officers were real, and Colonel Cody linked them together, satisfying the crowds who believed they had seen history in the making.

The Battle of Little Big Horn was a fitting close to the Wild West performance. Factual and fictive segments of the program worked together to make explicit the show's overriding message: the memory of the Wild West was one of heroic conquest. Dangerous wildness, in the form of hostile Indians, would be subdued by those who, like Buffalo Bill and the Rough Riders, had turned wildness into a skill or tool. The Wild West promised that the march of civilization would be exciting and fun (more fun than the solemn White City), and that the forces of law and order, of Western civilization, would still triumph.

The Wild West and the frontier thesis

Cody, Burke, and Salsbury were not the only ones thinking about the role of the West in American history during the summer of 1893. As other commentators have pointed out, an important juxtaposition occurred when Frederick Jackson Turner delivered his influential scholarly essay, "The Significance of the Frontier in American History," at a meeting of the American Historical Association held in conjunction with the World's Columbian Exposition in July 1893.[5] Although the paper attracted little attention at the time, it became a widely cited statement about the importance of the westward movement in the formation of American identity, as well as a marker of the moment when that movement radically changed character. Both of these matters were at the heart of Buffalo Bill's performances in 1893. Academic history and popular-culture history were thus, curiously, entwined.

Turner was not the first historian, of course, to stress the significance of the West in American development. Before the Civil War, Francis Parkman had undertaken a rigorous trip on the Oregon trail to provide the experiences underpinning his great project, eight volumes on the history of European settlement in North America, the last of which was published in 1892. Like George Bancroft before him, Parkman worked within a framework that celebrated the triumph of Anglo-Saxon conquest and saw English, and later American, domination of North America as a story of the progress of civilization over savagery and the extension of freedom over the continent.

Both Bancroft and Parkman lived into the 1890s, long enough to see the impact of their ideas on a historian-politician who would articulate a powerful interpretation of the West in American life and then express it in war and politics: Theodore Roosevelt. The Harvard-educated Roosevelt was already a published historian and an influential New York politician when he traveled to the Dakota Badlands for an extended stay in 1884. His sojourn in the West was an escape from personal disasters that had overwhelmed him over the course of several months: in February 1884 his mother and his wife died suddenly on the same night, and by the following summer he had become embroiled in a destructive political struggle. Roosevelt went west in search of physical, emotional, and intellectual refreshment. Riding and hunting while managing a cattle ranch, he turned his energies to writing history and memoirs: in 1888, he produced a travel memoir, *Ranch Life and the Hunting Trail*, and, beginning in 1889, a four-volume historical work, *The Winning of the West*.

Like Bancroft and Parkman, Roosevelt considered the story of the American empire as a triumphant narrative that he located firmly in the context of European imperialism. "During the past three centuries," *The Winning of the West* begins, "the spread of the English-speaking peoples over the world's waste spaces has been not only the most striking feature in the world's history, but also the event of all others most far-reaching in its effects and its importance." Roosevelt followed in some detail the different patterns of the settlement and conquest of North America in Atlantic, Northwest, Southwest, and Midwestern regions, insisting that territorial expansion was the "great work" of the nation, the force that produced a national life. "All other questions, save those of the preservation of the Union itself and of the emancipation of the blacks, have been of subordinate importance when compared with the great question of how rapidly and how completely they were to subjugate that part of their continent lying between the eastern mountains and the Pacific." In a preface added in 1894, he made his claim for the significance of the West in American history even stronger: the success of Western settlement "determined whether we should become a mighty nation, or a mere snarl of weak and quarrelsome little commonwealths."[6]

Much of *The Winning of the West* consists of heroic accounts of settlement, focusing on

leaders such as Daniel Boone and George Rogers Clark but also discussing unknown hunters and settlers who followed "the instincts working half blindly within their breasts, spurred ever onwards by the fierce desires of their eager hearts." Both leaders and followers, though, are imagined by Roosevelt as heroes, men who *created* the national destiny by their own deeds. This heroic narrative, of course, resembles the narrative of Western settlement told in dime novels and border dramas and then, compellingly after 1883, by the Wild West. Roosevelt's description of Daniel Boone could have been transferred from one of John Burke's descriptions of Buffalo Bill: "His self-command and patience, his daring, restless love of adventure, and, in time of danger, his absolute trust in his own powers and resources, all combined to render him peculiarly fitted to follow the career of which he was so fond."[7] Roosevelt infused history with the narrative drive and descriptive conventions of romance in a way that was not too different from John Burke's program booklet.

In fact, one could argue that popular representations of the West had been significant in convincing Roosevelt that the Badlands could be a place of healing and a stage on which to live out his version of the strenuous life. During his first summer in the West, Roosevelt was still searching for a suitable costume and language for his Western experiences: acquaintances were said to be amused by his Eastern locutions, such as his orders to cowboys during a roundup, "Hasten forward quickly there!" He wrote to a friend describing his frontier outfit: "my broad sombrero hat, fringed and beaded buckskin shirt, horsehide chaparajos or riding trousers, and cowboy boots, with braided bridle and silver spurs."[8] Where did he get his ideas of proper cowboy garb? Buffalo Bill had been described in such clothing as early as the Sheridan dude hunt; stage and arena appearances by Cody and his cast of cowboys had already made this costume synonymous with the Wild West.

Not only did Roosevelt present the West in a theatrical manner that recalled Buffalo Bill's Wild West, but his accounts, both the history volumes and *Ranch Life and the Hunting Trail*, were tinged with the same anticipatory nostalgia, the sense that the life of the frontier was quickly vanishing, that flooded the Wild West presentations from their earliest days. The preface to *The Winning of the West* describes the book as "a labor of love" and emphasizes Roosevelt's own connection with Western scenes, which, he writes, are disappearing. "The men who have shared in the fast-vanishing frontier life of the present feel a peculiar sympathy with the already long-vanished frontier life of the past." In *Ranch Life and the Hunting Trail* he frequently notes that the scenes he is describing are changing "before the onward march of our people; and we who have felt the charm of the life, and have exulted in its abounding vigor and its bold, restless freedom, will not only regret its passing for our own sakes, but must also feel real sorrow that those who come after us are not to see, as we have seen, what is perhaps the pleasantest, healthiest, and most exciting phase of American existence."[9] Roosevelt adopts and transmits a heroic vision of the West, and a sense of its transitoriness, that Buffalo Bill and his publicists had already absorbed and were circulating.

So the stage had been set when Frederick Jackson Turner stepped forward to deliver an academic paper in Chicago in the summer of 1893. Popular works of history had emphasized the importance of Western settlement for generations, and dime novels, stage shows, and the riveting, hybrid Wild West performances had provided vicarious frontier experiences for a broad public. Turner's paper, like his subsequent work about the frontier, brought to historical writing some of the vivid imagery and compelling energy of the Wild West performance itself, and placed the Western frontier at the forefront of historical discussions of national identity.

Turner drew upon some of the images of the frontier that had flowed through Buffalo Bill's performances as well as the historical writing of Roosevelt, Parkman, and Bancroft. Like Roosevelt and Buffalo Bill, Turner saw westward movement as central to the history of the

United States. "American history has been in a large degree the history of the colonization of the Great West," he wrote, and, even more forcefully, "The true point of view in the history of this nation is not the Atlantic coast, it is the Great West." And like all of them, he imagined that the westward movement exemplified a struggle between "savagery and civilization."[10] Roosevelt believed that Turner's essay merely restated well-established theories. He wrote to Turner congratulating him on his "first class ideas," and said that he had put "into shape a good deal of thought that has been floating around rather loosely."[11]

But the familiarity of Turner's characterization of the frontier masked some very important differences in his approach. Far from thinking that the conquering civilization stayed intact while transforming the "wild" land and peoples it encountered, Turner argued that the confrontation with wilderness changed the colonizers. He put it in sober historical terms: "In the settlement of America we have to observe how European life entered the continent, and how America modified and developed that life, and reacted on Europe." His language could also be vivid, metaphorical, performative: "The wilderness masters the colonist. It finds him a European in dress, industries, tools, modes of travel, and thought. It takes him from the railroad car and puts him in the birch canoe. It strips off the garments of civilization, and arrays him in the hunting shirt and the moccasin . . . The fact is, that here is a new product that is American."[12] As the historian Ray Allen Billington has argued, Turner "had moved far toward a modern understanding of historical processes."[13] By stressing the transformative power of the Western frontier, Turner overthrew the reigning metaphor of heroic conquest in favor of a much more complex, conflicted one of change and evolution. Although later historians have questioned Turner's view of progressive evolution, and debated such issues as the conflicts of cultures and dynamics of change in the natural environment, there is no denying the power of Turner's proposition that American settlers on the frontier underwent changes in their political and economic institutions as well as in their intellectual and moral traits.

How did this proposition relate to the story told by Buffalo Bill's Wild West? On one hand, it ran counter to the Wild West's apparent narrative of triumph, its happy-ending legacy drawn from the dime novel and the stage melodrama. Part of the pleasure of the Wild West was its reassurance that, no matter how noisy the gunfire or how loud the Indian war whoops, Buffalo Bill would always ride in to save the day, and that Buffalo Bill would remain recognizable, stable, identifiable. He would never be tempted to "go native." There is only one known photograph of Buffalo Bill wearing an Indian costume, dating from one of the early stage plays when the plot called upon him to disguise himself and sneak into the Indian camp. The structure of the Wild West, and its increasing reliance on the Congress of Rough Riders of the World, reinforced the show's underlying premise: in "the race of races," the juxtaposition between different peoples of the world, the viewers could always tell the cowboys from the Indians.

But one element in Turner's thesis did support the message so successfully conveyed by Buffalo Bill's Wild West: his observation that by now, the frontier should be considered a phenomenon of the past rather than a continuing fact of American life. The famous beginning of "The Significance of the Frontier in American History" cites the superintendent of the census for 1890 to the effect that an unbroken line of settlement – a clear demarcation between the "wild" and the "civilized," once a characteristic feature of American demographics – no longer existed. "This brief official statement marks the closing of a great historic movement," Turner maintained. The essay ended by restating his belief that the era of the frontier had now passed away forever: "And now, four centuries from the discovery of America, at the end of a hundred years of life under the Constitution, the frontier has gone, and with its

going has closed the first period of American history."[14] This was exactly the stance Buffalo Bill's Wild West had taken by 1893. Burke began the program booklet by quoting his own words from 1883, describing the frontiersman as "a class that is rapidly disappearing from our country." He ended it by expressing the hope that "in presenting our rough pictures of a 'history almost passed away,' we may have done some moiety of good in simplifying the work of the historian, the romancer, the painter, and the student of the future."[15]

At the White City, the Wild West reached out to historians quite specifically. The management invited participants in the American Historical Association conference to attend the show on the afternoon of July 12. Turner was not present, since he was hard at work completing the speech he would give that very night, but at least some of the historians who heard him deliver it had gunfire and Indian war whoops ringing in their ears, smoke or dust from the Wild West still on their clothes.[16] Buffalo Bill's dramatic claims to historicity formed part of the context and the rationale for the reception of Turner's historical analysis.

Buffalo Bill reborn

During its six-month season in 1893, Buffalo Bill's Wild West reached probably six million American spectators with a colorful, focused, well-defined show. Whatever a performance by Buffalo Bill had meant before, by now the Wild West was firmly entrenched as a dynamic show-business spectacle with strong appeal to audiences of different ages, regions, affiliations, and occupations. Cody and Salsbury had succeeded in creating an entertainment for a mass audience that was not a circus, not a burlesque, not a freak show; like vaudeville, it called on a variety of resources from high and low culture. It claimed "serious" historical significance and at the same time energetically deployed melodramatic conventions; it demonstrated feats of skill and also told stories. It used music, colorful costumes, and the display of "exotic" peoples. But in contrast to the more fluid Barnum-infected entertainment world where it started, the 1893 Wild West had found a place for itself in the increasingly hierarchical cultural milieu of modernizing America.

By 1893, urbanization, industrialization, and an ever more bifurcated social and economic structure took large areas of the United States far from their rural, relatively open and fluid past. The nostalgic tone that had been part of the Wild West's presentation from the start allied it with other forms of what T. J. Jackson Lears has named "antimodernism," including medievalism, Orientalism, and a renewed fascination with strenuous activities and sports.[17] Henry Adams returned from Chicago even more convinced that the coming of the twentieth century was sweeping away the America his family had helped to shape, and contemporary writers like Theodore Dreiser and Frank Norris were beginning to sketch a harsh new vision of the urban wilderness that was replacing it. While realists and naturalists portrayed a threatening world that could overcome a hapless victim, the Wild West continued to celebrate the heroic individual's ability to triumph over danger. The very qualities that seemed scarce in turn-of-the-century culture – optimism and national and personal self-confidence – were found in abundance in the colorful, dramatic, and thoroughly spectacular world of Buffalo Bill.

Notes

1 Two different front covers for the 1893 program have the same basic design, featuring a portrait of Cody surrounded by vignettes of prairie scenes that correspond to Wild West performance segments. (In both examples I have seen, the back cover is the same.) BBHC, MS 6, William F. Cody Collection, series VI A, box 1, folder 10.

2 *Buffalo Bill's Wild West and Congress of Rough Riders of the World, Historical Sketches & Programme* (Chicago: Blakely Printing, 1893), p. 4. James Fenimore Cooper, *The Pioneers, or the Sources of the Susquehanna: A Descriptive Tale* (1823; reprint, Albany: State University of New York Press, 1980), p. 456.

3 See Ralph F. Bogardus, *Pictures and Texts: Henry James, A. L. Coburn, and New Ways of Seeing in Literary Culture* (Ann Arbor: University of Michigan Research Press, 1984), pp. 103–7.

4 *Chicago Herald*, Aug. 13, 1893; *Inter-Ocean* and *Chicago Post*, Aug. 17. BBHC, MS 6, William F. Cody Collection, series IX: Scrapbooks, etc., box 8, Scrapbook 1893, Chicago Season.

5 See especially Slotkin, *Gunfighter Nation*, chaps. 1 and 2, and Richard White, "Frederick Jackson Turner and Buffalo Bill," in Richard White and Patricia Limerick, *The Frontier in American Culture* (Berkeley: University of California Press, 1994), pp. 6–65.

6 Theodore Roosevelt, *The Winning of the West* (1889; reprint, New York: G. P. Putnam's Sons, 1896), vol. 1, pp. 1, 25, xix.

7 Ibid., pp. 30, 162.

8 Henry F. Pringle, *Theodore Roosevelt: A Biography* (1931; reprint, New York: Harcourt, Brace, 1956), p. 69.

9 Roosevelt, *The Winning of the West*, p. xvi; Theodore Roosevelt, *Ranch Life and the Hunting Trail* (1888; reprint, New York: Century, 1896), p. 24.

10 Frederick Jackson Turner, "The Significance of the Frontier in American History," in Martin Ridge, ed., *Frederick Jackson Turner: Wisconsin's Historian of the Frontier* (Madison: State Historical Society of Wisconsin, 1986), pp. 27–28.

11 Theodore Roosevelt to Frederick Jackson Turner, Feb. 10, 1894, quoted in Ray Allen Billington, *The Genesis of the Frontier Thesis: A Study in Historical Creativity* (San Marino, Calif.: Huntington Library, 1971), p. 173.

12 Turner, "Significance of the Frontier," pp. 27–28.

13 Billington, *Genesis of the Frontier Thesis*, p. 176.

14 Turner, "Significance of the Frontier," pp. 26, 47.

15 *Buffalo Bill's Wild West*, pp. 4, 64.

16 Billington, *Genesis of the Frontier Thesis*, p. 166.

17 T. J. Jackson Lears, *No Place of Grace: Antimodernism and the Transformation of American Culture, 1880–1920* (New York: Pantheon, 1981).

Imagining Differences

VANESSA R. SCHWARTZ AND
JEANNENE M. PRZYBLYSKI

THE NINETEENTH CENTURY was characterized by extensive colonialist initiatives on the part of major European powers (France and Spain into the Americas; France, Belgium, and Portugal into Africa, etc.). Meanwhile, the US was engaged in an aggressive westward expansion that would not end until a contiguous United States of America stretched from the Atlantic Coast to the Pacific. The nineteenth century was also a period of intense urbanization within nations, in which significant migration from countryside to city meant the gendered divisions traditional to rural labor and life were blurred by a newly industrialized workforce and new forms of urban culture. As the West expanded its reach around the world, and as the economic system of capitalism transformed the urban public realm into "spectacle," gender, race, and ethnicity became ever more crucial and contested categories of identification and difference.

The geographical expeditions and topographic and ethnographic surveys that accompanied these colonialist ventures quickly adapted photographic technologies to their respective requirements of validating official policies of exploration and conquest. Back "home," illustrated travelogues, narrated slide shows and, of course, the multimedia extravaganzas of the great World's Fairs repackaged faraway lands as commodified representations—a world of things to see and buy. Moreover, the city itself produced a distinctively modern visual culture of the street where the intersecting glances of the dandy, the *flâneur* and the prostitute (not to mention the worker, the vagabond, and the middle-class matron) enacted a complex economy of empowerment and oversight.

Within visual culture studies our understanding of how difference is constructed has been derived substantially from Foucault's notion of "discourse" in *Discipline and Punish* and *The Archeology of Knowledge*. The exoticism of the East, the animal-like sensuality of the prostitute, the greed of the Jew are read as discursive maneuvers through which difference is constructed as timeless, self-evident, uncontested, and stereotypical. As Edward Said put it so succinctly in his ground-breaking (and Foucauldian) analysis *Orientalism*, difference "is."

First published in 1983, Linda Nochlin's essay on "The Imaginary Orient" represents an early attempt to carry Said's primarily text-based analysis of literary sources into the realm of visual practices. Difference may appear as a given, but the conventions of constructing

difference *are* historically constructed and, as Nochlin deftly argues, inevitably political—no matter how much traditional art history might prefer to define its history solely through questions of stylistic succession. Moreover, it would be mistaken to assume that the oppositional aesthetic stance of anti-academic, avant-garde, or "Modern" painting necessarily carried over into opposition to dominant political points of view. S. Hollis Clayson and Marcus Verhagen both argue this point in different but compelling ways. For Clayson, the prostitute emerged as a privileged figure of modernity in works by avant-garde artists from Manet to Cézanne precisely because her identity was fluid and unstable, and yet she also perfectly incarnated the frozen alienation of the commodity form. These paintings did not undermine the conventional positioning of the prostitute in modern life, but reinforced the delicious uncertainty that surrounded any woman in the public realm—"Was she or wasn't she?" For Verhagen, Bohemia's anti-middle-class stance of economic "disinterestedness" did not preclude demonizing the figure of the Jew as the locus of rampant materialism and venality. Avant-gardism and anti-Semitism sadly go hand-in-hand.

If difference "is," then Said also argues that the ahistoricity of difference takes the form of a "radical realism." Perhaps the most authoritative purveyor of difference as a form of "radical realism" in the nineteenth century was photography—especially because its authority as a mode of "documenting" difference was indistinguishable from its facility as a mode of "creating" likeness. As Gisèle Freund argues elsewhere in this volume, photography's refinement as a means of cataloguing and administratively managing the appearance of deviance in discourses of criminality, psychopathology, and racial inferiority depended upon its relation to the socially conventionalized norm of bourgeois portraiture. One can find explorations of photographic technologies as media of "radical realism" in other essays in other sections of the Reader—James R. Ryan on visual instruction or Shawn Michelle Smith on baby pictures, to give just two examples. In this section, Eric Ames takes up another, proximate form of realism— the ethnographic exhibition as a purveyor of the "exotic"—part positivist science, part carny hucksterism, and oftentimes including practices of human display and collection. As Ames so eloquently argues via Walter Benjamin's conception of "aura," these living *Völkerschau* (or "show of peoples") provided close encounters that only served to enforce an even greater (and more comfortable) sense of distance between the West and the "rest."

What is left out of all of these accounts is a sustained consideration of how the discursively (and historically) constructed "other" looks back. This is a matter of gaps in the current field of visual culture studies that are doubtless being filled even as this book goes to press (and Darcy Grimaldo Grigsby's moving analysis of works by the Creole painter Guillaume Guillon-Lethière, also in this Reader, provides a compelling foretaste of just how rich this line of inquiry can be). But it is also a matter of historical experience, and the unequal access to the visual technologies of modernity enforced in an age of imperialism. Not until the early twentieth century do we find the beginnings of a sustained back-and-forth deployment and redeployment of the conventions of reflecting and re-presenting otherness *to each other* through photography, film, advertising, the graphic media, and beyond that, by the beginning of the twentieth-first century, marks the definitive transformation from "nationalist" to "global" perspectives. But of course the visual culture of globalization must have its own prehistory, which is why it is all the more imperative to explore those precious earlier instances in their full theoretical implications.

LINDA NOCHLIN

THE IMAGINARY ORIENT

What is more European, after all, than to be corrupted by the Orient?
— Richard Howard

WHAT IS THE RATIONALE behind the recent spate of revisionist or expansionist exhibitions of nineteenth-century art—*The Age of Revolution, The Second Empire, The Realist Tradition, Northern Light, Women Artists,* various shows of academic art, etc.? Is it simply to rediscover overlooked or forgotten works of art? Is it to reevaluate the material, to create a new and less value-laden canon? These are the kinds of questions that were raised— more or less unintentionally, one suspects—by the 1982 exhibition and catalogue *Orientalism: The Near East in French Painting, 1800–1880.*[1]

Above all, the Orientalist exhibition makes us wonder whether there are other questions besides the "normal" art-historical ones that ought to be asked of this material. The organizer of the show, Donald Rosenthal, suggests that there are indeed important issues at stake here, but he deliberately stops short of confronting them. "The unifying characteristic of nineteenth-century Orientalism was its attempt at documentary realism," he declares in the introduction to the catalogue, and then goes on to maintain, quite correctly, that "the flowering of Orientalist painting [. . .] was closely associated with the apogee of European colonialist expansion in the nineteenth century." Yet, having referred to Edward Said's critical definition of Orientalism in Western literature "as a mode for defining the presumed cultural inferiority of the Islamic Orient [. . .] part of the vast control mechanism of colonialism, designed to justify and perpetuate European dominance," Rosenthal immediately rejects this analysis in his own study. "French Orientalist painting will be discussed in terms of its aesthetic quality and historical interest, and *no attempt will be made at a re-evaluation of its political uses.*"[2]

In other words, art-historical business as usual. Having raised the two crucial issues of political domination and ideology, Rosenthal drops them like hot potatoes. Yet surely most of the pictures in the exhibition—indeed the key notion of Orientalism itself—cannot be confronted without a critical analysis of the particular power structure in which these works came into being. For instance, the degree of realism (or lack of it) in individual Orientalist images can hardly be discussed without some attempt to clarify *whose* reality we are talking about.

What are we to make, for example, of Jean-Léon Gérôme's *Snake Charmer* [Figure 31.1], painted in the late 1800s (now in the Clark Art Institute, Williamstown, Mass.)? Surely it may most profitably be considered as a visual document of nineteenth-century colonialist ideology, an iconic distillation of the Westerner's notion of the Oriental couched in the language of a would-be transparent naturalism. (No wonder Said used it as the dust jacket for his critical study of the phenomenon of Orientalism!)[3] The title, however, doesn't really

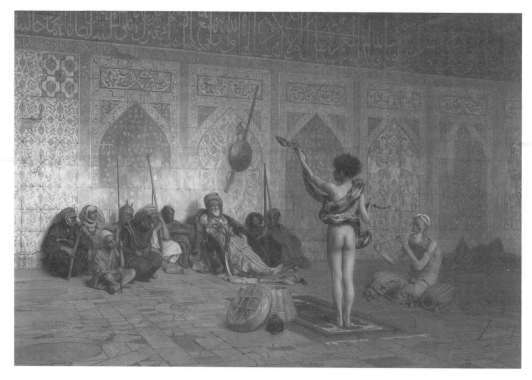

Figure 31.1 Jean-Léon Gérôme, *Snake Charmer*, late 1860s. Courtesy of Sterling and Francine Clark Art Institute.

tell the complete story; the painting should really be called *The Snake Charmer and His Audience*, for we are clearly meant to look at both performer and audience as parts of the same spectacle. We are not, as we so often are in Impressionist works of this period—works like Manet's or Degas's *Café Concerts*, for example, which are set in Paris—invited to identify with the audience. The watchers huddled against the ferociously detailed tiled wall in the background of Gérôme's painting are as resolutely alienated from us as is the act they watch with such childish, trancelike concentration. Our gaze is meant to include both the spectacle and its spectators as objects of picturesque delectation.

Clearly, these black and brown folk are mystified—but then again, so are we. Indeed, the defining mood of the painting is mystery, and it is created by a specific pictorial device. We are permitted only a beguiling rear view of the boy holding the snake. A full frontal view, which would reveal unambiguously both his sex and the fullness of his dangerous performance, is denied us. And the insistent, sexually charged mystery at the center of this painting signifies a more general one: the mystery of the East itself, a standard topos of Orientalist ideology.

Despite, or perhaps because of, the insistent richness of the visual diet Gérôme offers—the manifest attractions of the young protagonist's rosy buttocks and muscular thighs; the wrinkles of the venerable snake charmer to his right; the varied delights offered by the picturesque crowd and the alluringly elaborate surfaces of the authentic Turkish tiles, carpet, and basket which serve as décor—we are haunted by certain *absences* in the painting. These absences are so conspicuous that, once we become aware of them, they begin to function as presences, in fact, as signs of a certain kind of conceptual deprivation.

One absence is the absence of history. Time stands still in Gérôme's painting, as it does in all imagery qualified as "picturesque," including nineteenth-century representations of peasants in France itself. Gérôme suggests that this Oriental world is a world without change, a world of timeless, atemporal customs and rituals, untouched by the historical processes that were "afflicting" or "improving" but, at any rate, drastically altering Western societies at the time. Yet these were in fact years of violent and conspicuous change in the Near East as well, changes affected primarily by Western power—technological, military, economic, cultural— and specifically by the very French presence Gérôme so scrupulously avoids.

In the very time when and place where Gérôme's picture was painted, the late 1800s in Constantinople, the government of Napoleon III was taking an active interest (as were the governments of Russia, Austria, and Great Britain) in the efforts of the Ottoman government to reform and modernize itself. "It was necessary to change Muslim habits, to destroy the age-old fanaticism which was an obstacle to the fusion of races and to create a modern secular state," declared French historian Edouard Driault in *La Question d'Orient* (1898). "It was necessary to transform [. . .] the education of both conquerors and subjects, and inculcate in both the unknown spirit of tolerance—a noble task, worthy of the great renown of France," he continued.

In 1863 the Ottoman Bank was founded, with the controlling interest in French hands. In 1867 the French government invited the sultan to visit Paris and recommended to him a system of secular public education and the undertaking of great public works and communication systems. In 1868 under the joint direction of the Turkish Ministry of Foreign Affairs and the French Ambassador, the Lycée of Galata-Serai was opened, a great secondary school open to Ottoman subjects of every race and creed, where Europeans taught more than six hundred boys the French language—"a symbol," Driault maintained, "of the action of France, exerting herself to instruct the peoples of the Orient in her own language the elements of Western civilization." In the same year, a company consisting mainly of French capitalists received a concession for railways to connect present-day Istanbul and Salonica with the existing railways on the Middle Danube.[4]

The absence of a sense of history, of temporal change, in Gérôme's painting is intimately related to another striking absence in the work: that of the telltale presence of Westerners. There are never any Europeans in "picturesque" views of the Orient like these. Indeed, it might be said that one of the defining features of Orientalist painting is its dependence for its very existence on a presence that is always an absence: the Western colonial or touristic presence.

The white man, the Westerner, is of course always implicitly present in Orientalist paintings like *Snake Charmer*; his is necessarily the controlling gaze, the gaze which brings the Oriental world into being, the gaze for which it is ultimately intended. And this leads us to still another absence. Part of the strategy of an Orientalist painter like Gérôme is to make his viewers forget that there was any "bringing into being" at all, to convince them that works like these were simply "reflections," scientific in their exactitude, of a preexisting Oriental reality.

In his own time Gérôme was held to be dauntingly objective and scientific and was compared in this respect with Realist novelists. As an American critic declared in 1873:

Gérôme has the reputation of being one of the most studious and conscientiously accurate painters of our time. In a certain sense he may even be called "learned." He believes as firmly as Charles Reade does in the obligation on the part of the artist to be true even in minute matters to the period and locality of a work pretending to historical character. Balzac is said to have made a journey of several hundreds of miles in order to verify certain apparently insignificant facts concerning a locality described

in one of his novels. Of Gérôme, it is alleged that he never paints a picture without the most patient and exhaustive preliminary studies of every matter connected with his subject. In the accessories of costume, furniture, etc. it is invariably his aim to attain the utmost possible exactness. It is this trait in which some declare an excess, that has caused him to be spoken of as a "scientific picture maker."[5]

The strategies of "realist" (or perhaps "pseudo-realist," "authenticist," or "naturalist" would be better terms) mystification go hand in hand with those of Orientalist mystification. Hence, another absence which constitutes a significant presence in the painting: the absence—that is to say, the *apparent* absence—of art. As Leo Bersani has pointed out in his article on realism and the fear of desire, "The 'seriousness' of realist art is based on the absence of any reminder of the fact that it is really a question of art."[6] No other artist has so inexorably eradicated all traces of the picture plane as Gérôme, denying us any clue to the art work as a literal flat surface.

If we compare a painting like Gérôme's *Street in Algiers* with its prototype, Delacroix's *Street in Meknes*, we immediately see that Gérôme, in the interest of "artlessness," of inno-cent, Orientalist transparency, goes much farther than Delacroix in supplying picturesque data to the Western observer, and in veiling the fact that the image consists of paint on canvas. A "naturalist" or "authenticist" artist like Gérôme tries to make us forget that his art is really art, both by concealing the evidence of his touch, and, at the same time, by insisting on a plethora of authenticating details, especially on what might be called unnecessary ones. These include not merely the "carefully executed Turkish tile patterns" that Richard Ettinghausen pointed out in his 1972 Gérôme catalogue; not merely the artist's renditions of Arabic inscrip-tions which, Ettinghausen maintains, "can be easily read";[7] but even the "later repair" on the tile work, which, functioning at first sight rather like the barometer on the piano in Flaubert's description of Madame Aubain's drawing room in "Un coeur simple," creates what Roland Barthes has called "the reality effect" (*l'effet de réel*).[8]

Such details, supposedly there to denote the real directly, are actually there simply to signify its presence in the work as a whole. As Barthes points out, the major function of gratuitous, accurate details like these is to announce "we are the real." They are signifiers of the category of the real, there to give credibility to the "realness" of the work as a whole, to authenticate the total visual field as a simple, artless reflection—in this case, of a supposed Oriental reality.

Yet if we look again, we can see that the objectively described repairs in the tiles have still another function: a moralizing one which assumes meaning only within the apparently objectivized context of the scene as a whole. Neglected, ill-repaired architecture functions, in nineteenth-century Orientalist art, as a standard topos for commenting on the corruption of contemporary Islamic society. Kenneth Bendiner has collected striking examples of this device, in both the paintings and the writings of nineteenth-century artists. For instance, the British painter David Roberts, documenting his *Holy Land* and *Egypt* and *Nubia*, wrote from Cairo in 1838 about "splendid cities, once teeming with a busy population and embellished with [. . .] edifices, the wonder of the world, now deserted and lonely, or reduced by misman-agement and the barbarism of the Moslem creed, to a state as savage as the wild animals by which they are surrounded." At another time, explaining the existence of certain ruins in its environs, he declared that Cairo "contains, I think, more idle people than any town its size in the world."[9]

The vice of idleness was frequently commented upon by Western travelers to Islamic countries in the nineteenth century, and in relation to it, we can observe still another striking absence in the annals of Orientalist art: the absence of scenes of work and industry, despite

the fact that some Western observers commented on the Egyptian fellahin's long hours of back-breaking labor, and on the ceaseless work of Egyptian women engaged in the fields and in domestic labor.[10]

When Gérôme's painting is seen within this context of supposed Near Eastern idleness and neglect, what might at first appear to be objectively, described architectural fact turns out to be *architecture moralisée*. The lesson is subtle, perhaps, but still eminently available, given a context of similar topoi: these people—lazy, slothful, and childlike, if colorful—have let their own cultural treasures sink into decay. There is a clear allusion here, clothed in the language of objective reportage, not merely to the mystery of the East, but to the barbaric insouciance of Moslem peoples, who quite literally charm snakes while Constantinople falls into ruins.

What I am trying to get at, of course, is the obvious truth that in this painting Gérôme is not reflecting a ready-made reality but, like all artists, is producing meanings. If I seem to dwell on the issue of authenticating details, it is because not only Gérôme's contemporaries, but some present-day revisionist revivers of Gérôme, and of Orientalist painting in general, insist so strongly on the objectivity and credibility of Gérôme's view of the Near East, using this sort of detail as evidence for their claims.

The fact that Gérôme and other Orientalist "realists" used photographic documentation is often brought in to support claims to the objectivity of the works in question. Indeed, Gérôme seems to have relied on photographs for some of his architectural detail, and critics in both his own time and in ours compare his work to photography. But of course, there is photography and photography. Photography itself is hardly immune to the blandishments of Orientalism, and even a presumably innocent or neutral view of architecture can be ideologized.

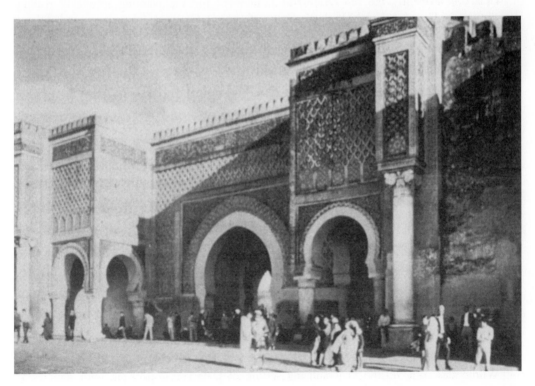

Figure 31.2 "Official" tourist photograph of the Bab Mansour.

A commercially produced tourist version of the Bab Mansour at Meknes [Figure 31.2] "orientalizes" the subject, producing the image the tourist would like to remember—picturesque, relatively timeless, the gate itself photographed at a dramatic angle, reemphasized by dramatic contrasts of light and shadow, and rendered more picturesque by the floating cloud which silhouettes it to the left. Plastic variation, architectural values, and colorful surface are all played up in the professional shot; at the same time, all evidence of contemporaneity and contradiction—that Meknes is a modern as well as a traditional city, filled with tourists and business people from East and West; that cars and buses are used as well as donkeys and horses—is suppressed by the "official" photograph. A photo by an amateur [Figure 31.3], however, foregrounding cars and buses and the swell of empty macadam, subordinates the picturesque and renders the gate itself flat and incoherent. In this snapshot, Orientalism is reduced to the presence of a few weary crenellations to the right. But this image is simply the bad example in the "how-to-take-good-photographs-on-your-trip" book which teaches the novice how to approximate her experience to the official version of visual reality.

But of course, there is Orientalism and Orientalism. If for painters like Gérôme the Near East existed as an actual place to be mystified with effects of realness, for other artists it existed as a project of the imagination, a fantasy space or screen onto which strong desires—erotic, sadistic, or both—could be projected with impunity. The Near Eastern setting of Delacroix's *Death of Sardanapalus* [Figure 31.4] (created, it is important to emphasize; before the artist's own trip to North Africa in 1832) does not function as a field of ethnographic exploration. It is, rather, a stage for the playing out, from a suitable distance, of forbidden passions—the artist's own fantasies (need it be said?) as well as those of the doomed Near Eastern monarch.

Delacroix evidently did his Orientalist homework for the painting, probably reading descriptions in Herodotus and Diodorus Sicilis of ancient Oriental debauchery, and dipping into passages in Quintus Curtius on Babylonian orgies, examining an Etruscan fresco or two, perhaps even looking at some Indian miniatures.[11] But it is obvious that a thirst for accuracy was hardly a major impulse behind the creation of this work. Nor, in this version of Orientalism—Romantic, if you will, and created forty years before Gérôme's—is it Western man's power over the Near East that is at issue, but rather, I believe, contemporary Frenchmen's power over women, a power controlled and mediated by the ideology of the erotic in Delacroix's time.

"In dreams begin responsibilities," a poet once said. Perhaps. Certainly, we are on surer footing asserting that in power begin dreams—dreams of still greater power (in this case, fantasies of men's limitless power to enjoy the bodies of women by destroying them). It would be absurd to reduce Delacroix's complex painting to a mere pictorial projection of the artist's sadistic fantasies under the guise of Orientalism. Yet it is not totally irrelevant to keep in mind that the vivid turbulence of Delacroix's narrative—the story of the ancient Assyrian ruler Sardanapalus, who, upon hearing of his incipient defeat, had all his precious possessions, including his women, destroyed, and then went up in flames with them—is subtended by the more mundane assumption, shared by men of Delacroix's class and time, that they were natu-rally "entitled" to the bodies of certain women. If the men were artists like Delacroix, it was assumed that they had more or less unlimited access to the bodies of the women who worked for them as models. In other words, Delacroix's private fantasy did not exist in a vacuum, but in a particular social context which granted permission for as well as established the boundaries of certain kinds of behavior.

Within this context, the Orientalizing setting of Delacroix's painting both signifies an extreme state of psychic intensity and formalizes that state through various conventions of

Figure 31.3 The Bab Mansour at Meknes. Courtesy of Linda Nochlin.

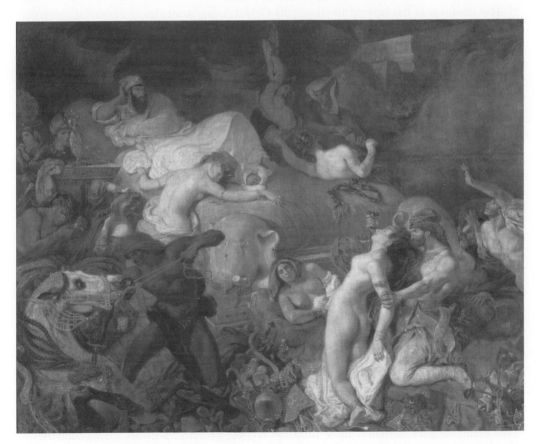

Figure 31.4 Eugène Delacroix, *Death of Sardanapalus*, 1827–8. © Photo RMN – Hervé Lewandowski.

representation. But it allows only so much and no more. It is difficult, for example, to imagine a *Death of Cleopatra*, with voluptuous nude male slaves being put to death by women servants, painted by a woman artist of this period.[12]

At the same time he emphasized the sexually provocative aspects of his theme, Delacroix attempted to defuse his overt pictorial expression of men's total domination of women in a variety of ways. He distanced his fears and desires by letting them explode in an Orientalized setting and by filtering them through a Byronic prototype. But at the same time, the motif of a group of naked, beautiful women put to the sword is not taken from ancient versions of the Sardanapalus story, although the lasciviousness of Oriental potentates was a staple of many such accounts.[13] Nor was it Byron's invention but, significantly, Delacroix's own.[14]

The artist participates in the carnage by placing at the blood-red heart of the picture a surrogate self—the recumbent Sardanapalus on his bed. But Sardanapalus holds himself aloof, in the pose of the philosopher, from the sensual tumult which surrounds him; he is an artist-destroyer who is ultimately to be consumed in the flames of his own creation-destruction. His dandyish coolness in the face of sensual provocation of the highest order—what might be called his "Orientalized" remoteness and conventionalized pose—may indeed have helped Delacroix justify to himself his own erotic extremism, the fulfillment of sadistic impulse in the painting. It did not satisfy the contemporary public. Despite the brilliant feat of artistic semisublimation pulled off here, both public and critics were for the most part appalled by the work when it first appeared in the Salon of 1828.[15]

The aloofness of the hero of the piece, its Orientalizing strategies of distancing, its references to the *outré* mores of long-dead Near Eastern oligarchs fooled no one, really. Although criticism was generally directed more against the painting's supposed formal failings, it is obvious that by depicting this type of subject with such obvious sensual relish, such erotic panache and openness, Delacroix had come too close to an overt statement of the most explosive, hence the most carefully repressed, corollary of the ideology of male domination: the connection between sexual possession and murder as an assertion of absolute enjoyment. [. . .]

Like other artists of his time, Gérôme sought out instances of the picturesque in the religious practices of the natives of the Middle East. This sort of religious ethnographic imagery attempted to create a sleek, harmonious vision of the Islamic world as traditional, pious, and unthreatening, in direct contradiction to the grim realities of history. On the one hand, the cultural and political violence visited on the Islamic peoples of France's own colony, Algeria, by specific laws enacted by the French legislature in the sixties had divided up the communally held lands of the native tribes. On the other hand, violence was visited against native religious practices by the French Society of Missionaries in Algeria, when, profiting from widespread famine at the end of 1867, they offered the unfortunate orphans who fell under their power food at the price of conversion. Finally, Algerian tribes reacted with religion-inspired violence to French oppression and colonization; in the Holy War of 1871, 100,000 tribesmen under Bachaga Mohammed Mokrani revolted under the banner of Islamic idealism.[16]

It is probably no coincidence that Gérôme avoided French North Africa as the setting for his mosque paintings, choosing Cairo instead for these religious *tableaux vivants*, in which the worshipers seem as rigid, as rooted in the intricate grounding of tradition and as immobilized as the scrupulously recorded architecture which surrounds them and echoes their forms. Indeed, taxidermy rather than ethnography seems to be the informing discipline here: these images have something of the sense of specimens stuffed and mounted within settings of irreproachable accuracy and displayed in airless cases. And like the exhibits displayed behind glass in the natural-history museum, these paintings include everything within their boundaries—everything, that is, except a sense of life, the vivifying breath of shared human experience.

What are the functions of the picturesque, of which this sort of religious ethnography is one manifestation? Obviously, in Orientalist imagery of subject peoples' religious practices one of its functions is to mask conflict with the appearance of tranquillity. The picturesque is pursued throughout the nineteenth century like a form of peculiarly elusive wildlife, requiring increasingly skillful tracking as the delicate prey—an endangered species—disappears farther and farther into the hinterlands, in France as in the Near East. The same society that was engaged in wiping out local customs and traditional practices was also avid to preserve them in the form of records—verbal, in the way of travel accounts or archival materials; musical, in the recording of folk songs; linguistic, in the study of dialects or folk tales; or visual, as here.

Yet surely, the very notion of the picturesque in its nineteenth-century manifestations is premised on the fact of destruction. Only on the brink of destruction, in the course of incipient modification and cultural dilution, are customs, costumes, and religious rituals of the dominated finally *seen* as picturesque. Reinterpreted as the precious remnants of disappearing ways of life, worth hunting down and preserving, they are finally transformed into subjects of aesthetic delectation in an imagery in which exotic human beings are integrated with a presumably defining and overtly limiting decor. Another important function, then, of the picturesque—Orientalizing in this case—is to certify that the people encapsulated by it, defined by its presence, are irredeemably different from, more backward than, and culturally inferior to those who construct and consume the picturesque product. They are irrevocably "Other." [. . .]

How then should we deal with this art? Art historians are, for the most part, reluctant to proceed in anything but the celebratory mode. If Gérôme ostensibly vulgarizes and "naturalizes" a motif by Delacroix, he must be justified in terms of his divergent stylistic motives, his greater sense of accuracy, or his affinities with the "tonal control and sense of values of a Terborch or a Pieter de Hooch."[17] In other words, he must be assimilated to the canon. Art historians who, on the other hand, wish to maintain the canon as it is—that is, who assert that the discipline of art history should concern itself only with major masterpieces created by great artists—simply say that Orientalists like Gérôme—that is to say, the vast majority of those producing Orientalist work in the nineteenth century (or who even appeared in the Salons at all) —are simply not worth studying. In the view of such art historians, artists who cannot be included in the category of great art should be ignored as though they had never existed.

Yet it seems to me that both positions—on the one hand, that which sees the exclusion of nineteenth-century academic art from the sacred precincts as the result of some art dealers' machinations or an avant-garde cabal; and on the other, that which sees the wish to include them as a revisionist plot to weaken the quality of high art as a category—are wrong. Both are based on the notion of art history as a positive rather than a critical discipline. Works like Gérôme's, and that of other Orientalists of his ilk, are valuable and well worth investigating not because they share the aesthetic values of great art on a slightly lower level, but because as visual imagery they anticipate and predict the qualities of incipient mass culture. As such, their strategies of concealment lend themselves admirably to the critical methodologies, the deconstructive techniques now employed by the best film historians, or by sociologists of advertising imagery, or by analysts of visual propaganda, rather than those of mainstream art history. As a fresh visual territory to be investigated by scholars armed with historical and political awareness and analytic sophistication, Orientalism—or rather its deconstruction—offers a challenge to art historians, as do many other similarly obfuscated areas of our discipline.

Notes

1 Organized by Donald A. Rosenthal, the exhibition appeared at the Memorial Art Gallery, University of Rochester (Aug. 27–Oct. 17, 1982) and at the Neuberger Museum. State University of New York, Purchase (Nov. 14–Dec. 23, 1982). It was accompanied by a catalogue-book prepared by Rosenthal. This article is based on a lecture presented in Purchase when the show was on view there.

2 Donald A. Rosenthal, *Orientalism: The Near East in French Painting 1800–1880* (Rochester, 1982), pp. 8–9, italics added.

3 The insights offered by Said's *Orientalism* (New York, 1978) are central to the arguments developed in this study. However, Said's book does not deal with the visual arts at all.

4 Driault, pp. 187 ff., cited in George E. Kirk, *A Short History of the Middle East* (New York, 1964), pp. 85–86.

5 J. F. B., "Gérôme, the Painter," *The California Art Gallery* 1–4 (1873): 51–52. I am grateful to William Gerdts for bringing this material to my attention.

6 Leo Bersani, "Le Réalisme et la peur du désir," in *Littérature et réalité*, ed. G. Genette and T. Todorov (Paris, 1982), p. 59.

7 Richard Ettinghausen in *Jean-Leon Gérôme (1824–1904)*, exhibition catalogue, Dayton Art Institute, 1972, p. 18. Edward Said has pointed out to me in conversation that most of the so-called writing on the back wall of the *Snake Charmer* is in fact unreadable.

8 Roland Barthes. "L'Effet de reél," in *Littérature et réalité*, pp. 81–90.

9 Cited by Kenneth Bendiner, "The Portrayal of the Middle East in British Painting 1835–1860," Ph.D. Dissertation. Columbia University, 1979, pp. 110–11. Bendiner cites many other instances and has assembled visual representations of the theme as well.

10 See, for example, Bayle St. John's *Village Life in Egypt*, originally published in 1852, reprinted 1973, I, pp. 13, 36, and passim.

11 The best general discussion of Delacroix's *Death of Sardanapalus* is Jack Spector's *Delacroix: The Death of Sardanapalus*, Art in Context Series (New York, 1974). This study deals with the relationship of the work to Delacroix's psychosexuality, as well as embedding the painting in the context of its literary and visual sources. The footnotes contain references to additional literature on the painting. For other discoveries about Delacroix's use of Oriental sources, see D. Rosenthal. "A Mughal Portrait Copied by Delacroix," *Burlington Magazine* CXIX (1977): 505–6, and Lee Johnson, "Towards Delacroix's Oriental Sources," *Burlington Magazine* CXX (1978): 144–51.

12 Cabanel's *Cleopatra Testing Poisons on Her Servants* (1887) has been suggested to me by several (male) art historians as coming close to fitting the bill. But of course the scenario is entirely different in Cabanel's painting. First of all, the male victims are not the sex objects in the painting: it is their female destroyer who is. And secondly, the painting is, like Delacroix's, by a man, not a woman: again, it is a product of male fantasy, and its sexual *frisson* depends on the male gaze directed upon a female object, just as it does in Delacroix's painting.

13 For a rich and suggestive analysis of this myth in the seventeenth and eighteenth centuries, see Alain Grosrichard, *Structure du Sérail: La Fiction du despotisme asiatique dans l'occident classique* (Paris, 1979).

14 This is pointed out by Spector throughout his study, but see especially p. 69.

15 For public reaction to the picture, see Spector, pp. 75–85.

16 Claude Martin, *Histoire de l'Algérie française, 1830–1962* (Paris, 1963), p. 201.

17 Gerald Ackerman, cited in Rosenthal, *Orientalism*, p. 80. Also see Ackerman, *The Life and Work of Jean-Léon Gérôme* (London and New York: Sotheby's, 1986), pp. 52–53.

S. HOLLIS CLAYSON

PAINTING THE TRAFFIC IN WOMEN

THE EXISTENCE OF PROSTITUTION on a scale so widespread and obvious that it alarmed contemporaries was a distinctive and distinguishing feature of nineteenth-century Parisian culture.[1] And as Parisian streets filled with prostitutes, so did French art and literature. Beginning in the early July Monarchy (1830–48), the prostitute became a regular presence in paintings, poems, prints, and novels and remained so through the end of the century and beyond. It would appear, then, that nineteenth-century French art on the subject of contemporary prostitution mimetically paralleled the rise of a "prostitute problem" in the capital city. This study of a group of such images concurs that the artworks depended upon the events and ideas of their time. That real prostitutes were constant points of reference for artists in the nineteenth century is undeniable. Indeed, in most instances later in the century, artists attempted to depict observable practices. Yet although it is clear that the prostitution problem and the outpouring of images of prostitutes coexisted, the precise correlation between these two phenomena is less certain. Explaining that relationship will be the principal goal of the present work, which focuses upon art made during the 1870s and 1880s.

The generation of artists and writers that matured during the reign of Louis-Philippe was the first to experience the new trademark of modern city life: conspicuous sexual commerce in the streets. For although the prostitute population of Paris was considered large and unruly enough to require systematized police regulation as early as 1800 (the year Napoleon created the office of *préfet de police*), it was during the 1830s that the number of prostitutes working openly in Paris increased dramatically.[2] The steep rise was a consequence of the demographic upheavals of the period: it was among the most striking social by-products of the first stage of growth of the modern industrial city. The women who swelled the ranks were job-seeking migrants from the countryside and unemployed (or underemployed) Parisian laborers. The demand for women in the labor force reached a low point in the middle third of the century, making prostitution a viable, even necessary, choice.[3] The prostitutes' customers were mostly partnerless male workers recently arrived from the provinces, as well as some middle- and upper-class Parisians fleeing from or lacking access to sexual contact with their female social equals.

The consequent impact of prostitution on Parisian life in the 1830s was vivid, and it is therefore not surprising that the first comprehensive, now-classic study of Parisian prostitution, that of A. J. B. Parent-Duchâtelet, was undertaken at this time (the first edition appeared in 1836).[4] The outpouring of representations of prostitutes from many writers and some artists disposed to focus upon modern subjects was in large measure inspired by the newly eroticized contours of city life. Generally speaking, though, artists and writers of the July Monarchy who focused upon prostitutes in their work tended to use them as symbols of the degraded morals or oppressive politics of their time. For example, Alfred de Musset wrote his lugubrious "Rolla" in 1833, Honoré de Balzac's ambitious *Splendeurs et misères des courtesanes* was written between

1839 and 1847, Eugène Sue's *Mystères de Paris* appeared in feuilleton in 1842–43, and Thomas Couture seized upon the prostitute as the perfect symbol of societal decadence in the painting that dominated the Salon of 1847 and was the star turn of his career, *Les Romains de la décadence*, In the same year Alexandre Dumas fils wrote *La Dame aux camélias*.

After a hiatus during the Second Republic (1848–51), the use of the prostitute and the adulteress as principal topoi of modern life in art and literature resumed and continued throughout the Second Empire (1851–70). As in the July Monarchy, the population of clandestine prostitutes (clandestine in the sense of being unregulated by the police) increased during this period. But the Second Empire came to be associated with a particular order of clandestine prostitute: the glittering courtesan, who emulated the fashions and refined postures of the upper echelons of bourgeois and court society. In the 1850s and 1860s representations of the prostitute centered on this figure. This occurred because there were highly visible "real" courtesans to depict, to be sure, but also because the rebuilding of the city by Baron Georges Haussmann and Emperor Napoléon III produced social fears explicitly tied to a discomfort with the blurring of social boundaries in Paris – a state of affairs that artists and moralists alike often found embodied by the courtesan.[5] [. . .]

In this work I recognize the durability and malleability of the theme of prostitution in French art throughout the nineteenth century. Indeed, to paraphrase Griselda Pollock, it is a striking fact that many canonical works held up as the founding monuments of modern art deal with female sexuality, and do so in the form of commercial exchange.[6] My concern is to contribute to an understanding of the extrapictorial reasons for this gendered pattern of representation, but I aim to demonstrate the specificities of a particular episode in the iconography of the prostitute during that century. Lying between well-known earlier and later moments of concentration on the theme of prostitution in the arts, this less-studied case was a no less intense outpouring of artistic enthusiasm for the prostitute. [. . .]

The years with which I am concerned are, of course, the years of Impressionism. Between 1874, the year of the first Impressionist exhibition, and 1886, the year of the eighth and final group show, the Impressionist group forged a high-profile group identity, and its distinctive professional strategy and generally shared style were widely acknowledged. Although the Impressionist attraction to certain subjects of modernity is well known and widely studied,[7] members of the Impressionist circle (like their pompier and caricaturist contemporaries) portrayed aspects of contemporary Parisian prostitution in their art of the late 1870s and early 1880s with greater frequency than has been observed heretofore. One of the principal reasons the presence of this theme in Impressionist works has been overlooked is the gendered nature of art historical practice. The narrative evasiveness of certain pictures in question has also helped to mask the prominence of this theme. Unlike the story-telling clarity that courted outrage in the case of the best-known prostitute picture of the Second Empire, Manet's *Olympia* and another troublemaking Salon picture, Courbet's *Young Ladies on the Banks of the Seine (Summer)*, key images from the later years appear instead to be merely slices of random vision – spectacles of sight, tableaux of disinterested visuality without appeal to the mind – so disorganized that it is difficult to state with any certainty what these painters have to say about their subject matter.

Elucidating the connection between, on the one hand, covert prostitution as subject matter and, on the other, evasiveness as narrational strategy among artists who operated within Impressionist circles during the 1870s and 1880s is among the principal goals of this book. Indeed it has always seemed paradoxical that during the time that naturalist writers specialized in the subject of contemporary prostitution, vanguard visual artists did not appear inclined to deal with the same thematic materials. I shall show that Manet, Degas, and Renoir, for

example, were also compelled by the subject during the same years but treated the theme elliptically in their public works, especially when these works are compared to the explicit imagery of their literary contemporaries and of their artistic predecessors and successors. The reserve of many avant-garde depictions of prostitutes certainly departs from the bluntness of contemporaneous pompier and caricatural treatments of the same subject. We shall see, however, that the differences between the various styles of address of the theme of prostitution did not prevent the sundry male-produced artworks from reinforcing certain female stereotypes. In other words, I shall argue that the detachment engendered by avant-garde haphazardness was much more apparent than real, that their self-consciously casual and ambiguous depictions served to reinforce stereotypical notions about the sexual instability, if not patent immorality, of "public women." This was especially pronounced in their images of working-class clandestine prostitutes.

Representations of the urban prostitute were, of course, shaped by changes in the practice and conceptualization of prostitution in the period. Paris during the early Third Republic was the stage of a heated debate on the status and morality of tolerated prostitution: just after the suppression of the Commune in 1871, concern erupted about the continuing expansion of covert prostitution and male sexual demand.[8] It appeared certain that the municipal system of regulation, called *réglementation*, was losing its ability to control the profession. Similar concerns had surfaced in the 1830s and 1860s, during which the population of clandestine prostitutes had increased markedly. Around 1880, however, the number of registered prostitutes reached an all-time low (about three thousand in 1883–84), and the collapse of the system appeared imminent. Partially as a consequence of such dispiriting statistics, the "neo-regulationist" hysteria of the partisans of the regulatory system in the early Third Republic was noticeably more shrill than the parallel outbursts of the regulationists of the 1830s and 1860s.

Through their "illegal" work in the expanding covert sexual economy, it appeared that prostitutes were responsible for altering the quality of social life. Indeed, it appeared that, thanks to them, social life was turning into economic life. At the same time, women's behavior seemed less governable and female morality seemed less stable than ever before. The question "Is she or isn't she?" became a commonplace obsession of Parisian men and women. The illustration "Paris Regenerated" [Figure 32.1], whose effectiveness depends upon the comic interchangeability of its figures from different social strata, clearly portrays this conundrum of modern life.

I shall argue that the avant-garde images of the contemporary prostitute made in the unsettled atmosphere of the 1870s and earlier 1880s were responses to the new meanings that were accruing to both the registered and unregistered prostitutes of the day.

The literature of modernity describes the experience of males.[9] Three men, Charles Baudelaire, Georg Simmel, and Walter Benjamin, were pivotal observers of metropolitan life; each saw the prostitute as the most typical figure of urban modernity, because under capitalism, they concurred, the modern social relationship tended increasingly to take the form of a commodity. In their diverse writings, all three pinpointed a lamentable and calculated cooling-off in personal relations as a trademark of modern life.

In the early 1900s, Simmel became the first theoretician of modern culture to posit the existence of a distinctively metropolitan mentality, which he called intellectualist, as opposed to emotional.[10] In Simmel's social theory, the proliferation of this consciousness was tied to the money economy. Largely because of her intrinsic connection with the operations of the money economy, the prostitute emblemizes the gulf between subjective and objective culture

LE MONDE COMIQUE 971

PARIS RÉGÉNÉRÉ

— Une femme du monde et une cocotte...
— Bah! quelle est la cocotte?

A la gare de l'Ouest.
Un gros négociant de province arrive pour as-
sister aux couches de sa fille, mariée à Paris.
Son gendre — un confrère — l'attend sur le
quai.

— Eh bien? lui dit le gros homme.
— C'est fait... une fille...
— F...! s'écria le provincial furieux, on aurait
bien pu m'attendre!
Louis XIV n'eût pas mieux trouvé.

Figure 32.1 Tricoche, "Paris Regenerated," *Le Monde Comique*, 1875–6 and *La Vie Amusante*, 1878–9. Cliché Bibliothèque nationale de France, Paris.

that Simmel finds characteristic of modern life. For Simmel, an exchange with a prostitute is both briefer and colder than any other transaction conducted in the society or the economy. "Only transactions for money," Simmel wrote,

> have that character of a purely momentary relationship which leaves no traces, as is the case with prostitution. With the giving of money, one completely withdraws from the relationship; one has settled matters more completely than by giving an object, which, by its contents, its selection, and its use maintains a wisp of the personality of the giver. Only money is an appropriate equivalent to the momentary peaking and the equally momentary satisfaction of the desire served by prostitutes, for money establishes no ties, it is always at hand, and it is always welcomed. . . . Of all human relationships, it is perhaps the most significant case of the mutual reduction of two persons to the status of mere means. This may be the most salient and profound factor underlying the very close historic tie between prostitution and the money economy – the economy of "means."[11]

In Simmel's view, paying for a physical sensation guarantees a double debasement: the experience is both impersonal and of short duration.

For Walter Benjamin, the prostitute's role in the subterranean Parisian economy qualifies her, like no other modern urban figure, for the position of matchless signifier of alienated relations under capitalism. Benjamin adumbrates this conclusion in the course of a demanding commentary on Baudelaire:

> The modern is a main stress in [Baudelaire's] poetry. . . . But it is precisely the modern which always conjures up prehistory. That happens here through the ambiguity which is peculiar to the social relations and events of this epoch. Ambiguity is the figurative appearance of the dialectic at a standstill. This standstill is Utopia, and the dialectical image therefore a dream image. The commodity clearly provides such an image: as fetish. . . . And such an image is provided by the whore, who is seller and commodity in one.[12]

The famous last line of the paragraph projects the doubled symbolic role of the prostitute in the society and economy of the modern city: like no other merchant, like no other good or service for sale, she is all of them at once.

Benjamin's use of "ambiguity" in his discussion of modern social relations parallels Simmel's discussion of the "purely momentary" quality of an exchange for money, the quintessentially modern transaction. Together these ideas constitute a second identity for the nineteenth-century prostitute. She is the living embodiment of the cold cash nexus but is ambiguous, evanescent, and transient as well – a conceptualization at the center of Baudelaire's thinking about the culture of his day. In his widely quoted prescription for modernity, Baudelaire wrote of the need for a dialectical art that could adequately address and record the Janus-faced quality of the new urban experience: "By 'modernity' I mean the ephemeral, the fugitive, the contingent, the half of art whose other half is the eternal and the immutable."[13]

In the characteristically guarded yet actively scrutinizing glance of the prostitute, Baudelaire saw condensed the typical gaze of the modern Parisian, "Her eyes, like those of a wild animal, are fixed on the distant horizon; they have the restlessness of a wild animal . . . but sometimes also the animal's tense vigilance." Simmel has agreed that such prehensile visuality is distinctively modern. It was left to Walter Benjamin to connect Baudelaire's words, quoted above, to Simmel's thoughts: "That the eye of the city dweller is overburdened with protective functions is obvious. Georg Simmel refers to some less obvious tasks with which it is charged. 'The person who is able to see but unable to hear is much more . . . troubled than the person who is able to hear but unable to see. Here is something . . . characteristic of the big city. The interpersonal relationships of people in big cities are characterized by a markedly greater emphasis on the use of the eyes than on that of the ears.'"[14]

We can begin to see that the attraction to prostitution was pervasive in these years – appealing especially to avant-garde painters of modern life but to many men in the larger culture as well – because "she" marked the point of intersection of two widely disseminated ideologies of modernity: the modern was lived and seen at its most acute and true in what was temporary, unstable, and fleeting; and the modern social relation was understood to be more and more frozen in the form of the commodity. In the 1870s and earlier 1880s, prostitution occupied an overdetermined place at the point of intersection of these two ideological structures. Hence, the two seemingly antithetical qualities of modernity central to the avant-garde could be resolved in the figure of the prostitute. . . .

The vulnerability of certain men to the confusing demands of the modern sexual market-place is manifest in a series of pictures of brothels painted by Paul Cézanne between 1870 and 1877. Although Cézanne's quirky series seems to be an unusually transparent record of some of the doubts, worries, and fantasies of a bourgeois living through the changes in the sexual economy in the big city, it also introduces one of the trademarks of the avant-garde project as it took shape during this period: the effort to contain and order the anxieties provoked by the modern sexualized woman in general and by the contemporary prostitute in particular.

Between approximately 1870 and 1877, Cézanne painted at least three images of Olympia.[15] He called his Olympias modern and based them, of course, upon Edouard Manet's *Olympia* of 1863. Cézanne's purpose was not documentary, nor did he pretend it to be, but these phantasmic homages to Manet by way of Delacroix address the theater of enticement that existed in the deluxe brothels of Cézanne's day. In so doing, the images confront one of the principal developments in the sexual marketplace of the 1870s but also educate us more generally about the logic (and illogic) of male desire – the force that produced and orchestrated the obsession with prostitution during this period in the first place.

In the first two pictures in the series – both titled *A Modern Olympia*, the former painted circa 1869–70 [Figure 32.2], the latter in 1872–73 – the man resembles the artist. This suggests that the pictures had a special personal significance for the painter, because he was not in the habit of including himself in his narrative paintings. The resemblance also suggests that these visions of just-unveiled prostitutes may correspond to the artist's own sexual feelings in ways that are unfamiliar and uncommon in the relatively cool, objective, and normative vanguard painting of the era. Think, for example, of its icily controlled eponym, Manet's *Olympia*, painted in 1863.

Of the idiosyncratic personal quality of some of Cézanne's early paintings, especially his pictures of women, Meyer Schapiro wrote: "In several early works by Cézanne, inspired by Manet, sexual gratification is directly displayed or implied. . . . Cézanne's pictures of the nudes show that he could not convey his feeling for women without anxiety. In his painting of the nude woman, where he does not reproduce an older work, he is most often constrained or violent. There is for him no middle ground of simple enjoyment."[16] Schapiro goes on to argue that for Cézanne the unmanageability of his strong sexual feelings for women led him to displace the theme of eros onto the realm of still life – in particular, onto an idealized and perfectly equilibrated cosmos of apples. The point is that Cézanne could not control the disclosure of his own uneasiness with women and that his strong sexual feelings for women were incommensurable with the normative painting of the nude. Schapiro concludes sensibly that the marked uneasiness on view in some early paintings is what led him eventually to set aside the theme of sexual fantasy and gratification.

Cézanne exhibited the second Olympia, *A Modern Olympia*, painted in 1872–73, in the first "Impressionist" exhibition in the spring of 1874. Lionello Venturi has found the painting to be ironic,[17] but in 1874 critics found it to be a deeply disturbed and disturbing painting. The champion of naturalism, Jules Castagnary, for example, found that the picture was spoiled by fantasy and romanticism, both utterly personal in origin and therefore anathema to Castagnary: "From idealization to idealization, they will end up with a degree of romanticism that knows no stopping, where nature is nothing but a pretext for dreams, and where the imagination becomes unable to formulate anything other than personal, subjective fantasies, without trace of general reason, because they are without control and without the possibility of verification in reality."[18] Emile Cardon did not like Cézanne's painting either, because he worried that the public might wrongly take the product of a disturbed artist as a seriously

intentioned work: "One wonders if there is in this an immoral mystification of the public, or the result of mental alienation that one can do nothing but deplore."[19] Marc de Montifaud's review was deeply sarcastic but full of interest for this study because she found Cézanne's little picture to be a failed effort at Baudelairean imagery. She consequently situated the image within a world framed by fantasy, literature, and opiates. She wrote:

> Sunday's public decided to laugh at this fantastic figure presented in an opium-filled sky to an opium smoker. This apparition of a little rose-colored, naked flesh that is thrust upon him, in the cloudy empyrean, a kind of demon, who presents herself as an incubus, like a voluptuous vision, this corner of artificial paradise has overwhelmed the bravest, it must be said, and M. Cézanne appears to be nothing other than a kind of fool, painting while agitated with *delirium tremens*. People have refused to see, in this creation inspired by Baudelaire, an impression caused by oriental vapors which had to be rendered under the bizarre sketch of the imagination. The incoherence of it, does it not have the quality, the particular character of laudatory sleep? Why look for an indecent joke, a scandalous motif in *Olympia*? In reality it is only one of the extravagant forms of haschisch borrowed from the swarm of drole visions which should still be hidden away in the hôtel Pimodan.[20]

The fantasies on view in Cézanne's pictures were hardly Cézanne's exclusive property. In the 1870s and 1880s, along with what I have already identified as the *embourgeoisement* of male sexual ideals came a preference for forms of prostitutional practice in which desire – "real feeling" – was convincingly simulated: the "new" male sexuality demanded a new sexual style for the "modern" female deviant.[21] For the up-to-date consumer in the changing sexual marketplace, a Simmelian cold-as-cash, heartless coupling would not do. By the late 1870s, these increasingly widespread demands were channeled toward two sectors of the venal sexual marketplace: the *maison de luxe* (Cézanne's terrain) and various forms of clandestine prostitution. The modern man wanted either a dash of recherché aristocratic eroticism (the trademark of the deluxe brothel) or a simulation of bourgeois romance (the specialty of many clandestine prostitutes).

Cézanne's attraction to the fabled allure of the stylized, romantic forms of eroticism offered in the deluxe brothel of the 1870s no doubt motivated the series. The tension in his pictures bespeaks an altogether modern clash: that between the fantasies of perfect pleasure to be found in such a place and the anxiety that desire will not be fully mutual, that the man will fail to excite the woman. A less-than-ideal erotic experience would threaten to remind the man of his sexual vulnerability. Finding pleasure in the deluxe brothel of this period was apparently a difficult job. The client was to appropriate the woman's desire as well as her body. But the attainment of the Baudelairean delights that awaited the successful customer would have made the risk of failure (of humiliation, of impotence?) worth taking. Cézanne's *Olympia* series addresses these problems.

In the earliest of Cézanne's pictures [Figure 32.2], the nude woman perches precariously on the draped bed in a surprising position that hints at an unfamiliarity with or dislike for the place: her legs are drawn up beneath her so that she squats while leaning forward and seems to anchor herself on the pillow with her crossed elongated arms. She looks directly at the dark profile of the timorous man who leans back slightly from the spectacle before him. The circumstances of his meeting with her are dramatized by the dark, bare-breasted servant behind the bed who raises a fan, enacting the rhetoric of presentation.

Figure 32.2 Paul Cézanne, *A Modern Olympia*, c. 1869–70. © Collection Roger-Viollet.

The anatomical features of this young woman provide a key to what this fantastic picture may be about. Her rounded body, pretty face, and long wavy hair exempt her from the stereotype of the lower-class, quotidian prostitute. (Or, to speak in shorthand, her attitude as well as her appearance would be out of place in Edgar Degas's brothel). The theatrical or operatic quality of the setting and space of the picture conjures up Delacroix more than it does any naturalist picture dating from the Second Empire.

There is a marked difference in scale between the woman and the man that exaggerates the distance between them and implies a gulf between the client and the displayed woman. The oversized baroque vase of flowers at the right edge is in his part of the picture and seems to substantiate the "real" world of the near space inhabited by him and to dematerialize the brightly lit "imaginary" world whose two female inhabitants appear as if projected on a screen

before him. The man is the solitary consumer of a confusing spectacle: an attractive young woman is bestowed upon him, but her participation in the transaction seems tentative. She is not made to appear forbidding or dangerous; in fact her precarious pose softens and offsets the drama of her prominence in the space and in the ostensible sexual narrative of the picture. She even appears frail, unpracticed at the role thrust upon her.

This nonrational picture, with its discontinuities of scale and inconsistent, occasionally expressionist handling (the vase, the flowers, and the man's profile), is connected to forms of contemporary Parisian brothel prostitution in real if implicit ways. In it a thoroughly modern anxiety is given form: a classic fantasy of voluptuousness has gone wrong at the eleventh hour. The picture is therefore a melancholy reverie about a missed opportunity in an imaginary world tailor-made for sensual enjoyment. Disappointment, it appears, in the theater of enticement.

The facial features of the pretty young woman are neutral and calm and contribute to the impression that this is a somewhat sad representation of a self-deprecating fantasy. The tentativeness and frailty of Cézanne's Olympia contradict what a man might expect – whether his expectations were shaped by Baudelaire, Delacroix, or reports of deluxe urban brothels of a beautiful unclothed young woman lying before him, and only him, on an ornamental bed surrounded by the trappings of a specialized, luxurious place of sensual pleasures.

It represents luxuriant sex just out of reach, because the woman provider of potential sexual gratification folded up and withdrew the offer. Cézanne suggests that the customer's inadequacy – his own? – destroyed the fantasy. And the veteran of the realm of "*luxe, calme et volupté*," Olympia, is a temporarily unavailable amateur in Cézanne's picture. It represents a spoiling of the man's prospects for indulging his fantasy, but not, it seems, a total disbelief in the substance of the fantasy that remains otherwise intact: she *is* beautiful and the room would have been the perfect arena for sensual enjoyment. The underpinning of the fantasy is a dream of voluptuous expert sex with no strings attached. But there is despair in the picture about the realization of this desire. Perhaps Cézanne reveals in this brothel image an unconscious realization of the fragility and elusiveness of this illusion in the modern world. Thus the modernity of this Olympia.

The 1872–73 picture takes up the same theme and reuses the same format, but its irony and humor are new. The ironic and humorous tone of this canvas, vis-à-vis the tentative and sad 1870 painting, is a consequence of changes in both the handling and the story. The uniform choppiness of the paint strokes and the staging of the unveiling on the bed as an ongoing process greatly increase the staccato activity of the picture, especially in the imaginative far space. The fragile curving woman of the 1870 version has been replaced by a rough, slightly grotesque caricature, which modifies the meeting of the man and the woman. The folded-up posture takes on a different significance: this woman rests fully on the left side of her angular and distorted body, which appears to be a natural and stable position rather than an unsure and wavering one. This Olympia is far from conventionally pretty and soft or poised. The client's aspect has also changed. His solidly anchored sitting position and the addition of hat and cane give him an air of composure and savoir-faire as he looks in and up at the pink Olympia edged in blue shadows, an Olympia who lies and crouches before him, only for him. The painting presents a lively and available grotesque regarded without apparent emotion by the seated man.

The mutual lack of conviction in the meeting between the two in the 1870 version has been replaced by an altogether more confident and urbane exchange: the sophisticated gentleman is unmoved by the extraordinary spectacle before his eyes. The man – the artist? – is shown to be under full emotional control but appears slightly foolish. Certain accessories in the room add to the burlesque quality of the scene: the jaunty, vibrating deep red table

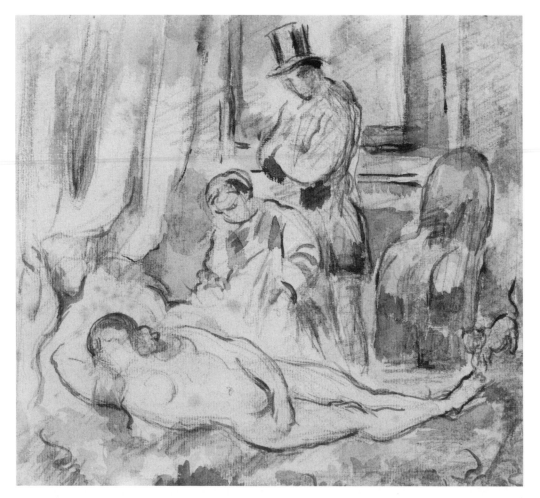

Figure 32.3 Paul Cézanne, *Olympia*, c. 1877. Courtesy of Philadelphia Museum of Art: The Louis E. Stern Collection.

and the impudent terrier. Here is an interior equipped and furnished exclusively for the pleasure and indulgence of the senses, but when the covering is swept off the woman, something incongruous is revealed.

This image seems witty and even slightly absurd compared to the 1869–70 version, but the absurdity of the situation carries an altered message, a subtly changed view of the prospects for and even the desirability of sexual gratification in luxurious circumstances. The fantasy of voluptuousness is here unmistakably diluted – undone – by the recognition of the implausibility of finding gratifying and uncommercialized sensual pleasure in the deluxe sexual marketplace. Yet Cézanne has somewhat distanced the client (himself) from the experience of disappointment with this turn of events by granting him (himself) greater control over the situation and, by extension, over the venal woman.

Cézanne's third *Olympia*, the watercolor version done around 1877 [Figure 32.3], presents a view of prostitute, servant, and client substantially different from the two discussed above. Although painted in a more generalized style, the setting of the work seems less fantastic:

most of the operatic equipment is gone, replaced by a common armchair, framed mirror, modestly dressed domestic, and man *en habit noir*. The servant and client contemplate the featureless, reclining blond nude from above. They seem to watch her, stare at her, as if she were a person apart, as though they were mourners or concerned visitors attending someone suffering from a serious if uncommon illness. Olympia is stiffly arranged, rigid like a naked corpse, with arms pressed into frozen contradictory imitations of sensuality (behind the head) and modesty (the chaste hand at the groin).

The bearing of her two spectators hints at a bewilderment; they seem to manifest focused concern but at the same time remain somewhat detached and immobile, all the while fundamentally in control of the situation. The two onlookers are differentiated from each other: the woman sits or kneels and leans slightly forward; the man stands behind her with his arms folded, more removed than she from the blond nude, whom he looks at nonetheless. The intensity of their scrutiny of Olympia is suggested by the dark strokes that denote their eye cavities. These faint indications of facial features are all the more significant because the nude's face is empty. Olympia's separation and tense immobility are enhanced by the cat, whose arched back and flaring eyes in Manet's original had stood for sensuality gone rampant, which now saunters in casually from the right edge of the painting.[22] The forms of this watercolor – its heavy, dark, vibrating contour lines, strongly rectilinear structure, and blocky transparent patches of colored wash (reds, yellows, greens, and blues) – freeze the picture's imagery of a conundrum.

Perhaps the puzzlement of Olympia's small but privileged entourage – the collaborator in the provision of paid pleasures and the potential consumer of her sexual services – is, at one level, provoked by her immobility, by her simply not acting according to the sexual agenda. But, perhaps, the puzzlement exists on, and is caused by, another level of bewilderment: the confusion in finding that there is no mystery, no eroticism in this nakedness. Another reading of the third *Olympia* is equally in order. The reclining figure of the prostitute (her body marks out the flat base of the picture's triangular order) is held down by the two stares, although she has no eyes of her own. This conventional Salon-type nude appears fixed, pinned down, rigorously controlled – in every way unlike the 1870 *Olympia*.

The sequence of Olympia images shows that there was a marked change, one might even say a development, in Cézanne's portrayal of this subject over a seven-year period, what we might today call a deconstruction of the fantasy of perfect voluptuousness in the lair of the beautiful, erotically able prostitute. The change in the series shows an increasing awareness of the impossibility of finding pleasure in the sexual marketplace, while the direction of the images is also toward an ever-greater containment of female force and male anxiety.

The direction taken by Cézanne's thoughts and feelings on this subject is vividly exemplified by his *The Eternal Feminine*, done at the same time as the watercolor version of Olympia (circa 1877).[23] In this picture, a nude, faceless woman is enthroned beneath a canopy while a gathering of men from diverse professions (painter, bishop, musicians among them) surround and pay tribute to her. This outpouring of veneration is hardly portrayed as a serious ritual but rather as a caricature of the homage paid blindly to sexualized womankind – her faceless nudity and vagina-shaped awning the signs of her sexualization. Cézanne seems to have found the theme of the luxury prostitute (the woman of *The Eternal Feminine* fits that definition as well) appropriate to his increasing pessimism (or even cynicism) about finding "real" eroticism in its old fantastic forms in the modern world and his increasing effort to gain control over his means of representation and over the themes he chose to paint.

A watercolor done about 1880, entitled (apparently by Cézanne himself) *The Courtesan's Toilette* [Figure 32.4], duplicates the scenario of the 1877 *Olympia*, but with small and telling

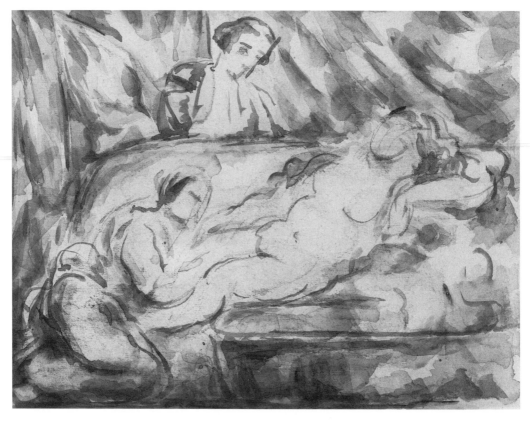

Figure 32.4 Paul Cézanne, *The Courtesan's Toilette*, *c.* 1880. Arkansas Arts Center Foundation
Purchase: 1994. 1994.002. Courtesy of the Arkansas Arts Center.

alterations. The changes constitute an image that closes off the pictorial and ideological cycle
Cézanne initiated with the *Modern Olympia* of 1869–70.

A maidservant and a man appear bewildered by the reclining courtesan, but the modern
dress and furnishings of the 1877 *Olympia* are replaced by an archaic, romantic-biblical setting
complete with tub. Most important, in this case Cézanne appended a text which, though
crossed out, has been deciphered to read:

> When she rises from the bath, the [zealous ?] servant
> pours on perfumes for her refreshment.
> And, with breasts palpitating and head thrown back,
> free from care she takes in the intrusive glances.[24]

With this ensemble of picture and poem, Cézanne has restored a vexing theme to the safer
world of literature, vouchsafed its generality and timelessness, and protected himself
from appearing to have enlisted his own libidinal feelings in its construction. With the last
line of his rather pathetic poem, Cézanne struggled to demodernize the subject matter of
desire in the fantasy brothel. Instead of the trademark "burning glances" of the professional,
deluxe prostitute, his literary courtesan appears nonplussed by the prospect of an admirer's
importunate advances. But the strain to return to the fantasy bordello of a Delacroix is

borne out by the patent mismatch between the text and the picture: the onlooker is stiff and inactive, the courtesan almost equally so.

This examination of a small group of images by Cézanne introduces in microcosm a central theme of my book: the ways in which the painters of the Parisian avant-garde devised the means to attain an appearance of truthful representation of and detachment from the charged subject of contemporary prostitution, while simultaneously perfecting a strategy of ideological containment of the erotic force of the women portrayed. I shall be tracking what becomes a trademark of vanguard art of the 1870s and 1880s: the devising of pictorial styles that appear to avoid (and evade) the explicit "expression" of sexual feelings, while at the same time achieving a measure of control over "their" elusively described women. [. . .]

Notes

1 The most important study of prostitution in nineteenth-century France is Alain Corbin, *Les Filles de noce: Misère sexuelle et prostitution aux dix-neuvième et vingtième siècles*, Paris, 1978. A good general overview of the rise of urban prostitution across Europe is Richard Evans, "Prostitution, State and Society in Imperial Germany," *Past and Present* 70 (1976): 106–29. [. . .]

2 See Jill Harsin, *Policing Prostitution in Nineteenth-Century Paris*, Princeton, N.J., 1985.

3 Gordan Wright, *France in Modern Times*, 3d ed. New York, 1981, pp. 178–179 and 294–95; and Louise A. Tilly and Joan W. Scott, "Women's Work and the Family in Nineteenth-Century Europe," in *The Family in History*, Charles E. Rosenberg (ed.), Philadelphia, 1975, pp. 146–47.

4 The best recent discussions of Parent-Duchâtelet's work are Alain Corbin's introduction to an abridged edition of the 1836 work, Alexandre Parent-Duchâtelet, *La Prostitution à Paris au dix-neuvième siècle*, Paris, 1981, pp. 9–55; and Charles Bernheimer, "Of Whores and Sewers: Parent-Duchâtelet, Engineer of Abjection," *Raritan* 6, no. 3 (Winter 1987): 72–90. Charles Bernheimer's *Figures of Ill Repute: Representing Prostitution in Nineteenth-Century France*, Cambridge, Mass., 1989, published after the final draft of this book was complete, appeared too late for my consideration and response.

5 T.J. Clark, *The Painting of Modern Life: Paris in the Art of Manet and His Followers*, New York, 1984, chaps. 1 and 2.

6 Griselda Pollock, "Modernity and the Spaces of Femininity," in *Vision and Difference: Femininity, Feminism and Histories of Art*, London, 1988, p. 54.

7 On the matter of Impressionist images and ideologies of modernity, the most important (though divergent) work to date has been done by T.J. Clark, *Modern Life*, and Robert L. Herbert, *Impressionism: Art, Leisure and Parisian Society*, New Haven, 1988. The particulars of my debts to (and quibbles with) each are acknowledged in what follows.

8 Alain Corbin, *Le Filles de noce*.

9 Janet Wolff, "The Invisible Flâneuse: Women and the Literature of Modernity," *Theory, Culture and Society* 2, no. 3 (1985): 37–46; and Pollock, *Vision and Difference*, pp. 50–90.

10 Georg Simmel, "The Metropolis and Mental Life" [1903], in *Georg Simmel: On Individuality and Social Forms*, Donald N. Levine (ed.), Chicago, 1971, pp. 324–39.

11 Georg Simmel, "Prostitution" [1907], in Levine, *Georg Simmel*, pp. 121, 122. [. . .]

12 Walter Benjamin, "Paris: The Capital of the Nineteenth Century" [1955], in *Charles Baudelaire: A Lyric Poet in the Era of High Capitalism*, Harry Zohn (trans.), London, 1973, p. 171.

13 Charles Baudelaire, "The Painter of Modern Life – Modernity" [1863], translated excerpt reprinted in *Modern Art and Modernism: A Critical Anthology*, Francis Frascina and Charles Harrison (eds.), New York, 1982, p. 23.

14 Quoted in Benjamin, "Some Motifs in Baudelaire," in *Baudelaire*, p. 151.

15 In Lionello Venturi, *Cézanne: Son art, son oeuvre*, Paris, 1936, the three works are identified as follows: *Une Moderne Olympia*, 1870, no. 106; *Une Moderne Olympia*, 1872–73, no. 225; and *Olympia*, 1875–77, no. 882. In his *Cézanne*, Geneva, 1978, Venturi revised the date of the third work to 1872–74. In dating it ca. 1877, I am following John Rewald, *Paul Cézanne: The Watercolors*, Boston, 1983, no. 135. And in dating the earliest of the three works ca. 1869–70, I am following Lawrence Gowing et al., *Cézanne: The Early Years, 1859–1872*, edited by Mary Anne Stevens, London, Royal Academy of Arts, catalog 40, 1988, pp. 150–51.

16 Meyer Schapiro, "The Apples of Cézanne: An Essay on the Meaning of Still-Life," in *Modern Art: Nineteenth and Twentieth Centuries: Selected Papers*, New York, 1978, pp. 9–10.

17 Venturi, *Cézanne* (1936), vol. 1, p. 115.

18 [. . .] Jules Castagnary, "L'Exposition du boulevard des Capucines, les impressionnistes," *Le Siècle*, Apr. 29, 1874; reprinted in *Centenaire de l'impressionnisme*, 2d ed., Paris, Editions des musées nationaux, 1974, pp. 235, 265.

19 [. . .] Emile Cardon, "L'Exposition des révoltés" *La Presse*, Apr. 29, 1874; reprinted in *Centenaire de l'impressionnisme*, p. 263.

20 [. . .] Marc de Montifaud [Marie-Amélie Chartroule de Montifaud], "Exposition du boulevard des Capucines," *L'Artiste*, May 1, 1874; reprinted in *Centenaire de l'impressionisme*, pp. 235, 267.

21 Corbin, *Les Filles de noce*, p. 249. [. . .]

22 Two of Cézanne's earlier watercolors also use a black cat in a context of sexual love. In both of them, the cat joins a naked reclining woman and man who are waited on by a servant bearing food. In Rewald's catalog of the watercolors, *Cézanne's Watercolors*, they are identified as: no. 34, *Le Punch au rhum*, 1866–67, and no. 35, *L'Après-midi à Naples*, 1870–72.

23 There are two of these, one oil on canvas and one watercolor. The oil on canvas version of *L'Eternel féminin*, Venturi (*Cézanne*, 1936), no. 247 is dated 1875–77. The watercolor version, also titled *L'Eternel féminin*, is Rewald, *Cézanne Watercolors*, no. 57, dated 1877. It is Venturi (1936), no. 895, dated 1875–77; Venturi (*Cézanne*, 1978), revised the date to ca. 1877. Simone de Beauvoir (*The Second Sex*, p. 168) reminds us that Cézanne's title is taken from the last lines of Goethe's *Faust*: "The Eternal Feminine/Beckons us upward."

24 [. . .] According to Rewald (*Cézanne Watercolors*, p. 118), "[Adrien] Chappuis has deciphered the lines written in ink beneath the watercolor and subsequently blotted out by the artist with a brush (the last word of the first line being cut off)." In Venturi (1936) it is no. 884, dated 1875–77; in Venturi (1978) the author revised the date to 1872–74. I am following the most up-to-date scholarship – Rewald, in *Cézanne Watercolors*, no. 137 – in dating it ca. 1880. (This poem sounds about as bad as the one by Zacharie Astruc that Manet appended to his *Olympia* in the Salon of 1865.)

ERIC AMES

FROM THE EXOTIC TO THE EVERYDAY
The ethnographic exhibition in Germany

In memory of Susanne Zantop

Under the sign of Hagenbeck

Anthropological exhibitions: Performances of representative foreign peoples for the satisfaction of visual pleasure and the dissemination of anthropological knowledge. In 1875, Hagenbeck first brought a group of Laplanders with their huts, tools and weapons, and exhibited them in Hamburg, Berlin and Leipzig; they were followed by groups of Nubians, Eskimos, Patagonians, Tierra del Fuegans, Sinhalese, Hindus, Indians and Cameroonians, some of which were also exhibited in France and England. After Hagenbeck, others have staged similar shows, such as Buffalo Bill's Wild West, which claimed to depict life in Western North America.

Meyers Konversations-Lexicon, 1893

ANTHROPOLOGICAL EXHIBITIONS were defined in Imperial Germany by the work of one showman in particular, Carl Hagenbeck (1844–1913). Hagenbeck began importing and displaying non-Western people in 1875 as an extension of his family-run trade menagerie in Hamburg. The phenomenal success of this "ethnographic" enterprise made the name Hagenbeck synonymous with an entire genre of nineteenth-century visual culture and marked his debut as an impresario of the exotic. When his 1883 Mongolian troupe appeared at the Berlin Zoological Garden, more than 93,000 visitors attended the show in a single day.[1]

Hagenbeck coined the word *Völkerschau* (or "show of peoples") for the various modes of human display that he and other impresarios popularized from the mid-1870s to the early 1910s.[2] Over the course of his career, Hagenbeck assembled and exhibited more than seventy troupes, which ranged in size from a family of three to a caravan of four hundred people. Each show constructed a particular geographical area or cultural group. As itinerant performances they appeared in pubs, museums, fairgrounds, velodromes, vaudeville houses, and world's fairs, but they ultimately landed in zoological gardens such as Hagenbeck's zoo in Hamburg. Here, re-created villages achieved epic scale, featuring dozens of huts, shrines, and other buildings, spread out across sculpted landscapes stocked with flora and fauna, and situated adjacent to outdoor zoological panoramas.

In the showman's memoir, *Beasts and Men* (1908), Hagenbeck claimed to have launched his ethnographic enterprise in order to recover a portion of his losses from a sharp drop in

the animal business, as a kind of insurance policy against the stock market crash of 1873 and the Long Depression which followed.[3] Yet ethnographic exhibitions gave the name Hagenbeck a remarkably robust currency of its own—a currency that traded in Germany and throughout the West. According to his first biographer,

> if Hagenbeck's name had already become known in his capacity as an animal trader, it became even more so through his ethnographic exhibitions, . . . with which he offered an undeniably great service: He gave to the millions of people who are unable to search out other kinds of fellow humans living in remote parts of the earth, in their homeland, the sight of them here among us.[4]

Hagenbeck's "service" can indeed be described as providing local access to remote places through the physical dislocation and display of foreign peoples. His ethnographic enterprise clearly responded to "the desire of contemporary masses to bring things 'closer' spatially and humanly," which Walter Benjamin would later attribute to cinema.[5]

This essay analyzes the practice of ethnographic exhibition in Wilhelmine Germany, concentrating on issues of human collection and display.[6] It seeks not only to investigate the case of Hagenbeck, but also to challenge some of our received ideas about ethnographic exhibition as a visual mode of dealing with the exotic. These ideas have been articulated recently in the form of two debates, one on the spectacle of empire, the other on early ethnographic cinema. On the one hand, building on the work of Edward W. Said, cultural theorists writing on the spectacle of empire (most notably Tony Bennett, Annie E. Coombes, Timothy Mitchell, and Mary Louise Pratt) have analyzed the discourse of vision in nineteenth-century museum displays, colonial exhibitions, and travel narratives. They explain how all of these forms typically deployed spectacle in order to arrest the audience's attention and redirect it toward some higher meaning, which was alternately defined in terms of Progress, History, or Empire.[7] On the other hand, film scholars (such as Alison Griffiths, Fatimah Tobing Rony, and Ellen Strain) have examined a similar array of materials—with the important addition of photography and other recording technologies—as pre-cinematic forms of virtual travel and ethnographic cinema. Thus, film historians have expanded and reinforced the now familiar argument that armchair anthropology functioned as a Western technique of power and authority.[8] While these debates reflect various theoretical concerns, they commonly suggest that nineteenth-century visual culture achieved its intended goal of making cultural difference visible. Moreover, researchers in both areas usually deal with the same (French, British, or American) examples that in one way or another visualize difference in evolutionary terms.

Now that the armchair anthropology paradigm is firmly in place, it needs to be tested. As James Clifford suggests, "A wholly appropriate emphasis on coercion, exploitation, and miscomprehension does not . . . exhaust the complexities of travel and encounter."[9] Hagenbeck offers a case in point, for his displays were neither intended nor arranged as visual corollaries of evolutionary narratives.[10] Instead, the German showman made a name for himself by exhibiting the everyday. While the lure of the exotic drew audiences to the *Völkerschau* in the first place, what they saw there was surprisingly familiar. In this essay, I argue that the ethnographic exhibition inadvertently counteracted its very premise that exotic peoples are inherently spectacular. I aim to show how live display de-exoticized the other, rendering it familiar and comprehensible, without destroying the lure of the exotic. The example of Hagenbeck complicates how we envision the relationship of visual culture to the imperial project because it highlights the lively interaction of sameness and difference that made

spectacles of empire popular with urban audiences. The *Völkerschau* thus represents much more than a "German" case of what we already know about ethnographic exhibitions.

At the same time, Hagenbeck's entertainments help shed light on the German imperial project in particular. According to Susanne Zantop, that project "articulated itself not so much in statements of intent as in 'colonial fantasies': stories of sexual conquest and surrender, love and blissful domestic relations between colonizer and colonized, set in colonial territory."[11] A prelude to German colonialism (1884–1919) and an unofficial part of it, the *Völkerschau* traded in "colonial fantasies" as well. In so doing, it corroborates Zantop's thesis that Germany's marginal role as a colonial power did not limit, but rather organized and expanded the colonialist imagination in Germany. Yet Hagenbeck's entertainments also offered alluring alternatives to what has been called the dominant colonial fantasy of late nineteenth-century Germany: "If precolonial fantasies had focused on ideal colonial relations and were set mostly in the New World, colonial fictions written during Germany's brief colonial interlude were inclined to stress the hardships and challenges of the actual 'colonial adventure' in Africa."[12] In contrast, ethnographic exhibitions stressed not only the ease, but also the thrill of "exotic" adventure around the world. Instead of focusing on Africa, Hagenbeck cast a wide net, beyond the range of Germany's colonial territories (as indicated by the 1893 entry from *Meyers Konversations-Lexicon*).[13] Adding visual culture to the study of colonial discourse likewise broadens our understanding of imperialism and the various forms it assumed in the context of Wilhelmine Germany.

This essay makes no attempt to undermine previous arguments about colonial fantasy and armchair anthropology. On the contrary, it seeks to excavate certain aspects of ethnographic exhibition that have never been seen or emphasized, in order to promote fresh discussion of nineteenth-century visual culture. There is nothing new or controversial about saying that Hagenbeck's entertainments were racist. They obviously were. Nor is there any question that entertainers and audiences generally thought of performers as different and therefore inferior; this is one of the most basic assumptions of ethnographic exhibition and spectatorship. What is so remarkable about this material, however, is the insistent attempt to render the foreign familiar, and thereby assimilate it into urban mass culture. My analysis therefore concentrates on the "vacillations" between familiarity and difference, as Edward Said has done in the context of Orientalism, in an effort to avoid flattening the complex relationship of inequality on which the ethnographic exhibition was ultimately based.[14] What such an approach brings to the study of nineteenth-century visual culture is an awareness of spectacle's dazzling power to harness familiarity for the purpose of representing cultural difference, and to mobilize the forces of identification in the service of empire and entertainment.

Circulation, collection, presence

> The expansion of Hagenbeck's enterprises, the animal trade as well as the ethnographic exhibition, was only possible in our era; earlier it would have been unthinkable. Only in the now highly developed system of railways and shipping lines, in connection with the telegraph and everything else that makes commerce flow today—only in this system was Hagenbeck in a position to plan and carry out these enterprises.
>
> Heinrich Leutemann, *Biography of the Animal Dealer*
> *Carl Hagenbeck*, 1887

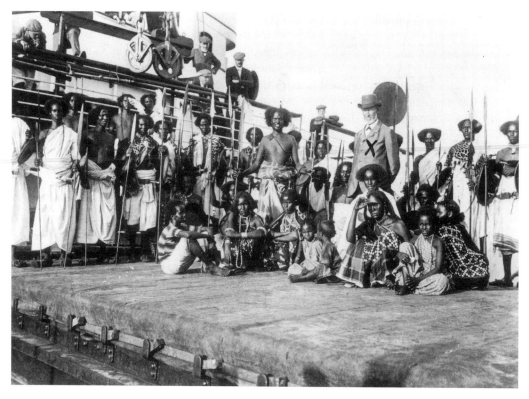

Figure 33.1 X marks the spot. Hagenbeck with Somali performers at the Hamburg docks, n.d.
Courtesy of Tierpark Carl Hagenbeck GmbH, Hamburg-Stellingen.

Hagenbeck's ethnographic project relied on an existing infrastructure, a rapidly expanding network of transportation and communication lines, which he was already using for his menagerie business. As a merchant, Hagenbeck had greater access to this network than was commonly available or affordable to urban audiences or even to professional scientists and entertainers. Between 1866 and 1886, he reportedly traveled an average of 50,000 kilometers a year by rail and steamship, to say nothing of the agents and performers who traveled in his service [Figure 33.1].[15] The circulation systems (railway, steamship, telegraph) that enabled the merchant to trade animals more widely and efficiently would now support the impresario in collecting and mobilizing foreign peoples.[16] Hagenbeck's new role as a showman strengthened his ties to the burgeoning industries of leisure and consumption in Wilhelmine Germany.[17] What these ties do not explain, however, is the relationship of human collection and circulation to the logic of ethnographic display.

In 1875, Hagenbeck enlisted his network of animal trappers for the first time in order to acquire, deliver, and exhibit humans. Urged by his friend Heinrich Leutemann, he decided to import and display a group of Sami (Laplanders), in addition to the reindeer that he was already having shipped to Germany from the upper reaches of Scandinavia.[18] The ensuing show, however unsophisticated, established certain standards that would define Hagenbeck's brand of ethnographic exhibition. As a genre, the *Völkerschau* involved three interrelated modes of display: the freak show, the everyday, and the theatrical.[19] Two of these modes already compete in the ur-narrative of Hagenbeck's ethnographic enterprise, as told by Leutemann:

With utmost excitement, I traveled to Hamburg in September, as soon as I received notice [from Hagenbeck] that the ship was about to arrive there, and—as we were both equally impatient—raced up the Elbe in a friend's boat, in order to intercept the steamship en route. As the incoming ship passed by, we climbed aboard through a hatch and suddenly found ourselves in between decks, right where the Lap woman, with her infant and a four year-old girl, had made herself comfortable. The sight was decisive in convincing us that the enterprise would succeed, and it was even more so when, walking up onto the deck, we found three yellow-brown, dwarfish Lap men together with their reindeer.[20]

Just as the picturesque view of a mother nursing her child anticipates the everyday mode of ethnographic display, the sight of "yellow-brown, dwarfish" men beside their reindeer recalls the established tradition of the freak show. Leutemann's description here invokes the notion of a continuum between animals and humans that freak shows typically posited. Unlike that tradition, however, the ethnographic exhibition was not about deception or "humbug," the watchword of P. T. Barnum.[21] Rather, Hagenbeck thought of himself as Germany's answer back to Barnum. By 1875, when the German made his debut as an impresario of the exotic, a powerful fascination with the "real" and the "authentic" had displaced the visual culture of hoaxing and huckersterism (as Barnum also recognized).[22] In contrast to the American showman, Hagenbeck would concentrate on exhibiting what he called "the real thing" (das Echte), the "typical" as opposed to the extraordinary. From that perspective, the "sight" of the Sami family

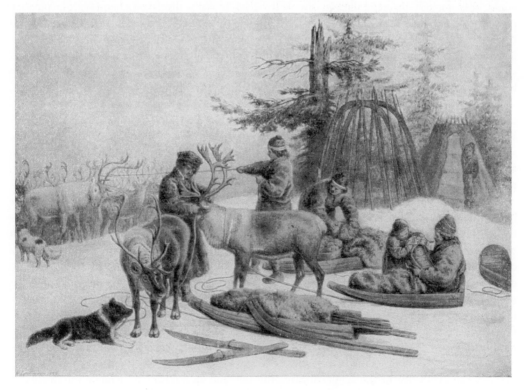

Figure 33.2 Laplanders, watercolor, Heinrich Leutemann, 1875, from Carl Hagenbeck's memoir, *Beasts and Men* (1908).

was in fact "decisive" for the success of his ethnographic enterprise. The move that Hagenbeck and Leutemann made upon boarding the ship—through a portal and into what seemed to be an everyday setting—was precisely the move that the impresario would urge audiences to make at the *Völkerschau* by offering them a voyeuristic look into the "real-life" activities of non-Western peoples. The depicted scenes here were so immediately recognizable that in other contexts they would have appeared mundane. In Hamburg, for instance, the Sami performed a variety of routine tasks before the public: assembling tents and sleds, ice skating, lassoing reindeer, cooking food, and nursing a baby. Each of these activities is depicted in Leutemann's 1875 watercolor, a synchronic summation of the show [Figure 33.2].

An animal painter by profession, Leutemann clearly envisioned the *Völkerschau* in pictorial terms. Hagenbeck's subsequent comments on this pastoral vision would undercut its importance, and with good reason, for

> what the artist had in mind was simply a picturesque Nordic scene, which he could only imagine in isolated perfection, complete with humans and animals, against a wintery background wherever possible. Nevertheless, hidden in this proposal was the happy idea of ethnographic exhibitions, which in the years to come followed one after another like a colorful chain.[23]

Though painting and illustration no doubt informed the ethnographic exhibition by providing a ready-made iconography of the exotic, as a frame of reference it fails to suggest the specific advantages of environmental display, which the showman evidently understood. What painting could only suggest through illusion the *Völkerschau* literally displayed: namely, the physical presence of human beings. In so doing, the ethnographic exhibition also distinguished itself from the museum tableau, as in the Scandinavian wax museum and folk museum, which tried in various ways to compensate for a mannequin's fundamental lack of presence and motion.[24]

At the same time, live displays such as Hagenbeck's developed a particular relationship between presence and absence in order to signify the "ethnographic." In human exhibitions, as Barbara Kirshenblatt-Gimblett has noted, "people become signs of themselves."[25] This semiotic manoeuvre enhanced the show's realism, creating a sense of unmediated encounter, without accounting for its specifically ethnographic effect. That effect was achieved by the show's use of synecdoche, a form of metonymy in which the part stands for the whole. In the *Völkerschau*, the individual body (or troupe) on display was posited as directly connected to the absent collective body (or people) for which it stood.

While this sign relation helped define itinerant performers as objects of ethnography, the "authenticity" of their performances relied on yet another maneuver, the denial of representation. Hagenbeck's assessment of the 1875 Sami show offers a case in point: "This first exhibition was a huge success, perhaps because the whole enterprise was conceived with a certain naïveté, like the presentations themselves. Our guests from the far North had no concept of display and everything that comes with it, and absolutely no performance was given."[26] On one level, this statement aims to retroactively support Hagenbeck's assertion that the Sami were "unspoiled natural people" and thus objects of anthropological knowledge.[27] On another level, it alludes to a particular strategy of mass entertainments which claim to merely offer up the real. According to Kirshenblatt-Gimblett, such hypermimetic entertainments involve "a suppression of *representation* markers and a foregrounding of *presentation* markers, an avoidance of the suggestion of 'theater' and an attempt to achieve the quality of pure presence, of a slice of life."[28] Indeed, as Leutemann observed, what most appealed to early audiences was not overt performance.

It was rather the unprompted activities that had an enormous allure for the public (only the ice skating show and the parade of people could be accurately called perform-ances). Of course, this allure was generated, above all, by the fact that everything appeared in the open air [*im Freien*], not in a circus or in a booth, which had the effect of winning authenticity.[29]

Extracting human display from the fairground milieu helped eschew the markers of repre-sentation, while appealing to the respectability of bourgeois audiences. In addition, this move out of the fairground booth and into the open air created new spaces of display, where more elaborate and "authentic" settings could be assembled.[30]

Rather than situate foreign performers in "isolated perfection," the *Völkerschau* surrounded them in a re-created environment custom built for each particular troupe. Whatever materials or existing structures could be dismantled, collected, and transported to Europe could also serve to furbish the depicted scene. A variety of accessories—tools, costumes, ornaments, musi-cal instruments, and cooking utensils—all served to bolster the setting's realism. These items were deemed authentic if they were collected "on location" by a foreign agent, or especially if they were brought to Germany by the performers themselves. Spectators and impresarios com-monly demonstrated a remarkable confidence in the setting's authenticity, in the physical token of the bodies, artifacts, and buildings on display. Audiences took particular interest in seeing the structures being built by the performers themselves. In that regard, the pleasures of look-ing reinforced the everyday mode of display and its emphasis on physical presence.

Ethnographic exhibitions recast the practice of human display by co-opting the exotic in the context of the everyday. The *Völkerschau* thus made a space for itself adjacent to other spectacles of the real, where it jostled for position as an urban entertainment. Just as the wax museum and the mass press rendered the everyday exotic, as Vanessa R. Schwartz has argued, the ethnographic exhibition created its niche by making the exotic familiar.[31]

Variations on a theme

Once the everyday mode of exhibition had been firmly established it provided the basis for extending the performance to include more overtly staged numbers and professionalized perfomers. During the late 1870s, in the face of growing competition, Hagenbeck began experimenting with different formulas for organizing display, above all, the variety program and the adventure story. These formulas were usually combined with one another, while augmenting other displays such as village installations. At the same time, Hagenbeck radically increased the number of animals, performers, and buildings on exhibit, a process that Leutemann described as "massification."[32] This process involved much more than an increase in the scale of production and a move toward more elaborate groupings; it meant the inte-gration of existing amusements into the space of ethnographic display. Hagenbeck transformed the *Völkerschau* into a diversified and kinetic show by incorporating blatantly staged perform-ances not exclusive to the ethnographic.

If "massification" demanded larger and more open spaces than the vaudeville house could offer, the *Völkerschau* adopted the program of that institution as a model for concatenating a diversity of spectacular performances and regulating them in a timely, flexible, and manage-able format. The program for Hagenbeck's 1902 "Indian Caravan: The Malabars" neatly demonstrates the principle:

1. Parade of the entire troupe. 2. Appearance of Indian acrobats, "the Gujaratis." 3. Gymnasts. 4. Gujarati Bird Dance. 5. Tightrope walkers. 6. Hindu acrobats (Shagonia, Fatma, Dolabie). 7. Indian magicians (Shekla und Sultan). 8. Sword swallowers and jugglers (Nagaiya and Wangatasamen). 9. Gujaratis on free-standing bamboo poles, hanging from knees, toes, and ankles. 10. Indian bayadères (temple dancers). 11. Gujaratis atop the bamboo pyramid, swinging from bamboo poles. 12. Fire and devil dancers.[33]

Ceremonial songs, religious rituals, dance numbers, circus tricks, and magic acts—all kinds of performances could be fit into the program. That each act was assigned a number and slotted into a routinized presentation helped audiences make sense of the show.

At first glance, the theatrical mode of display would seem to contradict the earlier focus on exhibiting the everyday with its appearance of unmediated encounter and its claim to authenticity. Yet the variety format served to make cultural difference more familiar to mass audiences (another form of "massification") by representing the exotic through a wider array of existing amusements. After visiting Hagenbeck's Indian Caravan in Berlin (which took place at the velodrome on Kurfürstendamm), a reporter for the *Berliner Illustrirte Zeitung* wrote a glowing review that began as follows:

India, the old land of magic has not yet lost so much of its national peculiarities and ancient customs through European culture as to already have acquired the veneer that blurs these international characteristics, which are apparent to everyone—a veneer that gradually makes countries and peoples the same, and thus decreases the varieties and particularities of the once so very colorful world crowd.

Rather than attacking the ethnographic exhibition as participating in the very process of nascent globalization that he critiques, this reporter offers up Hagenbeck's show as evidence that an "authentic" India can still be seen, not only in India, but also in Berlin. "At the moment, Berliners are able to see a piece of authentic, unaffected India, without the dangers of jungle poisons and tiger teeth, without the need for weapons in the belt or quinine in the pocket [a remedy for malaria]." Theatrical display apparently enhanced the experience of the show as a "slice of life." What is more, the combination of staged performance and *in situ* display suggested connections between the public and private spaces of everyday life in Berlin and the various spaces of ethnographic exhibition: "The ballet lover, who usually admires the arts of dell' Era in the Royal Opera House, can study the ur-forms of dance in the dancing of the Indian bayadères. No less interesting is the family life of the Malabars and Gujaratis. Berlin housewives can cast a glance into the kitchen of Indian women."[34] Indeed, the *Völkerschau* created new connections and identifications by "domesticating" difference. In other words, Hagenbeck concocted a potent mixture for vicarious travel and encounter: a small dose of danger plus enough familiarity for pleasure and security, "without the need for quinine."

The other formula that Hagenbeck used, beginning in the late 1870s, was the storyline. Instead of rehearsing evolutionary narratives, Hagenbeck's stories dramatized fictional conflicts between warring clans or ethnic groups.[35] In melodramatic fashion, they usually employed marriage as a device for "restoring peace" and achieving narrative closure. Wedding songs, dances, and other ceremonial performances followed; a "phantasia" or procession of humans and animals marked the proverbial happy ending. Narrative overlays served multiple functions at once: Structurally, they provided conventionalized and therefore recognizable formats for organizing sequences of dramatic numbers within a common framework, smoothing over

the abrupt cuts between the acts of a program otherwise typical of vaudeville. Thematically, narratives here intensified the audience's sensation of travel, inviting spectators to imagine themselves on safari with Hagenbeck, who was especially fond of re-enacting his own adventures abroad and inserting them into the show.[36] In the 1909 "Ethiopian Exhibition," for instance, the story revolves around a group of desert nomads who ambush a Hagenbeck animal transport.[37] That an animal trapper appeared as a figure in the show reinforced the identification of the spectacle with its sponsor. At the same time, every ethnographic performer was allotted a specific "character" in the story, as indicated by the employment contract for Hagenbeck's 1910 Sioux troupe.[38] Audiences were invited to identify not only with imaginary German adventurers, but also with non-Western characters tailor-made to fit local expectations.[39] Each of these formats—variety and narrative—rendered the exotic familiar by presenting it in a visual mode that was by this time entrenched in the West, and would later emerge in cinema.

Although Hagenbeck's exhibitions changed in many ways between 1875 and 1913, the showman consistently sought to offer a convincing expression of authentic space. For this reason, the construction of his private zoo or *Tierpark* in Stellingen (on the outskirts of Hamburg) marked the culmination not only of his career, as Hagenbeck understood it, but also of his ethnographic enterprise.

Open spaces, close encounters

Hagenbeck's *Tierpark* had less in common with zoological gardens than it had with amusement parks like Coney Island (where the showman also exhibited). In contrast to traditional zoos and museums, whose presentational modes Hagenbeck described as "dead" and "static," the *Tierpark* would offer a livelier, more dynamic and interactive performance.[40] The premiere site of ethnographic exhibition, its difference as an institution deserves comment.[41] This difference was announced by the name *Tierpark*, another coinage of Hagenbeck's, which combined the German words for animal garden (*Tiergarten*) and amusement park (*Vergnügungspark*). The term signaled to visitors that they would find there not an ordinary zoo, with its cages arranged according to genus and species, but a playful and touristic space. The world's first "open zoo" (*Freisichtanlage*), which opened to the public in 1907, the *Tierpark* eliminated the bars from the animal cage and replaced them with moats or trenches in order to permit unencumbered viewing. It invited audiences to explore the seemingly precarious boundaries that separated them from the wild animals on display. Hagenbeck's patented technique of cageless display derived in part from the ethnographic exhibition, with its emphasis on the thrills of presence and immediacy. The private zoo also offered an extensive site for amassing and arranging a diversity of existing amusements (spanning animal acts, outdoor panoramas, and magic lantern shows), all of which were "themed" around the exotic. This novel design made the *Tierpark* a tourist destination in its own right, listed in Baedeker's 1908 travel guide to Hamburg and its environs.[42] Yet Hagenbeck took a page out of Baedeker's book when it came to arranging ethnographic exhibitions at the *Tierpark*. Here, the *Völkerschau* fully elaborated its own touristic logic.

"On the Nile," the 1912 "Egyptian Exhibition," comprised a self-sufficient network of touristic settings, thirty-two in all, spread out across a section of the *Tierpark* devoted to ethnographic display. This network was clearly delineated by maps, signposts, and souvenir guidebooks. Like the paths that wound throughout the park, guidebooks helped move visitors past and sometimes even into the depicted scenes. In the manner of Baedeker guides,

Hagenbeck's brochures numbered each attraction and provided a brief description or photograph of it. Each number in the guidebook corresponded to a kind of street address mounted on the exterior of the appropriate building or station [see Figure 33.3]. Numerical, narrative, and iconic markers all served to give structure and coherence to the installation, organizing its sights so that they could be anticipated, imagined, and located. Work displays like "The Weaver," pictured here, were stock features of organized city tours in Paris and Berlin.[43] This example plainly demonstrates how the *Völkerschau* mimicked the urban logic of tourism. Hagenbeck not only appropriated conventions from guidebooks that served to make the city legible; he refunctionalized them in order to integrate the exotic into city space and render it comprehensible for urban audiences.[44]

At the *Tierpark*, Hagenbeck's exhibits were structured and experienced as shared space. They had an open-door policy, which invited customers inside to shop, play, and visit with the performers. Spectators strolling "On the Nile" could enter station "11. The Barber," sit down, and get a haircut "Oriental style"; a few doors down, they could lounge in an "Arabic Café" and drink an "authentic mocha" or take puffs on a water pipe.[45] Interactive attractions duplicated touristic services such as cafés, restaurants, and gift shops. The fact that performers served as roving salespeople, hawking postcards, brochures, and *cartes des visites* (for personal gain) throughout the park further blurred the boundaries between spectacle and spectator, if not between salesperson and customer.[46] This blurring of boundaries complicates Johannes Fabian's influential thesis that anthropological exhibitions situated non-Western performers in

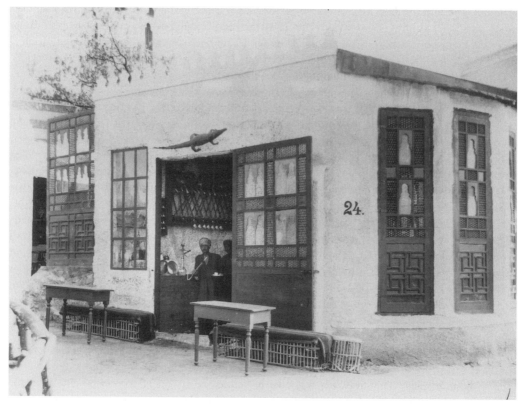

Figure 33.3 Station 24, "The Weaver," from Hagenbeck's 1912 "Egyptian Exhibition." Courtesy of Tierpark Carl Hagenbeck GmbH, Hamburg-Stellingen.

Figure 33.4 Hagenbeck-Bedouins, amateur photograph from Hagenbeck's 1912 "Egyptian Exhibition."
Courtesy of Tierpark Carl Hagenbeck GmbH, Hamburg-Stellingen.

a quasi-timeless realm, strictly separated from the time and space of Western observers.[47]
The presence of audiences and performers in shared space, which epitomized the increasingly
participatory aspect of Hagenbeck's exhibition, created a powerful sense of commonality that
competed with the expectation of difference.

This amateur photograph of the Egyptian Exhibition [Figure 33.4], one of the few existing
images that depict spectators (bourgeois women) as well as performers ("Bedouins"), seems
to capture the tension between commonality and difference that organized ethnographic exhibi-
tions. Most conspicuous here is the fence around the display, which visualizes the implicit
hierarchy of viewers and performers. Leutemann had earlier claimed that such barriers were
necessary if the foreign was to maintain its appeal to European audiences.[48] Less obvious in
this photograph is the powerful desire of spectators and performers alike to slip through the
fence or even trample over it. In fact, barriers were increasingly used to protect the performers
from throngs of prying visitors. Policemen were sometimes recruited to enforce these divisions,
but even they could not always contain the crowd or the yearning for closeness and contact.[49]

Though historical spectator accounts are extremely rare, there is no shortage of anec-
dotes about illicit encounters between visitors and performers. During the summer of 1896,
for instance, the Viennese writer Peter Altenberg frequented the "Ashanti Village" at the
Vienna Zoo, where he regularly entered the display space and mingled with the performers.
His 1897 collection of poetic sketches, *Ashantee*, describes the daily life of the performers and
the crowds who came to watch them. Altenberg's "participatory" mode of observation outraged
conservative Viennese audiences. In response, he not only criticized the majority of spectators

who saw the Ashanti as profoundly different; he also detailed his amorous adventures with various female performers. For some viewers, the sight of Altenberg living among the Ashanti was a sure sign of the bohemian's "degenerate" status; on the opposite side of the spectrum, he merely acted out a transgressive fantasy that he shared with other viewers.[50] To give only one example, Hagenbeck's 1878 Nubian troupe set off a "Nubian craze" among female spectators. At the Berlin Zoo, policemen were called in to separate pairs of German women and Nubian men, who refused to leave the zoo and board a train for Dresden (where the scene would later repeat itself).[51] These anecdotes elicit the forces of identification that operated indirectly at the *Völkerschau* and contended with its visual stereotypes of difference—forces that transgressed and destabilized the barriers that were intended to construct distinct spaces of identity.[52]

Ethnographic exhibitions have often been interpreted as visual corollaries of scientific knowledge or as spectacles of imperial power and authority. The example of Hagenbeck no doubt upholds these arguments. At the same time, however, it readily demonstrates the connective dynamic of early mass culture where we least expect to find it. To understand the lure of the exotic for urban audiences, we must examine the particularly visual and mass-cultural logic of difference and identification that made ethnographic exhibitions work. This logic helps explain how difference could be integrated into the context of the everyday, creating connections as well as dissonances. Rather than imagine a visual economy based only upon difference, Hagenbeck's ethnographic enterprise suggests that spectacle needed the familiar in order to visualize the exotic and render it accessible to mass audiences, whose support was more essential to the imperial project than the work of any one impresario.

Notes

1 Carl Hagenbeck, *Von Tieren und Menschen: Erlebnisse und Erfahrungen von Carl Hagenbeck* (1908; Berlin-Charlottenburg: Vita Deutsches Verlagshaus, 1909), 96. All subsequent citations refer to this edition; all translations are my own, unless otherwise indicated. The showman's memoir is also available in English, *Beasts and Men: Being Carl Hagenbeck's Experiences for Half a Century among Wild Animals*, abbr. trans. Hugh S. R. Eliot and A. G. Thacker (London: Longmans, Green, and Col, 1909). I am grateful to Dr. C. Claus Hagenbeck for permission to do research at the Tierpark Carl Hagenbeck in Hamburg-Stellingen, and to Klaus Gille for his assistance in the archive. Special thanks go to Jennifer Bean, Jessica Burstein, Marcia Klotz, Uta Poiger, and Vanessa Schwartz for their helpful suggestions and comments on earlier versions of this essay.
2 After Hagenbeck died in 1913, his sons continued to sponsor human displays into the 1920s, but only on occasion. For a partial list of Hagenbeck's shows and attendance numbers, see Hilke Thode-Arora, *Für fünfzig Pfennig um die Welt: Die Hagenbeckschen Völkerschauen* (Frankfurt am Main: Campus, 1989), 168–72.
3 Hagenbeck, 80.
4 Heinrich Leutemann, *Lebensbeschreibung des Thierhändlers Carl Hagenbeck* (Hamburg: Hagenbeck, 1887), 48.
5 Walter Benjamin, "The Work of Art in the Age of Mechanical Reproduction," in *Illuminations*, ed. Hannah Arendt, trans. Harry Zohn (New York: Schocken, 1969), 223.
6 There are other aspects of Hagenbeck's project that I address elsewhere. See Eric C. Ames, "Where the Wild Things Are: Locating the Exotic in German Modernity" (Ph.D. diss., University of California, Berkeley, 2000).
7 See Edward W. Said, *Orientalism* (New York: Random House, 1978); Tony Bennett, *The Birth of the Museum: History, Theory, Politics* (London: Routledge, 1995); Annie E. Coombes, *Reinventing Africa: Museums, Material Culture and Popular Imagination in Late Victorian and Edwardian England* (New Haven: Yale University Press, 1994); Timothy Mitchell, *Colonizing Egypt* (Cambridge: Cambridge University Press, 1988); Mary Louise Pratt, *Imperial Eyes: Travel Writing and Transculturation* (London: Routledge, 1992).
8 See Alison Griffiths, *Wondrous Difference: Cinema, Anthropology, and Turn-of-the-Century Visual Culture* (New York: Columbia University Press, 2002); Fatimah Tobing Rony, *The Third Eye: Race, Cinema, and*

Ethnographic Spectacle (Durham: Duke University Press, 1996); Ellen Strain, "Exotic Bodies, Distant Landscapes: Touristic Viewing and Popularized Anthropology in the Nineteenth Century," *Wide Angle* 18, no. 2 (April 1996): 70–100.

9 James Clifford, *Routes: Travel and Translation in the Late Twentieth Century* (Cambridge, Mass.: Harvard University Press, 1997), 198.

10 In this respect, Hagenbeck catered to the anti-Darwinism of Berlin anthropologists. See Andrew Zimmerman, *Anthropology and Antihumanism in Imperial Germany* (Chicago: University of Chicago Press, 2001). For a different take on the scientific reception of ethnographic shows in Berlin, see my "The Sound of Evolution," *Modernism/modernity* 10, no. 2 (April 2003): 297–325.

11 Susanne Zantop, *Colonial Fantasies: Conquest, Family, and Nation in Precolonial Germany, 1770–1870* (Durham: Duke University Press, 1997), 2.

12 Sara Friedrichsmeyer, Sara Lennox, and Susanne Zantop, eds., introduction, *The Imperialist Imagination: German Colonialism and Its Legacy* (Ann Arbor: University of Michigan Press, 1998), 23.

13 Only a fraction of Hagenbeck's shows featured performers from the German colonies: Cameroon 1886 and Samoa 1889. The vast extent of his private enterprise and its undefined relationship to official colonial policy allowed Hagenbeck (unlike many other showmen) to continue mounting ethnographic exhibitions when, in 1900, the German Colonial Society launched a national campaign against the public display of German colonial subjects. This ban was intended to maintain an indigenous labor force as well as to control the image of Germany in the colonies. Commercial entertainments, so the argument ran, paid colonized people for "doing nothing at all," thus undermining their subservient position in a colonial economy, while granting them a certain degree of financial independence. Itinerant performers, moreover, would gain a dangerously "liberal" view of Germany through their own experiences there, particularly in the urban entertainment centers – a view that would ostensibly destabilize Germany's authority in the colonies. See D. Strauch, "Zur Frage der Ausfuhr von Eingeborenen aus den deutschen Kolonien zum Zwecke der Schaustellung," *Deutsche Kolonialzeitung* 44 (1 November 1900): 500; 45 (8 November 1900): 511, 513; 46 (15 November 1900): 520; Erich Prager, *Die deutsche Kolonialgesellschaft, 1882–1907* (Berlin: Reimer, 1908), 144.

14 Said, 21; see also 58, 67.

15 Leutemann, 76.

16 See Daniel R. Headrick, *The Tools of Empire: Technology and European Imperialism in the Nineteenth Century* (New York: Oxford University Press, 1981).

17 Hagenbeck's obvious ties to consumer culture need to be made explicit here because the history of consumer culture (not to mention its relationship to imperialism) in Germany remains largely unexplored. See Alon Confino, "Consumer Culture Is in Need of Attention: German Cultural Studies and the Commercialization of the Past," in *A User's Guide to German Cultural Studies*, ed. Scott Denham, Irene Kacandes, and Jonathan Petropoulos (Ann Arbor: University of Michigan Press, 1997), 181–8. On empire and commodity culture in other contexts, see Curtis M. Hinsley, "The World as Marketplace: Commodification of the Exotic at the World's Columbian Exposition, Chicago, 1893," in *Exhibiting Cultures: The Poetics and Politics of Museum Display*, ed. Ivan Karp and Steven D. Lavine (Washington: Smithsonian Institution Press, 1991), 344–65; Thomas Richards, *The Commodity Culture of Victorian England: Advertising and Spectacle, 1851–1914* (Stanford: Stanford University Press, 1990), 119–67; Anne McClintock, *Imperial Leather: Race, Gender and Sexuality in the Colonial Contest* (New York: Routledge, 1995), 207–31.

18 Hiring local people to capture wild animals and accompany them overseas was standard practice in the animal trade. Hagenbeck's decision to also exhibit those people required him to develop new criteria for the recruitment and selection of "natives" based less on their ability to handle animals and more on visual codes of cultural difference. See Thode-Arora, 59–67.

19 See on this point Balthasar Staehlin, *Völkerschauen im Zoologischen Garten Basel 1879–1935* (Basel: Basler Afrika Bibliographien, 1993), 61–9; Barbara Kirshenblatt-Gimblett, *Destination Culture: Tourism, Museums, and Heritage* (Berkeley: University of California Press, 1998), 17–78.

20 Leutemann, 49; cf. Hagenbeck, 80–1.

21 Neil Harris, *Humbug: The Art of P. T. Barnum* (Boston: Little, Brown, 1973); James W. Cook, *The Arts of Deception: Playing with Fraud in the Age of Barnum* (Cambridge, Mass.: Harvard University Press, 2001).

22 Harris, 173. For more on this visual culture of the "real," see Vanessa R. Schwartz, *Spectacular Realities: Early Mass Culture in Fin-de-Siècle Paris* (Berkeley: University of California Press, 1998).

23 Hagenbeck, 80.

24 See Mark B. Sandberg, *Living Pictures, Missing Persons: Mannequins, Museums, and Modernity* (Princeton and Oxford: Princeton University Press, 2003).

25 Kirshenblatt-Gimblett, 55.

26 Hagenbeck, 81.

27 Ibid., 82.

28 Kirshenblatt-Gimblett, 74; italics in the original.

29 Leutemann, 49.

30 For more on open-air display in other contexts, see Edward P. Alexander, *Museum Masters: Their Museums and Their Influence* (Nashville: American Association for State and Local History, 1983), 239–75; Edward N. Kaufmann, "The Architectural Museum from World's Fair to Restoration Village," *Assemblage* 9 (June 1989): 21–39.

31 Schwartz, op. cit.

32 Leutemann, 66.

33 "Gebr. Hagenbeck's Indische Carawane: Die Malabaren," program brochure (n.p., n.d.), 2; Hagenbeck Archive.

34 "Indische Gaukler in Berlin," *Berliner Illustrirte Zeitung*, 6 July 1902, p. 424.

35 Thode-Arora, 107; cf. Coombes, 102.

36 Thode-Arora, 111. See also Nigel Rothfels, *Savages and Beasts: The Birth of the Modern Zoo* (Baltimore and London: The Johns Hopkins University Press, 2002), 129–30.

37 Johannes Flemming, "Völkerschau Aethiopien," program brochure (Hamburg: Friedländer, n.d.); Hagenbeck Archive.

38 "Contract," signed by James Red Horse, 16 February 1910; Hagenbeck Archive.

39 In this respect, Hagenbeck's narratives should also be situated vis-à-vis popular literature, especially Karl May's famous *Winnetou* novels (1893–1910), the fictional adventures of a Teutonic cowboy who becomes the "blood-brother" of an Apache warrior (the title character). On audience expectations in European Wild West shows, see Robert Bieder, "Marketing the American Indian in Europe: Context, Commodification and Reception," in *Cultural Transmissions and Receptions: American Mass Culture in Europe*, ed. Rob Kroes, et al. (Amsterdam: VU University Press, 1993), 15–23; Karl Markus Kreis, "Indians Playing, Indians Praying: Native Americans in Wild West Shows and Catholic Missions," in *Germans and Indians: Fantasies, Encounters, Projections*, ed. Colin G. Calloway, Gerd Gemünden, and Susanne Zantop (Lincoln and London: University of Nebraska Press, 2002), 195–212.

40 Hagenbeck, 52.

41 For more on Hagenbeck's zoo, see Ames, "Where the Wild Things Are," 182–229.

42 Karl Baedeker, *Nordwest-Deutschland: (Von der Elbe und der Westgrenze Sachsens an, nebst Hamburg und der Westküste von Schleswig-Holstein) Handbuch für Reisende*, 29th ed. (Leipzig: Baedeker, 1908).

43 Dean MacCannell, *The Tourist: A New Theory of the Leisure Class* (1976; Berkeley: University of California Press, 1999).

44 See Peter Fritzsche, *Reading Berlin 1900* (Cambridge, Mass.: Harvard University Press, 1996); David Henkin, *City Reading: Written Words and Public Spaces in Antebellum New York* (New York: Columbia University Press, 1998).

45 Johannes Flemming, "Am Nil: Bunte Bilder aus Egypten dem Wunderlande der Pyramide," program brochure (Hamburg: Friedländer, 1912), 18, 26; Hagenbeck Archive.

46 Thode-Arora, 114. See also Rhonda Garelick, "*Bayadères, Stéréorama*, and *Vahat-Loukoum*: Technological Realism in the Age of Empire," in *Spectacles of Realism: Gender, Body, Genre*, ed. Margaret Cohen and Christopher Prendergast (Minneapolis: University of Minnesota Press, 1995), 310.

47 Johannes Fabian, *Time and the Other: How Anthropology Makes Its Object* (New York: Columbia University Press, 1983), 121.

48 Leutemann, 69.

49 In October 1880, for instance, a raucous crowd knocked down a fence at the Berlin Zoo in order to get a closer look at Hagenbeck's second Eskimo troupe. When the traveling impresarios (Johan Adrian Jacobsen and Adolph Schoepf) failed to disperse the crowd, they enlisted the help of an Inuit performer named Abraham, who recorded the episode in his diary. As Abraham notes, "I did what I could. Taking my whip and the Greenland seal harpoon I made myself terrible. One of the gentlemen was like a crier. Others quickly shook hands with me as I chased them out." Quoted and trans. in J. Garth Taylor, "An Eskimo Abroad, 1880: His Diary and Death," *Canadian Geographic* (October/November 1981): 40.

50 Staehlin, 87. On the effacement of barriers between performers and spectators in Altenberg's text, see Werner Michael Schwarz, *Anthropologische Spektakel: Zur Schaustellung "exotischer" Menschen, Wien 1870–1910* (Vienna: Turia and Kant, 2001), 195–8.

51 See Leutemann, 57–8; Hagenbeck, 84; Thode-Arora, 117–9; Staehlin, 89–91.

52 The "incidents" at Hagenbeck's 1878 Nubian show were explicitly cited by members of the Colonial Society in their petition to ban public exhibitions of German colonial subjects. Such displays, they argued, fostered cross-ethnic identification if not miscegenation, and therefore posed a threat to the efficacy of German authority both at home and abroad.

Chapter 34

MARCUS VERHAGEN

BOHEMIA IN DOUBT

I N A J O U R N A L I L L U S T R A T I O N O F 1 8 8 2 by the Bohemian artist Adolphe Willette [Figure 34.1], a penniless Pierrot gazes up at a Venus-like figure who is framed by a giant, radiating coin. A shabby Cupid shields her with a parasol and her airborne carriage is drawn by a host of bees—the bee apparently doing duty for the pimp.[1] It is clear from the windmills and sloping ground that the scene is set in Montmartre, home of the fin-de-siècle Parisian Bohemia. In recycling the figures of Venus and Cupid in a degraded contemporary setting, the image, like so many other Bohemian productions, satirizes academic painting. But it carries other, more insidious barbs. The prostitute-cum-Venus posits a connection between venality and female sexuality. She also points to the materialism of contemporary French society; the words "République Française" are pointedly visible on the coin behind her. Pierrot, for his part, transparently stands in for the penniless Bohemian. A figure from the *commedia dell'arte*, or traditional pantomime, Pierrot was typically both dreamy and impulsive—and so he is here. The image may even be understood as suggesting that Venus and her aerial cortege are figments of his imagination. That would make him dreamier still.

Plainly, the image is organized around a central opposition. Woman and mainstream society are both in thrall to material concerns and in this they stand in contrast to the impoverished Bohemian. Willette is at pains to point out the source of Pierrot's poverty: the mime is too dreamy to make a living, he is out of step with the instrumental thinking of a mercantile society.

The image shows that Willette, like others in Montmartre, was anxious to define Bohemia—and that he did so in part by pointing to all that it was not. It also shows that Bohemianism was imagined primarily in terms of a given lived orientation to material accumulation. That was the central difference between Bohemia and the various contemporary avant-gardes. The Bohemians had no coherent stylistic program, no ambition to rethink the relation of sign and referent. They generally had no truck with the high finish of academic

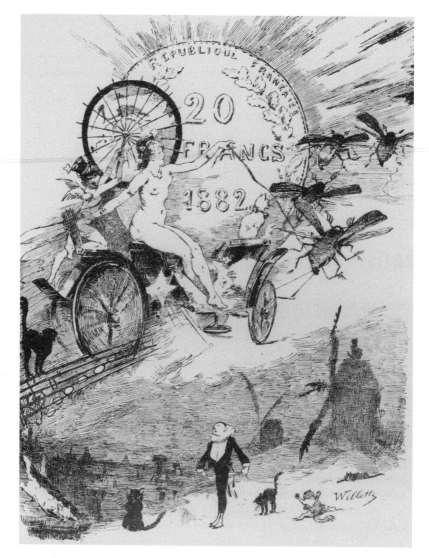

Figure 34.1 Adolphe Willette, *Passage de Vénus devant le soleil*, 1882. By permission of The British Library; shelfmark 10658.pg15.

art, and many renounced painting for drawing or lithography. But as a group they had no identifiable formal trademarks or agenda. Willette's own manner was feathery and in places awkward but entirely conventional. It was comparable to that of any number of illustrators and caricaturists, both within Bohemia and without. While certain Bohemians may have experimented with, say, the radical decorativeness of the Nabis or the optical division of the neo-Impressionists, that was not what made them Bohemians. Bohemia was not a movement but a community; its productions were not the working out of an artistic credo but the expressions of shared social and economic values.

Where the study of modernism revolves around novel formal solutions and the readings of modernity that are implicit in them, an understanding of Bohemian culture hinges on the iconography that was honed by the likes of Willette, and more particularly on privileged

metaphors of venality and disinterestedness. The elaboration of such an iconography was under-taken by artists in collaboration with the writers, singers, and assorted hangers-on with whom they fraternized in the cabarets of Montmartre. Many of the recurrent motifs that will be examined in this essay (Pierrot and the black cat, to name just two) were prominent not just in Bohemian art but also in Bohemian poetry, song, and drama.

In fact, the Bohemians had an ambivalent attitude to visual culture. On the one hand, they valued collective cultural forms over the isolated production and consumption of images. The performing arts had a crucial place in Bohemian culture (with the paradoxical result that Bohemian artists occasionally described the making of images as a performance). On the other hand, many Bohemians had trained as artists. When they were not contributing to Bohemian shows or journals, they were making flyers, posters, set designs, and program notes for the larger mass entertainment venues that soon appeared alongside the Bohemian cabarets in Montmartre. At a time when the city was being transformed into spectacle—when, in other words, the active negotiation of social roles was giving way to the consumption of ever-prolif-erating images—Bohemia both resisted and quickened the process.[2] That is what makes it a compelling object of study. It cannot entirely be circumscribed by the distinctions between avant-garde and mass culture, the dominant and the resistant, the collective and the priva-tized. As we will see, the visual productions of Bohemia illustrate with unwitting clarity the contradictory pressures to which the artist was subjected in an age that saw the rise of a new, spectacular, instrumentalized culture.

In the remainder of this essay I will examine a series of other Bohemian self-representations, most of them by Willette, who was the most celebrated of the Bohemian artists, certainly the one whose work was most widely commented on. We will see that Willette insisted on disinterestedness as the central Bohemian value. Not only was the Bohemian poor—he had, apparently, no aspiration to wealth, he was unmoved by financial considerations. We will find that in Willette's work the Bohemian was set off against various figures of venality and calcu-lation, mythical antagonists who served to underpin the ethos of disinterestedness and so shore up a sense of community in Bohemia. I will argue that Willette's vision of Bohemia constantly needed consolidating and painting anew, and that his unease was a sign of the contradictions that were slowly but surely eroding the coherence of Bohemian culture.

We will start at the Chat Noir, a cabaret on the southern flank of Montmartre. The Chat Noir opened its doors in 1881 and rapidly became one of the focal points of Bohemian culture, cultivating a reputation for seditious entertainment with its songs, recitals, and shadow theater. Many of the Bohemian cabarets that opened over the next few years were loosely modelled on it, and together they paved the way for larger venues such as the Moulin Rouge, but the Chat Noir retained a crucial place in Bohemian mythology. Rodolphe Salis, the one-time artist who ran it, dressed his waiters in the robes of Academicians and called the room he kept for regulars *l'Institut* after the seat of the Académie; ridiculing official culture was the order of the day. But in the cabaret Bohemian artists and poets rubbed shoulders with Parisian not-ables. The Chat Noir was, according to one commentator, a meeting place for the cat of Bohemia and the middle-class goose (the *oie* of *bourgeoisie*) in which, "contrary to tradition," they got along perfectly, the well-healed visitors drinking over-priced beer while the cat "scan-dalized them in moderation and gave them the illusion that they were slumming it."[3]

In 1885 Willette, who was a regular, made a stain-glass window for the Chat Noir [Figure 34.2]. In *The Golden Calf* as in other works he was intent on the elaboration of a specifically Bohemian iconography. Here is what the chronicler Rodolphe Darzens had to say about it:

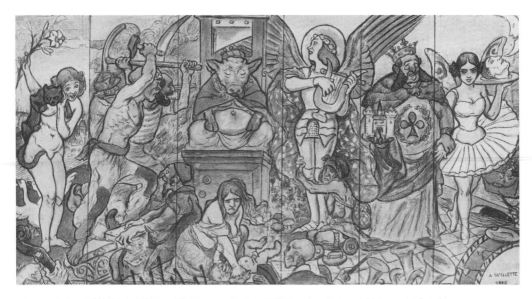

Figure 34.2 Adolphe Willette, *The Golden Calf*, 1885. By permission of The British Library; shelfmark 106580.pg15.

In the center is Death conducting the orchestra of Life, and along the edge appear the instruments of invisible musicians. Facing Death, Wealth—the Golden Calf, Israel—holds court while the naked people, their chains broken, menace it with implements of work. Next to the workers, Virginity is for sale, and elsewhere a mother strangles the child she has just brought into the world—but the gilded Divinity is unmoved. Further on, Poetry appears as Joan of Arc, armed from head to toe, and hideous, maimed Destitution hangs on to her legs. Yet Power, the crowned King of Clubs, seizes Beauty, that Dancer-of-Herod, by the wrist while she carries the head of a martyred Saint John the Baptist.[4]

This is an unusual passage. It is not a commentary on, or an evaluation of, the composition; nor is it a meditation on a theme suggested by the window. It is a decoding, an enumeration of allegorical figures and meanings. In departing from the critical protocols of the time, Darzens aligned himself with the artist and clearly assumed that the window's allegorical program needed elucidating. It could be argued that the allegory is more laboured than obscure, but Darzens was not alone in feeling that Willette's work was difficult.[5] In advancing his exegesis, he was trying to make it accessible to a wider audience and so implying that in the first instance it addressed an audience of initiates, that is to say, of Bohemians. And in this he was not entirely wrong: the black cat and Golden Calf were privileged figures in Bohemian culture. So were Pierrot and Colombine, who appear in the window to the very right. Salomé, Darzens's "Dancer-of-Herod," is dressed as Colombine, while the head of Saint John the Baptist is made up to resemble the white face of Pierrot and juxtaposed with Pierrot's traditional attribute and companion, the moon. Here, presumably, lay the appeal of allegory to an artist like Willette. It spoke to those who were familiar with a given code, it designated an audience, it presumed a degree of complicity. As Darzens inadvertently indicated, the window not only presented a Bohemian perspective on the socio-political landscape of

the time, it also conjured a specifically Bohemian viewer and in doing so it manifested a concern with Bohemian solidarity and communal identity.

Before discussing the window's ideological thrust, it is worth attending to those details that Darzens passed over. The geese to the left stand in for a timorous middle class, fright-ened off either by the violation of Virginity—the black cat here representing lechery—or by the anger of the workers and peasants. Joan of Arc denotes both the art of poetry and the principle of patriotism. Further, the decapitated head to the right is modelled on the artist himself, as Willette pointed out in his autobiography.[6] As for Salomé-Colombine, her posi-tion by the gutter suggests lowly origins or dubious motives and butterfly wings are a favored Symbolist sign of mutability. Plainly, the artist is here presented as the victim of female venality and worldly power, the Salomé-Colombine operating in alliance with the King of Clubs. The workers, for their part, are avenging angels; the window is one of many Bohemian images in which the artist and worker are imagined as struggling against the same forces. After all, Montmartre was a center of anarchist activity. Bohemians repeatedly pictured it as a refuge from the corruption of central Paris, a semi-rural outpost in which artists and workers were joined in their contempt for the ways of a money-grubbing urban middle class. Jules Vallès, the ageing Communard, saw it as the wellspring of the next revolution.[7]

The window is in effect an ideological map in which the disinterestedness of one set of figures is pitted against the acquisitiveness and corruption of another, the figure of Death arbitrating their coming together. As Darzens implies, the scene is a kind of *danse macabre*, a ritual dance of death. In other fin-de-siècle texts and images, the *danse macabre* was conceived as exposing the vacuity and impermanence of worldly gains, death serving as "the great leveller."[8] Willette himself explicitly staged one such dance of death in *Voilà le choléra!* [Figure 34.3]. A group of infantile Pierrots dance under a skull-shaped moon, while the caption over-leaf reads, "Cholera is here! Dance, undertakers! Dance, Pierrots! . . . The bailiff as much as the housekeeper, everyone can catch it. As for beggars, they don't give a fig, it's their revenge!"[9] But in the window Death plays a more nebulous role. It does not avenge the dispossessed or erase worldly inequalities, it brings no comfort to the legless cripple or despairing mother. On the contrary, it appears to work in concert with the Golden Calf, which is itself a death-dealing figure. The guillotine which presumably severed Pierrot's head forms a part of the Golden Calf's throne (the lower portion or pedestal is a safe). The window's macabre orchestra is there not to undermine the forces of venality but to present them in a more sinister and enduring light.

Willette and others used the Golden Calf as an emblem of the greed and speculation which, as they saw it, led to the marginalization of the artist and worker and to the gradual erosion of the patriotic ideal that is here personified by Joan of Arc. The Golden Calf was closely associated in their minds with the Stock Exchange, with the new industrial élite—and with the Jewish community. Below the enthroned figure in the stain-glass window sits a Jew, defending a box of gold from the workers above. Here, then, is another phobic figure of material accumulation. And the image's medievalism subtly supports its anti-Semitism. Fin-de-siècle anti-Semites saw in medieval France a pious society as yet untouched by rampant materialism. For them, the stain-glass windows of the Gothic cathedrals testified to the devout and patriotic values of a better time, as did iconic medieval figures such as Joan of Arc.[10]

We have seen that Willette entrenched the Bohemian principle of disinterestedness by calling on the figures of woman and the Jew. In *The Golden Calf* his misogyny dovetails with his anti-Semitism: Salomé-Colombine is surely to be understood as operating under the influ-ence of the Golden Calf, who as presiding "Divinity" oversees her lethal union with the King of Clubs.

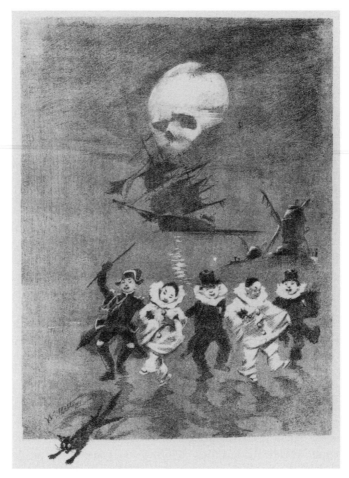

Figure 34.3 Adolphe Willette, *Voilà le choléra!*, 1887. By permission of the British Library; shelfmark X421/2108.

It is important to note that the anti-Semitism that is discernible in *The Golden Calf* was not anomalous. The Bohemians of Montmartre positioned themselves as a critical force on the margin of contemporary French society, but far from condemning the disastrous misogynist and anti-Semitic strains in mainstream French culture, they often embraced them. Commenting on a recital that was held at the Chat Noir, a critic noted its "elegant anti-Semitism" and observed that it went down well.[11] Many of Willette's collaborators at the cabaret shared his views, seeing in anti-Semitism a natural corollary of their patriotism and horror of the world of business. When Willette stood as an anti-Semitic candidate in the municipal elections of 1889, he was not stepping out of line. His election poster [Figure 34.4] featured a self-portrait in the traditional garb of the *rapin* or young artist; he stood, or claimed to stand, for the Bohemian community as well as for the anti-Semitic current in the *arrondissement*. Tellingly, the poster relates closely to both *The Golden Calf* and to work by more progressive Bohemians such as Théophile-Alexandre Steinlen, another regular at the Chat Noir. Like Steinlen in the lithographs he made to commemorate the uprising of the Commune [Figure 34.5], Willette pictures the artist alongside the worker, but Steinlen sees their association as underwritten by the nude figure of Liberty, while Willette introduces a more

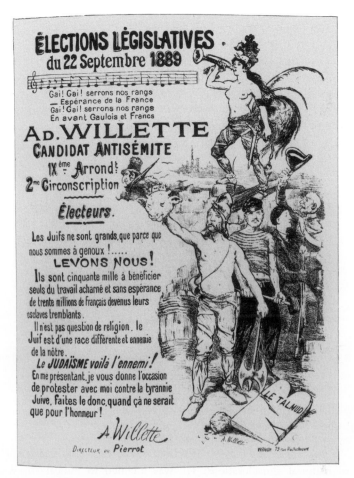

Figure 34.4 Adolphe Willette, election poster, Paris, 1889. By permission of The British Library; shelfmark 7858.cc.5.

unorthodox and openly patriotic figure, part *coq français*, part allegorical nude, and part ancient warrior. The ageing general and bare-chested Gaul too are figures of national pride. As in the window, one coalition of allegorical figures is set against another and the struggle between them is marked by a symbolic decapitation, but here the balance of power has shifted from the Golden Calf to Willette and his armed allies.

It comes as no surprise that Willette's work was admired by the anti-Semitic writer and editor Edouard Drumont. When Willette caused offence with his election poster, Drumont came to his defence.[12] Then, in a particularly lurid passage, the writer turned his attention to the Jewish prostitute and the "odor of the cemetery that attracts [men] to her," urging Willette to paint a "modern *danse macabre*" that would uncover her deathly power.[13] In the writings of Drumont as in the images of Willette, anti-Semitism was compounded by misogyny; in the work of both writer and artist, the principle of material accumulation was sexualized in the figure of the prostitute, who then took on an aura of death and decay.

Drumont and Willette also fashioned similar figures of virtue. Drumont's Aryan was above all disinterested and in this, of course, he resembled Willette's Pierrots. The Aryan, Drumont held, was inventive, generous and trusting, he was innately drawn to beauty and freedom,

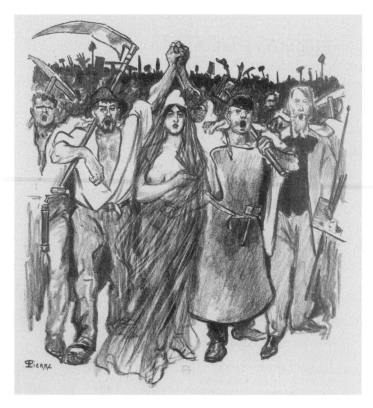

Figure 34.5 Théophile-Alexandre Steinlen, stencil colored lithograph commemorating uprising, March 18, 1894. Cliché Bibliothèque nationale de France, Paris.

he was blind to material considerations. He was inclined to radicalism, which, Drumont felt, only profited his enemies. Willette told an interviewer that his Pierrot was "saint-like in his naïvety" and hence helpless before the Jew's machinations.[14] Similarly, Drumont described the Aryan as "a giant child" whose naïvety made him easy prey to the Jew.[15] To the writer, the Aryan's strengths and weaknesses were exacerbated in his natural leader, the aristocrat, whose very dissipation had a heroic afterglow as it reflected a kind of principled recklessness, that is to say, an aversion to the sober, self-interested calculation that Drumont ascribed to the Jew. Like many writers of the time, Drumont presented the rise of the Jewish community and the decline of the aristocracy as inseparable developments, the one precipitating the other and the two bearing witness to the frenzied mercantilism and uncontrolled social mobility that (in this view) characterized contemporary France.

The reckless aristocratic victim, as described by Drumont, related closely to the Bohemian hero, as imagined by Willette and others, the wilful, carousing artist or poet whose hedonism was both the root of his (commercial) failure and the mark of his integrity. The image of the heedless, doomed Bohemian was advanced in countless texts and images, from the mid-century stories of Henri Murger, with their famished artists and poets, to Willette's *Parce Domine* of 1884 [Figure 34.6]. The huge canvas, painted for the Chat Noir and widely admired at the time, shows an aerial procession moving from right to left, the Pierrots dancing, singing, and throwing money to the wind while Paris (as seen from Montmartre) stretches out below them. Egged on by a series of female companions, the mimes wear first white and then black,

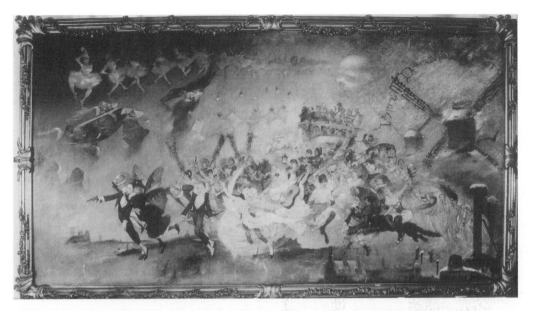

Figure 34.6 Adolphe Willette, *Parce Domine*, 1884. Courtesy of Musée de Montmartre, Paris.

the final Pierrot brandishing a gun as he turns to crime or suicide. The artist wrote in his autobiography that the painting was executed in a room above the cabaret, where he was constantly supplied with alcohol and could hear "the cheerful damned" in the cabaret below; as he worked, he mused on "the sad fate that awaited most of us, victims of heedlessness."[16] The Bohemian, like Drumont's aristocrat, was always a martyr in the making. This, surely, is what made the figure of Pierrot so compelling. Traditionally infantile, he followed his impulses and was regularly belittled or defeated by Harlequin. He was the perfect foil for the oblivious Bohemian.

Discourses of decline and failure had a certain currency in France in the decades that followed the Franco-Prussian war, but they had a particular resonance in Bohemia, which was in crisis from the moment of its re-emergence in Montmartre in the early 1880s. True, it exercised a fascination on intellectuals and pleasure-seekers alike with its air of defiant marginality. In a period which saw the rise of spectacular mass entertainment, with its emphasis on consumption and display, the Chat Noir and other Bohemian cabarets proposed a form of entertainment that was intimate and collaborative. It was also largely satirical in content—as we have seen, Bohemia lampooned both academic culture and the venality of middle-class society. Tellingly, Willette was championed not only by Drumont but by a host of progressive artists and critics.

All the same, the place of Bohemia in the cultural topography of Paris was insecure. The struggle against academic culture was no longer the proud contest it had been in the time of Murger and his mid-century Bohemia. By the 1880s the prestige of academic art was on the wane. The Salon was seen by many commentators as a giant bazaar, alternative exhibiting associations and venues were emerging, and private schools were drawing students away from the Ecole des Beaux-Arts. To the extent that those institutions still had a residual authority, it was less openly but more effectively undermined by the avant-gardist than by the Bohemian. The pranks and tirades of Bohemian Montmartre were open to assimilation by a class of

cultural consumers that had developed a taste for witty dissent, witness the fondness of the literary establishment for the Chat Noir. More disturbing were the avant-gardes with their new formal gambits that spoke of a radical engagement with modernity. Bohemia was simply not in the front-line of politico-cultural debate any more.

The increasingly ineffectual and peripheral nature of the Bohemian challenge to the existing order of society is one reason, likely the principal reason, for the abiding concern in Bohemian culture with solidarity and collective identity. That concern manifested itself in several ways—in a commitment to allegory, with its selective or pseudo-selective address, in the constant repetition of the community's central myths, and in the disparaging of real and imaginary antagonists. As we have seen, one such antagonist was the Jew, who served to entrench the myth of the disinterested Bohemian. The anti-Semitism of Willette and others was a reaction to the growing sway of mercantile values in fin-de-siècle France, a reaction that was appallingly misguided in its given allegorical form but not unreasonable in its broader appraisal of socio-economic change. The myth of disinterestedness lay at the root of some of the more progressive Bohemian narratives and ventures; after all, implicit in it was a critique of the instrumental logic that guides capitalist development. But as the relevance of the Bohemian challenge faded and the need for antagonistic figures of venality became more urgent, the myth was re-cast in new and shriller terms, overlaid with misogyny and an ugly, xenophobic patriotism.

Is it any wonder that the final eclipse and dispersal of the Bohemian generation under discussion more or less coincided with the Dreyfus Affair? In the late 1890s, a fierce public debate broke out after it emerged that forged evidence had been used in the trial of Alfred Dreyfus, the Jewish army officer who had been convicted in 1894 of passing military secrets to the Germans. Anti-Semites joined traditional defenders of the army and church in support of the conviction, while many progressive politicians and intellectuals rallied to Dreyfus's defence. Bohemia was divided; Steinlen for one was a *Dreyfusard*, while Willette and a number of his old collaborators from the Chat Noir sided with the *anti-Dreyfusards*.[17] The coexistence in the same journals and cabarets of an arch-patriotism and a modern progressive tendency was feasible before the Affair but unimaginable after.

There is, in the trajectory of Willette's Bohemia, a final irony. While the myth of disinterestedness was told and re-told, updated, and elaborated on, many Bohemians were successfully plying their skills in the new entertainment industry that was taking root in Montmartre. For Bohemia made a crucial contribution to the rise of spectacular mass culture. Jean Moréas spoke of the Bohemian poet "supping less often on steak than on verse."[18] But he was writing in 1882. In 1885, the Chat Noir moved to new and larger premises. Its success attracted a new breed of entrepreneurs. Soon the area was dotted with cafés, cabarets and dance halls. In 1889, the Moulin Rouge opened with great fanfare. Some Bohemians may still have been "supping on verse" but others benefited from the influx of capital. They were involved in the design, decoration, and management of many of the new venues, giving them something of the subversive glamor that had first attracted middle-class patrons to the Chat Noir. At the same time, Bohemians were employed in the production of posters for the burgeoning advertising industry, of which Montmartre was a hub. Willette himself produced posters and program designs, and made the first model for the Moulin Rouge.[19] The myth of the disinterested Bohemian was part of a package that was marketed with increasing professionalism and consumed with some enthusiasm. Predictably, commercial success created tensions within Bohemia, prompting regular accusations of greed and betrayal. Was it another reason for the embattled repetition of the myth of disinterestedness? Perhaps. Certainly, the myth was rehearsed with renewed stridency just as its relation to the economic circumstances of many Bohemians became more tenuous. And that is not just a measure of Bohemian alarm

or hypocrisy. It is also a powerful indication of the pertinence of the myth in an age that saw a marked acceleration in the instrumentalization of culture.

Acknowledgement

I would like to thank Jeannene Przyblyski and Vanessa Schwartz for their help in revising this essay.

Notes

1 That the bee is a figure for the pimp is made clear in another image of the same period, "Le Roman de la Rose," and its caption—see Adolphe Willette, *Pauvre Pierrot* (Paris, 1887), no page numbers.
2 I am using the term *spectacle* in the Debordian sense: "The whole life of those societies in which modern conditions of production prevail presents itself as an immense accumulation of *spectacles*. All that was once directly lived has become mere representation." Guy Debord, *The Society of the Spectacle* (trans. Donald Nicholson-Smith, New York, 1994), p. 12.
3 Jules Lemaître, *Les Contemporains, sixième série* (Paris, 1896), pp. 337, 340.
4 Rodolphe Darzens, *Nuits à Paris* (Paris, 1889), pp. 99–100.
5 The critic Arsène Alexandre wrote that Willette used "a symbolism so finely conceived that at times it eludes a less refined crowd" (*L'Art du rire et de la caricature* [Paris, 1892], p. 310).
6 Adolphe Willette, *Feu Pierrot* (Paris, 1919), p. 160.
7 Jules Vallès, "Le Tableau de Paris; le faubourg Saint-Antoine," *La France*, 24 Nov. 1882.
8 In his book on nomadic entertainers, for instance, Gaston Escudier described a puppet show in the following terms, "Death, the great leveller, conducted the dance; one by one the characters came to kiss the feet of the skeleton and recognize its ineluctable power, and it gave to each according to merit," *Les Saltimbanques* (Paris, 1875), p. 443.
9 Willette, "Enfin! Voilà le Choléra!," *Pauvre Pierrot*, no page numbers.
10 Laura Morowitz, "Anti-Semitism, Medievalism and the Art of the Fin-de-Siècle," *Oxford Art Journal*, 20: 1, 1997, pp. 35–49.
11 Jules Lemaître, *Impressions de théâtre, sixième série* (Paris, 1892), p. 346.
12 Edouard Drumont, *La Derniere bataille* (Paris, 1890), pp. 124–25.
13 Drumont, pp. 136–41. On Drumont and Willette, see Mireille Dottin-Orsini, *Cette femme qu'ils disent fatale* (Paris, 1993), p. 312.
14 Paul Hugounet, *Mimes et Pierrots* (Paris, 1889), p. 212.
15 Edouard Drumont, *La France Juive*, pp. 11–12, *et passim*.
16 Willette, *Feu Pierrot*, p. 162.
17 Once again, Willette was in the same camp as Drumont, who was instrumental in securing Dreyfus's initial conviction.
18 Jean Moréas, "Montmartre," in André Velter ed., *Les Poètes du Chat Noir* (Paris, 1996), p. 221.
19 Suzanne Grano ed., *Les Lautrec de Lautrec* (Brisbane, 1991), p. 60.

PART EIGHT

Inside and Out: Seeing the Personal and the Political

VANESSA R. SCHWARTZ AND

JEANNENE M. PRZYBLYSKI

I T IS A COMMONPLACE BY NOW to characterize the nineteenth century as "the golden age of private life." Historian of *la vie privée*, Michelle Perrot has argued that it was a time when the vocabulary and imagery of intimacy, individuality, family, and home intersected with new authority. This heightened sense of "privacy" was elaborated through a commensurate sharpening of the definition of public life and a strengthening of an ideological barrier between "public" and "private" more broadly speaking. In this context, social consensus regarding what behaviors and activities were intended for public view, what might be seen, what should remain unseen, and how and in what terms (celebratory or repressive) a person negotiated the fields of vision demarcated by the public/private distinction were crucial means of regulating that society across the range of differences within it.

Much of our understanding of a public/private dialectic in the nineteenth century has been derived from the work of philosopher Jürgen Habermas, who argued that the production of a "bourgeois public sphere" was fundamental to the constitution of the bourgeoisie as an ascendant social class. But Habermas was also quick to point out that even the private "was always already oriented toward an audience." If the nineteenth century's cult of private life was in many ways a reaction to the perception that modern life had become too invested in the "public," then the pretense of "home" and inner life being outside the realm of public scrutiny was also little more than a necessary fiction.

The essays in this final section serve as exemplary models for exploring the ways in which ideas of the private and public are reconfigured and reimagined in relation to the visual culture of the nineteenth century. They are also exemplary for refusing to reinforce the fiction of a discrete and inviolable private realm. If anything, they emphasize the permeability and even transparency of the disciplinary "wall" separating public and private life. This is particularly the case with respect to Sharon Marcus's interdisciplinary work on the apartment building as a dual response to the urbanization and domestication of everyday life in the nineteenth century. The *portière*, or female gatekeeper (as well as mail distributor, rent collector, and

maid), mediated not only between the apartment building and the street, but between the middle and working classes. She was a social "type," pervasive in the *Physiologies de Paris*, and also a social observer comparable to the male *flâneur* and the mostly male realist narrator. Americanist and photography historian Shawn Michelle Smith sees the photographically illustrated family album (a phenomenon bound to the innovation of Kodak box camera technology, which put a camera within reach of every middle-class mother's hands) in a similarly liminal way. One of the most intimate documents of family memory-making, it served broad social aims of disciplining the boundaries between the white and black races in the United States. A product of modern patterns of mass consumption conjoining domesticity with individuality, it also was fully participatory in the public, pseudo-scientific discourse of eugenics.

Lisa Tickner's book on *The Spectacle of Women* crosses art history with political history in ways that are both historically faithful to the political movement of the women's suffrage campaigns at the close of the "long nineteenth century" and methodologically indebted to the feminist movement of the late twentieth century. In doing so, she also crosses another *intra*-disciplinary border: the art historical divide between the major arts of painting and sculpture, and the minor arts of decoration and craft. Her careful analysis, included in this section, of the centrality of appliquéd and embroidered banners to the public identity of the Suffrage movement submits to a fundamental tenet of visual culture studies—that any hierarchical reading of the visual realm will produce only half a story. Debora Silverman's work on art nouveau style is focused on similarly gendered divisions—between art and craft, monumental public art programs and interior decoration, modern rationalism, and the fin-de-siècle fascination with the irrational. Silverman argues that art nouveau's sinuous curves and organic forms were directly influenced by psychiatric clinicians such as Dr. Jean-Martin Charcot, whose work on nervous palpitations, hypnotic suggestibility, and dream states often focused on women patients. The cross-fertilization of art, psychology and style not only makes it possible to see such apparently disequivalent objects as a blown glass vase by Emile Gallé and Auguste Rodin's unfinished masterpiece, *The Gates of Hell* within the same field of vision; it also begins to weave together the tenuous threads linking the modern French political ideologies of liberalism and republicanism to the institutional management of personal fantasy and sensation.

LISA TICKNER

BANNERS AND BANNER-MAKING

S UFFRAGE SPECTACLE WAS HEAVILY DEPENDENT on 'the long array of pennons, banners, trophies, garlands and badges, most resplendent in their gorgeous execution and workmanship'.[1] Banners celebrated a 'women's history' in their iconography, their inscriptions and their collective workmanship; they focused a sense of shared identity and imbued it with political significance [Figure 35.1]. In so far as they made reference to the past it was as part of a political strategy for the present; and in so far as they mobilised women's traditional needlework skills – so much a part of the contemporary feminine stereo-type as to be almost a secondary sexual characteristic – it was to challenge the terms of that femininity in a collective political enterprise.

Banners served both as rallying points for the march and as commentary on it [Figure 35.2]. Women formed up around them in predetermined sequence, so that a procession several miles long could be ordered according to its programme and move off smoothly. At the same time, for the onlookers (and for readers of the next day's newspapers perusing their half-tone photographs), they acted as a gloss on the procession itself, developing its mean-ings, identifying and grouping its participants and clarifying its themes. Together with the programme of the march, the banners emphasised the broad base of suffrage support, the diversity of women's achievements and the benefits the women's vote would bring to society at large. In this sense they were an essential part not just of the spectacle of suffrage demon-strations but of their argument. They went some way to informing the casual onlooker as to the 'what' and 'why' of women's presence on the streets.

They did, however, have other uses. They were portable, decorative, and in their own way informative,[2] so that they made good window-dressing for suffrage committee rooms and convenient backdrops to the public platform. They decked out the Albert Hall for larger meetings and took the place of honour like battle trophies, evoking the associations of the regimental colours rather than of the church banners of Mothers' Unions, stitched in Marian humility. Banner-makers themselves straddled the interests of arts and crafts and ecclesiastical embroidery, of women's domestic needlework and of the suffrage campaign. The banners they made could speak to each of these constituencies, and thereby bring within the para-meters of the campaign women who had never before expressed an interest in it. As cultural artefacts the banners could be admired for their design and workmanship, but it was neither possible nor desirable wholly to sever their political connections. An exhibition of banners, such as the Caxton Hall display preceding the NUWSS demonstration of 1908, made a rather convenient and unthreatening focus for attendant events – speeches, music, local newspaper publicity, competitions and school visits – altogether instructive and politically stimulating. A pilot exhibition in Yorkshire left in its wake the nucleus for a local suffrage society, and no doubt the broad audience attracted to the banners that 'looked gorgeous as the afternoon

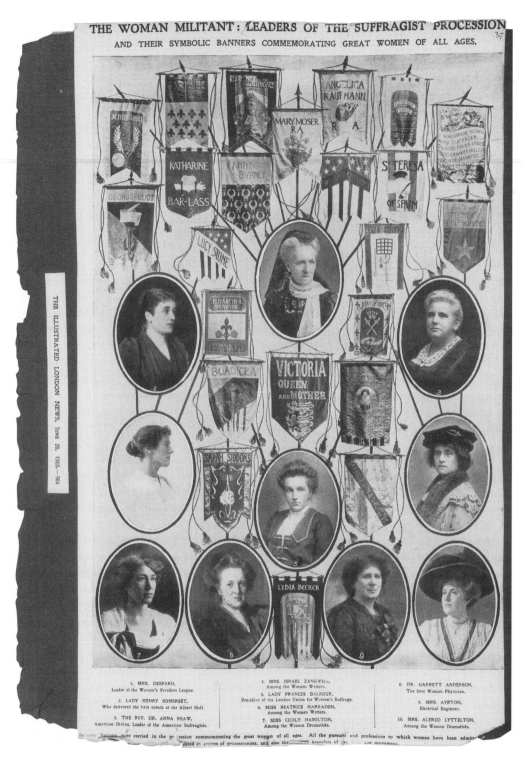

Figure 35.1 Page from the *Illustrated London News*, June 20, 1908. Courtesy of Mary Evans Picture Library.

Figure 35.2 Photograph, *The Actresses' Franchise League, assembled for the Women's Coronation Procession,* June 17, 1911. Courtesy of the Museum of London.

sun fell softly upon them'[3] swelled campaign funds with their sixpenny entrance fees. Banners produced a useful confusion of disparate categories: they were tributes to women of spiritual, moral or intellectual attainment and evidence of the 'feminine' capacities of the 'shrieking sisterhood'. In 1908 and 1909 they were relative novelties,[4] as yet uncomplicated by the associations of militant violence: conveniently ambivalent objects that were simultaneously soothing and subversive, celebratory and political, 'art' and propaganda, feminine and feminist.

There were various kinds of precedent for the suffrage banners and one significant point of comparison – with trade-union banners of the 1890s and early 1900s – was constantly returned to in the press and by the women themselves. John Gorman dates the earliest trade-union banner to 1821, but the 1890s was the true decade of 'banner mania', when ambitious examples were produced as part of an 'explosion of new union pageantry' for an expanding and increasingly powerful membership.[5] Women had designed and embroidered many of the most striking Chartist emblems, and it was not uncommon in unions to hear that 'Mother made the first banner the branch had.' But from 1837 more than three quarters of all the banners produced were manufactured by George Tutill, who built up a world-wide near-monopoly that lasted for more than fifty years.[6]

Tutill's banners were mostly expensive, allegorical, very large-scale and painted, with woven surrounds.[7] Most of the suffrage banners, on the other hand, were embroidered or appliquéd. This was significant for several reasons. Although presumably the forerunners of the union banners were the embroidered insignia of the incorporated livery companies, and although men and women professionals had produced the work that was the great glory of English embroidery, such needlework had become identified in the course of a series of social and economic shifts as craft rather than art, the product of amateurs rather than professionals, the product – indeed the guarantee – of a chaste and domestic femininity. The Victorians,

who revived an interest in medieval embroidery, misconstrued its history according to the ideals of their own time. In their account the medieval embroiderer was not a skilled artisan of either sex but, as they imagined her, the gentlewoman of courtly love or the convent workshop. What such accounts crystallised was the assumption that the embroiderer was a woman who worked out of love and dedication in the service of others. What they masked was the process by which needlework as a middle-class accomplishment kept women chastely at home, producing the adornments which helped to guarantee the social standing of the bourgeois household.[8]

But for women like Mary Lowndes looking for a history and a justification for women's political needlework, the Victorian association of women with embroidery had its uses, in the production of banners that dignified womanly skills while making unwomanly demands. She borrowed from nineteenth-century medievalism the claim that in 'all the ages it has been woman's part to make the banners, if not to carry them,' and mourned the loss of that tradition [Figure 35.3]. 'Woman has been out of work a long time in the matter of adventurous colours'; only women's church banners continued 'to be seen and loved'. But for the first time women were in a position to exploit an ancient, honoured, and particularly female service to their own ends: 'And now into public life comes trooping the feminine; and with the feminine creature come the banners of past times, as well as many other things which people had almost forgotten they were without.'[9]

By conventional criteria, of course, the feminine could *not* by definition come trooping into public life. That was not the arena for women, and straying there would sully them. In Mary Lowndes's account, however, the times were changing. Fighting heroes now came tailor-fitted 'and any flags they want can be ordered from the big manufacturers'. In streets, in camps, on ships, 'a tame uniformity of enormous size and intense vulgarity flaunt the taste of the present day for the shop article'. But with the new century a new phenomenon had come to fruition: 'Political societies started by women, managed by women and sustained by women. In their dire necessity they have been started; with their household wit they manage them; in their poverty, with ingenuity and many labours they sustain them.' The conventional association of embroidery with love (as women's amateur and domestic production it could not be called work), is reversed here to disparage the fighting heroes tailor-fitted (by Tutill's, presumably), and to celebrate by contrast women's superior taste, skills and collective endeavour. She does not use the word but it haunts her text: the associations of chivalry, banners, romance, and common commitment in the pursuit of just ends are those of the crusade. She uses the historical romance of the Middle Ages that was the Victorians' 'dream of order' implicitly to elevate the values of spirituality, femininity and justice above the claims of the tawdry, the commercial and the everyday.[10]

Certainly money came into it. Most trade-union banners were, by suffrage standards, very expensive. In 1890 a 128-by-11-foot woven and painted banner with poles, carrying harness and box cost about £55[11] (more than a year's wages for the highest-paid women industrial workers). The seven great silk banners donated for the 1908 WSPU procession cost 14 guineas each, and the organisers supplied the fabric for 500 others at eight shillings and sixpence each, or sixteen shillings ready-made with appliquéd lettering.[12] The silk and velvet materials for the more ambitious, emblematic banners of the Artists' Suffrage League, produced for the NUWSS procession eight days earlier, cost between fifteen shillings and £2.[13]

Trade-union banners were also much larger. Gwyn Williams remarks an increasing tendency towards banners 'as big as mainsails' that would embody in one enormous and cumulative statement the 'pictorial representation of the craft . . . its Samaritan functions, its history and traditions and its aspirations, all wreathed in scrolls and laurels and figurative females . . .

Figure 35.3 Mary Lowndes for the Women's Writers' Suffrage League, banner in appliquéd velvets, June 13, 1908. Courtesy of the Museum of London.

a *cathedral*'.[14] The cumulative effect of women's banners, on the other hand, derived from the honeycomb of their distribution across a particular procession. Some were bigger, but Mary Lowndes suggested that something 4 feet 6 inches by 6 feet 6 inches was 'as large as women . . . can carry should there be any wind'.[15] (The Men's League helped on occasion, but there was a certain pride and significance for the women in carrying their banners themselves.)

Because they are appliquéd, stencilled and embroidered rather than painted, and because of their smaller scale, the women's banners are emblematic rather than pictorial. They conceived of a banner as less of a painting and more of a flag, which sorted better with the methods of the needlewoman than those of George Tutill's teams of portraitist, sign-writer and 'corner-man'. As Mary Lowndes put it; a banner was not a literary affair, or a placard, but 'a thing to float in the wind, to flicker in the breeze, to flirt its colours for your pleasure, to half show and half conceal a device you long to unravel: you do not want to read it, you want to worship it.' Her training as a stained-glass designer encouraged the use of bold appliquéd shapes and a love of full, rich colours (striking combinations of green and blue, magenta and orange) combined with the free use of a heraldic vocabulary. 'You may think over *nebulée, ragulée, indented, engrailed*, as a method for bringing two edges together; your field may be *barred, fretty*, or *billetée*, the *chevron*, the *bend*, or the *saltire* may break its surface. There are a score of ways such as I speak of, some simple and easy, as the *fesse*; some only to be attempted by the most skilled workers, as the blue and white of vair and counter-vair.'[16]

In their designs the labour movement borrowed armorial bearings associated – in fantasy at least – with the craft guilds, and embellished them with all kinds of devices symbolic of the unions' aspirations and fraternal aids: rising suns, clasped hands, the all-seeing masonic eye, the bundle of fasces (united we stand), the serpent of capitalism, the muscular hero, the allegorical feminine virtue. Women had no such half-world of shadowy symbolism on which to draw, and the problems that confronted them in the depiction of women, as heroines or in a variety of female occupations, were difficult to resolve. They did not use 'figurative females' much, nor were their banners 'all wreathed in scrolls and laurels',[17] since they were rooted in arts and crafts embroidery and not in fairground or other vernacular motifs. Only in their cumulative effect did they emphasise a sorority equivalent to the iconography of fraternity packed into a single trade-union image. And it was a sisterhood based on diversity, not on what, for example, workers in a particular occupation held in common: obviously, the power of union organisation depended on a unity of class, whereas the women sought to identify and organise against an oppression shared across the different class positions that inflected it. Between and within the suffrage organisations there were a great many conflicts over questions of class, but the collective rhetoric of the banners, as of the accounts of processions in which they were carried, emphasises above all the image of the milliner or shopgirl shoulder to shoulder with the duchess. As *Votes for Women* described the constituents of the 'Coronation' procession in 1911, they were 'toilers from factory, workshop, field and garret; wave after wave, rank after rank. . . . Endless it seemed – Science, Art, Medicine, Culture, Ethics, Music, Drama, Poverty, Slumdom, Youth, Age, Sorrow, Labour, Motherhood – all there represented.'[18]

Distinctions between union and suffrage imagery which the suffragists had themselves promoted were in the end taken over by the press and used to divide them. Suffrage banners were praised for their picturesque elegance at the expense of labour images ('tawdry and muscular'),[19] but the femininity that was admired in them came close to repressing their politics and inhibiting their effect. A contributor to the *Vote* in 1910 remarked the crowds at a demonstration in Hyde Park in which a cabinet minister's wife was recognised, but asked whether a single member of the government had looked on. 'This is the sixth great Procession since "the great mud march". The danger is that London may get to regard us as a pageant of music and colour, a mere Roman holiday, and forget our march is the outward and visible sign of an inward and spiritual longing for Freedom and Justice.'[20]

Notes

1 *Votes for Women*, 30 June 1911, p. 640.
2 They were easily rolled up and driven round London in vans, or sent by rail to provincial demonstrations.
3 NUWSS Executive Committee minutes, 3 July 1908 (Fawcett Archives, Box 83). See the *Women's Franchise*, 9 July 1908, p. 16, for the decision to keep the banners together and tour them: 'Undoubtedly we have here an opportunity of presenting an artistic feast of the first order under circumstances that make it in itself, and in all the attendant conditions that may be grouped round it, a unique act of propaganda.' And see also NUWSS Executive Committee minutes, 23 July 1908: 'Decided that the National Union lend out the banners to societies and make a fixed charge of £3 10 0d for the whole number 76 and £2 0 0d for the half, the calculation being 1/- per banner, all expenses to be borne by the local Society with the exception of the carriage one way. Decided that the banners cannot be loaned for outdoor work'. The *Women's Franchise* (6 August and 17 December 1908) and the *Kensington News* (19 March 1909) refer to exhibitions in Manchester, Cambridge, Birmingham, Liverpool, Fulham and Camberwell. The NUWSS was so gratified with the response that it compiled a page of extracts from 'Press Reports of the Banners' (see Mary Lowndes's album in the Fawcett Archives, p. 60). *Reynolds's Weekly News* referred to it as 'almost another field of the cloth of gold'.

4 Probably there were a few suffrage banners in existence before 1908. The *Common Cause* (1910, p. 385) refers to 'a large white-and-gold banner made twenty-five years ago by the Bristol Suffrage Society, under the late Miss Helen Blackburn's direction' which was brought out on a Bristol demonstration in support of the Conciliation Bill. But these would not have been for outdoor use, and the banners made for the Mud March seem to have been chiefly lettered in red and white. It was Mary Lowndes and her colleagues of the Artists' Suffrage League who were responsible for the women's 'explosion of pageantry' in 1908. Only the 'ten great silk banners' of the WSPU were pictorial, and most of those were made by a commercial manufacturers (which might even have been Tutill's).

5 Gwyn A. Williams, introduction to John Gorman, *Banner Bright: An illustrated history of the banners of the British trade union movement*, Allen Lane, London, 1973, p. 7. The emergence of the unions as substantial working-class organisations with radical middle-class support and a national leadership in the 1860s (the first TUC Congress took place in 1868), and their development in the late Victorian and Edwardian period, exactly parallels the organisation, development and increasing militancy of the suffrage campaign.

6 Tutill's also produced banners and regalia for temperance societies, Sunday schools, Masons, Orange lodges, Friendly societies and even 'robes and false beards for the United Ancient Order of Druids'. John Gorman estimates that the firm produced about 10,000 banners between 1832 and 1939 (pp. 52 and 18).

7 Gorman (1973), p. 50. In 1861 Tutill took out a patent for his process of coating the silk with india-rubber to improve its durability. He used an elastic paint to prevent cracking, which Gorman observes is often bright and pliant 100 years later. The painting itself was highly specialised, with artists working solely on portraits, architecture, lettering, or as 'corner-men' on the baroque scrolls of the surrounds.

8 This history has been explored by Rozsika Parker, *The Subversive Stitch: Embroidery and the Making of the Feminine*, The Women's Press, London, 1984 (see particularly chapter 2, 'Eternalising the Feminine: Embroidery and Victorian Medievalism 1840–1905'). Callen notes that the revival of embroidery in the later nineteenth century was partly an effect of the religious revival and partly a reaction against machine production.

9 All quotations from Mary Lowndes, 'On Banners and Banner-Making', reprinted from the *Englishwoman*, September 1909 (there is a copy inserted in Mary Lowndes's album in the Fawcett Archives). The celebration of women's needlework skills in a *political* context was profoundly subversive of the conventional identification of femininity with embroidery which had developed from the Restoration onwards, and subversive in a manner that recognised the possibilities for creative pleasure which needlework allowed, as distinct from the direct refusal of them by some earlier feminists.

10 See also the *Common Cause*, 16 February 1911, p. 727: 'The Suffrage Societies have many such beautiful banners worked by Suffragists FOR LOVE, and into them have been stitched many hopes and aspirations, pretty fancies and steadfast resolves, memories and beliefs. It comes natural to women to use their clever fingers in decorating the outwards and visible signs of their heart-felt faith, and when we find the civic consciousness of women expressing itself through needlework, we may be sure that this consciousness has become part of the "WOMANLY WOMAN", and that its force is overwhelming.'

At the same time Mary Lowndes shifts the standing of femininity in courtly chivalry, taking her noble embroiderer back from the hearth and into the lists: her Brynhild (the warrior-maiden who 'could more skill in handicraft than other women') had a sword stained red with the blood of kings. No inimitable roses in fading silks in her castle. As Alice Chandler points out in *A Dream of Order* (1970), the Victorians used their myth of the middle ages to justify and reconcile the unequal dependencies of social life in the concept of 'chivalry'. Suffragists like Mary Lowndes (and militant suffragettes particularly) drew on the same language to opposite ends. (One might almost say that in so far as they were liberals they dreamed of a society in which each individual was free to compete equally, and that in so far as they were socialists they dreamed of a society in which inequalities and competition were dissolved.) In the order they dreamed of, exploitation was avenged by warrior virtues; and through the classical tradition of personification as it was conflated with the evangelical view of woman's 'mission', those virtues were feminine.

11 Gorman (1973), p. 54.

12 *Votes for Women*, 14 May 1908 and the WSPU *Annual Report* for the year ending 28 February 1909 (Museum of London).

13 See unidentified cuttings in Fawcett Archives Suffrage Album 3, SvL 1907–29: one (*c*. February 1908) notes the donation of fine silks and velvets for the Artists' Suffrage League banners (one exquisite piece of silk had been sent from India); the other (*Daily Chronicle*, June 1908) appeals to anyone who will give a banner – 'it costs something between 15s and £2' – or help make one. Mary Lowndes insisted

that nothing should be used because it was a scrap of something left over that would 'just do', and the design was 'the one thing most worth paying for. If the design is bad, for twenty pounds you will not get a banner worth looking at; if the design is good and practical, you may make a fine thing for three, and make it yourself.'

14 Williams in Gorman (1973), p. 11.
15 Trade-union banners could be anything up to 16 by 12 feet, or even 20 feet.
16 The firm of Lowndes and Drury advertised that it specialised in heraldic windows, and the heraldic associations of the banners were picked up and commented on in the press: 'As the procession moved away . . . it reminded one somehow of a picturesquely clad mediaeval army, marching out with waving gonfalons to certain victory' (*Sunday Times*, 14 June 1908).
17 Gorman (1973), p. 49.
18 *Votes for Women*, 30 June 1911, p. 640.
19 This is a leitmotif of press comment in 1908, which reasserts the connection between embroidery and a middle-class, drawing-room femininity, at the expense of the popular and 'muscular' imagery of working-class men. See the NUWSS 'Press Reports of the Banners' particularly the *Daily News*, *Daily Chronicle*, *Manchester Guardian*, *Sunday Times* and *Daily Telegraph*.
20 The *Vote*, 30 July 1910, p. 168.

Chapter 36

SHARON MARCUS

THE PORTIÈRE AND THE PERSONIFICATION OF URBAN OBSERVATION

WHY DID APARTMENT HOUSES become the dominant architectural elements in the Parisian landscape during the last decades of the Restoration (1814–30) and throughout the July Monarchy (1830–48)? Their popularity owed much to two factors: they provided spatially compact housing in a city with a rapidly increasing population and offered an expanding middle class opportunities for investing in relatively inexpensive and profitable properties. Demography and economics, however, do not sufficiently account for Parisians' adoption of the apartment building as their chief residential form; [. . .] In order to understand the Parisian enthusiasm for apartment buildings, we need to excavate the cultural beliefs about domestic and urban space embedded in the discourses of Parisian architecture and everyday life. Apartment buildings appealed to Parisians as a material figure of broad social conceptions of private and public life: the containment of social heterogeneity in a unifying framework; the imbrication of the domestic and the urban; and the transparency and fluidity of every component of urban space.

Paris in the first half of the nineteenth century reflected, in intensified form, the extreme social mobility that characterized France in the years following the fall of the old regime. Many of the aspects of urban modernity that marked Second Empire and fin-de-siècle Paris were already in place by the 1820s, including a culture based on commodification, spectacle,

and speculation, and a legible urban space easily mapped and navigated by the upwardly mobile.[1] The premium on legible urban space was matched by a desire to decipher the exact social position and moral character of any Parisian in a glance, as a series of urban "physiognomists" claimed the power to do. Within the July Monarchy's capitalist democracy, the desire for transparent space and citizens, whose exteriors would be windows onto their interiors, emphasized reading people in terms of commodities and wealth; by the cut of a man's suit, you could assess his income.[2] Specific as it was to that new regime, however, transparency also had deep roots in French political culture, which from Rousseau through the revolution had decried obscurity, duplicity, and theatricality as antithetical to democracy.[3]

The historiography of an urban culture and space as open as the society that generated them coexists uneasily, however, with the historiography of nineteenth-century domesticity, which describes a segregated private realm that emerged in the wake of the French Revolution, a realm strictly separated from public spaces and functions. That separation was most evident in political and medical discourses that aligned women with the private space of the home and excluded them from a public sphere of abstract masculine political activity as well as from a set of collective exterior urban spaces (the street, the café, the theater).[4]

Scholarly assumptions about domestic space as a separate sphere have occluded more representative discourses about Paris, discourses so invested in the notion of a legible, transparent urban space conducive to easy circulation and observation that they actively incorporated domestic space into the city and even extended urban mobility to the emblematic figures of the private sphere—women of all classes, and especially the women who lived in the middle-class apartment building. [. . .] The apartment building's ability to unify its disparate residents within a single frame mirrored the efforts of urban observers to contain Parisian heterogeneity within a single text; its transparency illustrated the fluid relationship between apartments and the city's exterior spaces, as well as the accessibility of every space in Paris, even domestic space, to urban observers. The strength of the urban observers' commitment to mobility, transparency, and visibility can be measured by their insistence that even married women circulate within the city, and by their deployment of a female figure, the *portière*, to personify the apartment building and the activity of urban observation. At the same time, however, their resistance to the implications of their own discourse can be measured by the satiric distance they took from the *portière* who so resembled them. [. . .]

The tableaux de Paris and the apartment-house view

Beginning in the 1830s, an unprecedented number of books about Paris not only posited a continuum between the apartment house and the street but also presented the apartment house as an ideal framework for visual observations of the city. The texts that critic Margaret Cohen has identified as "a characteristic nineteenth-century genre for representing the everyday" were known as *tableaux de Paris* and were accompanied in the early 1840s by an important subgenre, the *physiologies*.[5] Authored mostly by professional writers who worked for the popular press and wrote criticism, prose, and plays, the *tableaux* and *physiologies* mapped contemporary Paris for a public eager to consume images of the city. As the critic Richard Sieburth has pointed out, "these illustrated anthologies of urban sites and mores responded to the public's desire to see its social space as a set or gallery whose intelligibility was guaranteed both by its visibility as an image and its legibility as a text."[6] Issued by various publishers, the *tableaux de Paris* conformed to certain generic conventions: they were usually multivolume, large-format books utilizing a variety of typefaces, lavishly illustrated by artists such as Daumier and Gavarni, and written by multiple authors who provided an encyclopedic

overview of the city with fictional sketches and articles on Parisian history, geography, social types, and current events.

The authors of the *physiologies* often overlapped with contributors to the *tableaux*. The *physiologies*, however, were the work of only one author (and one illustrator); and where the kaleidoscopic *tableaux* aspired to a cumulatively exhaustive description of Paris, the *physiologies* adopted a [. . .] fragmentary approach, since each text anatomized, in a deliberately slangy style, an individual Parisian type (e.g., the grocer, the kept woman, the husband). Aubert published *physiologies* according to a standardized small, in-32 format of 120 pages, with copious but cheap illustrations. Priced at 1 franc each, the *physiologies* were considerably cheaper than the ordinary book, which cost roughly 3.50 francs, and much cheaper than the oversized, lavish *tableaux*. Their modish appearance and low price contributed to their popularity: more than 125 separate *physiologies* were issued between 1840 and 1842, and a total of approximately 500,000 copies were in print in the 1840s.[7]

Because the *tableaux* and the *physiologies* understood the city as a site in which events unfurled and as a decor within which character emerged, they frequently treated apartments as settings for the various episodes and types they recounted. Unlike architectural pattern books, which by convention eliminated all representations of people from their illustrations, the *tableaux* defined Paris as much by its population of *parisiens* and *parisiennes* as by its physical environment. Apartment houses were seen as privileged settings for Parisians and their plots, as figures for "this big city where misfortune, good fortune, pain and pleasure frequently live under the same roof," and as sites of a narrative available only to the urban initiate, who with the aid of the urban observer would become aware of "entire novels hidden in the walls of . . . [a] house."[8]

In addition to privileging the apartment house as a descriptive object and narrative device, the *tableaux* also shared formal traits with apartment buildings. The visual arts represented apartment houses as both static objects and animated scenes, as pictorial, frontal planes to be viewed and as spaces through which to move, if only illusionistically.[9] The *tableaux* similarly set out to combine a static "store of information," including history, statistics, and geography, with lively anecdotal incident and narrative.[10] Updating long-standing equations between literary and architectural construction, the frontispieces of several *tableaux* explicitly represented their own volumes as elements of architectural construction and, conversely, the *tableaux* frequently invoked the metaphor of buildings as books, pages, and lines, as if to endow readers with the ability to decipher a building as they would a text. The visual presentation of the *tableaux* even mirrored the structure of apartment-house facades: innovative page layouts intercalated text and image so that illustrations were situated like windows in the space defined by the text.

The writers who represented the city to itself thus not only emphasized apartment houses as elements of the Parisian landscape but also *saw through* the apartment house, treating it as a lens or as a point of view and not simply as an opaque visual object. In the process, they imagined apartment houses to be as transparent as they wanted the city to be. And by depicting the apartment house as though its facades and walls were transparent, Parisian chroniclers demonstrated that even the city's most private spaces posed no impediment to their vision. In a sketch called "Les Drames invisibles," which exemplified the *tableaux*'s representation of the apartment building, Frédéric Soulié, a frequent contributor to the genre, deployed the common device of describing Parisian society through a single apartment building. Even the most private events within the apartment house—what should be the "invisible dramas" of the title—become visible, with the narrator exposing blackmail and suicide on one floor and

a concealed pregnancy on another. For Soulié, to reveal the secrets of the building's occupants makes possible a more general exposure of the Parisian social body; for example, he describes a tenant's concealed pregnancy as "teem[ing] beneath the social epiderm."[11] Initially hidden by the woman's body, then inevitably revealed by it, the increasingly visible course of conception, pregnancy, and birth mirrors the trajectory of the apartment-house narrative, which transforms facades, walls, and doors from barriers that keep secrets into transmitters of sounds and stories. [. . .]

In a landmark article on the *flâneur*, Janet Wolff argues that urban discourse gave men a monopoly on urban circulation and observation, and consigned women to the role of objects of a masculine urban gaze.[12] Many moments in the *tableaux* seem to support her argument, but at the same time urban discourses also represented women as mobile urban observers, because to do otherwise would have been to acknowledge a limit to the transparency and accessibility of urban space. Indeed, even the most blatant examples of male voyeurism in the *tableaux* worked not only to constitute women as sexualized objects of a male gaze but also to liquidate the barrier potentially posed by the private space of the home. As a result, the objectification of women viewed either in the street or in their apartments had the unintended effect of bringing women into the city or bringing the city to women and did not, as Wolff implies, simply confine them to an impermeable private space.

In a contribution to *Les Rues de Paris* (1844), for example, Albéric Second attached his description of an entire Parisian neighborhood to a man who simultaneously observes an apartment building and its female tenants. In his story, a painter's ability to bridge the gap between facing apartment buildings becomes a device for depicting the Parisian neighborhood of Notre-Dame-de-Lorette: "it is in the person of his female neighbors that a painter indulges in observations of nature. His gaze pierces [*transperce*] windows and their light muslin armor; the couch [*divan*] and loveseat [*causeuse*] can hold no secrets for him; he deciphers at first glance all the hieroglyphics of the boudoir."[13] The painter's gaze takes on an ambulatory life of its own, and its remarkable capacity to penetrate is emphasized both by the verb *transpercer* and by the overstated opacity ascribed to the curtains: the painter does not merely catch a glimpse of something through parted muslin drapes but has a gaze that "pierces . . . armor." Once the painter's gaze has rendered the facade transparent and penetrable, it perceives the women's interiors as sexually legible. Second highlights the sexual connotations of the room and its furniture by using *boudoir*, the word for a woman's private bedroom, instead of the generic word for bedroom, *chambre*, and by singling out the loveseat; his claim that the painter deciphers "the hieroglyphics" of the bedroom "on first sight" underscores the immediacy of his access to the most intimate recesses of the woman's apartment.

For the young, unmarried male sexual adventurers featured in many of the *tableaux*'s sketches, access to women in the city's apartment buildings had all the hallmarks of the urban: it was deliberately transient, the result of a cultural understanding of the city as a place for fleeting, chance sexual contacts, yet all the more vulnerable to interference because of its very ephemerality. These texts conflated women with the city on the basis of rental, not ownership, and modeled men's temporary possession of women encountered in streets and buildings on their equally temporary rental of city property. [. . .]

The feminization of the apartment house clearly worked to adumbrate the status of both women and buildings as legible signs of male property, but at the same time, equations of women with apartment houses placed them in an open urban realm instead of in a sequestered private space. Not surprisingly, then, the *tableaux* often identified women with Paris, describing the city's regions in terms of the types of women who inhabited them and arguing that women

were condensed expressions of the city's essence, so that one could understand Paris by study-ing *la parisienne*.[14] Contributors to the *tableaux* developed a sexualized topography that classified Parisian neighborhoods according to the types of women found in them and defined female types in terms of their urban locations and their relative sexual availability to men. Examples of these types included the *lorette* who lived in and was named for the newly constructed quarter of Notre-Dame-de-Lorette and was a scheming, rapacious courtesan; the *grisette* who lived between the Bourse and the Palais-Royal (often on rues St-Denis and Vivienne) and selflessly helped support her student lover; and the *parisienne* who could be recognized by the unforgettable decor of her bedroom, to which all were welcome.[15] [. . .]

The portière and the personification of urban observation

The *tableaux* and *physiologies* directed their most concentrated animus against a female type whom they themselves associated with the power to see into apartment buildings—the *portière*.[16] By the 1840s the *portière* had become a standard presence even in buildings that lacked a formal entrance or porter's lodge. She often selected tenants for the landlord and collected rents; within the building, she distributed mail, cleaned landings and entrances, and did light housekeeping for some tenants (especially unmarried men); and she responded when tenants (who did not have keys to the main door) and visitors rang the bell.[17] The *portière* personified the passage between the street and the apartment because she let tenants into the building; because, as the historian Jean-Louis Deaucourt puts it, she "appeared everywhere, in the building's semiprivate spaces, in the open space of the street"; and because her *loge*, located off the building's vestibule or courtyard, was a "space both closed and open at the same time, eminently theatrical . . . propitious for exchanges, for comings and goings."[18]

The *portière* was a modern phenomenon, like the apartment house in which she worked, since only apartments constructed after the 1820s included a porter's lodge. Before then, only *hôtels* had porters (known as *suisses* or *concierges*, and exclusively male). During the July Monarchy, a *portière* signaled a modern building's bourgeois status and aristocratic preten-sions, although her own body also brought into the building the working-class presence that both landlords and tenants sought to exclude.[19] The authors of the *tableaux* and *physiologies* underscored the contemporaneity of the *portière*, who in their view personified the modern apartment house. Taxile Delord, in a *physiologie* entitled *Paris-Portière*, wrote that "the *portière* is a very recent creation, a product of modern civilization."[20] She was a "modern creation," wrote James Rousseau in 1841, like the "houses populated by a large number of tenants . . . that people build nowadays."[21]

Urban literature characterized the *portière* as an adept observer: her duties as mail distrib-utor, rent collector, and maid gave her an intimate and composite overview of the building's individual parts that perfected the totalizing yet local vision of the Parisian microcosm sought after by the authors of the *tableaux*. Skill at reading the city was not the only characteristic the *portière* had in common with the authors of the *physiologies*. They shared a liminal class position: the *portière* came from the working classes but lived among the bourgeoisie, worked as a servant but had the power to choose tenants and demand rents, while the authors of the *physiologies* were primarily lower middle-class men of letters who parlayed their skills at reading a range of modern types into cultural capital. Writers did not explicitly acknowledge their resemblance to the *portière*, but their satirical portrayals of her can be read as defensive attempts to distinguish between acceptable and unacceptable social climbing during a period of intense class mobility, as well as between their culturally endorsed interpretive activities

and those of the *portière*, whose information gathering was denigrated as feminized prying and gossip—*commérages*.[22]

The *tableaux* made the apartment house into an object and means of urban observation and the *physiologies* made the *portière* a stand-in for the apartment house: the *portière* was thus both a prime object of urban observation and embodied the activity of observing. The *physiologie* of the *portière* situated her at the intersection of the exterior street and the interior home, while *physiologies* as a genre assumed that external activities penetrated an individual's soul and mind, then reemerged at the body's surface as a set of typed expressions, behaviors, mannerisms, and physical signs.[23] The *portière* was herself a type, whose labor marked her appearance, but her topographical situation (at the door, in the stairwell and vestibule, shuttling between the apartment and the street, and even peering out of the space of the page) also emblematized the key locus of physiognomy—the point where external and internal coincided [Figures 36.1 and 36.2].[24]

Physiologists represented the porter as a personification of their own project of rendering the city "legible" by describing her as an Asmodeus figure, a knowing urban observer and an expert reader of physiognomies. Rousseau wrote that in terms of her "topographical position," the *portière* is "first in the house" and "knows how to read physiognomies admirably."[25] Other writers similarly identified the *portière* as a figure for the processes of reading and writing. In Henry Monnier's play *Le Roman chez la portière*, the author identified himself with

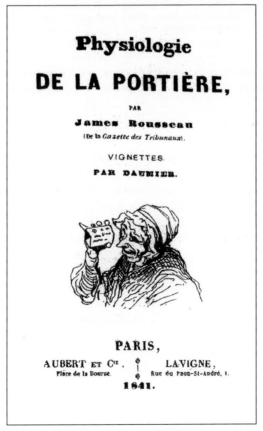

Figure 36.1 Honoré Daumier, the *portière* as voyeur and spy, examining the hidden contents of a letter, from James Rousseau's *Physiologie de la portière*, 1841.

Figure 36.2 The *portière* peers through a window and out of the page, with her fingers grasping a letter illuminated as a window-sill. Illustration by Honoré Daumier, from James Rousseau's *Physiologie de la portière*, 1841.

the *portière* by playing her in drag and mocked the *portière*'s obsession with finishing her novel by contrasting her desire to read with the constant interruptions of tenants ringing the bell to be let in.[26] Writers endowed the *portière* with authorial omniscience, placing her in the allegorical ranks of destiny and the fates: "It's hard to believe how much occult power is attributed to the *portière*," wrote Rousseau; "she plays the role of destiny in our lives." He entitled his eleventh chapter "On the *Portière*'s Influence on Everything in Life and on Lots of Other Things Besides That" and began it, "I've said it once and I'll say it again: the *portière* plays the role of Destiny on earth. She can, according to her whim, make your life sweet or turn your existence into a premature hell."[27] Eugène Scribe asked rhetorically in his one-act comedy *La Loge du portier* (1823),

> Who knows the news
> Of the whole neighborhood?
> In faithful accounts
> Who will publish it all?
>
>
>
> It's our *portière*,
> Who knows all, who sees all,
> Hears all, is everywhere.[28]

Porters were not exclusively female, and Parisian chroniclers also attributed acute visual power to male *portiers*. Jacques Raphael, in *Le livre des cent-et-un*, used language almost identical to Rousseau's when he wrote that the *portier* "admirably possesses what we could call topographical knowledge of every apartment in the building [maison]" and labeled the *portier* "the Argus of the building. . . . [H]e knows your habits . . . he penetrates into the most secret folds of your private life."[29] The reference to Argus recalls Janin's characterization of the *tableaux*'s multiple authorship and the city's multiple scenes: here the *portier* has an eye in every apartment because metaphorically he has thousands of eyes.

Writers evaluated the ocular powers of male and female porters very differently, however, indicating that their uneasiness about the powers of working-class porters in general was inflected by a particular hostility to the female porter. Commentators suggested that the spying of her male counterpart was official men's work by linking it to despised but legitimate forms of government surveillance and to the invisibility proper to the police. A contributor to the 1839 *Paris au XIXe siècle*, for example, invoked the *portier*'s "occult power" and "shadowy power . . . to know everything and everyone, to be aware of every detail . . . to read the lives of ten families like an open book . . . to be feared like a god or like a police commissioner."[30] Such analogies to a deity or the police placed the male porter at the invisible center of a complex web of surveillance that could easily extend over the entire city.[31]

The female porter's dominion, however, was overt rather than shadowy, limited to the immediate realm of her apartment building and tied to her overwhelming physical presence within it. She entered the political arena only through a metaphorical miniaturization that transformed her apartment building into a small kingdom:

> In all second- and third-class apartment buildings [*maisons de second et de troisième ordre*], the most influential person is without a doubt the *portière*. . . . She has the upper floors completely in her power [*sous sa domination immédiate*], is authorized to give people notice . . . if their political opinions aren't in sympathy with hers . . . [and] reigns like a sovereign . . . she has survived all the landlords who succeeded one another.[32]

The *portière* in this passage has a sovereign monarch's visible power but lacks the police's invisible stealth, and she can exercise that power only within the apartment building, within a *domination immédiate*. The characterization of the *portière* as grotesque and almost monstrous stemmed partly from the disparity between her quasi-divine powers and the minuscule space in which she exercised them, since the tableaux rarely showed the *portière* outside the vicinity of her apartment building and described her own apartment, the *loge*, as hyperbolically tiny. The *portière*'s ambitions and powers strained the bonds of her location.

Like the "blue-stocking" and the feminists of the 1840s, the *portière* became a figure for a female society that existed apart from heterosexual exchange, as well as for an inverted [. . .] domestic system. The physiologists associated the *portière* with a powerful circle of women who transformed the apartment building into a space permeated and governed by a network of female servants, female tenants, the *portière*'s children, almost inevitably daughters, and her many cats, who emphasized the *portière*'s femininity by functioning as both generic symbols of women and as slang references to female genitalia.[33] And the texts that showed the *portière* running her building with an iron hand and a sharp tongue also showed her dominating her husband, who typically made no sound, took up no space, and worked at home as either a cobbler or tailor, trades that had been feminized by the 1840s.[34] Monnier wrote, "she completely dominates her husband" and Rousseau emphasized the *portière*'s inverted

conjugal relations: "When the *portière* has a husband, he's just another piece of furniture in her lodge [*loge*]. In the *portière*'s household more than in any other the scepter has been conquered by the distaff. The poor husband is a purely passive being . . . and if people call him a porter, it's only because he's the husband of one."[35] Whereas Rousseau earlier described the *portière* as personifying the entire building, her husband's person is an inanimate portion of the building, a piece of the *portière*'s property—"just another item of furniture in her *loge*." Rousseau's reference to the scepter and the distaff invokes classic symbols of male and female power, political and domestic rule. The distaff that prevails in the *portière*'s household, however, is not simply domestic. It casts its net over the public sphere, since the *portière*'s work within the apartment house defines her husband's public identity.

The authors of the *tableaux* and *physiologies* represented the *portière* as, like themselves, an adept practitioner of urban observation, but also as a barrier frustrating men's visual access to the apartment building, and by extension to the city itself. [. . .] The literature of Paris suggested that their authors cared so intensely about keeping traffic fluid in both the home and the street that they extended fluidity to women, on the condition that women participate in heterosexual exchanges within those urban spaces. The *tableaux* depicted both the Parisian street and the apartment house as sites of display, voyeurism, and heterosexual exchange, whose open structures ensured women's availability to men, even in the city's potentially private apartments. The only significant threat to male enjoyment of the city was the *portière*, the apartment building's live-in caretaker. As a relatively independent woman who replaced heterosexual conjugality with powerful female homosocial networks and who controlled the commerce between domestic spaces and public thoroughfares, the *portière* came to symbolize an obstruction to men's heterosexual gaze precisely because she shared, even surpassed, their ability to penetrate and know the apartment building; [. . .] that apartment building, far from representing an opaque private enclave segregated from the public sphere, reveals the extent to which the July Monarchy's visual culture incorporated domestic space into its regime of transparency.

Notes

1 On the modernity of July Monarchy Paris, see Nicholas Green, *The Spectacle of Nature: Landscape and Bourgeois Culture in Nineteenth-Century France* (Manchester: Manchester University Press, 1990).

2 On the encoding and decoding of personal appearance during the earlier years of the Directory, see Margaret Waller, "Disembodiment as Masquerade: Fashion Journalists and Other 'Realist' Observers in Directory Paris, *L'Esprit créateur* (spring 1997): 44–54.

3 On transparency, see especially Jean-Jacques Rousseau, *Lettre à Monsieur d'Alembert sur les spectacles* (1758) and Jean Starobinski, *Rousseau: la transparence et l'obstacle* (Paris: Gallimard, 1971); on transparency in the French Revolution, see Lynn Hunt, *Politics, Culture, and Class in the French Revolution* (Berkeley: University of California Press, 1984); and Susan Maslan, "Representation and Theatricality in French Revolutionary Theater and Politics" (Ph.D. dissertation, John Hopkins University, 1997).

4 See Janet Wolff, "The Invisible *Flâneuse*: Women and the Literature of Modernity," in *Feminine Sentences: Essays on Women and Culture* (Berkeley: University of California Press, 1990), 34–50.

5 Margaret Cohen, "Panoramic Literature and the Invention of Everyday Genres," in *Cinema and the Invention of Modern Life*, eds. Leo Charney and Vanessa R. Schwartz (Berkeley: University of California Press, 1995), 227–252.

6 Richard Sieburth, "Une idéologie du lisible: le phénomène des 'Physiologies,'" *Romantisme* 47 (1985): 41.

7 See Andrée Lhéritier, "*Les Physiologies*: catalogue des collections de la Bibliothèque nationale," *Etudes de Presse*, n.s., 9, no. 17 (1957): 13–58; and Claude Pichois, "Le succès des *Physiologies*," ibid., 59–66.

8 Paul de Kock et al., *La Grande ville: nouveau tableau de Paris* (Paris: Maulde et Renou, 1843–44), 1: 139, and Frédéric Soulié, "*La Maîtresse de maison de santé*," in *Les Français peints par eux-mémes* (Paris: Curmer, 1841), 4: 350.

9 On the distinction between a "pictorial code" that depicted space as composed and a "spatial code" that represented space as something that a viewer might immerse herself in or move through, see Green, *Spectacle of Nature*, 2, 184.

10 Walter Benjamin uses the term "store of information" in the context of a comparison of the *tableaux* and *physiologies* to the panoramas, popular visual amusements that projected illusionistic urban and natural scenes on interior walls and used lighting effects to simulate movement and change within the panoramic scene. He writes: "These books consist of individual sketches which, as it were, reproduce the plastic foreground of those panoramas with their anecdotal form and the extensive background of the panoramas with their store of information" (*Charles Baudelaire: A Lyric Poet in the Era of High Capitalism*, trans. Harry Zohn [London: Verso, 1983], 35). Benjamin's point is both incisive and suggestive, but I would argue for the apartment house as the crucial, missing term linking the *tableaux* to the panoramas.

11 Frédéric Soulié, "Les Drames invisibles," in *Le Diable à Paris* (Paris: Hetzel, 1845), I: 118.

12 Wolff, "Invisible *Flâneuse*."

13 Albéric Second, "Rue Notre-Dame-de-Lorette," in *Les Rues de Paris: Paris ancien et moderne*, ed. Louis Lurine (Paris: Kugelman, 1844), 1: 139.

14 "Une Fenêtre du faubourg Saint-Jacques" for example, identified the grisette as an *article de Paris*, a Parisian commodity, similar to a Bordeaux wine or the truffles of Périgueux (in *Paris au XIXe siècle* [Paris: Beauger, 1839], 35).

15 See, for example, J. B. Ambs-Dalès, *Les Grisettes de Paris* (Paris: Roy-Terry, 1830), which organizes its chapters about different types of women workers according to the occupation associated with each neighborhood ("Quartier du Palais-Royal: modistes," "Quartier du Panthéon: blanchisseuses," etc.). Each chapter of this semipornographic text links the urban geography of women workers to prostitution.

16 Some writers associated female types other than the *portière* with a combination of urban and domestic knowledge; see, for example, L. Roux, "La Sage-femme," in *Les Français peints par eux-mêmes* (Paris: Curmer, 1840), 1: 177–184; and Madame de Bawr, "La Garde," in ibid., 1: 129–137.

17 For a social history of male and female porters in the nineteenth century, see Jean-Louis Deaucourt, *Premières loges: Paris et ses concierges au XIXe siècle* (Paris: Aubier, 1992); Deaucourt's thorough work is compromised by his insistence on reading descriptive and even literary texts as transparent sources of empirical data about the daily lives and duties of his subjects.

18 Deaucourt, "Paris et ses concierges," 488, 742.

19 In response to the upheaval of large-scale demolitions and increased class segregation by neighborhood effected by Haussmannization, Second Empire writers retrospectively perceived the July Monarchy as a time when buildings were more integrated by class, but this perception was more nostalgic than accurate. On class restrictions in bourgeois buildings, see Daumard, *Maisons de Paris*, 90–92.

20 Taxile Delord, *Paris-portière*, part of the series *Le Petit Paris* (Paris, n.d.), 3. This book probably appeared in the mid-1850s.

21 James Rousseau, *Physiologie de la portière* (Paris: Aubert, 1841), 6 and 61.

22 The *portière*'s daughter was stereotypically portrayed as a negative figure of class mobility. See, for example, Henry Monnier, "La Portière," in *Les Français peints par eux-mêmes* (Paris: Curmer, 1841), 3: 41: "they dip into a world more elevated than that into which they were born. . . . From their first years, they travel perpetually from the *loge* to the apartments and from the apartments to the *loge*."

23 Physiologists took their inspiration from Lavater, whose work on physiognomy appeared in French translation in 1841. There Lavater wrote that "physiognomy is the science, the knowledge of the relationship that links the exterior to the interior, the visible surface to what it covers of the invisible" (*La Physiognomie ou l'art de connaître les hommes* [1841], quoted in Henri Gauthier, *L'Image de l'homme intérieur chez Balzac* [Geneva: Droz, 1984], 252).

24 If the physiologists read the *portière* as typical of the space she occupied, there also existed an architectural physiognomic tradition of reading space anthropomorphically: "the comparison of facades and faces was entrenched in the classical anthropomorphic tradition . . . [and] . . . gained currency from the mid-eighteenth century with the attempt to develop a coherent theory of character for different building types" (Anthony Vidler, *The Writing of the Walls: Architectural Theory in the Late Enlightenment* [Princeton: Princeton Architectural Press, 1987], 121).

25 Rousseau, *Physiologie*, 8 and 12.

26 Henry Monnier, *Le Roman chez la portière* (Paris: Au magasin central des pièces de Théâtre, 1855).

27 Rousseau, *Physiologie*, 63, 73. See also Henry Monnier, "Une Maison de Marais," in *Paris, ou le livre des cent-et-un* (Paris: Ladvocat, 1831), 1: 342, in which he describes the porter's lodge as a courtroom: "There, every evening, sits the tribunal presided over by the *portière*. There are judged all the actions of the tenants, questions of high politics, and literary productions."

28 Cited in Edith Melcher, *The Life and Times of Henry Monnier: 1799-1877* (Cambridge, Mass.: Harvard University Press, 1950), 92.
29 Jacques Raphael, "Le Portier de Paris," in *Paris, ou le livre des cent-et-un* (Paris: Ladvocat, 1833), 10: 347.
30 "La Loge du portier," in *Paris an XIXe siècle* (Paris: Beauger, 1839), 17 and 18.
31 Edouard Monnais, in his article "Le Propriétaire," called the *portier* a "minister of the interior," "a minister of the police," and "a minister of war" (in *Nouveau tableau de Paris, au XIXe siècle* [Paris: Mme Charles-Béchet, 1834], 3: 120).
32 Monnier, "Une Maison de Marais," 333 and 342.
33 See Rousseau, *Physiologie*, 17: the *portière* "maintains intimate relations . . . [with] the servants . . . above all with the female servants. With the latter . . . [s]he is always sure to find an echo in her inter-locutrix [*interlocutrice*]."
34 Personal communication, Victoria Thompson, October 24, 1992.
35 Monnier, "Une Maison de Marais," 342; Rousseau, *Physiologie*, 23.

Chapter 37

SHAWN MICHELLE SMITH

"BABY'S PICTURE IS ALWAYS TREASURED"

Eugenics and the reproduction of whiteness in the family photograph album

"A baby's photograph, to all save doting parents and relations, is a stupid thing."[1]

R.H.E., *Godey's Lady's Book*, April 1867

TO TWENTY-FIRST-CENTURY READERS accustomed to the now ubiquitous nature of "baby's photograph," R.H.E.'s observation about the stupidity of these images seems either shocking or wonderfully perverse. Despite the fact that such photographs typically depict fleshy, wrinkled creatures, with eyes not quite focused, and expressions rather startled, baby pictures remain highly valued commodities in contemporary culture. Today the family photograph albums that protect these images are nearly sacred records. Indeed it is almost impossible to imagine dismissing the importance of those documents which twentieth-century Americans consistently herald as the most important things to save from the imagined disasters of proverbial floods and fires.

Considered in its own historical moment, R.H.E.'s proclamation continues to surprise. Where is the nineteenth-century rhetoric of maternal love and pride? Wasn't R.H.E. addressing, in *Godey's*, a reading audience of white middle-class women raised on the rhetoric

BABY'S PICTURE

is always treasured; more of them might be had by investing in a camera. A picture made with home surroundings is certainly more attractive than one obtained in a strange studio. With our

Cyclone Cameras

and outfits ANY ONE can make and finish good pictures. We manufacture cameras selling from $3.50 to $50.00. Our $6.00 · CYCLONE, SR., makes pictures 4 x 5 inches.
Our MAGAZINE CYCLONE CAMERAS make TWELVE PICTURES WITHOUT RELOADING, and are without doubt the only up-to-date cameras on the market. YOU DO NOT OPEN CAMERA TO CHANGE PLATES—ONE TURN OF A BUTTON DOES IT. The shutter automatically sets itself. ·
Send for our 1898 catalogue. CYCLONE POSTER in five colors mailed on receipt of ten cents.

WESTERN CAMERA MFG. CO.
New York Office: 79 Nassau St. Silversmith Bldg., Chicago

Figure 37.1 Advertisement, "Baby's Picture Is Always Treasured," Cyclone Cameras, *Ladies' Home Journal*, July 1898.

of True Womanhood?[2] The sentimental response to baby's photograph that one might expect to find here surfaces thirty years later in an 1898 advertisement for the Cyclone Camera in the *Ladies' Home Journal* [Figure 37.1] This advertisement, which encourages white middle-class women to buy newly manufactured hand held pocket cameras, proclaims: "Baby's Picture is Always Treasured."[3]

This utter reversal in the estimation of baby's picture does not settle the question of how or why the transformation itself occurred. Surely baby's photograph did not change dramatically over the course of 30 years. Perhaps focus was improved with shorter exposure times, but was there really anything more to see in a sharp rendering of baby's corpulence? What, then, *did* transform white middle-class evaluations of baby's picture over the course of the late nineteenth century?

In the period that separates R.H.E.'s disdain for these photographs from later exuberance over such images, "baby's photograph" came to emblematize a racial fantasy as eugenicists claimed it for scientific evidence. The family album was a particularly important evidentiary document for Francis Galton, the founder of eugenics, who defined "race" as an essential,

biological characteristic rooted in heritable moral and intellectual capacities.[4] In eugenics the family became central to the discursive production of race and of racial hierarchies, and the family album became one of the social institutions through which heredity was charted. Within this eugenicist context, photographs of children became powerful familial records through which racial hierarchies could be reproduced and maintained. In this way, the science of eugenics transformed the signifying context for baby's "private" picture. What I propose to consider here is whether or not eugenicist appropriations of baby's picture in turn informed the shifting evaluation of these representations in popular white middle-class venues. How can we make sense of the formal consonance and temporal congruence of popular and eugenicist family albums? To what degree do these parallel representational practices share ideological contingencies?

Mechanically reproducing baby

From the moment of its 1839 inception in daguerreotypy, the first photographic process, the photographic image has been conceptualized as a means of preserving family history and of documenting family genealogy. For many members of the middle classes, daguerreotypy provided the first affordable means of recording their own images, and of collecting representations of their loved ones.[5] Parents frequently had their daguerreotype portraits made in order to give them to their children as heirlooms and keepsakes. Attesting indirectly to the cultural use of the daguerreotype as heirloom, T.S. Arthur, a popular nineteenth-century writer for *Godey's Magazine and Lady's Book* proclaimed: "If our children and children's children to the third and fourth generation are not in possession of portraits of their ancestors it will be no fault of the Daguerreotypists of the present day; for, verily, they are limning faces at a rate that promises soon to make every man's house a Daguerrean Gallery."[6]

The documentation of the family, and of individual members within the family, grew and was practiced with increasing enthusiasm as the invention of new photographic technologies dramatically expanded the potential for photographic consumption. As early as the 1850s, with the invention of the negative/positive, collodion/albumen process, exposure times were shortened significantly, and photographic images became mechanically reproducible. Unlike the daguerreotype, which was a single, unique, non-reproducible image, the negative/positive process enabled unlimited copying of any given image; consequently, photographs became both easier to obtain and easier to circulate. As a result of such innovations, photographic reproduction began to expand exponentially. In this era of mechanical reproduction, technological advances that shortened exposure times, combined with new business ventures, served to instigate popular new fads; by the 1860s, people began to collect mass-reproduced carte-de-visite and cabinet card portraits of famous actors and actresses, of politicians, of one's own friends, and of family members. To assist collectors in organizing, preserving and cataloguing all these images, the photograph album became a popular cultural form.

By the 1890s, the family became a social unit increasingly imagined through the process of photographic representation. The advertisement for Kodaks in the *Ladies' Home Journal* of December 1897 reads: "The annual family gathering at the Thanksgiving table, the children's Christmas tree, groups of friends gathered to pass a winter evening—all make delightful indoor subjects for winter Kodaking. . . . Put a Kodak on your Christmas list." Situated as both the subject and the object of the verb "to kodak," the family becomes one holiday package among others. Things central to holidays regarded as particularly familial, objects around which the family is constructed—the Thanksgiving table, the children's Christmas tree— become ideal subjects to photograph: "Holidays are Kodak Days."[7] And, of course, holidays

were not the only camera days: As we have already seen, by the end of the nineteenth century, anytime was the right time to photograph children – "Baby's picture is always treasured."

As the family was posed vis-à-vis photographic reproduction at the turn of the century, the photographic industry situated white middle-class women at the cornerstone of this technological process. The Cyclone camera ad of 1898 appeals to mothers as the producers of infant photographic treasures, and some of George Eastman's famous "You press the button we do the rest" advertisements for the Kodak camera also depict white women photographing their children. More directly, in 1898, the *Ladies' Home Journal* featured two articles instructing white middle-class mothers in how to photograph children successfully. In "Getting Good Pictures of Children," E.B. Core gives "a few suggestions to the mother," acknowledging her role as orchestrator of photographic documentation, and offers eleven photographs of children as "models of their kind for the guidance of parents."[8] While "Getting Good Pictures of Children" assumes that parents will want to employ a professional photographer to enact their instructions, an article published ten months later, entitled "Photographing Children at Home," addresses parents themselves as photographers [Figure 37.2]. Isaac Porter, Jr., author of "Photographing Children at Home," offers parents "at home" photography tips in how to "preserve little records of their [children's] life, such as nothing but a good photograph can do." Again, sample photographs are reproduced in order to spark the reader's imagination, and extensive preparation is emphasized: "Having all the details in readiness before the child is called upon to take its part in the process of taking the photograph makes success almost sure of attainment."[9] Porter's detailed instructions, and the emphasis he places on "proper" preparation, suggest that "family life" was not only technologically mediated but also construed with rather serious intent.

The "charm" of the sample photographs Porter offers as models for the production of middle-class family life is created through references to the adult world, representing children as mini-adults: young boys and girls are shown reading, holding their babies, and staring at their reflections in the mirror. "Photographing Children at Home" becomes a guide in how to perpetuate middle-class "family values": Photographs of children project them into the educated, heterosexual, reproductive world of their parents, tracing the imaginary trajectory of the middle-class family line. Commenting on the staged rigidity of turn-of-the-century amateur photographs made of children at play, Philip Stokes remarks that parents may have felt "an unwillingness to record the disorder and untidy behavior of the children, who were, after all, the family's centre and its future."[10] In this context, "baby's photograph" ceases to be a stupid thing as it becomes the harbinger of the middle-class family's posterity.

A 1902 stereograph card produced by H.C. White further demonstrates how the act of photographing baby was becoming a normative performance, a kind of ancestral legacy in and of itself at the turn of the century. White's stereo card depicts a young white girl photographing her own "baby," and the text reads: "Now smile a little dolly, while I take your picture" [Figure 37.3]. By the turn of the century, family photography had permeated white middle-class culture so thoroughly that photographing baby had itself become a self-reproducing act.

Reproducing racial inheritance

As popular women's magazines targeted white middle-class women as engineers of the mechanical reproduction of the white middle-class family, scientific discourses posed these women as the biological reproducers of whiteness. By the turn of the century, white women were situated at the center of a new kind of "moral order," posed as the foundation of white propagation. While the rhetoric of motherhood in the antebellum period construed white

PHOTOGRAPHING CHILDREN AT HOME
By Isaac Porter, Jr.

There is no Kodak but the Eastman Kodak.

PERHAPS it may be that your little assistant will tell you when the goldfish are still, so that they may be photographed. A little patience will generally result in a negative which will amply repay the time and care given to its production. If the

ONE of the most interesting undertakings of amateur photographers is the attempt to secure good pictures of the children at home, and perhaps more disappointments result from such attempts than from their work in any other field. To get good pictures indoors, in the homes of the children,

SOME excellent portraits of children were shown in the JOURNAL of February last, and the suggestions given by the writer of the article must have led many amateur photographers to try to obtain pictures of little ones in their own homes. It is with a desire to aid such that these photographs and suggestions are offered. It is well to bear in mind the fact that a child's

surrounded by familiar objects; to catch them while at play, and to preserve little records of their life such as nothing but a good photograph can do, is not so difficult as many imagine, but it requires considerable thought and any amount of patience.

HAVING in mind a clear idea of what is desired, arrange the accessories, and make sure of all the light it is possible to get; then place your camera, and by that time

children are to be caught out-of-doors, as shown on the first column of this page, the foregoing suggestions hold good, and, as the light is so quick, it may at first prove easier than getting pictures indoors.

THERE are many opportunities of interesting children if one will only consider their ways. It may be that their sympathy is

moved, as in the case of the pet dog whose foot is injured. It was not difficult to get the children very much interested and full of pity for the little sufferer, and they were then anxiously "Waiting for the Doctor."

The interest of a child is very easily aroused, and once enlisted in the getting of a picture the rest is comparatively easy, but there must be no impatience on the part of the photographer, and no commands and no reprimands if the most satisfactory pictures are to be secured.

Holidays are
Kodak Days

Indoors and out the holiday season is a delightful one for amateur photography, making the Kodak an especially welcome **Christmas Gift**.

The Christmas tree, groups of friends at the dinner-table or at the card party, are all fascinating subjects for the flash-light, and the winter days give ample opportunity for indoor portraiture, while outside, the barren, wind-swept fields, or the trees covered with their feathery mantles of white, offer unlimited possibilities to the amateur artist.

Flash-light pictures and daylight pictures are easy with a Kodak.

Kodaks, $5.00 to $35.00

Catalogues free at the dealers' or by mail.

EASTMAN KODAK CO.
Rochester, N. Y.

1899 MODELS

Of RAMBLER BICYCLES are the best we have ever made and the 1899 price popular and fair,

$40

We are confident, after 20 years' experience, that we can build and are building "THE BEST BICYCLES IN THE WORLD"

Catalogue is free.

GORMULLY & JEFFERY MFG. CO.
Chicago Boston Washington New York
Brooklyn Detroit Cincinnati Buffalo
Cleveland London

The Best
Xmas Gift for
Young or Old

To give our Improved "Bo-Peep B" Folding Camera immediate and wide-spread popularity, we are now offering it at the special price of

$14

In every respect as good as a $25 Camera. It is fitted with our new '99 Model "Wizard" Shutter, and our improved rapid rectilinear lens.

Everything in the Photographic Line
Use our new printing papers—Platinum, Platbaid Florograph and Wizard Ferro. Catalogue FREE if you mention THE LADIES' HOME JOURNAL.

MANHATTAN OPTICAL CO. of N. Y.
Works and Executive Office: CRESSKILL, N. J.

Christmas Stationery

Why not consider Stationery a suitable gift for your friend? We can supply all that is new and in good taste.

Our Monograms and Address Dies are exclusive in design.

Write, explaining your wants.
DEMPSEY & CARROLL
The Society Stationers of New York
26 West 23d Street, NEW YORK

interest may be very easily awakened, but not easily held for any great length of time, making it necessary to get everything ready except the subject before attention is turned to the child.

Too much stress cannot be laid upon this point, as the pursuing of a different course is almost certain to defeat the desired result, while having all the details in readiness before the child is called upon to take its part in the process of taking the photograph makes success almost sure of attainment.

perhaps your subject has become interested or is ready to be easily interested. The next step is to get the child to help you. It may be a little girl who will hold her dollies so that you may get a picture of them, as in the photograph of the "Happy Little Mother."

Again, it may be that the little one may be induced to give some time to "Reading Mother Goose," or, after a visit to the "Zoo," be easily led to trust her dollies to take "A Ride on the Elephant."

The pictures which are sure to be most valued, and which will prove most pleasing to all concerned, are those which show the little ones occupied as they are found to be when left to their own devices, so one has but to learn what the children like to play, how they amuse themselves, or what interests them, in order to choose a subject. It may be that "The New Bonnet" is to be admired, or that "Cutting Paper Dolls" is fun.

Figure 37.2 Isaac Porter, Jr., "Photographing Children at Home," *Ladies' Home Journal*, December 1898.

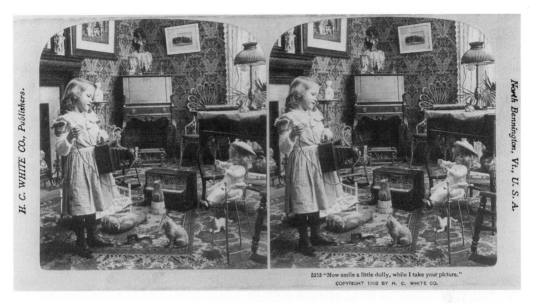

Figure 37.3 H. C. White Co., "Now smile a little dolly, while I take your picture," stereograph card, 1902. Reproduced from the collections of the Library of Congress.

middle-class mothers as the moral educators of their children, racialized discourses in the post-bellum era situated white middle-class mothers at the locus of biological inheritance. As a child's character was deemed the result of the True Woman's training in the antebellum period, it was seen as the gift of the white woman's biological heritage in the latter half of the nineteenth century. In the context of eugenics, white womanhood came to represent not the moral but the biological superiority of white middle-class character.

The role of the middle-class white woman as both the mechanical reproducer of "baby's picture" and the biological reproducer of whiteness (in baby's body) converged in the nine-teenth-century science of eugenics. It is within eugenicist research that "baby's picture" came to function most directly as a sign of racial inheritance. Situated within this cultural context, R.H.E.'s cantankerous rejection of the sentimentalized image of baby begins to take on new meaning. Indeed, a closer look at R.H.E.'s essay uncovers a new signifying register in which baby's picture might be treasured, ultimately, as the emblem of racial reproduction.

The image of a baby holds no great value for R.H.E. because one cannot read in the "features of obese babyhood" the "resemblances to those who have worthily wrought out their own lineaments of face and character." In other words, a baby's pudgy body does not yet resemble that of its progenitors; family resemblances are not yet legible in the baby's face. R.H.E. explains further in a particularly morbid passage that decisively situates the author beyond the pale of maternal affection: "Death will give you a more worthy picture of your baby's face than any mortal artist can do. Sharpened by disease, its little rigid features shall stand out to you with a storied distinctness, so that you may read, as from an open page, your child's possible and probable character and bearing."[11] For R.H.E., baby's face (and any representation of that face) does not become interesting until one can read inherited character in its tiny features. In these terms, baby's photograph is valued as the documentation of an ancestral trace, the visible continuation of the hereditary line. The baby's pudgy body does not signify sufficiently the "origins" of its physical features, it does not yet serve as an

index of ancestral character, and therefore, according to R.H.E., there is no good reason to record the corpulent physique.

In social practice, the child's photograph eventually did serve as a testament to ancestry, inheritance, and continuity in family genealogies. By the late nineteenth century, family photography entered new cultural terrain as the images of loved ones were harnessed to science. If the photographic portrait was first circulated *as* a family heirloom, it was later exchanged as a document that *recorded* an ancestral heirloom, namely the "inherited character" heralded by R.H.E. Over the course of the nineteenth century, "baby's picture," the "treasure" of the family photograph album, became the evidence of the eugenicist album, the record of ancestral physical features and their supposed analogues, namely, racialized character traits. In 1884, Francis Galton designed two "family albums": The *Record of Family Faculties* and *The Life History Album*. Aiming to acquire practical data to support and expand his theoretical descriptions of racial improvement through planned procreation, Galton promoted the albums to "those who care to forecast the mental and bodily faculties of their children, and to further the science of heredity."[12] Galton hoped that by encouraging a standardized method of accumulating and documenting "biological histories," a vast colloquial resource could be tapped for scientific purposes. As an incentive, Galton opened a national (British) competition and offered 500 pounds in prize money to those who could supply him with the best family records by May 15, 1884.[13] Similar contests were held at Midwestern fairs in the United States in the early twentieth century; however, in the United States such competitions evaluated not the quality of genealogical documentation but the eugenic fitness of the family itself.

Galton's *Record of Family Faculties* aimed to help parents predict the development of their children by tracing their physical and mental attributes back through their ancestral heritage. In the *Record*, an entire page is devoted to each ancestor, going back at least as far as the child's great-grandparents, and seventeen questions are asked about each relative. In addition to information generally recorded by the state, such as date and place of birth, residences, occupation, age at marriage, and date and age at death, the record also requires information about the physical attributes and character of each individual, including adult height, color of hair and eyes, general appearance, bodily strength, ability or imperfection of senses, mental powers, character, temperament, favorite pursuits, and artistic aptitudes. A separate section is left for ailments and illnesses, which Galton describes as "the most important of all in statistical investigations into the rise and fall of families," and, consequently, the rise and fall of races. In his description of the tables, Galton suggests that category number 8, for "general appearance," would be augmented by "a list of the best extant photographs or portraits of the person at various ages," which could be inserted as an extra page.[14]

Designed under the guidance of Galton by a committee of the British Medical Association in 1884, *The Life History Album* served as a pair to the *Record of Family Faculties*, and encouraged parents to document the physical and mental growth of a child by following a standardized schedule of measurements and observations, and by collecting a continuous photographic record of the child's growth. If the *Record* allowed parents to place children (and themselves) within a history of inheritance, locating individuals in relation to a familial past, *The Life History Album* aided parents in projecting their bloodlines into the future, tracing their own features in the development of their immediate progeny.

The Life History Album begins with a condensed, one-page chart on which to record the child's family history, followed by a page on which to document the family's medical history. Subsequent pages are devoted to the child's individual history, which begins with a detailed description of the child at birth, including both physical and temperamental characteristics [Figure 37.4]. First the mother's labor is described, and then the child's tiny body is

Description of Child at Birth.

Name ...

Date of Birth ...

Previous health of Mother* ...

Birth at full time, or premature ...

Labour natural, or instrumental ..

Physical peculiarities, if any (including " Mother's marks ")

Weight at birth (naked) ...

Length ...

Girth round nipples ...

Colour of eyes† ...

Colour of hair, if any ...

Child healthy, or ailing ..

 ,, quiet, or active ..

 ,, feeble, or vigorous ..

 ,, good-tempered, or fretful ..

 * Any strong mental impression, fright, shock, or fancy, occurring to the mother previous to the birth of the child, should be recorded if possible *before* the birth.

 † The eyes of infants at birth are always dark blue; but it should be observed at what period after birth their colour begins to change. This generally occurs within a few days.

Figure 37.4 Francis Galton, "Description of the Child at Birth," *The Life History Album* (London: Macmillan, 1884).

documented in terms of "physical peculiarities," weight, length, girth, color of eyes and hair, general health, and comportment. From this point the album divides into five-year periods, from birth to age 25, with less detailed segments devoted to the years 25–50 and 50–75. Each five-year period provides a graph on which to record the child's annual stature and weight, and two blank pages on which to date and annotate important events in the child's life. Anthropometric observations are made at the end of the fifth year, and every five years thereafter, including color of eyes and hair, chest girth, strength of pull, acuteness of vision and color vision, and hearing in each ear. Descriptions of acuteness or dullness in the other senses, of trials of physical strength and endurance, of hard intellectual work, of artistic ability, and of physical or mental attributes that resemble those of other relatives are also requested. Each period ends with a page for photographs. Parents are asked to make two photographic portraits of their child every five years, "an exact full-face and a profile,"[15] to be used along with other documentation to measure the child's physical and mental growth. Galton empha- sizes uniformity in the photographic recording, stating that the images should be consistent in size to enable accurate comparisons. It is here, then, in *The Life History Album*, that the photograph becomes an important historical and scientific document.

Galton imagined that these standardized "family albums" would further enable his study of eugenics, which he deemed both a "science of heredity" and a "science of race." Initially a study of the reproduction of individual genius, Galton's study of heredity rapidly expanded to include the intellectual capacity of "races," and the "character" of races in general. Indeed, Galton's first major study, *Hereditary Genius*, published in England in 1869, was conceived as Galton was studying "the mental peculiarities of different races,"[16] and this first study of "hered- itary genius" concludes with a comparative evaluation of the supposed intellectual capacities of different races. Further, Galton devised his theory of eugenics with a practical purpose in mind; he suggested that "the improvement of the natural gifts of future generations of the human race is largely, though indirectly, under our control."[17] Ultimately, what Galton proposed with the science of hereditary he later named "eugenics" was a system of racial improvement through breeding.

Eugenicist understandings of character in biological and racialized terms offer a means of comprehending R.H.E.'s strange estimation of familial character in 1867. When read through Galton's work, R.H.E.'s statements ring both ideologically pregnant and racially charged, providing the foundation for a new kind of racial identity. Once again, the antebellum discourse of moral maternal influence in the formation of a child's character is transformed into a discourse of biological maternal inheritance in the scientific register of eugenics and in R.H.E.'s essay itself.

R.H.E. suggests that one's inherited character, the heirloom of "worthy" parents, eventu- ally will be legible in the outward indices of one's body; similarly, Francis Galton believed that ancestral character (a racialized construct) was visible in one's physical features, as his family records and albums demonstrate.[18] While it is difficult to discern the extent to which Galton's *Record of Family Faculties* and *Life History Album* were adopted by American parents, similar records were promoted enthusiastically in the United States in the early twentieth century. According to Marouf Arif Hasian, Jr., "In the first decades of the twentieth century, thousands of families eagerly filled out their 'Record of Family Traits' and rushed to mail them to eugenicists for analysis by Davenport or other experts stationed at the Cold Spring Harbor Research Laboratory on Long Island."[19] Albert Wiggam, journalist and prominent popularizer of eugenics in America, distributed family-record forms to the audiences he addressed on his Chautauqua speaking tours, to be filled out and mailed to the American Eugenics Society,[20] and,

as noted above, eugenicists sponsored "fitter family contests" at Midwestern fairs, in addition to sponsoring eugenics displays and shows at such events.[21] In the United States, eugenicists augmented famous "negative" family studies with photographs of "degenerates," often doctoring the images to make subjects appear strange and even diabolical. Such works include Henry Herbert Goddard's *The Kallikak Family* (1912), Frank W. Blackmar's, "The Smoky Pilgrims" (1897), Elizabeth S. Kite's, "The 'Pineys'" (1913), Mina A. Sessions's *The Feeble-Minded in a Rural County of Ohio* (1918), and A.C. Rogers and Maud A. Merrill's *Dwellers in the Vale of Siddem* (1919).[22]

An investigation of early-twentieth-century U.S. "baby books" also suggests that the construction of genealogical identity, in terms surprisingly similar to those outlined by Galton, permeated early-twentieth-century U.S. culture. Indeed, it appears that Galton's attempt to harness popular family albums to science was quite effective, for over the course of the early twentieth century, American baby books adopted many eugenicist terms and structures, even mirroring Galton's *Record of Family Faculties* and *Life History Album*. As Galton appropriated and aimed to standardize the popular form of the family album, that very popular venue was itself transformed, adopting the terms of standardized data in *The Modern Baby Book*. It would seem that the popular and scientific forms of the family album mutually influenced one another in the early years of the twentieth century.

In *The Modern Baby Book and Child Development Record*, published by *The Parents' Magazine* (in connection with W.W. Norton) in 1929, John E. Anderson and Florence L. Goodenough attest to the popularity of baby books in the early twentieth-century United States: "For years parents have been attempting to keep records of the early development and behavior of their children. Pink and blue baby books abound." Framed in contrast to "the old-fashioned Baby Books, containing merely a heterogeneous collection of snapshots, 'cute sayings,' locks of hair and what-not," Anderson and Goodenough designed *The Modern Baby Book* to standardize family records and serve the purposes of both science and practical parenting, much as Galton had devised *The Life History Album*.[23] Similar to Galton's *Life History Album* (which, once again, begins with a condensed, one-page chart on which to document the child's family history), *The Modern Baby Book* begins with a short family history, in which parents are called upon to record the "interests and accomplishments" of the child's ancestors. In this section, photographs of the parents and all the grandparents are to be collected at the time of the baby's birth, establishing a portrait of the family line at the time in which the baby enters that ancestral lineage. Following this section in *The Modern Baby Book*, the baby's birth and initial stature are described in much the same terms outlined by Galton: As Galton requested a detailed description of the child's physical characteristics at birth, including an extensive record of the child's tiny body, *The Modern Baby Book* calls for a record of the baby's weight, length, and circumference. Subsequent measurements of height and weight are made every week for the first year and once a year thereafter to age sixteen. What Goodenough and Anderson add to the "scientific" terms of the baby book are explicit markers of class status — they ask parents not only to record the child's anthropometric measurements each year, but also to describe the child's birthday party and to list the presents he or she received.

Both Galton's *Life History Album* and Goodenough and Anderson's *Modern Baby Book* are future-oriented, self-reproducing projects. While Galton imagines that the child will take over the process of self-documentation in adulthood, Goodenough and Anderson predict that when the child becomes an adult, the baby book will become especially significant, allowing him or her to compare "his [or her] own early development with that of his [or her] children and grandchildren."[24] Like Galton, Anderson and Goodenough imagine that the familial bloodline will reproduce itself long into future generations.

Sentimental aura and the evidence of race

Re-examining the advent of the popular family photograph album from the cultural position established by Galton's "family albums," one can begin to see how the "treasured" image of baby secured by white middle-class mothers with pocket cameras may obscure a very troubling cornerstone of racial reproduction. The slippage between the seemingly innocuous evaluation of baby's picture in the family photograph album and the explicitly racialized measure of baby's photograph in Francis Galton's albums may be clarified by thinking about these two photographic practices in relation to Walter Benjamin's theories of photographic meaning. When addressing the popular form of family photography that developed contiguously with Galton's eugenicist records, the famous distinctions Walter Benjamin draws between the auratic and the evidential image become significant precisely as they are effaced.

According to Walter Benjamin, the technological shift from daguerreotypy to mechanical reproduction (which enabled both the popular form of family photography and Galton's eugenicist family records) fundamentally altered the character of photographic meaning. In Benjamin's estimation, the dissolution of "aura" surrounding the work of art begins with the invention of mechanical reproduction, or the negative/positive photographic printing process, and heralds a revolutionary moment in art history, one that frees the work of art from its "parasitic dependence on ritual." Benjamin argues that the modern painting, in its singular originality, trapped within the museum, remains intricately tied to a tradition of religious ritual; the artist is analogue to the creator, and the modern painting, marked as an original creation, retains the aura of a pseudo-spiritual glow. According to Benjamin, mechanical reproduction frees the work of art from the tyranny of originality, destroying the unique in multiplicity, enabling the work of art to be harnessed to the work of politics. Negative/positive photography, with its capacity for endless reproduction, is, for Benjamin, the first revolutionary art form.

Yet even as he describes mechanical reproduction, or the negative/positive photographic process, as a gestalt, Benjamin also notes that aura maintains a lingering stronghold in the most popular of early photographic forms – the portrait. According to Benjamin, aura or "cult value" haunts the photographic portrait, hovering around the photographed face, before it is finally dispelled by evidential standards. Benjamin describes the aura of the photographic portrait as the viewer's nearly sacred devotion to a loved one, which is analogous to the worship of the religious devotee before a cherished icon.[25] Here we have in Benjamin's analysis the one function of the photograph that satisfies that cantankerous critic of "baby's picture," R.H.E. – the images serves as "a link between you [the viewer] and the memory of its owner."[26] For Benjamin and for R.H.E., then, the aura of the photographic portrait is the beholder's investment of the image with sentiment.

While sentimental bonds rhetorically dominated photographic meaning in the family photograph album, what Benjamin has described as the "evidentiary" quality of non-auratic images was privileged at least partially in the evaluation of baby's picture in Francis Galton's *Life History Album*, in *The Modern Baby Book*, and in R.H.E.'s essay. I would like to suggest, therefore, that the photographs Francis Galton aimed to procure with his *Record of Family Faculties* and his *Life History Album* signified at the convergence of Benjamin's auratic portraits and evidentiary documents. Benjamin distinguishes the "evidential" photographic record from the "auratic" photographic portrait by its relative "emptiness." For Benjamin it is only the "deserted" image that can replace cult ritual with "hidden political significance," that can provide revolutionary evidence of "historical occurrences" like the "scenes of crime." It is only when "man withdraws from the photographic image" that ritual value is superseded by exhibition value, the "revolutionary" estimation of historical occurrences.[27] Finally, even such "deserted" images

require captions in order to maintain their radical import, in order to harness photographic meaning to revolutionary objects.[28]

Providing detailed instructions regarding the size, format, and style of images to be collected, and situating those images within an extensive narrative "caption" of detailed documentation, Galton also attempted to demystify the once sentimental meaning of the individual portrait, reclaiming it for science. While certainly not "deserted," Galton's images, drained of sentiment, would have been valued not simply as keepsakes, but as testaments to the family bloodline. Transforming the portrait into a scientific record, Galton reinscribed the photographic likeness as the evidence of family character, and thus, in the terms of eugenics, as the sign of racial identity. While clearly evidential, Galton's use of the photograph was certainly not the counter-hegemonic force that Benjamin envisioned. On the contrary, while Galton's "family portraits" are divested of a specifically sentimentalized aura, they are reinvested with what one might call a pernicious ritualistic aura of racism, which not only establishes racial distinctions, but also reinforces racial hierarchies. In Galton's albums the evidential quality of the image is reinvested with an aura that links the viewer, through baby's picture, to a racialized family bloodline. To summarize bluntly, in Galton's albums baby's picture is treasured as a measure of white supremacy.

How does this conversion of evidence and racialized aura in Galton's albums help us to understand the sentimentalized investment of white middle-class Americans in "baby's picture" at the turn of the century? If Galton's albums infuse the sentimental image with the fantasized "evidence" of racial superiority, do popular family photograph albums perform the inverse function? Does "baby's picture" become a kind of racial document invested with sentimental aura in the family photograph album? Surely many will protest such a suggestion, proclaiming that they do not think about the future, health, or dominance of their race when they photograph their children. But then how can we understand contemporary birth announcements that include baby's first photograph and document the weight and length of the newborn? And what does it mean when those same photographs are placed in baby books that reproduce so closely the terms of Galton's eugenicist albums?

Richard Dyer has argued persuasively that whiteness secures its cultural power by seeming to be nothing at all, by being invisible.[29] Does it not make sense, then, that the practices and rituals of white desire would also be invisible, remaining racially unmarked, perhaps masked by other terms, such as those of gender, class, or even sentiment? Today baby's picture is certainly not a stupid thing; but then again, a lot may depend on what it is we "always treasure."

Acknowledgment

A longer version of this essay was published originally in *The Yale Journal of Criticism* 11: 1 (Spring): 197–220, and reprinted in Shawn Michelle Smith, *American Archives: Gender, Race, and Class in Visual Culture* (Princeton, N.J.: Princeton University Press, 1999).

Notes

1 R.H.E., "My Photograph," *Godey's Lady's Book and Magazine* (April 1867): 341–5, 343.

2 Barbara Welter, "The Cult of True Womanhood: 1800–1860," *Dimity Convictions: The American Woman in the Nineteenth Century* (Athens, Ohio: Ohio University Press, 1976), 21–41.

3 Advertisement, "Baby's Picture," *Ladies Home Journal* (July 1898).

4 Francis Galton's influential studies include: *Hereditary Genius: An Inquiry into its Laws and Consequences* (London: Macmillan, 1892); *Inquiries into Human Faculty and its Development* (London: J.M. Dent and Sons, 1907) (London: Macmillan, 1884); *Memories of My Life* (London: Methuen, 1908); *Natural Inheritance* (London: Macmillan, 1889).

For studies of the impact eugenics had on late-nineteenth and early twentieth-century United States culture, see Marouf Arif Hasian, Jr., *The Rhetoric of Eugenics in Anglo-American Thought* (Athens, Ohio: University of Georgia Press, 1996); Daniel J. Kevles, *In the Name of Eugenics: Genetics and the Uses of Human Heredity* (New York: Alfred A. Knopf, 1985).

For analyses of the role photography played in eugenics, see David Green, "Veins of Resemblance: Photography and Eugenics," *Photography/Politics Two*, Patricia Holland, Jo Spence, and Simon Watney (eds.) (London: Comedia Publishing Group, 1986), pp. 9–21; Allan Sekula, "The Body and the Archive," *October* 39 (Winter 1986): 3–64.

5 John Tagg, *The Burden of Representation: Essays on Photographies and Histories* (Amherst, Mass.: University of Massachusetts Press, 1988), p. 37.

6 T.S. Arthur, "American Characteristics: No. V—The Daguerreotypist," *Godey's Magazine and Lady's Book* (1849): 352–5, 352.

7 "Kodaks," *The Ladies' Home Journal* (December 1897): 21.

8 E. B. Core, "Getting Good Pictures of Children," *The Ladies' Home Journal* (February 1898): 13.

9 Isaac Porter Jr., "Photographing Children at Home," *The Ladies' Home Journal* (December 1898): 35.

10 Philip Stokes, "The Family Photograph Album: So Great a Cloud of Witnesses," in *The Portrait in Photography*, Graham Clarke (ed.) (London: Reaktion, 1992), pp. 193–205, 200.

11 R.H.E., "My Photograph": 343.

12 Francis Galton, *Record of Family Faculties* (London: Macmillan, 1884) p. 1.

13 This announcement was included as an insert in Francis Galton's *Record of Family Faculties*.

14 Francis Galton, *Record of Family Faculties* pp. 8–9.

15 Francis Galton, *The Life History Album* (London: Macmillan, 1884) p. 5.

16 Francis Galton, *Hereditary Genius* p. 23.

17 Francis Galton, *Hereditary Genius* pp. xxvi, xxvii.

18 Galton also devised a system of composite portraiture through which he claimed to be able to capture the central physiognomic characteristics of any given biological "type" of individuals. Francis Galton, Appendix A: "Composite Portraiture," *Inquiries into Human Faculty and its Development* pp. 221–41.

19 Marouf Arif Hasian, Jr., *The Rhetoric of Eugenics* 31.

20 Hasian, *The Rhetoric of Eugenics* pp. 37–8. Albert Edward Wiggam, *The Fruit of the Family Tree* (London: T. Werner Laurie Ltd., 1924).

21 Hasian, *The Rhetoric of Eugenics* pp. 43–4.

22 For a description and reproduction of many of these documents, see Nicole Hahn Rafter, *White Trash: The Eugenic Family Studies 1877–1919* (Boston: Northeastern University Press, 1997).

23 John E. Anderson and Florence L. Goodenough, *The Modern Baby Book and Child Development Record* (New York: W.W. Norton and *The Parents' Magazine*, 1929) pp. v, ix.

24 John E. Anderson and Florence L. Goodenough, *The Modern Baby Book* pp. x.

25 Walter Benjamin, "The Work of Art in the Age of Mechanical Reproduction," *Illuminations*, Hannah Arendt (ed.) (New York: Schocken, 1968) pp. 217–52, 224–6.

26 R.H.E., "My Photograph": 343.

27 Walter Benjamin, "The Work of Art in the Age of Mechanical Reproduction" p. 226.

28 Walter Benjamin, "The Author as Producer," *Reflections*, Peter Demetz (ed.) (New York: Schocken, 1968) pp. 220–38, 230.

29 Richard Dyer, "White," *Screen*, 29: 4 (Autumn 1988): 44–64, 44–6.

DEBORA L. SILVERMAN

PSYCHOLOGIE NOUVELLE

[. . .]

BY 1889 A DECADE OF CLINICAL EXPLORATION of new dimensions of the self had already gained public attention. Georges Valbert, writing for the *Revue des deux mondes*, noted that a cult of the self had emerged to compensate for the challenges to individuality wrought by machine production and colossal technology. Valbert commented that at the very moment that spatial forms and social life threatened the individual with anonymity and insignificance, self-cultivation and self-analysis had been given new life and power. If "society aligns us to conformity" and machines rule us "by the spirit of symmetry, exactitude, and precision," psychological man liberates himself by relentless self-expansion and convolutions of thought and speech. The continual search for new and varied sensations, however, denied to the ego both contentment and stable boundaries. If self-reflexiveness countered regimentation and social leveling, it also transformed modern man into an "agitated" and weary "neuropath."

Restless neuropaths and contorted interior meanderings were themselves the objects of clinical discussion at scientific congresses held during the 1889 Paris Exhibition. The International Congress on Physiological Psychology addressed the conventional topic of psychological heredity but also explored the controversial and less definitively physiological issues of hypnotism and hallucinations in nonpsychotic individuals. The exhibition also provided the occasion for the First International Congress on Experimental and Therapeutic Hypnotism, whose three hundred participants included "philosophers, neurologists, psychiatrists, and practitioners of hypnotism."[1] Although delegates vigorously debated the extent of receptivity to hypnosis and its use as a curative tool, a consensus was evident in the scientific community by 1889 that hypnosis had revealed that the mind was subject to divided consciousness, incorporating a double ego: a conscious ego and an unconscious one that, unknown to the conscious one, acted autonomously.[2] Jules Héricourt's survey on the nature of the unconscious, based on a wide range of sources, concluded in 1889 that "even in our daily life, our conscious mind remains under the direction of the unconscious."[3] The expansion of the discoveries, debates, and personnel of French mental medicine between 1889 and 1900 deepened public awareness of and preoccupation with unconscious domination, calling into question the Enlightenment legacy of self and social mastery.

In charting the emergence of a new cult of the self and the primacy of the irrational in fin-de-siècle France, historians usually invoke the ideology of Symbolism. French Symbolism originated as a literary movement but emerged in the 1880s as a broad theory of life and an attitude toward the material world that inverted outer and inner reality. Conceived as an attack on Parnassian naturalism, Symbolism was officially launched by two poets, Jean Moréas

and Gustave Kahn, in 1886. Their published statements of that year articulated four goals that were to galvanize a varied segment of the artistic community in a "reaction against positivism"[4]. The first was idealism, a commitment to disengage an essential order of reality beneath the surface of appearances. Kahn asserted that "the aim of art is to objectify the subjective," the "externalization of the Idea." The second was subjectivism, the redirection of artistic activity to an inner psychic world, with particular emphasis on the dream state. Kahn stated that "we carry the analysis of the self to the extreme," where "the dream is indistinguishable from life." Third, Symbolists redefined artistic language, aiming to communicate through suggestion, allusion, and association rather than by direct statement, description, or depiction. The purpose of Symbolist art was to express the inexpressible, to convey and evoke emotional states in the reader or viewer similar to those experienced by the artists. Fourth, the Symbolists sought to appeal directly to the inner world of the audience through the suggestive power of sound and the dynamic formal elements of the visual arts—line, color, and shape.[5]

The extension of Symbolist ideals to the applied arts was one source for the redefinition of the interior from an accretion of material objects to an arena of self-discovery. For the setting for the Symbolists' exploratory subjectivism was in private ensembles coordinated for the purpose of continually extending the boundaries of sensibility; the decor functioned not to locate the inhabitant historically but to stimulate him visually. The brothers de Goncourt had established this link between interior decoration and psychological interiority. Their vision of the interior as activator of both nervous vibration and visual suggestion became a central feature of the Symbolist enterprise. Where the Goncourts were delicately poised between historicism and psychology, between realism and subjectivism, the Symbolists embraced the cult of artifice, of life from the inside out. The interior was no longer a refuge from but a replacement for the external world.

The Goncourts were directly connected with the literary Symbolists of the 1880s who redefined the interior as a field of visual evocation and nervous palpitation. Joris-Karl Huysmans, a friend and admirer of the Goncourts', stated that his manifesto of Symbolism, the 1883 novel *A rebours*, was inspired in form and in substance by Edmond's *Maison d'un artiste*.[6] Like Edmond's book, Huysmans's work repudiated conventional narrative coherence and descriptive action. It recorded the inner world of one major character, Des Esseintes, through the unfolding of his experience in a succession of elaborate interiors he himself had crafted. The objects in those interiors were the vehicles for his synaesthesia and visual fantasies; his dependence on this continuous aesthetic stimulation consigned him to physical lassitude and nervous hypersensitivity. One of the models for Huysmans's protagonist was Count Robert de Montesquiou-Fezensac, a Symbolist poet and visual artist who also engaged in a form of interior decoration in direct emulation of the Goncourts' aesthetic and psychological model.[7] De Montesquiou organized his apartment on the rue Franklin as an evocative scene in which individual objects dissolved into a field of suggestive visual energy.[8]

We can thus trace affiliations in the artistic avant-garde that explain the new link between psychological self-exploration and interior space as a domain of suprahistorical self-projection. This diachronic line extends from the Goncourts, via Huysmans and de Montesquiou, to Marcel Proust. Proust amplified the Symbolists' ideal of the expressive and visual capacities of language to evoke the fluid, suggestive power of the interior realm. He chronicled a flowing give-and-take between the insulated narrator and his furnished decor, correlating the materials of the innerspace with the nervous vibrations they stimulated, even as the concrete rooms dissolved in the transfiguring fevers of inner vision.[9] The Goncourts' projection of visual animation onto the walls of the bedroom in the *Maison d'un artiste* led finally to the whirling

room envisioned by the narrator in the opening section of Proust's *Swann's Way*. Edmond de Goncourt had relished lying in bed at night, half-asleep, thinking of the bed's former inhabitant, the princesse de Lamballe, and gliding his eyes about the room. His inner vision assumed visual and dynamic shape as he imagined the figures woven into the eighteenth-century Aubusson-tapestried walls coming to life, dancing, cavorting, and encircling him.[10] In Proust's version, the narrator no longer needed historical cues to provide an anecdotal frame for visual projection; the tumult of mental energy set the room spinning around, trapping all the furnishings in the centrifuge of the psyche.[11]

Significantly, the transformation of the interior to a subjectivist dream room was not confined to the artistic avant-garde. Indeed, the association between psychological knowledge and interior decoration had wider cultural resonance and broader historical meaning. At the same time the Symbolists were inventing the interior as the emblem of self-fashioning, a new body of medical knowledge was being consolidated and generalized, called the *psychologie nouvelle*.[12] The medical clinicians concentrated their efforts in two areas: first, the exploration of the interior of the human organism as a febrile, mechanistic system of nerves and, second, the examination of visual dimensions of the thought process, with particular emphasis on the role of images in the mental operations underlying states of hypnotism, suggestion, and dreams. Originating in studies restricted to individual pathologies, the conceptions of nervous excitation and degeneration and of the dynamic visual properties of thought extended well beyond the boundaries of medical science. By the 1890s the diffusion of the *psychologie nouvelle* had indelibly stamped elite and popular culture.

Although the Symbolists are usually credited with redefining rational consciousness and with championing a new subjectivist relation to the world, the diffusion of medical psychology facilitated a broader reevaluation of space and self in the French fin de siècle. Some evidence, indeed, indicates that the Symbolists themselves drew directly on medical sources for their conception of the psychological interior. To Des Esseintes, for example, Huysmans attributed clinical states of nervous excitation and exhaustion that he had absorbed from a careful reading of Doctor Alexander Axenfeld's 1883 text *Traité de névroses*.[13] More broadly, the four goals of Symbolist artistic philosophy—subjectivism, idealism, the dream world, and the power of visual and aural suggestion—were the very objects of medical research on the mind. They appeared at the center of medical debates on contending models of the unconscious, the results of which were widely publicized in late nineteenth-century France. Most important, the widespread dissemination of medical ideas about the workings of the nerves and the visual dynamism of cognition were assimilated by artists and sponsors of the decorative arts movement, shaping their understanding of the modern style as one of psychological interiority.[14]

The *psychologie nouvelle* in the 1890s originated with the discoveries of the two medical pioneers, Doctor Jean-Martin Charcot of Paris and Doctor Hippolyte Bernheim of Nancy. In three ways the generalization of this *psychologie nouvelle* had direct relevance for the redefinition of interior decoration. First, in the wide-ranging political discussion of the pathological degeneration of the national body, attributed to the sensory overstimulation of the urban metropolis, the city was identified as an agent of "neurasthenia"; the interior took on a new role as a soothing anaesthetizer of the citizen's overwrought nerves. Second, the meaning of interior space was transformed by its new association with the visually charged fluidity of the "*chambre mentale*."[15] If the overstimulated citizen could find refuge in the interior from the sensory barrage of the metropolis, he nonetheless transported with him the propensity for animating the interior by that very same mechanism of the nerves. No longer could the interior be construed as a stable and static historical setting. Rather, by the 1890s it had emerged as an arena of dynamic and reciprocal interaction between subject and object. Finally, the

convergence of interior design and the new psychology was sealed by the engagement of a medical psychologist in the decorative arts. The new space and the new self were bound together by Doctor Charcot's practice as an artist and interior decorator.

From decadence to degeneration: aesthete debility to national pathology

In 1862 Jean-Martin Charcot, the son of a Parisian carriage builder, was appointed resident physician to the Salpêtrière Hospital. Charcot had studied medicine at the University of Paris and was awarded his medical degree in 1853, upon presenting a doctoral thesis on gout and chronic rheumatism. Beginning in 1862, Charcot devoted his research exclusively to neurological disorders, and within the next eight years he founded the field of modern neurology. His publication of a series of studies and his innovative teaching techniques gained him widespread recognition. In 1872 he was appointed professor of pathologic anatomy in the faculty of medicine, and in 1892 he accepted the chair for the study of nervous disorders at the Salpêtrière. This appointment represented the first official acknowledgment of neurology as a specialty in its own right.[16]

Charcot's work unfolded in two directions that were destined to have significant public impact by the late 1880s. First, he defined and characterized a series of diseases of the nervous system, called *maladies nerveuses*, each of which was associated with a set of interior lesions on the spinal cord. Second, Charcot developed a variety of new therapies to treat the different pathologies of the nervous system. These included "galvanization," or electric shock therapy; "ferronization," or the ingestion of iron; and the suspension of the patient from the ceiling in a contraption resembling an iron harness.[17] Underlying these treatments was a belief in the physical and organic origins of nervous disorders, whose causes were attributed to the atrophy, or degeneration, of the nervous system.

By 1885, French creative artists had assimilated Charcot's elaboration of nervous pathologies, with particular emphasis on a condition called neurasthenia. This was a clinical state of mental hypersensitivity and physical debility, resulting from continuous mental exertion unrelieved by physical action. Following the mechanistic model of the nervous system formulated by Charcot, neurasthenia was diagnosed medically as a condition of nervous exhaustion, in which excessive stimulation atrophied the nerves to a point of extreme irritability and physical lassitude.

The clinical states of neurasthenia and degeneration were transposed into literary form by such writers as Edmond de Goncourt, Paul Bourget, Joris-Karl Huysmans, and Emile Zola, who attributed the qualities of individual degeneration to the nation as a whole. In 1880, for example, Edmond de Goncourt characterized the nineteenth century as a "feverish, tormented" century, one of "anxiety and nervous corrosion."[18] In 1896 Emile Zola traced infirmity to the nervous tension of modern life:

> Ours is a society racked ceaselessly by a nervous erethism. We are sickened by our industrial progress, by science; we live in a fever, and we like to dig deeper into our sores. . . . Everything suffers and complains in the works of our time. Nature herself is linked to our suffering, and being tears itself apart, exposes itself in its nudity.[19]

The extension of the pathological findings from the individual to the national body went far beyond the confines of aesthetic culture after 1880 because of the widespread diffusion and generalization of the Salpêtrière discoveries. As the typologies of the *maladies nerveuses* left

the halls of the Salpêtrière and permeated the public domain, the arena of susceptibility expanded; politicians, journalists, literary critics, and social theorists were faced, in the late 1880s, with the startling revelation that nervous debility was not restricted to the hothouses of literary decadence but was incubating as a collective condition of national degeneration. The urban metropolis, whose inhabitants faced a relentless barrage of sensory excitation and lived at an accelerated pace, threatened to transform France into a nation of physically exhausted and mentally hypersensitive Des Esseintes.[20] [. . .]

In the context of widespread application of the medical studies of nervous pathologies to national life and of worry over collective degeneration, the official craft sponsors promulgated a modern interior style based on vitalizing organic forms. Their retreat to a healthy chamber of naturist physicality was posed against the nervous erosion wrought by the overloaded metropolis. But a second feature of the *psychologie nouvelle* undermined the possibility for a stable and concrete interior anchorage. By 1890 the psychological phenomena of suggestion, hypnosis, and dreaming had left the Salpêtrière and had shaped a new theory of mind and attitude toward reality, inextricably joining the practice of interior decoration to the unstable fluidity of the *chambre mentale*.

Hypnotism, suggestion, visual thinking, and the new French concept of the irrational: psychopathology or model of mind?

After 1875 Charcot shifted the focus of his work from the systematic characterization of nervous disorders and their clinical remedies to the particular study of hysteria. This pathology posed a special challenge to the medical pioneer, for unlike the other diseases of the nervous system classified by Charcot, it had no discernible and consistent anatomical base. Moreover, hysterical patients demonstrated a host of bewildering symptoms: amnesia, paralysis, anesthesia, contractions, and spasms. Charcot observed these patients intensively, using hypnosis as one method of investigation.[21] By the 1880s the results of these studies, together with Charcot's volatile debates with another clinician of hypnosis, Dr. Hippolyte Bernheim of Nancy, yielded a reevaluation of rational consciousness. The Charcot-Bernheim conflict over hypnosis and mental suggestion is usually noted for its impact outside France: Sigmund Freud went to Paris and Nancy between 1884 and 1886 to absorb the lessons of both Charcot and Bernheim, transposing their conclusions into a radically new theory of sexuality and the unconscious. But the clinical explorations of hypnosis and suggestion had an equally powerful effect in France in the fin de siècle. To French psychologists, hypnosis unveiled a nondiscursive, dynamic ideational flow. Images were discovered as an irresistible force in the thought process, permeating the brain directly from the outer world, and projected outward as if to shape the world in accord with inner visions, unmediated by rational discretion. Although less shattering to the rationalist legacy than the Freudian formulation of the connection between the unconscious and the unbridled aggressiveness of the id, French explorations of hypnosis, suggestion, and the peculiar propensity of the mind to receive and project images posed a striking challenge to the positivist understanding of the relationship between the mind and the external world.

Hypnotism had been discredited in medical circles in the nineteenth century by its relation to the eighteenth-century practices of Mesmer and his animal magnetism. Charcot dismissed the Mesmer legacy as metaphysical quackery but defended the utility of hypnotism and suggestion under carefully controlled conditions. The enlightening forces of modern medicine revealed that hypnotism and suggestion had nothing to do with the supposed magical power of the inducer but were attributable to physiological causes in the subject to whom

they were applied. The highly sensitive and pathological state of the nervous systems of hysterical patients rendered them receptive to hypnosis, a tool whose therapeutic use Charcot intended for only this type of nervous disorder. His presentation on hypnosis and hysteria to the Académie des Sciences in 1882 marked the official recognition of hypnotism as a respectable subject of scientific investigation.[22]

After repeated experimentation, Charcot divided the phenomenon of hysterical hypnosis into three phases. The first was lethargy or drowsiness, which the doctor induced by having the patient concentrate intensely on a moving object. The second stage, called catalepsy, referred to a state in which the patient was irresistibly receptive to suggestion from the doctor, due to the contraction of consciousness to a single idea or impression, unimpeded by other ideas or impressions. During the third and final phase, somnambulism, Charcot observed what he described as the dissociation of personality—the hypnotized patient was able to act out suggested commands with no recollection afterward. Charcot considered this acting out of gestures, signs, or other behavior suggested by the doctor a splitting and externalization of states of consciousness normally coordinated and controlled. Suggested ideas, implanted in the mind of the patient, settled in "isolation from the Ego," revealing an autonomous inner development and a direct outer materialization.[23]

During the three phases of the hypnotic process Charcot discovered the particular potency of images to affect the minds of hysterics. The hypnotic trance was induced when the patient concentrated intensely on a moving object. Of the many types of suggestion that provoked automatic behavior among hypnotized patients, Charcot found that visual materials—colored discs and signs—were often more effective than verbal commands. Charcot explored this special receptivity of hysterical patients to visual material in a series of experiments during the 1880s. In one session, two of Charcot's colleagues tested the effects of various colors on the hypnotized patients. Not only did they find that visual stimuli provoked an immediate and visible set of gestures among the patients, but the clinicians were also able to correlate specific colors with emotional states.[24] This correlation paralleled in the medical sphere the Symbolist artists' attempts to discover the emotional equivalents of visual language. During the 1880s Seurat and Gauguin, among others, proposed the evocative power of colors, believing that painters could formally convey and evoke in the viewer emotional responses independent of the subjects they represented. In the Salpêtrière experiments, doctors exploring the visual effects of suggestion confirmed the propensity of color to assume evocative, emotional form. Red colored discs provoked gestures of joy and pleasure among the patients; blue triggered a sad, dejected look; yellow produced signs of panic and fear. The visual artists of the 1880s had similarly construed the emotional valences of these colors.[25]

Besides the particular susceptibility of hypnotized patients to visual material, Charcot and his co-workers discovered the tendency of these same patients to externalize their inner visions. The acting out of what Charcot called sensory hallucinations[26] during the last stage of hypnosis was considered the projection outward of "the true nature of the painting that is drawn in the brain of the sick."[27] Those who observed this imagistic projection by hysterical patients described it as dreaming, which had been discussed earlier in the century but which Doctor Charcot isolated with clinical accuracy. One systematic account of the dreaming of hysterical patients was discussed by Charcot in 1889:

> Visual hallucinations are frequent. . . . They preside especially in the third stage: The patient becomes a character in a scene, and it is easy to follow all the sudden changes of the drama he believes to be unfolding and in which he plays the principal role by the expressive and animated mimicry to which he has given himself over. When the

patient is a woman, two very different orders of ideas share in the hallucinations. That painting has two aspects, one happy, the other sad. In the happy phase, the patient believes herself to be transported to a magnificent garden, a kind of Eden, where flowers are often red and inhabitants are dressed in red. Music is playing. The patient meets there the object of her dreams and her previous affections, and scenes of love-making sometimes ensue. But this erotic part is often lacking and plays a secondary role in the numerous and varied manifestations that constitute the great hysterical attack. The sad paintings are fires, war, revolutions, assassinations, etc. Almost always blood flows. Among men, these dismal and terrifying visions alone occupy almost the entire third period.[28]

Charcot consistently emphasized that the special visual receptivity and imagistic exteriorization that he observed among hypnotized patients were abnormal, pathological phenomena, attributable to the irregularities in the nervous systems of hysterical subjects. The confinement of hypnosis, suggestion, and visual projection to individuals afflicted with nervous disorders, however, was vociferously contested in the 1880s. A respected medical center outside of Paris, which followed a system of clinical experimentation equal to that of the Salpêtrière, arrived at conclusions very different from those of Charcot. The Ecole de Nancy, officially established in 1882 under the direction of Doctor Hippolyte Bernheim, entered into protracted debates with the Salpêtrière during the 1880s. These debates undermined the primacy of rationalist regularity in the thought process.

Doctor Hippolyte Bernheim was forty-two in 1882 and had worked for ten years as an assistant to Doctor Ambroise-Auguste Liébault at the Faculté de Médecine in Nancy. Liébault was the first medical practitioner to embrace hypnosis as a serious clinical tool. Beginning in the 1850s, he conducted numerous experiments with hypnosis, inducing artificial sleep in patients suffering from functional handicaps as well as nervous disorders. It was his intention to discredit definitively the mesmeric theories of magical fluid transmission and faith healing that stigmatized hypnosis and to examine its physical and psychological underpinnings. Until he began to collaborate with Bernheim, however, Liébault had little success in convincing his medical colleagues that hypnosis was a useful therapeutic tool. The lengthy treatise he compiled in 1866 was largely ignored; indeed, it was read by only five readers in seven years.[29]

Hippolyte Bernheim was one of them. After adopting Liébault's position, Bernheim worked with his mentor in the hopes of expanding the purely medical and therapeutic uses of hypnosis and suggestion. By the late 1870s, however, Bernheim's experiments yielded unanticipated results, which led him beyond Liébault's theories and into a collision with Charcot and the Salpêtrière school.

Bernheim discovered four startling phenomena. First, he was able to alter patients' behavior by visual and verbal suggestion *without* initially hypnotizing them, thereby reversing the order stipulated by Charcot. The linchpin of Charcot's theories and methods was the assumption that suggestion was a function of hypnosis, which produced a state of mental passivity in the subject; only after this artificial sleep state was induced could a patient be receptive to suggestion. Bernheim found, on the contrary, that hypnotism was itself a function of suggestion, to which the subject was susceptible in a waking state—"*la suggestion a l'état de veille.*"[30] Related to this reversal was Bernheim's observation that the impact of suggestion lasted longer than the duration of the hypnotic state. When he instructed hypnotized patients to perform certain tasks in a month's time, they did as they were told at the appointed date but recollected neither the instructions nor the performance of the tasks. Bernheim attributed this gap between memory and action to the splitting or dissociation of personality, which Charcot had also defined

as the mechanism underlying the actions performed upon suggestion. But Bernheim argued that this mechanism could carry over from the immediate situation of suggestion into future actions by what he called the "transmission" or "extension" of thought.[31]

Bernheim's most important challenges to Charcot related to two of his conclusions regarding the mechanisms of suggestion and hypnosis in healthy individuals. Charcot insisted that hypnosis was a clinical tool for examining one type of nervous pathology: only hysterical patients were hypnotizable, and hypnosis itself was a manifestation of hysteria. Yet Bernheim executed repeated experiments with normal individuals, who revealed a striking susceptibility to suggestion and hypnosis, equal to that of abnormal patients. Finally, he found that the particular potency of imagistic suggestion and the tendency to externalize visual material, identified by Charcot as the exceptional features of nervous pathology, were in fact characteristic of normal subjects. Bernheim's findings led him to elaborate a fundamental redefinition of consciousness.

In his 1884 treatise *De la suggestion dans l'état hypnotique et dans l'état de veille*, Bernheim explained that "visual images" penetrated the mind directly from the external world. The thought process transformed ideas into images: "One should not consider the transformation of an idea into an image as a morbid operation but rather a normal property of the brain."[32] Bernheim argued that the mind was an acutely sensitive chamber, receptive to the dynamic flow of images and ideas and to the subtle influences of social interaction, independent of rational control. Energy, visual impressions, and intangible forces emanating from the external environment were elements as powerful as conscious decision making or assimilation of information about the world. Rather than a concrete surround from which the individual selected and processed information, the external world was a torrential flow of stimuli, to which the individual was unpredictably and imagistically impressionable:

> Suggestion, that is, the penetration of the subject's brain by the idea of the phenomenon through a word, a gesture, a view, or an imitation, seems to me the key to all the hypnotic phenomena that I have observed. Supposedly physiological phenomena seem to be, in their greater part if not in their entirety, psychic phenomena. . . . Suggestibility is such that, in the waking state, an idea accepted by the brain becomes . . . an image. . . .
> Suggestive phenomena do have their analogies in everyday life . . .; nature produces them spontaneously. . . . Sensorial illusions, hallucinations, realize themselves in all of us. . . . We are all suggestible and can experience hallucinations by our own or other peoples' impressions. . . . No one can escape the suggestive influence of others.[33]

Accompanying Bernheim's discovery of the mind as a febrile, permeable chamber was the notion that the individual projected this animated imagistic material back out, shaping the external environment in accord with his inner vision. Although Charcot insisted that externalized visualization, or dreams, were the identifying features of hysterical abnormality, Bernheim retorted that "sensorial hallucinations" formed part of the daily existence of all individuals:

> The truth is that we are all subject to hallucinations for a great part of our lives. . . .[34]

> Poor human reason has taken flight. The most ambitious spirit yields to hallucinations and becomes . . . the plaything of dreams evoked by the imagination.[35]

Bernheim initially considered the primacy of "sensorial hallucinations" a short-term condition of normal sleep, when the relaxation of what he called the higher centers of judgment and verification tumultuously released unconscious images. But his study of suggestibility in the waking state led him to conclude that the mind yielded to the "flight of reason" and to the domination of hallucinations "for a great part of our lives." He observed in normal subjects what Charcot had identified in hysterics: the implantation of suggested ideas, their isolation from "the ego proper," and their direct and unmediated materialization into acts. Bernheim called this irresistible influence of suggested "ideas over acts" "cerebral automatism," or "ideodynamism."[36] Bernheim was particularly interested in the visual dimensions of ideodynamism, and he devised experiments to test visual perception and suggestion. He noted that "suggested images" were "fictitious," "subjective images" "evoked by the subject's imagination."[37] Yet these subjective images were projected outward onto physical reality, even in ways contrary to the laws of optics:

> The hallucinatory image may be as distinct, as bright and as active to the subject as reality itself. . . . He sees it as he conceives it, as he interprets it. . . . It is a psychical cerebral image and not a physical one. It does not pass through the apparatus of vision, has no objective reality, follows no optical laws, but solely obeys the caprices of the imagination.[38]

Bernheim stated in these writings that "imagination rules supreme,"[39] and his experiments demonstrated clinically the Symbolist ideal of the "objectification of the subjective," the referring of interior images to the outer world as if they were true.[40] Charcot associated the "*rêve vécu*" ("living out the dream") with hysterical ideodynamism.[41] Bernheim, in contrast, found that "hallucinations" were "universal" and that "supposedly physiological phenomena seem to be in their greater part, if not in their entirety, psychic phenomena."[42] Two years before the Symbolist assault on positivist materialism and rational discourse in the manifesto of 1886, Doctor Bernheim proclaimed, with scientific authority, the dissolution of the stable boundaries between inner and outer, subjective and objective, reality.

The epistemological and social challenges inherent in this model of a mind prone to suggestion and imagistic externalization were widely recognized and debated in fin-de-siècle France. As early as 1885 the Chamber of Deputies heard an official statement of the problematic implications of suggestion for the law: M. Liégeois's *De la suggestion hypnotique daus ses rapports avec le droit civil et criminel*. A number of well-publicized trials began to rely on the theory of actions induced by hypnosis as the basis for a criminal defense. The most sensational of these was the trial in 1888 of Henri Chambige, who claimed he murdered a married woman under the influence of hypnosis.[43]

Hypnotism and suggestion also inspired numerous novels, some of which were the result of writers' direct contact with Doctor Charcot. Charcot's weekly public demonstrations of hysterical hypnosis drew a surprising range of "tout Paris" to the Salpêtrière. Artists in the audience found it difficult to confine Charcot's lessons to the afflicted inhabitants of the hospital wards, and they explored what one Symbolist writer called Charcot's revelation of the "unsuspected realms of the mind."[44] The protagonist of Guy de Maupassant's novella *Le Horla* suffered from strange visions and unaccountable actions, only to realize that he was a victim of his own unconscious cerebral automatism: "Someone possesses my soul and governs it. Someone directs all my actions, all my movements, all my thoughts. I myself am nothing but a terrified, enslaved spectator of the things I am accomplishing."[45] Jules Clarétie, who attended the Salpêtrière lectures regularly, wrote a novel, *L'Obsession, moi et l'autre*, describing a painter's

preoccupation with the involuntary actions that might be performed by a hidden second personality lurking within his own psyche.[46] Even Charcot's medical colleagues adopted fictional form to examine some of the perplexing implications of the new discoveries of the mind. Charles Richet, under the pseudonym Charles Epheyre, published a novella in the *Revue des deux mondes* that told the story of a split personality.[47] Alfred Binet, a respected clinician who experimented widely with suggestion and visual thinking, collaborated with a playwright, André de Lorde, in dramatizing Charcot's lessons at the Salpêtrière, hypnotic somnambulism, and states of hallucination. Three of these plays were performed at important Paris theaters after 1901, and two became puppet shows at the Grand Guignol.[48]

A range of popular sources registered the intellectual tremors of suggestion and hypnotism during the 1890s. Alfred Robida, the writer and illustrator of best-selling anthologies, devoted a section of his volume *Le XIXe Siècle* to a humorous tale of hypnosis used to extract a confession and description of a lurid amorous past.[49] The columns of *L'Illustration* contained a fictional account of the hypnosis of an idle bourgeois matron in her home.[50] Caricatures in this same popular journal recorded the use of hypnotism and suggestion to implant ideas in the minds of powerful friends: in 1892 a cartoon presented Edmond de Goncourt hypnotizing Emile Zola to induce, by suggestion, the idea that Zola approach the ministry and recommend that Edmond be awarded the Legion of Honor.[51] An entry in the popular press indicated that the implications of hypnosis for a fundamental redefinition of the ego were widely understood: Hypnotic experiments "demonstrate that the personality is neither really defined, nor permanent, nor stationary; that the sense of free will is essentially floating and illusive, memory multiple and intermittent; and that character is a function of these variable qualities and can be modified."[52]

The discovery of the febrile, suggestive power of the external world and the dynamic extension of inner vision outward also transformed assumptions held by the elite in culture and politics. Henri Bergson, whose writings mark the intellectual center of fin-de-siècle French redefinitions of reason, was deeply involved in neuro-psychiatric research on hypnosis, suggestion, and ideodynamism. His conceptions of the fluidity and indeterminacy of the mind, first expounded in his 1889 *Essai sur les données immédiates de la conscience*, depended in part on his incorporation of the findings of medical clinicians. As professor in Clermont-Ferrand between 1883 and 1888, Bergson observed hypnotic sessions organized by a Doctor Moutin. In 1886, Bergson himself experimented with the effects of hypnosis and suggestion on the perception and mental processes of a number of subjects.[53] He witnessed in particular the unmediated penetration of images from the outer world, the tendency, as Bernheim had indicated, to "transform ideas into images," and the deep unconscious "imprinting" established between the hypnotizer and the subject.[54] In the *Données*, Bergson pressed his clinical understanding of imagistic suggestibility into the service of a new theory of the mind, ascribing a fundamental position to the artist. The book opened with a discussion of the way that the artist replaced the hypnotist as the agent of a direct, unmediated access to the unconscious. The artist, like the hypnotist, functioned to "put reason to sleep" and "to trigger emotional states by suggestion."[55] The artist's visual material "fixes our attention," "suspending the barriers" blocking the release of the unconscious. Caught in the "contagion" of the artist's vision, the boundaries of individual consciousness dissolve, and we are automatically transported to a dream state, where we experience irresistibly the same emotional state provoked in the artist.[56] In a subsequent passage, Bergson indicated that the intensity of the artist's "imprinting" on us corresponds to the stages of hypnosis. At its most intense, we experience what Bergson described as a total loss of self; even our physical being becomes inhabited by another, whose movements our bodies mechanically imitate, while our consciousness is completely given over

to "the indefinable psychological state experienced in the other."[57] Bergson construed the artist's compact with the unconscious only as the most concentrated form of suggestibility present in all interactions. The Données developed the idea that all of nature is dynamically charged and affects us, like art, by suggestion. We are irrevocably "oscillating," Bergson noted, between consciousness of self and the dissolution of the ego. Even a hint of an idea, suggested without our being cognizant of it, suffices to "absorb" our entire psyche in unconscious simulation.[58]

Like Bergson, important republican thinkers also used the discoveries of the new psychology to redefine reality and individual consciousness. In the 1880s Alfred Fouillée began to chronicle the experiments with hypnotism and suggestion at the Salpêtrière and in Nancy for the *Revue des deux mondes*.[59] By 1891 Fouillée had written a series of articles for the same journal, summarizing the medical debates and transposing the psychiatric discoveries into a radical inversion of outer and inner reality.[60] Fouillée's articles reveal the elements of clinical material that interested him. First, the medical experiments with suggestibility contributed to Fouillée's antimaterialism; he came to construe the external world not as a clear, legible structure but as "a tumultuous ocean,"[61] "a continuum" of unstable energy.[62] "The material world that surrounds us is animated by an atmosphere of psychic life. . . . We are not plunged into a material world, we bathe in mental atmosphere. . . . All is sympathetically and telepathically related."[63]

Second, the new psychology revealed to Fouillée what he called the subterranean disaggregated parts of the self that were released during induced hypnosis or, as in Bernheim's view, during normal sleep or in a relaxed waking state.[64] For Fouillée this finding disclosed the mind as a psychic "theater," where a "troupe of different, multiple actors enacted an interior drama."[65] Third, Fouillée was fascinated by the neuropsychiatric research on ideodynamism. Concurring with the Bernheim school of "universal hallucinations," Fouillée was struck by the dynamic extension of inner vision to the outer world. He explained that hypnotism had revealed the "astonishing influence of the mental over the physical" and cited Bernheim's experiments with sensorial suggestion in which blank white pieces of paper were perceived distinctly as red.[66] Fouillée concluded that "hypnotic phenomena demonstrate precisely that completely psychic images can be projected outward in the form of real objects."[67]

Fouillée assimilated these psychiatric discoveries into three striking revisions of liberal rationalism. First, he transposed ideodynamism into a philosophical doctrine of "*idées-forces*," the power of ideas over action. This was a new idealism, anchored in nonrational sources.[68] Fouillée extended the principle of *idées-forces* to the national body, arguing that France's preoccupation with decline and degeneration operated as a powerful form of autosuggestion that could be countered by promoting ideas of national strength and vitality.[69] Second, he used suggestibility to resolve the major problem of liberal political theory of the 1890s—how to move beyond atomism to community. Fouillée asserted that the "new psychology has wrested from us the illusion of a bounded, impenetrable, and autonomous ego."[70] Our pride in our discrete individuality, he explained, is utterly compromised by the irresistibility and omnipresence of suggestion. The permeable, shifting centers of personality rendered the mind itself a vessel of the social, injected, by "mutual penetration," with "a vast society of beings."[71] Fouillée thus celebrated suggestibility as a new, unconscious imperative for the "law of solidarity and universal fraternity." "*Rien de si un qui ne soit multiple, rien de si mien qui ne soit aussi collectif*":[72] this was the lesson he drew for republicans from the revelations of antirationalism. Finally, the new psychology compelled Fouillée, like Bergson, to redefine the self as an artist, involved in a continuous process of ego creation. The clinicians of the psyche exposed to Fouillée the fragility of the notions of the unity of being, of reality as a given,

and of free and conscious will. He responded with a call to liberation: the self is not a discrete substance but an idea, and we are each therefore responsible for constructing and reconstructing our own self-image.[73] Identity, like the rest of external reality, is a representation, and we must extend the idea of our ego outward. "Like an artist who invests the idea with material and real form," we must select and project the form of our self, materializing our shifting inner vision of an identity.[74] Without interior construction and representation, Fouillée concluded, we risk being "swallowed up in the vast, disordered, tumultuous ocean that envelops us."[75]

"Charcot-Artiste": visual medicine and interior decoration

While philosophers, novelists, and journalists interpreted Charcot's theories as catalysts for new models of mind and society, the doctor himself maintained a stringent positivism, insisting that the powers of suggestibility and imagistic externalization were restricted to patients suffering from nervous disorders. Yet evidence indicates that Charcot understood some of the radical implications of his own clinical discoveries for a redefinition of consciousness. Contemporary accounts and Charcot's own behavior suggest that he was drawn to the underside of rationality and acknowledged the power of dreams, suggestion, and visual thinking not only in hysterics but in all normal minds, including his own [Figure 38.1].

Charcot was particularly fascinated by artistic creativity, and although officially he linked artists to hysteria and neurosis, both his scientific work and his personal history were marked by the primacy of the visual. Charcot's own unprecedented clinical methods and innovative educational techniques were based precisely on a model of imagistic thought, on "raising the image," as one of his students noted, "to the rank of the first order."[76] Indeed, Charcot was celebrated by his contemporaries, Sigmund Freud among them, specifically for transporting artistic categories to medicine and for creating a new visual language of diagnosis. Charcot's organization of a visual medicine at the Salpêtrière was complemented by his lifelong practice of drawing, design, and interior decoration at home. [. . .]

Whereas his three brothers chose the army, the sea, and the carriage shop, respectively, Jean-Martin was offered a choice: as he had shown his talents for both art and book learning, his father would sponsor his higher education, either as a painter or as a doctor.[77] At eighteen, Jean-Martin Charcot chose medicine. Yet he still retained yearnings for an artistic vocation, which deeply affected his relation to his chosen medical career. Charcot pressed his acute visual thinking into the service of his medical practice by advocating in his clinical methods and educational techniques the power of images above all other forms of communication and diagnosis. The fusion of art into medicine provided a means of personal integration while it revolutionized the practice of nineteenth-century psychopathology: "That he knew how to put the artist's temperament with which he was naturally gifted to the service of his medical studies is not the least of the reasons or his scientific success. . . . For Charcot, the artist went hand in hand with the physician."[78] [. . .]

Charcot's own practice of thinking in images made possible the invention of a new visual language for diagnosis, which was his greatest contribution as a clinician. Until Charcot, the identification of nervous diseases rested solely on postmortem examinations, which located particular organic lesions or deterioration related to a specific nervous pathology. Charcot systematized an unprecedented method of diagnosing the diseases of living subjects. By acute observation, he correlated external signs and symptoms to an internal state of deformation and degeneration. Charcot's "clinical-anatomical method" celebrated the correspondences between external physical form and internal organic essence:

The anatomy of the human body's exterior forms does not concern only artists. It is of primary use to doctors. . . . It is not on an inert corpse that one can chart the incessant movements that life, with its infinite variations of movements, impresses on all parts of the human body. It is hence on the living that the anatomy of forms should be studied. . . . Its procedure is the synthesis. Its means are the observation of nudes, its aim to find the multiple causes of the living form and to fix it into a description. . . . Exterior forms show, through their relations with interior ones, . . . what is hidden in the depths of the body through what is visible on the surface.[79]

Sigmund Freud watched Charcot at work and noted how the French clinician scrutinized a procession of patients, seizing an essential image of their inner disorder by penetrating observation. Freud called Charcot not a "thinker" but an "artist" and quoted Charcot telling him,

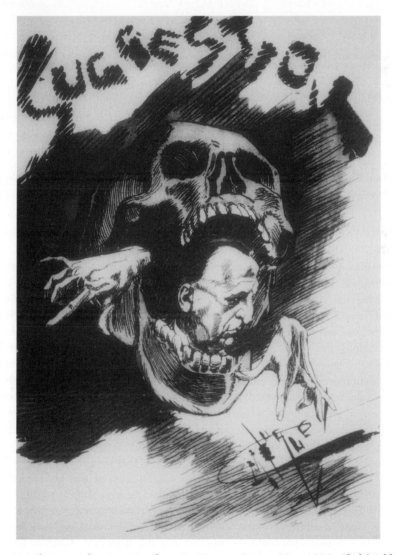

Figure 38.1 Dr. Charcot and suggestion, from *Les Hommes d'aujourd'hui*, 1889. Cliché Bibliothèque nationale de France, Paris.

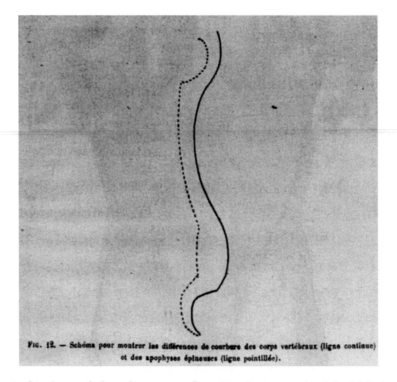

FIG. 12. — Schéma pour montrer les différences de courbure des corps vertébraux (ligne continue) et des apophyses épineuses (ligne pointillée).

Figure 38.2 Paul Richer, pathological curvature, from *Nouvelle Iconographie de la Salpêtrière*. Cliché Bibliothèque nationale de France, Paris.

"*Je suis un visuel*." Freud characterized Charcot as an "impressionist," registering visual material directly and able to distill an essential pattern immediately.[80]

Visual morphologies and design patterns formed the grammar of Charcot's language of clinical identification. Manifest physical curvatures, contours, contortions, and distended facial gestures provided the correlation between external appearance and internal disorder. The essential visual "trope" in Charcot's system of correspondences between outer physicality and inner pathology was the curve. Nervous diseases, Charcot believed, were caused by lesions or "trophisms" along the spinal cord, which found their physical equivalents in the irregularity, asymmetry, contortion, and curvature in the patient's comportment [Figure 38.2].

Charcot documented various outward signs of internal disorder not only during clinical lessons at the Salpêtrière blackboard with colored chalks but also in a series of works he conceived as clinical picture books. One of these was the remarkable project called the *Nouvelle Iconographie de la Salpêtrière: Clinique des maladies du système nerveux*. Published every year after 1888, the *Iconographie* collected and presented case histories of patients at the Salpêtrière. The volumes were committed to the new "method of analysis that completes written observations with images."[81] Each case was described through a combination of text and image, identifying the physical features of the disease and illustrating the gestures and movements of patients under different therapeutic conditions. Different media were used to give a detailed and comprehensive visual rendering of the subjects. Gestures, contortions, and physical curves were depicted in extensive photographs, engravings, and drawings. Charcot himself and his assistant Paul Richer, a former artist and sculptor, supplied the drawings and prints in the volumes. [. . .]

Pressing art into the service of his medicine, Charcot may have discovered his own psychological integration by inventing the visual identification of pathology in others. In so doing, he unwittingly strengthened Bernheim's redefinition of reason in the fin de siècle.

The tension between reason and fantasy, order and disorder that shaped Charcot's artistic-medical persona was expressed in his personal practice of interior design. Charcot collaborated with his family to create a unified personal environment where historical materials were animated by private memories and "exteriorized dreams."[82]

The Charcot family's first residence was in a wing of the Hôtel de Chimay on the quai Malaquais, adjacent to the Ecole des Beaux-Arts. The other wing was inhabited by the family of the writer Edouard Pailleron, who introduced Charcot to many other artists. In 1884 Charcot, at the height of his medical preeminence, moved the family to a mansion on the boulevard Saint-Germain. The splendid residence and gardens had originally been built as a rococo palace, the Hôtel de Varengeville.[83] Charcot transformed the interior into a showcase for his art collection and his own artistic designs. There, at his weekly evening salons, which became as well known as the doctor's weekly hysteria demonstrations at the Salpêtrière,[84] sculptors, painters, writers, and art connoisseurs mingled with politicians and medical colleagues.

An avid traveler, Charcot sketched incessantly throughout his frequent trips to Italy, Holland, and England, trying out models for his own interior decor by copying the "decorative relics of the past" in European museums.[85] Aided by his marriage to an extremely wealthy widow, the carriage maker's son supplied himself with fine woods and precious stones, which he used for the armoires of his own creation. When Sigmund Freud was invited to Charcot's home, he was dazzled by the "magic castle in which he lives." He noticed "cases containing Indian and Chinese antiques," "walls covered with Gobelins and pictures," and "the walls themselves painted terra cotta."[86] Freud did not note that the painted walls and the wood cases were Charcot's own work or that Charcot had carefully coordinated the space and contents:

> Charcot participated directly in ornamenting the interiors. Certain ceramic panels in the hearth . . . were designed by his own hand. . . . His choices of those art works with which he surrounded himself, his care to direct the ornamentation of his interior space personally, the active part he took in this decoration make Charcot appear not only like an informed connoisseur but like a fervent devotee of beauty's purest manifestations. One has . . . praised the arrangement of his apartment on the boulevard Saint-Germain . . . No frame could have better harmonized with Charcot's personality. This frame was also his masterpiece. Vast rooms, . . . furniture of dark luxury, of faded golds, of faultless designs, paintings, sculptures: all were set up to form the most perfect harmony of an ensemble and to be the most satisfactory to the eyes. The walls covered with tapestry . . . the wooden panels' alternating columns with elegantly interlaced leaves, . . . arabesques of ironwork highlighted with gold. . . . In this interior, a total synthesis, Charcot liked to rest.[87]

Charcot did not design and coordinate the ensemble of his interiors single-handedly. Indeed, he was the *chef* of an artisanal "atelier," whose members were all female and familial—his wife and two daughters. As in any other atelier *de haut luxe*, the production of any one object necessitated an extensive division of labor. Together the family workshop made furniture designed by Charcot, hammered leather bindings for books, embellished lamps, sculpted bas-reliefs, and carved terra-cotta figures [Figures 38.3 and 38.4].

Charcot found in his family entourage affectionate and skilled helpers who knew how to fashion the beautiful things to which he was accustomed. . . . Under his inspiration, everyone fulfilled her task and did her part for the decorative project. . . . Charcot provided the idea, the initial design—its execution would follow. Once the work had started, he would supervise its progress, making a comment and correcting an error here and there and would be happy only if the smallest details conformed to his aesthetic desires. Thus he was the master of a studio of the decorative arts, instituted through his care in his house, with his family as practitioners and students. All raw material was used: earth, metal, glass, wood, leather, and tissue. From them would come sculptures of round shapes or bas-reliefs, chiseled or compressed

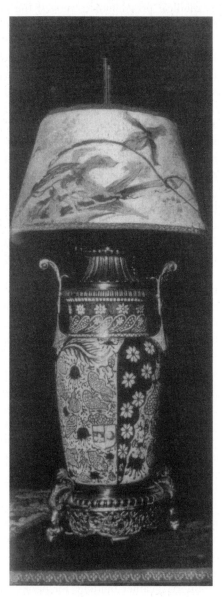

Figure 38.3 Madame Charcot, faience and painted lamp, from *Revue des arts décoratifs*, 1900.

Figure 38.4 J.-M. Charcot, with Madame Charcot, mantle and fireplace, from *Revue des arts décoratifs*, 1900.

ornaments, gilded or painted table settings, stained-glass windows, enameled works, furniture with sculptures, engraved, and colored panels . . . small coffers, tables, and a flood of statuettes.[88]

The component parts of the Charcot home, objects with clear historical reference, were unified by personal expression and the themes of personal memory and family intimacy. Meige noted that the furniture and decorations Charcot re-created from his sketches of historical styles were marked by an infusion of his own "artistic fantasies" into both the drawing and design processes. In interior decor he could "exteriorize his dreams."[89] Not historical accuracy but subjective transformation characterized Charcot's replication of fifteenth- and sixteenth-century furniture and objets d'art. In re-creating objects, Charcot stamped them with personal memory, suggesting and evoking the places he and his family had visited on their many travels.[90] The Charcot interior ensemble thus became an envelope of *personnalité*:

No frame could have harmonized better with Charcot's personality. . . . How many platters, how many plates were transformed by his hand into little commemorative paintings! . . . They are composed of unconsciously evoked memories that . . . would materialize and take shape.[91]

The interjection of personal memory and fantasy into the interior was complemented by a second level of personal feelings: family insulation. A second commentator on Charcot's art and design joined Henri Meige in emphasizing the unity of the doctor's interior ensemble in the theme of "familial intimacy." Surrounded by their own creations, the family bonds were encrusted in the very walls and material objects of daily use. The interior was charged with powerfully personal meanings. "This artistic project," "this ensemble," is "a *chez soi* of the dream wherein everything is precious, where every object calls out. . . . This splendid residence . . . is charged with such beautiful artistic dreams."[92]

The personal meanings and evocative memories animating Charcot's interiors may not have been confined to pleasant remembrances of travels and family occasions. Some of the objects Charcot created may have stimulated darker fantasies. What is one to make of Albrecht Dürer's *Dance of Fools*, whose images of madness and the macabre Charcot reconstituted as a set of porcelain slabs attached to the facade of his house?[93] Charcot probably selected this set consciously as an example of a retrospective diagnosis, an artistic anticipation of his own discovery of the forms of hysteria. But the writhing dance may have functioned more ambiguously as an announcement of the dark insulated chambers where "he liked to rest." Dürer's contorted shapes prefigured the visual themes of Charcot's work on the interior, the wood columns Meige described as having "interlaced leaves" and "arabesques of ironwork."[94] All of these elements of spatial design suggested a hidden "total synthesis" vitalizing the historicist frame. Together they composed an evocative image of irregularity, a dynamic cue to the memory of the phantasmagoric "interlacing leaves" and "zigzags" unleashed by the younger Charcot's artistic intoxication. These traces of a hallucinatory organic interior as well may have been more than a reinvoked memory of youthful abandon: Edmond de Goncourt stated that the mature Doctor Charcot relied on a powerful narcotic potion of bromide, morphine, and codeine to "procure" such "exhilarating dreams on a daily basis."[95]

The discovery that the interior of the human organism was a sensitive nervous mechanism, prone to suggestion, visual thinking, and imagistic projection in dreams—these elements of a new psychological knowledge would alter the meaning of interior decoration in the fin de siècle. This specifically French version of psychological interiority provided the intellectual vehicle for the transformation of the domestic interior from a place to display a historical anchorage to one that expressed personal feeling. Aware of the first level of psychological exploration from the Salpêtrière—nervous vibration—the brothers de Goncourt had realized in the 1860s a personally designed environment that lay poised between historical reference and subjectivity: they fused a *Gesamtkunstwerk* of rococo nature and literary nerves. Jean-Martin Charcot, the clinician who had penetrated that inner world of the nerves, offered a second example of the interior ensemble between history and the psyche. Although he consciously rejected the antirational implications of his own discoveries, Charcot's practice of interior design translated into spatial form the principles of subjective self-projection and imagistic suggestibility. The artist, never purged from the interior of Doctor Charcot, unwittingly brought fantasy, memory, and dreams into the concretion of private space.

Notes

1 Henri F. Ellenberger, *The Discovery of the Unconscious: The History and Evolution of Dynamic Psychiatry* (New York: Basic Books, 1970), pp. 759, 340.

2 The writings of Pierre Janet were particularly important in establishing this consensus. See the discussion in Ellenberger, *Discovery of the Unconscious*, pp. 358–374, and Paul Janet's influential early works, "Les Actes inconscients et lè dédoublement de la personnalité pendant le somnambulisme provoqué," *Revue philosophique* 22 (1886): 577–592, and *L'Automatisme psychologique* (Paris: Alcan, 1889).

3 Quoted in Ellenberger, *Discovery of the Unconscious*, pp. 314–315.

4 The term used by H. Stuart Hughes, *Consciousness and Society: The Reorientation of European Social Thought, 1890–1930* (New York: Vintage Books, 1958), p. 33.

5 I have drawn my discussion of the Symbolists' formal innovations and their inversion of reality from the surface to the depths from the writings of Edward Engelberg, *The Symbolist Poem* (New York: Dutton, 1967), pp. 17–46; C. M. Bowra, *The Heritage of Symbolism* (New York: Macmillan, 1947), pp. 2–12; Edmund Wilson, *Axel's Castle* (New York: Scribner, 1931), pp. 8–27; Eugenia Herbert, *The Artist and Social Reform: France and Belgium, 1885–1898* (New Haven, Conn.: Yale University Press, 1961), pp. 59–86; John Rewald, *Post-Impressionism from Van Gogh to Gauguin*, 2nd ed. (Garden City, N.Y.: Doubleday, 1962), pp. 142–158; Robert Goldwater, "Symbolic Form: Symbolic Content," in *Problems of the Nineteenth and Twentieth Centuries, Studies in Western Art, Acts of the International Congress of the Library of Art* 4 (1963): 111–121. Kahn's Manifesto, which I quote here, is reprinted in Rewald, *Post-Impressionism*, pp. 134–135.

6 Letter from Huysmans to Edmond de Goncourt, cited in Bibliothèque Nationale. *Joris-Karl Huysmans: Du naturalisme au satanisme et à Dieu*, Catalogue de l'exposition (Paris: Bibliothèque Nationale, 1979), p. 33. Huysmans was a regular member of Edmond's weekly salons. See Edmond de Goncourt and Jules de Goncourt, *Journal, Mémoires de la vie littéraire* (Paris: Fasquelle & Flammarion, 1956), 3: 111, 142–143, 163, 345, 354–355, 452, 732; 4: 37, 61–62, 73, 464, 467, 553, 693, 902 (hereafter cited as *Journal des Goncourts*).

7 De Montesquiou's visits to the Goncourts are described in the *Journal des Goncourts*, 3: 179, 357, 603, 1189–1190; 4: 115–117, 249–251, 275–279, 380–381, 580–581, 594–597, 756, 800–810, 900, 1010. De Montesquiou wrote volumes of Symbolist poetry in the 1890s, executed in the new free verse, among them *Les Chauves-souris* (1893), *Les Hortensias bleus* (1896), and *Le Chef des odeurs suaves* (1893). Many of the poems in these volumes recorded personal visions stimulated by objets d'art and interior space. De Montesquiou dedicated some of the poems to Edmond de Goncourt, testifying to his discovery of a new union between the literary cult of artifice and the aesthetic coordination of private space.

8 De Montesquiou's conception of the interior as evocative psychological form emerges most clearly in his essay "Le Mobilier libre," in *Roseaux pensants* (Paris: Charpentier, 1897), pp. 159, 163–164, 165–166.

9 Throughout *Remembrance of Things Past*, Proust articulated a new definition of interior space, not as a characteristic of historical eras but as an index of personal memories.

10 Edmond de Goncourt, *La Maison d'un artiste* (Paris: Charpentier, nouvelle ed., 1904; first published 1881), 2: 202–204.

11 Proust, *Swann's Way* (New York: Vintage Books, 1970), pp. 10, 240; *Within a Budding Grove*, pp. 83, 178.

12 Alfred Fouillée used the term in "Les Grandes Conclusions de la psychologie contemporaine—la conscience et ses transformations," *Revue des deux mondes* 107 (1891): 814.

13 Huysmans explicitly acknowledged Axenfeld's book as a source. Des Esseintes is presented as a victim of neurosis, which Huysmans studied scrupulously in the medical text: "Je me suis gêné, tout au long du livre, à être parfaitement exact. J'ai pas à pas suivi les livres de Bouchut et d'Axenfeld sur la névrose." Huysmans later called his book *A rebours* "mon hobereau névrosé." Both statements are cited in Bibliothèque Nationale, *Joris-Karl Huysmans*, pp. 32–33.

14 The first exploration of the affinities between Symbolist theory and psychological research was Filiz Eda Burhan, "Vision and Visionaries: Nineteenth-Century Psychological Theory, the Occult Sciences, and the Formation of the Symbolist Aesthetic in France," Ph.D. diss., Princeton University, 1979.

15 The words are those of Jules Bois, "Les Guérisons par la pensée," *La Revue* 35 (1900): 29.

16 Georges Guillain, *J.-M. Charcot: His Life, His Work* [1955], trans. Pearce Bailey (New York: Paul Hoeber, 1959). See also Jan Goldstein, "The Hysteria Diagnosis and the Politics of Anticlericalism in Late Nineteenth-Century France," *Journal of Modern History* 54 (1982): 222–235, on the role of triumphalist, opportunist republicanism as the precondition for Charcot's selection and success.

17 Guillain, *J.-M. Charcot*, pp. 97–132, esp. 118–125. A popular discussion of some of the therapeutic techniques appeared in *L'Illustration* no. 2404 (March 23, 1889): 231.

18 Quoted in "Souvenirs des Goncourts," *La Revue encyclopédique* no. 153 (August 8, 1896): 546.

19 Quoted in "Souvenirs des Goncourts," p. 552.

20 On the application of medical ideas to national problems, see Robert A. Nye, *Crime, Madness, and Politics in Modern France: The Medical Model of National Decline* (Princeton, N.J.: Princeton University Press, 1984). Nye's study emphasizes the medicalization of social policy and criminology in the fin de siècle. He includes a compelling and original discussion of the role of neurasthenia in the development

of Emile Durkheim's social theory. I limit my own discussion to noting the widespread contemporary linkage of neurasthenia to the city as Charcot and his followers publicized the ideas and affected a new cultural understanding of interiorization.

21 Guillain, *J.-M. Charcot*, pp. 133–146, 165–169; Goldstein, "Hysteria Diagnosis," pp. 214–220.

22 Guillain, *J.-M. Charcot*, pp. 133–146, 165–169; Goldstein. "Hysteria Diagnosis," pp. 214–220; Susanna Barrows, *Distorting Mirrors: Visions of the Crowd in Late Nineteenth-Century France* (New Haven, Conn.: Yale University Press, 1981), p. 121. See also E. Boirac, "La Suggestion," *La Grande Encyclopédie* (Paris: Lamirault, 1902), 30: 662–664: and Alfred Binet, "Le Problème hypnotique," in *Etudes de psychologie expérimentale* (Paris: Doin, 1888), pp. 279–298.

23 See the Charcot lecture cited in Ellenberger, *Discovery of the Unconscious*, p. 149; and Binet, "Le Problème hypnotique," p. 281. A good description of the stages of hysterical hypnosis may be found in Boirac, "La Suggestion," pp. 662–664.

24 Georges Guignon and Sophie Woltke, "De l'influence des excitations sensitives et sensorielles dans les phases cataleptique et somnambulique du grand hypnotisme," *Nouvelle Iconographie de la Salpêtrière* 4 (1891): 78, 81.

25 The Symbolists' quest for a direct emotional response to visual form is described in Rewald, *Post-Impressionism*, pp. 148–188, and, in the artists' own words, in *Impressionism and Post-Impressionism: Sources and Documents, 1874–1904*, ed. Linda Nochlin (Englewood Cliffs, N.J.: Prentice-Hall, 1966), pp. 107–203. I discuss the psychophysical basis of color response embraced by the Neo-Impressionists in my unpublished MS "The Quest for Harmony: Neo-Impressionism and Anarchism in France, 1885–1900," pt. 1, chap. 2.

26 Jean-Martin Charcot and Paul Richer, *Les Démoniaques dans l'art* (Paris: Delahaye & Lecrosnier, 1887), p. 92.

27 Guinon and Woltke, "De l'influence des excitations sensitives," p. 87. Elsewhere in the essay the authors describe such imagistic projection as "les tableaux qui défilent devant les yeux du malade" (p. 79).

28 Charcot and Richer, *Les Démoniaques dans l'art*, pp. 92, 102.

29 In my discussion of Bernheim and Liébault I draw upon Jean Vartier, *Histoire de notre Lorraine* (Paris: Editions France-Empire, 1973), pp. 336–345. For other accounts, see Ellenberger, *Discovery of the Unconscious*, pp. 85–89; Barrows, *Distorting Mirrors*, p. 120; and Drinka, *Birth of Neurosis*, pp. 138–143.

30 Boirac, "La Suggestion," pp. 662–663; Hippolyte Bernheim, *De la suggestion dans l'état hypnotique et dans l'état de veille* (Paris: Doin, 1884).

31 Vartier, *Histoire de notre Lorraine*, pp. 341–342. Vartier recounts Bernheim's discovery that patients acted upon suggestion over a month after their sessions with him.

32 Quoted in Vartier, *Histoire de notre Lorraine*, p. 343.

33 Hippolyte Bernheim, *De la suggestion dans l'état hypnotique, Response à Paul Janet* (Paris: Doin, 1884), pp. 5–6, 7, 10, 14.

34 Quoted in Vartier, *Histoire de notre Lorraine*, p. 343.

35 Hippolyte Bernheim, *De la suggestion dans l'état hypnotique et dans l'état de veille* (Paris: Doin, 1884), pp. 89–90.

36 Hippolyte Bernheim, *Suggestive Therapeutics: A Treatise on the Nature and Uses of Hypnotism* [1884], trans. Christian Herter, M.D. (New York: Putnam, 1887), pp. 28, 125, 129, 130, 137–139, 184. Henri Ellenberger first identified the importance of ideodynamisn in the work of Charcot, Liébault, and Bernheim in *Discovery of the Unconscious*, esp. pp. 148–151, 760.

37 Bernheim, *Suggestive Therapeutics*, pp. 96, 99, 100, 103. The entire discussion, from pp. 95–104, is fascinating.

38 Ibid., pp. 103–104.

39 Ibid., p. x.

40 Ibid., p. 125.

41 The words are those of Charcot's associate Paul Richer, *Etudes cliniques sur la grande hystérie ou hystéro-épilepsie* (Paris: Delahaye & Lecrosnier, 1881), p. 730.

42 Bernheim, *Suggestive Therapeutics*, pp. 183–184.

43 Ellenberger, *Discovery of the Unconscious*, pp. 758, 163; Barrows, *Distorting Mirrors*, p. 123.

44 Tribute to Charcot by the Symbolist critic Téodor de Wyzewa, published in *Le Figaro* in 1893, quoted in Ellenberger, *Discovery of the Unconscious*, p. 99. Ellenberger's book contains an encyclopedic list of the literary works inspired by the Charcot-Bernheim hypnosis debates, though he does not discuss any in detail (pp. 99–100, 164–167, 758–759).

45 Cited in Ellenberger, *Discovery of the Unconscious*, p. 165; Guillain prints a letter written by Charcot's friend and traveling companion of 1893, René Vallery-Radot, documenting Charcot's reaction to de Maupassant's psychiatrically inspired stories (*Charcot*, p. 72); Charcot called them "the work of a sick man."

46 Ellenberger, *Discovery of the Unconscious*, pp. 165–166. Other examples of the incorporation of Charcotian ideas into literary works are noted in De Monzie, "Eloge de Charcot," pp. 1159–1162; Signoret, "Une Leçon à la Salpêtrière," pp. 697–701; and Barrows, *Distorting Mirrors*, p. 122.

47 Charles Epheyre, "Soeur Marthe," *Revue des deux mondes* 93 (1889): 384–431. Richet wrote a novel, *Possession* (1887), under the same pseudonym, evoking the horrors of a suicide committed by a character with a somnambulic double personality.

48 Binet and de Lorde called their project *le théâtre épouvante* and *le theater de la peur*. Their best-known production was an exposé of Charcot's despotic practices, *Une Leçon à la Salpêtrière*, which was performed at the Grand Guignol in 1908. The play represented the women patients, in alliance with the young medical interns, rebelling against the master doctor. De Lorde's psychiatric play *La Dormeuse* was performed at the Théâtre de l'Odéon in February 1901, and his *L'Homme mystérieux* at the Théâtre Sarah Bernhardt in November 1910. The only scholar, to my knowledge, who has mentioned the expression by the clinicians Binet and Richet of new neuropsychiatric themes in literary and theatrical representations is Jacqueline Carroy-Thirard, "Hystérie, théâtre, littérature au XIXe siècle," *Psychanalyse à l'université* 7 (1982): 299–317.

49 Alfred Robida, *Le XIXe Siècle* (Paris: Decaux, 1888), pp. 159–174. The story involved a mischievous nephew, who took revenge on his aging stingy uncle by hypnotizing him. Once the uncle was in the state of somnambulic receptivity, the nephew was able to ask him about his indolent youth. The uncle remembered nothing upon waking from his "nap."

50 Paul Bonnetain, "Maternité," *L'Illustration* no. 2397 (February 2, 1889): 94–95.

51 Caran D'Ache, "Nouveautés pour étrennes: Revue comique de 1889," *L'Illustration* no. 2440 (November 30, 1889): 473–476.

52 From an article by Philippe Daryl, "La Suggestion et la personnalité humaine," *Le Temps* no. 8970 (November 21, 1885): 3, cited in Robert G. Hillman, "A Scientific Study of Mystery: The Role of the Medical and Popular Press in the Nancy-Salpêtrière Controversy on Hypnotism," *Bulletin of the History of Medicine* 39 (1965): 163–182. Hillman notes how the ideas of the new psychiatry were spread by the press. The index of the middle-brow journal *La Revue*, not used by Hillman, also illustrates the diffusion of ideas, listing hundreds of articles devoted to hypnosis, suggestion, and dreams between 1888 and 1902. See *Table générale des travaux publiés par les revues, 1880–1902*, under "Psychologie."

53 James Joll refers in passing to the link between Bergson and neuropsychiatry in *Europe since 1870: An International History* (New York: Harper & Row, 1973). Henri Ellenberger also mentions Bergson's involvement with mental medicine, specifying his knowledge of local hypnotists and hypnosis. Close examination of Bergson's writings does indeed indicate that his theories of fluidity and imagistic thought processes were informed by the new psychiatric research. Ellenberger also discovered that Bergson wrote an early article on the mechanism of hypnosis and an interior visual language: "De la simulation inconsciente dans l'état d'hypnotisme," *Revue philosophique* 22 (1886): 525–531. Only more research can establish the precise impact of neuropsychiatry on Bergson's conceptions of the irrational, of creativity, and of the unconscious. I have attempted a beginning here.

54 Bergson uses the term *imprinting* in his *Essai sur les données immédiates de la conscience* [1889], 8th edn. (Paris: Alcan, 1911), p. 12.

55 Ibid., pp. 11–14.

56 Ibid., esp. pp. 11–12, 14.

57 Ibid., pp. 13–14.

58 Ibid., pp. 11–14.

59 Fouillée reported on the discoveries and debates of the new psychology every month after 1883. His many articles devoted to psychology are enumerated in the *Revue des deux mondes: Table générale* (Paris: Bureaux des deux mondes, 1904), vols. 1–3, 1883–1904.

60 Alfred Fouillée, "Le Physique et le mental à propos de l'hypnotisme," *Revue des deux mondes* 105 (1891): 429–461; "Les Grandes Conclusions de la psychologie contemporaine—la conscience et ses transformations," *Revue des deux mondes* 107 (1891): 788–816.

61 Fouillée, "Les Grandes Conclusions," p. 815.

62 Fouillée, "Le Physique et le mental," pp. 433–434.

63 Ibid., pp. 431, 461.

64 Fouillée, "Les Grandes Conclusions," pp. 798–799.

65 Ibid., p. 798. Fouillée uses the same language and image of subterranean psychic theater in "Le Physique et le mental," p. 440.

66 Fouillée, "Le Physique et le mental," p. 446; see also 431.

67 Ibid., p. 445: "Les phénomènes hypnotiques prouvent précisément que des images toutes cérébrales peuvent être projetées sous forme d'objets réels."

68 Ibid., pp. 431, 442.

69 "Nothing is worse for a people than the autosuggestion of its own disintegration. By repeating to itself that it is going to fall, a people makes itself dizzy and induces the fall" (Alfred Fouillée, "Dégénérescence," pp. 793, 795).

70 Fouillée, "Les Grandes Conclusions," pp. 811–813.

71 Ibid., p. 814.

72 Ibid., p. 816.

73 Ibid., pp. 814–815.

74 Ibid., p. 815.

75 Ibid. Fouillée was only one of many political and social thinkers to be directly influenced by the new psychology. Books by both Susanna Barrows and Robert Nye isolate the way that antirepublican theorists, in particular Gustave Le Bon, channeled medical suggestibility into a new doctrine of the crowd. See Barrows, *Distorting Mirrors*, and Robert A. Nye, *The Origins of Crowd Psychology: Gustave Le Bon and the Crisis of Mass Democracy in the Third Republic* (London: Sage, 1975). I have concentrated on Fouillée because I am most concerned with the way that republicans incorporated the new irrationalism into their doctrine of liberalism, which paralleled the similar efforts of visual and decorative artists sponsored by the state.

76 A. Souques, "Charcot intime," *La Presse médicale* no. 42 (May 27, 1925): 697.

77 Recounted in Meige, *Charcot-artiste*, p. 8.

78 Ibid., pp. 7, 15. Souques states the same idea in "Charcot intime," p. 697.

79 Paul Richer and J.-M. Charcot, "Note sur l'anatomie morphologique de la région lombaire: Sillon lombaire médian," in *Nouvelle Iconographie de la Salpêtrière* 1 (1888): 13, 14–15.

80 Cited in Ernst Freud, *Sigmund Freud*, p. 117.

81 Paul Richer, Giles de la Tourette, Albert Londe, "Avertissement," *Nouvelle Iconographie de la Salpêtrière* 1 (1888): ii. For another interpretation of the Salpêtrière iconographic practices, see Didi-Huberman, *L'Invention de l'hystérie*.

82 The words are those of Henry Meige, *Charcot-artiste*, pp. 17, 10.

83 See Guillain, *J.-M. Charcot*, pp. 12–13; Pierre de Roux, *L'Hôtel Amelot et l'Hôtel Varengeville, Faubourg Saint-Germain* (Paris: Bank of Algeria, 1947), pp. 5–44. The rococo architect Jacques Gabriel built the original residence in 1704 (de Roux, pp. 5–6).

84 On Charcot's salons, see Guillain, *J.-M. Charcot*, pp. 32–33; Roudinesco, *La Bataille*, p. 37; and Freud's account, in *The Letters of Sigmund Freud*, ed. Ernst Freud (New York: Basic Books, 1975), pp. 193–204.

85 Meige, *Charcot-artiste*, p. 23; Guillain, *J.-M. Charcot*, p. 22; Souques, "Charcot intime," p. 696.

86 *Letters of Sigmund Freud*, p. 194 (letter of January 20, 1886).

87 Meige, *Charcot-artiste*, pp. 20–21, 22.

88 Ibid., pp. 23–24; see also Souques, "Charcot intime," pp. 696–697; and Goetschy, "Madame Charcot," pp. 41–51.

89 Meige, *Charcot-artiste*, pp. 18, 20–23, 17.

90 Ibid., pp. 24–26.

91 Ibid., pp. 18, 20, 22.

92 Goetschy, "Madame Charcot," pp. 41, 42, 51.

93 Souques, "Charcot intime," p. 696; Guillain, *J.-M. Charcot*, p. 21.

94 Meige, *Charcot-artiste*, pp. 20–21, 22.

95 *Journal des Goncourts*, 3: 932, March 8, 1889.

Index

eBooks – at www.eBookstore.tandf.co.uk

A library at your fingertips!

eBooks are electronic versions of printed books. You can store them on your PC/laptop or browse them online.

They have advantages for anyone needing rapid access to a wide variety of published, copyright information.

eBooks can help your research by enabling you to bookmark chapters, annotate text and use instant searches to find specific words or phrases. Several eBook files would fit on even a small laptop or PDA.

NEW: Save money by eSubscribing: cheap, online access to any eBook for as long as you need it.

Annual subscription packages

We now offer special low-cost bulk subscriptions to packages of eBooks in certain subject areas. These are available to libraries or to individuals.

For more information please contact webmaster.ebooks@tandf.co.uk

We're continually developing the eBook concept, so keep up to date by visiting the website.

www.eBookstore.tandf.co.uk

Also in the *In Sight: Visual Culture* series:

The Feminism and Visual Culture Reader
Edited by Amelia Jones

Challenging the notion of feminism as a unified discourse, *The Feminism and Visual Culture Reader* assembles a wide array of writings that address art, film, architecture, popular culture, new media and other visual fields from a feminist perspective.

Combining classic texts with six newly commissioned pieces, all by leading feminist critics, historians, theorists, artists, and activists, *The Feminism and Visual Culture Reader* provides a framework within which to understand the shifts in feminist thinking in visual studies. The reader also explores how issues of race, class, nationality and sexuality enter into debates about feminism in the field of the visual.

Hb: 0–415–26705–6
Pb: 0–415–26706–4

Available at all good bookshops
For ordering and further information please visit:
www.routledge.com

Related titles from Routledge

The Visual Culture Reader
Edited by Nicholas Mirzoeff

This thoroughly revised and updated second edition of *The Visual Culture Reader* brings together key writings as well as specially commissioned articles covering a wealth of visual forms including photography, painting, sculpture, fashion, advertising, television, cinema and digital culture.

Taken as a whole, these essays provide a comprehensive response to the diversity of contemporary visual culture and address the need of our postmodern culture to render experience in visual form.

Hb: 0–415–25221–0
Pb: 0–415–25222–9

Available at all good bookshops
For ordering and further information please visit:
www.routledge.com